EARTH FROM ABOVE 365 Days

Photographs by
YANN ARTHUS-BERTRAND

Additional photography by JOAKIM BERGLUND, HANS BLOSSEY, HELEN HISCOCKS, PHILIPPE MÉTOIS, TOMASZ STEPIEN, VINCENT M.

Coordination of captions by Olivier Milhomme and François Le Roch-Briquet

With text by

Nathalie Chahine, François Chartier, Isabelle Delannoy, Pascale d'Erm, Dr. Peter H. Gleick, Gary Haq, Clémence Hébert, Jean-Marc Jancovici, Tristan Lecomte, Grégoire Lejonc, Julien Leprovost, François Letourneux, Alain Liébard, Serge Orru, Pierre Rabhi, Jean-Christophe Rufin, Pierre Sané, Alan Simcock, Florian Thévenot, and John Whitelegg

Translated from the French by Anthony Roberts

ABRAMS, NEW YORK

COVER IMAGES: June 10/New Caledonia, France (front); February 09/Cape Cana, Dominican Republic (back); July 26/Mount Discovery, Antarctica (spine)

PHOTOGRAPHIC CREDITS: All the photographs in this book are by Yann Arthus-Bertrand, with the exception of February 11 (© Hans Blossey), March 06 (© Joakim Berglund), July 16 (© Helen Hiscocks), July 23 (© Tomasz Stepien), November 30 (© Vincent M.), and December 09 (© Philippe Métois).

The photographs in this book are distributed by Agence Altitude, Paris, France (www.altitude-photo.com).

ENGLISH-LANGUAGE EDITION:

Editor: Esther de Hollander Designer: Shawn Dahl Cover design: Shawn Dahl Production Manager: Jules Thomson

Project Manager: Magali Veillon

Cataloging-in-Publication Data has been applied for and may be obtained from the Library of Congress.

ISBN: 978-0-8109-8461-5

Copyright © 2008 Éditions de La Martinière, an imprint of La Martinière Groupe. Paris

English translation copyright © 2009 Abrams, New York

Originally published in French under the title 365 jours pour réfléchir à notre terre by Éditions de La Martinière, Paris, 2008.

Published in 2009 by Abrams, an imprint of ABRAMS. All rights reserved. No portion of this book may be reproduced, stored in a retrieval system, or transmitted in any form or by any means, mechanical, electronic, photocopying, recording, or otherwise, without written permission from the publisher.

Printed and bound in China

10987654321

Abrams books are available at special discounts when purchased in quantity for premiums and promotions as well as fundraising or educational use. Special editions can also be created to specification. For details, contact specialmarkets@abramsbooks.com or the address below.

115 West 18th Street New York, NY 10011 www.abramsbooks.com

THIS BOOK WAS PRINTED USING ECOLOGICALLY FRIENDLY PAPER AND INKS.

Preface SUSTAINABLE DEVELOPMENT AND THE FUTURE (Anne Jankeliowitch)

Introduction THE EARTH IN FIGURES—TAKING STOCK

January BRINGING ECOLOGY HOME (Serge Orru)

February CLIMATE CHANGE—OR CLIMATE APOCALYPSE? (Jean-Marc Jancovici)

March ANCIENT FORESTS IN PERIL (François Chartier and Grégoire Lejonc)

April BIODIVERSITY—A CONDITION OF SURVIVAL (François Letourneux)

May THE SEAS AND THE OCEANS (Alan Simcock)

June FRESHWATER (Dr. Peter H. Gleick)

July AGROECOLOGY—AN ALTERNATIVE FOR THE FUTURE (Pierre Rabhi)

August RENEWABLE ENERGY (Alain Liébard)

September MOBILITY, EQUITY, AND ENVIRONMENT (John Whitelegg and Gary Haq)

October ABOLISHING POVERTY (Pierre Sané)

November HUMANITARIAN WORK AND SUSTAINABLE DEVELOPMENT (Jean-Christophe Rufin)

December TRADE WILL BE FAIR (Tristan Lecomte)

CONTENTS

SUSTAINABLE DEVELOPMENT AND THE FUTURE

Since 1950, the world's economic growth has been phenomenal; production of goods and services has increased sevenfold. During the same period, the world's population has increased twofold; the yield of the fishing industry and the volume of meat production, fivefold. Likewise, energy demand is five times greater today than it was in 1950; consumption of oil—half of which goes to fuel the transport industry—is seven times greater; and emissions of carbon dioxide, the greenhouse gas principally responsible for climate change, four times greater. Since 1900, there has been a sixfold increase in human consumption of freshwater, most of which is used for agricultural purposes.

At the same time, 20 percent of the world's population has no drinking water, 25 percent lives entirely without electricity, and 40

percent lacks sanitary facilities. An astonishing 842 million people are undernourished, and at least 50 percent of humankind lives on less than two dollars per day.

One-fifth of the planet's population lives in industrialized countries, amid modes of production and consumption that are excessive and polluting. The remaining four-fifths lives in developing countries, mostly in dire poverty, and is forced to exert great pressure on natural resources just to survive. The consequence is a steady deterioration of the earth's ecosystem, which today is stretched to the limit.

And that's not all. By 2050, there will be nearly 9 billion people on the planet, most of them in developing countries. Economically, these countries will have to catch up with the industrialized nations

without overtaxing the natural limits of the earth, which cannot simply expand to accommodate them.

If all humankind lived like Westerners, we would need two more planets just like this one to satisfy the demand. Nevertheless, there is a way to improve the living conditions of today's majority while preserving the world's natural resources for coming generations. We must promote technologies that pollute less and that are more sparing of water and energy. This approach—sustainable development—holds out the possibility of real progress for humanity. It doesn't necessitate consuming less, but consuming more wisely.

The situation is not yet hopeless, nor is disaster inevitable. Changes are necessary and, most important, possible. Sustainable development—based on a system of economic growth that respects both humankind's needs and the natural resources of our unique planet—would allow us not only to improve the living conditions of all the world's inhabitants, but also to safeguard the future.

This means we must turn to new ways of producing what we need, and we must change our habits of consumption. This is a task in which all citizens of the world must share, playing their part in ensuring a future for the earth and for all humankind.

There is not a moment to lose.

Anne Jankeliowitch for Yann Arthus-Bertrand and his EARTH FROM ABOVE team

INTRODUCTION

THE EARTH IN FIGURES TAKING STOCK

The world's population has more than doubled in the last fifty years, and a further 50 percent increase is expected by the year 2050.

Year	Total population
1950	2.5 billion
2007	6.6 billion
2050	9.4 billion ¹

Imagine the Earth as a village with 100 inhabitants. Sixty of these people would live in Asia, 14 of them in Africa, 9 each in South America and Europe, 5 in North America, 2 in Russia, and 1 in Oceania.²

A large proportion of the population has no access to adequate health care or education.

- » 850 million people (1 in 7) are malnourished.³
- » 1.1 billion people (1 in 6) have no access to clean drinking water.4
- » 133 million children (1 child in 5) do not go to school, and 97 percent of these children live in developing countries.5
- » 774 million adults (1 adult in 5) cannot read or write: 6 of these, 544 million are women.
- » 19 percent of children between 5 and 14 years old are obliged to work.⁷

Rising demand for energy and a massive reliance on nonrenewable fossil fuels mean that these resources will not last long.

Energy source	Share of world output
Oil	35 percent
Gas	20.7 percent
Coal	25.3 percent
Nuclear	6.3 percent
Other (renewab	ple energy) 12.7 percent (10 percent of which are biomass, mostly wood)

- Every six weeks the world consumes as much oil as it did in one year in 1950.8
- Between now and 2020, our energy use has been projected to increase at the rate of 1.5 percent per year.9
- In 2007, 87.3 percent of primary energy production came from fossil fuels. 10

SIGNIFICANT INEQUALITIES

For many, health care is out of reach.

L	east developed countries	Developing countries	Industrialized countries	World
Mortality rate for child under 5 years old per thousand	dren 142	79	6	72
Risk of mother's death as a result of childbir	1 in 24	1 in 76	1 in 8,000	1 in 92

- In 2006, the average life expectancy worldwide was 67 years. In Africa, it was 53 years, while in North America it was 77 years, and in Japan, 82 years. 12
 - In 2007, HIV/AIDS affected 33.2 million people.¹³ Of these, 90 percent lived in developing countries and 63 percent lived in sub-Saharan Africa.

A minority of the population consumes most of the world's resources.

- 20 percent of the world's population live in developed countries.
 - » They consume 48.7 percent of the total world output of energy. 14
 - » They eat 44 percent of the total world output of meat. 15
 - » They own about 80 percent of the total number of motor vehicles.

Unequal access to clean drinking water produces major disparities in consumption.

Country	Daily consumption of clean water per person ¹⁶
United States	156 gallons (590 liters)
France	77 gallons (290 liters)
China	23 gallons (88 liters)
Mali	3 gallons (12 liters)

^{1.} Total Midyear Population for the World: 1950–2050, U.S. Bureau of the Census, International Data Base, www.census.gov/jpc/www/idb/worldpop.html. 2. World Population Data Sheet 2002, Population Reference Bureau, www.prb.org. 3. FAO 2005 statistics.

^{4.} Joint Monitoring Programme September 2002, UNO. 5. Human Development Report (HDR) 2002, UNDP. 6. UNESCO, 2007 figure released on World Literacy Day, September 8, 2007. 7. UNICEF. 8. Vital Signs 2006–2007, Worldwatch Institute (oil consumption in 1950).

^{9.} World Energy Outlook 2006, AIE, www.iea.org. 10. Key world energy statistics 2007, AIE, www.iea.org. 11. The State of the World's Children, 2008, UNICEF. 12. World Population Data Sheet 2006, Population Reference Bureau. 13. ONUSIDA. 14. Key world energy statistics 2007, AIE, www.iea.org. 15. FAO statistic 2002. 16. FAO, AQUASTAT database.

SIGNIFICANT ISSUES THAT CONFRONT HUMANITY

Human activity accelerates the conditions leading to the greenhouse effect, leading to climate change.

- For more than 150 years, industry has been releasing carbon dioxide into the atmosphere at a rate millions of times greater than the rate at which it ever accumulated underground.
- If nothing is done to stop it, global temperatures could rise by 11°F (6°C) by 2100,¹⁷ with drastic economic, social and environmental consequences.
- To limit the catastrophic effects of global warming, carbon dioxide emissions must be reduced worldwide by 50 percent—with an 80 percent reduction in carbon dioxide emissions by the world's most developed countries.

We must ensure that our levels of energy consumption allow for sustainable development.

Country ¹⁸	Equivalent carbon dioxide emissions in lbs (kg) per inhabitant per year (2000)	Rate by which present emmissions exceed the sustainalbe level of 1100 lbs (500 kg) per inhabitant per year
USA	12,407 (5,628)	11.3
Germany	5,904 (2,678)	5.4
France	3,613 (1,639)	3.3
Mexico	2,531 (1,148)	2
Mozambique	60 (27.3)	less than sustainable level

The loss of biodiversity not only damages the sustainability of an ecosystem, it also has a negative impact on land fertility and the possibility of discovering new medicinal resources.

- In 2007, 25 percent of mammals, 12 percent of birds, and 30 percent of fish were in danger of extinction.¹⁹
- · Half of the world's mangrove forests, essential to the life cycles of 75 percent of the world's commercialized marine species, have disappeared.
- Primary tropical forests, which constitute the world's greatest reserves of biodiversity, are being destroyed at a rapid rate—over 32 million acres (about 13 million hectares) annually (an area twice the size of Ireland)

BRINGING ECOLOGY HOME

Man is neither big nor small: he is only the size of the things he knows how to love and respect.

Is it asking for the moon for us to respect the earth?

Is it right for us to value ecology and ethics, to promote human rights and be on the side of living things? Is it correct to defend biodiversity and cultural diversity?

Is it utopian folly to dream of a civilization founded on equality and mutual respect?

Everyone has his or her own answers to these questions. But every one of us also has his share of responsibility to our planet, our own beautiful, delicately balanced blue world, rolling through the infinite universe.

We have no right to lead humanity into a graveyard of the elements, or to behave like egotistic "masters of the universe." We must acknowledge, now, that our present way of life is destroying the environment, now and forever. East, West, North, and South—each one of us must contribute to a new wave of planetary ecological awareness. Let us seed this idea both within ourselves and around ourselves. With undaunted—and peaceful—activism, we can create a philosophical revolution. Let us begin to live in harmony with nature, and rediscover our link with what is essential to life.

At this beginning of the twenty-first century, we need to call into question the techno-economic dogmas by which we continue to be ruled. We need to win over the decision makers and skeptics, awaken the sleepers, and bring our full quota of human energy together in a single coalition. We must dispose of our present civilization (in which everything is disposable anyway) and move on to one that is sustainable. This must be the first step if we are to prevent the continued massive erosion of our natural environment and the accelerated extinction of species. After all, the molecules you breathe, the paper you are holding in your hands at this very moment, are gifts of the earth. In everything you do, every minute of your existence, you are connected to the great chain of life.

"Let us create a 'light' economy," wrote eco-designer Thierry Kazazian. Our present economy is compelled to become ecological; if it does not become ecological, we will cease to exist. So let us put a stop to all pointless production. Instead, let us produce things that are genuinely useful. The lives of future generations should not be endangered for the sake of profits made by companies and stock exchanges. Every day, we sign a bad check on a planetary scale, wreaking appalling ecological damage wherever we go. Our children and grandchildren do not need to inherit this damage.

The great paradox we face is that the economy of our present world does not take into account the immense services offered to all living things by the biosphere. From now on we must take account of the ecological price of the products we make, so as to interrupt the dangerous spiral of waste in our world.

Everything depends on our power to propose, invent, create, and believe. Our businessmen and politicians must be constantly prodded to change direction because soon there will be 9 billion human beings on the face of this earth, and already climate change is causing significant disasters and disruptions. It is crucial that all our regional, national, and international political strategies take account of this.

Ecology requires democracy: We all breathe the same air. Water is essential to our existence. The earthworms, the trees, the chimpanzees, the bees, and the stinging nettles are our best friends. So, citizens of the earth, let us bring ecology home, and may the seeker of common sense supplant the seeker of oil.

We must all sign on to the great cause of the environment—for none of us wants to endure the fate of the lonely lighthouse-keeper who views an immense horizon but has a very limited existence.

Our concern for our living environment must determine the quality of life offered by our human civilization. Now is the time for us to embrace our Mother Earth in a spirit of ecology and humanism, rooted in the universal; and, in order that our world can be truly viable and balanced, men and women should have equal access to all the levers of power, all over the planet.

We must work hard to make our world a sweeter place.

Here and everywhere, all of us must work together.

So open this book, day after day, or at random; read it, savor and absorb the power of its superb photographs; then consider what you yourself can do for the reconciliation of man and nature, for the individual and the collective good, now and in future years.

Serge Orru

Director of the World Wildlife Foundation (WWF) France

Mission of Aviation sans Frontières to Casamance, Senegal (12°29′N - 16°33′W)

Casamance, a broad semiarid region covering 11.583 square miles (30.000 square kilometers) in southwestern Senegal, is sandwiched between the Gambia and Guinea-Bissau, some 373 miles (600 kilometers) from Dakar. It possesses next to no medical infrastructure. To assist in the evacuation of the sick and injured, the nongovernmental organization (NGO) Aviation sans Frontières is constantly on call to ferry patients in urgent need of treatment to the local hospital at Tambacounda—or even, in the most serious cases, to distant Dakar, Specializing in emergency assistance to isolated communities, Aviation sans Frontières is one of many hundreds of international NGOs functioning in Africa, a continent paralyzed by underdevelopment. Out of 650 million Africans, 40 percent live below the poverty line (on less than one U.S. dollar per day); life expectancy is around 46 years, compared to 66 years in the rest of the world. Civil war, political instability, AIDS, and famine make this situation even direr. Today, contributions toward development aid are constantly diminishing, but the world's 63,000 NGOs and government organizations continue to provide direct assistance to the poorest people.

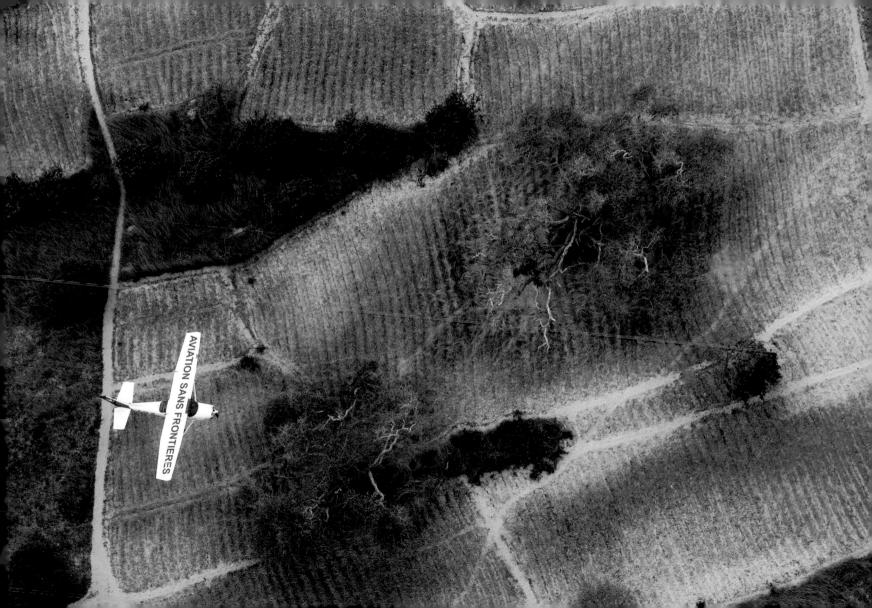

Lake Jökulsárlón, at the southern end of the Vatnajökull Glacier, Iceland $(64^{\circ}00'N - 17^{\circ}03'W)$

The dark parallel lines on the glacier's surface consist of volcanic ash residue from successive eruptions over the last few centuries. This zone lies on the edge of the Vatnajökull ice cap, where the ice flows down in multiple ribbons before melting. The ice cap, covering 3,108 square miles (8,050 square kilometers)—an area larger than Corsica—is the biggest in Europe. In its 3,280-foot (1,000-meter) depth, it takes in several active volcanoes, most notably the Grímsvötn. Magma rising beneath it has caused the base of the ice cap to melt, and in major eruptions (like that of 2004) columns of gas and ash burst through the frozen layer into the atmosphere. The intense heat blasts forth quantities of water that filter through layers of ice and rock to the surface. These spate waters (*iokulhlaup* in Icelandic) then spread out over the plains, carrying all before them.

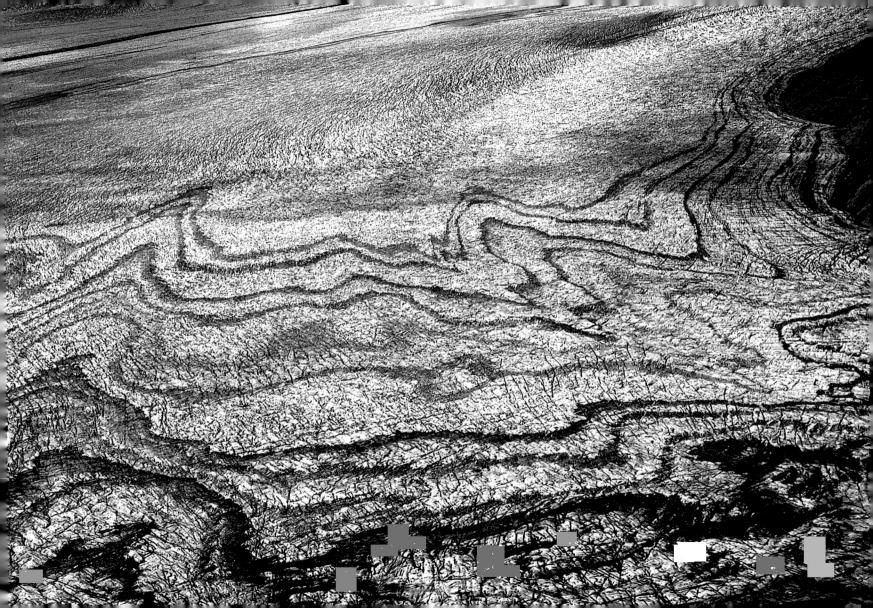

Cattle in marshland, Nhecolândia region, pantanal, Mato Grosso do Sul, Brazil (19°27'S - 56°38'W)

With its 72,510 square miles (187,8000 square kilometers), the pantanal (which means marsh in Portuguese) forms one of the biggest freshwater wet zones on the planet. It extends across a major part of the Brazilian southwest, right up to Bolivia and Paraguay. In the dry season, thousands of head of cattle graze the grass-covered plains of the pantanal, but these natural pastures are short-lived. From November to March, they are inundated by the overflowing Paraguay River and its tributaries. During this period, the herds go back to the few islands of dry ground that remain above water, and are supplanted by an immense bird population of more than 650 species, many of which feed off the area's 250 species of fish. This veritable tropical Noah's Ark, whose biodiversity is comparable to that of the Amazon, is also home to jaguars, caimans, tapirs, and giant otters—and cohabitation between the increasing numbers of cattle and the animals, especially the jaguars, has become fraught. Overgrazing, the introduction of exotic new grasses, and the destruction of the forestland or around the edges of the marsh country to allow the cultivation of soybeans is threatening this fragile ecosystem, which has been a UNESCO World Heritage Site since 2000.

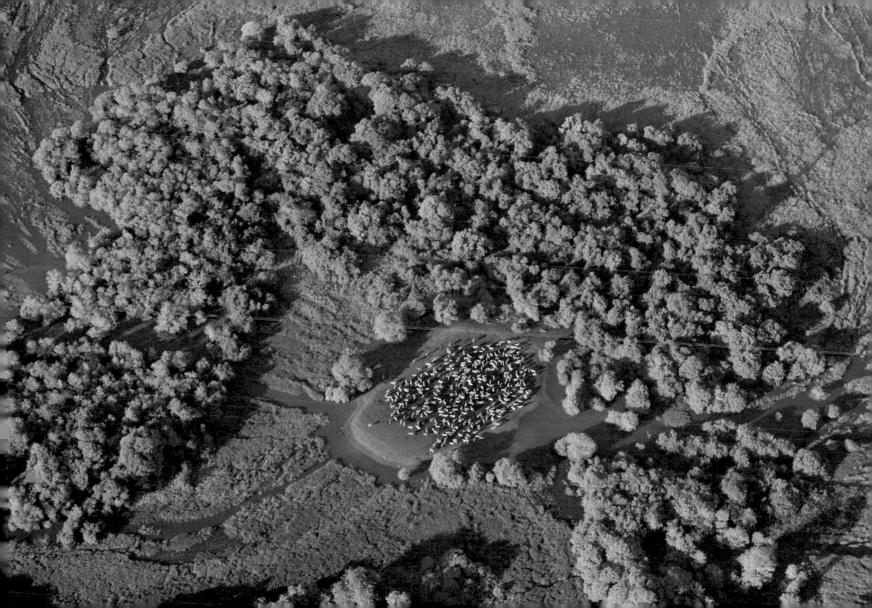

Market near the Xochimilco quarter, Mexico City, Mexico (19°20'N - 99°05'W)

Beneath this mosaic of parasol awnings is a lively, noisy local market, set up for the day in a Mexico City street. Shaded from the sun are stalls of fruits, vegetables, medicinal plants, spices, fabrics, and crafts. The street market is a vital daily institution in every corner of Mexico, testifying—along with the country's crafts, traditional clothing, and building facades—to a national affinity for scintillating, gay colors, like *rosa mexicana*, a particularly bright pink. On the international scene, Mexico has become the tenth richest economy on earth, and the richest in Latin America, boasting a great leap in growth since 2004. However, Mexico's economic success has left much of its population behind; 40 percent of Mexicans live below the poverty line, and 18 percent live in extreme want, particularly in rural areas.

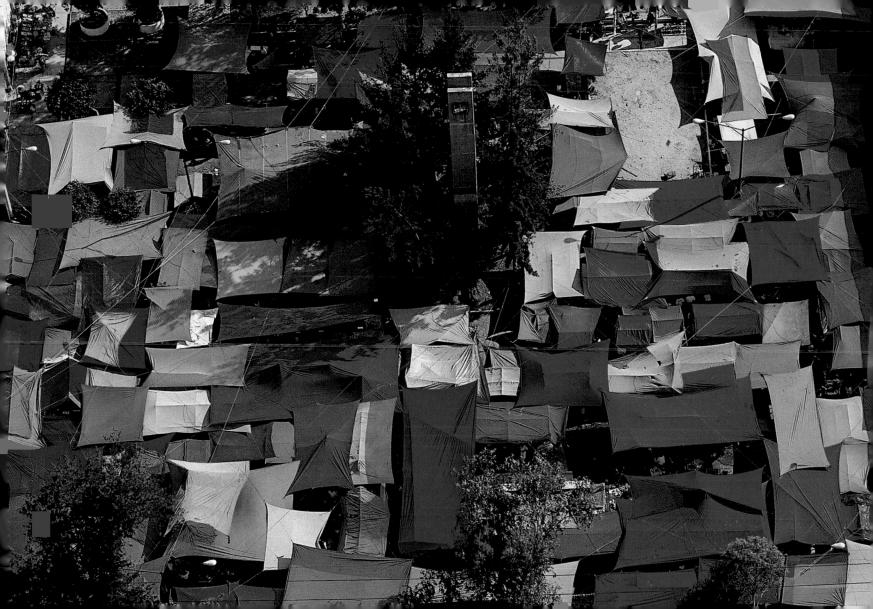

Pesticides being sprayed on a carrot field, Jeju-do, South Korea $(33^{\circ}27'N - 126^{\circ}34'E)$

The province of Jeju-do is an island 56 miles (90 kilometers) south of the Korean peninsula. The 6.400-foot-high (1.950-meter-high) Hallasan volcano, which originally created the island, is the highest mountain in the country. It consists of a main crater 1.312 feet (400 meters) in diameter and 368 smaller craters dispersed all around the island. The land is extremely fertile and is suitable for growing cacti, tangerines, pineapples, and carrots. The protective clothing worn by the agricultural workers would lead us to suppose that they are handling particularly dangerous products—and so they do. In 2000, Korea was the ninth most prolific fungicide and bactericide user in the world, with an annual consumption of 8665 tons. Worldwide. pesticides represent an annual turnover of 30 billion dollars. They have been the cause of at least 5 million poisonings and several thousand deaths in developing countries. Although the toxic nature of certain products is well known and their use is even forbidden in several countries, some are still used on a large scale and often without the precautionary measures advised by the industry that produces them. For many farmers, the wearing of protective clothing in a tropical climate is simply out of the question, while for others the clothes are unavailable. Pesticides pose a public health problem in every country in the world. Less than an ounce is enough to make 26 million gallons (10 million liters) of water undrinkable, and the toxic substance remains present in the treated products.

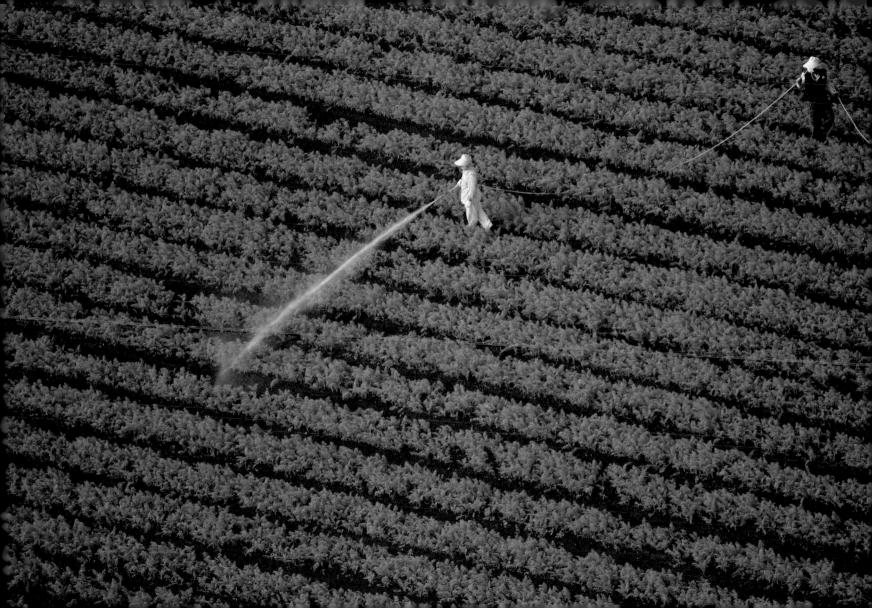

The Buddhist sanctuary of Bamian, Afghanistan (34°49′N - 67°31′E)

On March 10, 2001, Taliban fanatics, seeking to eradicate all trace of any religion other than their own, dynamited two world-famous 1,500-year-old sandstone statues of the Buddha, which had graced the cliffs above the town of Bamian. Respectively 125 feet (38 meters) and 180 feet (55 meters) tall, the statues formerly stood in huge niches that protected them from erosion. Five staircases conducted the faithful to the statues, which they could circumambulate via fresco-covered passages. These passages in turn led to caves adapted for prayers and ceremonies, whose ceilings were covered in friezes and stucco. In the sixth century, a thousand monks lived in and around the Bamian valley, and Buddhism and Islam coexisted harmoniously until the ninth century, after which the Buddhas of Bamian survived for more than a millennium before succumbing to the Taliban. Today, it has become urgent to shore up the cliffs that were severely weakened by the explosions, conserve the remaining artworks, and generally defend the site from looting and vandalism; significantly, shortly after they were blown up, fragments of the two sculptures appeared on the international art market.

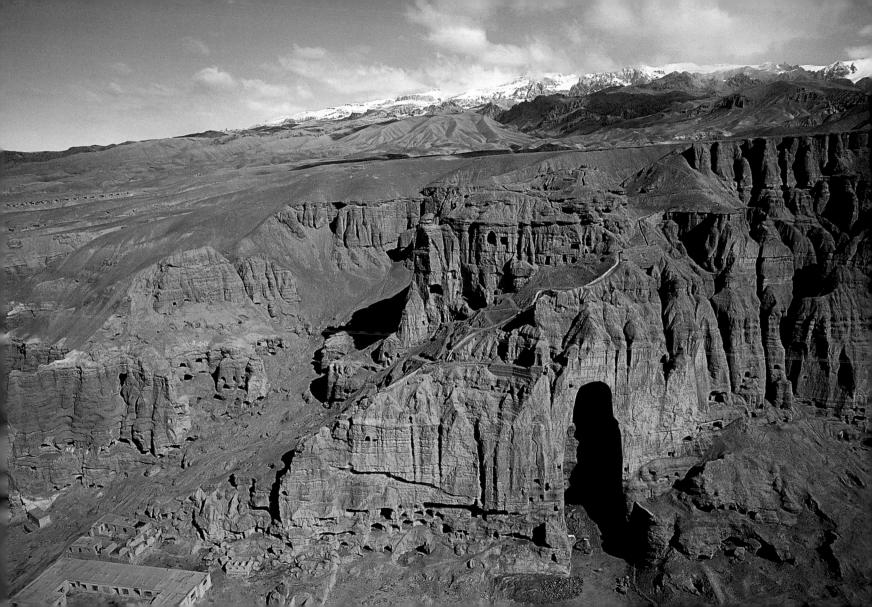

Boat among eroded icebergs, Uunartoq, Greenland $(60^{\circ}28'N - 45^{\circ}19'W)$

Most of the icebergs drifting in Baffin Bay and the Labrador Sea originate on the west coast of Greenland. Every year between ten thousand and forty thousand of them make their appearance. In spring and summer, at the tops of the fjords, the glaciers "calve," meaning that blocks of ice break loose under pressure from the ice behind. from the sea swell, and from the tide. To deserve their name, icebergs (literally "ice mountains") must officially rise at least 5 meters above the surface of the water. They move about and run aground at the mercy of the winds and currents. The largest of them, with shapes that are more and more eroded the older they get, take two or three years or even longer to arrive off Newfoundland in the North Atlantic, and some even drift below the 40th parallel. One of these was the cause of one of the greatest sea disasters in history when the *Titanic* went down in 1912, and over 1,500 people lost their lives. The Greenland ice cap is the largest in the world after that of the continent of Antarctica. Born from the accumulation of snowfall for the last hundred thousand years, it covers 82 percent of the vast island and its thickness in places exceeds 9,800 feet (3,000 meters). If all this immense reserve of ice were to melt, the general level of the world's oceans would rise by nearly 23 feet (7 meters). With the effects of global warming, the Greenland ice cap is now melting at a rate of 60 cubic miles (248 cubic kilometers) per year, and scientific studies have shown that the phenomenon has speeded up significantly in the last ten years.

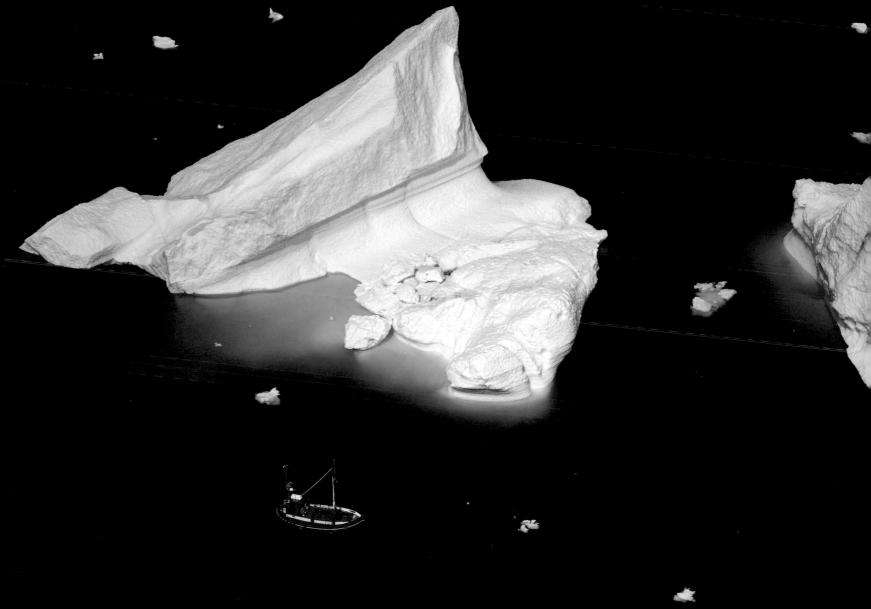

The Louvre Pyramid, Paris, France (48°52′N - 2°20′E)

This 71-foot-tall (21.65-meter-tall) transparent pyramid at the heart of the Louvre Palace in Paris has covered the entrance hall of one of the world's great museums ever since 1988. A spectacular technological achievement in itself, the pyramid consists of 603 diamond shapes and 70 triangles of glass mounted on a metal frame weighing more than 95 tons. This contemporary structure requires a special form of maintenance. It was only in 2003, after over a year of work, that a French firm invented a robot capable of cleaning it automatically. A single operator can control this robot from the square below, using a sophisticated mechanism never before developed to clean the windows. A well of light in the midst of the historic buildings that had been the residences of French kings, the pyramid has become the emblem of the Louvre Museum. All the same it represents just one outer aspect of the otherwise wholesale changes made to the museum, within the framework of a broad restructuring project carried out by the Chinese-American architect I. M. Pei. In 2007, the collection of 35,000 art objects, paintings, and sculptures assembled in over 645,830 square feet (60,000 square meters) of rooms dedicated to the museum's permanent exhibitions attracted nearly 8.3 million visitors.

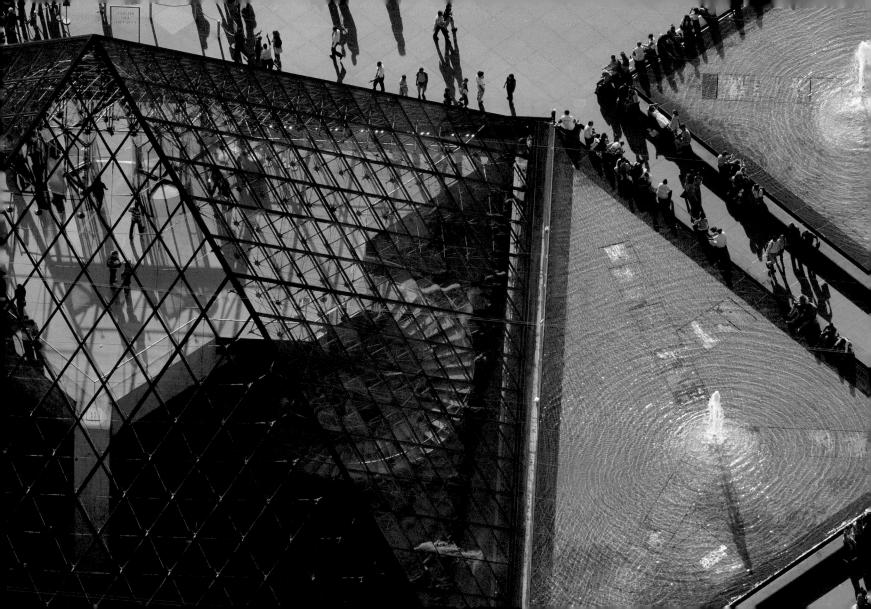

Piles of apples, Plougrescrant, Côtes d'Armor, Brittany, France (48°51′N - 3°14′W)

These cider apples have been left in this field as feed for livestock. Brittany, which produces 25 percent of France's cider apples, has been faced with overproduction for many years now, largely owing to a steady 5 percent annual decline in the consumption of cider. As France's foremost postwar agricultural zone, Brittany produces some 40 percent of the nation's total agricultural output. But foreign competition, notably from the former Eastern Bloc, and pressures from buying centers have driven down prices for produce by an average of 25 percent in the last three years. The solutions under consideration call for diversification and the development of lines of "quality" products. Today Brittany is France's number-one producer of organic chickens, and its number-two producer of milk.

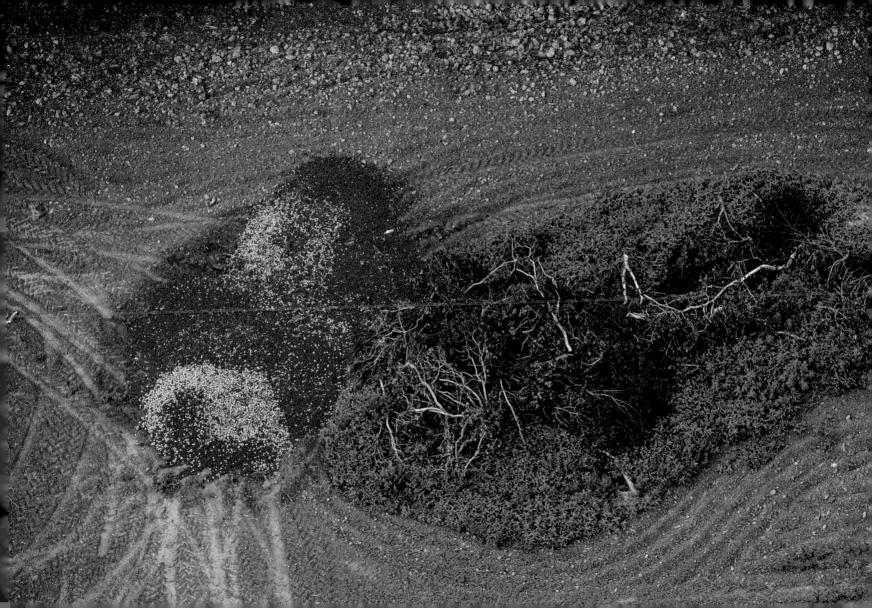

Iguazu Falls, Missiones Province, Argentina (25°41'S - 54°26'W)

The Iguazu Falls, on the border between Brazil and Argentina, are 230 feet (70 meters) tall and trace a semicircle 1.68 miles (2.7 kilometers) long, which is admired by some 1.5 million visitors every year. On the Argentine side, they are integrated into the Iguazu National Park, which was added to the UNESCO list of World Heritage Sites in 1984. This park alone contains about 44 percent of the country's animal species and constitutes one of the least altered vestiges of the South American Atlantic jungle. A unique ecosystem of subtropical forest, this zone extends to Brazil's ocean fringe and spills over into Paraguay. In general it is viewed as one of the five most important zones for the conservation of world biodiversity, given that it shelters some 20,000 plant varieties, of which 8,000 are endemic, and 1,668 species of land vertebrates, of which more than 500 can be found nowhere else on the planet. But this natural wealth is under great threat; in fact, deforestation and urbanization have already reduced the original area by 90 percent.

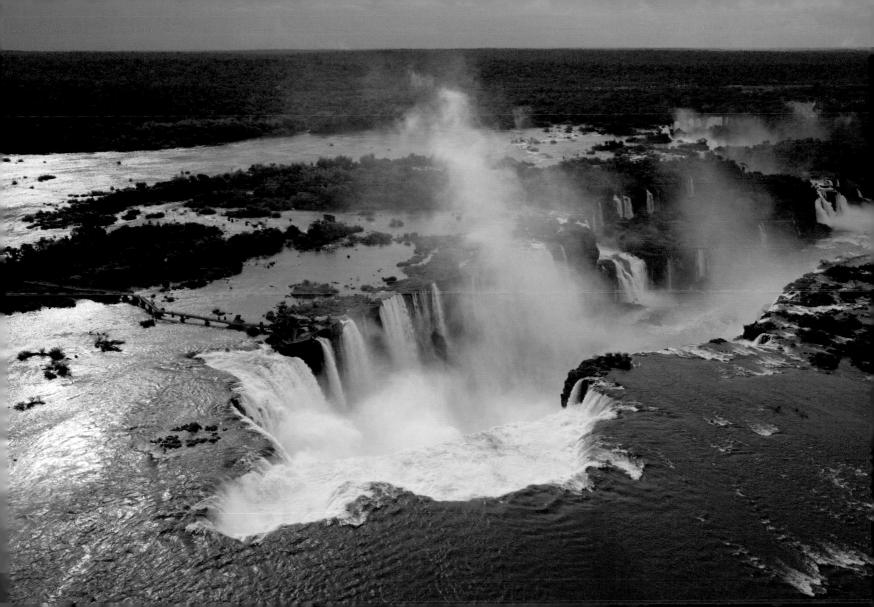

Police at the July 14 parade, Paris, France (48°52′N - 2°20′E)

Public order in France is maintained by two corps: the gendarmerie (103,000 men and women), a branch of the army run by the Ministry of Defense, and the police (240,000 men and women), a civilian force controlled the Ministry of the Interior. The gendarmerie patrol largely in rural areas and small towns, while the police take care of the cities. This division was made early in France's history. during the twelfth century, when the struggle against deserters and looters was entrusted to gens d'armes (armed people) of the mounted constabulary, whose authority covered the entire kingdom, with the exception of the cities. The cities organized their own security systems, and in 1254 King Louis IX formed the first armed forces specifically assigned to ensuring public safety. This consisted of a knight of the watch (up until the French Revolution, the security of the realm was the responsibility of the aristocracy), twenty mounted policemen, and twenty-six policemen on foot. This complement of police was put in place in every city in the kingdom; it was not until much later, in 1667, that Louis XIV's minister Colbert separated the functions of the justice system from those of the police. Colbert created the Royal Police Force, which may be seen as the ancestor of the present National Police force. Since 1996, detachments of the Police Nationale have taken part in the annual July 14 parade, in celebration of the national holiday.

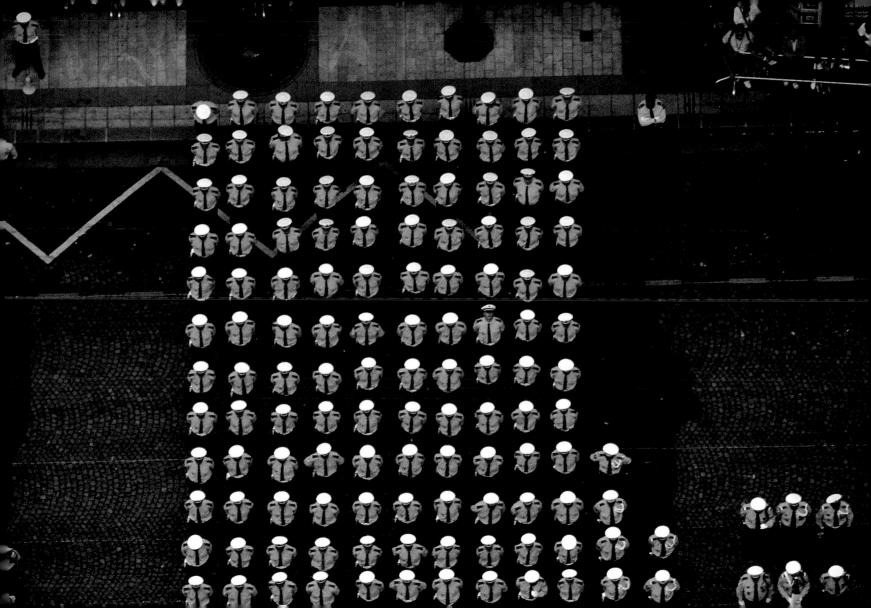

Fishing boats, Lake Victoria, Kenya (0°09'S - 4°37'E)

Lake Victoria, the second largest reserve of freshwater in the world, is shared by three countries: Uganda, Tanzania, and Kenya, which respectively control 45 percent, 49 percent, and 6 percent of its surface. For the 35 million people who live around Victoria's shores, the Nile perch has become a vital food resource. Introduced in the 1950s as a sport fish and a much-needed source of food, this predatory species—which can grow to a length of 6.6 feet (2 meters) and a weight of 441 pounds (200 kilograms)—quickly proliferated by devouring practically all the other fish in the lake; to date, two hundred species have disappeared altogether. Today, the dream has turned to a nightmare. World demand for Nile perch has steadily increased since the 1980s, and prices have skyrocketed to such an extent that most of Victoria's 350,000-ton annual yield is exported to Israel, the Middle East, and Europe, depriving the local population of an important source of protein. Putting the globalized economy ahead of traditional fishing for sport and food purposes has taken a heavy toll; moreover, the economic benefit will be short term, because both the catch sizes and the fish sizes are rapidly shrinking. Despite this alarming situation, authorities in Kenya, where the economy depends heavily on the export of Nile perch, are considering a fresh introduction of the fish.

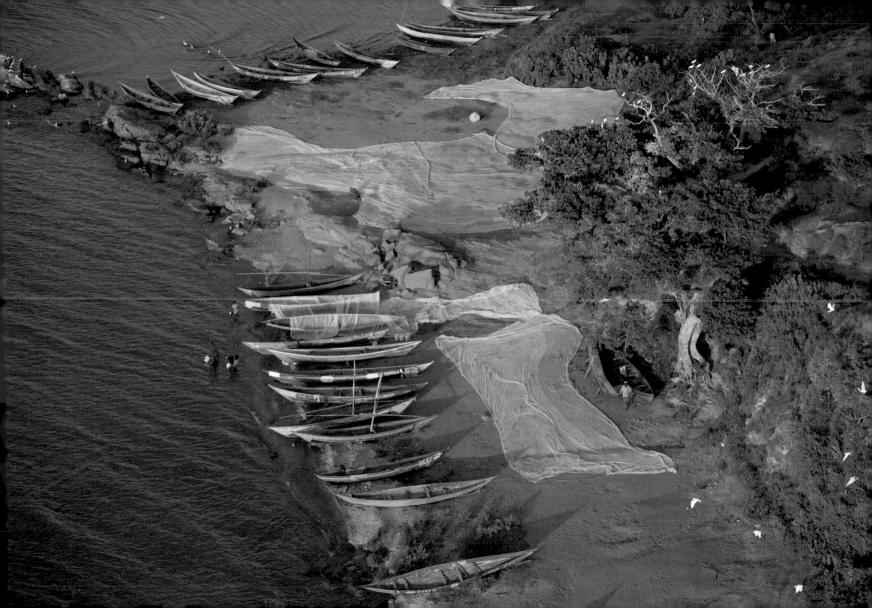

Camels and their jockeys after a race, January 2004, Ar Rayyan, Qatar $(25^{\circ}17'N - 51^{\circ}25'E)$

In Qatar, as in all the Bedouin monarchies of the Arabian Peninsula, camel racing is a hugely popular national sport. For several years, these races were at the root of one of the worst forms of child exploitation, with children being smuggled into the peninsula to become jockeys. Often barely six years old, these children were chosen for their light weight—they were not supposed to weigh more than 44 pounds (20 kilograms)—and they frequently suffered from undernourishment, dehydration, and broken bones; some of them were even killed in the camel races. In 2005, robots weighing less than 6.6 pounds (3 kilograms) replaced human riders, and in 2006, the local authorities definitively banned the use of child jockeys. In 2008, 2,500 of these Swiss-made robots were delivered to Qatar. But the exploitation of many of the world's children in a host of other spheres remains a disquieting reality. Today it is thought that 218 million children are forced to work for a living, many in dangerous conditions.

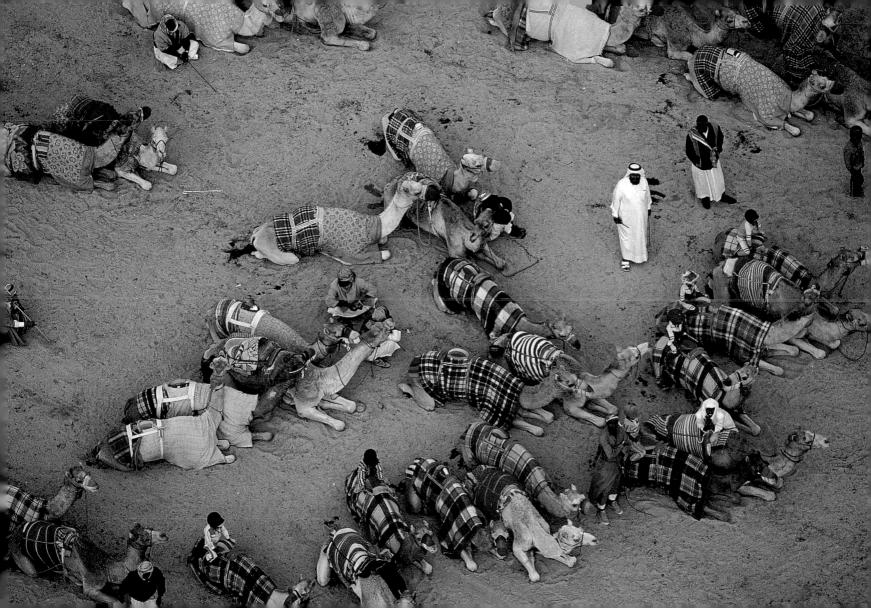

Laurentides, province of Quebec, Canada (48°00'N - 71°00'W)

The Laurentides Mountains, north of Montreal, run parallel to the Saint Lawrence River for which they are named. In this 8.494-square-mile (22.000-squarekilometer) region, covered in richly colored forest and boasting over four thousand different lakes and rivers, the forest is viewed as a national resource. Nature tourism, woodcutting, the extraction of side products such as maple syrup and mushrooms, and the paper-manufacturing industry have kept these vast woodlands at the heart of the local economy. This is a tradition in Canada, where half of the land's surface is clothed by trees (some 988 million acres [400 million hectares]). A third of this area is exploited, yielding an annual revenue of \$80 billion. Canada is the world's second largest producer of wood pulp for paper. after the United States. In order to limit pollution and reduce deforestation, the Canadian paper industry has adopted a more sustainable mode of production by eliminating chlorine, only using wood from certified pulp forests, and recycling more paper than ever. In Canada, paper is made up of 24 percent recycled paper and 56 percent wood shavings and offcuts; in other words, 80 percent of it consists of recycled material. This is significant in a world where 40 percent of trees felled go to the manufacture of paper.

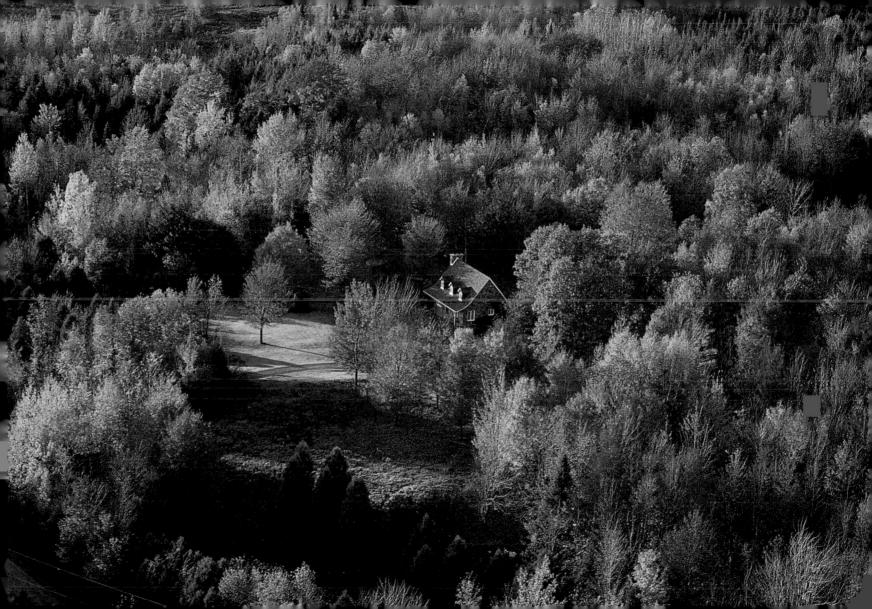

The salt pans at Salin-de-Giraud, Bouches du Rhône, France $(43^{\circ}22'N - 4^{\circ}41'E)$

Salt, long a staple for the conservation of food, is today used principally by the chemical industry. The color of salt marshes depends on the microorganisms present in the water; the hue varies according to the water's salinity. Low-salinity salt marshes are green because of the presence of algae. Where the salinity is greater, Dunaliella salina algae produce a hue varying between pink and red. The orange seen here reflects the prawns that inhabit moderately salty water. but in different conditions other bacteria contribute a variety of color nuances. The salt pans of the Camarque, close to the sea in the Rhône delta, are former lagoons that people have adapted to salt production. Today they occupy an area of 34,594 acres (14,000 hectares). Heavily populated by birds (pink flamingoes nest and feed here in abundance), they offer valuable ecosystems that contribute immensely to the biological richness of the Camargue, one of Europe's largest wetlands. The equilibrium of this environment depends on the management of the water supply, which is a source of conflict between rice farmers and salt producers. Such were the difficulties that arose in late 2007 that the French government voted to extend the Camarque's status as a regional nature park until February 18, 2011.

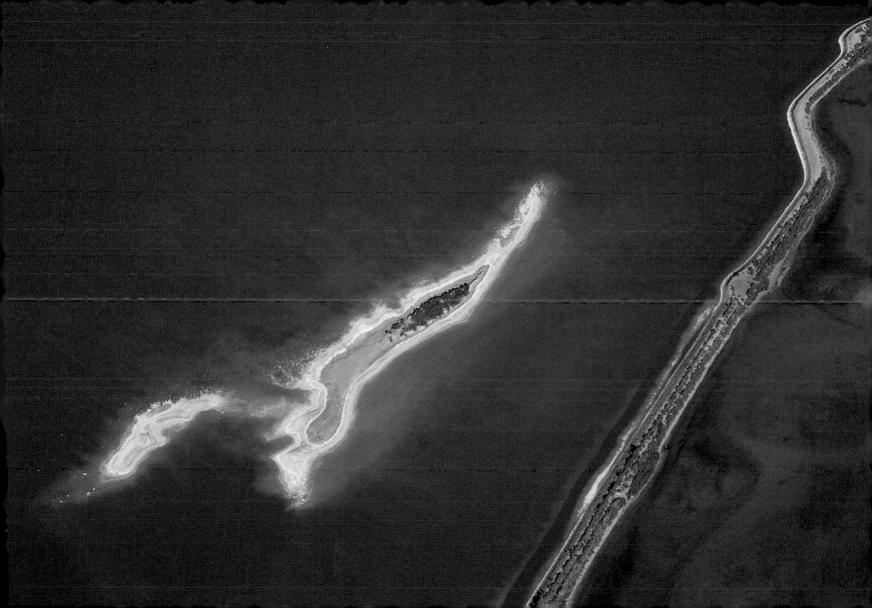

The gold mine at Poconé, pantanal, Mato Grosso do Norte, Brazil (16°10'S - 56°25'W)

The topsoil and subsoil of this land have been stripped away to access the veins of gold-bearing quartz beneath them. The tailings are washed and passed through a centrifuge to isolate their heavier constituents, and these are then mixed with mercury in order to extract gold. The wastewater from the mine has a characteristic red hue. The rivers and sediment that disperse the wastewater are contaminated by both the mercury and the tailings, which cover a surface of 4.6 square miles (12 square kilometers) in the Poconé region and contain up to two tons of mercury. Exposure to mercury vapor is very dangerous to local people, as well as to mine workers—from those who work at washing the gold to the refiners, who are in danger of mercury poisoning. The toxicity of this heavy metal is seldom recognized, and protective equipment is too expensive for small groups of gold washers. Since the late 1970s, it has been calculated that 5,000 tons of mercury have been spilled into the natural environment of Latin America. In other words, in Latin America, the volume of mercury waste released has been roughly equivalent to the quantity of gold extracted.

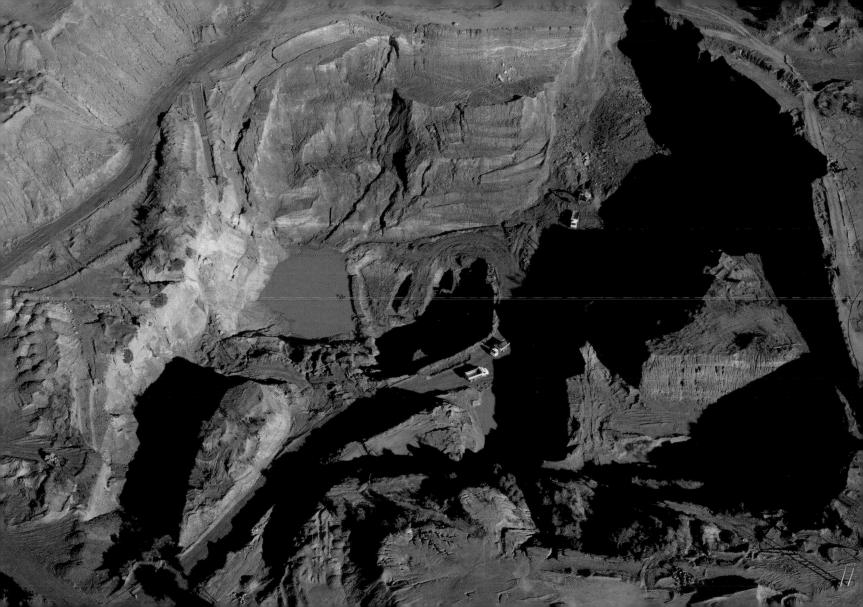

Domestic appliance dump, Aspropyrgos, Attica, Greece $(38^{\circ}02'N - 23^{\circ}35'E)$

Aspropyrgos, an industrial town that is a little over 9 miles (15 kilometers) northwest of Athens, has a population of about 30,000 people. Directly adioining the Aspropyrgos public garbage dump, squeezed between steelworks, refineries, and high-tension electrical pylons, there is a Rom (gypsy) encampment (rom means "human being" in Greek). In 2004, because of the Olympics, there were wholesale expulsions of Rom families from the places earmarked for sport infrastructure. Some of the Rom families, who traditionally make a living as scrap metal merchants, had been living in these places for over thirty years and were evicted from their longtime homes, losing everything they had. Yet contrary to the original plan, no sporting facilities were ever erected in this Athenian suburb. The situation provoked heavy criticism of Greece from the United Nations and the European Union, as well as two condemnations in 2005, one proceeding from the European Court of Human Rights. The Rom, a nomadic people originating in northern India, have hitherto largely escaped the yearly census, though many of them appear to have become settled. The European Rom population is estimated to be between 7 and 9 million, of whom 70 percent live in the territory of the most recent new members of the European Union.

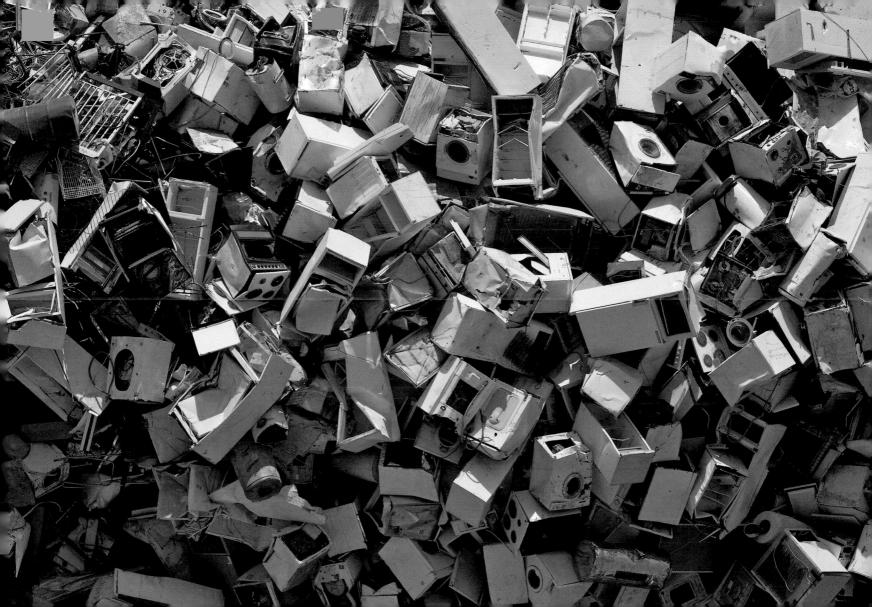

Wineglass Bay, Tasmania, Australia (42°10'S - 148°18'E)

Wineglass Bay, on the east coast of the great island of Tasmania, is fringed by a perfect curve of white sand; behind, the pink and gray peaks of the Hazard Mountains compose the skyline. The site looks like a tourist's paradise, but since it is located in the Freycinet National Park, it is heavily protected—as are Tasmania's seventeen other national parks, which cover more than a third of the island's land mass. The Tasmanian Wilderness World Heritage Area, for example, which encompasses 3.4 million acres (1.38 million hectares)—or 20 percent of the island—has been a UNESCO World Heritage Site since 1982. It constitutes one of the largest natural areas in the Southern Hemisphere. To protect this priceless heritage, the Tasmanian authorities have developed a particular brand of tourism focused on fully respecting the environment; the entire tourism infrastructure, including hotels and campsites, is located well outside the protected zones.

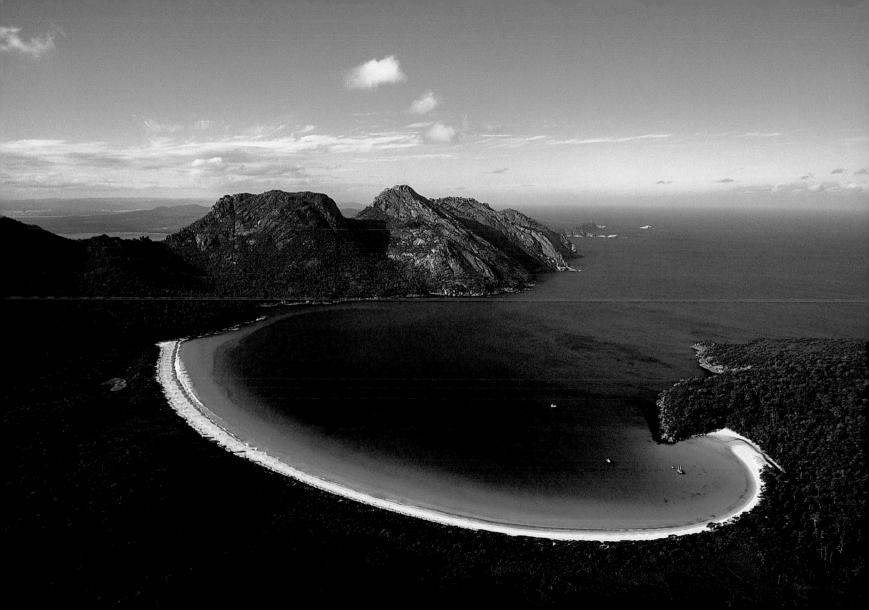

Lone rock in the desert, near Tishit, Aoukar region, Mauritania $(18^{\circ}00'N - 9^{\circ}30'W)$

In the landscapes of the Aoukar region in central Mauritania, traces of abandoned villages reveal a dying history. The pastoral Arab and Berber tribes of the central and northern regions of the country-Moors, Toucouleurs, Onalofs, and Peulsare perennial migrants, fleeing the onslaughts of desertification and locusts, and constantly in search of water sources, which grow scarcer by the year. In this vast desert territory, which covers over 390,000 square miles (1 million square kilometers, twice the size of France) and harbors a population of about 3 million, the nomadic way of life is much more than a search for greener pastures; it is a way of life of great antiquity. Yet ever since independence in 1960 and the successive droughts from 1970 to '80, Mauritania has seen an unprecedented trend toward a sedentary culture around the larger cities. The nomads, who formerly made up 75 percent of the population, were reduced to 6 percent by the year 2000. Although "nomad culture" is now fashionable, the world's 90 million nomads—constricted as they are in regions with artificial frontiers, and weakened by recurring drought or the destruction of the environment—are everywhere on the retreat.

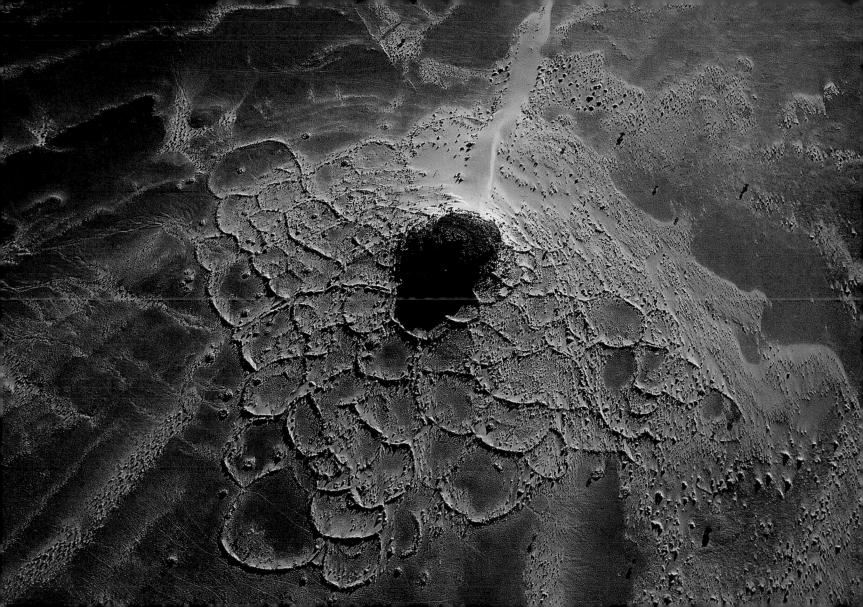

Playground at Beit She'an, Galilee, Israel (32°30′N - 35°30′E)

Several centuries ago the city of Beit She'an, in the Jordan Valley a little over 18 miles (about 30 kilometers) upstream of Lake Tiberias, commanded the roads that crossed eastern Galilee. The town's prosperity depended on the fertility of the valley and the presence of numerous springs and pools in the area. Conquered and occupied by a succession of invading peoples, it already had 30,000 to 40,000 inhabitants during the period of Byzantine rule in the fifth and sixth centuries. In the first years following the creation of the state of Israel, Israeli immigrants took possession of the town, which now has a population of 18,000 people. Within its modern urban sprawl, there exist numerous Roman and Byzantine remains, a Frankish fortress, a mosque from the Mameluke period, and a Turkish seraglio. The valley of Beit She'an is traversed by the Harod River, a 22-mile-long (35-kilometer-long) tributary of the Jordan; its water is polluted by industrial, agricultural, and urban effluents.

Since 1994, a restructuring program has been underway. The new water purification plant inaugurated in 2005 is expected to gradually lower pollution and salinity levels that had reached alarming heights. While Israel is capable of treating wastewater in this way, elsewhere in the world 2.6 billion people must go without proper decontamination facilities.

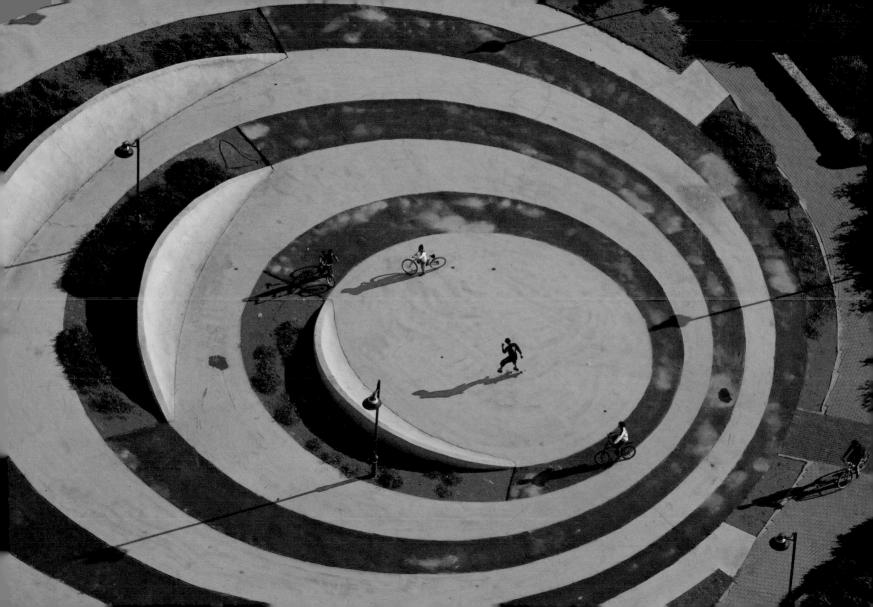

Gardens created in the middle of the desert in Wadi Rum, Jordan $(32^{\circ}30'\,\text{N} - 38^{\circ}30'\,\text{E})$

This water garden, a maze of canals and pools edged by giant reeds—in the midst of the desert—was undoubtedly built on the whim of a very wealthy man, for it is well known that the Kingdom of Jordan is desperately short of water. In this country of about 6 million inhabitants, the annual volume of water consumed far outstrips any renewable reserves. Underground aquifers are drawn upon at twice the rate of their natural replenishment; indeed, reserves that consist of non-self-replenishing fossil water are rapidly being used up. It is thought that the annual renewable ration of water per Jordanian is 5,000 cubic feet (140 cubic meters), one of the lowest in the world. And according to the Jordanian ministry of irrigation and water resources, this figure will have fallen to 3,200 cubic feet (90 cubic meters) by 2025. As a consequence, the authorities are currently creating informational campaigns to persuade Jordanians to reduce their water consumption. Recycling water has also become a necessity, and—on a positive note-2 billion cubic feet (60 million cubic meters) of recycled wastewater are already being used annually to irrigate crops and supply fish farms.

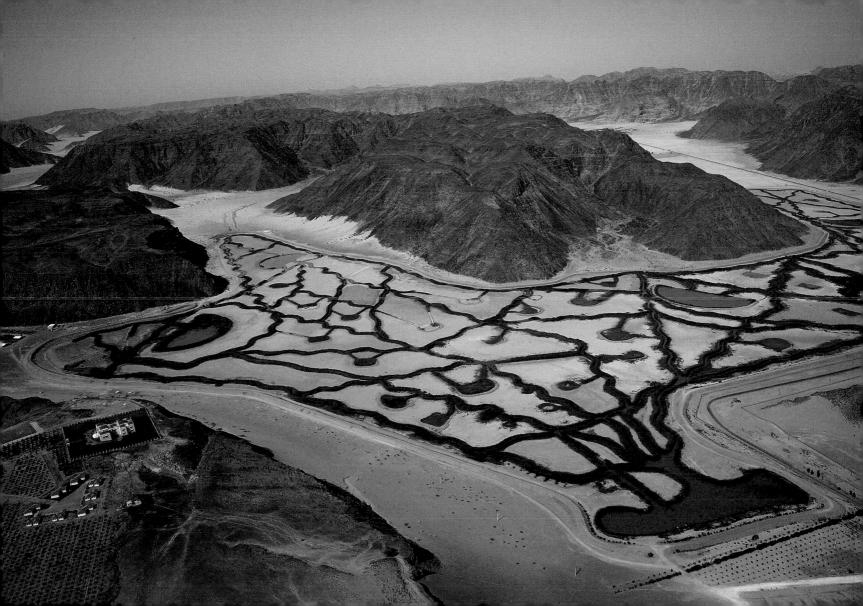

Feedlot near Bakersfield, California, USA (35°09'N - 119°06'W)

The United States is the world's largest producer of beef. The central Great Plains (Iowa, Nebraska, North Texas, and Colorado), where the flat and spacious region is well adapted to huge feedlots, is where the beef industry's animals are fattened. The beef sector has had a very strong ecological impact. Its overall contribution to the factors affecting global warming is higher than that of the world's entire transportation system, being responsible for 65 percent of emissions of nitrogen hemioxyde. This is a gas, basically attributable to manure, with a global warming potential that is 296 times higher than that of carbon dioxide. As the living standards of human beings improve, so does the increased consumption of meat and dairy products. The world's production of meat is forecast to more than double by 2050, increasing from 229 to 465 million tons per annum.

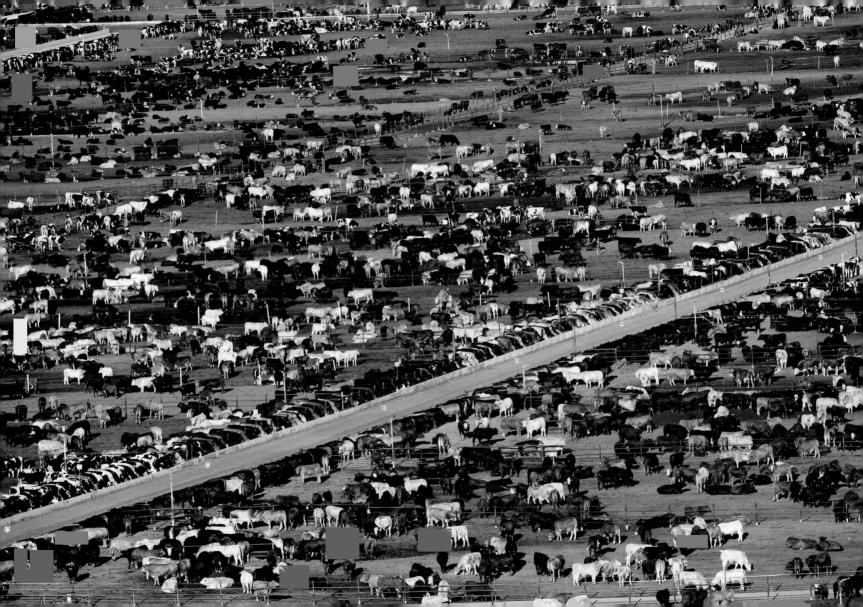

Metal sculpture, by Richard Serra, on a private estate, Yvelines, France $(48^{\circ}50'N - 1^{\circ}50'E)$

Fashioned by the American artist Richard Serra, this metal piece belongs to the minimalist school, characterized by aesthetic sobriety and economy of means. Space, an essential concept for this artist, is an integral part of the piece, which is positioned and balanced directly on the ground. Minimalist art emerged in the early 1960s, a period of strong economic growth, and a time when environmental pollution was beginning to cause serious damage. The larger, original minimalist movement was originally a reaction to the society of superabundance (in the 1930s), and decades later, to figurative art. It looks to have been prophetic; the Western model of total consumption has brought about an accelerated degradation of natural resources and a tripling of greenhouse gas emissions. It is estimated that if Europe continues to grow at an average annual rate of 2 percent, these emissions will increase by 50 percent before 2020. In the absence of a sustained individual and collective effort to curb consumption and energy use, the climatic imbalance will continue to worsen.

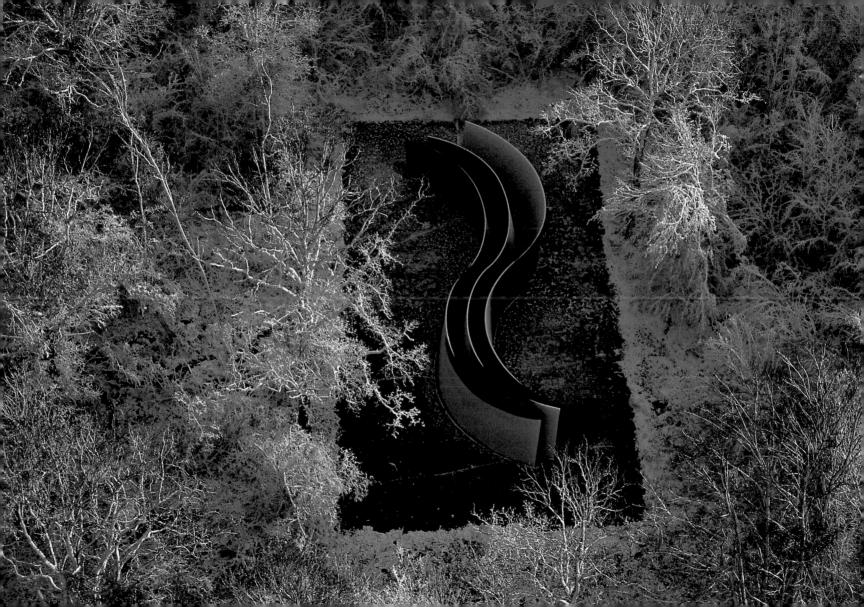

Watering maize fields near Aigues-Mortes, Gard, France (43°35'N - 2°13'E)

Maize is a plant of tropical origin. Sown in spring and harvested in fall, it is cultivated as a cereal; but because it is extremely demanding in terms of heat and irrigation, it requires large quantities of water in regions that have very dry summers. In France, thanks to the Rhône River, the Gard region is largely unaffected by summer droughts, and so the irrigation of maize in the Mediterranean region is clearly unwarranted. On the whole, France is a country with plentiful water resources—15 trillion cubic feet (440 billion cubic meters) of rainfall in a typical year—but good water management today is a worldwide concern because water consumption is rising twice as fast as population numbers. To allow for water shortages, countries like Israel have perfected increasingly economical irrigation techniques. In India, Jordan, Spain, and California, drip irrigation around the roots of plants has reduced agricultural water consumption by 30 to 70 percent, while raising crop yields between 20 and 90 percent. But still faced with persistent water shortages, some countries have now turned to recycling wastewater. After treatment, wastewater can furnish up to 30 percent of the water used by agriculture.

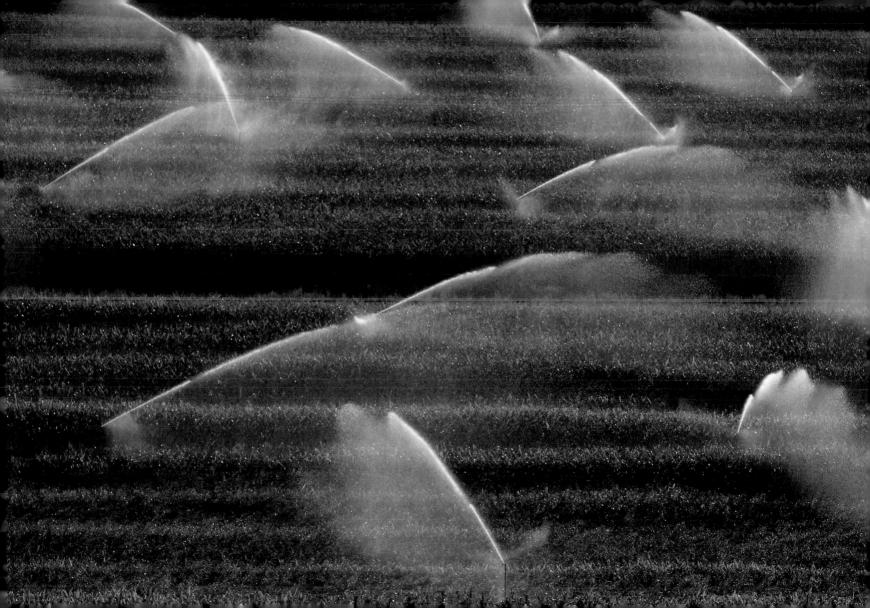

Gazelles, Somalia (6°00'N - 48°00'E)

A member of the antelope family, the gazelle is remarkable for its speed and grace. It can average 31 miles (50 kilometers) per hour over long distances, 62 miles (100 kilometers) per hour in short bursts. Gazelles tend to graze selectively, preferring tender shoots and grasses, and during the dry season they survive on moisture from plants and dew. Their frugal diet allows them to subsist in the plains and savannas of the Somali hinterlands. Apart from the mountains of the northern coast, which reach altitudes of 8,727 feet (2,660 meters), the country consists of a broad, semiarid plateau sloping gradually toward the sea. The only permanent vegetation is found along two rivers, the Shabeelle and the Jubba, which rise in the high plateaus of Ethiopia. Ever since the 1980s, Somalia has been in the grip of poverty and drought. The Ogaden War with Ethiopia, then civil war and repeated catastrophic droughts, have ruined the country. Today, dogged by political insecurity and a chronic lack of food, Somalia faces a situation more precarious than ever.

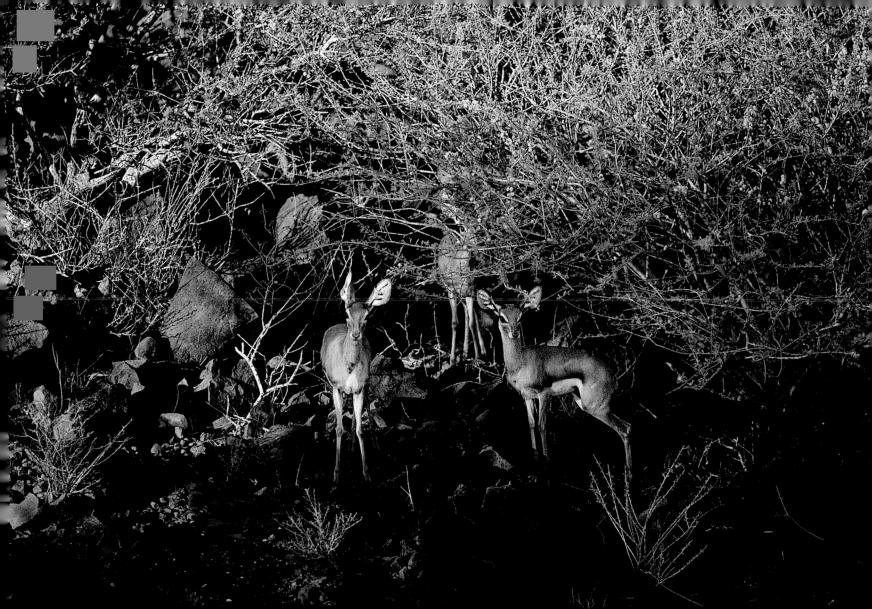

Shantytown of Alexandra, Johannesburg, Gauteng Province, South Africa $(26^{\circ}06'S - 28^{\circ}05'E)$

A district of Johannesburg of about 19 square miles (50 square kilometers). Alexandra is estimated today to have a population of about 470,000 people. although its infrastructure was originally planned to cope with no more than 70,000. The branches of the river that cross the township are so filled with garbage that they can no longer drain the area, and as a result, the annual floods are increasingly destructive; after a flood in 2000, 1,500 people had to be moved away and a cholera epidemic broke out. Alexandra has a very high crime rate and it is also ravaged by AIDS (between 30 and 40 percent of the population have tested positive for HIV, according to some estimates). With the prospect of soccer's 2010 World Cup to be held in South Africa, Johannesburg has announced programs to create sustainable development; this will probably lead to the relocation of some Alexandra residents. The term apartheid first appeared in South Africa in 1935, at a time when the country was reeling from the effects of a world economic crisis: with it appeared the forms of urban development that are the basis of today's townships. The original houses were standardized "matchboxes" with a single room, small hostels for workers, and "shacks" in the shantytowns. Although apartheid was abolished in 1994, social segregation has continued to exist in these townships, where poverty is still rife. According to the United Nations, 8 million people out of a population of nearly 48 million live in the slums of South Africa.

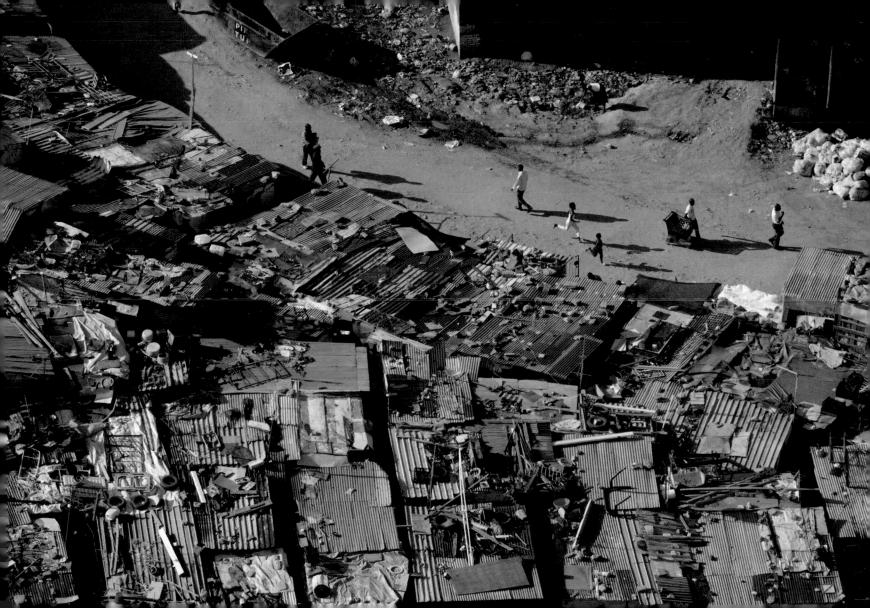

Shipyards at Ulsan, South Korea (35°32′N - 129°19′E)

Since the end of the Korean War in 1953, South Korea has passed from the status of a developing country to that of the world's eleventh-largest economic power. This growth is attributable to the association of the state with giant private business groups, Today, with its 36 percent share of world production, South Korea has the largest shipbuilding industry in the world, well ahead of Japan and China, Ulsan, Korea's principal shipyard city with a 40 percent share of the national output, is home to 132 firms that employ 36,000 people. After the Exxon Valdez oil spill in 1989 and the wreck of the Prestige in 2002, the use of doublehulled oil tankers became general practice in the United States and the European Union, Because of the sheer scale of these sea disasters, single-hulled tankers are set to disappear altogether by 2026; nevertheless the regulations still differ from country to country, which makes it possible for aging hulks, badly maintained and potentially very dangerous, to remain at sea. When their useful lives are over, they are sent to underdeveloped countries like Bangladesh, where the task of breaking them up is undertaken. Not only is there a strong risk of polluting the environment during this procedure, but the workers are also routinely exposed to dangerous substances.

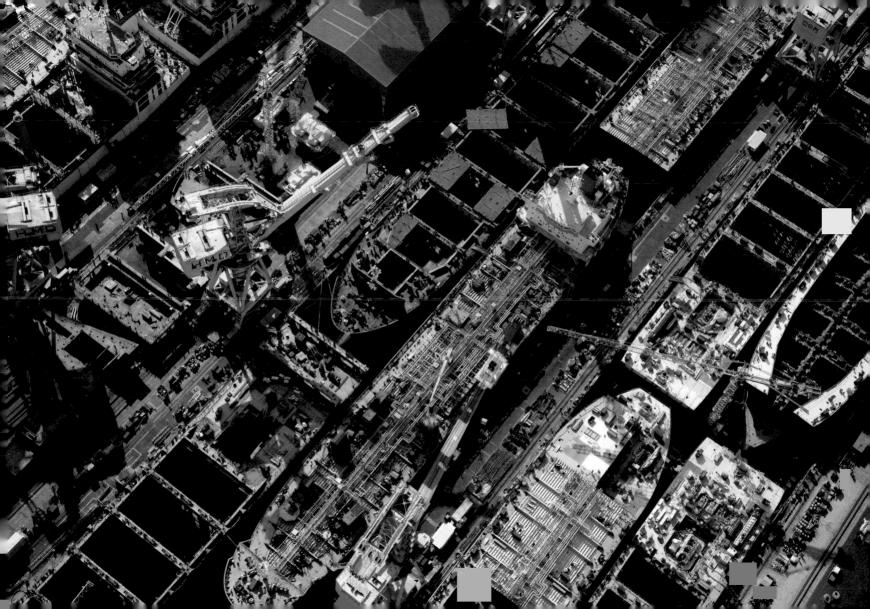

City of Shibam, Wadi Hadramaut, Yemen (15°55'N - 48°38'E)

The caravan city of Shibam, in the mountains of Yemen, formerly linked Qatar and the Gulf of Aden along the Incense Route. Today it is like an open-air museum. Its five hundred-odd houses, which are actually tower blocks varying between five and ten stories, some of them 82 feet (25 meters) in height, have earned Shibam the nickname Manhattan of the Desert. Built of pisé (a mixture of straw, water, and sun-dried clay), some of these white-and-ocher constructions date from the fifteenth and sixteenth centuries. They are clustered around one of the oldest mosques in the country, forming a kind of walled fortress, perched on a hilltop over 8,694 feet (2,650 meters) in altitude. During the rainy season, the town is completely cut off by water. Although its rainfall, which is unique in the Arabian Peninsula, makes Yemen a fertile country, the abundant water causes considerable damage to Shibam's pisé constructions; to protect the structures would require regular renovation, but Yemen—where in 2006 the average annual net income was about 880 dollars—lacks the funds to protect its heritage. Moreover, the country is slowly recovering from a civil war that broke out in 1994 after the reunification of North and South Yemen in 1990. Fortunately, Shibam has been listed since 1984 as a World Heritage Site by UNESCO, which has latterly subsidized the maintenance of this architectural jewel.

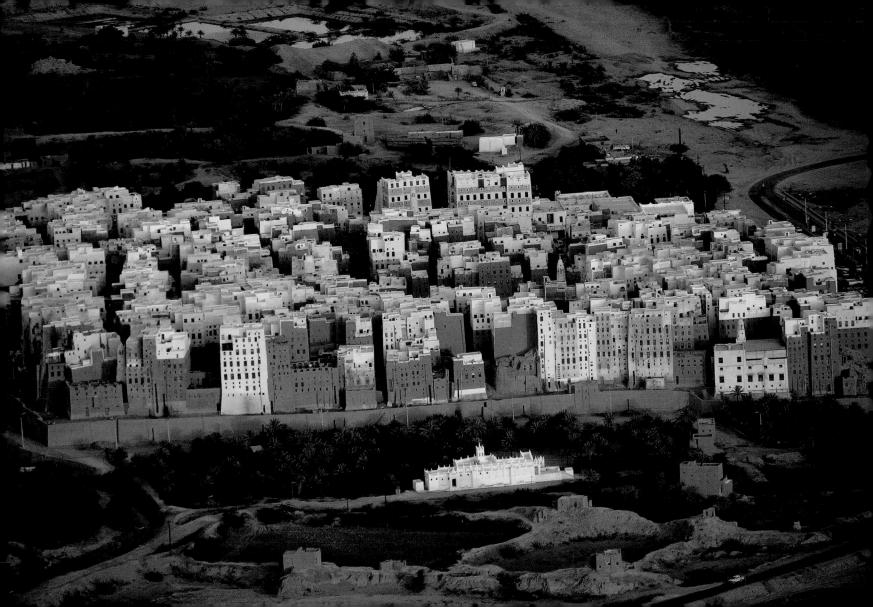

Freeway toll zone, San Lazzaro di Savena, Emilia-Romagna, Italy $(44^{\circ}30'\,\text{N} - 11^{\circ}25'\,\text{E})$

This broad asphalted toll area is at the entrance to the principal freeway network outside Bologna, the capital of Emilia-Romagna, close to the resort towns of Rimini and Cervia. The world's first freeway, or autostrada, was constructed in Italy in 1924 to link Milan with the northern lake regions—it was 53 miles (85) kilometers) long. Since that time, road traffic has steadily increased in volume. and the consumption of gasoline in western Europe has reached an annual average of 113 gallons (427 liters) per inhabitant. Traffic has become so heavy that at any moment of the day 10 percent of Europe's roads are jammed. Worldwide. transportation alone accounts for 70 percent of total gasoline burned. The development of other forms of fuel and the devising of more economical modes of transport have become urgent priorities; within fifteen years, the production of oil will no longer be enough to satisfy steadily increasing rates of consumption. Indeed, improving the energy efficiency of industry right across the board is paramount. Already other highways, such as the Internet's information highway. are showing possible new paths to progress—never before has humankind been able to circulate so much data with so little energy.

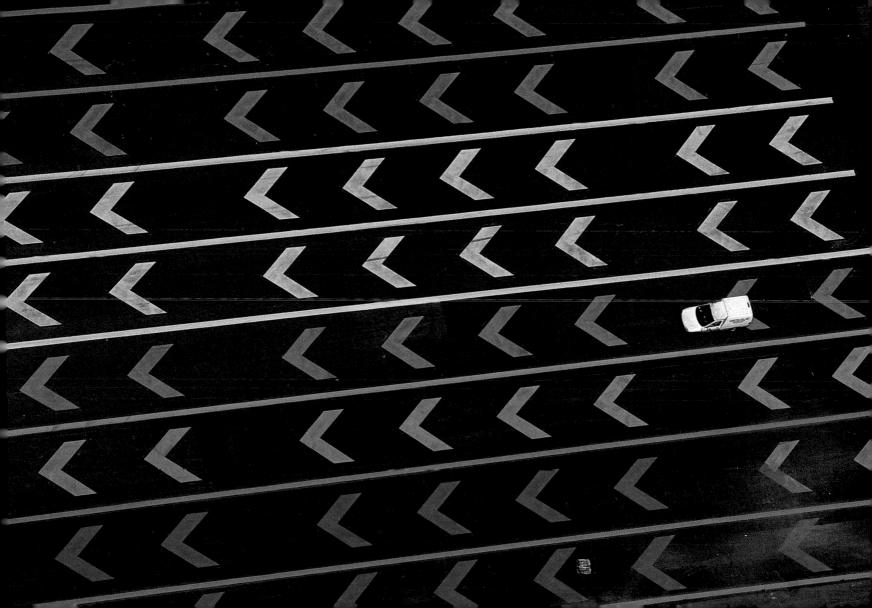

Lavakas, Toamasina region, Madagascar (17°55'S - 48°08'E)

The disappearance of foliage covering these hills has compounded the effects of erosion to the point where steep lavakas have begun to form. This Madagascan word designates the giant gullies formed by groundwater flow. Lavakas also exist in South Africa and the state of South Carolina—or indeed wherever a red soil. compact and more or less hardened, covers a zone of thick but porous rock. Thus the plateaus are scarred by deep gullies dug out by the runoff of rainwater. The alluvial soil, or baiboho, swept off the slopes deposits fertile earth in the plains below. In Madagascar, erosion is closely linked to overgrazing and to tavy, the local slash-and-burn form of agriculture. Although officially outlawed today, the use of tavy has intensified as the population of Madagascar has grown; the population has doubled in the last thirty years. Three out of four inhabitants live in rural areas on small holdings averaging 2 acres (0.9 hectares) in size. The eroded land being no longer cultivable, usable land has been reduced to a mere 5 percent of the total surface area of the island. Worldwide, almost 5 billion acres (2 billion hectares) of land has so far been ruined by deforestation, overcultivation, or overgrazing—the main causes of erosion.

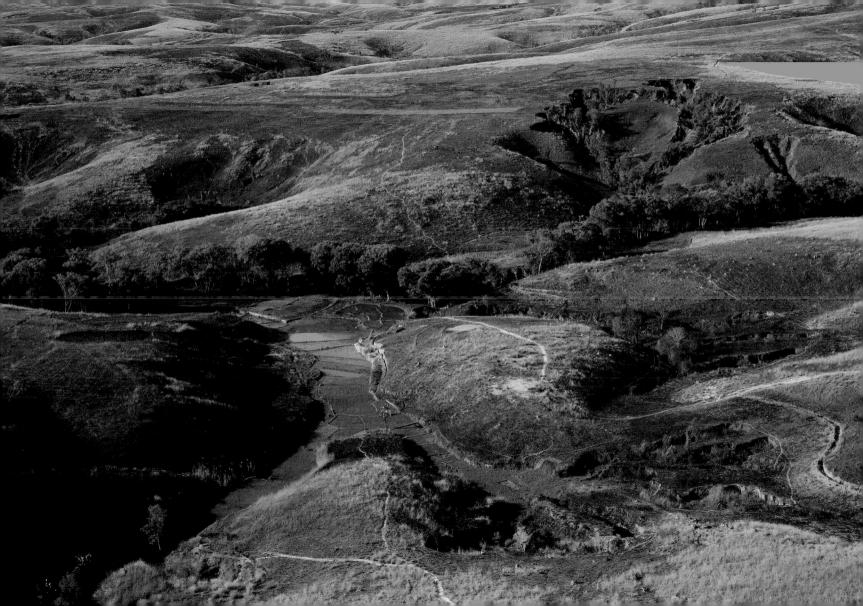

The Western Wall and the Temple Mount, Jerusalem, Israel (31°45′N - 35°15′E)

The Muslim sanctuary of Haram esh-Sharif, also known as the Temple Mount, makes Jerusalem the third Holy City of Islam, after Mecca and Medina. The Dome of the Rock and the al-Aqsa Mosque were built in the seventh century, on the ruins of the Jewish temple—of which only the western wall survives. This was called the Wailing Wall, in reference to the Jews who came to lament over its destruction. According to tradition, some three thousand years ago, it was the site of a temple built by King Solomon to house the Tables of the Law. Twice destroyed and twice rebuilt, it was finally razed in AD 135 by the Romans. Today the Western Wall is a fundamental holy site of Judaism, to which the faithful come to pray, whispering their prayers into the cracks of the masonry. This sacred place, near Christ's tomb, reminds us that Jerusalem, with its three thousand years of history, is also a thrice holy city and a religious capital for Jews, Christians, and Muslims. Its incomparable spiritual dimension has made it the object of violent secular passions and tensions.

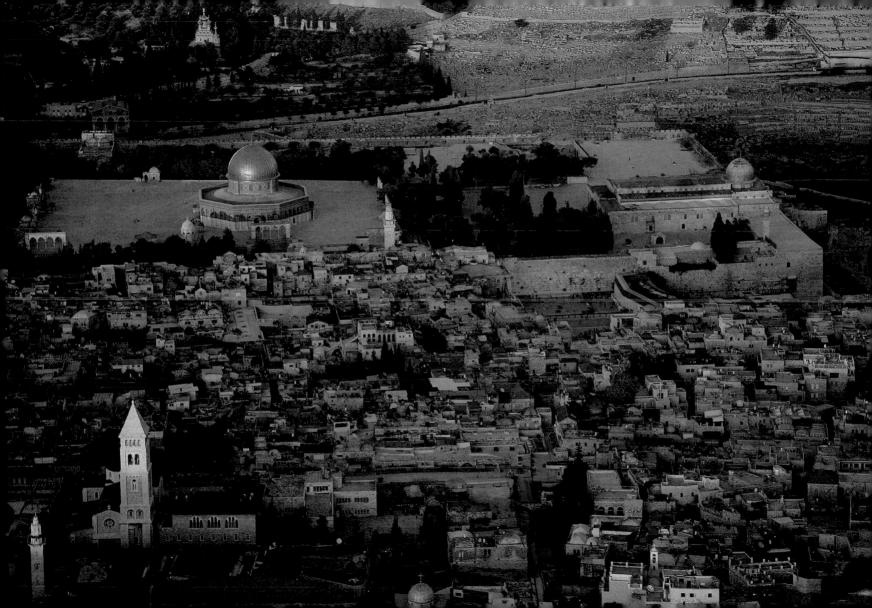

In climatic terms, the future as perceived by our ancestors of ten and twenty thousand years ago may have seemed uncertain, but at least its survival did not depend on their behavior. They could afford to slaughter a few mammoths to appease the forces of nature, with the knowledge that their doing so would change very little about the way the global climate might develop centuries hence.

The power to modify the climate, which they did not possess, we have acquired—unfortunately, and to our very great cost. For the first time in history, humankind has become a climatic agent. How? By emitting large quantities of greenhouse gases, which have significantly reinforced a greenhouse effect already in existence on our planet for several thousands of years, and without which the average temperature here would hover around 5°F (-15°C). If this were the temperature, life as we know it would probably not exist at all. Greenhouse gases, principally water vapor (0.3 percent of the atmosphere), carbon dioxide (0.04 percent), and methane (0.0002 percent), are transparent to the rays received by earth, allowing the sun's energy to penetrate right down to the ground. On the other hand, they are opaque to the infrared rays emitted by our planet, thus preventing energy from reflecting back into space. Today our species has brutally upset that equilibrium; since 1850, we have increased the atmospheric concentration of carbon dioxide by nearly a third, while doubling the concentration of methane.

Such concentrations have not been present for at least 400,000 years. The mean temperature of the planet, which has been stable for 10,000 years, may actually increase by a few degrees in a single century if we continue with the present relentless increase in emissions. This fact has been known for some time; a Swedish chemist, Svante Arrhenius (who won the Nobel Prize in 1903) was the first to reveal it in 1896. A rise of even a very few degrees in the world's average temperature is no laughing matter; a few degrees, after all, is all that separated a "hot" period (like the one we are experiencing today) from the ice age during which the entire northern parts of Europe and Canada were covered in a layer of ice several miles deep, with the sea 394 feet (120 meters) below its present level, and France a meager frozen steppe, totally

incapable of feeding millions of people. Moreover, the subsequent thawing process took about 10,000 years. While it is impossible to gauge with any accuracy what might result from a rise of several degrees in the average global temperature over the next one or two centuries, it is to be feared that the effect would be a genuinely disastrous "climate shock," and not a matter of wearing one layer more or less during the winter months. So sudden a change in the world's temperature might signify a major disruption in the water cycle, with more and more severe floods and droughts, ever more powerful hurricanes, the possible melting of Greenland's ice cap and part of the Antarctic—in which case the sea level would rise by 39 feet (12 meters)—or the disappearance of the Gulf Stream over a few decades. This last scenario would lower the mean temperature in western Europe by 9 to 11 degrees Fahrenheit (5 to 6 degrees Centigrade), entirely destroying the agriculture of France (for example). Coral reefs would vanish altogether from the world's oceans; tropical diseases such as yellow fever, malaria, dengue fever, and other scourges would rapidly expand toward the Poles, wreaking havoc on plants and animals as well as on human beings.

Indeed, we have scarcely an inkling of the unpleasant surprises in store for us. The situation is no fantasy of science fiction, but a consequence of our behavior that is confidently forecast by serious science and confirmed by all the technical and scientific research at our disposal. Human society's eventual response to sudden climatic change is still in doubt today, but we should remember that everything, or nearly everything, in the world around us is adapted to local climate conditions. This is true of our agriculture, our forests, our buildings, our lines of communication—and even our wardrobes.

So what are we to do? Greenhouse gases, once emitted, take only a few months to spread and merge entirely with the air, whereas they remain in the atmosphere for more than a century. Since the exact whereabouts of such emissions are irrelevant to the climate disturbance they cause, we, the human race, are obliged—or rather compelled—to make a concerted agreement to reduce them. A single renegade country is capable of nullifying the best efforts of all the others. This does not preclude the virtue of example, which

we all too often ignore. How far must we reduce emissions? To halt the enrichment of the atmosphere with carbon dioxide, we must halve the world's production of this gas, at the very least. In theory, if every inhabitant of the earth had the same "right to emit" in the best of all possible worlds, the French (again, for example) would have to cut their emissions by 75 percent per capita, requiring a division by the same factor of their consumption of oil, gas, and coal (nuclear power and renewable energy sources remaining available, though with very different potentials, depending on the directions chosen), Likewise, Americans would have to cut their emissions by 91 percent per capita, and the Chinese could not venture beyond their present levels. With our current technologies, all we need to do to reach this personal emission limit is make a single flight across the Atlantic, heat our houses for a few months with natural gas, drive six or so thousand miles in our cars, buy several score pounds of manufactured products (which have to be produced and transported to us), or eat a couple hundred pounds of beef (since chemical agriculture and the use of modern farm implements ensure that the fabrication of just about everything we eat involves the emission of greenhouse gases). And all this leads to the conclusion that stabilizing the climate will involve a radical change in humanity's goals for itself, not just a few minor corrections around the edges. Instead of "consume more and more," we should be saying, "emit less and less." The hitherto perpetual growth of our material consumption will not survive this change of course. But if we wish to make sure our own children are guided toward a world that can still welcome them as we ourselves were welcomed, do we have any choice?

Jean-Marc Jancovici
Consultant on energy problems and the greenhouse effect

Ile Blanche, Grenada (12°15′ N - 61°35′ W)

The Caribbean state of Grenada, 124 miles (200 kilometers) north of Venezuela, in the Lesser Antilles, is a 133-square-mile (344-square-kilometer) archipelago, and home to about 100,000 souls. It consists of three main islands: Grenada itself, the site of the capital; Carriacou; and Petite Martinique. All three are right in the path of seasonal tropical storms. In 2004, Grenada was severely damaged by Hurricane Ivan, which killed 37 people and wrecked 90 percent of the main island's infrastructure. The following year, Hurricane Emily ravaged Carriacou. The idyllic Lesser Antilles attract many visitors, and the country's economy is heavily dependent on tourism; in fact, the service sector employs 60 percent of the population. But the current process of climate change, which has had the effect of intensifying the already major threats of hurricanes and rising sea levels, has recently emerged as a mortal threat to the entire region.

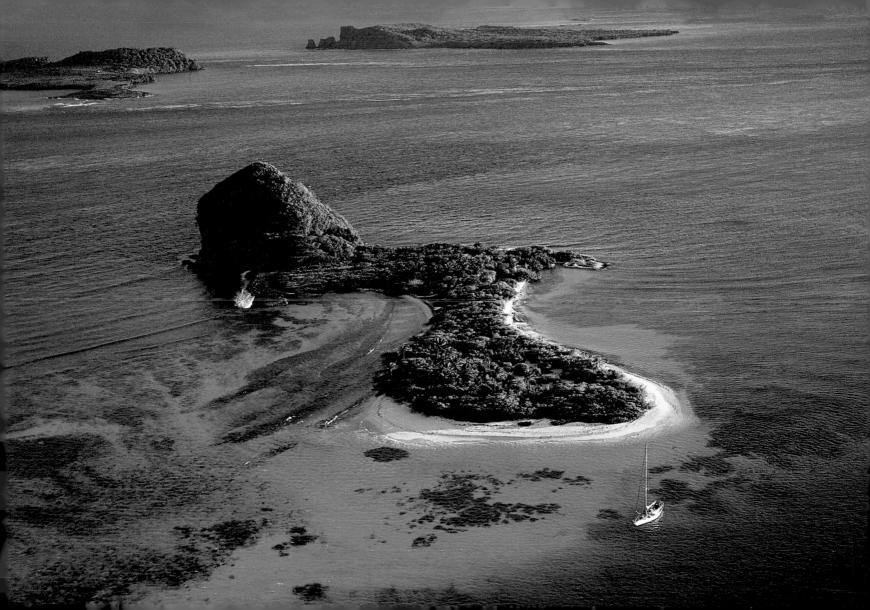

Market in Marrakech, Morocco (31°37′N - 7°59′W)

Fresh fruit and vegetables, sold in large quantities at markets like this one, constitute Morocco's principal agricultural export. But the agricultural sector, which continues to employ about 40 percent of the country's inhabitants, does not explain the economic boom Morocco has experienced since the year 2000. Instead, tourism has been the driving force, with breakneck hotel construction and a rapid increase in urban population ratios; this in turn has begun to cause serious complications. Morocco's road system, which is largely decrepit, is unable to absorb the increased number of vehicles. Drainage and waste disposal problems are beginning to threaten people's health. In 2007, Marrakech had a record 1.7 million visitors, and the Moroccan government proposes to attract nearly three million visitors in 2010. Globally, international tourism is now the leading industry, representing 12 percent of the annual income generated worldwide and employing 200 million workers (8 percent of the planet's total workforce).

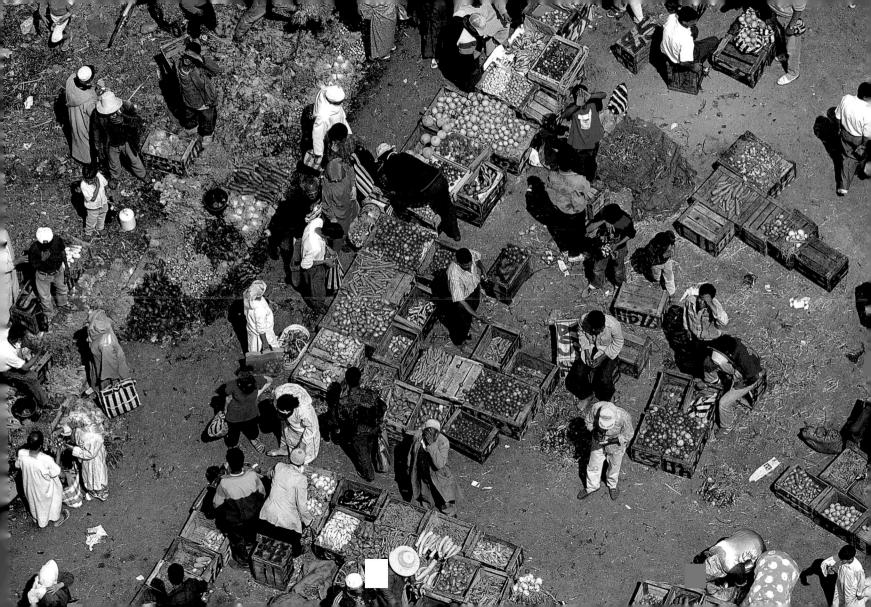

Pink ebony trees on Kaw Mountain, French Guiana (4°30'N - 52°00'W)

Before it blooms so spectacularly, this tree of the Guiana jungles loses all its leaves. Botanists have given it the scientific name *Tabebuia impetiginosa*. The Brazilians call it *pau d'arco* (bow-wood tree) or *ipe roxe*; the Argentineans call it *lapacho*. It grows in humid, tropical forests from Mexico to Argentina; its wood, being very hard, will not float in water; and it is known in South America for its medicinal properties. Unlike temperate forests, which can support plantations of a few species at most (pines, oaks, beeches), tropical forests contain literally thousands of vegetable species. French Guiana is home to over 5,500 distinct plants, of which more than a thousand are tree species. Just two and a half acres of jungle can harbor up to three hundred different varieties, more than the whole continent of Europe can muster. Given biodiversity on this scale, we can easily understand that these jungles cannot be exploited like other woodlands have been.

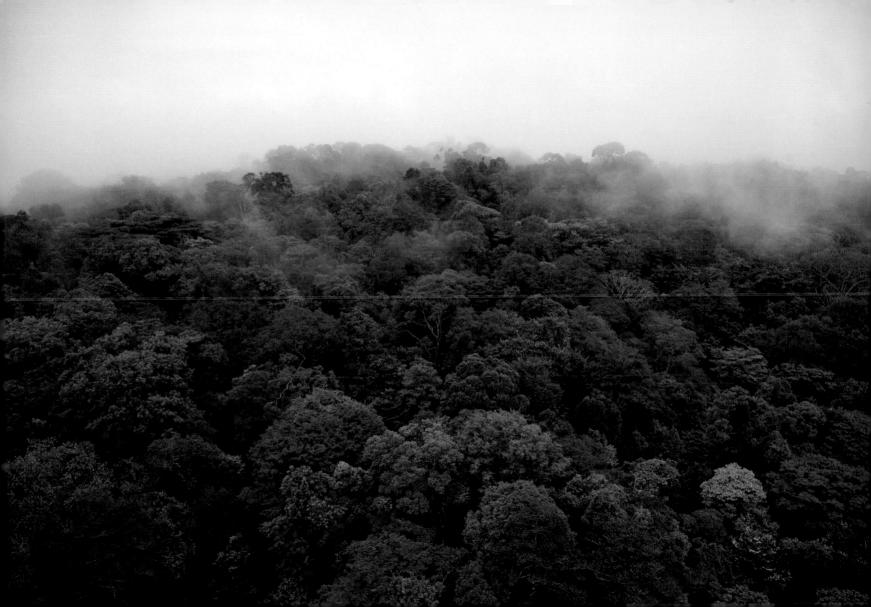

Alpine glaciers, Wright Valley, Antarctica (South Pole) (77°50'S - 165°10'E)

These dry valleys, with their huge expanses of rock and sand, occupy 2 percent of the Antarctic land mass. So similar is the region to the surface of Mars that during the 1970s NASA used the area to prepare its Voyager 1 and 2 space probes. Here, the tonguelike formations of the Wright Glacier flow outward into a dry zone, offering superb contrasts of texture and color. What appears at first to be a deserted mineral landscape is in fact home to Antarctic fauna, which thrives on the ice cap. In all, nineteen species of bird (of which five are web-footed) and six types of seal (including sea lions and elephant seals) have acclimatized to this extreme environment, which they share with whales and a few species of fish. Of these, the most arresting is the icefish, semitransparent because its blood contains no hemoglobin; icefish synthesize antifreeze proteins to resist the icy water temperatures through which they move. All of these living things are part of a varied and fragile ecosystem, which until now has been protected by its isolation. But today, life itself hangs by a thread here, and the smallest imbalance can lead to catastrophe.

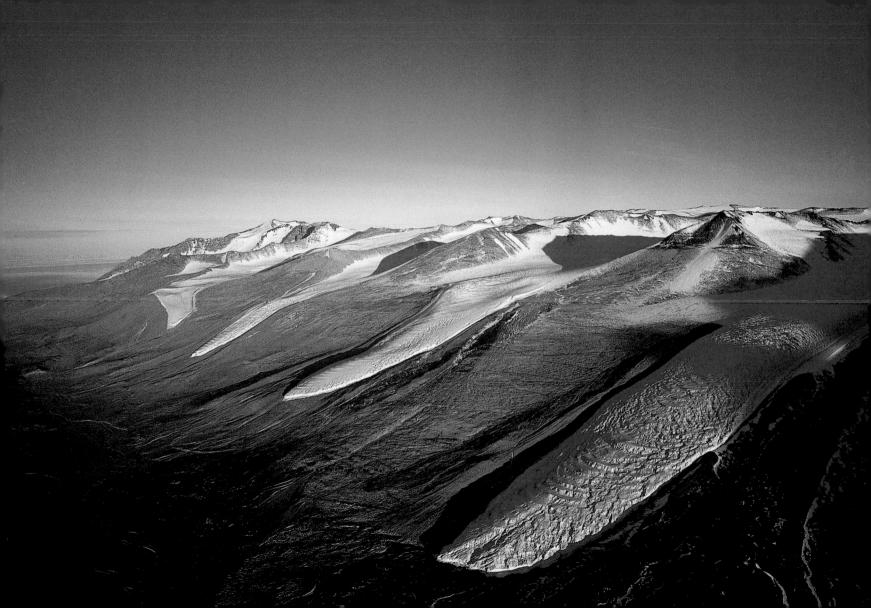

Oil rig, Al-Shaheen, Qatar (25°30'N - 51°30'E)

On the face of it, the flat desert peninsula of Qatar appears thoroughly forbidding—yet immigration levels there are among the highest in the world. For although Qatar's soil is infertile, beneath it lie the world's richest deposits of oil and gas. This small nation, one-third the size of Belgium, ranks eleventh worldwide in oil reserves, and third (after Russia and Iran) in the production of natural gas. Sure of its wealth and confident in its future, Qatar has carried out an impressive program of public works (including roads, universities, hospitals, an international airport, and sport and tourism facilities), while continuing to develop its oil industry. Moreover, the absolute monarchy currently in place is moving gradually toward democratization. But, unfortunately, the bulk of these improvements only concern Qatari citizens, who make up a mere 20 percent of the people living on the peninsula. The remainder are immigrant workers, who have no political or social rights beyond that of free primary education for their children.

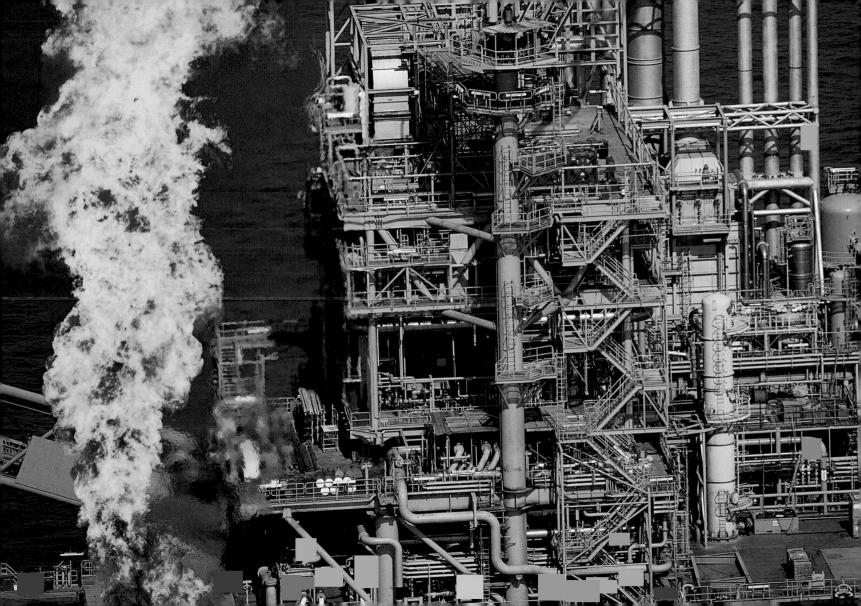

Ginseng fields around Cheorwon, Gangwon-do Province, South Korea $(38^{\circ}14'N - 127^{\circ}12'E)$

Few plants are as prized for their medicinal properties as ginseng, whose Latin name, *Panax*, echoes *panacea*, meaning a remedy that can cure all ills. The first European reference to the fabulous virtues of ginseng dates from the first century AD, but the Chinese have been using it for three thousand years. Two types of ginseng make up the bulk of world production and trade: North American ginseng (*Panax quinquefolius*) and Asian ginseng (*Panax ginseng*). Both are undergrowth plants that dislike too much light and humidity. The former is grown in forests, while the latter is produced in fields under shade fabrics or rice-straw coverings, which filter out 80 percent of the sun's rays and imitate the light conditions of the forest floor. These conditions are optimal for growth, allowing the ginseng to be harvested after only two or three years (as opposed to the eight or ten years it takes for the plant to mature when grown in the woods). Korea, along with China and Canada, is one of the world's largest producers of ginseng.

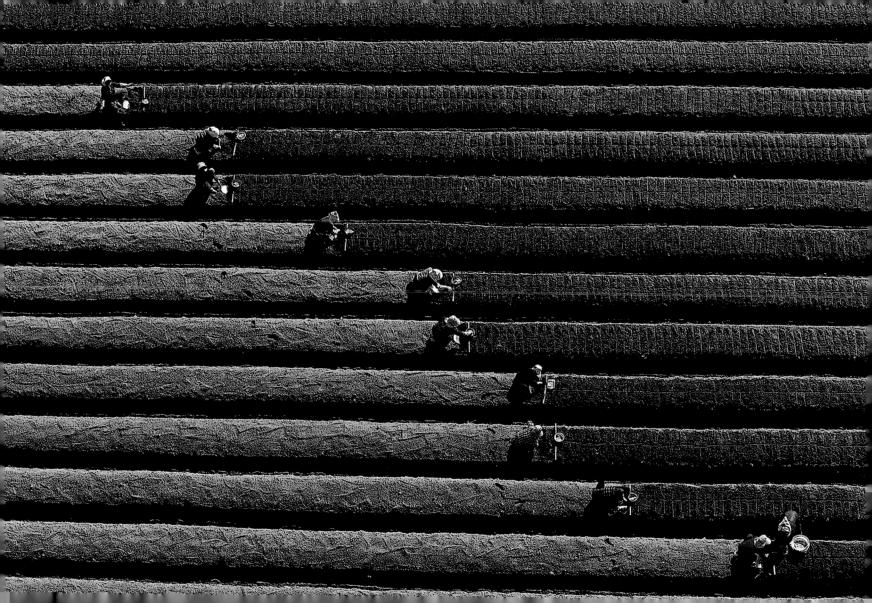

River close to the Tsingy de Bemaraha, Madagascar (20°00'S - 45°15'E)

Although rivers manage to penetrate the Tsingy de Bemaraha, a UNESCO World Heritage Site, it is otherwise a giant labyrinth of karstic needles covered by dry. tropical forest. In Madagascar, which suffers from chronic drought, the three thousand odd streams and rivers constitute the most precious of resources. But given the country's uneven and unreliable rainfall (varying from 150 inches [3,800 millimeters] annually in the northern regions to 15 inches [380 millimeters] annually in the western regions) and the absence of firm legislation to protect waterways from chemical and industrial pollution, water in Madagascar is not only a rare commodity but also a threatened one. Today, 95 percent of the country's wastewater is returned to the earth without undergoing any prior treatment, and only 27 percent of the population has access to a network of drinking water (one of the worst records in the world). To assist places such as Madagascar, attending states at a 2005 international conference on Africa's water and sewage issues pledged to extend drinking and water facilities to 80 percent of Africa's population by 2015.

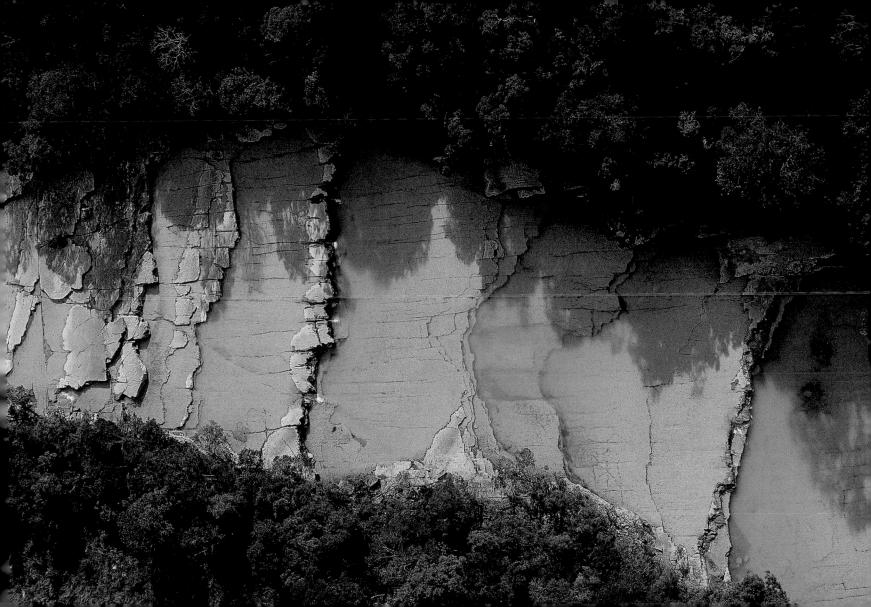

Lake Assal, Republic of Djibouti, (11°42′N - 42°20′E)

Lake Assal is the lowest point on the continent of Africa, at 508 feet (155 meters) below sea level. The territory of Djibouti lies along the Great Rift Valley, between the Arabian and African tectonic plates. Rifts are cracks in the earth's crust; where they occur, the vast plates gradually move away from each other, accompanied, at times, by strong tectonic and volcanic activity. Under the heat of the sun, the bowl of Lake Assal turns into a veritable furnace that accelerates the evaporation of the water. Mineral salts here are so concentrated that they form thick crusts on the shore and on the bottom of the lake. For many scientists, the Lake Assal region is of enormous importance, being a place where it is possible to observe the formation of a future ocean. In a few million years, with the parting of the plates at a rate of a quarter inch (2 centimeters) per year, the fault will be inundated by the sea.

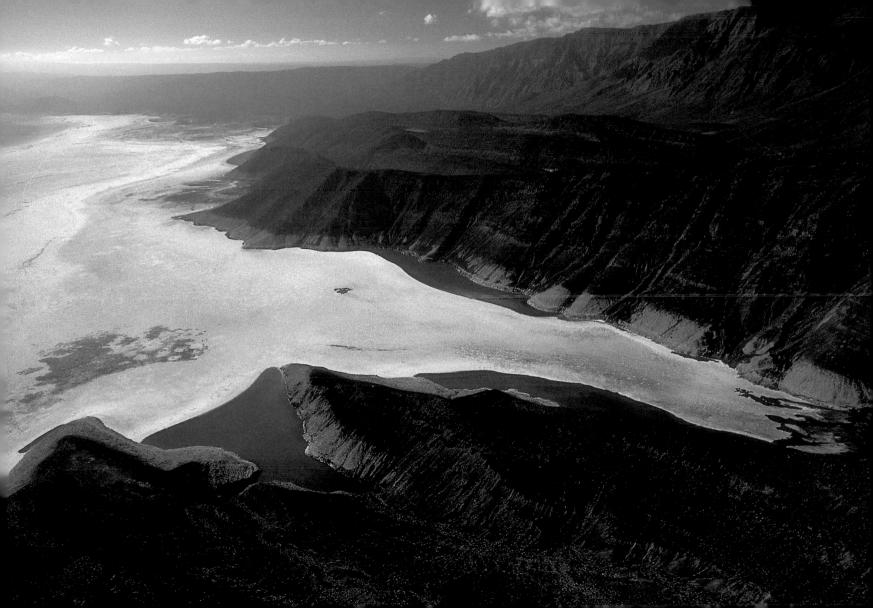

Construction of a golf course, Cape Cana, southeastern Dominican Republic $(18^{\circ}25' \text{N} - 68^{\circ}25' \text{W})$

With its freshwater pool and its newly seeded strip of turf, this recently constructed eighteen-hole golf course serves Cape Cana, a brand-new town close to a natural park and a major coral reef. Intended for wealthy tourists seeking relaxation in a Caribbean-island paradise, the golf course is part of a giant hotel complex built along miles and miles of fine, sandy beaches. Tourism, which generates 55 percent of the Dominican Republic's resources, has in recent years supplanted the traditional cultivation of sugar, bananas, and tobacco, which now represents only 11 percent of the area's wealth. The country used to be a major exporter of these commodities, but now the bulk of its food is imported, resulting in a net deficit of \$3.5 billion to swell foreign debt. Less than a tenth of the population (of 9 million) shares 40 percent of the country's revenues, and more than a quarter of the population lives below the poverty line.

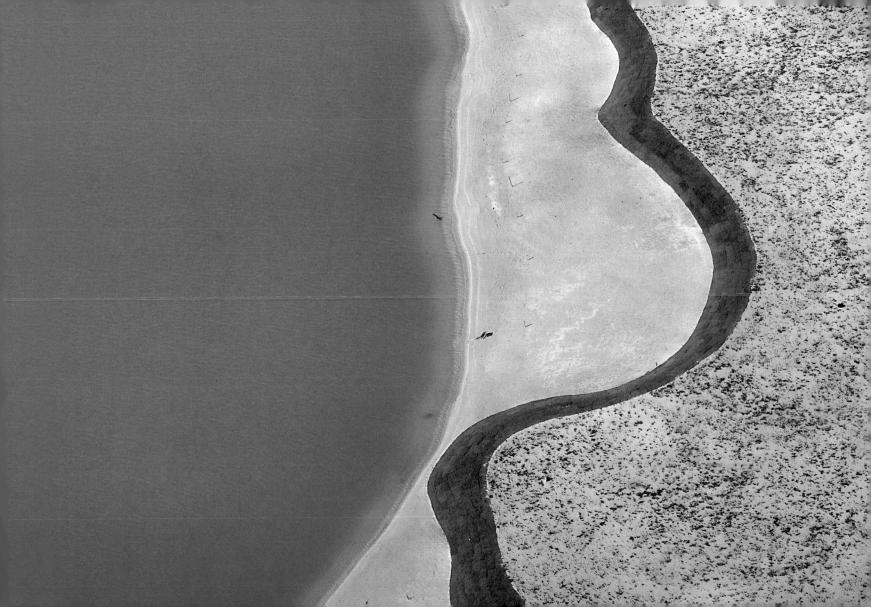

Nets used for drying seaweed, Wando Island, South Korea $(34^{\circ}19'N - 127^{\circ}05'E)$

In this archipelago in the southwestern corner of the Korean peninsula, aquaculture and seaweed culture are the dominant economic activities. In the old days, the seaweed was simply gathered by hand; today seaweed for human consumption is cultivated on an industrial scale. Along with China and Japan, the Koreans are among the world's principal consumers of seaweed, and in 2004, Korean production of edible algae topped 71,000 tons dry weight. Some types are sold dried in leaf form and are used for wrapping sushi; others are incorporated into soups and sauces. This sea "vegetable" is a major source of proteins and vitamins, and the cultivation of algae falls well within the guidelines of sustainable development. The activity requires unpolluted waters and it does not threaten the marine environment in any way. Today the United Nation's Food and Agriculture Organization (FAO) encourages the cultivation of algae around the world as a preventive measure against food shortages.

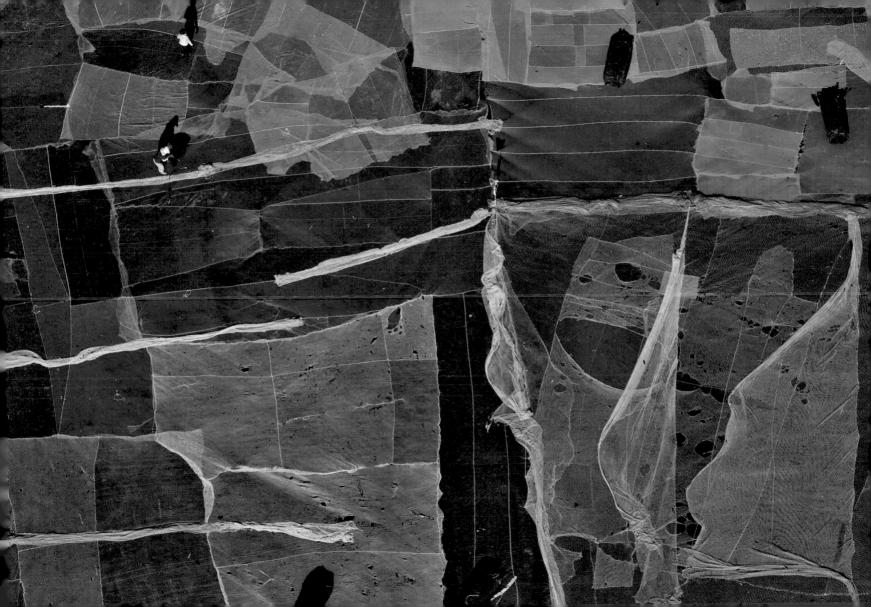

The Lippe River in a flood near Olfen, Ruhr region, northern Westphalia, Germany (51°40′N - 7°25′E)

The Rhineland of northern Westphalia is one of the most populated areas of unified Germany, with 18 million people, one-fifth of its population. Despite nearby urban concentrations, much of the course of the river Lippe, a tributary of the Rhine, has remained natural and undisturbed. The river's meanderings double back freely on one another, and there are no dikes to inhibit the spread of its winter overflow across the alluvial plain. Nearly 50 percent of the Ruhr valley has remained agricultural, and 17 percent of it is clothed in forest—in a part of Germany that coal mines and steel industry made the heartland of the Industrial Revolution in northern Europe. After the 1960s, crises and industrial restructurings profoundly altered the region. Today, with 5.3 million inhabitants, the Ruhr valley forms one of the largest urban concentrations in Europe after London, Paris, and Moscow. Meantime, the old industrial sites have gradually been depolluted and, in many cases, converted to service new activities and technologies.

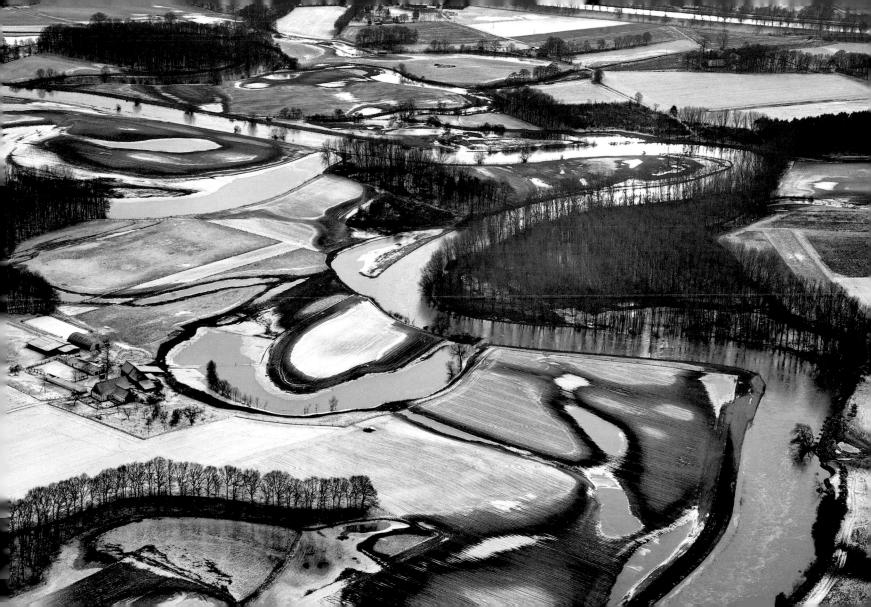

Water games, Cataño, San Juan, Puerto Rico (18°26'N - 66°07'W)

Puerto Rico in the Greater Antilles is an island of 5,328 square miles (13,800 square kilometers) with 3.9 million inhabitants. The climate is hot and humid. In the capital, San Juan, people cool themselves in summer by opening the spigots on fire hydrants. Given that water is relatively abundant and living standards on the island are high, access to good quality water and purification facilities should be assured. To improve the distribution of drinking water and the purification of wastewater, the water system was privatized in 1995 and entrusted to Veolia Environmental Services, the world's largest water distribution company, which serves 110 million users. But after heavy financial losses, a deteriorating service-more than half the water was lost because of leaks in the network of pipes for drinking water—and numerous cases of environmental pollution by untreated wastewater, the authorities terminated Veolia's contract in 2002. A new ten-year management agreement was then concluded with a subsidiary of Suez, the world's second-largest water distribution group. This only lasted two years, whereupon the government reassumed the direct management of the island's drinking water supplies and purification facilities. This episode of failed privatization was made complete in 2006 when the United States Justice Department condemned local authorities to a fine of 9 million dollars for failing to respect the law in regard to water. The Puerto Rican government was made to pledge an outlay of 1.7 billion dollars over the next fifteen years to improve the island's wastewater purification facilities.

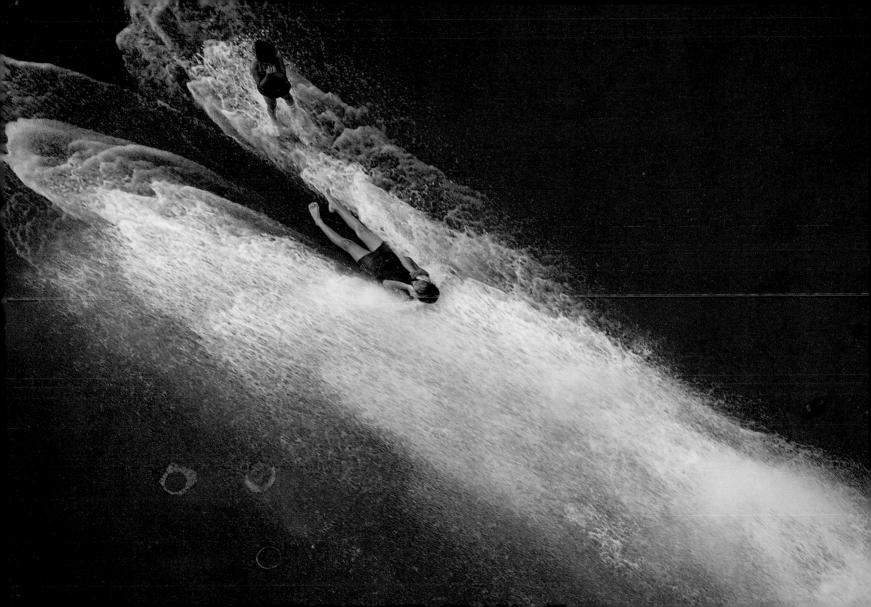

Village in the Niokolo-Koba, Senegal (12°59'N - 13°01'W)

Created in 1954, Niokolo-Koba Park was added to the list of UNESCO World Heritage Sites in 1981 and classed as a biosphere reserve. Its 2 million acres (900,000 hectares) of lakes and marshes is home to some 350 species of birds, 60 species of fish and reptiles, and 80 species of mammals. Also living there are 120 lions. 25,000 buffalo, 2,200 hippos, and 10,000 warthogs, along with numerous jackals. hyenas, and crocodiles. Although 400 specimens of the world's largest species of antelope—the Derby eland, threatened with extinction—are still present in Niokolo-Koba Park, the populations of leopards, painted hyenas, and chimpanzees are thinning rapidly, menaced by poachers. Since 1990, Niokolo-Koba has merged with Badiar Park in Guinea-Bissau to create the cross-border park of Niokolo-Badiar. These vast protected areas should have made it possible to coordinate the efforts of the two countries to greater effect, but the alliance has yet to respond effectively to a number of urgent concerns. The numbers of elephants (less then fifty survive) and lions have reached a critical threshold. For several years now, both fauna and flora have suffered greatly from successive droughts and the ravages of poachers, and to these will shortly be added the effects of a new dam on the Gambia River. Lack of funds and the sheer breadth of the conservation efforts make it clear that the park will never accomplish its mission without help. In June 2007, UNESCO placed Niokolo-Koba Park on its list of endangered sites in an effort to mobilize the international community to preserve this haven of biodiversity.

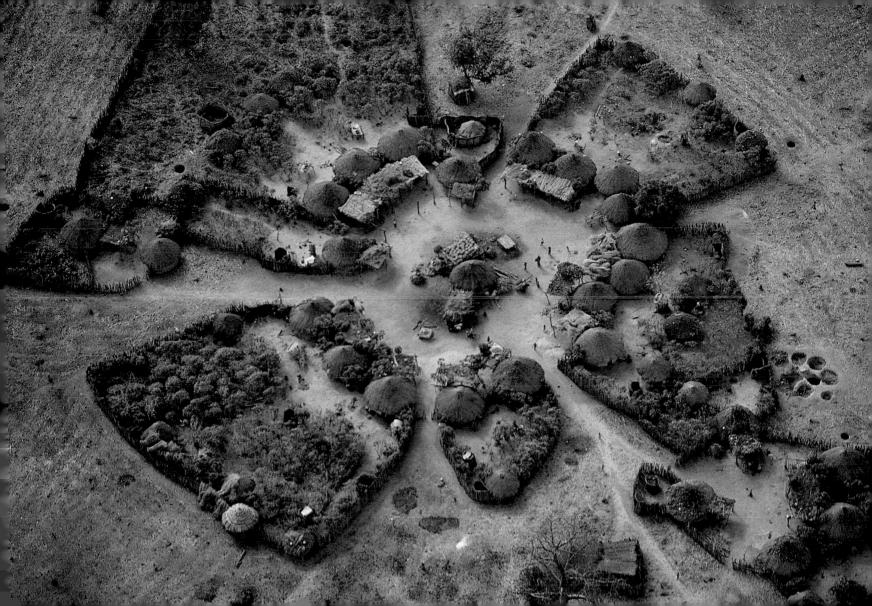

Marshes, Río de la Plata, province of Buenos Aires, Argentina (35°56′S - 57°47′W)

The River Plate forms the natural frontier between Argentina and Uruguay, and at its mouth it forms the broadest estuary in the world. In 1832, Charles Darwin arrived there aboard the HMS *Beagle* and recorded that the ship was surrounded by crowds of seals and penguins, swimming in a phosphorescent ocean. Today the scene is very different, as human activity has caused pollution, erosion, and sedimentation of the estuary. Fishermen are alarmed by the constant shrinkage of fish stocks. The fragile ecosystem of the Plate estuary is threatened by a population of 15 million along its shores (1.5 million in Montevideo, the Uruguayan capital, and 13 million in Buenos Aires). In an effort to save the estuary, EcoPlata, a project launched by the International Development Research Center, has occupied Canadian and Uruguayan scientists for the last sixteen years in working out sustainable management proposals for this international zone. As a result of these efforts, in 2001, the Uruguayan government created a special commission dedicated to the Río de la Plata shoreline.

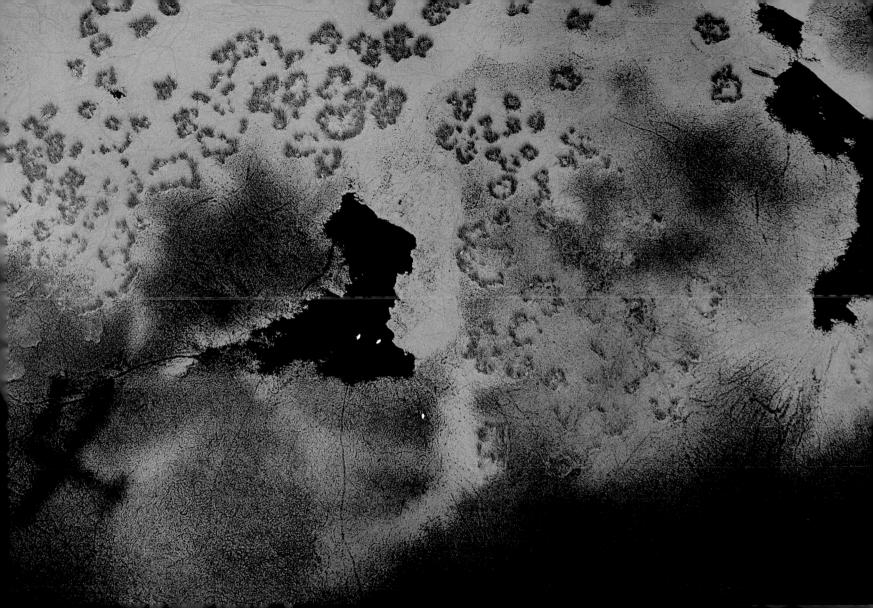

Jussieu, campus of the University of Paris VI and VII, Paris, France $(48^{\circ}51'N - 2^{\circ}21'E)$

Built in 1964 on the site of Halles aux Vins, the old wine market, the Jussieu campus covers 32 acres (13 hectares) and contains some 40,000 students. The fire protection for the metal structures of the buildings, known as le gril, and of the central tower were achieved by using asbestos flocking, in accordance with prevailing safety regulations at the time. The total surface covered by asbestos was over 2 million square feet (190,000 square meters). But in 1974, researchers in the laboratories of the university began to notice that their experiments were being polluted by asbestos dust particles. After 1977, successive government decrees banned the use of asbestos flocking in residential buildings and limited its use in other types of construction by fixing the thresholds for asbestos dust pollution. In 1995, the Ministry of Education ordered a diagnosis of asbestos pollution in and around the campus and decided to undertake a cleanup plan. But it was not until January 1, 1997, that asbestos was banned outright in France, even though the United States had banned it much earlier, in 1970. The decontamination work, commenced in 1997, is still only two-thirds completed. The French government has promised to finish by 2011. In France, more and more individuals whose health has been affected by asbestos exposure are going to court to have their afflictions acknowledged and to claim indemnities. The Institut National de la Santé et de la Recherche Médicale estimates that by 2025, 100,000 people will have died from the side effects of exposure to asbestos.

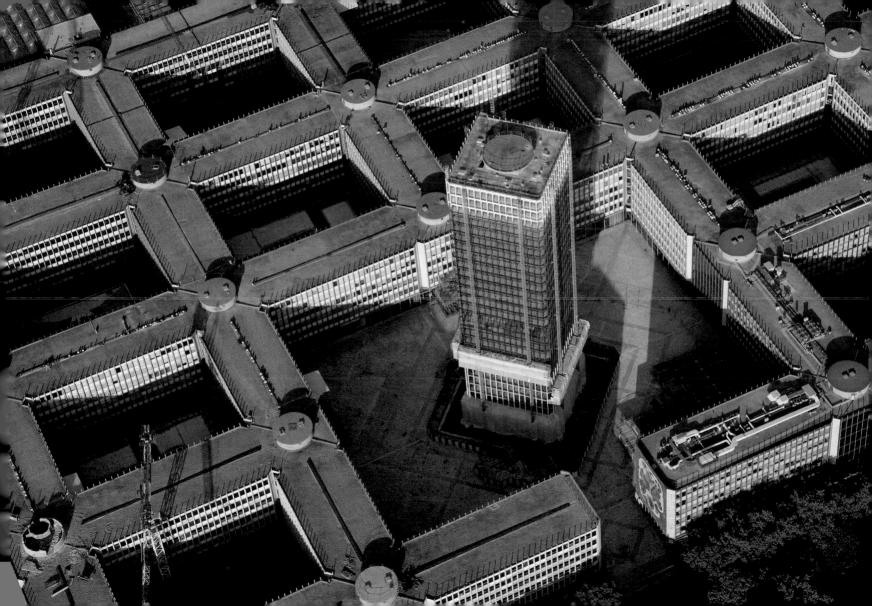

Namib Desert, west of Gamsberg, Windhoek region, Namibia $(22^{\circ}35'S - 17^{\circ}02'E)$

The road linking Windhoek, the capital of Namibia, with the coastal resort of Walvis Bay crosses the plateau of Mount Gamsberg, from whose foot the Namib Desert stretches as far as the Atlantic coast. Formed 100 million years ago, this desert is the oldest in the world; it is made up of rocky plains and 13,127 square miles (34,000 square kilometers) of sand dunes, some of which are over 984 feet (300 meters) tall. The Namib Desert is the sole habitat of one of the most mysterious of all plants, the *Welwitschia mirabilis*; some specimens are 1,500 years old. Two national parks cover a total area of 26,000 square miles (66,400 square kilometers, one quarter of the Namib); these are the Namib-Naukluft (part of which has been a reserve since 1907) and the Skeleton Coast Park (a reserve since 1971). Together, these parks contribute significantly to preserving the equilibrium of their arid ecosystem; tourism at the parks is strictly limited so as not infringe on the delicate environment.

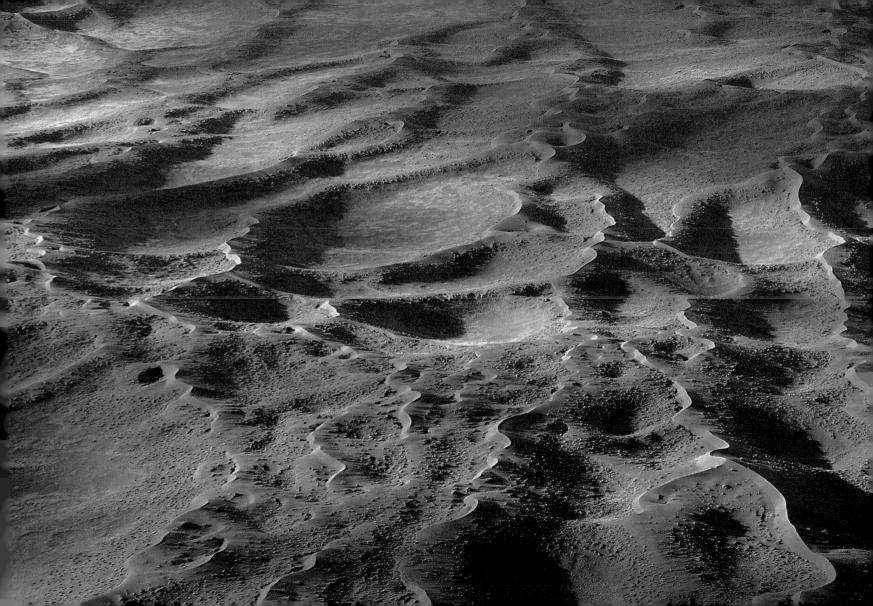

Caguas, residential quarter, central region, Puerto Rico (18°13'N - 65°60'W)

With a population of 140,000, Caguas is the fourth-largest town in Puerto Rico. The island was discovered in 1493 by Christopher Columbus, who claimed it for Spain; but following the Spanish-American war in 1898, Puerto Rico was ceded to the United States. The island obtained the status of a U.S. state in 1952, an arrangement whereby it submitted to American federal law. According to that law, Puerto Ricans can elect a delegate to the Congress, but have no right to vote in presidential elections. Puerto Rico's status has been a principal political theme since the 1950s, pitting supporters of Puerto Rican independence against those who favor the territory's full integration as America's fifty-first state. Three referendums were carried out in 1967, 1993, and 1998, but none led to any modification. With about 1,000 people per square mile (445 inhabitants per square kilometer), Puerto Rico is one of the world's most densely populated territories. At present, 3.8 million Puerto Ricans live on the U.S. mainland, almost as many as live in Puerto Rico itself.

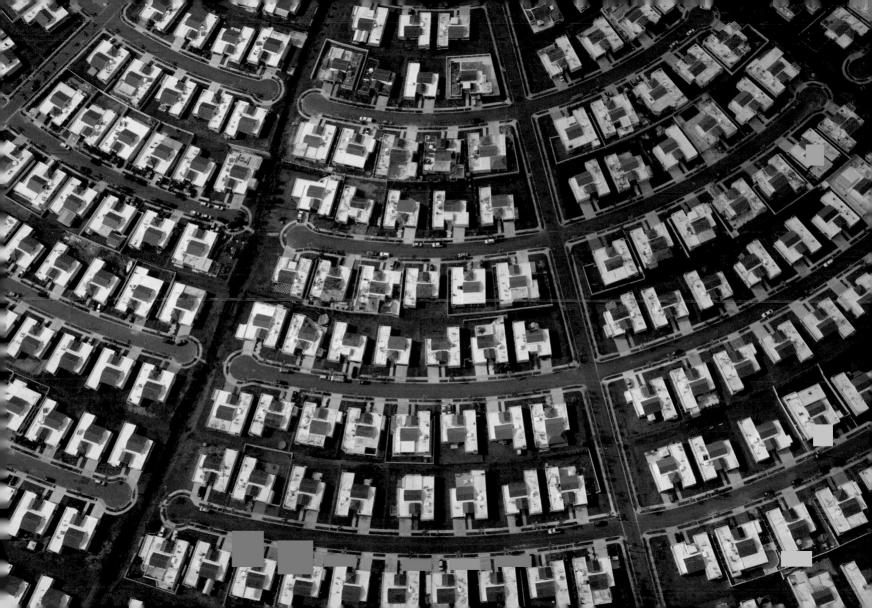

Village among the rice paddies near Antananarivo, Madagascar $(18^{\circ}57'S - 47^{\circ}31'E)$

In the region of Antananarivo in Madagascar, the Merinas, an ethnic group originally hailing from Indonesia, cultivate rice paddies in the areas around their villages, using traditional techniques. In an effort toward self-sufficiency in sustenance, islanders have planted rice fields that have now spread to cover two-thirds of the country's agricultural area. Two types of rice-growing are practiced on the island: wet cultivation in flood lands along the river valleys, and dry cultivation on burned-off sloping land. Madagascar is the world's second largest consumer of rice (inhabitants eat an annual average of 284 pounds [129 kilograms]) after Myanmar (where they consume an annual 463 pounds [210 kilograms]); nevertheless, it's only the twentieth largest producer (averaging an annual 2.8 million tons) and has for many years imported poor quality rice, while exporting its own greatly superior grain. Rice, along with wheat and maize, is one of the world's most heavily consumed cereals.

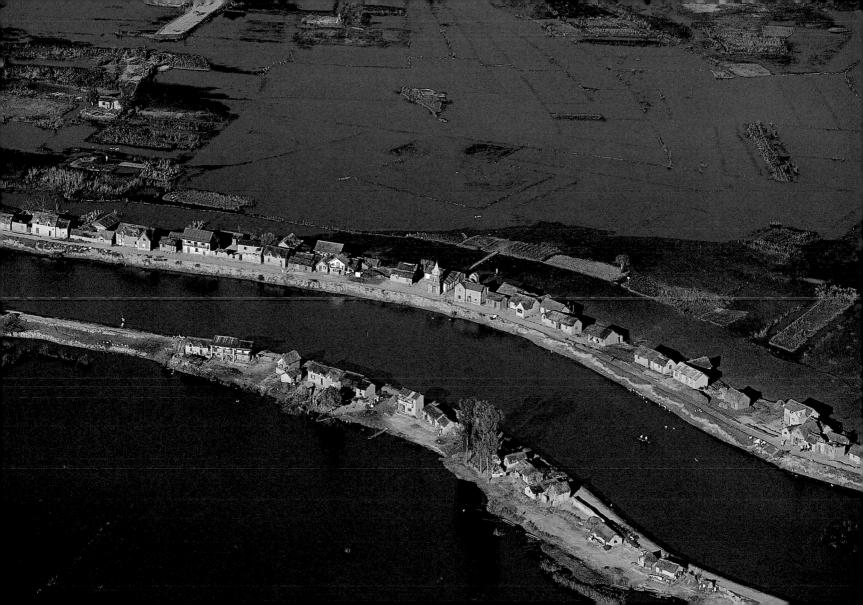

Fishermen on the seashore between Abidjan and Grand-Bassam, Ivory Coast $(5^{\circ}13'N - 3^{\circ}53'W)$

Traditional fishing methods are used all along Ivory Coast's 342 miles (550 kilometers) of shoreline, as well as in the broad lagoons that penetrate its eastern shore. The fisheries are largely dominated by foreigners, particularly Ghanaians, who make up about 90 percent of the roughly 10,000 fishermen in this region. They use big pirogues, based in Abidjan, and fish at night with broad-mesh drift nets. This technique makes it possible to catch large migratory fish (sharks, marlin, sailfish, and swordfish) and contributes substantially to the country's fish production. However, the nets unnecessarily snare and kill large numbers of birds, sea mammals, and reptiles along with the fish.

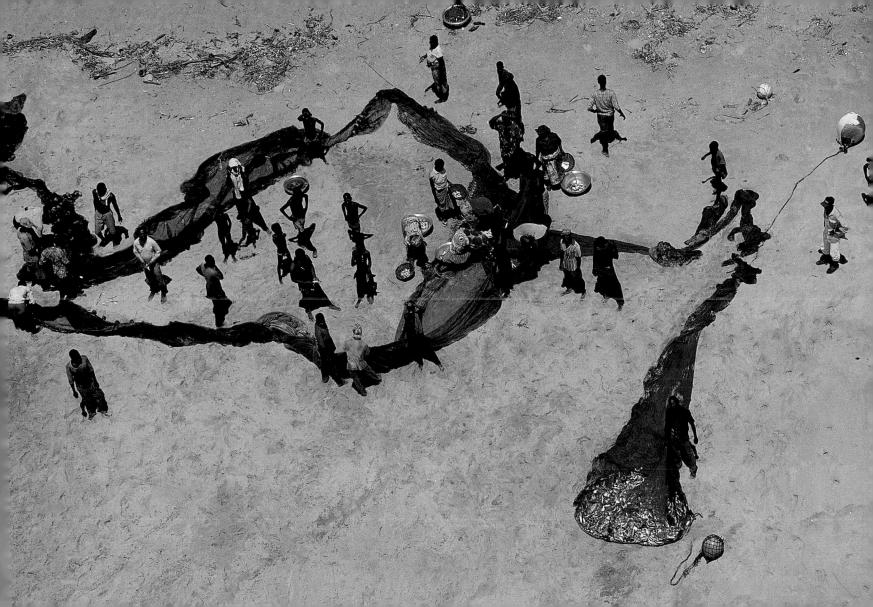

Shell gasoline depot, Singapore (1°22′N - 103°48′E)

Singapore, at the mouth of the Strait of Malacca, between Malaysia and the islands of Indonesia, was occupied for centuries by fishermen and pirates. Today the tiny republic (266 square miles [690 square kilometers]) is a strategic hub for maritime commerce, through which a quarter of the world's trade passes annually, as well as nearly all the oil imports of Japan and China. With 390 million tons of merchandise handled every year, the port of Singapore has become the world's busiest seaport, ahead of Rotterdam. This development is the result of an ambitious strategy steadily applied by the Singapore authorities since the island won its independence in 1965. The game plan involved first focusing on the business of warehousing and exporting, and then on high-return activities such as oil refining. Today the island has lost none of its dynamism; it excels in the field of information technology, and has even wrested leadership in that domain from the United States. This is no coincidence—information technology has become a key sector in global trade, as was oil in recent decades. And the oil business today is on the brink of irreversible decline.

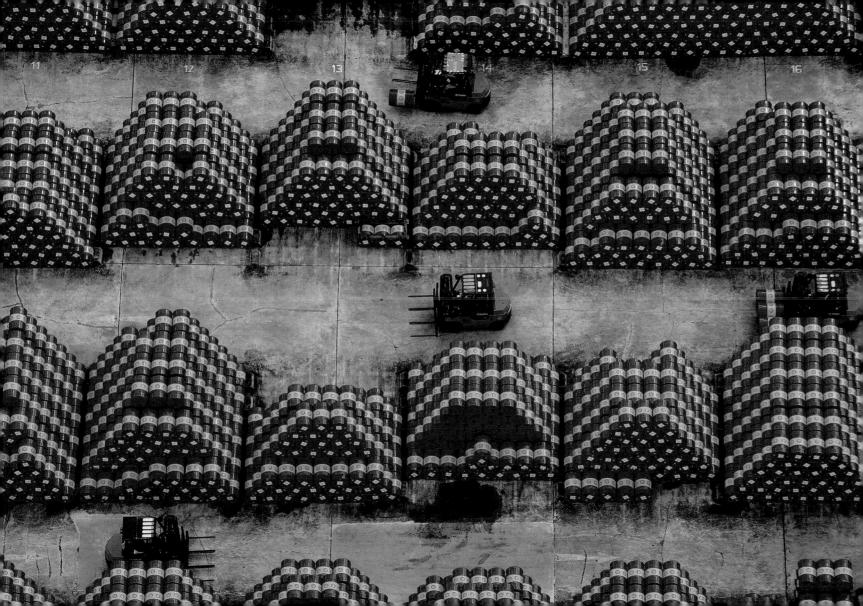

Shrimp farm, Phang Nga, Thailand (8°23′N - 98°34′E)

The sites chosen for shrimp farms tend to be coastal mangrove swamps in developing countries. Growing between the land and the sea, mangroves protect the coastline and serve as nurseries for ocean life. Fully 90 percent of the world's population of fish depend on the incredible richness of this ecosystem, especially for their reproduction; more than 2,000 species of fishes, crustaceans, and plants prosper in the mangroves. In 2004, the Indonesian villages that were least affected by the tsunami were those sheltered behind barriers of mangroves. And yet these forests of marsh trees have recently been destroyed on a gigantic scale in Indonesia, the Philippines, Thailand, Brazil, Ecuador, Panama, and many other countries. Between 1980 and 2005, the earth's tropical regions sacrificed 20 percent of their mangroves to make way for agriculture and aquaculture. This is clearly a very bad idea in terms of sustainable development, given that a report by the UN Environmental Program estimated in 2006 that per year, the economic services rendered by these ecosystems could be valued from \$150,000 to \$800,000 per square kilometer.

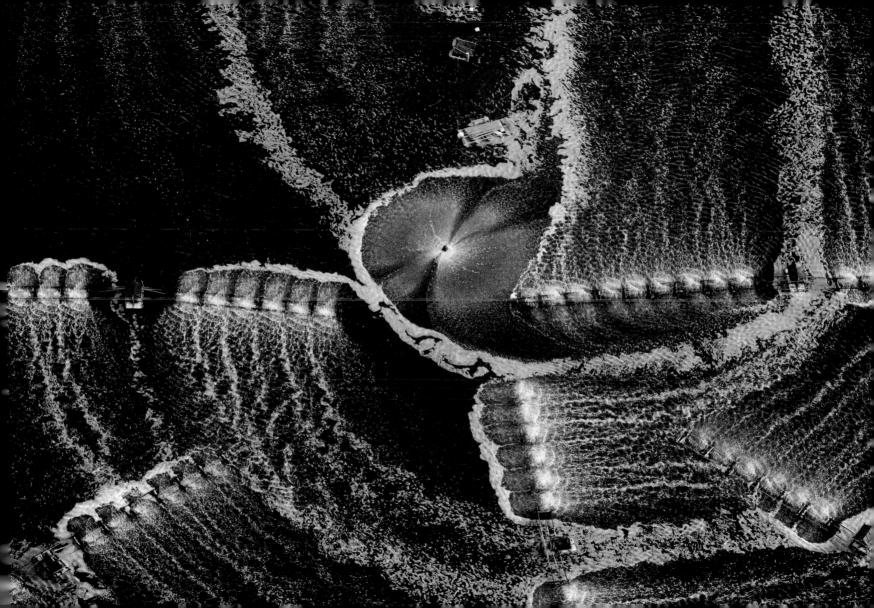

Fields near Halba, Akkar, Lebanon (34°33'N - 36°01'E)

Along the Akkar coastal plain in northern Lebanon, the majority of agricultural land is irrigated. The intensive growing of lettuce, tomatoes, potatoes, green beans, and eggplant has blossomed in the Mediterranean climate softened by proximity to the sea. Market gardens occupy 85 percent of the land surface, the remainder being reserved for citrus trees. Yet the thriving agriculture of the Akkar region is not representative of the overall situation in Lebanon. Although a quarter of the country, some 642,474 acres (260,000 hectares), is cultivable (exceptional for an Arab nation), Lebanese agriculture has still not entirely recovered from the civil war and the economic crisis that followed. As a sector, agriculture has long been neglected by the authorities; it generally consists of small farms, roughly 10 acres (4 hectares) in size, and Lebanese farmers—who now represent only 7.3 percent of the country's active workforce—are completely ill equipped to bring nutritional self-sufficiency to the population of 4.3 million.

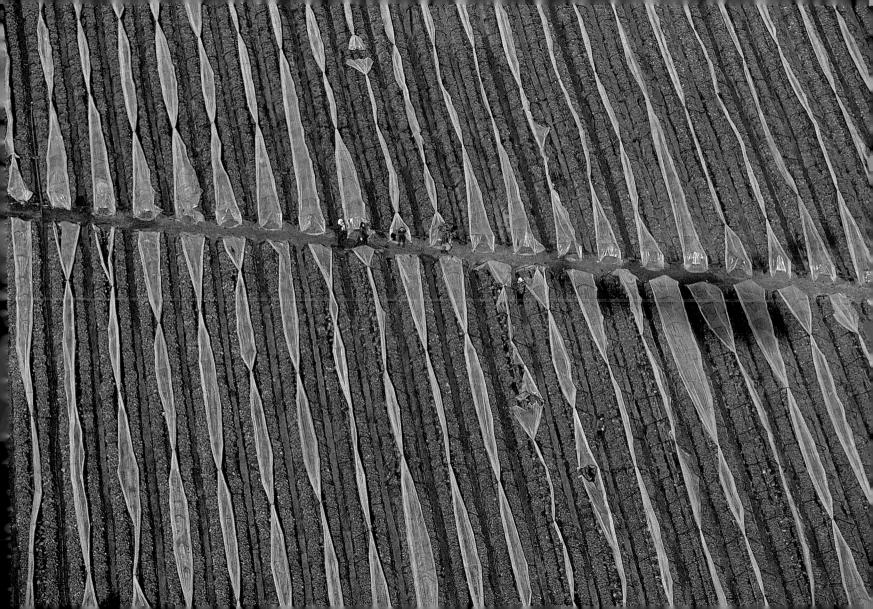

City of Ushuaia, Tierra del Fuego, Argentina (54°47′S - 68°18′W)

The Tierra del Fuego archipelago in the far south of Argentina owes its name to Magellan. Cruising along the coast in 1520, the Portuguese navigator saw columns of smoke rising into the sky, from fires lit by the local Indians. The capital, Ushuaia, was founded in 1884 and now has a population of about 50,000; it is the southernmost city in the world, with winter temperatures that can fall to -4°F (-20°C)—thus the sheer ice cliffs of the Patagonian Andes hint at Antarctica's frozen solitudes. In addition to its naval shipyards, logging, and fishing, Ushuaia's economy depends to a great degree on tourism. The Tierra del Fuego National Park preserves a landscape of steppes, lakes, forests, and peat bogs, which are home to nutrias, beavers, and many bird species; offshore, the sea abounds with whales, seals, and dolphins. In 1992, Argentineans selected this wild, carefully protected place for the burial of a time capsule—a small monument that may not be reopened until 2492. It contains videos, records, and messages to future generations that bear witness to human life and thought in our era.

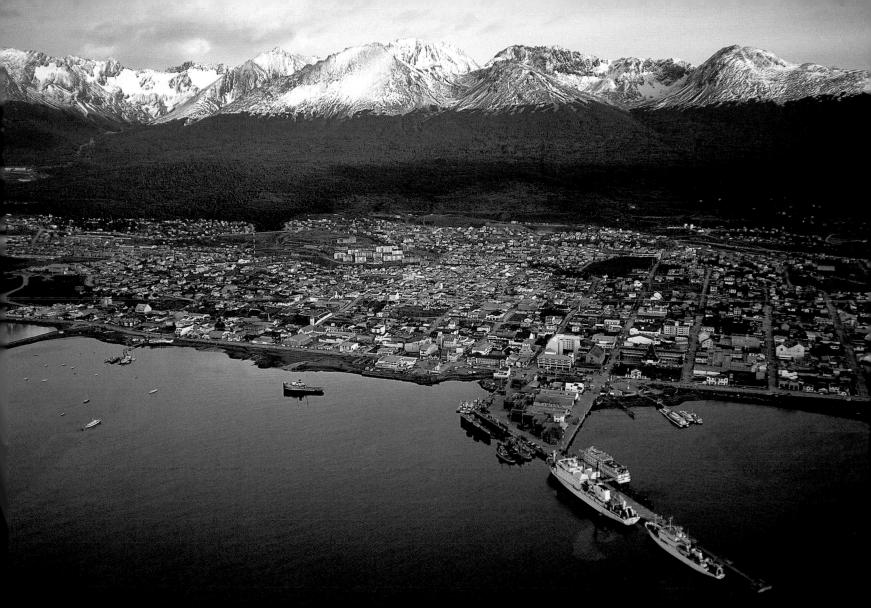

Diamond mine at Tortiya, Katiola, Ivory Coast (8°08'N - 5°06'W)

The story of Katiola, in the heart of Ivory Coast, began in 1947 when a prospector from the Saremei mining company discovered diamonds there. He named the place Tortiya after a novel he was reading at the time—John Steinbeck's *Tortilla Flat.* Soon a town had mushroomed around the drilling, and the site quickly became industrialized, with a power station and a factory turning out between 150,000 and 200,000 carats of diamonds a year. In 1974, the Seremei mine went bankrupt and ceased operations, whereupon the place became a magnet for independent prospectors, who flocked there dreaming of easy pickings. Today, amidst a climate of brutal violence, many are still around, braving appalling conditions, delving with hand shovels, and sinking deep into shafts that threaten to collapse at any moment. While diamond mining has never proved profitable in Ivory Coast, the trade has brought great wealth to Sierra Leone and Angola, the two major diamond suppliers of the African continent, but this wealth has tended to cause conflicts rather than to encourage development.

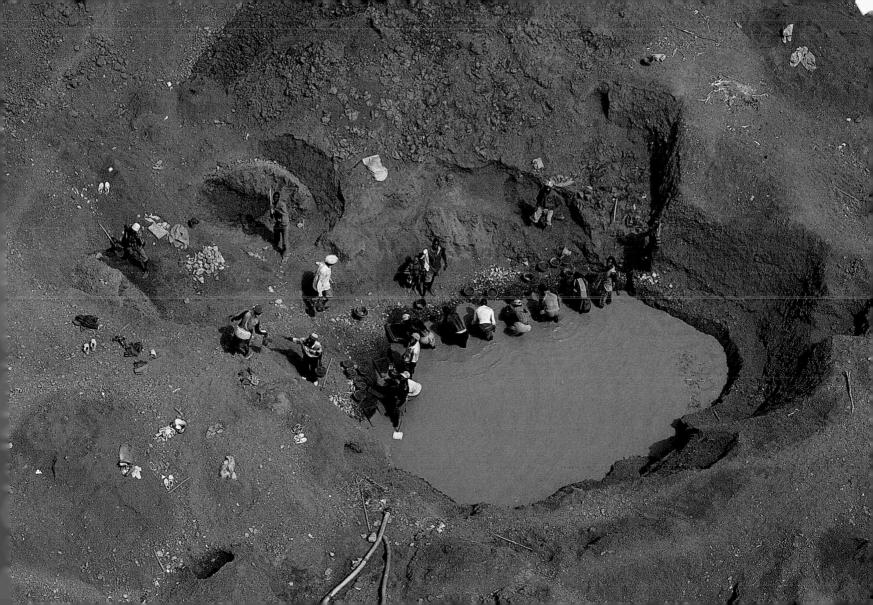

Vinkeveen Polder, South Amsterdam, The Netherlands (52°12'N - 4°56'E)

Close to a quarter of the territory of the Netherlands lies below sea level. The Low Countries largely consist of polders, meaning land that has been reclaimed from the sea and is surrounded by dykes. After the catastrophic floods of 1953, a program of major works known as the Delta Works was put in place. The final phase of this plan was the construction of a storm barrier near Rotterdam. inaugurated in 1997. Despite cutting-edge hydraulic engineering, the Dutch are still threatened by the consequences of climate change. The future increase in periods of heavy rainfall in Europe will be the cause of major flooding of the Rhine and Meuse rivers, which cross Holland, and which will add to the effect of rising sea levels. To counter the rising water levels predicted by the experts of the IGECC (an intergovernmental group of experts on climate change) the city of Dordrecht, which is built on a river island close to an estuary filled by the sea at high tide, has developed innovative amphibious buildings that will not be affected by high water, enabling inhabitants to live and work as usual. On a national scale, the Dutch government has begun organizing flood alerts aimed at testing the efficiency of public and emergency services in the event of catastrophic flooding.

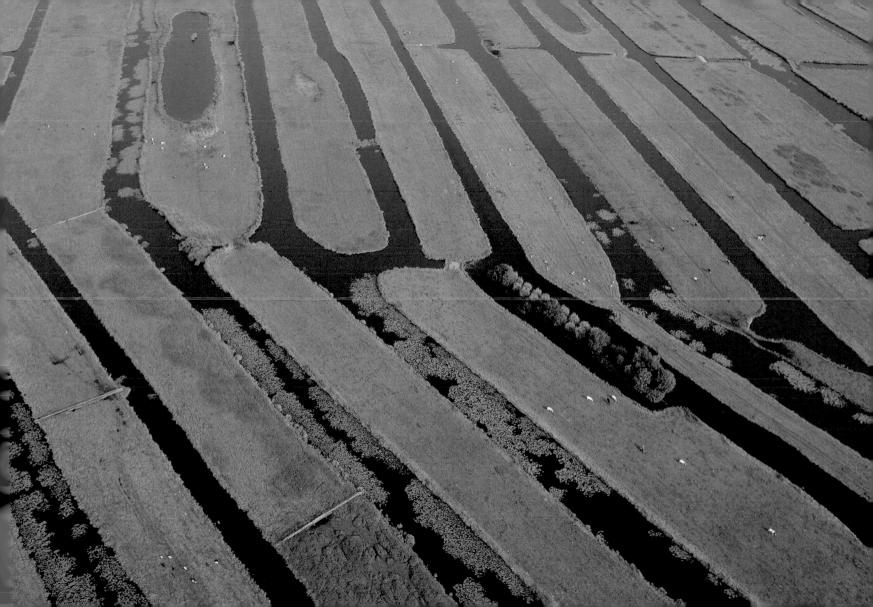

Dovecotes at Mit Gahmur, Egypt (30°42′N - 31°16′E)

These dovecotes, which resemble lookout towers, are imitations of the rocky cliff faces that were home to wild pigeons before they were domesticated five thousand years ago. Initially raised for food, the pigeons came to be used as message carriers, on account of their determination to return to their home dovecotes. This talent was exploited not only by the Egyptians, but also by the Greeks, Romans, Persians, and Chinese. As late as the Second World War, 16,500 English pigeons were parachuted into France to bring back intelligence. The magnetic sensors the birds carry in their tissue helps them, much like a compass, to know their exact geographical position. Supplanted in our own time by telegraph, telephone, and satellite, pigeons are no longer used for communications. But there is still no shortage of pigeon fanciers—especially in Egypt, where the national dish is stuffed pigeon.

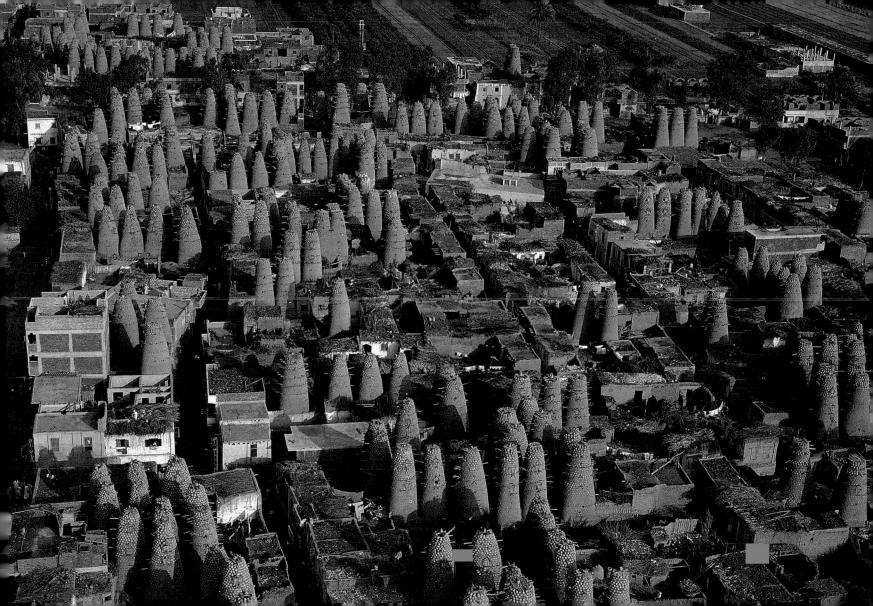

A branch of the river in the Okavango delta, Botswana (18°58'S - 22°29'E)

All rivers lead to the sea, but the Okavango delta is an exception that proves the rule—the Okavango ends in a sea of sand, the Kalahari Desert. The river's source is in Angola, where it is called the Cubango; thereafter it traverses Namibia before petering out in a vast inland delta 5,600 square miles (14,500 square kilometers) wide within Botswana. All along its 900-mile (1,450-kilometer) length, the river carries vast quantities of sediment that it deposits in the delta, providing resources for fishermen, farmers, and ranchers. The surrounding areas nourish about 1,000 different plant species, 400 bird species, and at least 40 large mammal species. This biodiversity—and its landscape of surpassing beauty—have made the Moremi Reserve, west of the delta, world famous. With a protected area of 26,502 square miles (68,640 square kilometers), this region is the largest site on the Ramsar List of Wetlands of International Importance, an intergovernmental agreement, signed in 1971, to preserve wetlands.

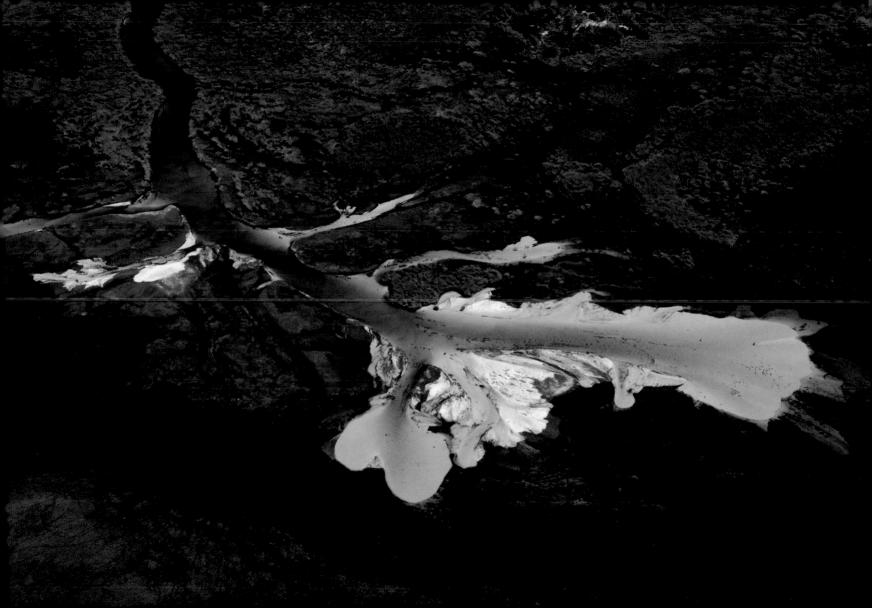

Fields near Larissa, Thessaly, Greece (39°39'N - 22°25'E)

This lone windmill in the Thessalian plains is probably a holdover from traditional agricultural methods, which were still widely in use as recently as the 1960s. By joining the European Economic Community (now the European Union) in 1981, Greece obtained substantial development aid to modernize its agriculture. Thus the landscape of Thessaly, the most fertile region in Greece, was profoundly altered by tractors, combine harvesters, and the systematic use of fertilizers and pesticides. It became an area of intensive farming, producing olive oil, tobacco, and cotton—Greece's main agricultural exports today. Larissa, in the middle of the plain, is now a major agricultural market and produce center, while Thessaly itself is the granary of this otherwise arid, mountainous country, only 20 percent of which can be used for farming. But intensive systems are now being called into question, and if today only 3.15 percent of Greece's farmland is organically cultivated (as compared with 14.2 percent in Austria, the European leader in the field), this proportion is increasing with every year that passes.

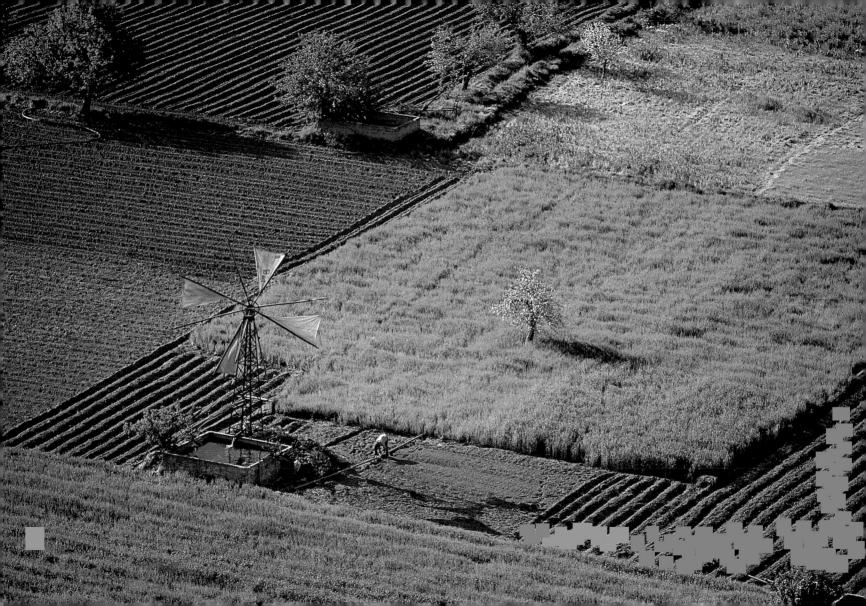

ANCIENT FORESTS IN PERIL

Are the planet's last remaining ancient forests condemned to certain destruction? Today almost 80 percent of the original covering has disappeared, most of it in the last thirty years. Over 32 million acres (13 million hectares) of trees (an area about the size of South Carolina) continue to vanish every year. Every forest is affected, from the tropical jungles of Amazonia, the Congo basin, and Southeast Asia, to the temperate rain forests of Canada's British Columbia and the vast northern tree scapes of Russia.

And yet the protection of old forests is essential to securing the livelihoods of the millions of people who depend on them, as well as to the preservation of the world's biodiversity and the reduction of greenhouse gas emissions. The last primary forests took millions of years to develop and they still provide shelter for two-thirds of the biodiversity that exists on the world's dry land. If humans continue to shamelessly exploit these resources, they will be irremediably destroyed. Should the forests die, our closest relatives in the animal world—the orangutans, gorillas, and chimpanzees—will die with them. So will hundreds of thousands of other animal and vegetable species, some of which haven't even been discovered yet.

When forests disappear, soil quickly erodes, affecting the drinkability of the water; then both animal and human inhabitants of the surrounding land are forced to move away. The destruction of forests affects biodiversity irreparably, and the humans whose lives depend on them. Deforestation is also to blame for one-fifth of the greenhouse gas emissions for which humankind is responsible. This is more than the world total of emissions created by human transport. Thus deforestation is a powerful accelerating agent for the climatic changes that are now under way.

Yet timber production is a major source of wealth and a force for development, especially for poor countries. The exploitation of forests for wood and the manufacture of paper is the principal cause of deforestation. In most cases, the companies that are devastating the last natural tropical forests on the planet are European or Asian organizations that share none of their profits with ordinary local people,

only with corrupt local leaders. These organizations practice a form of forestry exploitation that is highly destructive, and which often supports the world's illegal timber trade.

Moreover, the development of intensive agriculture by agribusiness consortia is having a negative effect on the world's precious forests. This is the case in Brazil, where the growing of soybeans to feed livestock in Europe and the United States is destroying the Amazon rain forest at an unprecedented rate. The paper industry, to satisfy a worldwide growing demand, is rapidly eroding the northern forests of Canada, northern Scandinavia, Russia, and Southeast Asia. In Indonesia, plantations of oil palm trees—oil that is used to make fuel, animal feed, and cosmetics—have been directly responsible for the loss of millions of acres of forest. Forest fires, accidentally or deliberately started, are used to create charcoal or to clear land; meanwhile a growing human population and overgrazing by livestock have worsened a situation that is already critical.

What can we do? Is it already too late to act? Will it be enough simply to replant? Reforesting with commercial species like eucalyptus or teak is no solution. A forest is much more than an area covered with trees: it is a complex ecosystem, at once vigorous and luxuriant . . . and very fragile.

Can the process be reversed? Yes, on condition that existing commercialization is managed in a sustainable way, that no new concessions are opened up, and that zones of old forest are protected to ensure their survival. At the same time, the consumers of the industrialized countries—and all political leaders—must face their responsibility for creating this crisis. There is no question that the problem can be solved largely by the populations of Europe and North America, because it is the inhabitants of the countries on those continents that are the main consumers of tropical wood cut in the forests and jungles of the Southern Hemisphere.

We must learn to restrict ourselves to locally grown wood for construction, and we must turn to recycled paper for all our paper and cardboard requirements.

But should we boycott all tropical products? This could provoke the leaders of those countries that still possess primary forests to cut them down in order to develop other sources of revenue. Hence we need to put in place genuinely sustainable management practices, fight the illegal exploitation of forestland, and address poverty by making sustainable forestry a genuine source of local employment. One way to support practices of this kind is to install a system of independent and credible certification. The consumer should be able to select ecologically certified products (i.e., products that do not come from the destruction of forestland) when buying wood, furniture (notably garden furniture), and paper. Today, the practices of certification and labeling are increasing, but most of us are still unable to tell the difference between serious labels and mere marketing tools. For the record, for all tropical wood, and for all paper products, there is only one certification that is both credible and recognized by international non-government organizations dedicated to the protection of the environment. This is the label of the FSC (Forest Stewardship Council), which is an international and independent organization.

Every individual consumer needs to make the right choices on a daily basis, and to exert pressure on decision makers, so that international forestry management projects can be worked out and put into action.

For example, given that the timber trade is one of the least regulated in the world, the European Union must quickly pass legislation guaranteeing that timber and timber by-products reaching the European market should not only come from legal sources but also contribute to the sustainable and equitable use of woodland. They should *not* proceed from the exploitation of the planet's last natural forests, to the utter detriment of biodiversity, humankind, and the world's climate.

François Chartier and Grégoire Lejonc Greenpeace Forests Campaign

Parasols on a beach near Agia Napa, Famagusta, Cyprus $(34^{\circ}59'N - 33^{\circ}54'E)$

The island of Cyprus is the easternmost state in the European Union. Its geographical location at the crossroads of three continents and all the great Mediterranean civilizations has profoundly affected the small nation, which has been invaded seventeen times in the course of its nine-thousand-year history. Cyprus still bears the scars of a sixteenth-century Turkish-Byzantine onslaught; the Turkish-speaking North is inhabited by the descendants of soldiers who arrived at that time. On the pretext that its people were not properly represented in the government, this region seceded and formed its own administration in 1974. Today, Cyprus is still divided between the North and the wealthy, Greek-speaking South, which has been a full member of the European Union since 2004; Nicosia has the sad privilege of being the only European capital to be divided in two. Such rivalry can only damage a country's image abroad, and so it has proved with Cyprus; despite its manifold attractions, the island draws only 2.2 million tourists a year.

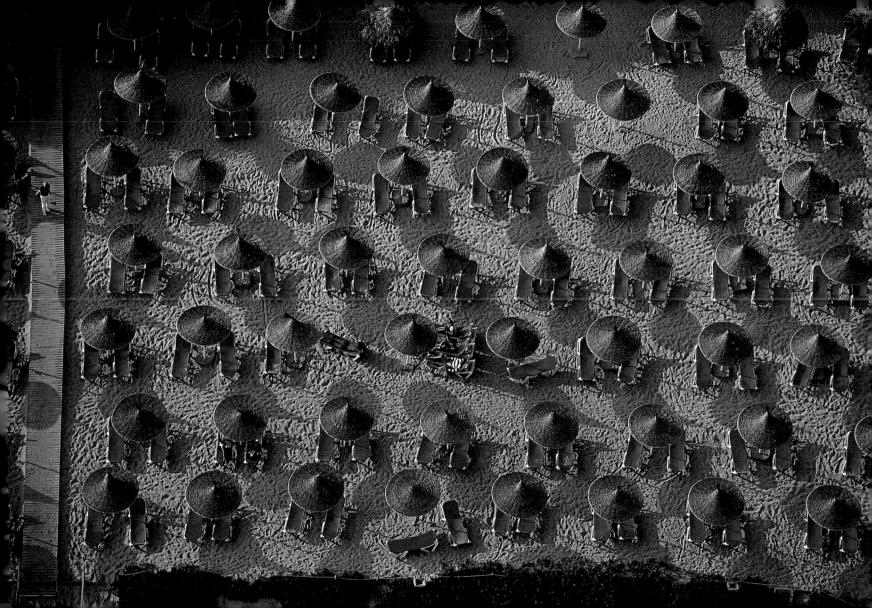

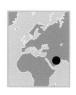

LNG tanker at the port of Ras Laffan, Al Khor, Qatar (25°41′N - 51°30′E)

Ras Laffan-located halfway between the European and Asiatic markets and in the center of the Arabian Gulf-is a major hub for the export of liquefied natural gas (LNG). After Russia and Iran, Qatar has the world's third-largest reserve of this resource. Since the principal North Field wells are a long distance from major consumer zones, tankers still provide the least expensive means of transporting LNG. The chemical gas-to-liquids (GTL) conversion makes it possible to produce a diesel GTL fuel that is considered "clean," and a gigantic GTL plant, the largest in the world, is soon to be completed in Qatar. The facility will produce 140,000 barrels of fuel per day and will bring a thousand new jobs to Ras Laffan. In tandem with this growth in the gas industry, environmental initiatives are under way in Qatar to replant the black mangrove (Avicennia marina) and restore the beaches where green sea turtles (Chelonia mydas) and hawksbill turtles (Eretmochelys imbricata) still come to lay their eggs. And to stimulate the recovery of local coral, "reefballs," or artificial reefs, have been sunk along Qatar's coastline

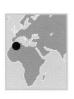

The Green Barrier at Hassi Bahbah, Algeria (35°04′N - 3°01′E)

The Sahara occupies 85 percent of Algeria's territory, covering some 770,000 square miles (2 million square kilometers) south of the Atlas Mountains; the 3 percent of the country's land that is cultivable is concentrated along the northern coastal plains. To protect this valuable resource from the encroaching desert, a spectacular project known as the Green Barrier was developed in the 1970s. This herculean operation consisted of planting a strip of forest 2.5 to 16 miles (4 to 25 kilometers) wide and 746 miles (1,200 kilometers) long between the Tunisian and Moroccan frontiers. But of the planned 7.4 million acres (3 million hectares), only 395,000 acres (160,000 hectares) were actually planted (between 1974 and 1981). Today, at Hassi Bahbah, 34 miles (54 kilometers) north of Djelfa, the wall of trees seems to be holding, but many other sectors are dying out, penetrated by illegal logging or ravaged by caterpillars. Following the advice of agronomists, the military officers in charge of the project opted to plant only a single species: the Aleppo pine. In retrospect, this looks to have been a mistake. Since the year 2000, the Algerian government—which ratified the United Nations convention on the struggle against desertification in 1994—has taken a renewed interest in strengthening and extending the Green Barrier to cover 7.4 million acres (3 million hectares), while improving and, above all, diversifying the existing plantations.

The Grand Canal and the Rialto Bridge, Venice, Italy (43°35′N - 12°34′E)

Venice is actually an archipelago of 118 islands, separated by 160 canals that are traversed by over 400 bridges. Along the city's principal artery, the Grand Canal, stand over a hundred Renaissance and baroque palaces, built by Venetian merchants to bear witness to their wealth and power at a time when Venice was opening up to the outside world. From the year 1000 onward, Venice imposed her supremacy first on the Adriatic and then on the entire Mediterranean, maintaining many outposts until such time as continental trade supplanted sea commerce at the close of the seventeenth century. With this development Venice was eclipsed from the international commercial scene. Today, her eclipse threatens to become total: La Serenissima may vanish altogether under the water, a victim of the floods resulting from the enlargement of her canals, the slow settling of her subsoil, and the general rise in sea levels (0.2 inches [6 millimeters] per year). In 2002, an ambitious and expensive effort (the MOSE Project) was undertaken to control the passes that connect the lagoon with the open sea; nearly eighty mobile barriers are to be installed and operational before 2011.

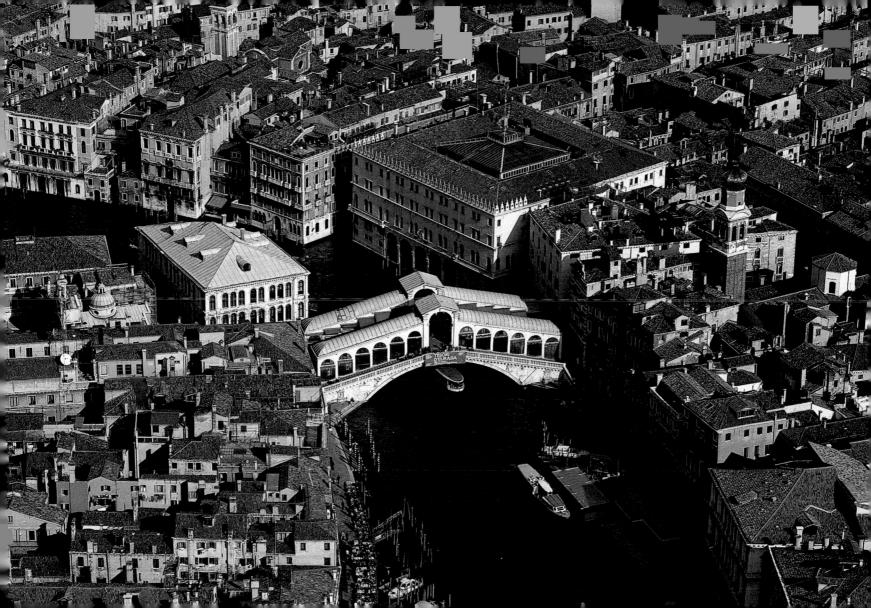

Market at Yamoussoukro, Ivory Coast (6°48'N - 5°17'W)

Like cities within cities, the great African markets are often organized into streets specializing in various wares: food, jewelry, leatherwork, or—as seen here in Yamoussoukro—secondhand shoes and goods. These commerce-devoted quarters are sometimes staggering in their size; the Dantokpa market in Cotonou (Benin), for example, packs some 15,000 vendors into an area covering 44 acres (18 hectares), and attracts up to 100,000 customers at peak hours. The markets are the official sites of mercantile exchange, but they also contain swarms of small vendors selling cigarettes, handkerchiefs, even telephones. Abidjan in particular is famous for its maguis, small clandestine restaurants improvised by local women. Such informal enterprises escape all control by the state, and they are certainly illegal; however, they demonstrate the great vitality of African societies as they attempt to lift themselves out of poverty. The underlying dynamism of African economies is often underestimated, because statisticians generally don't take into account unofficial commerce—which provides at least 40 percent of the continent's per-capita income and employs 50 percent of its workforce.

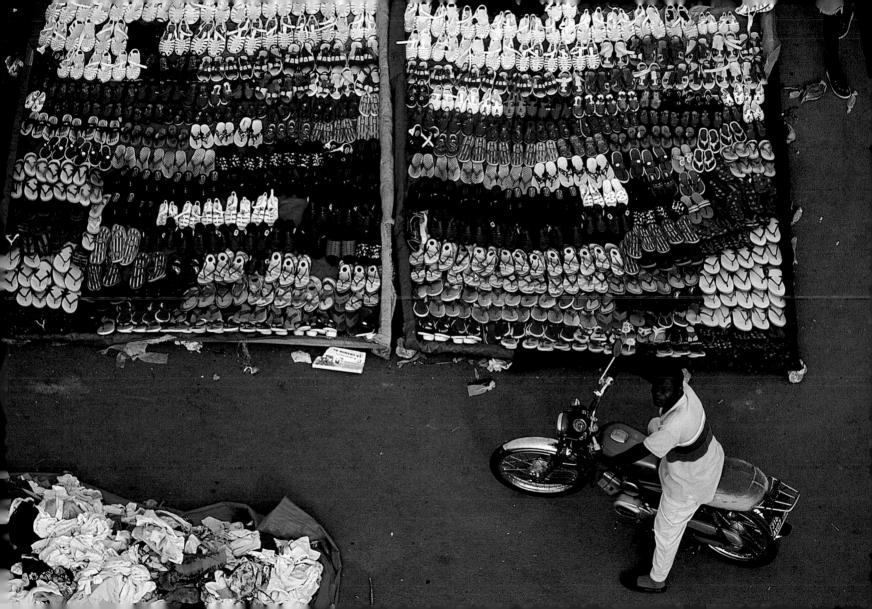

Conifer plantation devastated by Hurricane Gudrun in January 2005, Småland, southern Sweden (57°20′N – 15°00′E)

The outline on the ground might be that of an oak tree; actually the outline's trunk and main branches are defined by tracks into a plantation, while the ground. covered in dry branches, has the look of autumn foliage. Hurricane Gudrun, which swept across Sweden in January 2005, isolated many hundreds of thousands of people, depriving them of electricity. Heavy snowfalls, trees torn up by their roots, and a brutal cold snap combined to hamper rescuers, and a number of people died as a consequence. In the aftermath, Swedish tree growers were forced to clear huge areas of their plantations flattened by Gudrun; three full years of production were lost, and lumber prices collapsed. In recent decades, profithungry foresters have rushed to replace the natural southern hardwood forests of beech and oak with faster-growing conifers. But pines, with their permanent foliage, are more vulnerable to winter gales than hardwoods, whose leaves fall each autumn. So there is a certain irony in the fact that this ghostly image of an oak tree may unintentionally serve as a lesson to today's tree planters. Today the forestry and lumber industry accounts for 4 percent of Sweden's gross national product.

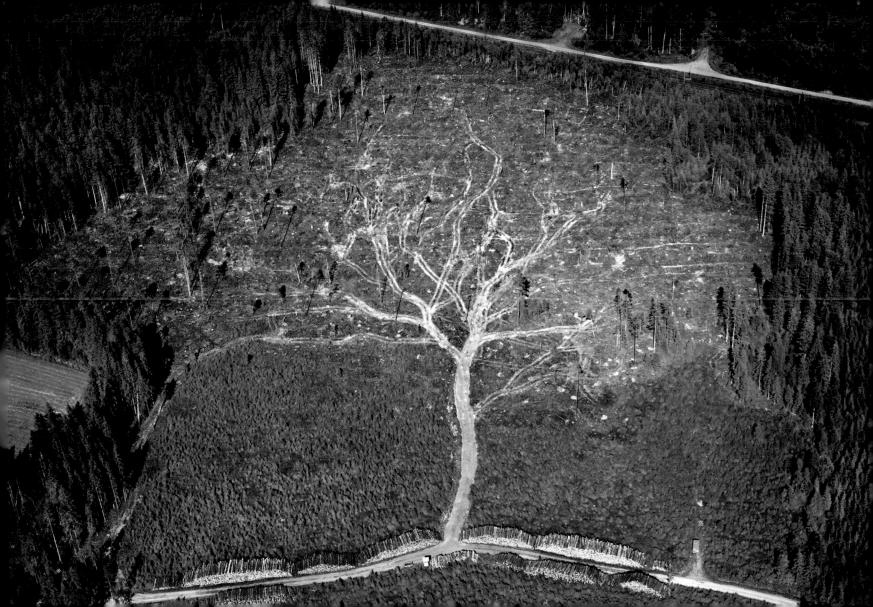

The Passy reservoirs, Paris, France (48°52'N - 2°17'E)

The city of Paris grew up around the Seine, but spring water was tapped in the mid-nineteenth century for a freshwater and drainage system. Today, Paris's water distribution network is 1,510 miles (2430 kilometers) long and serves a population of 215 million inhabitants spread over an area of approximately 19,700 acres (8,000 hectares). At every stage, from making the water drinkable to distributing it, the water is repeatedly checked so as to guarantee an irreproachable standard of hygiene. Every day over 21.188 cubic feet (600.000 cubic meters) of drinking water is consumed; the wastewater flows back to the sewers where, in dry weather, over 35 million cubic feet (1 million cubic meters) of liquid pass through them every day. This wastewater and a proportion of the rainwater are channeled to one of the city's four water purification plants before being drained away into the Seine. There is also a network of nondrinking water used for cleaning the streets and sewers and for watering green areas; this is fed by reservoirs with a total capacity of over 42 million cubic feet (1.2 million cubic meters), the largest of which are at Passy, Villejuif, and Ménilmontant. The provision of drinking water and the purification of wastewater are major concerns; public health and the preservation of the environment must be guaranteed.

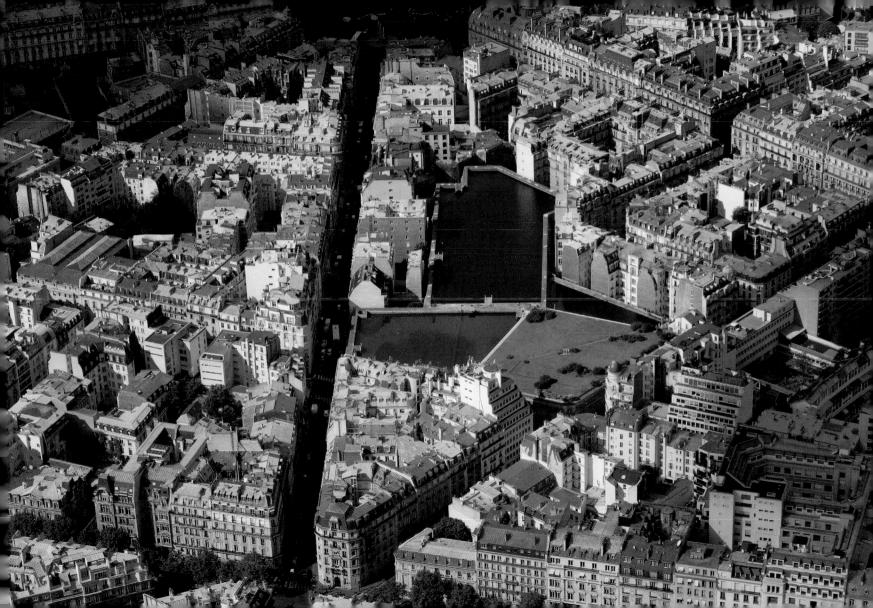

Field work, south of Jaisalmer, Rajasthan, India (26°46′N - 70°47′E)

The northwestern region of Rajasthan, the second largest state in India (at 132,000 square miles [342,240 square kilometers]), is two-thirds covered in sandy desert. The scarcity of surface water accounts for the low productivity of local agriculture. Nevertheless, extensive irrigation, which elsewhere is used to water some 40 percent of India's cultivable land, has made it possible to grow millet, sorghum, wheat, and barley in Rajasthan. These cereals are harvested at the end of the dry season; the task is usually assigned to women, who wear the traditional orhni, a long, brightly colored shawl specific to the region. Agriculture employs 60 percent of India's workforce, provides nearly 17 percent of its gross national product, and occupies more than 50 percent of its territory. With an annual crop of roughly 210 million tons of cereals, India is one of the world's major cereal producers. But the battle between increasing production and increasing population demands the wise management of underground water reserves from here on out. These reserves are steadily diminishing, and the situation has only been compounded by climatic events like the severe drought in April 2000, which affected 20 million people in Rajasthan.

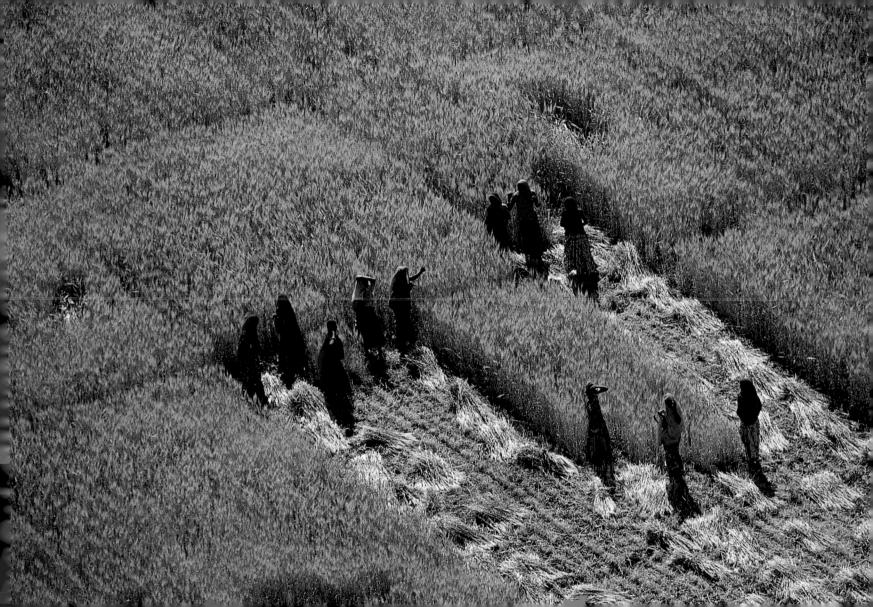

Ohau hydroelectric plant, South Island, New Zealand (40°40'S - 175°15'E)

South Island is hilly country, dominated by the New Zealand Alps. These mountains rise to nearly 12,500 feet (3,800 meters), and many rivers flow from them. Many watercourses have been artificially channeled to satisfy the energy needs of the country. This is the case with the Ohau hydroelectric complex in the upper reaches of the Waitiki River, now a long sequence of dams and canals. Its construction began in 1971 and involved the excavation of 70 million cubic feet (2 million cubic meters) of rock from the banks of the Ohau, plus 17.6 million cubic feet (500,000 cubic meters) mined for the construction of the evacuation channels. Hydroelectric plants were initially favored because they made use of a renewable resource and produced relatively little pollution, but there is increasing awareness today that these gigantic dams are having a negative impact on the surrounding ecosystems. Consequently, in a country famous for ecological tourism, the emphasis is now being placed on solutions that offer greater respect to the environment, such as wind power.

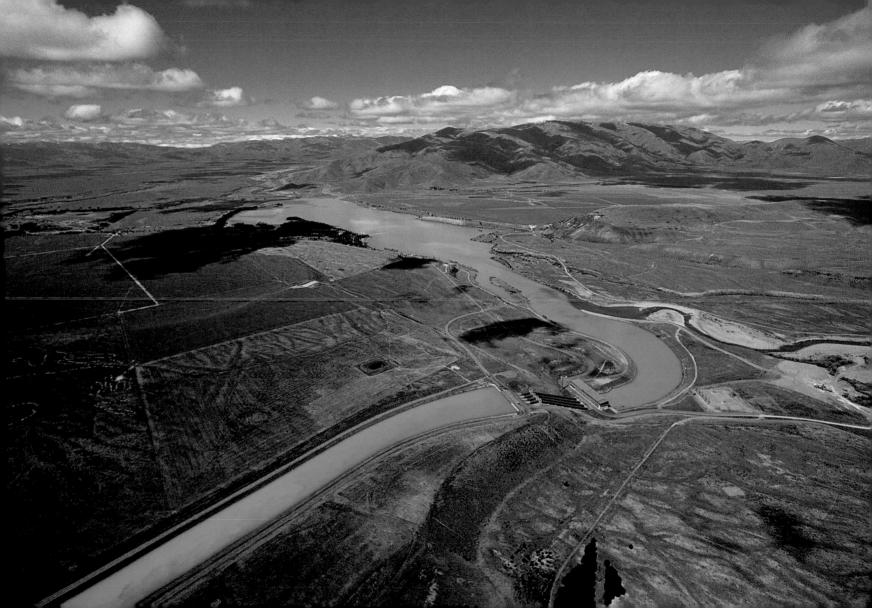

Nuclear power station, Saint-Laurent, Loir-et-Cher, France $(47^{\circ}42'N - 1^{\circ}35'E)$

Of the world's 443 nuclear power reactors, 59 are in France, supplying 80 percent of the nation's electricity; indeed, after the United States, France is the second largest electronuclear power on the planet. Since the 1960s French governments have opted for an all-nuclear energy policy to reduce dependence on other energy sources. France officially maintains this position today, pointing out that nuclear power production emits no pollutants into the atmosphere. China, Finland, and, most recently, India have followed the same nuclear path in response to a growing demand for energy, which is projected to increase by 60 percent before 2030. Yet in France, as elsewhere, most of today's reactors have already passed the halfway point in their useful lives, and a debate over their eventual renewal is in full swing. Certain countries, like Germany and Sweden, are cautiously determined to "get out of nuclear," on the grounds that the solid radioactive waste it generates will somehow have to be stored safely for thousands of years; this is altogether too heavy a burden to place on future generations.

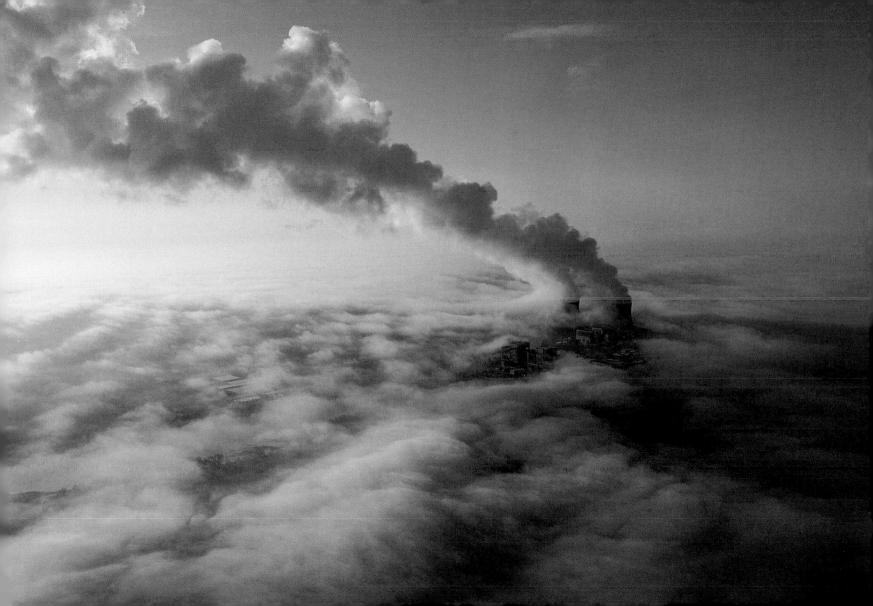

Dome of the Sultanahmet (Blue) Mosque, Istanbul, Turkey (41°1'N - 28°58'E)

Turkey is a Muslim country—99.8 percent of its population subscribes to Islam but it has had a secular constitution ever since the presidency of Kemal Atatürk in 1923. It has also been a member of the Council of Europe since 1949, and of NATO since 1952. Although 97 percent of Turkish territory is located in Asia, the country also possesses a European enclave, Eastern Thrace, which includes the historic center of Istanbul. Since 1987 Turkey has sought membership in the European Union, but it was only in 2005 that formal negotiations on the matter finally got under way. The frontiers of Europe remain vague, insofar as European identity is less a territorial matter than something forged by a shared history of conquest and submission to successive empires. Since the eighteenth century, the European identity has also settled around common political movements, such as the Enlightenment, revolution, the birth of the modern state, the welfare state, and secularism. Turkey shares much of this history, yet its entry into the European Community has been more protracted, difficult, and uncertain than that of any other country.

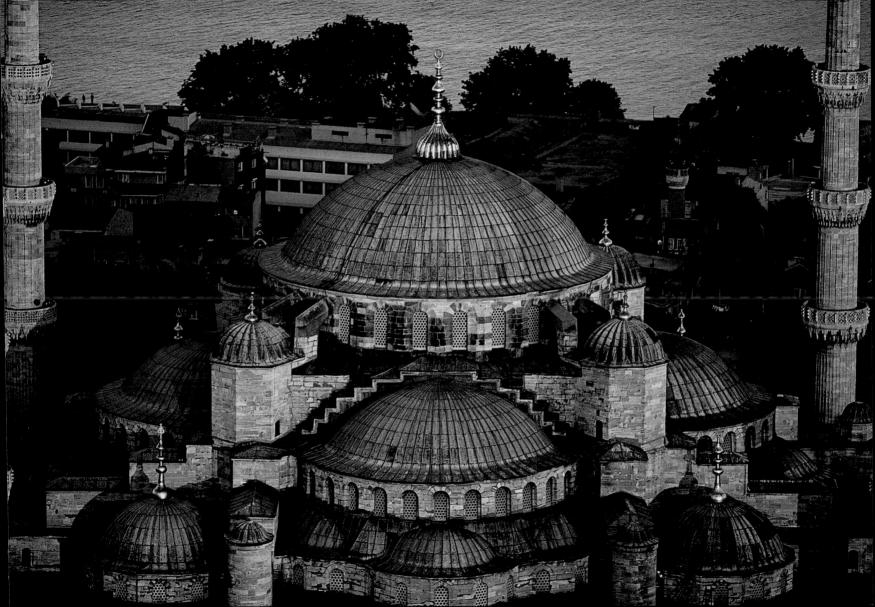

Giraffes in the Masai Mara National Reserve, Kenya (1°15'S - 35°15'E)

Together with its Tanzanian extension, the Serengeti, the Masai Mara National Reserve forms the largest protected area in the world (9,652 square miles [25,000 square kilometers]). But the wild animals living there cannot escape from the ecological problems caused by Kenya's rapid population growth, which has grown from 5 million in the 1950s to nearly 37 million today. The rapid conversion of territory into cultivated areas or pasture, the wholesale destruction of forests for timber that can be transformed into charcoal, poaching, the drying up of rivers, and urbanization—all constitute a direct threat to the flora and fauna of this country. Thus between 1977 and 1994 Kenya lost 44 percent of its wild animals, and over 200 animal and plant species are now threatened with extinction. Responsible forms of tourism that respect nature as well as create viable jobs may help maintain the region's biodiversity and improve living conditions for local populations.

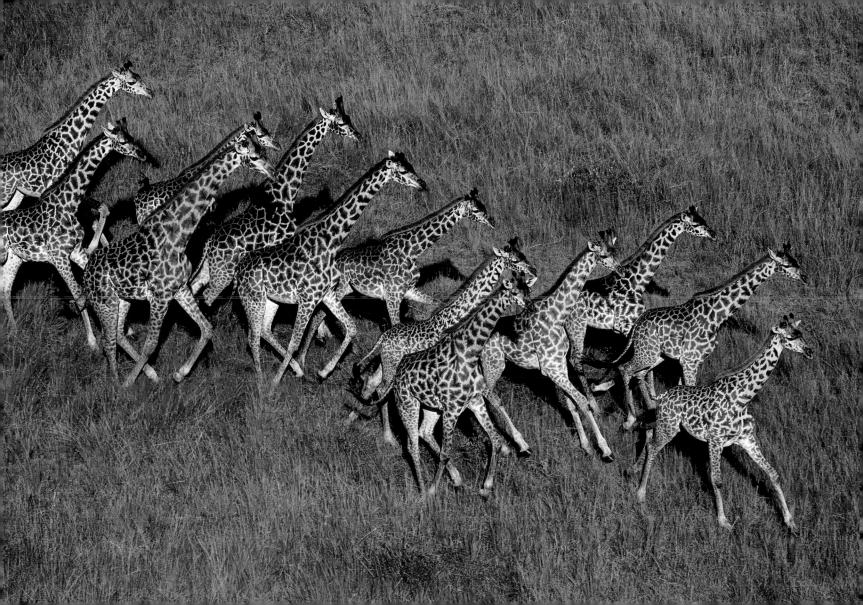

Cattle dung drying in the sunshine near Agra, Uttar Pradesh, India (27°10'N - 127°'E)

Hindus view the cow as a sacred animal whose flesh may not be eaten, but they do not hesitate to make use of its milk and excrement. Each year in India, up to a billion gobars, or cow pies, are gathered and recycled. Dried and mixed with clay, the gobar is used for brick making and for wall and floor surfaces in houses; blended with dry straw, it is made into fuel for heating and cooking; and. of course, on its own it makes for the best free, renewable fertilizer available to humankind. In general Indian farmers prefer to fertilize with dung rather than to use it for burning, in order to save on the cost of chemical fertilizers. But in the meantime, the forests of India are disappearing at an alarming rate; today, trees occupy only 11 percent of the country's land area, compared to the 30 percent they occupied in 1950. To counter the effects of rampant deforestation while allowing farmers to return cattle dung to their land as fertilizer, the Indian government subsidizes a "social forestry" program whereby trees are planted around field edges, preventing erosion and supplying future stocks of wood for fuel.

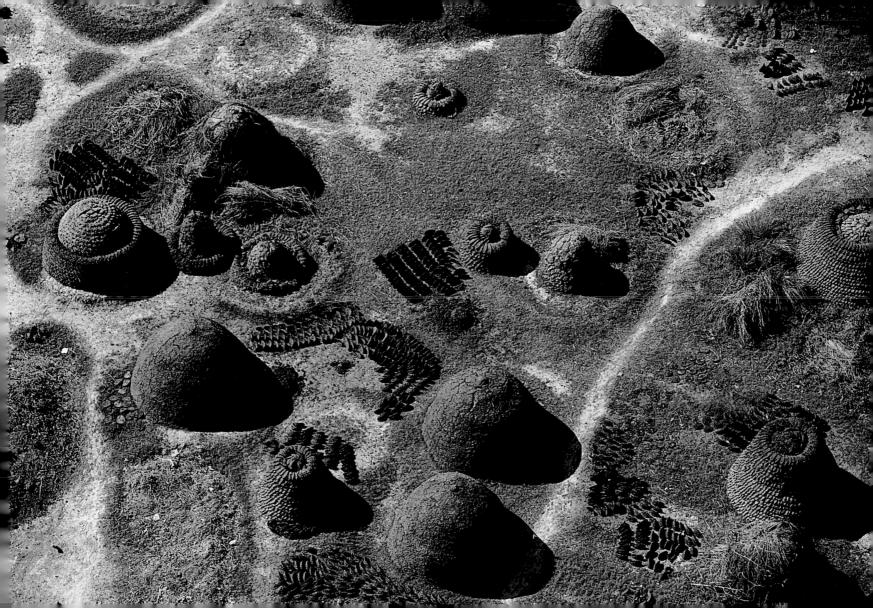

Eroded plateau, Poike, Easter Island, Chile (27°06'S - 109°14'W)

The erosion of this plateau has stripped away layers of topsoil, exposing the volcanic substrata. Sheep imported by European colonists in the twentieth century, followed by cattle and horses, are responsible for this aggressive erosion—which has hollowed out ravines several yards deep—and scattered plantations of eucalyptus trees have done little to impede the process. In the early twenty-first century, the advent of new inhabitants and tourists has created new perils for this island, which has been on UNESCO's World Heritage list since 1995. Who would believe that this 66-square-mile (171-square-kilometer) island in the middle of the Pacific, nearly 124 miles (2,000 kilometers) from the nearest land, was once covered by a forest of giant palms? After its early colonization by Polynesians in the fifth century, Easter Island was steadily stripped of trees. The islanders built houses, shrines (ahu), and gigantic statues (moai). The shortage of wood ultimately put an end to the construction of statues, and of canoes isolating this people who found themselves trapped—as we now appear to be—by an environment heading for destruction. For many, the history of Easter Island is a parable foretelling the environmental crisis that now affects our entire planet.

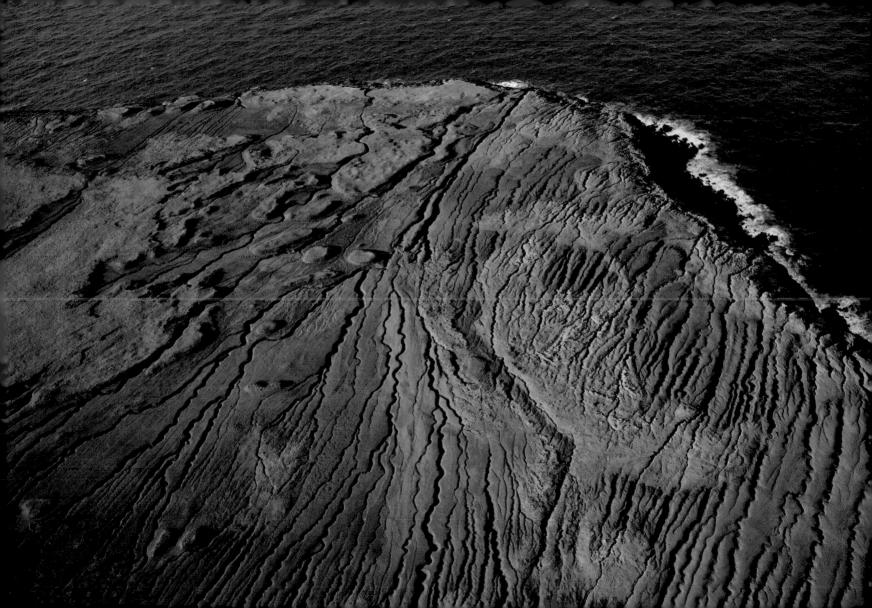

Floating fields of water lilies, pantanal, Mato Grosso do Sul, Brazil (19°14'S - 57°02'W)

The giant water lily Victoria amazonica—whose leaf can grow up to 10 feet (nearly 3 meters) in diameter-grows in all the tropical freshwater areas of South America. The pantanal region, which is flooded for six months of the year, is dry for the rest of the year, so water species like these have to take refuge in permanent marshland, and lakes. The pantanal, which is shared by Brazil, Bolivia, and Paraguay, is the largest freshwater wetlands area in the world, covering 72,510 square miles (187,800 square kilometers). Its unique association of natural ecosystems provides habitat for abundant flora and fauna, but only 1.3 percent of its total area is protected within reserves or national parks. Though included on UNESCO's World Heritage list since 2000, and protected from human encroachment by regular flooding, the biodiversity of the pantanal is threatened nevertheless. Today, within the framework of a vast navigation canal project, there is a plan to develop 2,112 miles (3,400 kilometers) of the Paraná and Paraguay rivers to link Cáceres in the Brazilian state of Mato Grosso with Nuevo Palmira in Uruguay. This involves straightening and dredging the rivers to allow big ships to ply to and fro, carrying Brazilian soybean exports. These works will certainly affect the flow of water in the basin as well as the natural regulation of floodwaters in the pantanal.

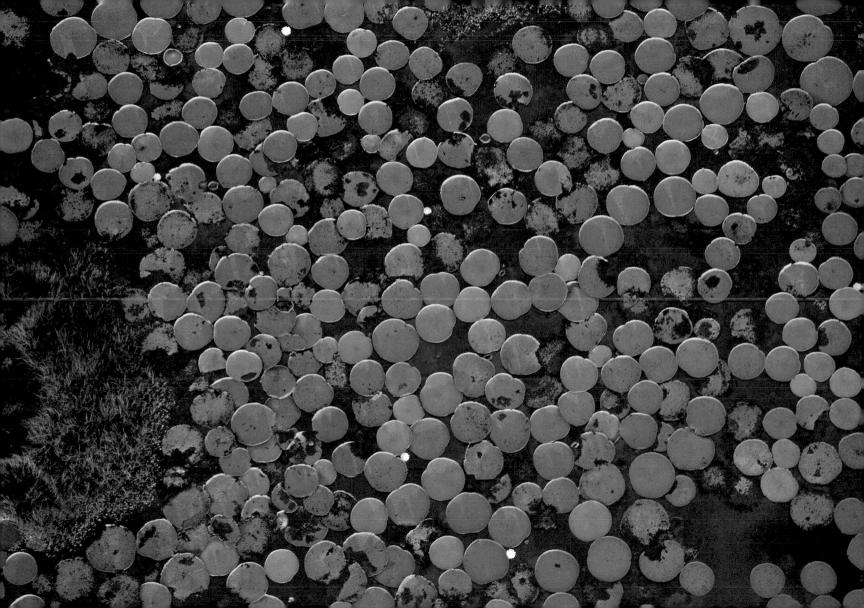

Teenagers among the hot springs of Hammam Meskoutine, Algeria $(36^{\circ}26' \text{N} - 7^{\circ}16' \text{E})$

Hammam Meskoutine, northwest of Constantine in Algeria's Kabylia region, is known as the Baths of Hell or the Baths of the Damned. The extravagant rock layers, walls, cones, and rising steps are the result of erosion from the hot springs. Apart from being of interest to tourists, Hammam Meskoutine is potentially a major geothermal resource for Algeria. In the interest of diversifying the country's sources of energy, the government has launched a broad program to evaluate potential sources of renewable energy. Today, hydrocarbons such as oil and gas are omnipresent in Algeria. The French Public Affairs Ministry estimates that this sector alone accounts for 50 percent of per capita income and 98 percent of Algeria's currency reserves. However, experts contend that Algeria's oil reserves will be exhausted within fifteen years, and that the country will thus be forced to import its oil from 2020 onward.

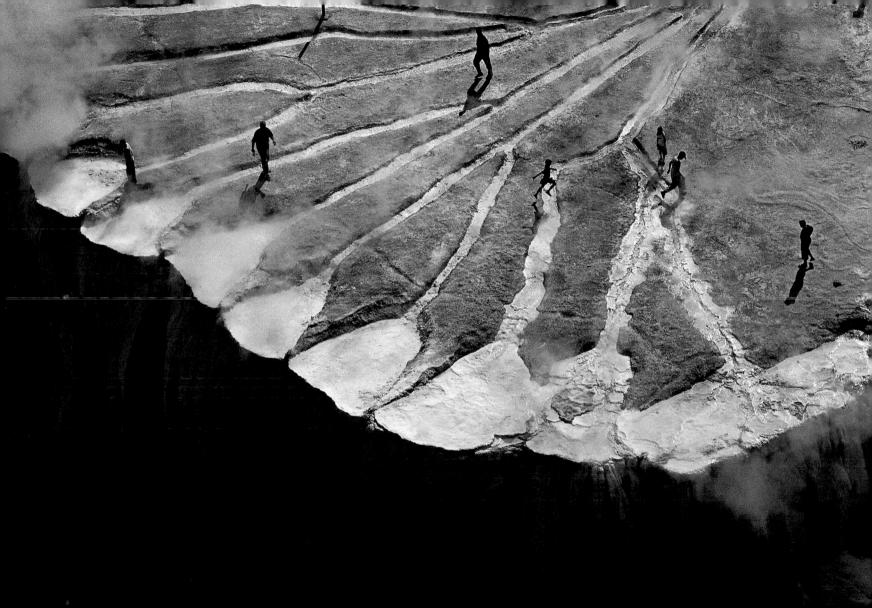

Wrecked boats in the Khao Lak nature reserve after the December 2004 tsunami, Thailand (8°36′N - 98°14′E)

On December 26, 2004, an earthquake registering 9.0 on the Richter scale took place off the coast of the Indonesian island of Sumatra and provoked a tidal wave of such force that the shorelines of twelve Indian Ocean nations were completely laid waste. In some places the waves were 33 feet (10 meters) high; 290,000 people are known to have died. In Thailand, the tsunami hit not only towns serving the tourist industry, but also coastal villages, where equipment and nets, in addition to 4,500 fishing boats, were badly damaged or lost. For the affected fisherfolk, the situation remains catastrophic; the income lost due to their inability to work was estimated (in 2005) at \$16.6 billion—quite apart from the sheer cost of replacing their equipment. Although military infrastructure allowed for effective international aid following the disaster, immediate priority was given to the tourist zones. When will the fishermen be able to return to their jobs and homes?

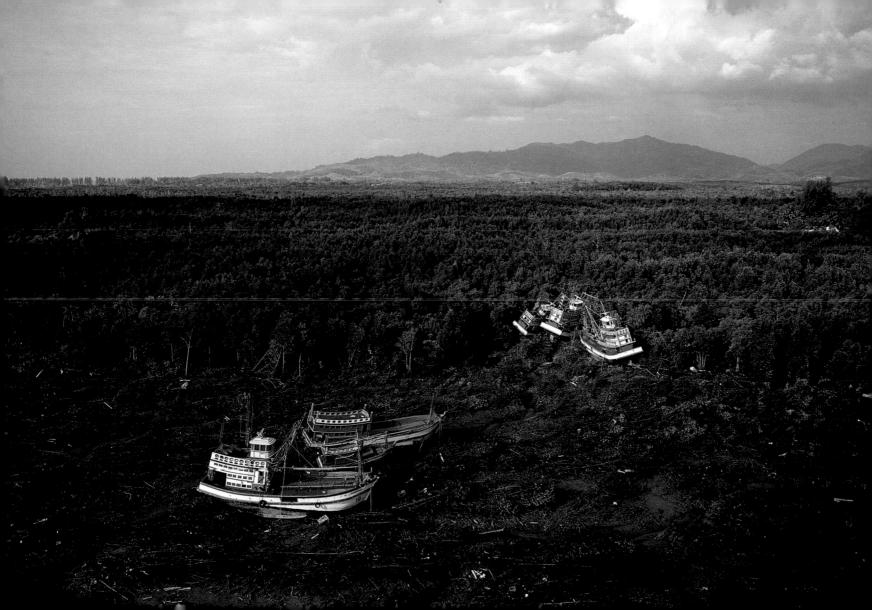

Village on Cheongsando Island, South Korea (126°53′E - 34°11′N)

This village is on one of the southernmost of South Korea's many islands, with a population of about 2,000 people. The houses are built to standard plans in the form of an L or U, or as squares with central courtyards. But since the urbanization of Korea in the late 1960s, *hanok* traditional houses have become increasingly rare, and the only ones left are in mountainous or rural regions. With the effects of demographic growth and above all of urbanization, South Korea has become one of the world's most densely inhabited nations, with 1,299 inhabitants per square mile (480 per square kilometer), of whom 85.54 percent live in cities. High levels of consumption and pollution have accompanied South Korea's economic growth. In the megalopolis of Seoul, with its 10.3 million inhabitants, air pollution has burgeoned into a very serious problem.

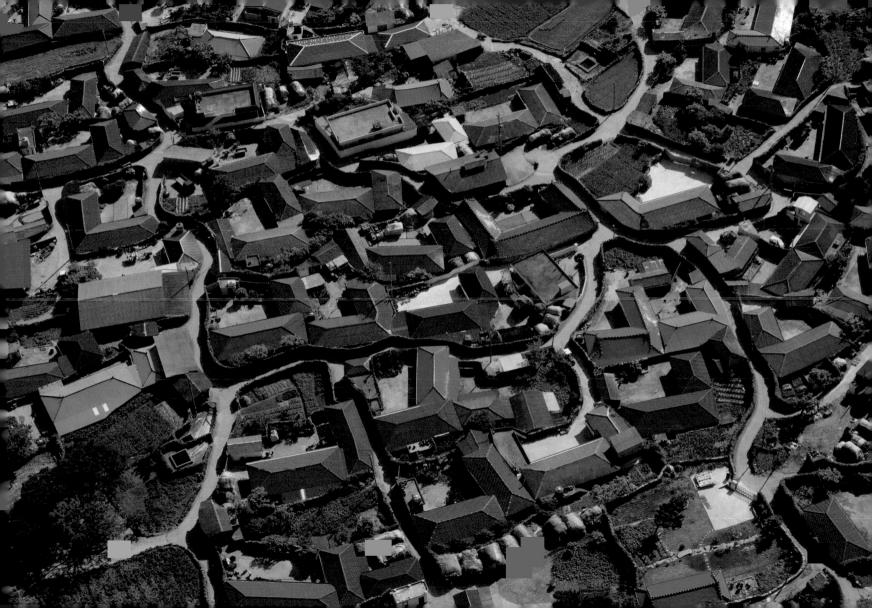

Agricultural landscape in Quiché country, Guatemala (15°30'N - 91°00'W)

Western Guatemala contains about thirty steep-sided volcanoes, whose successive eruptions have spewed forth the lava and ashes that makes the soil there so fertile. In a region where more than 50 percent of the people are involved in agriculture and only 25 percent of the land is cultivable, agricultural production is crucial to the economy. Produce for export accounts for 23 percent of per capita income, while coffee—Guatemala has been the world's leading coffee exporter for over a hundred years—sugar, cardamom, bananas, and other fruits and vegetables are produced in the lowlands of the Pacific coast, However, the vast majority of Guatemalan peasants can barely make ends meet growing maize, rice, and beans on small plots of land too steep for tractors. The devastation caused by Hurricane Mitch in 1998 and a subsequent series of savage droughts, the collapse of coffee prices in 2001, and an unstable, corrupt political climate have combined to exacerbate the social inequalities, which continue to stall the country's development. In Latin America and the Caribbean, 221 million people live in abject poverty; 64 percent of them reside in rural areas.

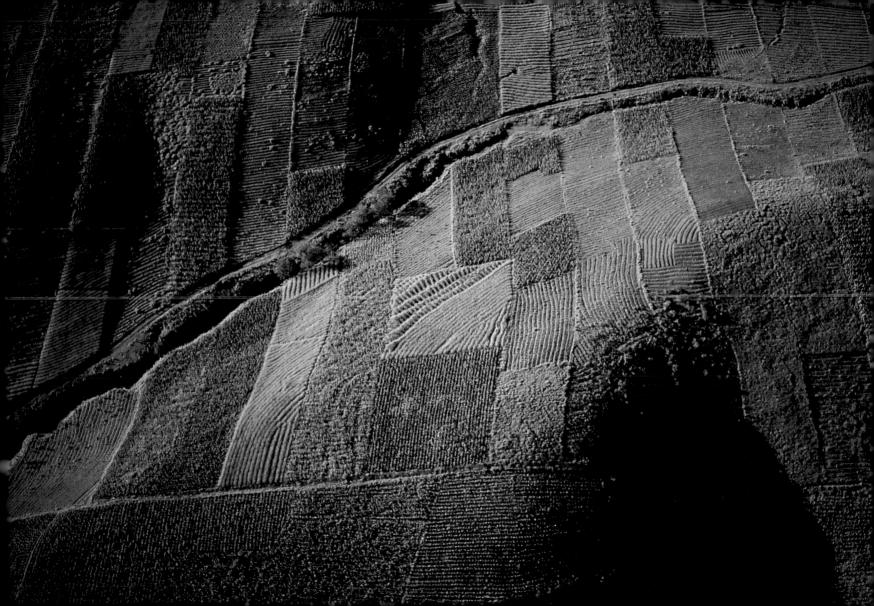

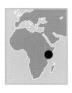

Masai cattle enclosures, in the Masai Mara Reserve, Kenya (1°13'S - 35°00'E)

According to religious belief, God (Enkai) created the Masai people to be owners of all the world's livestock. The wealth of a Masai family is thus measured by how much cattle it owns; land ownership, on the other hand, is of no importance whatsoever. The Masai protect their herds from wild animals by keeping them behind thorn enclosures—much more formidable than barbed wire fences.

After the day's grazing, the cattle are milked by the women, and are kept in the enclosures overnight. Partly for economic and partly for cultural reasons, the Masai seldom vaccinate their cattle. They use natural cures instead, and their knowledge in this field is now being closely studied by the Food and Agricultural Organization of the United Nations, which has plans to promote traditional veterinary techniques, though not over modern Western methods.

Lately in this country, which is 75 percent agricultural, Masai tribespeople are becoming increasingly sedentary, a trend that accelerated after the droughts of 1999 and 2000, which decimated animal stocks. But this change in the Masai way of life has put huge pressure on the land, which is now permanently overstocked.

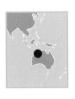

Livestock in transit, near Kununurra, East Kimberley, Australia (15°46′S - 128°44′E)

The East Kimberley region in northern Australia is a major livestock-rearing area. The ranches, most of which belong to commercial companies, each cover 400 square kilometers on average, and fewer than eight head of cattle feed per square kilometer. Despite the vastness of the land, the tropical and dry savannas in the region are showing the effects of overgrazing, especially in the vicinity of rivers and waterholes; fortunately, the creation of enclosures and well points makes it possible to preserve these fragile environments. Kimberley's sheer distance from consumer centers like Perth or Sydney (both are more than 932 miles [1,500 kilometers] away) has significantly slowed the development of cattle ranches in the district. Today, cattle are moved by road straight to the abattoirs and, more and more, to seaports, where they are exported live to Southeast Asia. Recently, the outbreak of mad cow disease in Europe opened new markets for Australian beef in North Africa and Egypt. The animals are loaded onto ships in batches of two to three thousand; thereafter they travel under hideous conditions, sometimes at sea for weeks on end. Many die en route. Associations against cruelty to animals worldwide have denounced these appalling practices, and are calling for a complete ban on the transportation of living animals.

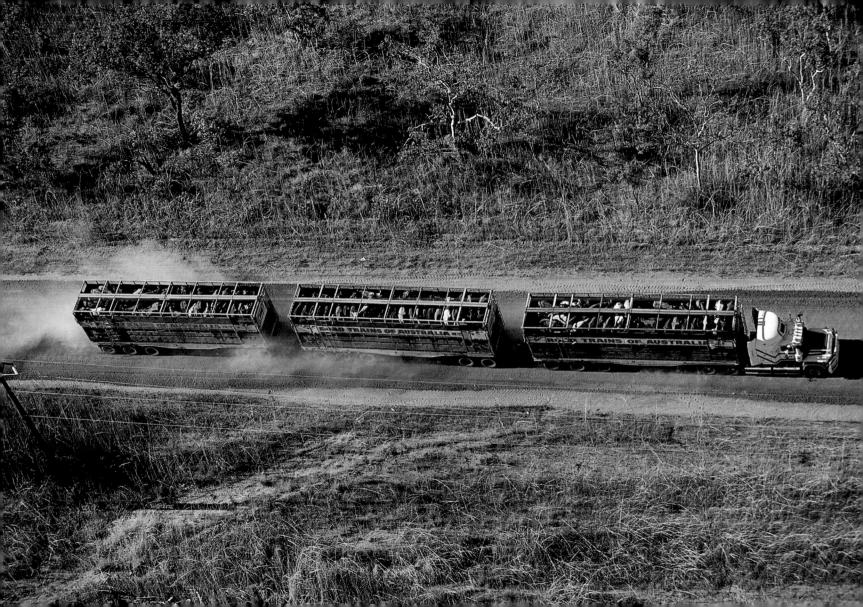

Beni Izguen, valley of the M'zab, Algeria (32°29'N - 3°40'E)

El-Atteuf, Bounoura, Melika, Beni Izguen, and Ghardaia form a pentapolis in the valley of M'zab. Organized as a confederation, the five towns were originally built in the eleventh century by the Ibadites, devotees of a particularly ascetic form of Islam who had been driven to this Saharan valley 373 miles (600 kilometers) from Algiers. Religious instruction still has pride of place in Mozabite society (Mozabite, after the Wad M'zab). A federal council of doctors of religion (the Halka of the Azzaba) supervises the now eight Ibadite towns, consisting of the original pentapolis, plus three more recent additions. The Halka constitutes a collegiate Islamic division of power that is unlike any other in the world. It is responsible for the strict observance of the precepts of Ibadite doctrine, for the settlement of disputes, and for all other matters affecting the community-from the weight of gold given to women as a dowry to the length of marriage ceremonies and the redoubtable practice of "blacklisting" a transgressor. But ever since the discovery of oil and gas deposits in the valley, the towns of M'zab have become the economic hub of southern Algeria, and it is now much easier for Ibadites to defy the many interdicts of their community.

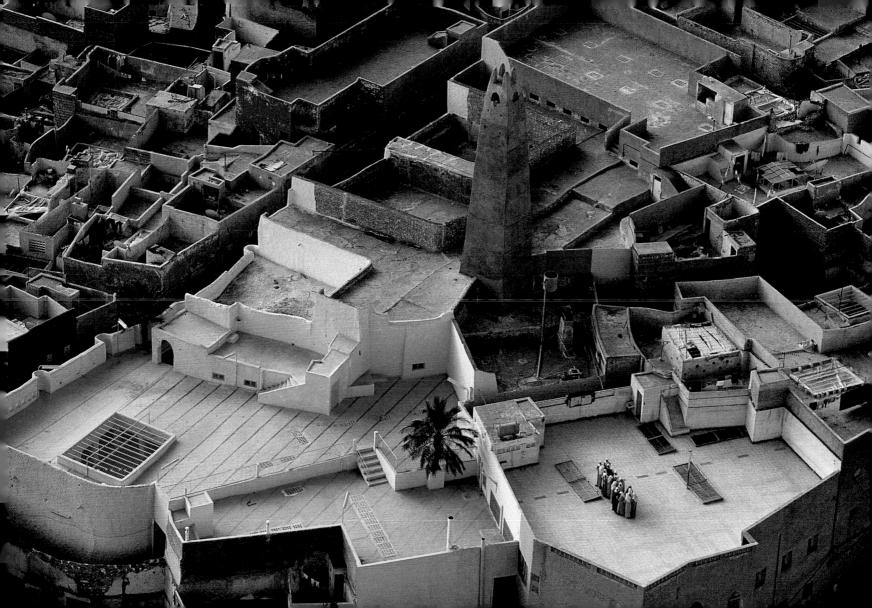

Buildings on the south bank of Seoul, South Korea (37°29'N - 126°57'E)

With more than 10.7 million inhabitants in its metropolitan area, the capital of South Korea is today the eleventh largest city on the planet. In 2005 it concentrated 25 percent of all Koreans, and over 80 percent of the country's urban population, as compared with 35 percent in 1970. This astonishing growth upset the original fabric of Seoul, and today austere concrete facades are the city's most marked characteristic. The traditional Korean family house, built according to the principles of geomancy (the art of divining positive- and negative-energy flows around a given site) has been swept aside by Koreans' newfound passion for cement buildings. The *tanji*, or all-inclusive high-rise, is prized by the citizens of Seoul as a symbol of modernity. Other forms of urban development mark the periphery of the city, where the Korean elite has built luxury villas that respect the old geomantic norms. The continual evolution at the urban heart of Seoul stands in sharp contrast to the Western tendency to turn cities' central districts into museums.

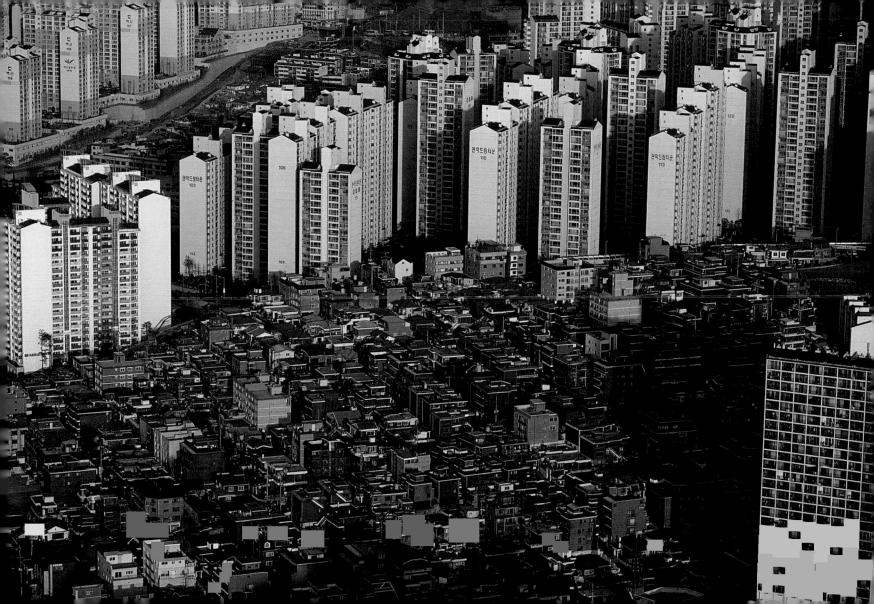

Agricultural landscape near Bozeman, Montana, USA (45°40'N - 111°02'W)

Despite boasting 146,000 square miles (377,000 square kilometers), Montana has less than a million inhabitants, making its population density 46 times smaller than that of France. Its relative lack of people, however, does not keep this American state, north of the Rocky Mountains, from being a gigantic producer of cereal crops, notably wheat, which represents a third of its farm output. Montana's harvest is invariably sold abroad; the United States remains the world's largest exporter of food products, to such countries as Algeria, which imports 75 percent of its food; Egypt, which imports 60 percent; and the entire Arabian Peninsula. The globalization of the world's economy has led to the globalization of agriculture, whose modes of production are ever more attuned to the world market. The price of wheat, the size of its stockpiles, and its rarity or abundance are not decided in Algiers or Cairo, but in Chicago and Washington.

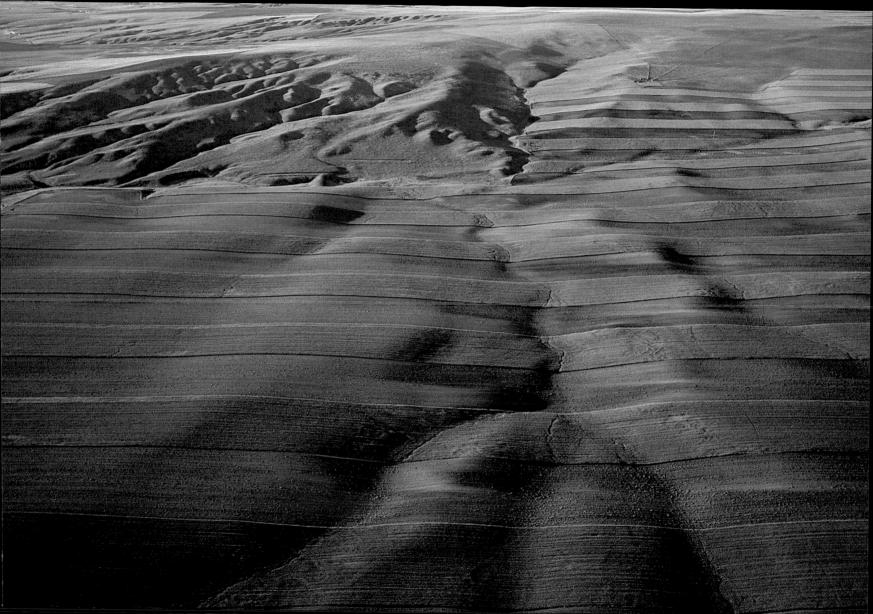

Start of the Golden Bowl Regatta, Lake Geneva, Switzerland $(46^{\circ}15'N - 6^{\circ}10'E)$

The Golden Bowl Regatta was first organized in 1939, under the name *Tour du lac des faces pales*. Today it is the biggest nonmaritime regatta in Europe, attracting six hundred sailing boats every year. Geneva, the starting point, is famous as a city of peacemaking and international negotiations, and has been since the second half of the nineteenth century and the creation of the International Committee of the Red Cross. In 1919, the League of Nations, the predecessor of today's United Nations, was conceived of in Geneva; the League was intended as a force for peace, and was introduced by the Treaty of Versailles following the First World War. Today, Geneva is home to about 170 nongovernmental organizations and over 20 international organizations. In all, more than 40 percent of Geneva's inhabitants are nonnative, representing almost 180 different nationalities and making the city an extraordinary center of cultural diversity.

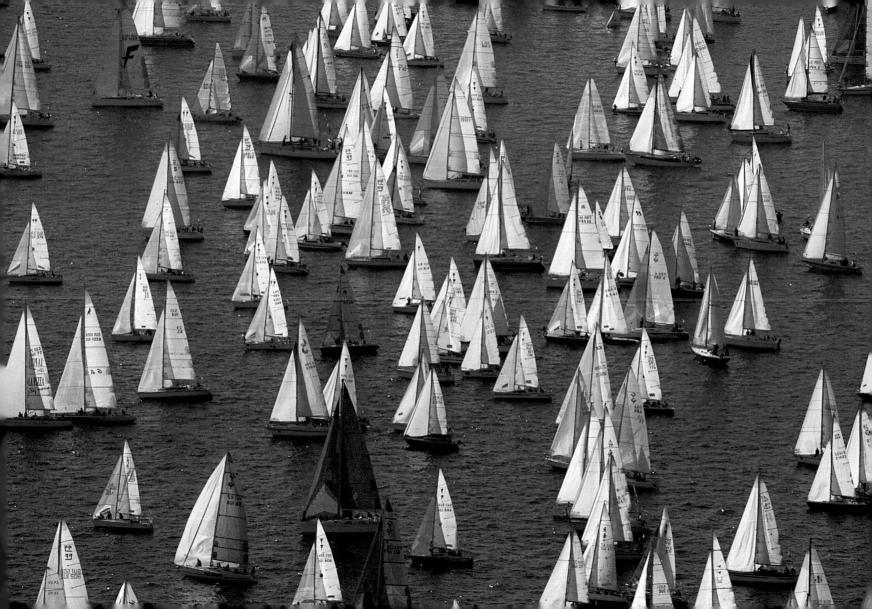

Fish farm near Roura, French Guiana (4°28′N - 52°31′W)

The seventy-five freshwater ponds of this fish farm cover 94 acres (38 hectares) along the Comte River in French Guiana. Originally built in the 1980s to produce an average of 25 tons of Southeast Asian giant prawns (known locally as chevrettes) per year, it was adapted in 2000 for the production of fish (17 to 22 tons a year) for the local market. Aquaculture has been practiced in Guiana since the 1970s. The climate conditions—mild temperatures, abundance of water, and marginal weather changes from season to season—are ideal for the industry, so much so that in 2006 there were 23 such farms with a total water surface of 202 acres (82 hectares). The fish farmers use the most environmentally sound methods available, and the introduction of new species is very carefully controlled. According to the United Nations Food and Agriculture Organization (FAO), the contribution of aquaculture to the world's food supply of fish, crustaceans, and mollusks is increasing more rapidly than that of any other sector. By 2030, the world individual consumption of products derived from aquaculture should rise from 35 pounds to 44 pounds (16 kilograms to 20 kilograms) per year. Today Asia has a 95 percent share of world production, more than 70 percent of which comes from China.

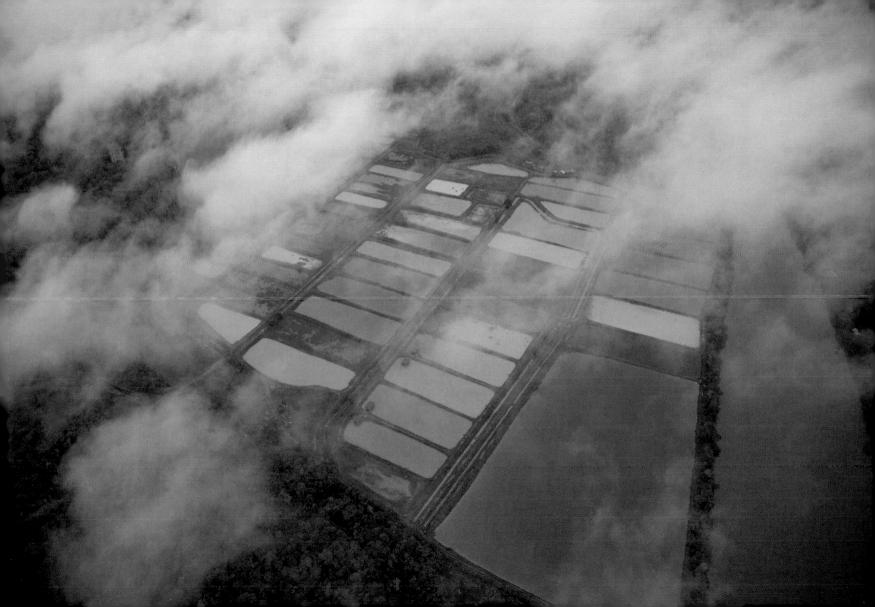

Refugee camp at Goz Amer, near the Sudanese frontier, Chad $(12^{\circ}00' N - 21^{\circ}23' E)$

Sudan, an African giant with no fewer than nine different frontiers, has only seen eleven years of peace since it won independence in 1955. The present civil war originated in a confrontation between the dominant Arab and Muslim North, and the black African South, where the people are largely Christian and animist. Since 2003, the conflict has escalated and changed in nature in the Darfur region, to the southwest, where the struggle is between Arab Muslims and black Muslims. More than five years after the start of the conflict, the Janjaweed Arab militia, armed by the government, has killed 300,000 people and driven out 1.8 million people, of whom 230,000 have taken refuge in neighboring Chad. Taking into account the scope of the tragedy, the U.N. has asked the International Criminal Court to investigate the crimes committed in Darfur. Today, civil wars are much more common than wars between nations; since 1990, fifty-five of the fifty-nine conflicts in the world have taken place within countries' borders, directly involving civilian populations. More than 2 million children have been killed in this fighting. and 20 million have been displaced. Villages burned to the ground; the systematic destruction of means of subsistence; instances of pillage, rape, and murder people in today's world are all the more defenseless against such unimaginable violence when it comes from their own governments.

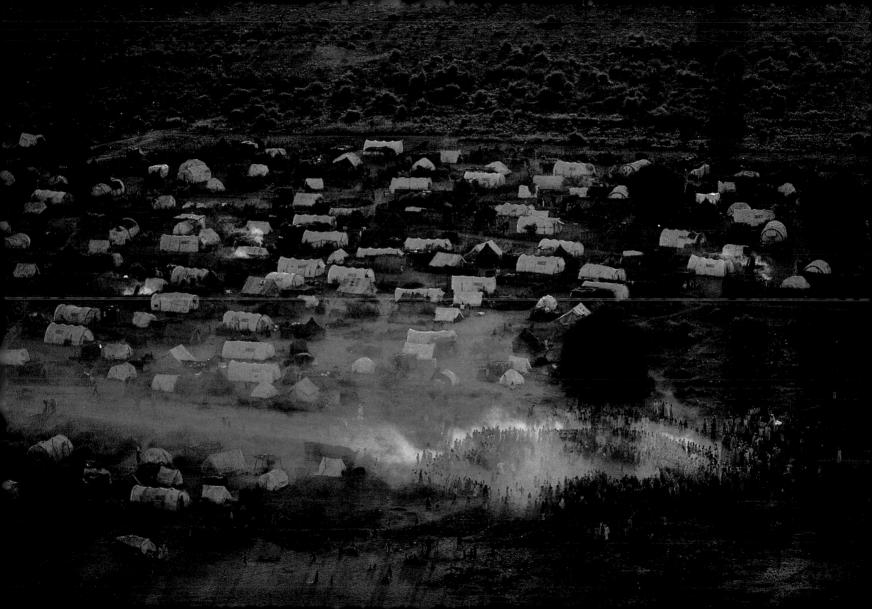

Surface polygons in Beacon Valley, McMurdo Dry Valleys, Antarctica (South Pole) (77°50′S - 160°50′E)

The bottoms of the McMurdo Dry Valleys, among the very few places on the Antarctic continent not coated in ice, are sprinkled with many-sided plaques that give the formations the look of dried-up, cracked lakebeds. Extreme seasonal temperature variations—in winter, a night lasting six months envelops the continent, driving temperatures down to -58°F (-50°C)—provoke alternate phases of thawing and freezing in the underground ice, creating strange mineral tapestries on the surface. Although how this land phenomenon is formed is not completely clear to us, it is found wherever the ground is permanently frozen—in the Arctic and the Antarctic, and even on Mars. The images sent back by the *Mars Global Surveyor, Spirit,* and *Opportunity* satellites prove that similar polygonal surfaces occur in the polar regions of the Red Planet, though in gigantic form; the polygons on Mars are several miles wide, as opposed to those on Earth, which are only 33 to 100 feet (10 to 30 meters) wide.

Drying fish in the countryside north of Bangkok, Thailand $(14^{\circ}00' \, \text{N} - 100^{\circ}36' \, \text{E})$

Thailand, at the heart of Southeast Asia, has a population of 63 million on a territory of 198,116 square miles (51,000 sqaure kilometers), and is one of the most prosperous nations in Asia. Nevertheless, Thailand's almost total dependence on the cultivation of rice has made the country highly sensitive to production variations and fluctuating rice prices. The Thai government has tried to mitigate this by diversifying the national economy. Like Thai farmers, Thai fishermen have always had to face extreme climate conditions. Their difficulties reached a climax on December 26, 2004, when an earthquake of record magnitude (8.9 on the Richter scale) hit the Indian Ocean and the northern end of the Indonesian island of Sumatra. Eight Asian countries and five African ones were affected by the ensuing tsunami (from Japanese *tsu*, carry, and *nami*, wave) that ravaged their shorelines. In some zones, 98 percent of the mangroves, where fish, crabs, and prawns used to reproduce in vast numbers, have completely vanished.

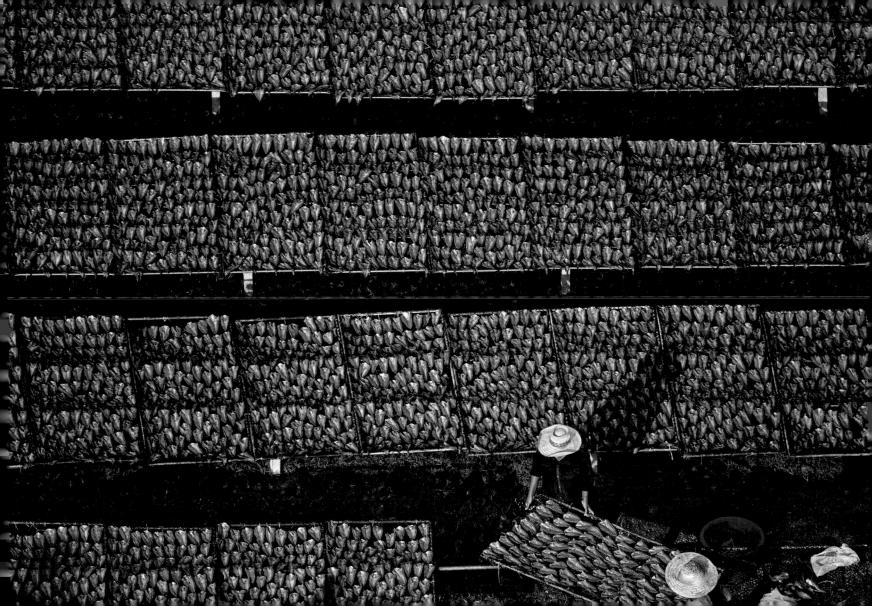

Makeshift sugar mill, Kenya (1°00'N - 38°00'E)

Many tropical countries grow sugarcane for their own use. In Kenya, this activity is carried out by small farmers, who in 2003 provided 90 percent of the 4.5 million tons of cane harvested; refined, this cane yielded 448,000 tons of sugar. About 5 million people in Kenya depend, directly or indirectly, on the sugar crop for their livelihoods, but even so, Kenyan sugar is far from being competitive in terms of world prices. To protect the networks and jobs that depend on the crop, Kenya's sugar imports are subject to quotas; the nation covers only 70 percent of its own needs, but on account of illegal, low-priced imports, a part of the local sugar production still fails to sell. A small fraction of Kenya's annual sugar output is bought at a preferential price, exceeding the world average, by the European Union, within the framework of the Lomé Agreement—a way of assisting the development of the African, Caribbean, and Pacific (ACP) countries. But the general weakness of world sugar prices, resulting from a global overproduction of sugar, has conspired to punish the developing countries, who now claim that the subsidies made available to European sugar-beet producers are undermining their ability to compete.

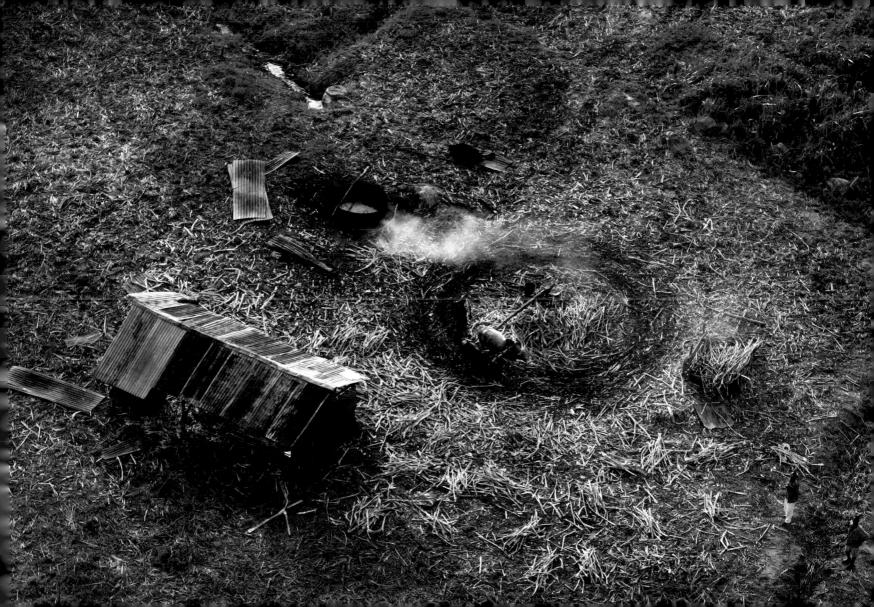

Strait of Hormuz, Musandam, Oman (26°34′N - 56°15′E)

Known as the Sentinel of the Gulf, the Musandam Peninsula, at the northernmost point of southeastern Arabia, is separated from the rest of Oman by the United Arab Emirates. The peninsula projects into the Persian Gulf toward Iran, and thus forms the Strait of Hormuz, linking the Gulf with the Sea of Oman. Musandam was a military no-go area for many years on account of its strategic importance, but today it is open again. The Strait is central to the interests of many states in the region, and has latterly become one of the world's busiest sea-lanes, and a strategic bottleneck for a vast amount of traffic; every day, 15 million barrels of oil from the Gulf countries pass through on their way to Asia, the United States, or Europe. This region alone contains 65 percent of the world's known reserves and about 40 percent of its present production of oil. At a time when the demand for hydrocarbons is spiraling steadily higher, this waterway cannot cope with any further increase in traffic. Several pipelines have been built to circumvent it, but their combined capacity still falls far short of that of the Strait of Hormuz.

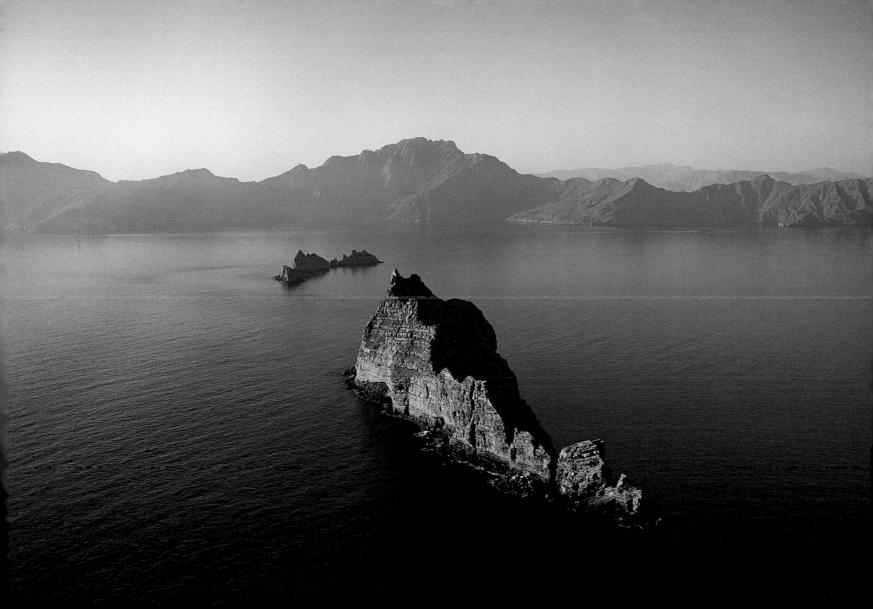

BIODIVERSITY— A CONDITION OF SURVIVAL

It is estimated that about 1.7 million animal and plant species are already known to humankind. Some are spectacular, like the elephant and the parasol pine; others are practically invisible, like microscopic algae and tiny insects. Some are popular, making us want to protect them, like the panda and the members of the orchid family; still others are less enchanting, like scorpions or poison sumac. But all are equally precious.

Many more species have yet to be identified. How many? 15 million or so? And how many subspecies and populations with different characteristics contribute to the diversity of the living world? The North American grizzly bear, for example, a giant weighing 1,500 pounds (700 kilograms), belongs to the same species (*Ursus arctos*) as the Pyrenean brown bear, which is seldom heavier than 440 pounds (200 kilograms).

All of these species are interdependent and all are irreplaceable; if one dies out, all its potential dies, too. Without it, we might never discover a certain new medicine, or a set of hitherto undiscovered immune-defense mechanisms. Likewise, all the delicate balances in which that species shared will be called into question; the organisms that fed on it will die of hunger, and those it fed on will multiply beyond measure.

Until recently, the advents of new species and the disappearances of old ones took place at a roughly equal rate, and thus canceled one another out. Today we know that a hundred times—perhaps a thousand times—more species are vanishing than are emerging. Of course, there have been crises of a similar magnitude before. On five different occasions the fauna and flora of this world have been exterminated by some kind of cataclysm, caused by the earth's collision with a meteorite or by a volcanic eruption. The dinosaurs disappeared in this way. And many millions of years had to pass before the living earth was able to win back a comparable richness and variety.

What is unique about today's threatened "sixth extinction" is that humans will have been solely responsible for it, and will perhaps be a victim of it, too. This time, the event will be no cataclysm. It will be a collapse of biodiversity, brought about because certain species are overexploited, and above all because natural environments have been degraded and destroyed by clear-cutting; forest burning; urbanization;

pollution of the air, water, and earth; climate change; and the introduction of invasive species. The few hundred years it took to bring this situation to a head may seem to us like a long time, but on a geological timeline it is very sudden indeed.

In response to this crisis, the World Conservation Union (IUCN) brings together over a thousand public and nongovernmental organisms and about ten thousand scientists and experts from 181 countries. It has put in place a system for the observation of biodiversity and has been able to evaluate the exact level of threat posed to each of the 40,000 species it keeps under surveillance. This is the "Red List of Endangered Species," a final catalog of which was published on May 2, 2006. The conclusion offers cause for great concern. One-third of the world's amphibious species (frogs, salamanders, and so on), one-quarter of its mammals, one-eighth of its bird species, and one-quarter of its coniferous trees are now considered to be in danger of extinction. The situation continues to worsen, despite a goal clearly defined at international conference after international conference; put a brake on the loss of biodiversity before the year 2010. More often than not, we humans are to blame. In the Mediterranean basin, for example, galloping urbanization, mass tourism, intensive agriculture, and the pollution that accompanies these trends are imperiling half the existing species of freshwater fish and several endemic plants (those unique to the region). In the Democratic Republic of the Congo, 95 percent of the hippo population has vanished because of rampant political instability and armed conflict.

Sometimes, however, the consequences are more indirect. The polar bear, for example, may see its population reduced by 30 percent in the next few years because of the effects of global warming in its habitat, the polar ice cap.

This collapse of the diversity of living things is not some fantastic scenario dreamed up by specialists. The richness and variety of the living world to which we belong is an inheritance we share with the rest of creation—if we continue to waste it, and if we do not take remedial action, our children will not inherit it at all.

Nature's productivity is essential. In vast areas of the world, the survival of billions of men and women depends every day upon the natural resources to which they have direct access. Even in our cities, nature's produce feeds us, cures us of our ills, shelters us, and clothes us. Oil and coal are no more than a result of the biodiversity of the past, accumulated over millions of years in the great forests and oceans of ancient geological eras.

Finally, biological diversity is the foundation of our world's resilience and its ability to reestablish its equilibrium. Global climate change represents a major imbalance. If the temperature rises a few degrees, local conditions will become intolerable for huge numbers of species. Others may take their place—but only insofar as we have made possible those species' continued existence. Preserving as broad a spectrum of biodiversity as possible will enable us to minimize and mitigate the effects of this warming we've brought on.

Are we capable of this? What can we actually do? We need to start by taking positive action. Programs for saving the rarest and most threatened species have already met with success; for example, the ban on shooting migrant brant geese during their passage through France has increased their numbers to over three thousand pairs. Magnificent bearded vultures are once again soaring over the mountains of Europe, thanks to their reintroduction to the region. We also need to strengthen the network of refuge areas, parks, and reserves dedicated to and specifically managed for biodiversity. But above all, we must change our own behavior as individuals. That behavior may seem harmless in isolation, but when added to the sum total of human environmental folly, it is anything but. Every unnecessary journey made in a car—most of which are still highly pollutive—contributes to the death sentence hanging over the animals that inhabit the polar ice packs. Every time we carelessly buy furniture made from exotic tropical timber, we unwittingly help to destroy the last redoubts of our close cousins, the bonobos and chimpanzees.

Little by little, and for our own selfish reasons, humankind has created a pollutive, destructive civilization in the interest of ensuring our own well-being. But what will remain of that well-being once we have annihilated all biodiversity and turned our earth into a desert?

François Letourneux
President of the French Committee of the IUCN

Pilgrimage to Nuevo San Juan Parangaricutiro, Michoacán, Mexico (19°27'N - 102°14'W)

In February 1943, close to the village of San Juan Parangaricutiro, a farmer saw what appeared to be coils of smoke rising above a field planted with maize. Within a few months a cone of ash some 1,500 feet (450 meters) high had risen in the place—a young volcano had emerged to join the three hundred odd others along the trans-Mexican fault line. This volcano killed nobody during the nine years when it was active, but the hamlet of Parícutin and the village of San Juan Parangaricutiro were entirely engulfed by lava. All that emerged from the bed of solidified lava were the clock tower and nave of the church of Parangaricutiro—and the name Paricutín. Today, visitors flock to the site, particularly on the day before Easter. In Mexico, 90 percent of the population is Roman Catholic, and the feasts and rituals of the church play a major part in the nation's culture. In fact, the feast of the Virgin of Guadalupe, the patron saint of Mexico, attracts 100,000 pilgrims alone.

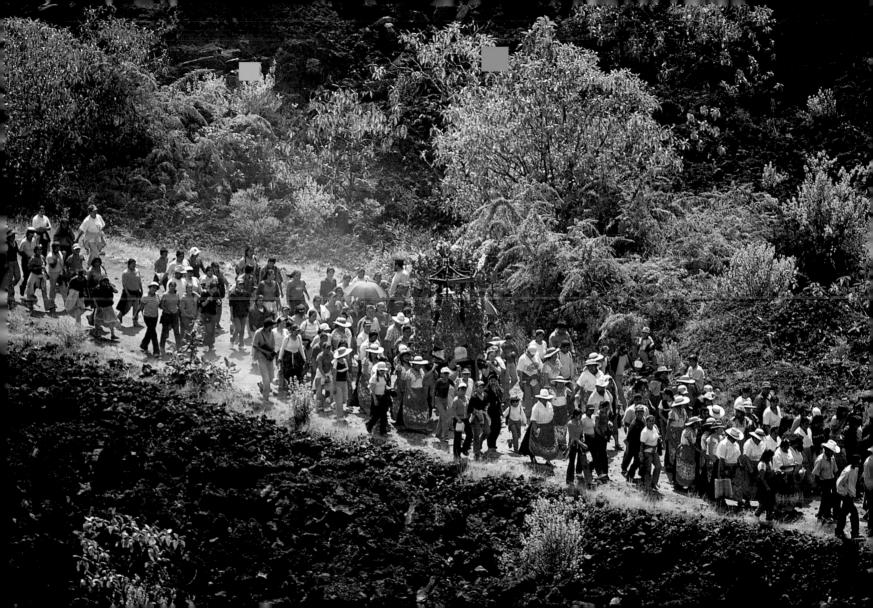

Brickworks east of Agra, Uttar Pradesh, India (27°04'N - 78°53'E)

The outskirts of the North Indian city of Agra are dotted with brickmaking factories, many of which employ children. In Asia, 19 percent of children between the ages of five and fourteen work, often under dangerous conditions (in mines or while exposed to noxious substances). Girls tend to do domestic and agricultural jobs or work in small shops. The money the children earn is essential to the survival of countless desperately poor families, so there is little chance of solving this delicate problem; as it is, children banned from ordinary work very often fall into far worse jobs—even into the sex industry. Nevertheless, there are approaches that can enable children to combine school and work, or otherwise help families financially in their efforts to educate their children. These have been adopted by some governments and international institutions. Globally, some 246 million children aged between five and seventeen have full-time jobs, and 70 percent of these work in environments that place their mental and physical health at risk.

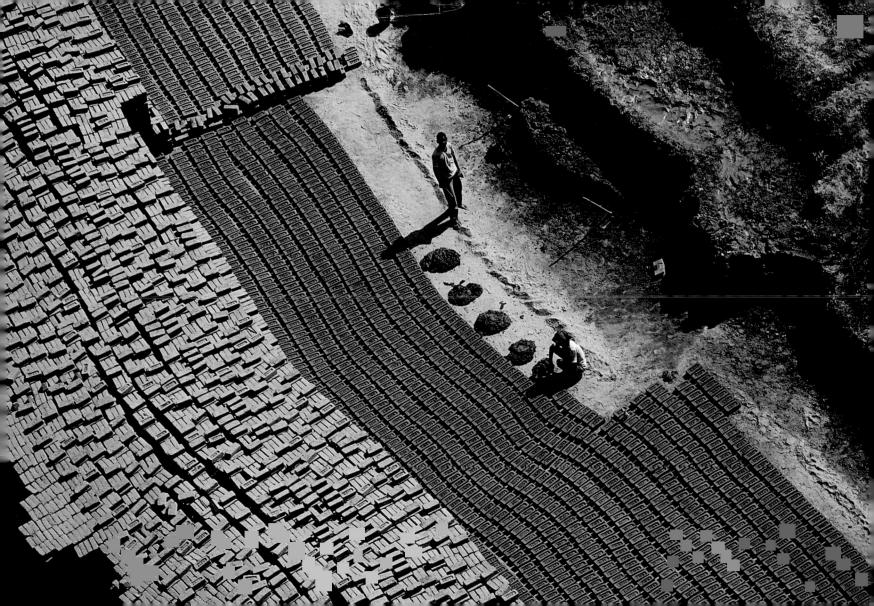

Fish farm on Wando Island, South Jeolla, South Korea (34°18'N - 126°47'E)

The aquaculture industry is generally confined to seawater ponds along coastlines, such as these on South Korea's Wando Island. Korea has evolved a giant fish industry, and is among the world's top-ten fish producers. With every passing year, aquaculture represents a more significant percentage of food production. The decline in wild fish stocks and the conversely growing demand for fish as a protein source have given huge impetus to the sector worldwide. By definition, aquaculture includes fish-farming (salmoniculture, pond-fish farming, and marine-fish farming) and shellfish cultivation (of oysters, mussels, and so on). It involves the use of large quantities of chemicals, fertilizers, and antibiotics, making it a substantial source of pollution. In fact, at Wando, the 1,595 islands—despite being close to the Tadohae Haesang National Park and protected on account of the great purity of their seabeds—are seriously threatened.

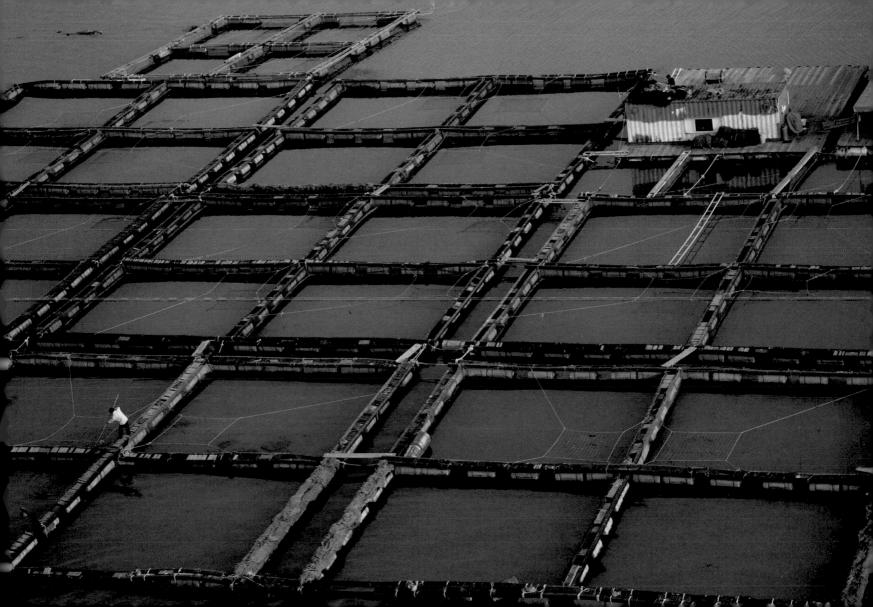

Millau Viaduct, Aveyron, France (44°06′N - 3°05′E)

The Millau Viaduct—8,000 feet (2,460 meters) long and 1,100 feet (340 meters) high—is the tallest bridge on the planet. It is made up of sixteen sections, each weighing 2,230 tons, supported by seven concrete piers and 1,056 miles (1,700 kilometers) of metal cable. The viaduct is the last link in France's A75 autoroute. Beneath it lies the small town of Millau, traversed by 25,000 vehicles every day in summer. Many people believe the viaduct will open the region up to new industries, businesses, and tourism; some even think the viaduct will become the second most visited site in provincial France (after Mont-Saint-Michel). In a matter of a few decades, the improvement of France's network of freeways and the development of its TGV express-rail system has transformed the economic landscape by distributing commercial activities much more evenly around the country.

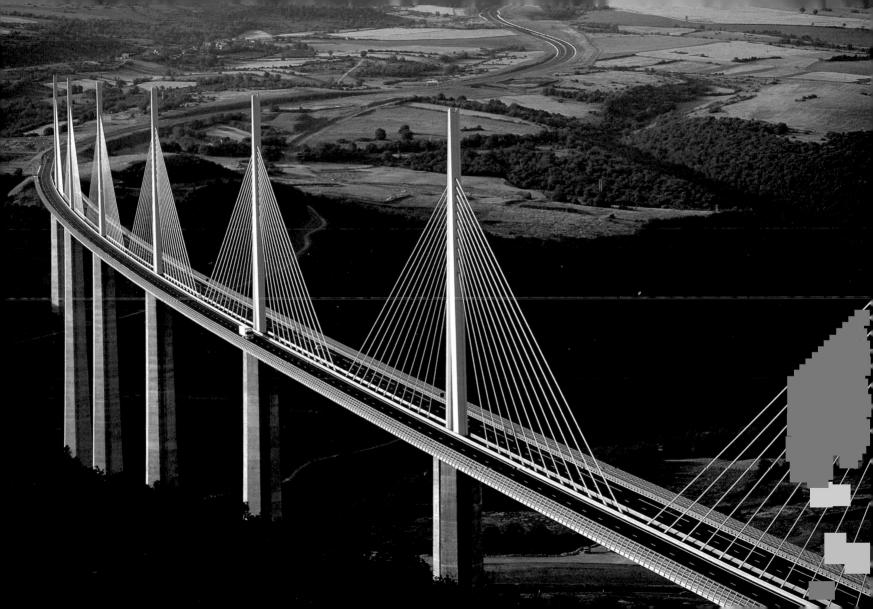

Las Purgas market, Santo Domingo, Dominican Republic (18°28' N - 69°53' W)

In the southwest of Santo Domingo, in the little market of Las Purgas, Dominican and Haitian merchants position their stalls beneath awnings that both shade and advertise their wares. The market is open every day; the ambience is warm and the crowd diverse. Electrical appliances, furniture, clothing; everything, old or new. can be bought, exchanged, or sold. The dealers are both licensed and otherwise; indeed. Las Purgas reflects a growing informal economy that actually supports seven out of ten Haitians and nearly one out of two Dominicans. Markets like it have sprung up all over the island. The expansion of this brand of economy in the countries of the South is closely linked to a surplus of labor and to the trend of mass migration to the cities. In recent decades more and more women have taken jobs—out of choice or necessity. Because their education tends to be more circumscribed than men's, they are often less qualified for jobs than men, and by comparison their access to capital, credit, and professional training is restricted. As a result, they end up in second-rate positions and are subject to all manner of discrimination.

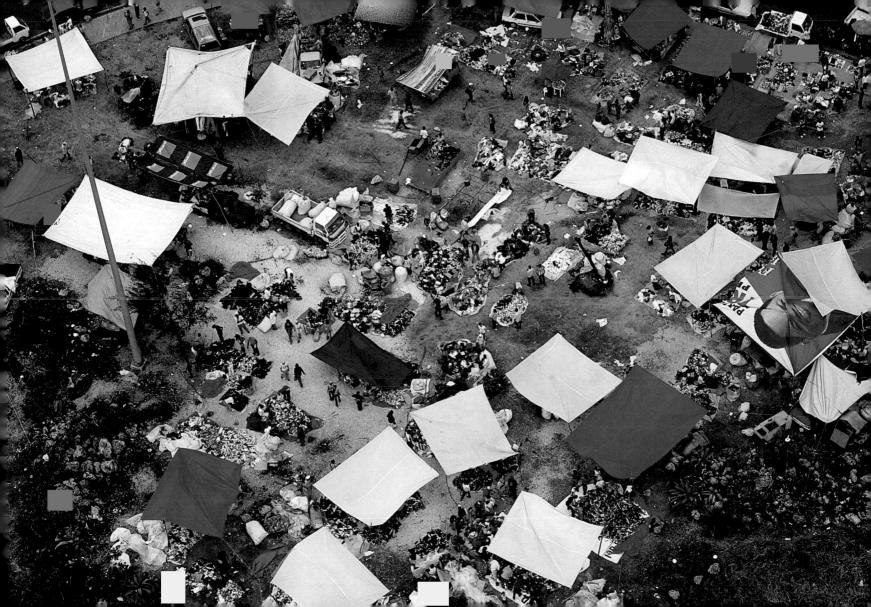

Slums along wadi El Hamiz, near Algiers, Algeria (36°43′N - 3°14′E)

The rapid urbanization of Algeria (in 1966, 31 percent of Algerians were city dwellers; today 61.5 percent are), coupled with the complete absence of townplanning policies over the last thirty years, has favored the development of unofficial, unregulated housing sites, or gourbis. Originally a gourbi was a crude dwelling in the Algerian countryside—to all intents and purposes, a cabin; today. by extension, the term describes the nation's slums. Algeria's capital has a population of between 2.4 and 4 million; much of this humanity is crowded into hovels in the city center. But the slums have been extending farther and farther out, to the point that they encroach on agricultural land. This particular gourbi has developed along the wadi El Hamiz, which serves as its open sewer, Hemmed in by private properties, the gourbi's linear extension is restricted to the wadi's banks, which have been designated nonconstructible by the authorities. Sanitary conditions are appalling, and many residents suffer from serious skin complaints. Throughout Algeria, many wadis are extremely polluted, and this has become a major public health problem.

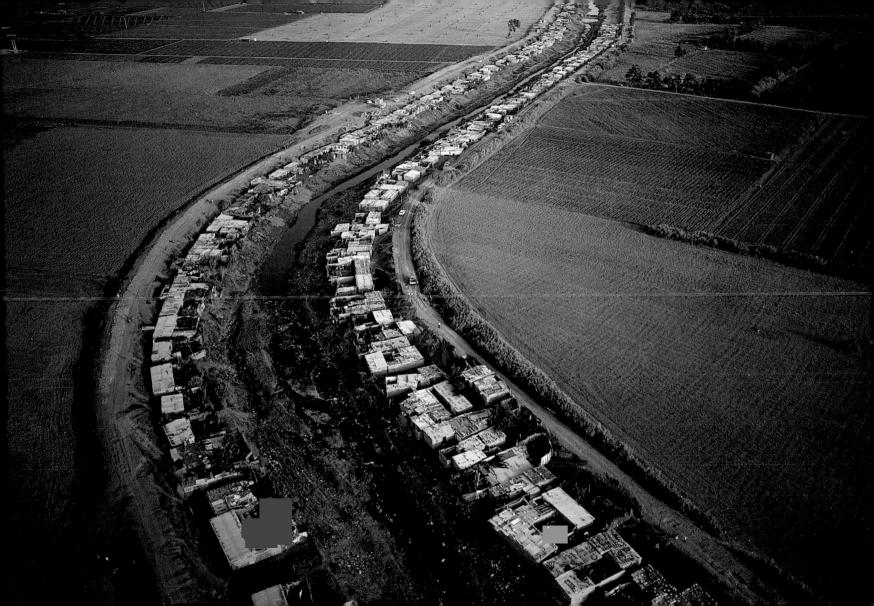

McMurdo base, Ross Island, Antarctica (South Pole) (77°50'S - 160°50'E)

Here there is no trace of ancient civilizations, no picturesque ruins battered by time and weather—this is Antarctica, the only continent where humankind has hitherto been unable to establish a permanent settlement. Since the 1950s. however, several countries have set up scientific research stations in Antarctica. and there are a total of thirty-five today. The largest, which is occupied all year round-by 1,200 people in summer and 200 in winter-is the American base of McMurdo, at the foot of the Mount Erebus volcano. This small polar settlement, the only one of its kind in Antarctica, resembles an Alaskan mining town, with its church, two pubs, hospital, bank, post office, dormitories, and hydroponic hothouse for growing lettuce, tomatoes, and flowers. There is even a bowling alley. But McMurdo also has one of the most polluted harbors in the world. riddled with hydrocarbon residues and PCBs (Polychlorobiphenyl)—carcinogenic chlorine composites whose manufacture is illegal today. The reason for the heavy pollution? In Antarctica, it is so cold that nothing ever decomposes. As a consequence, since 1988, every waste item from McMurdo, even the most insignificant, has been shipped back to the United States for disposal.

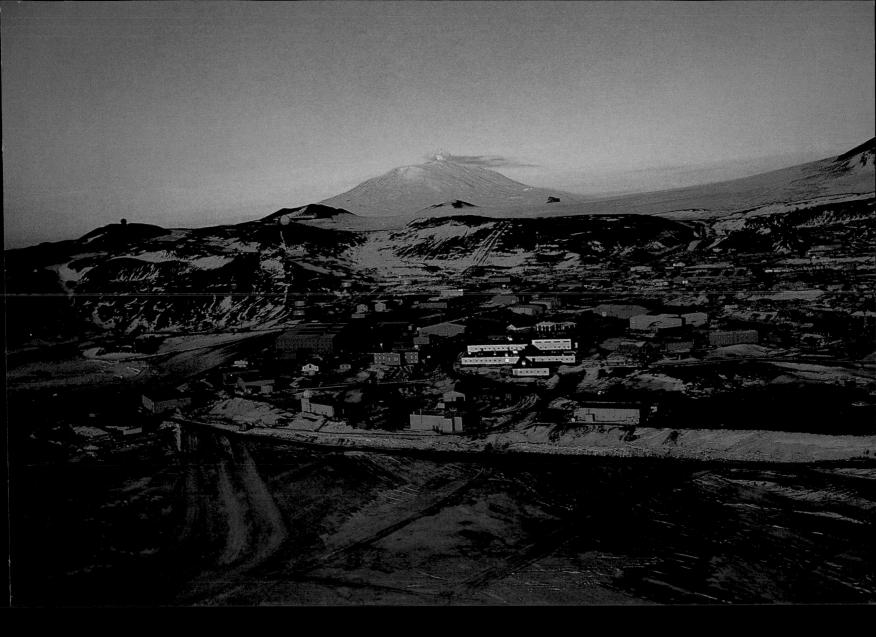

Sheep in the lava fields, Snæfellsnes peninsula, Iceland (64°45′N - 24°30′W)

Iceland, Europe's second-largest island, is a comparatively young volcanic, arid

Iceland, Europe's second-largest island, is a comparatively young volcanic, arid country whose interior has undergone depopulation. The soil, which is 90 percent basalt, is largely hostile to vegetation, and more than 50 percent of Iceland's territory has virtually no vegetation at all. Instead, lava fields like these cover 11 percent of the island; the first vegetable species to appear on these areas are mosses and lichens, which lend the landscape its coppery hue. They make up a vegetable carpet on which other, more evolved species can prosper, provided the sheep don't eat them. Half of Iceland's vegetable covering disappeared at the time of the island's colonization in the ninth century; forest now occupies less than 1.1 percent, as opposed to the 30 percent it occupied when the first settlers appeared. For a century, Icelanders have tackled their country's erosion problem by replanting trees; 531,000 acres (215,000 hectares) are expected to be transformed into woodland over the next forty years.

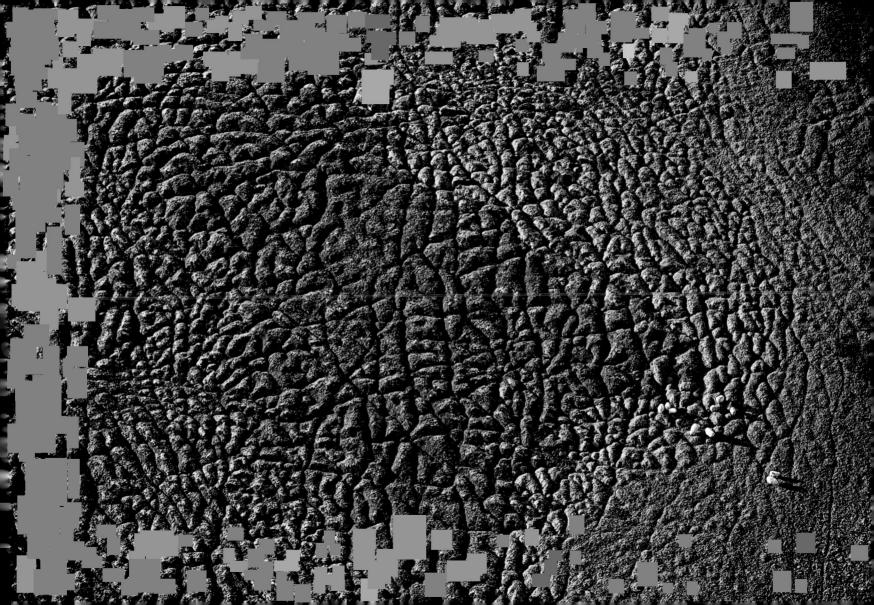

Cotton prints drying in the sun, Jaipur, Rajasthan, India (26°55'N - 73°49'E)

As a center for textile production, Rajasthan has been famous for centuries for its handicrafts dved and printed on cotton and silk. Much coveted by tourists. the work is done principally by women—consequentially, because Indian women are more affected than Indian men by the extreme poverty that touches a quarter of the population. Boys are traditionally preferred over girls because they perpetuate the family name and business, however modest these may be. They will also support their parents in old age and perform the religious rites at their cremations. On the other hand, girls are bound to leave the family when they marry, at which time they will require a dowry, and are consequently often viewed as a burden. The aborting of female fetuses is officially repressed in today's India but universally acknowledged as a fact of life—along with the sudden deaths of baby girls and death by sari-burning (which are seldom accidental). The government is concerned by the upsurge in these acts, and laws have been passed against them; in some Indian states today, there are fewer than eight hundred women to every thousand men.

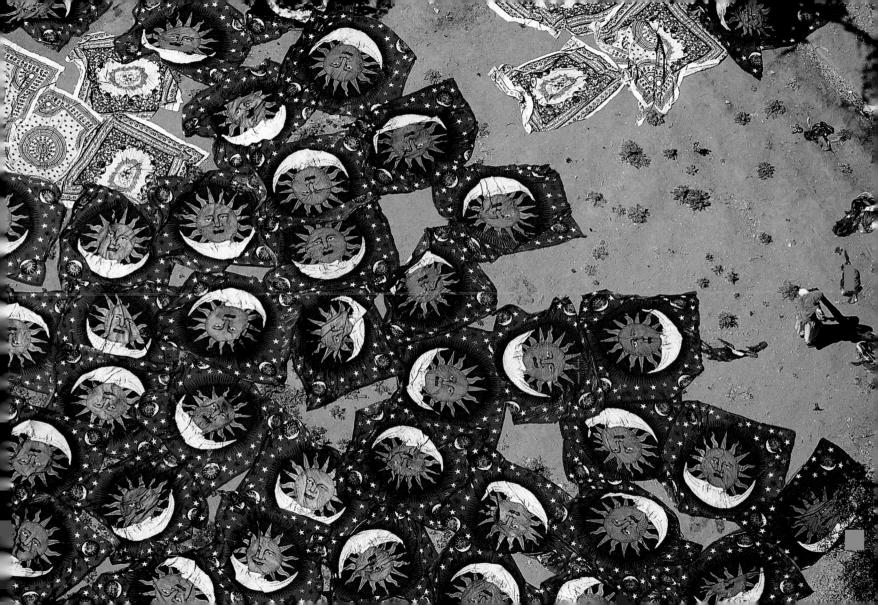

Rice fields in the San Salvador River basin, Soriano, Uruguay (33°39'S - 57°59'W)

Rice, the most heavily consumed cereal on earth, is nevertheless not as heavily cultivated as wheat or maize. The regions in the east of Uruguay are favorable for rice, which thrives near rivers or in marshy areas. In 2005, there were 438,117 acres (177,300 hectares) of rice fields in Uruguay producing 1.3 million tons of rice per year. Nearly 90 percent of the rice harvested is for export, and rice farming supplies about 3,600 permanent and seasonal jobs for the country's 3.31 million people. However, growing rice on the same soil inevitably leads to the depletion of the soil's nutrients after the second year, which means that the land must be left fallow every third year. Moreover, in wet zones like eastern Uruguay, the land has been drained—which has led to the destruction and fragmentation of the natural environment.

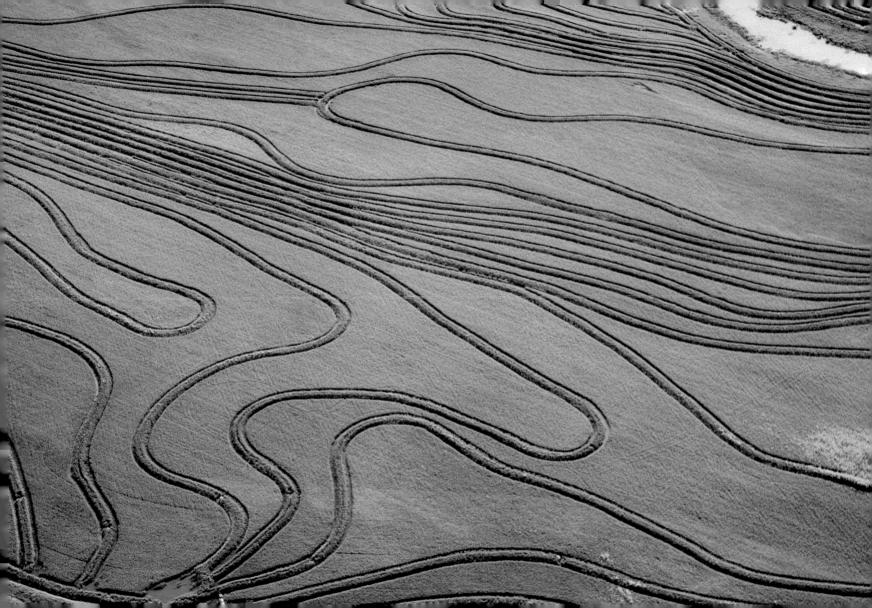

Cotton harvest near Banfora, Burkina Faso (10°48'N - 3°56'W)

In the south of Burkina Faso, near the Ivory Coast frontier, the land parcels used for cotton growing lie side by side with the food-producing ones. The cotton here is still picked by hand, which limits plant height to 3 to 6 feet (1 to 2 meters). Once harvested, the fibers are gathered into "balls" for marketing. In all likelihood they will be transported to Sofitex, the main textile and fiber company in Banfora. The climate in this region is perfectly adapted to the growing of cotton, which requires 27 inches (700 millimeters) of water and a minimum of 120 days of sunshine per year, as well as a dry season that will prevent the fibers from rotting before they reach maturity. Burkina Faso is Africa's principal cotton-producing country and this industry alone employs no fewer than 3 million people, 2 million of whom are producers. Cotton represents 25 percent of Burkina Faso's gross national product and 60 percent of its exports, which makes it vulnerable to the fluctuation of prices on the world market. After refusing genetically modified cotton for years, the authorities gave permission for it to be grown in 2008, in order to "guarantee" a regular yield.

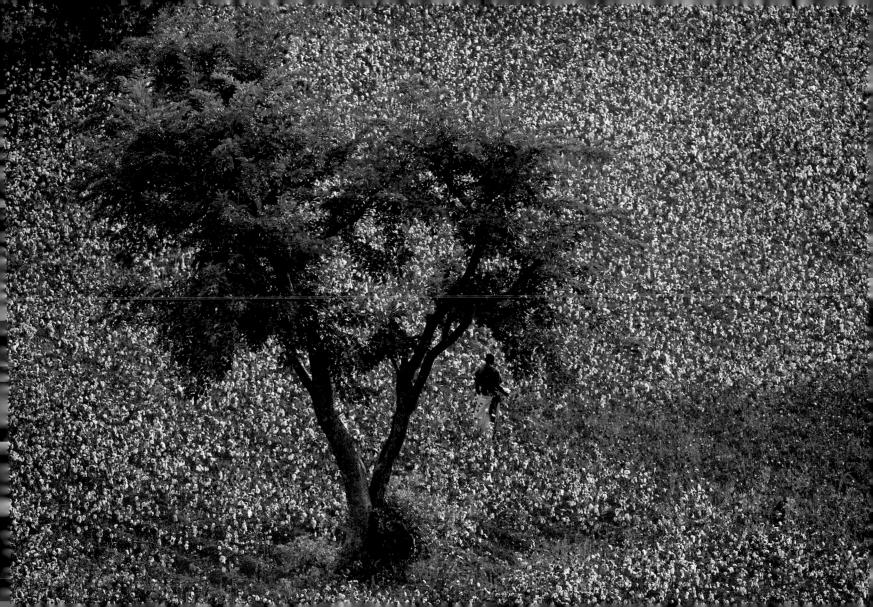

Workers in the Lake Assal salt pans, Republic of Djibouti (11°41'N - 42°25'E)

The waters of Lake Assal are among the most saline on earth—at 12 ounces per gallon (350 grams per liter), the lake is ten times as salty as the Red Sea, An accumulation of crystals from the evaporation of this water has formed a bank of salt some 197 feet (60 meters) deep, which occupies 20 square miles (52 square kilometers) at the north end of the lake; the salt pans have been exploited on an industrial scale since 1998. Workers with their feet in brine and their heads in the sun bag up salt extracted by mechanical diggers, which eat away at the exceedingly saline shallows on the rim of the bank. The wages are high, but so is the turnover of laborers; nobody can work for long in such horrendous conditions. In the Republic of Diibouti, life expectancy is very low (forty-three years, in contrast with the world average of sixty-six), and half of the population lives below the poverty line. To redress this situation, the government has taken advantage of Djibouti's strategic position at the mouth of the Red Sea to develop its tourist and service industries. Faced with a severely malnourished population and a wholesale migration of farmers to towns, the authorities are also trying to open up the country's agricultural potential, weak though it is, and provide more food security for the people.

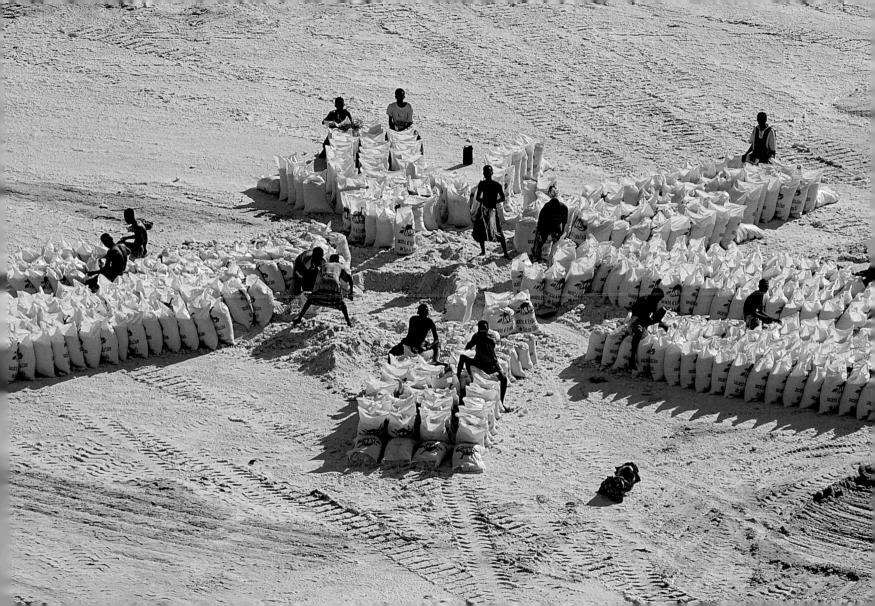

Open-cast coal mine, near Delmas, South Africa (61°10'S - 28°44'E)

Coal is still a widespread source of energy around the world. In South Africa, it produces 94 percent of the country's electricity. Nevertheless, South Africa still cannot meet its own energy needs and is debating whether or not to build new coal-fired power stations in the years to come. In 2007, coal still accounted for over 25.3 percent of the world's energy consumption. In Europe, most of the mines were closed down in recent decades because they were unprofitable, but elsewhere coal extraction continues, buoyed by low labor costs. In openpit mining, the veins of coal are located close to the surface and although the technique disturbs the landscape and requires a huge investment, the working conditions of miners are supposed to be less arduous than they are in underground mines. The world's coal reserves are still immense and relatively easy to exploit, so the growth in the world's demand for energy is expected to support coal-mining activity throughout the twenty-first century. On the other hand, coal's future is a severe problem because when it burns it generates carbon dioxide, a greenhouse gas. If we are to win the battle against global warming, we must drastically reduce our consumption of coal, and soon plan to do without it altogether.

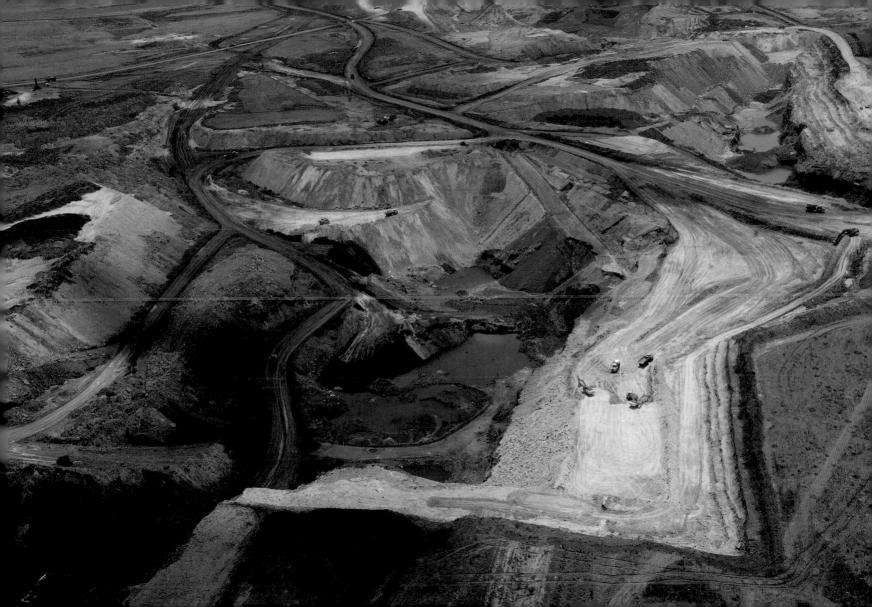

Olive groves, Galilee, Israel (32°54′N - 35°20′E)

Agriculture was at the heart of the creation of Israel; the first Jewish colonists set out "to make the desert flower." More than fifty years on, they have well-nigh succeeded, to the great detriment of local water resources. The Jordan, one of the world's most disputed rivers, runs along Israel's borders with Syria and Jordan and is heavily overexploited. The aguifers beneath the West Bank are being pumped beyond their capacity to replenish themselves, and are claimed by the Palestinians. To deal with this shortage without giving up its agricultural development, Israel has resorted to drip irrigation (which reduces waste), the use of briny water, the recycling of wastewater for agricultural purposes, and desalination of seawater (at the rate of 2 million cubic feet [60,000 cubic meters] per day). Although the water allotted to irrigation has been reduced from 80 percent in the 1970s to 60 percent today, this is still not enough, and a new approach to agriculture is inevitable. It will likely involve the abandonment of crops that need too much water (like citrus trees and cotton) in favor of traditional ones like olives, wheat, and almonds. The preferential prices currently accorded to farmers will also undergo revision in an effort to remedy the situation. On a global scale, 70 percent of all freshwater is used to irrigate crops.

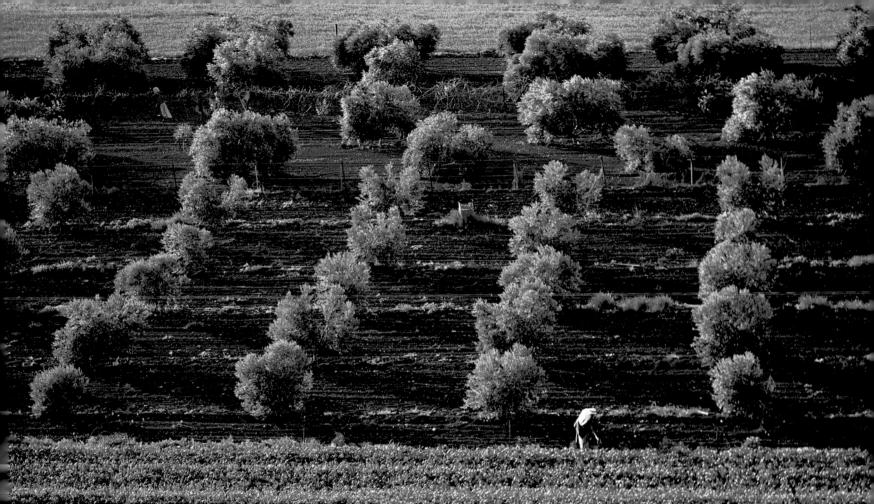

Control of the Contro

Al-Kabir Mosque, old city of Sana'a, Yemen (15°21'N - 44°12'E)

The magic of Sana'a, the capital of Yemen, has long withstood the curiosity of Western travelers. Situated in a bowl at an altitude of 7,700 feet (2,350 meters). it was always very difficult to reach; today the old town remains a labyrinth of alleys scented with the spices, myrrh, and incense of which Yemen is one of the world's chief producers. In the heart of the souk, the white minaret of the Great Mosque contrasts with the warm brown of the five thousand traditional tower-houses surrounding it. These tall pisé constructions are made of a sundried mixture of straw, water, and clay, with facades delicately decorated in plaster friezes. As recently as 1975, this spectacular city had a population of only 80,000, but in 1990 it saw a sudden influx of a million Yemenis, driven out of Saudi Arabia because of their government's pro-Iraqi stance during the Gulf War. Concrete high-rises were quickly erected on the edge of town to accommodate them-subsequently, strict bylaws were established to prevent such planning blunders. Since 1994 the old city of Sana'a has been listed as a UNESCO World Heritage Site.

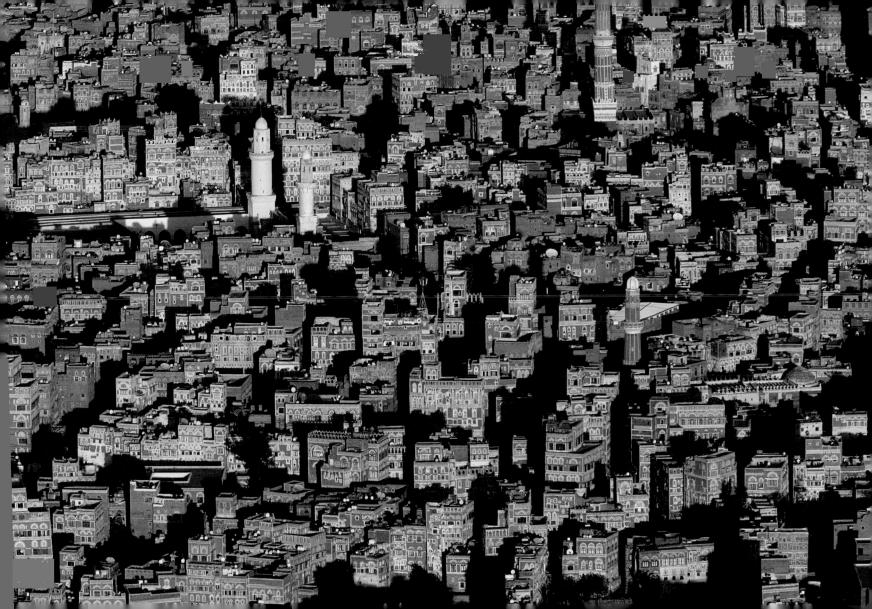

Favelas in Rio de Janeiro, Brazil (22°55'S - 43°15'W)

A million and a half Rio residents (Cariocas), one in seven of the total population, live in the shantytowns surrounding the city. These six-hundred-odd favelas have spread rapidly since the early twentieth century and are fertile ground for delinquency and lawlessness. Mostly constructed on steep slopes, the quarters are rarely serviced by public utilities and are at the mercy of killer mudslides during rainy season. Beneath the favelas, along the seashore, sit residential areas monopolized by a better-off middle class. The stark social contrast of these areas mirrors the whole of Brazil; 10 percent of the population controls the lion's share of the nation's wealth, while nearly 50 percent of the remaining population lives below the poverty line. Since 1996, Rio's municipal authority has been progressively integrating the favelas into the fabric of the towns by building roads and installing electricity, water, drainage, and garbage-disposal facilities, as well as setting up viable employment agencies. Worldwide, more than a billion people live in slums and shantytowns—one-third of the planet's urban population.

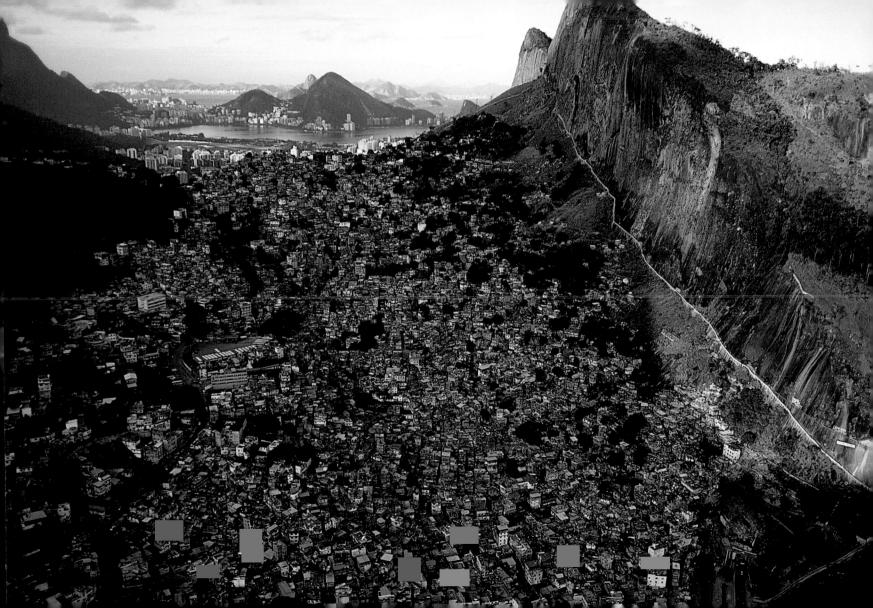

Erosion southwest of Lake Ysyk-Köl, near Kara-Koo, Kyrgyzstan (42°12′N - 76°37′E)

Located in the heart of central Asia, Kyrgyzstan is a nation largely dependent on livestock, where agriculture is confined to mountainsides and a few valleys 13,000 to 23,000 feet (4,000 to 7,000 meters) above sea level. In these extreme regions, the topsoil is highly vulnerable to erosion; 60 percent of Kyrgyzstan's land is threatened by a loss of fertility due to the leaching of arable topsoil. After the country won its independence in 1991 and abandoned the Communist regime of the USSR, the return of private livestock ownership quickly led to overgrazing problems. Economic uncertainty drove herders to invest heavily in their stock, a traditional way of preserving capital. By 1994 Kyrgyzstan had twice as many sheep and cattle as its pastures could reasonably support; when grazing is too heavy, the grass has difficulty regenerating itself and the soil begins to erode.

Tea harvest in the Kericho region, Kenya (0°24′S - 37°00′E)

The Kericho region lies between the Rift Valley and Lake Victoria, at an altitude of 7,200 feet (2,200 meters). Its soil is impoverished by erosion, but its tea plantations continue to flourish thanks to abundant and frequent rainfall alternating with warm sunshine. Only the topmost leaves on the tea bushes are harvested, and each bush is unique, with its own particular hue; the sheer variety of greens in this region is a testament to the quality of the tea produced. Narrow paths run through parcels of lands belonging to the farm owners, who produce 60 percent of the total yield and keep Kenya in the forefront of the world's tea exporters. In this regard, Kenya stands in sharp contrast with other countries, where multinational companies own huge tea plantations, employing huge numbers of laborers. The mechanization of harvesting tea is only possible with uniformly planted and cloned tea bushes—and any benefit derived from reducing labor costs is cancelled out by the poor quality (and hence low value) of the resultant tea leaves.

Greek Orthodox monastery of Mar Saba, Judaean desert, Israel (31°35'N - 35°00'E)

The monastery of Mar Saba was founded in 439 by Julian Sabas, who was later canonized Saint Sabas of Cappadocia. It stands on other cliffs in the Judaean desert, a few miles from Bethlehem, and its maze of steep alleys and monastic cells constitutes one of the oldest still-functioning monasteries in the world. Today only a dozen monks remain, but for seven centuries the monastery housed a continuous complement of nearly four thousand. An important site of the Orthodox Church of Jerusalem, Mar Saba is headed by Theophilus III, the Patriarch of Palestine of the Holy City of Jerusalem, who hosts a total congregation of some 130,000 souls. It is responsible for guarding the holy places of Palestine; among the innumerable jewels in its crown are the Church of the Holy Sepulcher in Jerusalem, the Church of the Nativity in Bethlehem, and even the land on which the Knesset is built. Indeed, the Orthodox Church of Jerusalem is the largest landlord in the state of Israel. On a global scale, one person in threeor nearly 2 billion people—belongs to the Christian tradition. Of these, 1 billion are Catholics, 356 million are Protestants, 218 million are Orthodox, 83 million are Anglican, and 245 million (mostly in Africa and Latin America) do not belong to any specific church.

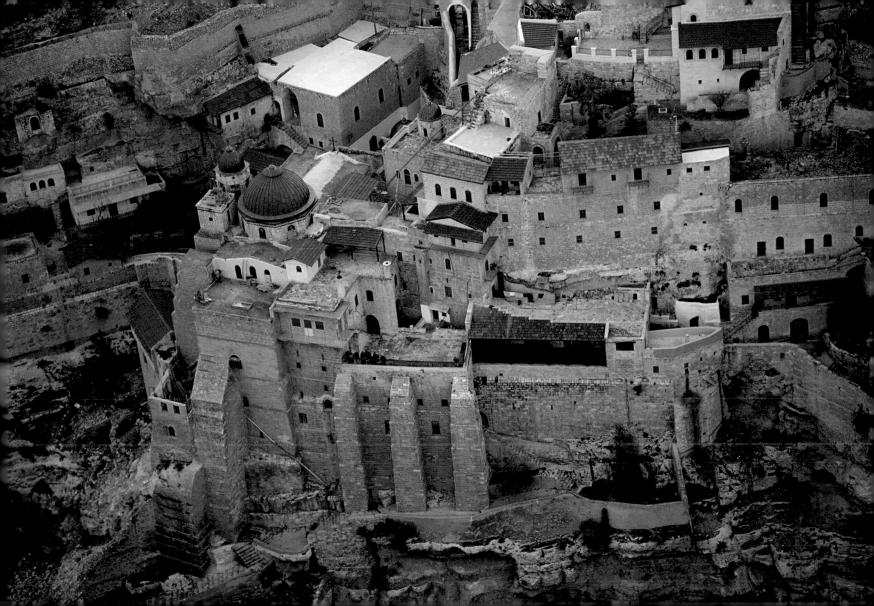

The Hodna Mountains after a snowfall, near El Hammadia, Algeria $(35^{\circ}55'N - 4^{\circ}47'E)$

The Hodna Mountains in northeastern Algeria run parallel to the coast and reach a maximum altitude of 6,200 feet (1,900 meters). Agriculture and sheep raising are the major concerns of the region, and fruit trees, olive trees, truck farms, wheat, and vines grow in small plots. In earlier times, the hills were clothed in forests of olive trees, cedars, and oaks; most of that land is cleared today and subject to overgrazing and erosion. In fact, in the last 150 years, Algeria has lost over 40 percent of its forests. The semiarid climate of the Hodna Mountains yields hot, dry summers and harsh winters; the region has an annual rainfall of between 28 to 39 inches (700 and 1,000 millimeters). A rare snowfall occurred in early 2005—the heaviest in sixty years, according to locals, and a seeming anomaly in view of the current global warming trend. But although meteorologists predict that, in the long term, far less snow will fall in mountain zones and snowmelt will occur much earlier in the year, they also suggest that extremes like this in no way repudiate global warming and its inexorable progression.

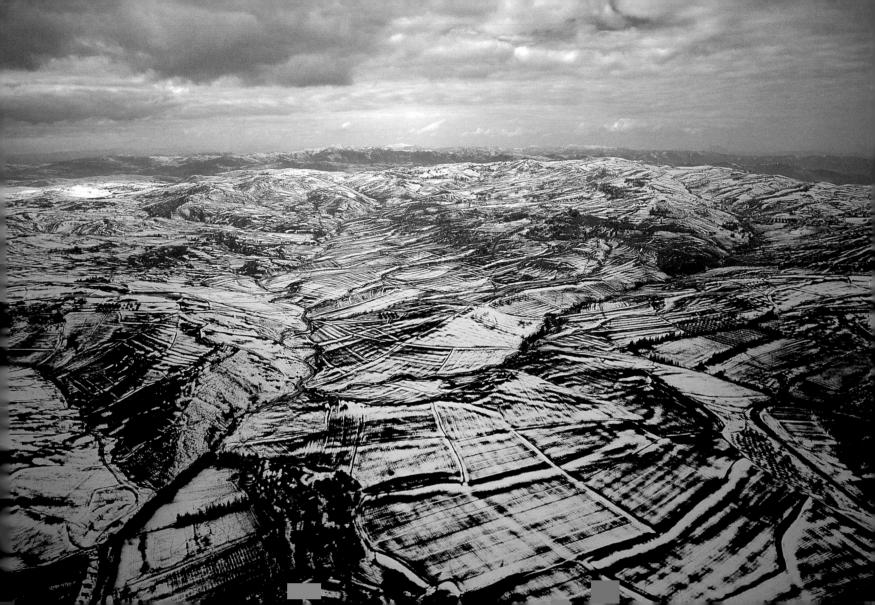

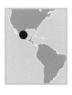

Chalupas on the canals of the Xochimilco gardens, south of Mexico City, Mexico $(19^{\circ}16' N - 99^{\circ}06' W)$

Every year more and more locals and tourists visit the Xochimilco canals, 17 miles (28 kilometers) south of the Mexican capital, to stroll, dine, and listen to mariachi bands—often aboard these colorful barges (*trijineras* or *chalupas*). Xochimilco, with its network of canals and artificial islands made of woven reeds, is a testament to Aztecan efforts to make the best of an environment that, on the face of it, was far from promising. The floating gardens (*chinampas*) and the 112 miles (180 kilometers) of canals have been extremely well preserved; in 1987, they were added to UNESCO's list of World Heritage Sites. But the uncontrolled urban expansion of the valley of Mexico City (population 18 million), the overexploitation of water resources, and the releasing of untreated wastewater constitute a growing threat to this small lake-enclave, so much so that Xochimilco has now been added to another, less praiseworthy list, that of World Heritage Sites in peril.

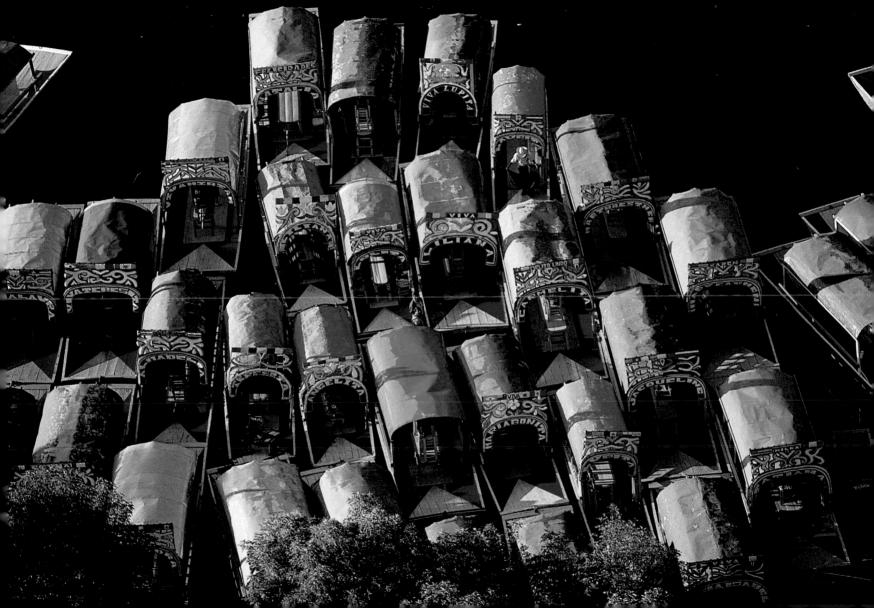

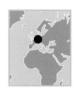

Jewish Museum Berlin, Germany (52°30′N - 13°25′E)

With its facade of zinc, a material that oxidizes with exposure to the elements, and its heavily significant layout in the form of a reinterpreted Star of David, architect Daniel Libeskind's Jewish Museum Berlin offers much to contemplate. Libeskind's interior references the idea of a vacuum, by leaving some rooms vacant to symbolize the absence of those who died in the extermination camps and those who, as a result, were never born. The museum retraces 1,700 years of German Jewry, and commemorates the Holocaust during the Second World War, which swallowed up 6 million Jews in the worst genocide of the twentieth century. Since 2001, the museum has attracted more than 700,000 visitors annually; host to extensive educational and publishing programs, it makes its mission one of information and remembrance. Genocide has been considered a crime under international law since 1948. However, other genocides perpetuated in the twentieth century include that of the Cambodians by the Khmer Rouge between 1975 and 1979 and that of the Tutsis by the Hutus in Rwanda in 1994.

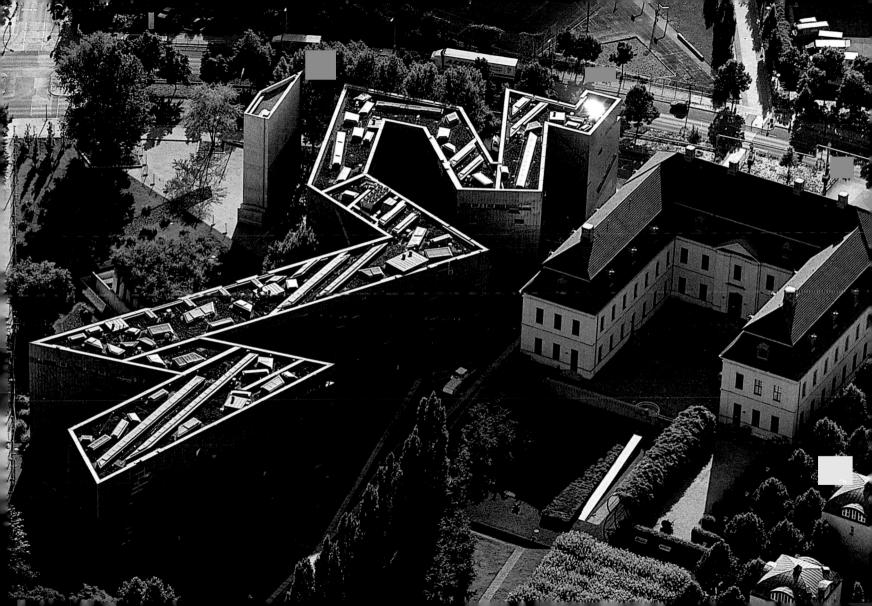

Snow-covered forest in Seoraksan, South Korea (38°30'N - 128°20'E)

Seoraksan, on the South Korea/North Korea frontier, rises to an altitude of 5,600 feet (1,708 meters) and is the third highest point in all of Korea. When snow melts there, the water flows downward before being absorbed by ground vegetation. whereupon it filters through the permeable rock stratum until it meets with a waterproof layer—upon which it forms what we call a water table. In regions where the land surface is uneven and hilly, the top of this table is often well above the levels of valleys, hence the phenomenon of mountain springs, which feed streams and rivers below them. But the way water runs over a continent is merely one aspect of that water's overall cycle; of the precipitation that reaches the land, 65 percent evaporates, 24 percent flows, and 11 percent filters down to the water table. Ninety-seven percent of the water in the atmosphere results from the evaporation of the oceans as a result of the sun's heat. The water particles condense, forming clouds; when those clouds are sufficiently laden with moisture, they release it in the form of rain. In this way, the water cycle makes possible the transformation of saline seawater into the freshwater that nourishes living things.

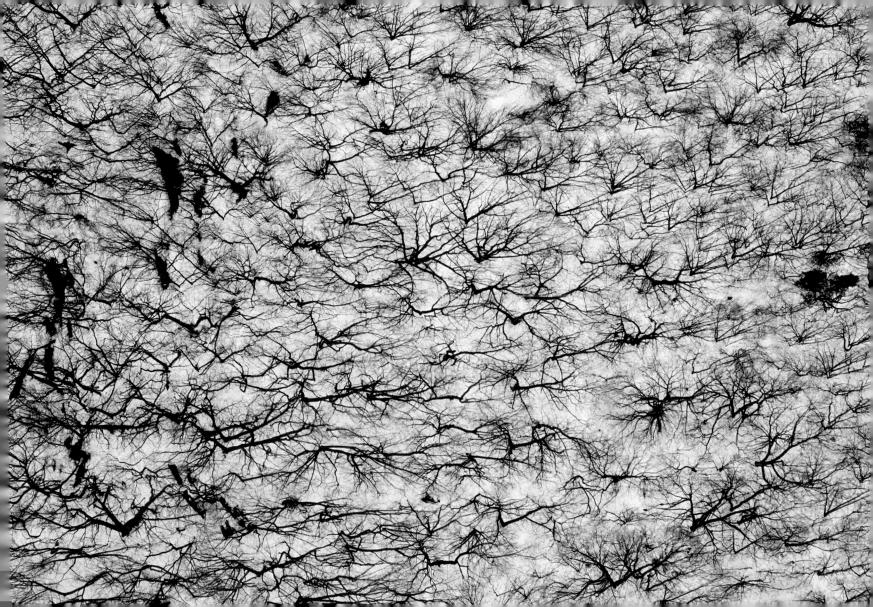

View of a Himba village enclosure, Kaokoland, Namibia (18°15'S - 13°00'E)

From his hut in the center of the kraal, the chief watches over the sacred fire. Other villagers live in smaller huts, made from branches overlaid with a mixture of mud and cattle manure. The 10,000 to 15,000 Himbas of the desert region Kaokoland are sprinkled all over the landscape in small seminomadic clans, in order to ensure the survival of their herds. But the Himbas' dispersion has not always benefited them; in the nineteenth century, other tribes took advantage of it to plunder their settlements, forcing them to become hunter-gatherers and beggars to survive—the very name Himba means "people who ask for things." Today, having gone back to herding, the Himbas are much visited by tourists, and they are well aware of their exotic appeal. Although they refuse to abandon their ancestral way of life, they aren't averse to selling jewelry or acting as tour guides. Their chiefs make skillful use of the media to defend their rights—reconciling traditional practice with the ways of the modern world.

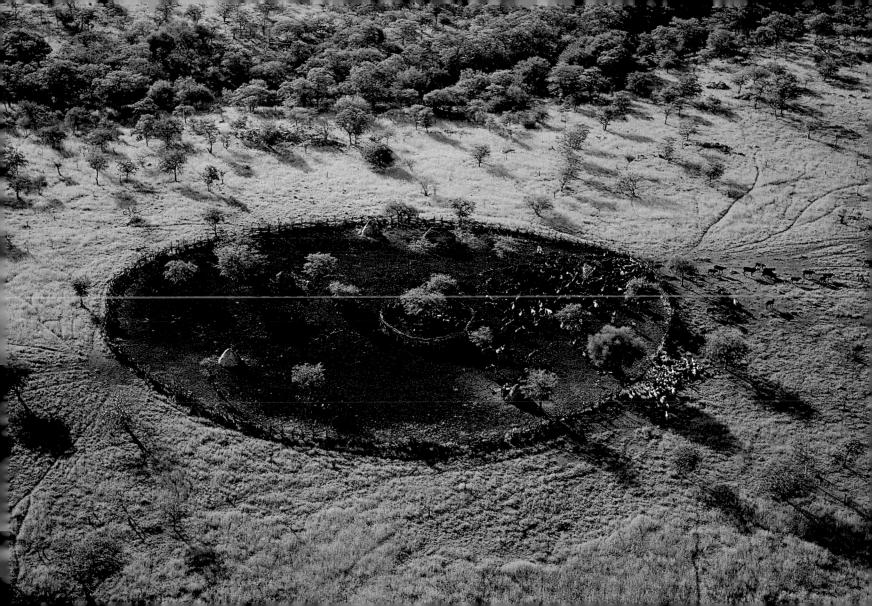

"The Hand" (La Mano) on the beach at Punta del Este, Maldonado, Uruguay $(34^\circ57'S - 54^\circ56'W)$

This 16-foot-tall (5-meter-tall) concrete sculpture on the El Emir beach at Punta del Este is known as "La Mano" or "El Manotazo del Ahogado." The world-famous Chilean artist Mario Irrazábal created it in 1982. Irrazábal fashioned several other giant hands for other cities, such as Madrid, Nairobi, and Venice; over the years the one at Punta del Este has become one of the resort's principal emblems. Situated at the point where the Rio de la Plata meets the Atlantic, Punta del Este is identical to Miami Beach, with its line of tall beachfront buildings. The resort is still much favored by wealthy South Americans. In South America, as in many other places, the tourist industry has grown faster than any other sector and it is thought that the number of international tourists visiting will quadruple in the next twenty years.

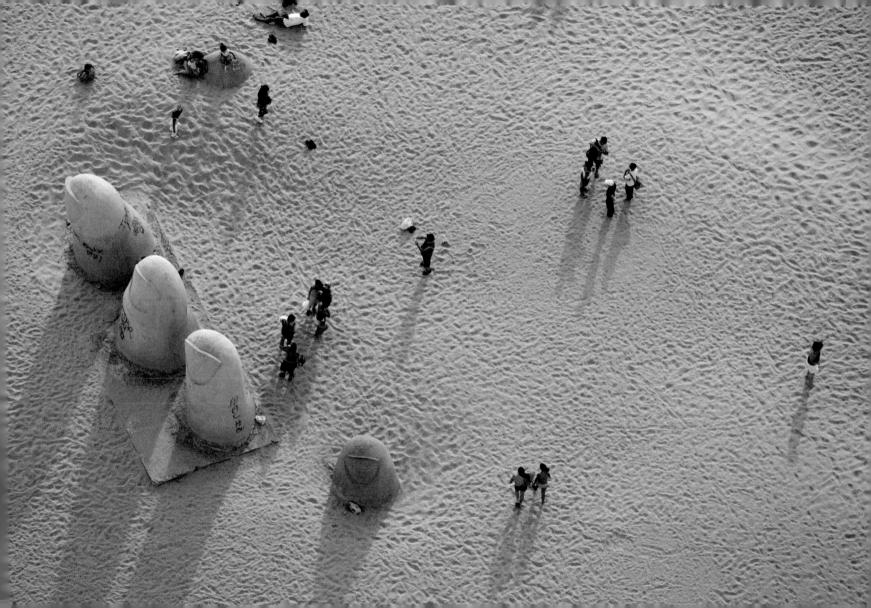

Rice fields in Casamance, Senegal (12°49′N - 16°09′W)

The Casamance region of southern Senegal is one of the few areas on the African continent where the density of water permits the growing of irrigated rice. These mosaics of green and yellow are fed by the Casamance River and its tributaries; the rice raised here is an Asian variety (Oryza sativa) imported 450 years ago by Portuguese navigators. For 3,500 years, a local variety has also been used (Oryza glaberrima); this is well adapted to the environment, but less productive. At this crucial time, when rice has become the staple food of West Africa, the decrease in rainfall has slowly begun to take rice fields out of cultivation. Consequently, African countries have been obliged to raise their quotas of imported rice (which already accounts for 25 percent of the total rice consumed), at the risk of weakening their economies. As a solution to this crisis, a new rice variety has been developed called New Rice for Africa (NERICA)—the brainchild of the African Rice Center, an intergovernmental research organization introduced in 1996. The result of crossing local species with Asian ones, NERICA combines a robust tolerance for the African climate with huge yields. Now grown in ten West African countries, NERICA is making a huge contribution to the stability of the local food supply.

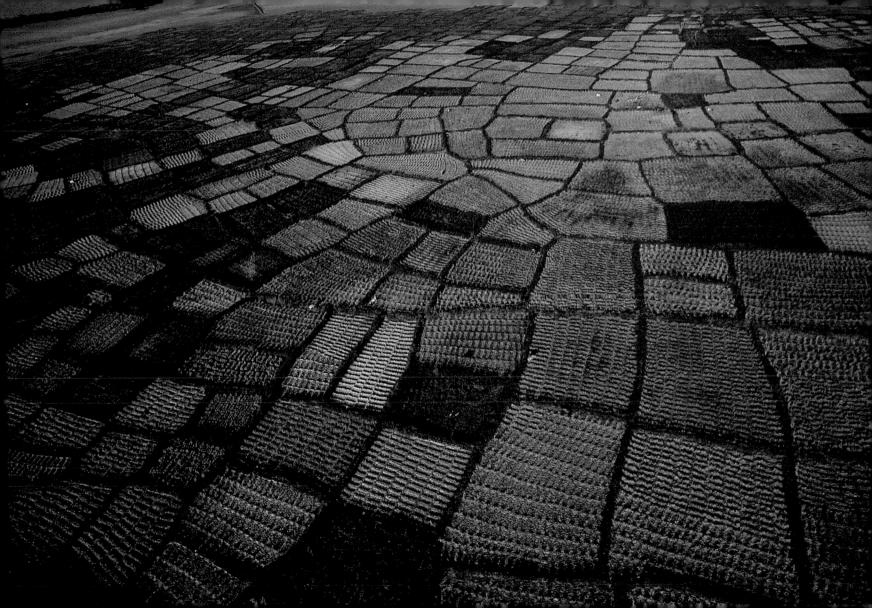

Riders near Barskoon, southeast of Lake Ysyk Köl, Kyrgyzstan $(42^{\circ}10' \text{ N} - 77^{\circ}38' \text{ E})$

"A man without a horse is a man without feet" goes the Kyrgyz proverb. And although the horses of Kyrgyzstan are infinitely crossbred, they all have in common endurance, rapidity, agility, and small size. The entire history of central Asia has been encapsulated by the horse: even now, nomads ride from early childhood; they use horses to watch and manage their livestock; and their pictures and legends are laden with equine imagery. Horses were also the vehicles of the great waves of conquest that rolled out of Asia into Europe. Today, equestrian sports form the lifeblood of Kyrgyzstan. During the traditional end-of-summer festivals, riders compete in the *kok-par*, the modern equivalent of the ancestral wolf hunt. Young unmarried men and women alike can practice the *kyzkumai*, the ancient tradition of carrying off a chosen spouse. In summer, horses are used to patrol the herds and transport the family's property, and in winter they are called upon to move goods and merchandise. In this wild, broken terrain, few means of transport can rival them.

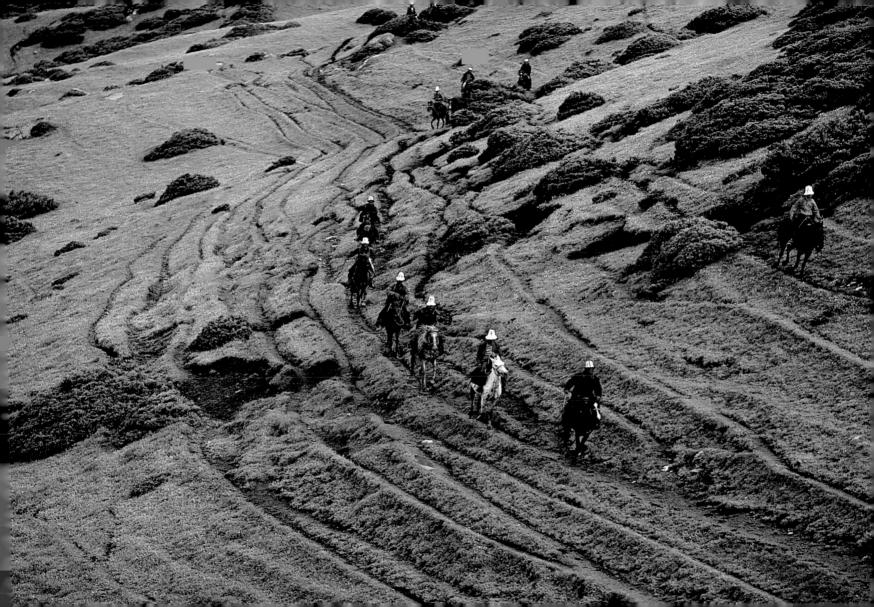

Snowy mountains of Bard-e Amir, Afghanistan (34°24′N - 69°20′E)

Bard-e Amir, in Bamian Province, is Afghanistan's first designated national park, covering an area of 101,000 acres (41,000 hectares). It contains five crystalline blue lakes, set between red cliffs and separated by natural limestone ridges. Popular tradition attributes this wonder of nature to Ali, the son-in-law of Muhammad and founder of the Shiite sect. Pilgrims come here in great numbers, attracted by the curative lake waters; they bathe in them each Friday, the day of prayer. A major boon to Afghanistan's nascent tourist policy, Bard-e Amir seems likely to one day tempt back the foreign tourists not seen since the late 1960s. The Afghan authorities plan to propose the park for inclusion in UNESCO's list of World Heritage Sites; if they succeed, the local population, which at present subsists on agriculture and fishing (notably for the large yellow chush fish of the lakes) stands to benefit greatly.

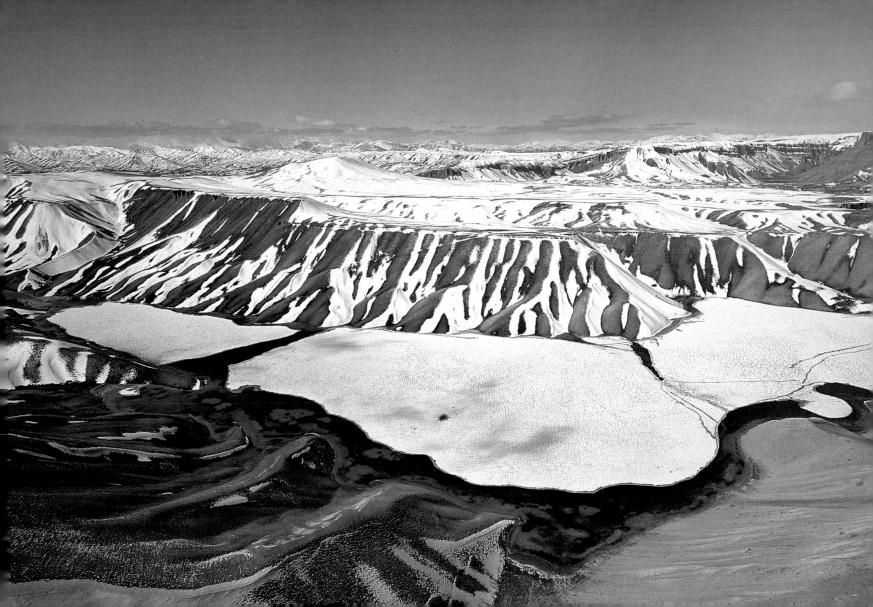

Ships off Al Jahra, Kuwait (29°20'N - 47°40'E)

Kuwait, on the Arabian Peninsula, boasts 180 miles (290 kilometers) of coastline and nine small islands, the most famous being Failaga Island, at the mouth of the bay. Its sea frontiers with Iran and Iraq in the Arabian-Persian Gulf have yet to be defined. The Gulf divides the Arabian Peninsula from Iran and covers an area of 90,000 square miles (233,000 square kilometers). Its name derives from ancient Persia, which corresponds to present-day Iran. Since 1981, the six Persian Gulf Arab States (Kuwait, United Arab Emirates, Bahrain, Saudi Arabia, Oman, and Qatar) have come together under the aegis of the Gulf Cooperation Council (GCC). They are, with the exception of Oman and Bahrain, members of OPEC and between them own 45 percent of the world's proven oil reserves. A 2003 agreement created a customs union, and the GCC members have formed a common market since January 1, 2008, which will then hold a single currency in 2010. The headquarters of their future central bank will be in the United Arab Emirates.

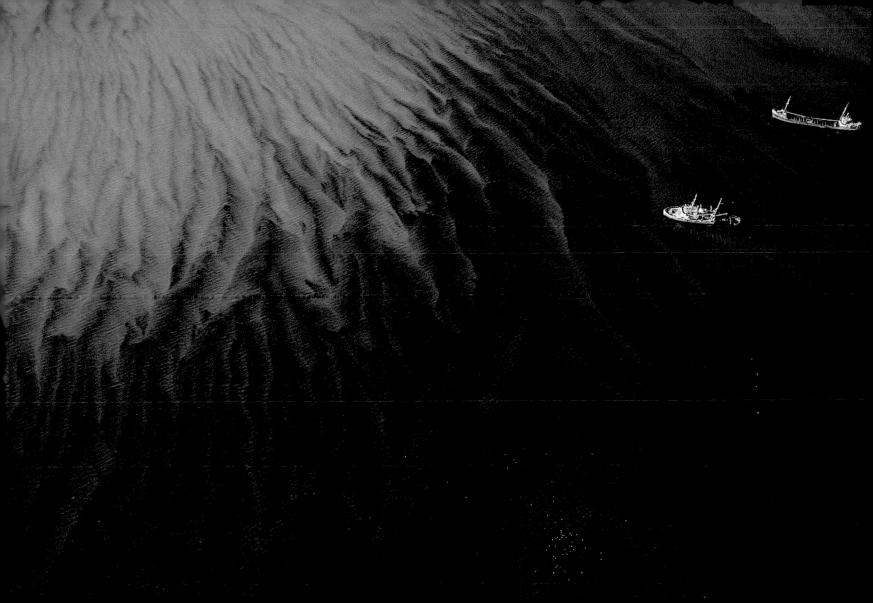

Football (soccer) match on a sand pitch, Beirut, Lebanon $(33^{\circ}53'N - 35^{\circ}29'E)$

It is estimated that 240 million people worldwide regularly play football (soccer, to Americans), a game beloved in nearly two hundred countries. The World Cup final in 2002 was the most watched match in the sport's history, with 1.1 billion fans following it on television. Football is the ultimate global sport; the rules of the game are simple, and all you need to play it are a ball and a stretch of flat ground. In the world's poorest countries, the balls are rudimentary, and any small open area—be it a street, a courtyard, or a piece of wasteland—is a potential site for barefoot players. The whole world has championed "the beautiful game," with one exception: the United States. The most powerful country on the planet still resisted the sport—but thanks to women's and Hispanic teams, the country is gradually paying more attention. In Los Angeles, a city where half the population has Latin American origins, soccer matches are more heavily attended than those of baseball, basketball, or American football. All over the world the game catches people's imaginations. And the salaries of star players like David Beckham (\$50 million annually), of the L.A. Galaxy, keep the myth alive.

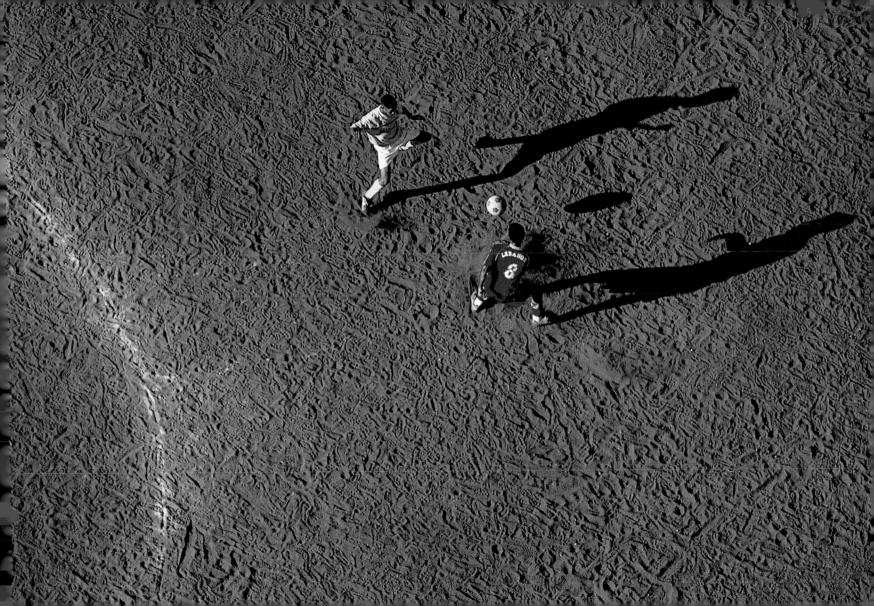

THE SEAS AND THE OCEANS

Most of our planet is covered by seas and oceans, which shape its climate and yield the resources humankind needs. Wherever we are, we are affected by their presence in one way or another. Pictures of earth taken from satellites, which are now commonplace, clearly show that we are living on the Blue Planet, seven-tenths of the surface of which is girdled by oceans and seas. The biosphere—that part of the terrestrial globe inhabited by living organisms—also includes the oceans. At a depth of 13,000 feet (4,000 meters), on the abyssal plain of the Atlantic, life exists; everywhere, the sea contains living organisms that are totally different from those on land.

Terrestrial life, along with most sea life, depends on the energy of the sun, which is initially converted by vegetable organisms. But recently, in sea depths fed by thermal springs, new forms of life have been discovered that derive their energy directly from the melting core of the planet. The gigantic reservoir of life in the oceans is highly diversified, the variety of species just as rich in a sea-loch as in a tropical forest. Indeed, the seas and oceans form a vast system that is in motion around the planet—a system that influences the atmosphere and determines the climates in which we live. New York has harsh winters and hot, humid summers. Lisbon, which is on the same latitude as New York, is also situated by the sea, yet it has nothing like the same extremes of climate. The difference derives from the ocean currents.

We have come to understand that ocean currents are far from stable. Changes in current direction—in the Pacific, for example—can affect the entire planet. From time to time, warmer waters displace the northern cold current of the Peruvian coast. This phenomenon causes the yields of the fishing grounds off Peru to diminish substantially around Christmastime—hence the name El Niño (the Christ child). El Niño's impact is not merely local. It can modify weather conditions all over the planet. The storms, floods, and droughts associated with El Niño in the year 1982–1983 were especially catastrophic, causing \$8 billion worth of damage from India to Tahiti to Bolivia.

Most human beings live on the coastal fringes of the world's islands and continents, and much of their food comes from the sea. In Asia, fish provides 40 percent of the population's protein. The oceans and their vegetable life also play a major role in the absorption and conversion of carbon dioxide. According to a report drawn up by the UN Committee on Sustainable Development, the seas and oceans furnish the vital resources that alone can ensure the well-being of present and future generations and provide enough food for the planet's needs. Thus our welfare depends on the condition of the seas and oceans—yet we continue to threaten them with our various activities.

Overfishing, for example, needlessly endangers a major source of food. If the world's fisheries were only managed with an eye to sustainable development, they could easily guarantee reserves of food—and sufficient income—to present and future generations. But the current all-out exploitation of many fish stocks demonstrates that we have reached the rational fishing limit for practically all the traditional species. And so we are turning to others. Many undersea mountains and many islands have species that exist nowhere else; these too are being threatened by overfishing.

Navigation is indispensable to world trade. Without it, the global economy would cease to function. But ships in very poor condition are allowed to carry cargoes such as oil, which, if spilled, can cause incalculable damage to seas and coastlines. Waste is still dumped into the sea—or into drains and waterways that lead into the sea—on a vast scale, and whole countries still refuse to find solutions for its disposal on their dry land. Such waste, often industry emitted, can flood the marine environment with dangerous substances that threaten the reproduction of fish and shellfish, rendering them unfit to eat. Moreover, untreated wastewater contains nutrients that upset the balance of the natural ecosystem, sometimes resulting in a shortage of oxygen in the sea that leads to widespread fish mortality.

Intensive building operations along coastlines intensify humankind's disturbance of the marine environment. We need only look at the havoc caused by tourist development along the Mediterranean coast:

wastewater, erosion-derived sedimentation in fish-reproduction areas, the destruction of humid zones where wild animals reproduce, and degradation of the ecosystem by intense human seaside activity. For years this phenomenon has been steadily increasing in every corner of the world.

The seas and oceans are also coveted as potential sources of oil and gas, and increasing amounts of sand and gravel are being extracted from the seabed for construction, endangering fish reproduction and shoreline nursery zones. The wholesale extraction of metal ores, too, is currently being considered. The infrastructures necessary to these industries have massive negative consequences for the environment—and this includes structures anchored in the open sea, though they are less visible.

The climate changes provoked by human activities likewise affect the seas and oceans. In certain areas of the world, the increase in ultraviolet rays as a consequence of the hole in the ozone layer is having a devastating effect on fish reproduction. And in general, the warming of the climate is bound to have an impact on ocean currents, with consequences difficult to predict.

All is not yet lost. In the last three decades, the international community has begun to confront these many threats. The International Maritime Organization is doing a lot to improve the legislation that governs shipping. The UN Food and Agriculture Organization has established programs of action for the world's fisheries. A robust plan to combat terrestrial pollution has been adopted within the framework of the UN Environment Programme. Around the world, no fewer than eighteen organizations are tackling these different problems at the regional level. Their efforts require much more involvement on the part of government authorities, with a view to implementing the agreements that have been signed. If they do so, then perhaps the alarms and looming threats of the present may one day lead to truly sustainable management of the seas and oceans, for the greater good of the planet.

Alan Simcock, Executive Secretary of the OSPAR Commission for the Protection of the Marine Environment of the North-East Atlantic, and Copresident of the United Nations Consultation Committee on the Oceans, 2000, 2001, 2002

Shantytowns, Guayaquil, Guayas, Ecuador (2°13′S - 79°54′W)

The shantytowns at the mouth of the Guayas River, built on land fashioned from flotsam thrown up by the tides, are a measure of the disproportionate wealth in Guayaquil. A huge industrial and commercial center, this port city is the most populous urban agglomeration in Ecuador, with 2.6 million inhabitants (the capital, Quito, has just 1.8 million). Guayaquil's prosperity has long attracted migrants from neighboring rural areas; their growing numbers have swelled the population of slum dwellers. Following the financial crisis of the late 1990s, the American dollar became Ecuador's official currency (in September 2000), replacing the sucre. The economic depression provoked an exodus of more than half a million people over the next five years. Today, Ecuador is gradually recovering from economic chaos, riding a dynamic oil sector that generates about 20 percent of the gross national product. But the wealth oil brings is unequally distributed, and a rich minority holds sway—10 percent of the country's households control 40 percent of the total income.

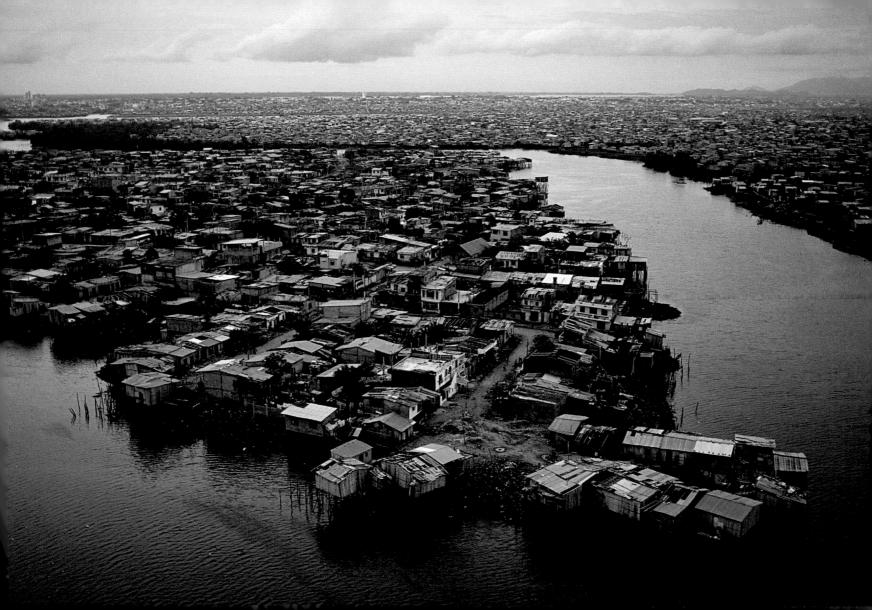

Moshav (cooperative farming village) of Nahalal, Jezreel plain, Israel $(32^{\circ}41' \, \text{N} - 35^{\circ}13' \, \text{E})$

Israel's first moshavim were established in the fertile northern plain of Jezreel, bordered to the east by Lake Tiberias and the Jordan River, and to the west by the Mediterranean. These collective farms, inspired by Socialist and Zionist ideology and established during the second wave of Jewish immigration in the nineteenth century, played a central role in the creation of the state of Israel. Unlike in kibbutzim, in moshavim farmers hold on to their own possessions but pool their labor and share natural resources like water. Any profits they make are plowed back into the community. The family is at the center of social life in these villages, and the children benefit from free education of a very high quality. Nevertheless, since the political and economic crisis of the 1980s, moshavim members are increasingly employed in nonagricultural sectors or else go away to work in nearby cities. Still, such forms of interdependent collective production are highly pertinent in the present context of financial instability, globalization, and generalized liberalism.

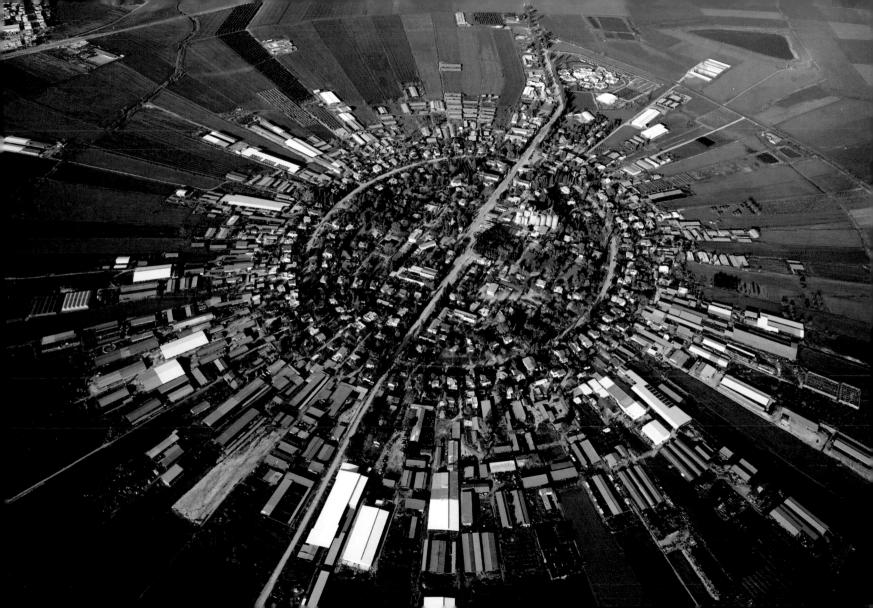

Marshy landscape in the West Coast National Park, Republic of South Africa (33°12′S - 18°09′E)

The Langebaan Lagoon, broad and swampy, is a nesting zone for more than 55.000 birds. Many are migrants that fly from the Arctic and Antarctic to take advantage of the warmer summer climate. With more than two hundred animal parks and reserves, covering 27,000 square miles (70,000 square kilometers, or 6 percent of the nation's territory), South Africa is one of the world's largest natural sanctuaries for wild creatures. Here, in a single region, it is still possible to meet with the "big five": the lion, the leopard, the elephant, the rhino, and the buffalo. South Africa has been a pioneer of ecological policy, with legislation for protecting nature dating back to the early twentieth century (though mostly at that time introduced by and on behalf of Western big-game hunters). Today, photographic tourism has replaced the hunt, and its economic ramifications are huge, with 5.5 million tourists a year visiting South Africa purely to see its wild fauna. Following South Africa's lead, other countries in the region are developing Transfrontier Peace Parks, a shared system of protected areas that can answer the space requirements of migrating animals.

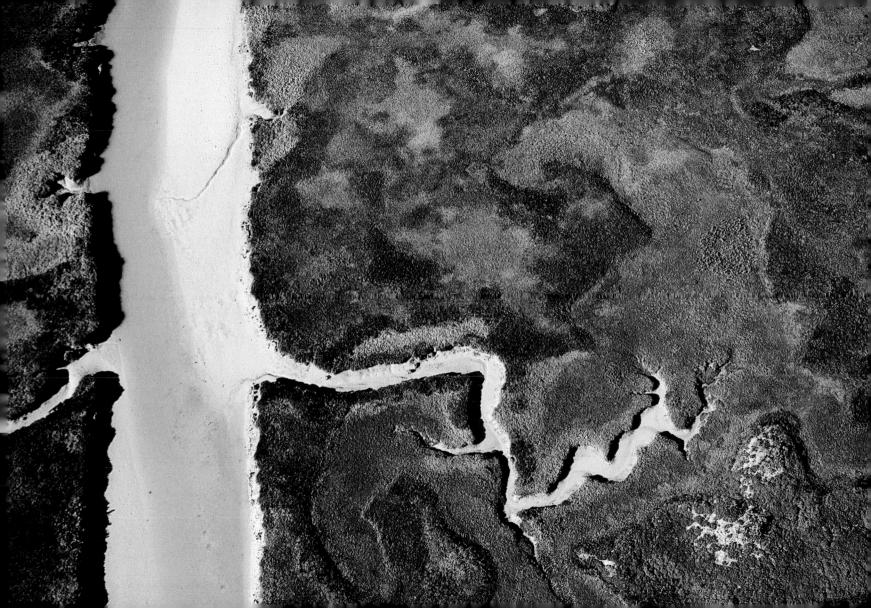

Rocky formations near Nurek Dam, Tajikistan (38°10′N - 72°44′E)

No mountain on earth escapes erosion, and even the hardest rocks gradually disintegrate from the effects of wind and water. These sedimentary layers of alternating light and dark gray were built up at the bottom of a lake or sea, before they buckled upward with the earth's crust. According to the rock cycle principle, devised two centuries ago by James Hutton and confirmed more recently by the tectonic plate theory, the earth's surface is constantly remodeling itself. On the one hand, tectonic movement is pushing up mountains and enlarging oceans; on the other, erosion is destroying the former and filling up the latter. These phenomena are occurring, of course, simultaneously. Life also has a part to play in this process. Some mountain rock was once live coral, and certain sedimentary layers derive from immense accumulations of fossilized shell and vegetable matter; coal is a prime example. Today's rocks, even, will eventually be turned into soil by bacteria, lichens, and plants.

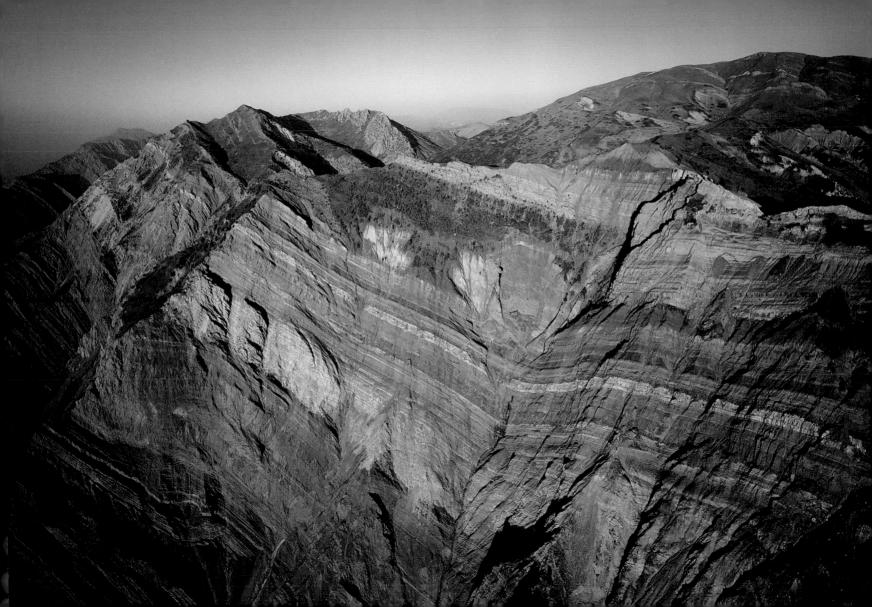

Herd of zebus near Cáceres, Mato Grosso, Brazil (16°05'S - 57°40'W)

Mato Grosso is one of the richest agricultural regions in Brazil. Here, livestock rearing and crop cultivation are practiced in huge, extensively farmed fazendas. In this country, nearly two-thirds of the cultivable land area is in the hands of less than 4 percent of the population. Half of it goes unused, while nearly 25 million. poor peasants, 5 million of whom have no land at all, survive by doing precarious agricultural work. This situation has led to violent conflicts, which have left more than a thousand people dead in the last ten years. The MST (a movement for landless rural workers) has been leading the struggle to impose a more equitable division of the land ever since 1984. Over the last twenty years, its actions in occupying land have obliged the state to cede ownership of property to more than 350,000 families. Only agrarian reform can provide anything like a lasting solution, but Brazil's politicians are still reluctant to go against the interests of the rich landowners and multinational companies. When President Lula da Silva was elected in 2002, having promised to tackle this problem, he carried the hopes of many deprived Brazilians. Today, however, the MST bitterly denounces his inertia.

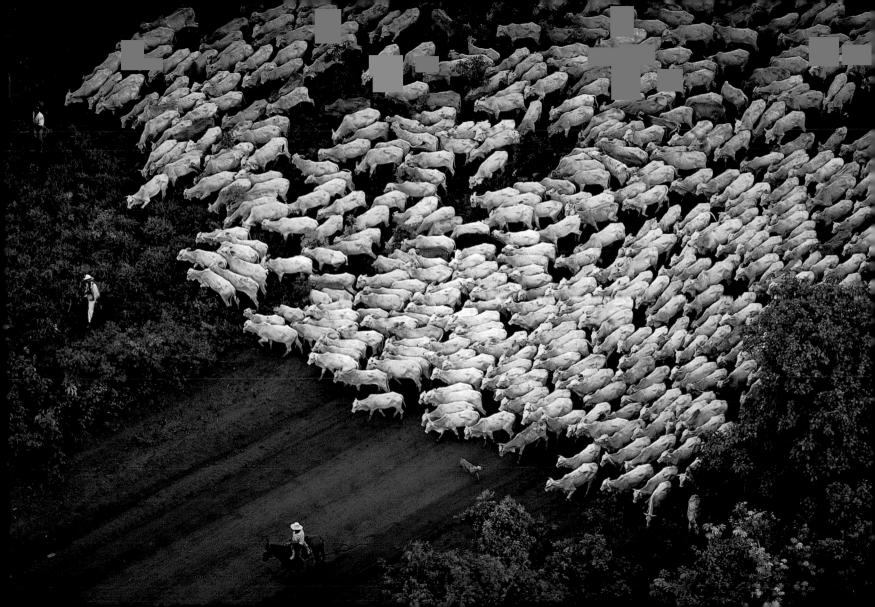

Salt drying, Ocoa Bay, Dominican Republic (18°20'N - 70°44'W)

Like many other Caribbean islands, the Dominican Republic is involved in salt production, an industry that is cheap to run and easy to set up along the seashore. The salt crystals are harvested for six months each year; women frequently supply the necessary unskilled labor. All over the world, salt production is an important industry. What with seawater containing about 4 ounces of salt per gallon (30 grams per liter), and its presence in seawater-derived rock form, the resource is widely available. It is either mined, or produced by the natural evaporation of seawater. In all, 240 million tons of salt were produced in 2006—20 percent in the United States and 15 percent in China; other leading producers are Germany, Canada, and India. Some 60 percent of the salt used annually around the world goes to the chemical industry; some 10 percent goes to deice roads. The remainder goes into the preserved fish industry, into our foodstuffs, and into the saltcellars on our tables.

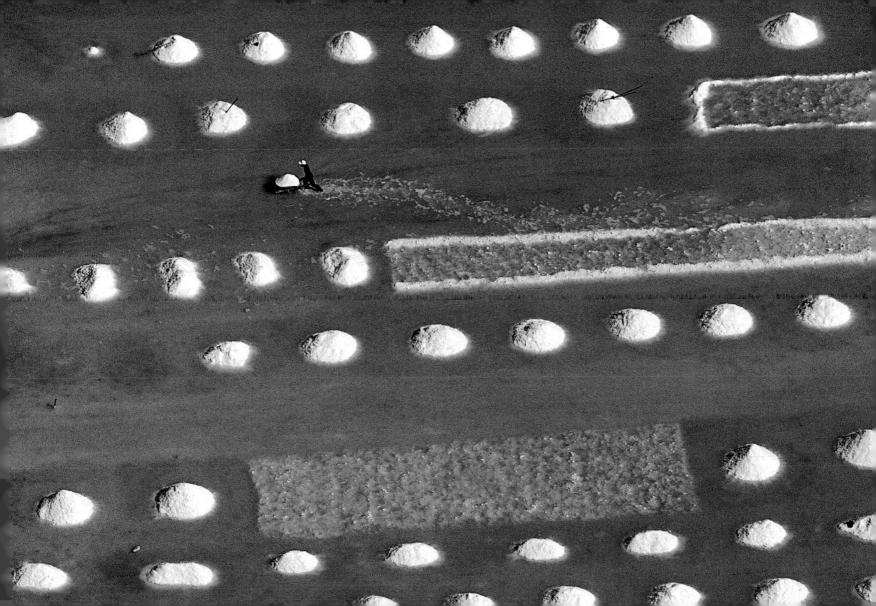

Agricultural land between Ankara and Hattusa, Anatolia, Turkey $(40^{\circ}00' \text{N} - 33^{\circ}35' \text{E})$

These neatly ordered and subdivided fields demonstrate the modernization. process that transformed Turkish agriculture in the 1950s and created regular agricultural landscapes on the Anatolian plateau north of the line between Ankara and Sivas. Primary sectors (agriculture and forestry) represent 9.7 percent of Turkey's gross national product, and in general farms remain small and family owned. Agriculture here has traditionally been associated with cereal growing and livestock, but the modernization process has brought about considerable diversification. Since the nineteenth century, certain regions have had their own specific products, and today nearly a third of the active Turkish population works in the agricultural sector (in France the figure is less than 3 percent). Olive trees, fig trees, vines, and citrus fruits are cultivated in the coastal areas, while cotton and greenhouse vegetables are plentiful all along the country's Mediterranean fringe. Tobacco is grown in the Aegean region and on the delta plains of the Black Sea. Walnut and tea plantations thrive on the Black Sea coast, while sugar beet is a major product in the high central plains. Nearly 50 percent of Turkish exports go to the European market, but today this development has been slowed by the imposition of new private and public standards.

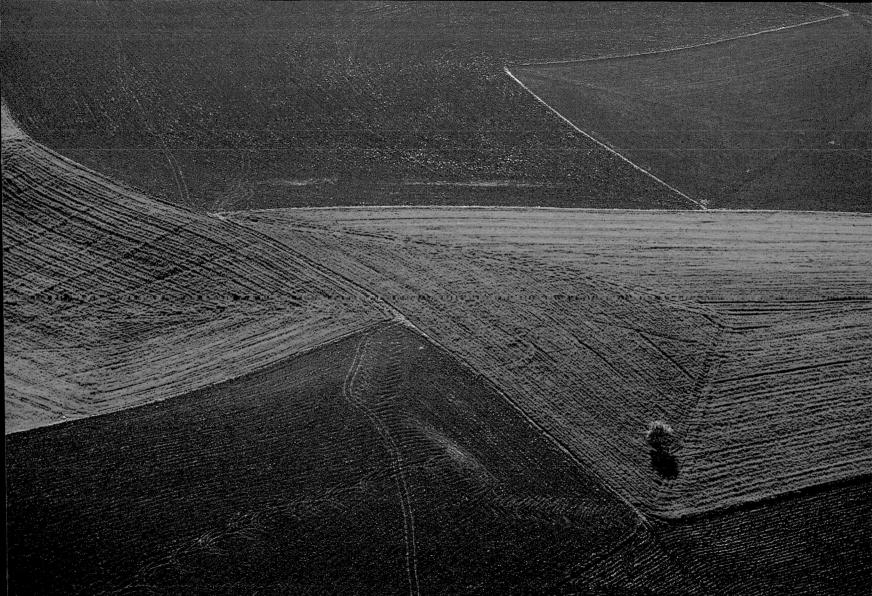

Lake Palace and City Palace, Udaipur, Rajasthan, India (24°35′N - 73°41′E)

The city of Udaipur, founded in 728, had its moment of glory when Maharajah Udai Singh II made it the capital of the Mewar in 1567. The Mewar, a fertile country in the southeast of Rajasthan, is separated from the Marwar, the "country of death," by the Precambrian Aravalli Range, which extends 435 miles (700 kilometers) north to south and divides Rajasthan in two. One half benefits from the ocean climate; the other is desert, and barely sees 8 inches (200 millimeters) of rainfall per year. In 1746, Jagat Singh II built the Lake Palace, a marble jewel perched on a small island, to serve as a summer residence for the royal family. After India's independence in 1947 it was converted into a hotel; its architecture is a wondrous play of water and marble, and its facades are reflected on the lake surface. Water also tinkles through the building's interior in a succession of fountains, pools, and hanging gardens. Thus the maharajahs succeeded in making into a reality the mirage of floating palaces in the Thar Desert.

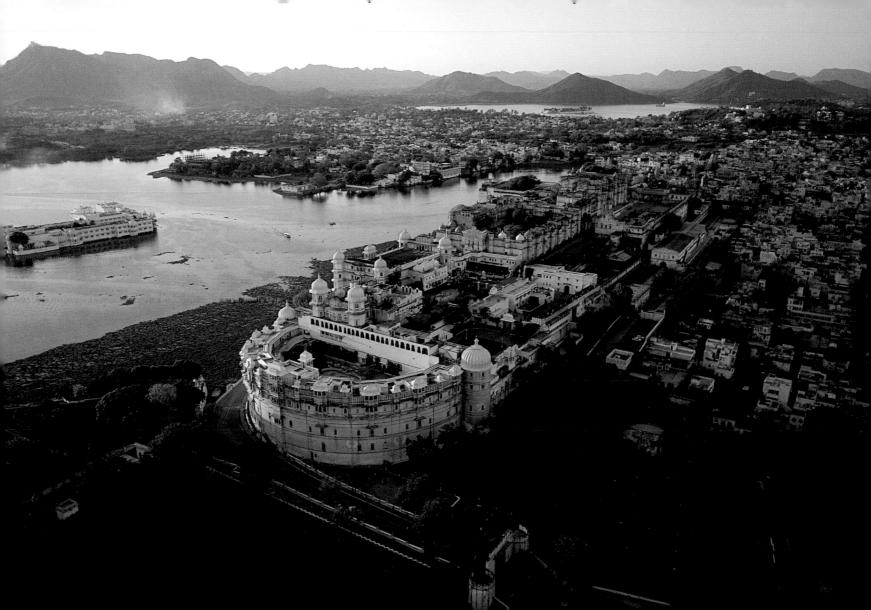

Oil separation pond at a purification plant, Marne, France $(49^{\circ}00' N - 4^{\circ}20' E)$

In this water degreasing unit, air blown into mixed liquids makes it possible to separate oil from water. The oils are then fused into a kind of white scum that can later be removed or incinerated. The depollution process is carried out using two successive treatments: the physical and chemical separation of the solid elements, then the biological purification that degrades the organic components responsible for asphyxiating rivers. With 15,000 such plants on its territory, France now possesses one of the best water purification networks in the world; yet only 49 percent of France's wastewater is ultimately depolluted. This is because the purification stations have limited output and do not serve every residence in the country. Other procedures are now being developed for water purification, such as *lagunage*, an old technique of natural purification that uses the sun, the wind, and certain plants, such as reeds, to absorb pollutants. The wastewater produced by the town of Rochefort in France is entirely treated using this technique.

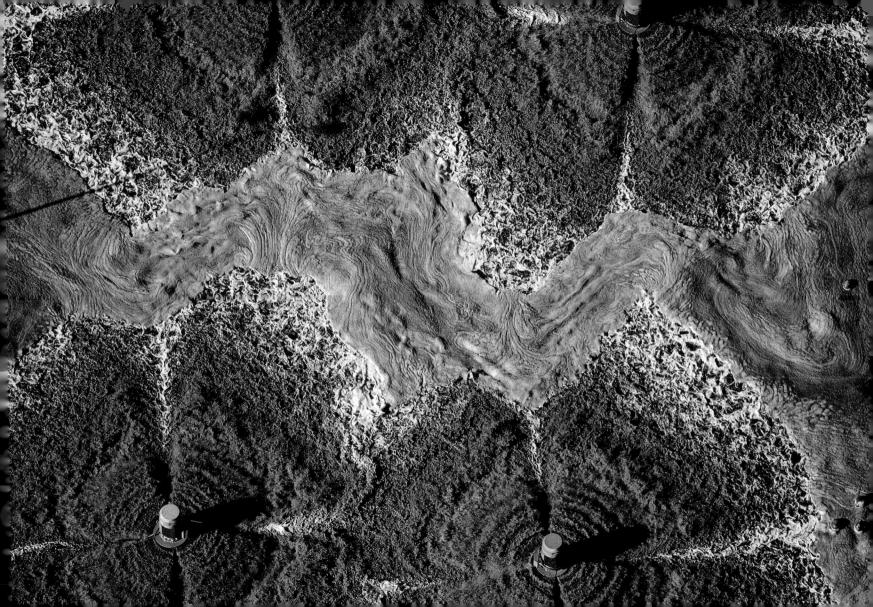

Field work in the mountains south of Pokhara, Kali Gandaki Valley, Nepal $(27^{\circ}42'N - 84^{\circ}25'E)$

Out of the mighty Himalayan peaks flow hundreds of wild, untamable torrents, like the Kali Gandaki—one of the sacred rivers of Nepal. Its course, studded all along with cremation sites, winds down from the Himalayas to the fertile valley of Pokhara. A popular destination for hippies in the 1960s, Pokhara has become Nepal's second-most-visited tourist destination, with a population that reflects the multiethnic region around it. Hindu castes are in the majority, and the original inhabitants, the Gurungs, live in surrounding villages. For Nepalis, ethnic groups or castes are the fundamental elements of their identity, even more so than citizenship. The Hindu castes are at the top of the hierarchy, and their values have spread through every level of Nepali society. In Nepal, 90 percent of the population is Hindu, 5 percent is Buddhist, and the remainder is animist. But over the centuries a kind of synthesis has taken place among the religions, and animist beliefs remain very strong.

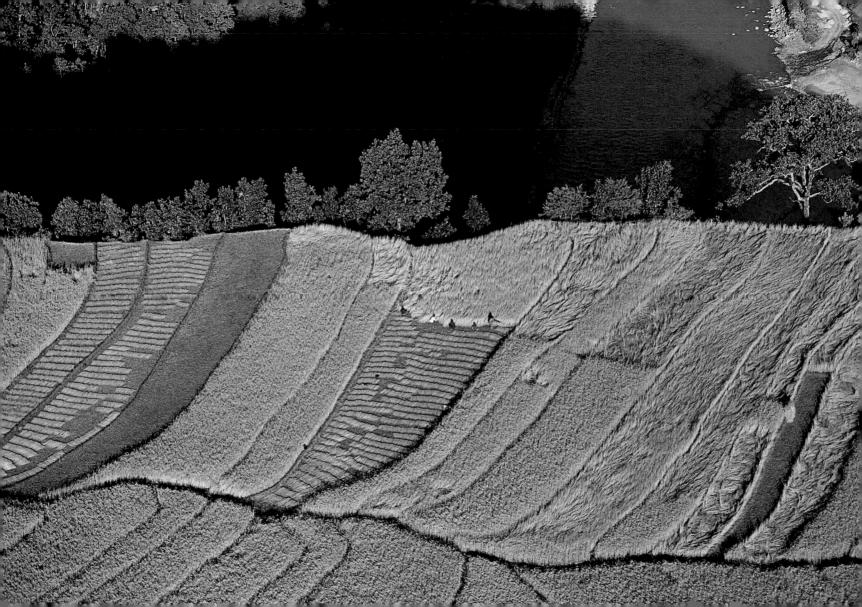

Tree trunk on a coral seabed, Dominican Republic (18°20'N - 68°55'W)

In the Caribbean Sea, between the islands of Saona and Catalina, a tree trunk hooked on the coral turns round and round on itself, making these curious designs. The Dominican Republic occupies the eastern end of Hispaniola, an island in the Antilles. The south side of the island faces the Caribbean Sea and its 280,000 square feet (26,000 square meters) of coral reefs, which serve to protect the local population from hurricanes by forming a natural barrier. Yet the coral itself is seriously threatened. Hurricanes have become more and more frequent in the region, and their destruction combines with pollution from agriculture and from the hydrocarbons discharged by pleasure boats. It is thought that two-thirds of the coral in the region is now under severe threat. If this degradation continues, a good part of the country's economy will be crippled; after all, the Dominican Republic, the principal tourist destination in the region, derives most of its revenue from the 2 million visitors who come each year to enjoy its beaches and coral reefs.

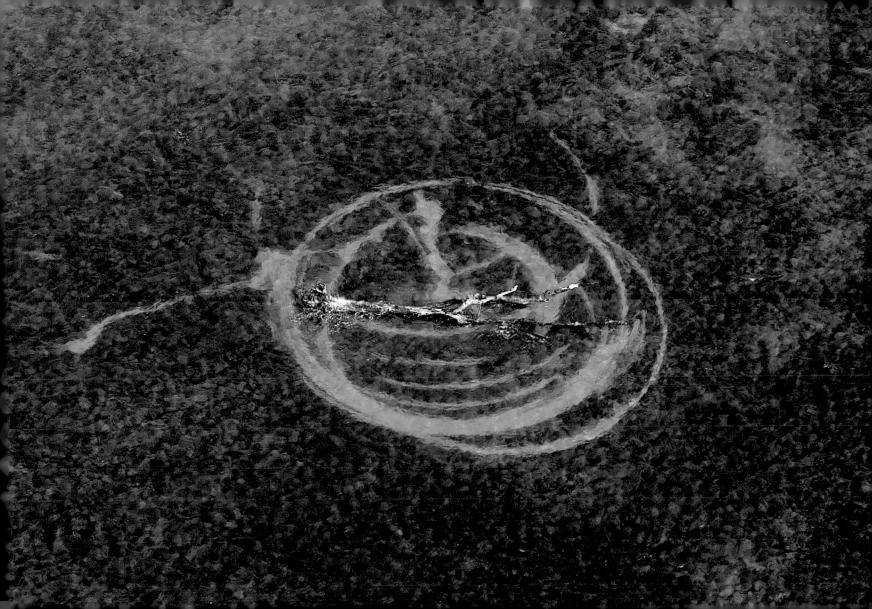

University of Science and Technology, Doha, Qatar (25°17'N - 51°32'E)

On the roofs of the educational halls of residence at Doha's University of Science and Technology, the motifs of the Islamic tradition—which here resemble the crystalline structure of sand—blend with the pure lines that characterize the work of Japanese architect Arata Isozaki. Using the revenues from its vast reserves of oil and mostly gas, Qatar is investing in the future by approaching the world's most prestigious universities with offers to set up branches alongside the Qatari ones, thereby encouraging the immigration of a new technological elite. American universities were the first to respond to this appeal, and four of them now have branches in this corner of the Arabian Peninsula, where students are trained in company management; computer technology; chemical, electronic, mechanical, and oil-field engineering; practical medicine; medical research; art; and media studies.

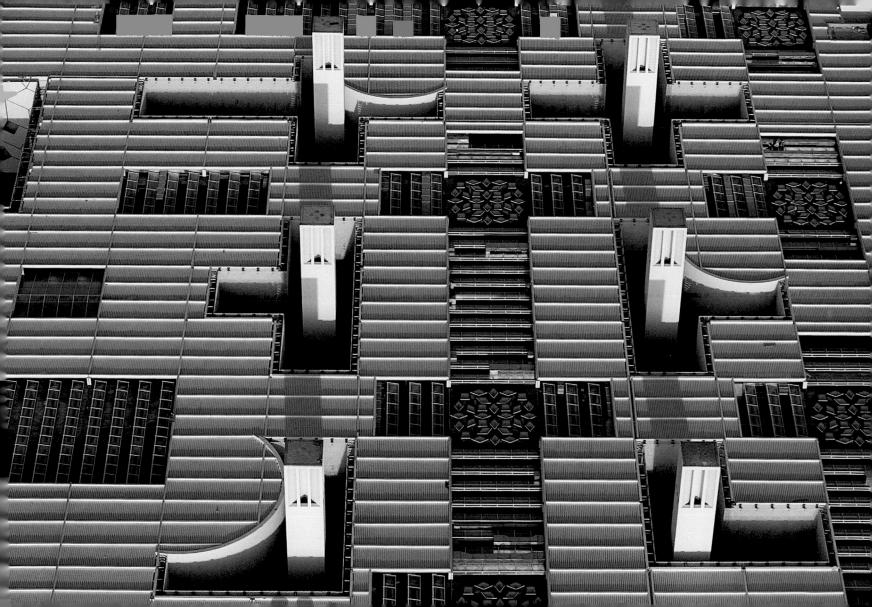

Open garbage heap, Santo Domingo, Dominican Republic (18°28′N - 69°53′W)

Since 1996, the economy of the Dominican Republic has grown spectacularly, a growth basically fueled by tourism. But although they bring in plenty of foreign currency, the millions of tourists who flock to the seafront hotels also produce huge volumes of garbage, which doubled between 1994 and 2000. The country is sorely lacking in disposal infrastructure, and as a result, less than 2 percent of solid waste is recycled, and open-air dumps foul the coast and the surroundings. The garbage collected by the city is simply left in open, unguarded vacant areas, causing disease, degraded landscapes, noxious odors, and toxic-gas emanations: the levels of pollution have skyrocketed. The occasional incineration of these garbage heaps causes 20 percent of air pollution; and perhaps most worrying of all, the toxic waste from hospitals is not disposed of separately. In a region located right in the middle of the cyclone belt and regularly hit by powerful storms, the potential consequences for the health of the population, for tourism, and above all, for the environment, are utterly devastating.

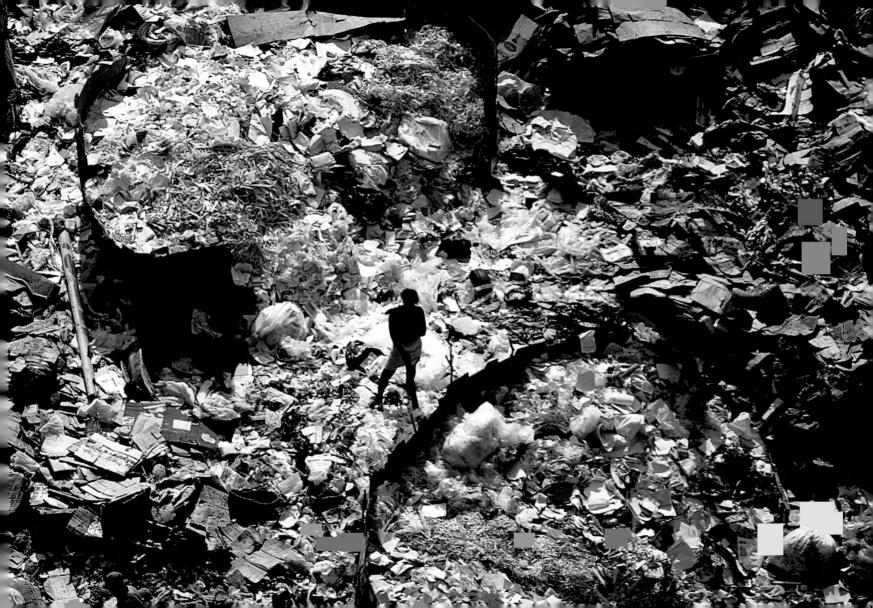

Library of Celsus, archaeological site of Ephesus, Anatolia, Turkey $(37^{\circ}56' \, N - 27^{\circ}21' \, E)$

This monumental facade is the last vestige of the Library of Celsus; it has miraculously survived the invasions, fires, and earthquakes that ravaged Ephesus over the centuries. The colossal statues, framed by two stories of Corinthian columns, represent Wisdom, Virtue, Intelligence, and Science qualities attributed to the proconsul Julius Celsus Polymaenus, in whose honor the consul Julius Aguila (his son) built this monument in AD 135. The library is thought to have contained up to 12.000 manuscript scrolls, stored in the niches of a great reading room behind. In fact, the library was a part of a much greater complex at Ephesus—once one of the greatest port cities of the Greco-Roman civilization—which was ultimately engulfed by the alluvium of the Cayster River. The Temple of Artemis, one of the Seven Wonders of the World, was at Ephesus: it was essentially destroyed, along with the Pharos of Alexandria, the Colossus of Rhodes, the Hanging Gardens of Babylon, the Statue of Zeus at Olympia, and the Mausoleum at Halicarnassus. The only original Wonders still to be seen today are the Pyramids of Egypt.

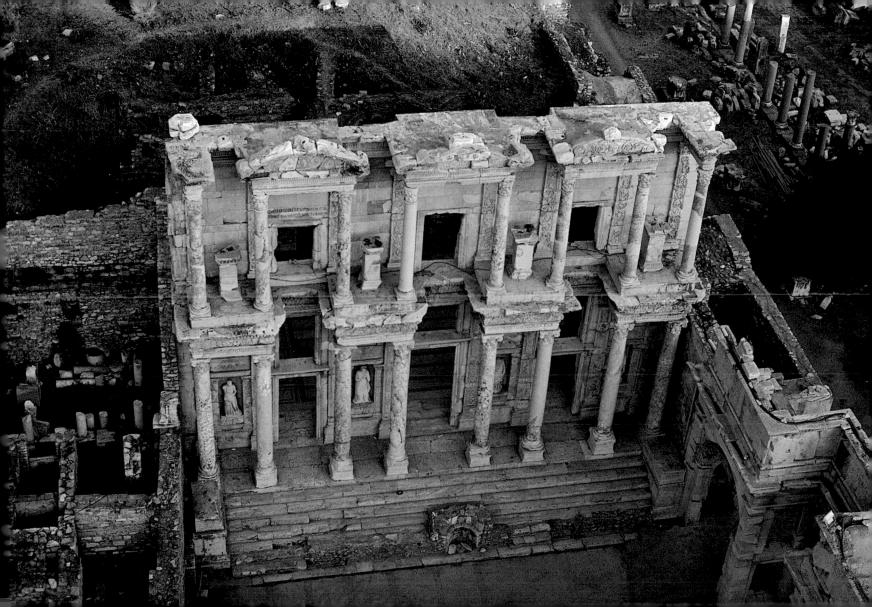

Herd of cattle, Laguna Merin near Punta Magro, Rocha, Uruguay (33°22′S - 53°36W)

The Merin lagoon basin lies on the Atlantic coast of South America, in a subtropical zone. It occupies about 15 million acres (6 million hectares), the western half of which covers 18 percent of Uruguay, the remainder being in Brazilian territory. The landscape is gently undulating, with broad plains covered in pastures and marshy areas. Rainfall totals are between 47 and 59 inches (1,200 and 1,500 millimeters) per year, and the ecosystem is one of the richest in Uruguay. As an immense freshwater lake of 965 square miles (2,500 square kilometers), the Merin lagoon has a fundamental ecological role. The survival of millions of migratory birds depends on the conservation of these marshes, which are part of one of the earth's 15 principal migration routes. These plains have remained undisturbed for many years, yet with the development of the cultivation of rice in the last two decades, damage to the environment has intensified. Over the last century, half the wet zones of the planet have been drained for human cultivation.

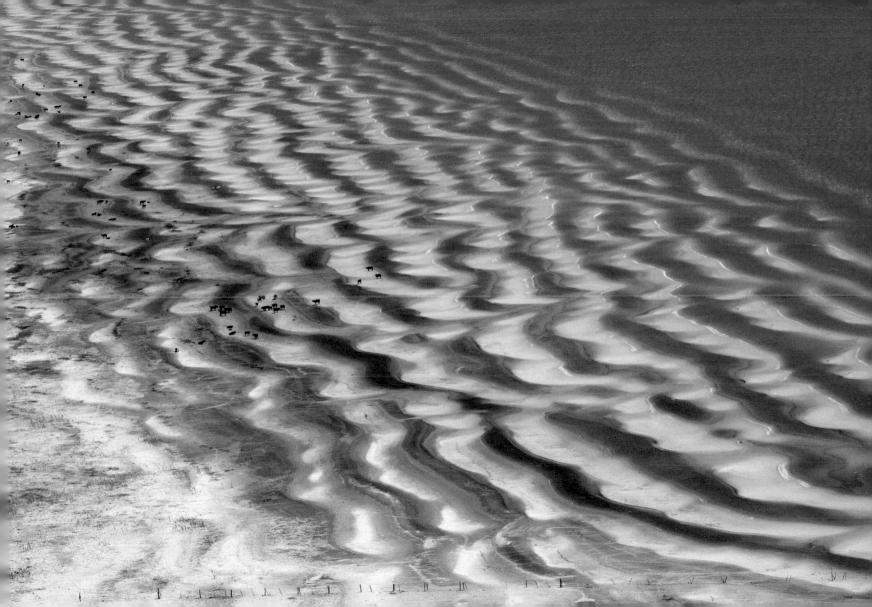

Fishing net caught in the ice, Lake Paro, South Korea (38°11'N - 127°50'E)

In Korea, freshwater fishing in locales like Lake Paro is a secondary activity whose product is sold on the domestic market. Fish is an essential ingredient in the Korean diet, as it is in most Southeast Asian countries. Indeed, Korea has developed a powerful fishing industry, which has led to the intense exploitation of the coastal waters on its three ocean shorelines (the Yellow Sea, the Southern Sea, and the Eastern Sea). Today Korea is classed as one of the ten principal fishing nations in the world. But this strategy has led to overexploitation of local fish resources, and within a few years catches have fallen by a third, from 1.8 million tons in 1990 to 1.2 million tons in 2000. Worldwide, overfishing is common in industrialized countries, whose sea resources are now well-nigh exhausted by the sheer size of the previous decades' catch. Today, 70 percent of the world's fishing grounds are either substantially overfished or entirely fished out.

Chain of volcanoes, Lakagígar, Iceland (64°04′N - 18°15′W)

The Lakagígar region of southern Iceland still bears the scars of one of the most violent eruptions in history. In 1783, two 16-mile-long (25-kilometer-long) fissures suddenly opened on either side of the Laki volcano, spewing forth 4 cubic miles (15 cubic kilometers) of molten rock, which eventually covered 200 square miles (520 square kilometers) of land—the most gigantic lava flow in memory. A cloud of carbon dioxide gas, sulfur, and ash blanketed the entire island, contaminating all pastures and surface water. Three-quarters of Iceland's livestock population was annihilated and, after a second eruption, one-quarter of the human population (more than 10,000 people) succumbed to famine. Crowned by 115 volcanic craters, the fissures of Lakagígar are now closed, and the lava flows are covered by a thick carpet of moss. With more than two hundred active volcanoes, Iceland has been home to a full third of the world's gaseous volcanic emanations over the last five centuries.

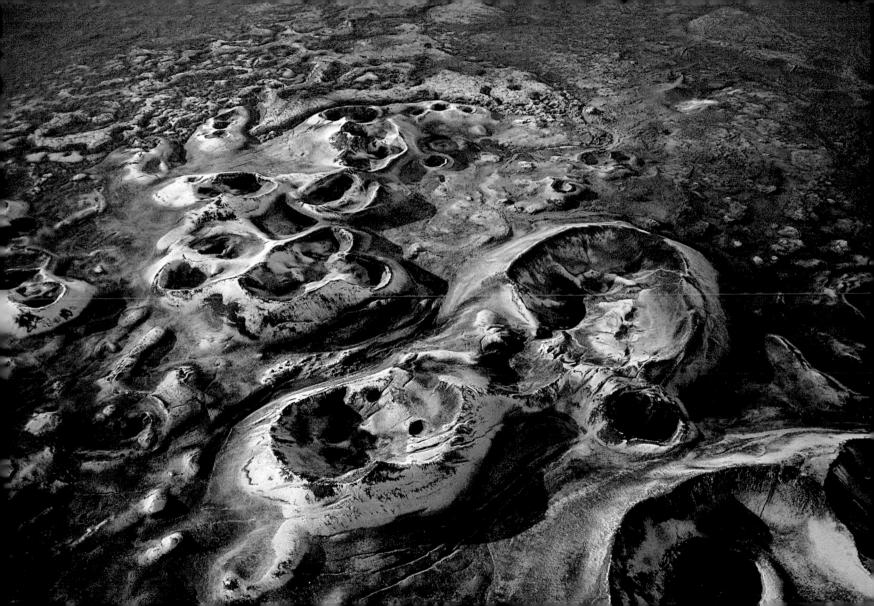

Six thousand hearts for a red ribbon, Le Mans, Sarthe, France $(47^{\circ}60'N - 0^{\circ}10'E)$

Since the early 1980s, HIV/AIDS has killed more than 28 million people. In a single year—2006—2.9 million died from it, 380,000 of them children, and more than 5 million individuals were infected. This brings the number of people infected by the virus worldwide to over 39.5 million. Sub-Saharan Africa remains the area worst hit by the epidemic; every five years, ten countries in the region lose 10 percent of their active adult population to HIV/AIDS. Associations have sprung up all over the world with the aim of bringing support to those stricken with the disease. On Saturday, September 25, 2004, at 5:15 p.m., in a field belonging to the Arche de la Nature reserve near Le Mans, nearly six thousand men, women, and children met to trace the shape of an immense heart on the grass, the photos of which were later published as a postcard. The 1er Décembre Sarthe collective, which orchestrated this event, uses the funds received to finance the preventive- and health-care initiatives of the Kenedugu Solidarity Association in Mali.

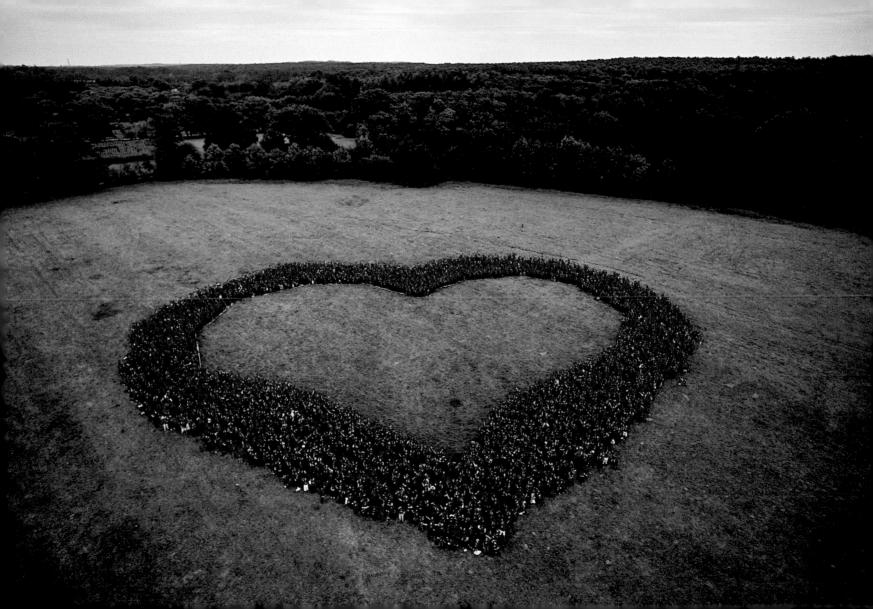

The frozen Pukhan River, South Korea (37°56'N - 127°39'E)

The Pukhan's source is located in the center of the Korean Peninsula, right on the border of North and South Korea. From there it winds southward to the periphery of Seoul, where it joins with the Han River. Because of its strategic position, the Pukhan saw heavy fighting during the 1950–1953 war between the North and the South. In South Korea, June 6 has been declared a day of memorial, and for more than a decade now a festival evoking the conflict has been held in the province of Gangwon. In 2005, in addition to the traditional military parade and the customary speeches by veterans, a giant South Korean flag (246 feet by 164 feet, [75 meters by 50 meters]), woven by children, was hoisted over the river, in a highly symbolic gesture—Pukhan means "North Korea." The hope of reunification endures.

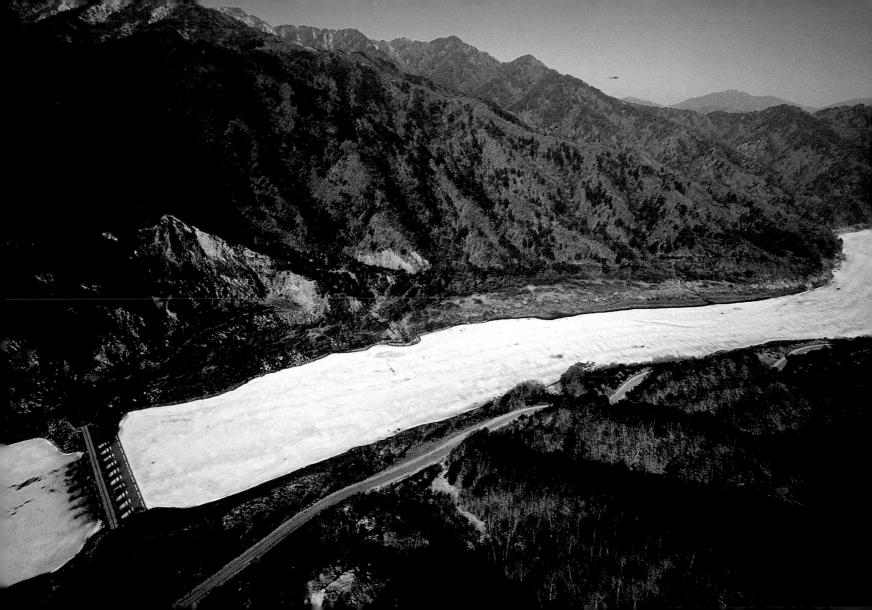

Salt formations on the west side of the Dead Sea, Israel (31°20′N - 35°25′E)

A landlocked sea 47 miles (75 kilometers) long and 9 miles (15 kilometers) wide, the Dead Sea is the lowest point on the entire planet, at 1,400 feet (418 meters) below sea level. Its color, which varies from one point to another, is punctuated by white streaks, attesting to its very high salinity (nine times higher on average than that of the ocean); little plant or animal life can survive in its environs. The Dead Sea is shared by Israel and the West Bank on its west side and Jordan on its east. Since 1972, the Dead Sea has lost 30 percent of its water surface; its level continues to fall by 3 feet (1 meter) a year because its waters, as well as those of the Jordan River that feed it, are being diverted to irrigate the Negev Desert. In the bordering regions, water shortages have reached a critical point, with renewable resources below or about equal to 5,400 square feet (500 square meters) per inhabitant. More than ever, access to this resource—in rivers, lakes, and the water table—is a strategic issue for the countries of the region, and a source of conflict.

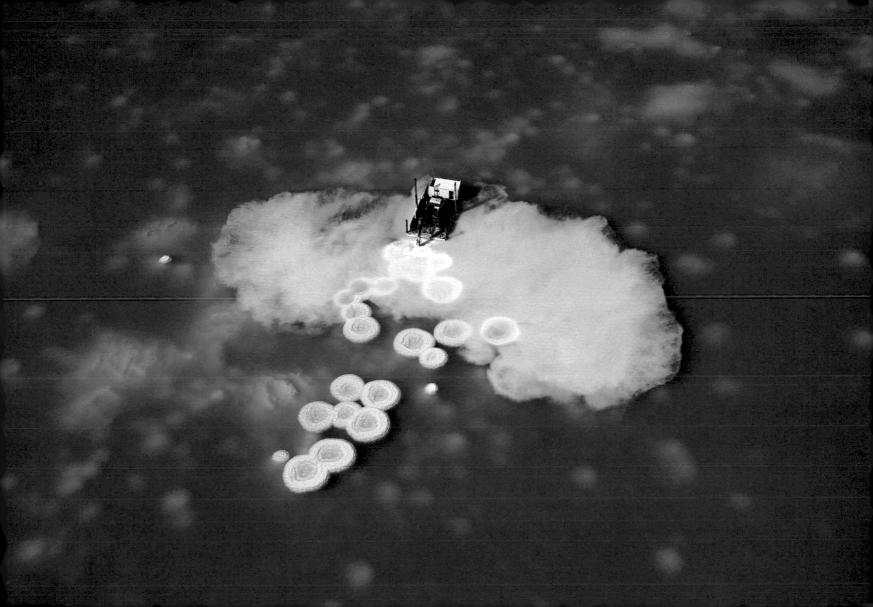

Switching yard at Maschen, Lower Saxony, Germany (53°23'N - 10°04'E)

Built in 1977, the station at Maschen, just south of Hamburg, is the largest switching yard in Europe. These railway bottlenecks, in which boxcars transporting international merchandise are coupled and uncoupled, are altogether too numerous, and slow down rail traffic drastically. Railway freight infrastructure, much of which was built in the early nineteenth century, is largely obsolete today. bearing little resemblance to modern, reactive, ultracompetitive road networks. As a result, 45.5 percent of European merchandise is transported by road—only 10.5 percent is transported by train, and 3.3 percent by barge (37 percent are moved via airplanes, ships, or pipelines). Trucks on the roads are three times more numerous than they were thirty years ago, and if the trend persists their number will have doubled again by 2010. This is problematic, because the great road axes of Europe will never be able to absorb this increase in traffic. Every day, at any given moment, there are 4,660 miles (7,500 kilometers) of traffic jams around Europe; in other words, 10 percent of the entire network is gridlocked. The cost of these delays represents 0.5 percent of the European Union's gross national product and will reach 1 percent of GNP by 2010. It is time to reevaluate the "real costs of the road," taking into account the hidden ones—and the grave impact of air and noise pollution on human health.

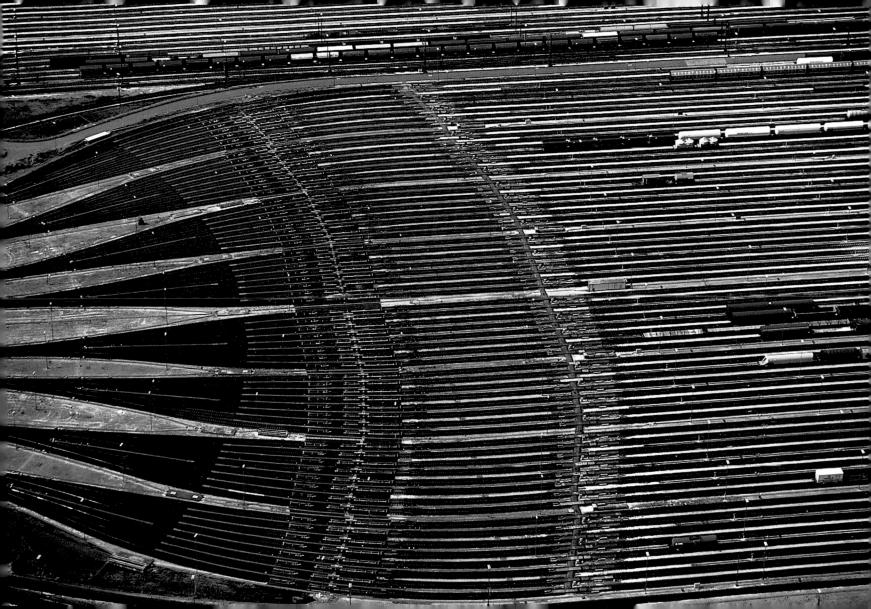

Field work in the north of Phuket Island, Thailand (8°14′N - 98°19′E)

The rice paddies that occupy almost 55 percent of Thailand's arable land dominate the landscape right up to the valleys of the country's north. The paddies are largely worked by farmers, each owning an average of 7 acres (3 hectares) of land, with 3.7 million families cultivating rice for their own consumption. Rice cultivation is usually organized in a traditional way, without the use of machines. From sowing time to harvest, all family members contribute to the process. Their crops make Thailand the sixth-largest rice producer in the world (29 million tons were produced in 2007), and the world's principal rice exporter (9.4 million tons in 2007). Despite this huge turnover, Thailand remains a profoundly impoverished and agricultural country. In 2004, the rural population made up 68 percent of the total number of working people, and 49 percent of these were directly involved in cultivating the land. Because the rice fields are mostly worked by hand, crop yields made it impossible for farmers to produce sufficient surplus to earn much extra money. Thus 12 percent of the rural population in Thailand today is thought to live below the threshold of relative poverty.

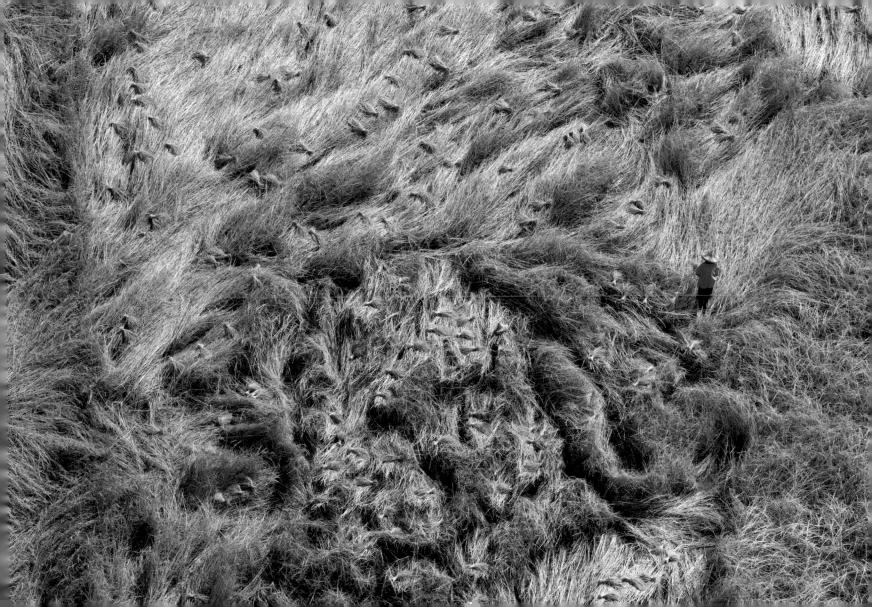

Solar electrical plant at Sanlúcar la Mayor, near Seville, Andalusia, Spain $(37^{\circ}26'N - 6^{\circ}15'W)$

With 320 days of sunshine per year, the broad plains surrounding Seville are an ideal site for thermoelectric solar power plants. With an output of 11 megawatts, the first plant in this complex—eight are planned—has been operative since the end of 2006. It comprises 624 adjustable mirrors, each 1,302 square feet (121 square meters) wide, which together cover an area of about 173 acres (70 hectares). Distributed at the foot of a 377-foot-tall (115-meter-tall) tower. these mirrors concentrate the sun's rays on its top, where there is a huge boiler. The temperature obtained (between 1112°F and 1832°F [600°C and 1,000°C]) produces vapor, which drives an array of turbines and alternators, generating electricity. While these installations require space, they can (as long as the sun shines) produce power on a par with that of fossil-burning power stations. By 2013, the eight completed solar plants will provide electricity for 180,000 homes, the equivalent of a city like Seville. Today, in Europe, renewable energy (solar, hydro, biomass, wind, and geothermal) represents no more than 14.4 percent of electrical power production.

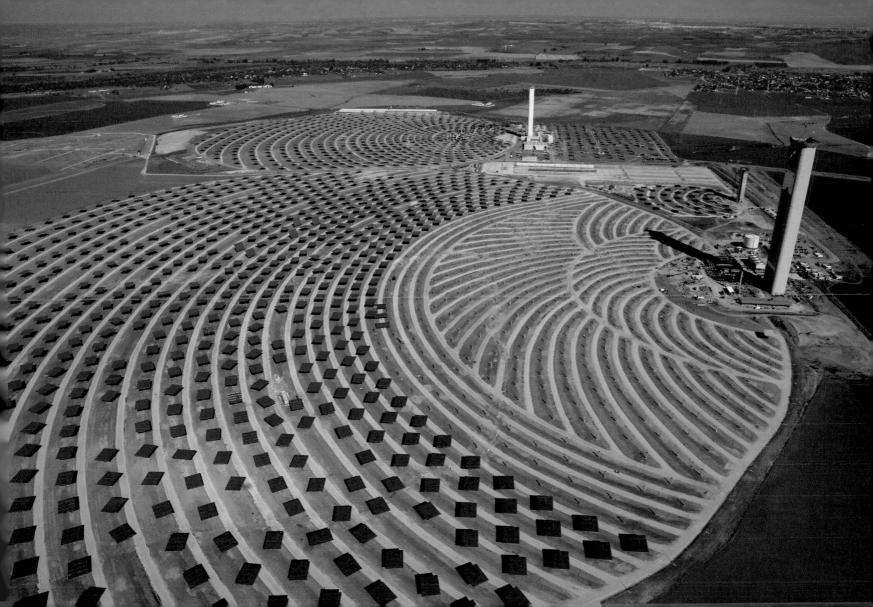

The mouth of Wadi Kalou, Lake Assal, Republic of Djibouti (110°37′N - 42°23′E)

The republic of Djibouti is situated in one of the world's most unstable tectonic zones, at the junction of two major fractures in the earth's crust. The rift between East Africa and the rifts of the Red Sea and the Gulf of Aden run between Africa and the Arabian Peninsula. Here earthquake events are very intense because the plates involved are not at the same level. They ride up on each other, grind together, and draw away from each other; some reach 6,561 feet (2000 meters) in height above sea level, and others dip 508 feet (155 meters) below. The bowl of the salty Lake Assal—Africa's lowest point—is furnace-hot, which accelerates the evaporation process. Once or twice a year heavy rains swell the wadis that feed the lake, pouring down for a maximum of thirty to forty hours. The water carries sediment—pebbles, sand, and clay—along with mineral salts, which crystallize with the subsequent evaporation on the basaltic riverbeds, leaving the traces shown in the photo.

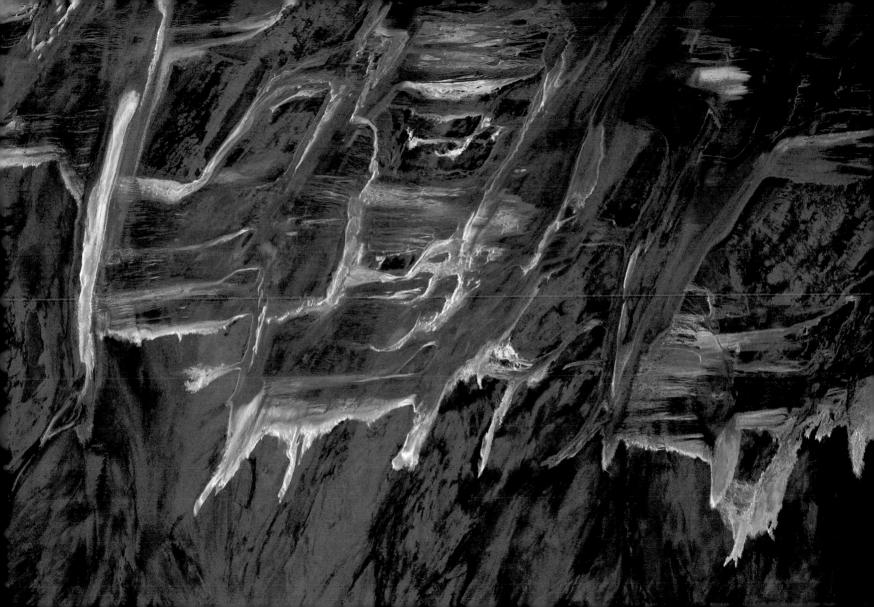

Island off Guanaja, devastated by Hurricane Mitch, Bay Islands, Honduras $(16^{\circ}27'N - 85^{\circ}53'W)$

The paradise island of Guanaja, the largest in this bay (bahía), was struck by Hurricane Mitch in 1998. Its coral reefs, beaches, mangroves, tropical forest, and beautiful streams were completely devastated in the space of a few days. Nearly 7,000 Hondurans were confirmed killed and more than 10,000 were never heard from again; material damage to the country was estimated at nearly \$4 billion. Since that time, however, life and tourism have returned to the area. Plantations of Caribbean pines have taken the place of the forests flattened by the wind and the saltwater it carried inland. The ecosystems, on the other hand, are regenerating themselves very slowly. The herons, egrets, and pelicans are back, but the damage wrought upon the mangroves looks to be irreversible. Without question, the amplification and increased frequency of extreme weather events such as Hurricane Mitch are due to climate warming, brought on by human activity.

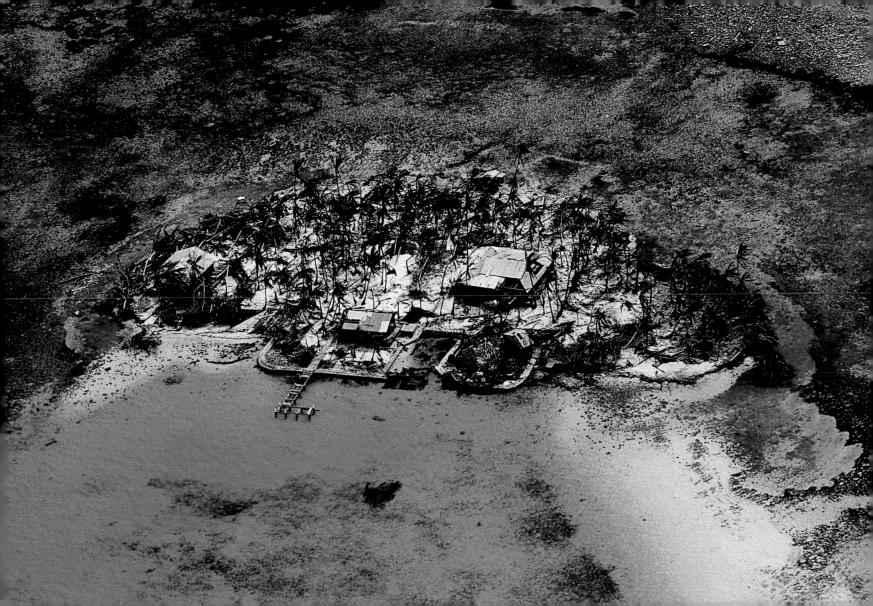

Village of Fachi, Aïr Mountains, Nigeria (18°06'N - 11°34'E)

The oasis of Fachi, nestled in a depression at the foot of the Aïr Mountains in the Ténéré Desert, is inhabited by a settled population of three thousand Kanooris. The local economy depends on the exploitation of the palm groves; 300,000 date palms cover an area of about 4 square miles (10 square kilometers). South of the village there is an open-air salt pan, the bottom of which is divided into pools. each about 22 square feet (2 square meters) in size. The salt is molded into loaves for use in animal feed, in palm wood or clay moulds enveloped in camel skins. according to a local tradition that goes back to the fifteenth century. Since then, the oasis has been a halfway house for an annual salt caravan, which was the foundation for its prosperity. This mythic 370-mile (600-kilometer) voyage, which once took each caravan some forty days to complete, continues today, beginning in October—the start of the cool season—and continuing until the following June. Today the caravans are less numerous, but the growth of interdependent tourism in the region contributes to the livelihoods of local people and allows them to subsist.

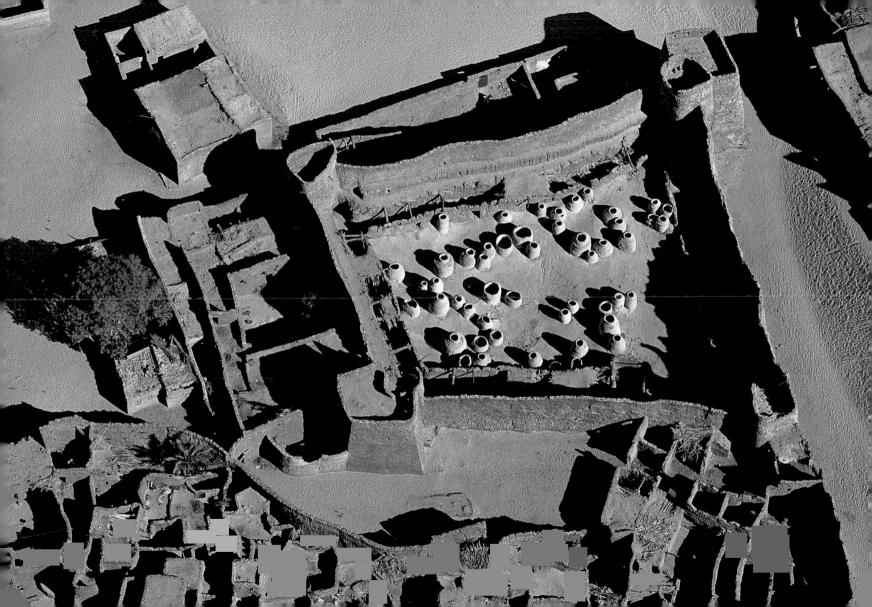

Farm and tree plantation near Christchurch, Canterbury region, South Island, New Zealand (43°28'S - 172°34'E)

With the drying up of agricultural subsidies and the deregulation of the economy since the mid-1980s, New Zealand has been able to diversify and increase its agricultural productivity. Although financial aid for production and exportation once represented up to 30 percent of the value of their agricultural output. the farmers of New Zealand make better livings today than they did before subsidies were abolished. The problems of overproduction and environmental degradation have been overcome. The once-encouraged overconsumption of fertilizers has been stopped, and less-than-productive land—once only worth employing for the subsidies—has been returned to nature or reforested. While the total area in cultivation has been reduced, the number of farms—80,000 in all—remains perfectly stable, and agriculture's share of the gross national product (GNP) has risen 2 percent over the last two decades. New Zealand agriculture, which employs more than 11 percent of the working population, is largely geared toward export (90 percent of output is exported) and the sector is making inroads into the markets of countries that heavily subsidize their farmers. Worldwide, developed nations still spend \$365 billion annually to assist their agriculture sectors.

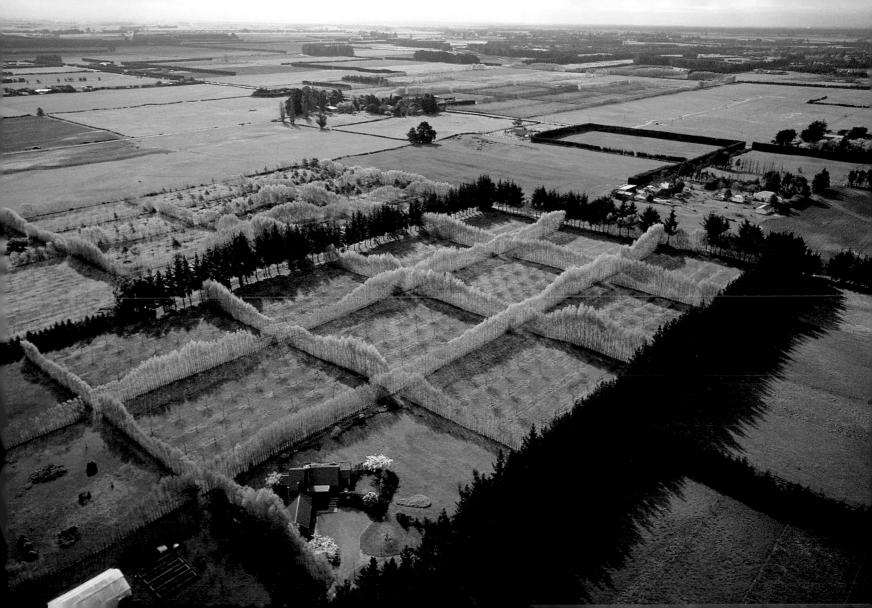

The dividing wall between Israel and the Palestinian West Bank $(31^{\circ}50' \text{N} - 35^{\circ}14' \text{E})$

In 2002, Israel decided to build a wall all along the Green Line that constituted the frontier between the West Bank and Israeli territory prior to the Six-Day War of 1967. From Qalqiliya to Bethlehem by way of Jerusalem, this wall—and its crossing points, its waiting lines, and its separate aisles for Israelis and Palestinians—is now part of the daily life of the local inhabitants. This barrier is twice as long as the Green Line, and it resolves neither the security problems nor the territorial disputes that have persisted there for the last forty years. This 26-foot-tall (8-meter-tall) construction occasionally strays up to 3 miles (5 kilometers) into Palestinian territory; in 2004, the International Court of Justice in The Hague declared it illegal and ruled that it should be dismantled. Since the early 1970s, the expansion of Israeli colonies has continued unabated. Today, about 450,000 Israelis live on land claimed by the Palestinians, and assaults, kidnappings, and rocket attacks keep the Israeli population in a constant state of apprehension. For some Israelis, the building of this wall is an answer to terrorism and insecurity. For others, only territorial concessions can restore peace. But this peace, the condition for which is the creation of a Palestinian state within the 1967 frontiers. would seem to be illusory as long as some Palestinian leaders advocate the total destruction of Israel.

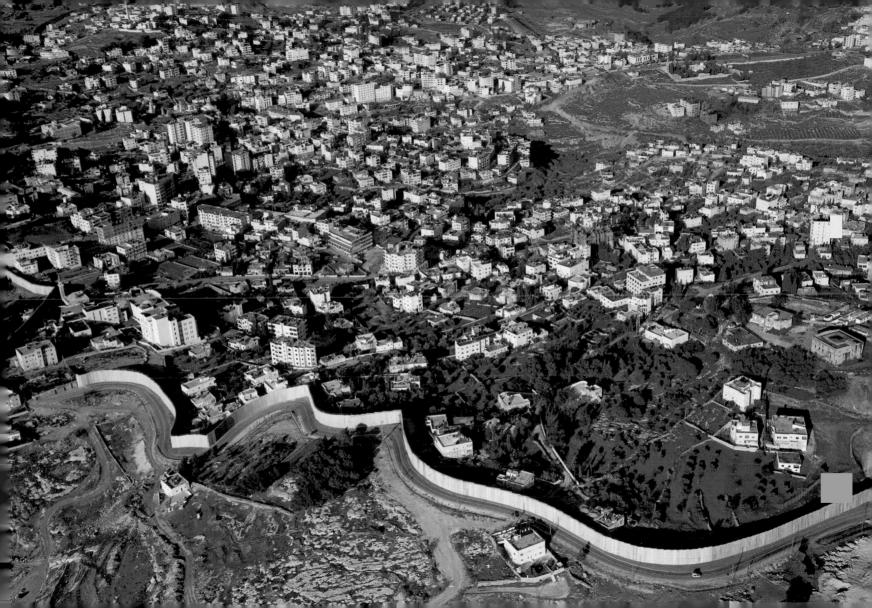

White maize stockpile, Masai Mara National Reserve, Kenya (1°30'S - 35°10'E)

Known throughout the world for its landscapes and its wild animals, the Masai Mara Reserve, with its Tanzanian extension into the Serengeti, forms the world's largest protected area (at 9,700 square miles [25,000 square kilometers]). The Masai, now living on "ranches" on the edge of the reserve, have been evicted from their ancestral land and are no longer allowed to hunt or to graze their cattle there. Forced to settle, they still live from their cattle, but more often than not they rent their land to agricultural contractors, who operate in a much more profitable sector than traditional extensive livestock raising. Thus, around the reserve, the surface area of land rented for mechanized culture has multiplied over a hundred times in the past twenty years. White maize, which constitutes one of the staple foods in Africa, is far preferred to the yellow variety, which is viewed as an emergency food aid item, only good for animals. In Africa as a whole, white maize constitutes more than a quarter of the total agricultural output. It is exclusively for human consumption and, in countries periodically afflicted by famine, plays a major part in the security of the food supply.

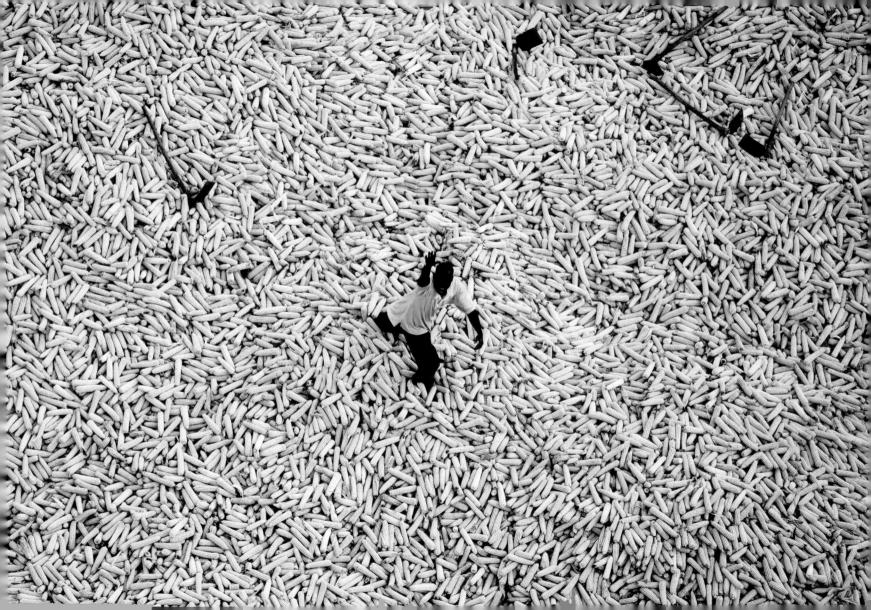

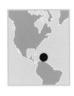

Whale in Samana Bay, Dominican Republic (18°20'N - 69°50'W)

After their season in the Arctic, whales head south in winter to reproduce. As a migrant sea mammal, the whale was hunted for its meat and oil until the 1950s, at which time it came close to extinction. But the world community's recognition of its plight (during the previous decade) resulted in the creation of the International Whaling Commission (in 1946), and in 1982 an international moratorium outlawed whaling for commercial purposes. In further support, the Southern Seas Whale Sanctuary was established in 1994, joining the previously opened Indian Ocean Whale Sanctuary. Despite this mobilization, however, it is estimated that since the moratorium was first implemented, more than 25,000 whales have been killed, principally by the Norwegians and Japanese. After years of protection, seven of the thirteen whale species still have only a few thousand members (ten to sixteen times less than at the start of the twentieth century), and are therefore still considered to be under threat.

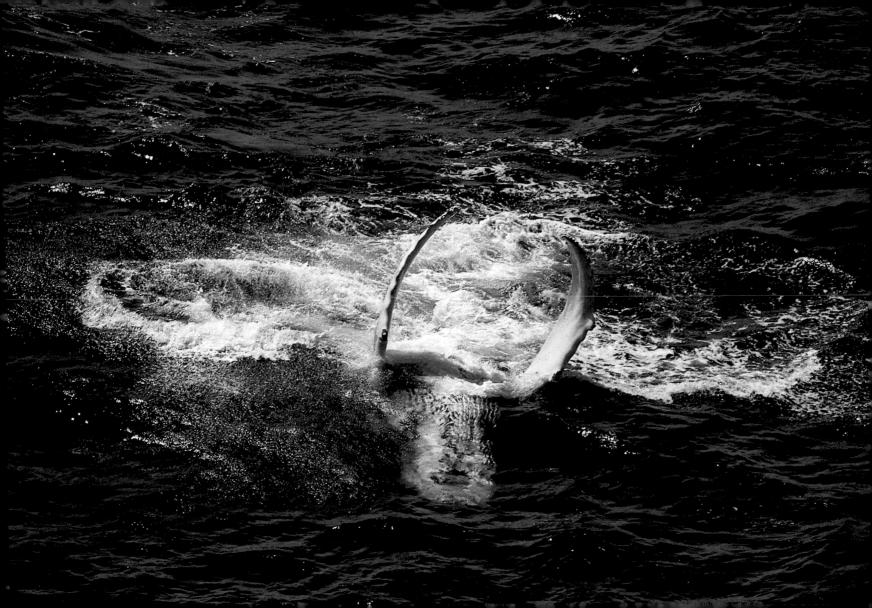

Cattle enclosure near Cáceres, Mato Grosso, Brazil (15°59'S - 57°42'W)

With 193 million head of cattle (one per inhabitant), Brazil today has the largest commercial stock of cattle in the world. It is principally made up of zebus, cattle of Indian origin introduced in the nineteenth century, which adapt well to the tropical climate. Most of the national herd is located in the state of Mato Grosso, where it is raised in the natural pastures of the pantanal. During the dry season, this swampy zone on the Paraguayan border is covered in grass, and extensive grazing is practiced on vast ranches. Today nearly 80 percent of Brazilian beef is consumed domestically, with per-head consumption among the highest in the world (79 pounds [36 kilograms] per year). To conquer the international market, the pantanal cattle ranchers are seeking to diversify their activities for greater profit. Their present practices should earn them the "certified organic" label without much difficulty, but whether this will be sufficient to make them competitive remains to be seen.

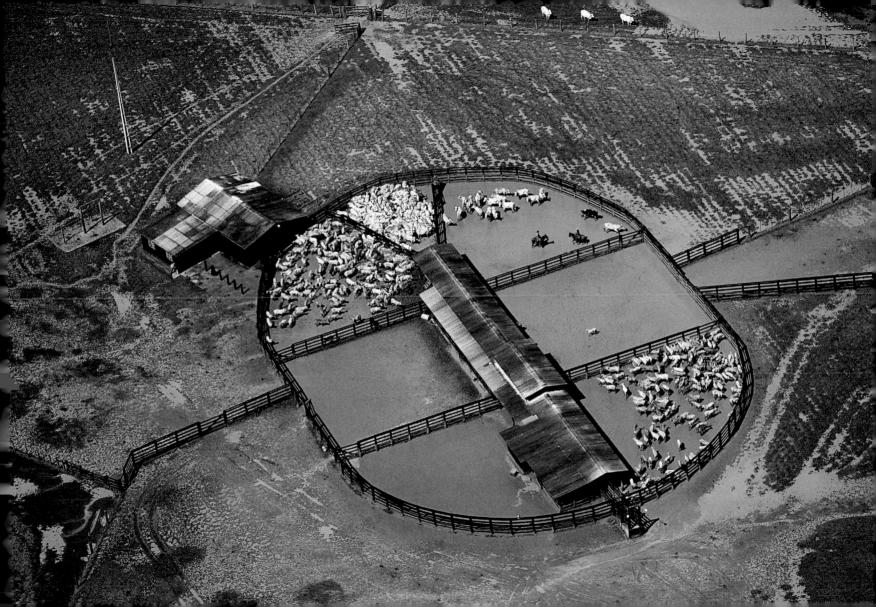

FRESHWATER

Although the planet on which we live bears the name Earth, freshwater, rather than the ground beneath our feet, is its most essential resource as far as humankind is concerned, and the one we miss most when we cannot access it. The courses of civilizations, the wealth of nations, and the health of individuals are all determined by the presence or absence of freshwater. Humans can hold out for a relatively long time without solid food but can only survive for a few days without water.

The history of humanity is closely linked to our use of the freshwater resources at our disposal. Our first agricultural communities appeared in places where the presence of rivers and the frequency of rainfall favored the growing of crops; later, rudimentary irrigation systems made it possible to obtain greater yields and intensify cultivation. The expansion of villages and towns diminished local water resources, leading to the development of hydraulic systems and drainage programs. Later, the first industrial nations depended on waterpower to operate their machinery and increase the efficiency of their labor.

Vast quantities of water are contained in the oceans, the ice caps, the water tables, the clouds, and the rivers and lakes around us—even in living tissues. They circulate in the form of condensation, rain, and surface water. But only a tiny proportion of the total volume of water on the planet is fresh—barely 3 percent of the global reserve—and most of this is locked up in the glaciers and ice caps of Greenland and the Antarctic, or in subterranean aquifers. The water that remains has to answer to the needs of individuals and ecosystems. Humankind's water requirement is increasing with the growth of the world's population; it provokes political tensions, economic difficulties, and ecological problems. We live in a water-dominated society. The supply of water to 6 billion human beings relies on colossal irrigation systems—because while fewer than 20 percent of the world's crops are irrigated, the land on which those crops grow produces 40 percent of our food. Our overcrowded cities would collapse without their complex networks of reservoirs, aqueducts, and wastewater treatment plants, and they consume immense quantities of electricity from hydroelectric dams. Yet, thanks to improvements made in our sewage systems, diseases

transmitted by water, such as typhoid and cholera—once endemic—have been eradicated from the most developed nations.

These achievements have their downside. While many of the world's religions view water as a divine gift, most of us continue to treat it either as an inexhaustible commodity or as a valuable substance that can be moved from one place to another, a substance that can be exploited for gain and can therefore lead to conflict. Despite our progress in the fight against poverty and the prodigious advances in electronics and information systems in developed nations, for half of the world's population water resources are more exiguous than they were for the Greeks and Romans of antiquity. More than a billion individuals today have no access to decent drinking water, and nearly 2.5 billion live without proper sanitation. Every day, avoidable diseases carried by water kill between 10,000 and 20,000 children. Statistics like these demonstrate that we are falling behind in our struggle to resolve our water problems.

Our present water-management policies are endangering human health. Entire cities have had to be evacuated to build dams. Over 20 percent of the world's freshwater-fish species are directly threatened today because of humankind's interference with lakes and watercourses. The vast Aral Sea, in central Asia, has been emptied to irrigate cotton fields. Irrigation everywhere is degrading the quality of both soils and water. Water tables are being pumped faster than they can renew themselves in parts of India, China, the United States, and the Persian Gulf, to name a few places. Great rivers, notably the Huang (Yellow) River in China, the Colorado River in America and Mexico, the Jordan in the Middle East, and the Nile in North Africa, are withering away before they reach the sea because humankind has deprived them of their water. Conflicts over the sharing of water are breaking out everywhere, at both the local and the international level.

Today, we have two choices. Our first option is to carry on as usual, building gigantic infrastructures such as dams, aqueducts, reservoirs, and centralized water-treatment plants. During the twentieth century,

this policy brought immense benefits to hundreds of millions of people. However, it also wrought great social, economic, and ecological damage, whose full gravity we are only now beginning to comprehend. While some carried out this policy, billions of less fortunate human beings were left unaided.

The second, gentler, option is to take full advantage of the appropriate infrastructures, but do so by complementing them with decentralized installations, technologies, and effective management policies, respecting the human and economic capital at our disposal. The emphasis would be on improving the existing global productivity of water management, rather than on casting about for new means of supplying ourselves with the commodity. But we simply cannot produce more food, steel, or computers and use less water. This choice implies that governments, local communities, and private companies must work in harmony to satisfy our water-related needs, rather than contenting themselves with providing water. It calls for real engagement on the part of local authorities, for effective new technologies, and for traditional approaches applied with savoir faire.

The power and beauty of the water that flows through our landscapes cannot leave us indifferent. Water has been venerated by humankind since the dawn of time, inspiring music and poetry. But now we need to acknowledge its true value as a vital resource for all humanity and for all the world's ecosystems. In this beginning of the third millennium, let us resolve to protect this precious liquid, and thus defend our health and the equilibrium of our environment. Water must have pride of place in our daily lives, for while access to good water does not on its own guarantee a civilization's survival, no civilization whatsoever can survive without it. This is one of the great lessons of history.

Dr. Peter H. Gleick
President of the Pacific Institute for Studies in Development, Environment, and Security
United Nations expert on freshwater issues

House amid floodwaters south of Dhaka, Bangladesh (23°41′N - 90°25′E)

Since 1971, Bangladesh has endured about two hundred natural catastrophes storms, tidal waves, cyclones, floods, and earthquakes, all with their attendant epidemics—causing more than half a million deaths. To make matters worse, this densely populated nation is already classified as the third poorest on earth. In 2004, appalling floods again devastated the country and submerged its capital. Dhaka, where between 9 and 11 million people live. Nine-tenths of Bangladesh's territory, including the enormous Ganges Delta and its tributaries the Brahmaputra and the Meghna, is situated at an altitude of less than 33 feet (10 meters) above sea level. Every year, the monsoon plunges 50 percent of the country underwater. The Food and Agriculture Organization of the United Nations estimates that before 2030, 16 percent of Bangladesh's cultivated land could be swallowed up entirely as a result of global warming (via glacier melt in the Himalayas, redoubling of the monsoon, multiplication of cyclones, and a rise in the sea level). This would force 10 percent of the population to go into exile in the northern cities or in India. The UN now predicts that there will be 50 million "climate refugees" in the world before 2010.

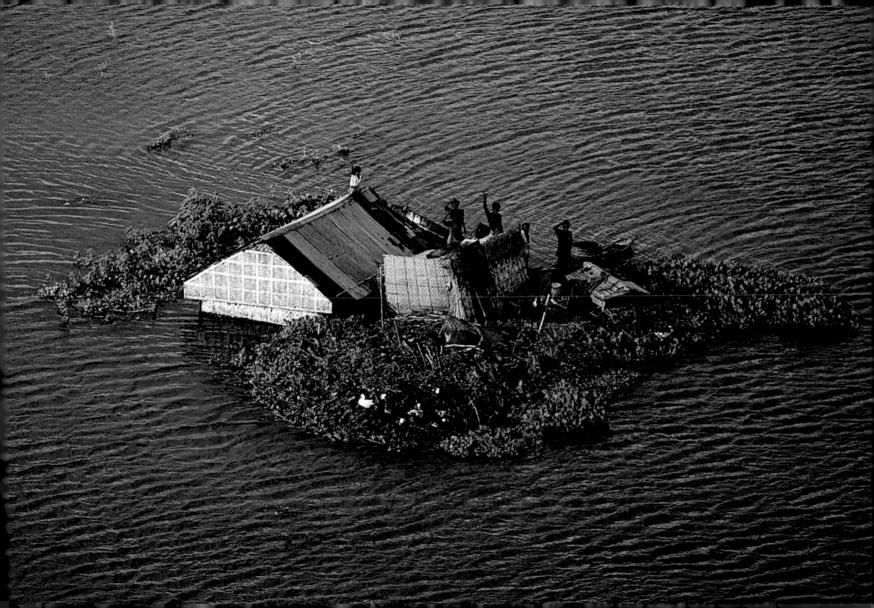

Flocks of sheep in Murgia, Basque Country, Spain (42°57′N - 2°49′W)

The Basque Country (País Vasco in Spanish, Pays Basque in French) is a mountainous region of 10,300 square miles (26,664 square kilometers), of which 84 percent is in Spain and 16 percent is in France. Forests line the high altitudes, so that only 30 percent of the Spanish Basque Country is arable land. But sheepherders keep their tradition alive in these isolated zones, lending structure to the territory, guaranteeing employment, and today accounting for 5 percent of the region's gross agricultural revenues. To survive a reduction in sheep's milk quotas, Basque farmers have begun specializing in high-profile regional specialties. Idiazabal cheese—which has been under a controlled patent for twenty-five years—made from unpasteurized sheep's milk, is one example. This product, 80 percent of which is consumed within the Basque Country, is produced by a federation of some five hundred local ventures. For Spanish Basque farmers, whose holdings seldom exceed 37 acres (15 hectares), the symbol that represents their ancestral homeland has become a marketing tool. From honey to lamb's meat, from farm chickens to tuna fish, twelve strongly identifiable Basque products have already been tagged Eusko Label Kalitatea, a regional appellation that groups some 3,500 farms, one-third of the total farms in the area.

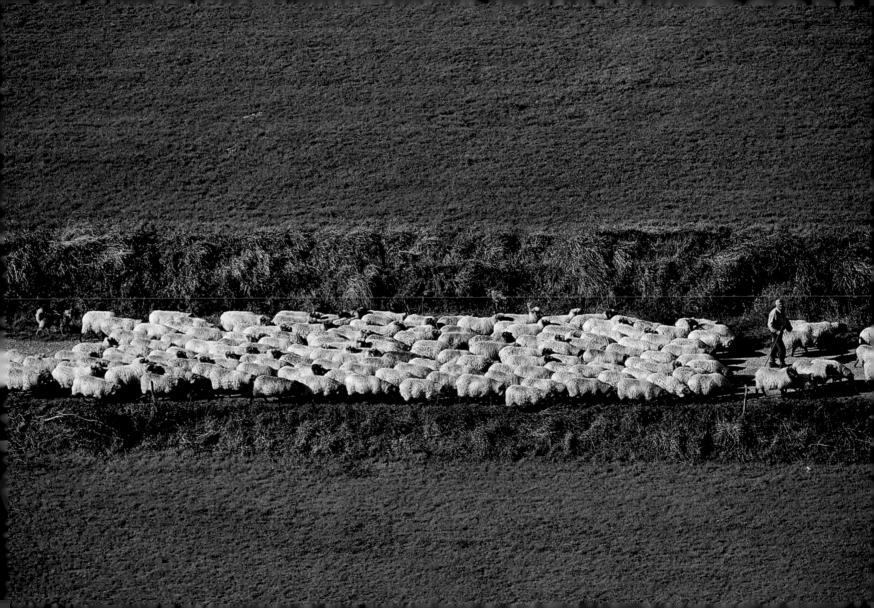

Neolithic grave south of Djanet, Tassili n'Ajjer, Algeria (24°26'N - 9°34'E)

Neolithic tombs dating from the first appearance of agriculture about ten thousand years ago to the advent of writing four or five thousand years ago dot the Sahara. These are usually simple tumuli covered in stones. But in Tassili n'Ajjer, enclosed graves are abundant, the oldest among them dating back 5,500 years. They can be seen from some distance, as they were systematically dug into the hilltops. A first circle surrounds the tumulus, beneath which is the funeral chamber; a second surrounds the entire structure. Only men were buried in these tombs, lying on their sides, with their heads pointed eastward. The Sahara contains thousands of records, carved or painted, dating from thousands of years before our own time, making it the world's greatest open-air museum of the Neolithic era.

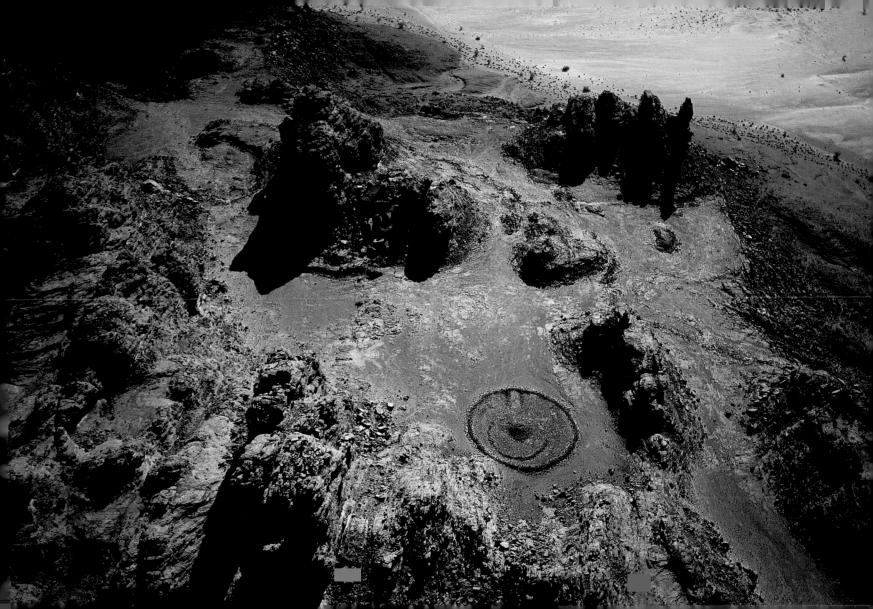

Lignon housing estate, Geneva, Switzerland (46°12'N - 6°09'E)

Built in 1962, the Lignon complex contains 2,780 apartments accommodating more than 5,500 people of nearly every nationality. Today, 70 percent of the Swiss population is spread around the nation's sixty towns and eight hundred communes. In Geneva, a population spurt and a real estate crisis has driven many citizens into the suburbs, leading to an increase in commuter traffic. Every year, 5,200 acres (2,100 hectares) of undeveloped countryside are sacrificed to urban growth, with half that area going to housing; in a single generation, a land area the size of Lake Geneva has been covered in houses and roads. Since the 1980s, the building surface per inhabitant has increased by 4 percent in Switzerland; if this trend continues, the populations of Geneva and Rorschach will merge into a single giant conurbation, squeezed from fields, orchards, gardens, and vineyards. Worldwide, city expansion lays hold of nearly 5,000 square kilometers of agricultural land annually.

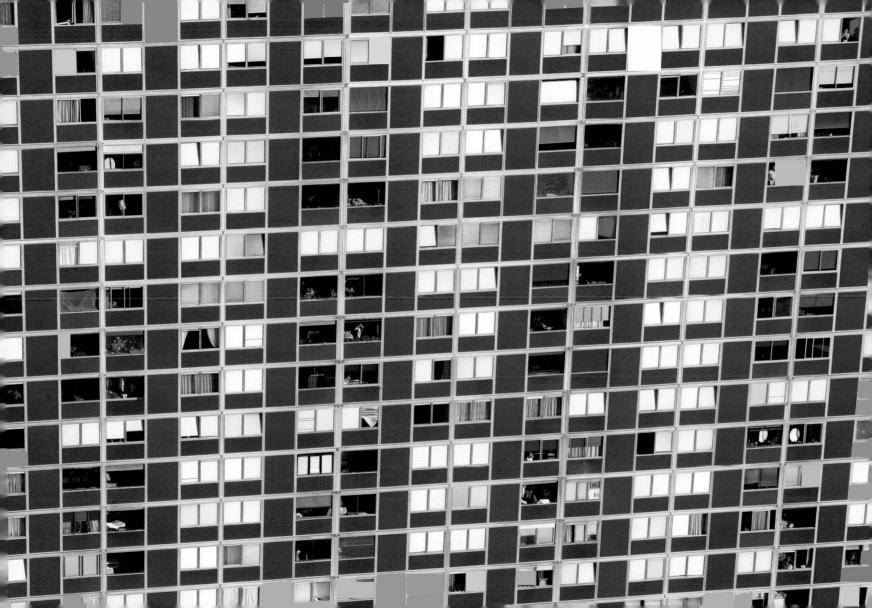

Plowed land, Misiones Province, Argentina (26°53'S - 54°35'W)

This Argentine province bordering Brazil owes its name to the Jesuit missions installed there in the sixteenth and eighteenth centuries. Irrigated by the Paraná and Uruguay rivers, Misiones was originally clothed in a tropical forest, most of which was subsequently removed to create huge agricultural plantations. Plowing here involves following the curves of the landscape, leaving intermittent grassy strips—this has been obligatory since 1953, to protect the land from erosion due to the frequent torrential rains. A number of different crops have been developed, including cotton, tobacco, tea, and rice, but the region is above all the cradle of yerba maté, the base for Argentina's national beverage. If Argentina today is one of the six top agricultural producers in the world, it is thanks to the soybean, which represents a quarter of the country's exports. The legume is, of course. genetically modified, Argentina being the world's second most prolific producer of transgenic plants (more than 46 million acres [19 million hectares] of corn and cotton included), after the United States. In the rest of the world, genetically modified crops already cover more than 16 percent (more than 358 million acres [145 million hectares]) of arable land.

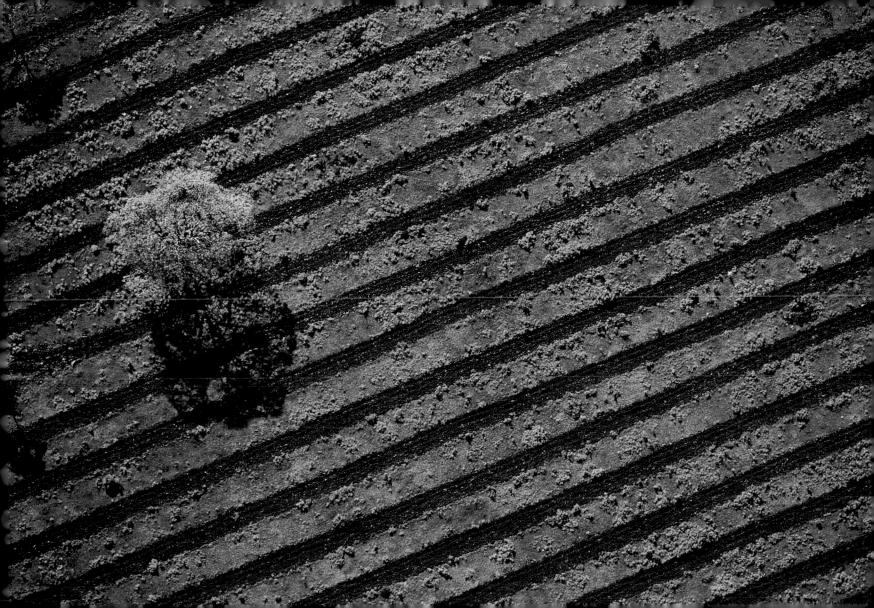

Crocodile showmen near the Banco National Park, Abidjan region, lvory Coast $(5^{\circ}24'N - 4^{\circ}03'W)$

Félix Houphouët-Boigny, the first president of Ivory Coast, was in the habit of feeding the crocodiles in the presidential lake at Yamoussoukro, with much pomp and circumstance. This ritual had the effect of turning the croc into a national icon, even though it is becoming rare in Ivory Coast, as it's heavily poached for its skin. Crocodiles have also been severely weakened by the disappearance of their habitat around Abidjan, where the lake and jungle environs were particularly well suited to them; after thirty years of intense urban development, the city has over 12 million inhabitants. Nevertheless, the reptiles are putting up a fight; in June 2005, the town of Yopougou was greatly disturbed by the unexpected arrival of four crocodiles, who took up residence in a rainwater pond beneath a bridge. In the end they were captured and dragged away to the Abidjan zoo. Worldwide, one out of every four mammal species are threatened with extinction, as are one out of every eight bird species, one out of three fish species, and two out of five amphibians.

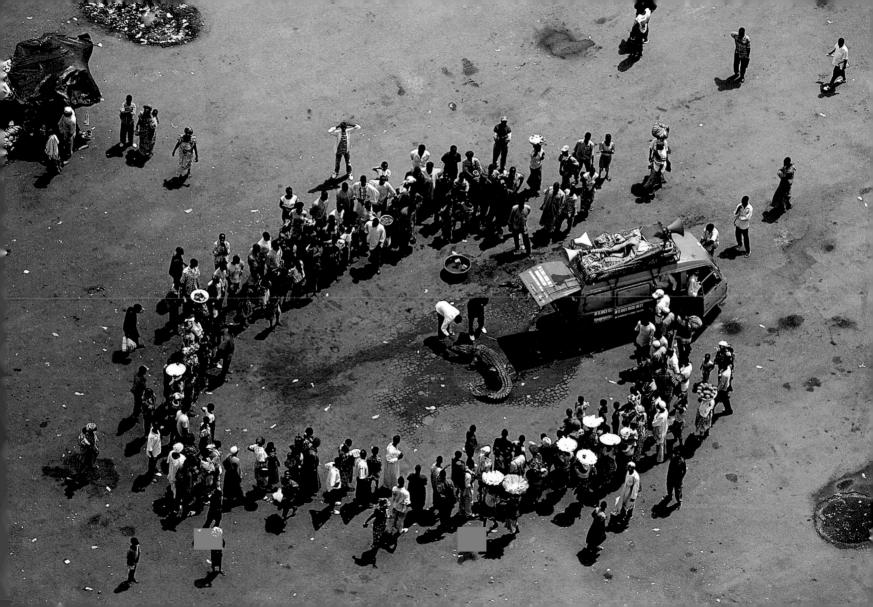

Clandestine alluvium-and-gold-washing plant, French Guiana $(4^{\circ}00'N - 53^{\circ}00'W)$

French Guiana is confronted with a very serious pollution problem, stemming from the exploitation of gold deposits. In this region, the land condition makes it especially difficult to control the pollution problems, even from legal production, which produces close to 2.6 tons of gold annually. The waste from clandestine gold washing puts an additional strain on the environment. To procure gold flakes, river mud is extracted with powerful pumps and washed with a mercury solution, which separates the gold from the silt. The poisonous liquid mud is then returned to the rivers, devastating the ecosystem, where the mercury contaminates the entire food chain. Those who eat the fish, notably Native Americans, are in turn poisoned by the metal, which attacks the central nervous system. And each year, for the sake of gold, 5 to 10 tons of mercury are dumped into the country's rivers. A local ban on the use of mercury went into effect on January 1, 2006, but it has had no effect whatsoever on the clandestine gold washers.

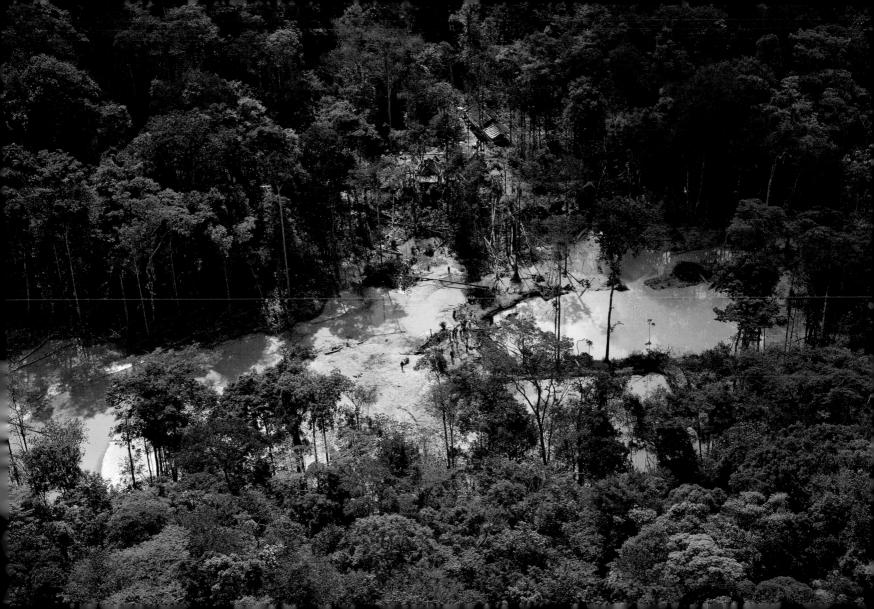

Traditional fish trap off Bubiyan Island, Kuwait (29°48′N - 48°10′E)

In this beachside outfit, fishermen have set up an *al-hazra*, a fish trap made up of a reed fence leading to two cages divided into two parts. The larger, called *al-housh*, is next to the smaller, *al-ser*, which is set at the exact point of low tide. Fish enter the trap at high tide, and the fishermen walk down and pick them up at low tide. Kuwait's fishing industry has yet to recover from the adversities occasioned by the Gulf War. The buildup of a military force and the ravages visited on Kuwait by Iraqi troops during the occupation of August 1991 to February 1992 (evaluated at \$75 billion) left few funds available for the development of fisheries. Consequently, this sector now represents no more than 0.05 percent of the country's economic activity.

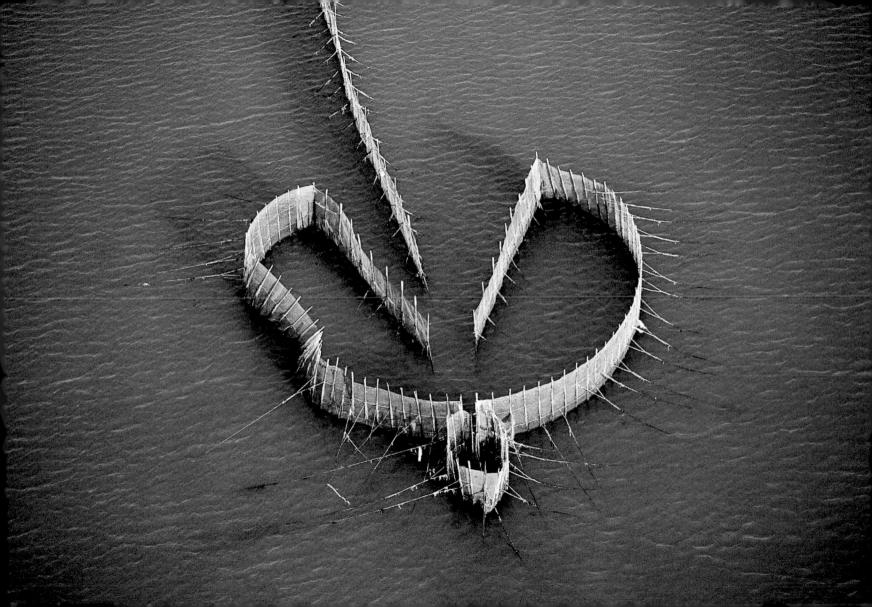

Raising a yurt near Kara-Saz, northern Naryn region, Kyrgyzstan (41°30'N - 76°00'E)

From Turkey to Mongolia, the yurt is the traditional dwelling of central Asia. The bell-shaped frame, consisting of flexible, articulated laths, is covered with several layers of woolen felt, blanketing a surface of 215 square feet (20 square meters). Relatively light—it weighs between 441 and 551 pounds (200 and 250 kilograms)—it is raised directly on the ground and is self-supporting, which makes it suitable for every type of terrain and resistant to storms. In this circular tent, everything has its own meaning; indeed, the yurt is a symbolic representation of the world. The opening at the top, which has a damper to clear the smoke from a stove, symbolizes the window to the sky, while the converging shafts of the roof illustrate the rays of the sun. Residents and their guests move though the yurt in only one direction, clockwise, which for the nomads of central Asia represents the general direction of all harmonious movement.

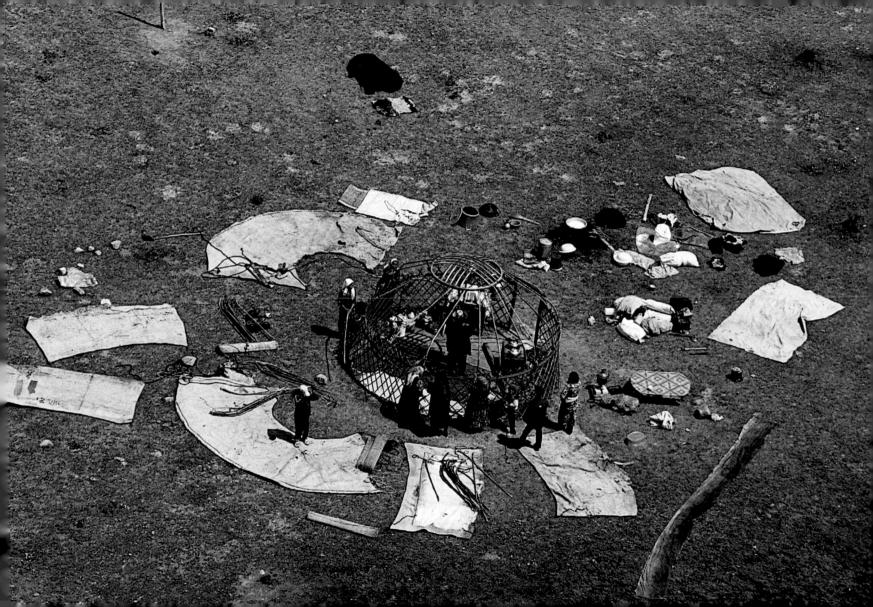

Nuami Island, Nokan Hui Atoll, south of Île des Pins, New Caledonia, France $(22^{\circ}45'S - 167^{\circ}34'E)$

As part of the reef fringe around its atoll, the island of Nuami constitutes the largest area of land above the ocean surface in its group. Like the rest of the New Caledonian archipelago, Nuami is a fragment derived from the Australian continent that has evolved entirely on its own. This tectonic and geological origin explains the wealth of fauna and flora that thrives there. The flora of the four main ecosystems that exist in New Caledonia (mangrove, savanna, bush, and forest) make up about 3,500 species, while the known fauna include 6,500 different mollusks, a thousand fish species, and 4,300 land-bound species. Yet, on the International Union for Conservaton of Nature (IUCN) Red List, which globally monitors endangered species, France and its overseas territories are wretchedly placed at fourth worst for animal species and ninth worst for plants.

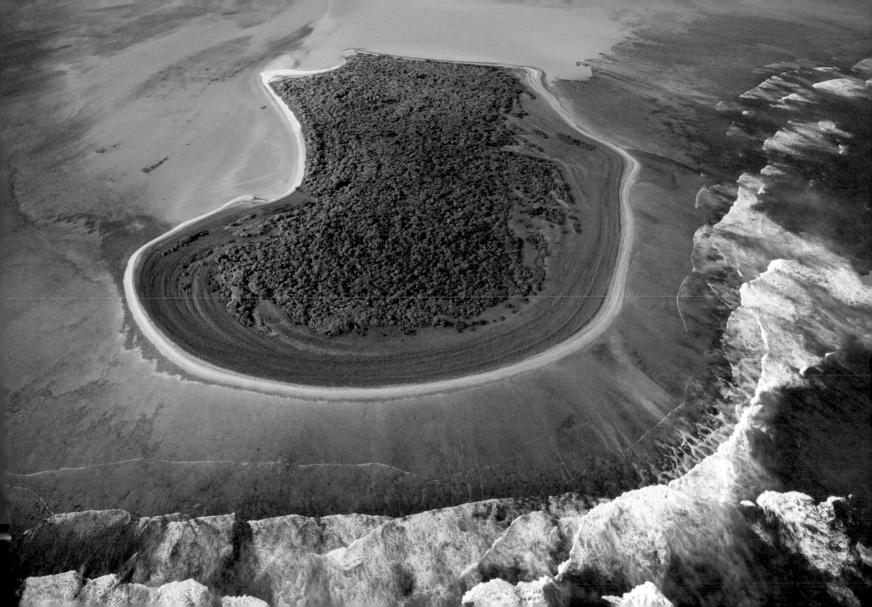

New palm-oil plantations near Pundu, Borneo, Indonesia (1°59'S - 113°06'E)

On the island of Borneo, palm-oil plantations are rapidly replacing virgin tropical forests. Deforestation has brought about the loss of 80 percent of the original flora and between 80 and 90 percent of animal species, such as the orangutan. The world demand for palm oil is the main cause of deforestation in certain parts of Asia. Indonesia is about to become the world's largest producer of the commodity, ahead of Malaysia. In early 2007, there were nearly 15 million acres (6 million hectares) of these palm-oil plantations as compared to 600,000 in 1985, and the Indonesian government plans to plant another 17 million acres (7 million hectares) in the next five years. Palm oil is used in the composition of a wide variety of food products from potato chips to ice cream, as well as in detergents and cosmetics. It can also be used in the manufacture of biofuels for industrialized countries; in developing countries, it may soon become too expensive as a food oil for poor consumers.

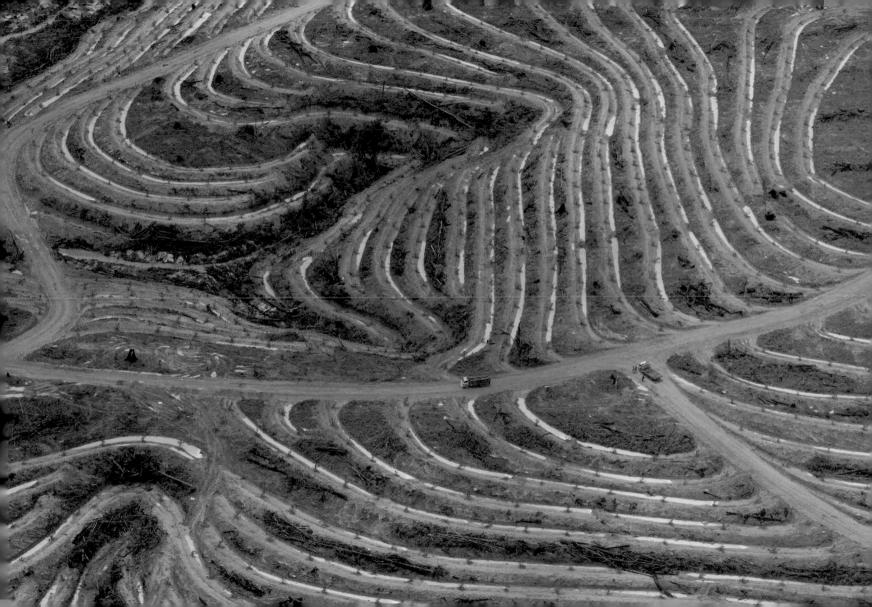

Glacier near Mount It-Tish, Ysyk-köl region, Kyrgyzstan (41°50'N - 78°10'E)

The glaciers of Kyrgyzstan are so numerous—there are about three thousand of them—and cover such a huge surface area (2,510 square miles [6,500 square kilometers]) that some of them have never even been named. Their slow descent has hollowed out the valleys of the Tian Shan Mountains, which have more peaks than any other range, bar the Himalayas. The highest, Pobeda Peak, is 24,400 feet (7,439 meters) above sea level. Kyrgyzstan is in the heart of central Asia, situated between Uzbekistan, Tajikistan, Kazakhstan, and China. Its territory averages more than 9,800 feet (3,000 meters) above sea level, 95 percent of it consisting of rugged mountain landscape. There is little room here for settled agriculture, with the result that the country remains solidly anchored in the nomadic tradition.

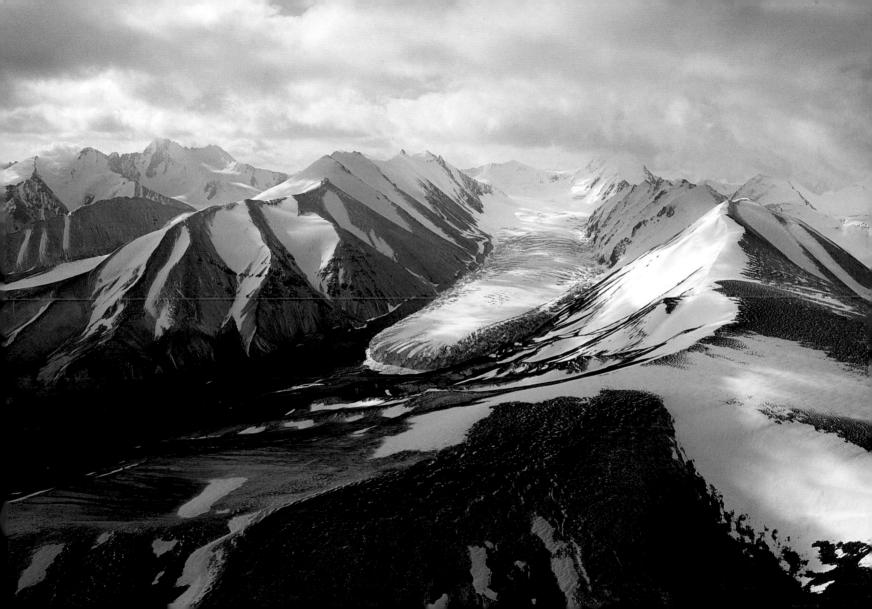

Pirogues on Lake Chad, near Bol, Chad (13°28'N - 14°43'E)

Amid a tracery of reeds and papyrus, narrow pirogues nose along one of Lake Chad's innumerable channels. This, Africa's fourth largest lake, is the theater of a lively traffic of fishermen, angling between Chad, Niger, Nigeria, and Cameroon. Their uncontrolled, incessant movement has become a headache for authorities trying to combat illegal fishing in Chadian waters. Well-equipped fishing professionals from Nigeria, Ghana, and Mali compete with the locals, whose equipment is rudimentary and who are forced to pay heavy taxes. Chad's economy has been weakened by the gradual drying up of the lake, which has upset the region's entire ecosystem. The economy looks, however, to be receiving a boost from the oil sector. In 2005, Chad's oil output reached 9,000 tons, and the new Chad-Cameroon oil pipeline has already swelled the country's gross national product. But this increase in wealth will have no effect on the lives of ordinary Chadians if it is not plowed back into health education, and infrastructure.

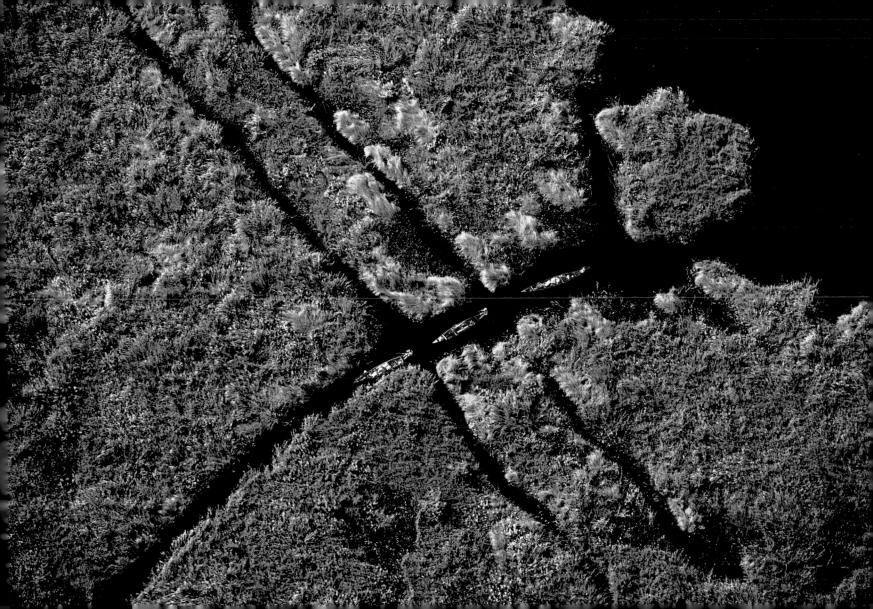

Cormorants and sea lions on Seal Island, False Bay, Cape Province, South Africa $(34^{\circ}08'S - 18^{\circ}35'E)$

The sea lions of South Africa (*Arctocephalus pusillus pusillus*) are gregarious creatures that form immense colonies to mate and breed. More at home at sea than on dry land, these mammals spend most of their time in the water, cruising the shoreline looking for fish, squid, and crustaceans to eat. This subspecies is only found on the southern African coast between Cape Fria, in Namibia, and Algoa Bay, in South Africa. There are over a million of them, and though sea lions are listed in Appendix II of the Convention on International Trade in Endangered Species of Wild Fauna and Flora, they continue to be commercially exploited in Namibia. Every year, tens of thousands of pups and thousands of adults are killed there. Another subspecies (*Arctocephalus pusillus doriferus*) frequents the southern coastline of Australia. In all, there are sixteen species of sea lions on earth.

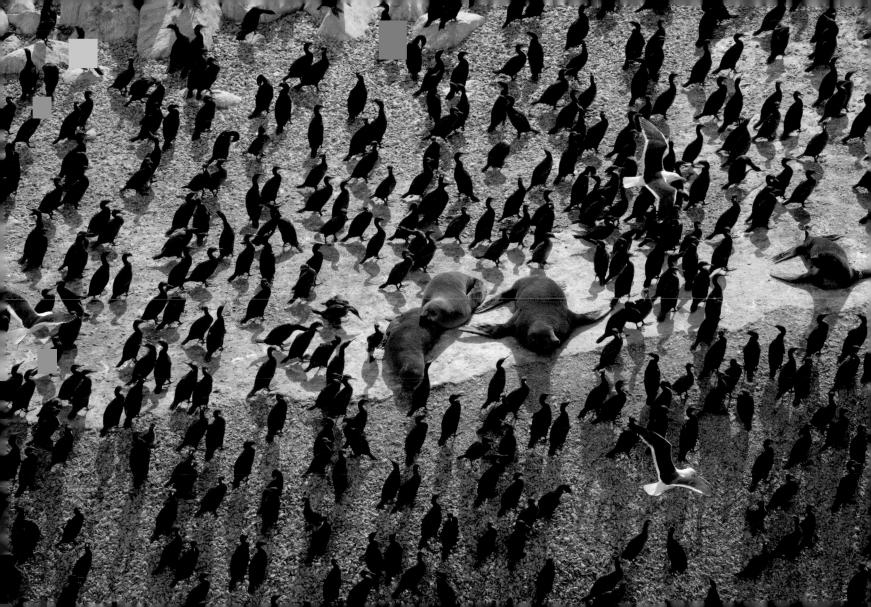

Village surrounded by cropland, near Ambatolampy, Vakinankaratra region, Madagascar (19°22'S - 47°26'E)

The highlands south of Madagascar's capital, Antananarivo, are among the most fertile areas in this country, where half the population is malnourished. Apart from the rice fields, where the Madagascan staple foodstuff is grown, there are plantations of strawberries, maize, and beans. But local agricultural techniques do not produce adequate yields, and over the last decade the quantity of rice consumed per person in Madagascar has fallen annually from 298 to less than 265 pounds (135 to 120 kilograms). The traditional slash-and-burn farming practices introduced by Southeast Asian immigrants have had devastating consequences on Madagascar's environment; 85 percent of its forests have disappeared, transformed into pastures, charcoal, crafts, or firewood. Every year, between 494,000 and 741,000 acres (200,000 and 300,000 hectares) of forest disappear—and the poverty that affects 75 percent of the population is in no way relieved by this destruction.

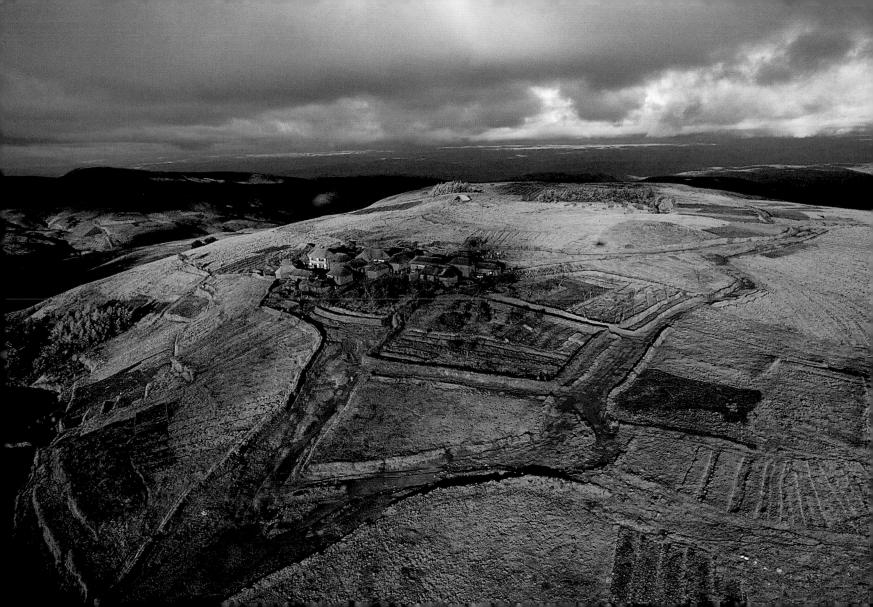

Royal tombs, Petra, Ma'an region, Jordan (30°20′N - 35°26′E)

Lawrence of Arabia described this place as the most beautiful in the world. Founded in the seventh century BC, the cave city of Petra was the capital of the Nabataean Arabs. The limestone cliffs from which its monuments are carved shimmer with hues of ocher and pink tinted with mauve, scarlet, or blue, according to the time of day. Nearly eight hundred tombs or temples remain, many of which bear mysterious inscriptions left by nomads and traders, for whom Petra was a major crossroads and a center for commercial and cultural exchange. Recently, the site has been subjected to a worrisome threat: the mineral salts that have dissolved in the water table are seeping into the bases of the monuments. Once having penetrated the stone, the salts make it crumble. The situation is only worsened by wind erosion, and Petra—a UNESCO World Heritage Site since 1985—is now steadily deteriorating.

Charcoal boat, Haiti (18°35'N - 72°00'W)

This vessel is freighted with charcoal, which will serve as cooking fuel in Haitian cities. In a country where 80 percent of the population has no access to electricity, wood alone supplies more than 70 percent of energy needs. The consequence in Haiti has been almost total deforestation—all but 1.4 percent of the country's territory is stripped of woodland. Despite the stripped mountains, eroded soils, water shortages, and recurrent droughts the deforestation causes, it is continuing unabated in Haiti. The farmers in the hills are aware of the extent of the disaster, but with their land eroded as it is, they have little other source of income. At the end of this chain of destruction are families who cook with the wood, using inefficient, wasteful wood-burning stoves that they are too poor to replace. Hence the deforestation of Haiti is a global question that cannot be solved without developing viable economic alternatives for farmers, or without a deliberate initiative to change the country's energy supply.

Township, Cape Town, Republic of South Africa (33°54'S - 18°34'E)

These rows upon rows of cabins on the edge of Cape Town are a holdover from apartheid, the racist political and ideological program implemented by white South African governments between 1948 and 1994 in an effort to establish systematic segregation in every area of national life. The government-built townships, where blacks were forced to live in segregation, consisted of houses known as "matchboxes," in reference to their size. They had few utilities, and their legal status was heavily confining: no private ownership, no private businesses, no elected municipal authority (until the 1980s). Apartheid was abolished in 1994, but evidence of it remains in South Africa's cityscapes, though many houses have since been enlarged and renovated, and businesses have sprung up everywhere. The townships, which were formerly imposed on the people, now belong to them; the law of the market has taken the place of apartheid. But while in theory the residential areas of Cape Town are racially mixed, in practice they are still socially homogenous. In short, residential segregation is still a fact of life in South Africa.

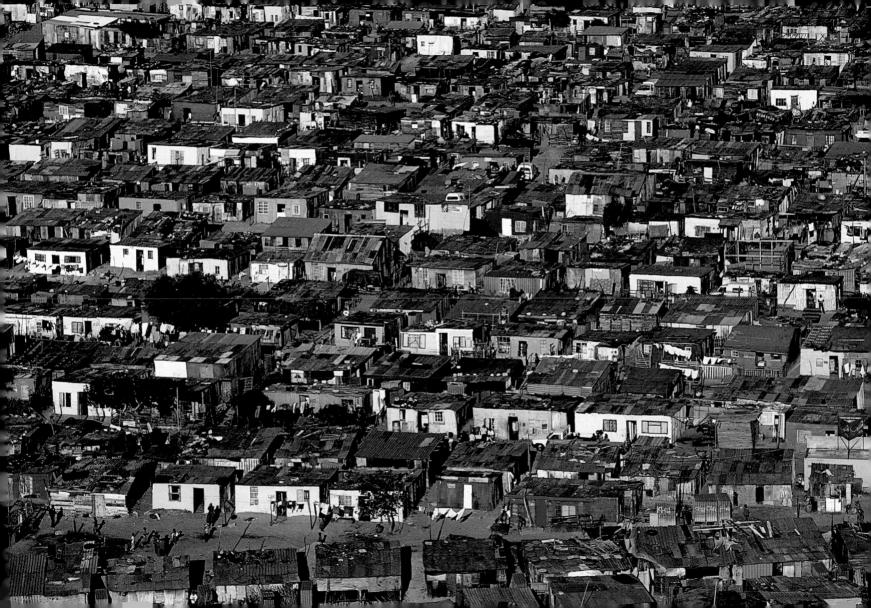

The Seta Valley devastated by fire, August 2007, the island of Euboea, Greece (38°32′N - 23°56′E)

The island of Euboea is 93 miles (150 kilometers) long and between 6 and 31 miles (10 and 50 kilometers) wide; after Crete, it is the largest of the Greek Islands. Its landscape used to consist of cultivated hollows and tree-covered hills. Then in August 2007, an arsonist deliberately set a hundred forest fires in the north of the island opposite the Peloponnese. The fires were fanned by winds so strong that Athens and its suburbs were blanketed by thick white smoke and ashes. A state of emergency was declared throughout the country, and when Greece proved unable to control the fires alone, 16 countries of the European Union came together in the most extensive joint firefighting operation ever seen in Europe, Sixty-five people died in the two weeks the flames continued to spread; thousands of residents were evacuated, hundreds of houses were burned to the ground, and 444,790 acres (180,000 hectares) of land were reduced to ashes. The ecological and economic consequences of this catastrophe will be felt for years to come. The damage has been assessed at more than \$1.2 billion (0.6 percent of Greece's gross national product), and environmental experts suggest that it will take twenty years for the former landscape to be reestablished. It is also highly probable that much of the burned real estate will become prey to real estate speculators.

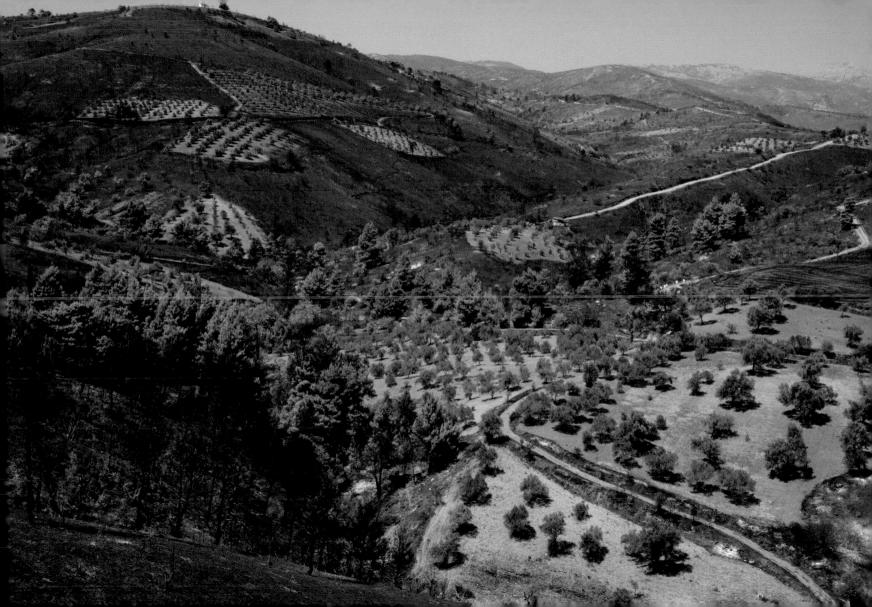

Yurt near the Jukuu Valley, east of Lake Ysyk-köl, Kyrgyzstan (42°30′N - 78°30′E)

The former Soviet republic of Kyrgyzstan has been an independent state since August 31, 1991. The period of Russian domination was a harsh one for Krygyz nomads, many of whom were forcibly settled during the periods of agricultural reform (in the 1920s) and collectivization (in the 1930s). The environment also suffered—Krygyzstan is still feeling the consequences of secret uranium extraction and the industrial development of nuclear weaponry by the Soviet navy at Ysyk-köl. The government of Askar Akayev, freely elected after the fall of the Soviets, promptly closed these plants, but they continue to emit high levels of radiation. Today, Askar Akayev is in exile, following the Tulip Revolution. which brought down his autocratic regime in March 2005. After new elections were denounced as fraudulent by international observers, 15,000 opposition supporters called for the resignation of the government and took the presidential building by storm, vowing to make the president bow to their demands "before the tulips flower." This event was the latest in a series of "color revolutions," such as the Rose Revolution in Georgia in late 2003, the Orange Revolution in the Ukraine in late 2004, and the Cedar Revolution in Lebanon in 2005.

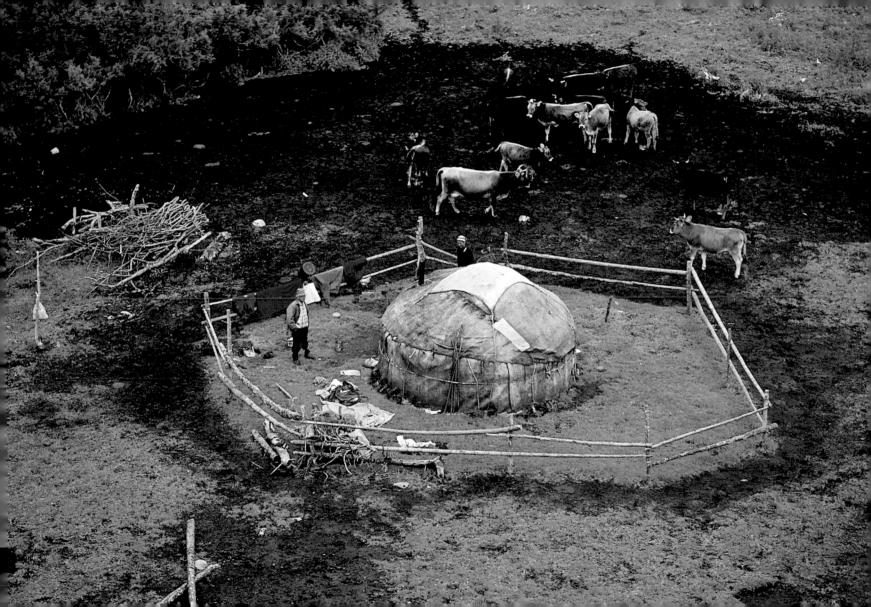

Timimoun oasis, Algeria (34°02′N - 6°06′E)

Named the Red Oasis after the bright color of the sand and clay (*toub*) used in its buildings, Timimoun (population 15,000), located in the Sahara, is a former French military post and a key control point for the Western Grand Erg, now a crafts center specializing in fine fabrics (for burnooses, veils, and carpets). As with all oases, Timimoun originally attracted inhabitants seeking its water. The installation of a collective water supply system spurred the building of a fortified village, or *ksar*, and the planting of date palms. Today, the landscape of the oasis offers three levels of vegetation: date palms, which can grow 65 feet (20 meters) tall; fruit trees (bearing olives, figs, pomegranates, and almonds); and vegetables, which grow in the shade of the trees and are irrigated by a tight network of channels. Plunging their roots deep into the water table, the plants are surrounded by moats of sand, which must be constantly attended to prevent the crops from being choked by the encroaching desert.

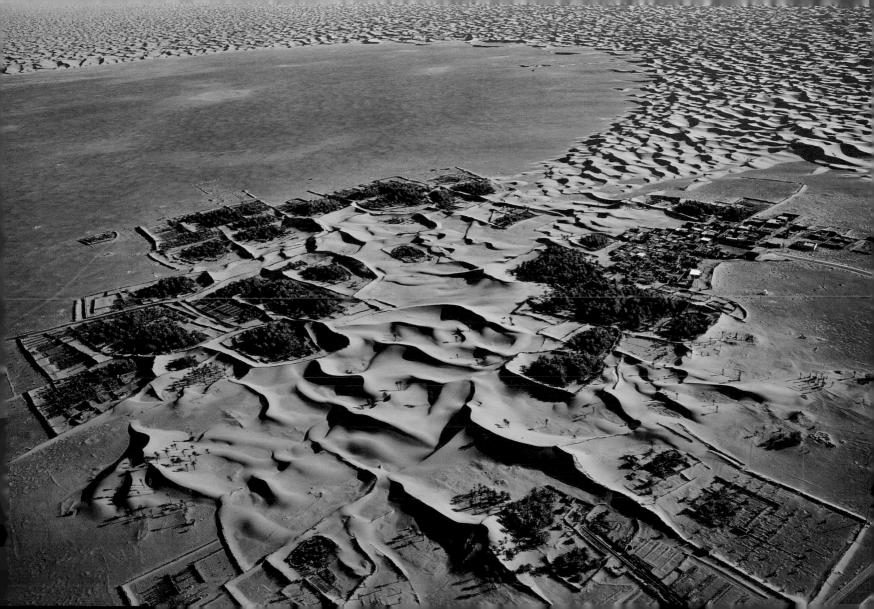

Chalets at Hahnenkamm, south of Kitzbühel, Tyrol, Austria $(47^{\circ}26' \text{ N} - 12^{\circ}24' \text{ E})$

Kitzbühel is a name that has special resonance for those who love skiing in the Alps. It is the site of a legendary event in the alpine skiing World Cup, the Hahnenkamm run, named after the mountain that overlooks the town. Two-thirds of Austria is occupied by the eastern extremity of the Alpine range—with 680 peaks over 9,800 feet (3,000 meters) tall—and for this reason the country is a paradise for winter-sports enthusiasts. Tourism has easily meshed with the local fabric in these skiing villages, which have never experienced a major rural exodus. Unlike the French ski resorts built in the 1970s out of nothing, scornfully referred to as "cruise ships in the snow," the Tyrol has relatively small facilities, built around villages whose capacity to house visitors does not exceed a ratio of ten to each year-round resident. The buildings are designed with an eye to local architecture so as to maintain real harmony between tourism and the natural environment. These are the key ingredients of the "Tyrolean model," promoted by European planners, and today even the French are catching on, designing village resorts like Bonneval-sur-Arc in Savoy.

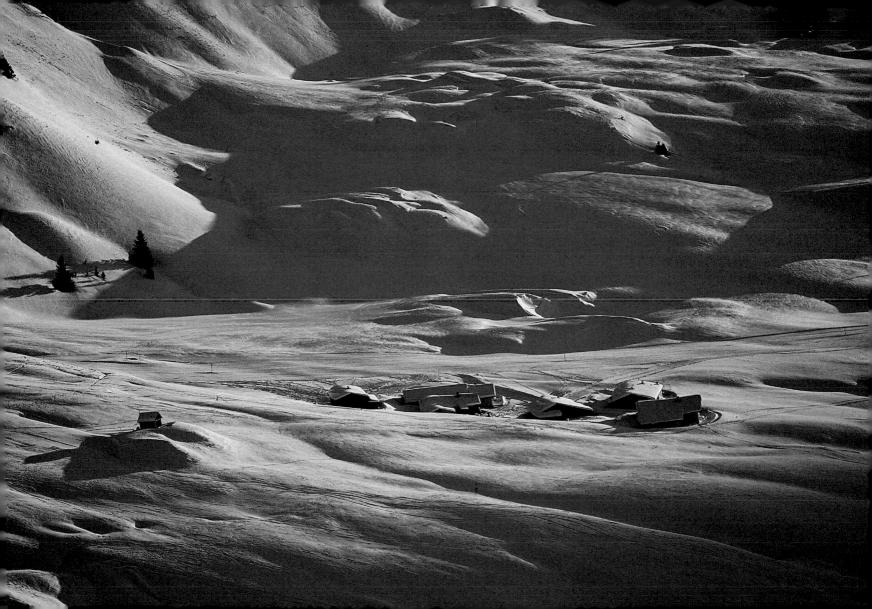

Artificial island of Palm Jumeirah, Dubai, United Arab Emirates $(25^{\circ}07'N - 55^{\circ}08'E)$

Fifty years ago, Dubai consisted of a few adobe houses, a souk, and a port used by dhows cruising the Gulf and the Sea of Oman. After its enrichment by oil reserves—which are now exhausted—Dubai directed its economy toward tourism. launching a construction program for a series of artificial islands. Palm Jumeirah. planned in the form of a palm tree, is the smallest of the three islands currently being developed. Its outer crescent, studded with palaces and luxury hotels. surrounds a gigantic inner layout in the form of a palm tree, made up of a "trunk" a little over 1 mile (2 kilometers) long that is linked to the mainland by a bridge. and seventeen "branches" adapted for private villas. Overall, 40,000 people took part in the creation of this artificial island, including a team of Dutch engineers specializing in construction on water. The project would never have been completed, however, without the wholesale use of imported labor. Dubai today has a population of nearly 1.5 million people, 80 percent of whom are underpaid immigrant workers. Their work conditions in this city-state, and in the United Arab Emirates in general, are qualified as "inhuman" by Human Rights Watch.

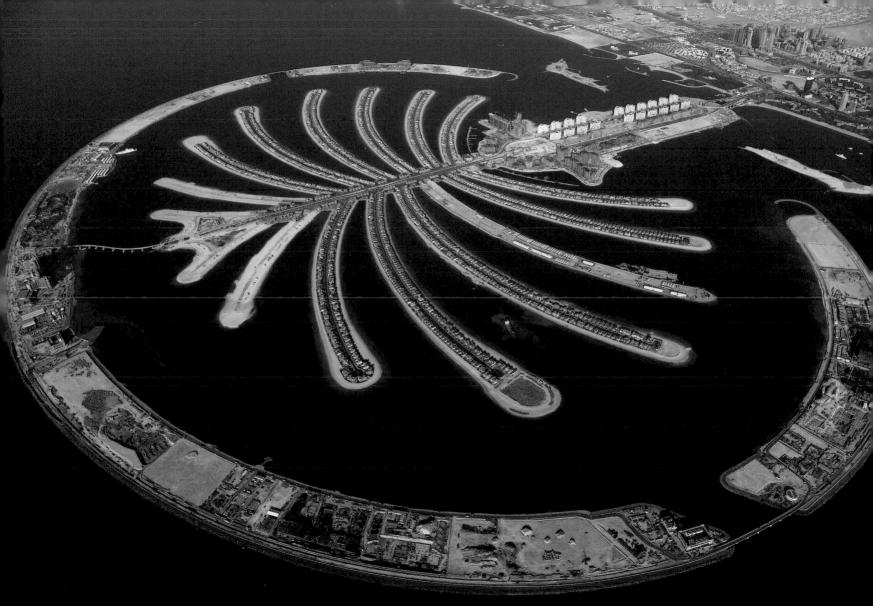

Boat moored by the shore between Kas and Myra, Turkey $(36^{\circ}08'N - 29^{\circ}40'E)$

The Anatolian coastline, a crossroads of civilization for over nine thousand years. is one of the last well-preserved areas on the Mediterranean seaboard. Its islands and their surrounding countryside contain archaeological remains from the first Greek trading posts, and from the so-called Lycian civilization, which was in fact governed by a confederation of cities like Myra (present-day Demre) from the fifth century BC to the seventh century AD. Monk seals and sea turtles also dot the shores in large numbers, and the World Wildlife Fund has classified these shores as needing urgent protection, along with the Aegean and the Sardinian-Corsican and Ligurian-Provençal basins, home to numerous whales and dolphins. The Mediterranean coastline, with its human population of 150 million, is fouled by galloping urbanization, oil spillage, and agricultural and industrial pollution. Nearly 15 percent of the Mediterranean coast is already deteriorated, notably the Italian Adriatic coast, the east coast from Syria to the Nile Delta, and the seaboards between Barcelona and Valencia and between the mouth of the Rhone and Spain. In fact, less than 1 percent of the coastal zones of the Mediterranean are genuinely protected.

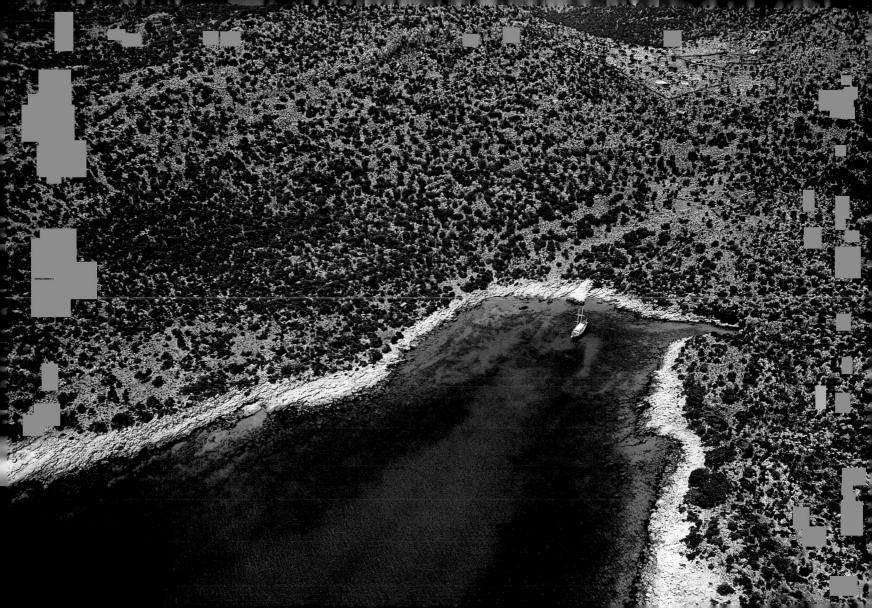

Ash dump near Secunda, Mpumalanga Province, South Africa (26°31'S - 29°07'E)

These huge cinder landfills are the by-products of coal liquefaction operations conducted nearby Sasol, the South African oil company. Their installation is the largest, and probably the only, synthetic fuel plant in the world, employing the Fischer-Tropsch process to convert low-quality coal and natural gas into liquid hydrocarbons. The Sasol plant alone occupies an area of 5 square miles (13 square kilometers), and it owes its existence to the international embargo placed on South Africa during its years of apartheid. While the production of synthetic fuel has remained marginal in volume, the technology has aroused new interest recently because of the rise in oil prices. From an environmental point of view, the production of less than a gallon of synthetic fuel drawn from coal engenders twice as much greenhouse gas as an equivalent amount of fuel made by refining oil.

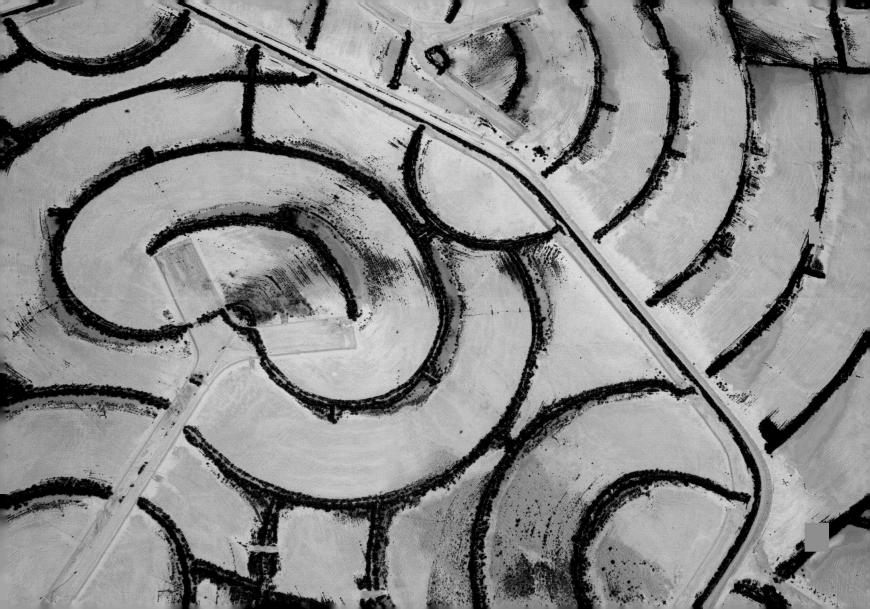

Palm grove and palm-oil factory, Monte Plata, Dominican Republic $(18^{\circ}48' \, \text{N} - 69^{\circ}47' \, \text{W})$

Worldwide output of palm oil has tripled in the last decade; soon the product could become our leading vegetable oil. Already very popular in Brazilian and African cooking, it has begun to penetrate new markets (such as India and China), and to appear in products (such as margarine, lipstick, shampoo, and biofuels). This has led to an expansion of palm-oil (*Elaeis guineensis*) plantations—at the expense of tropical forests. The situation is especially critical in Malaysia and Indonesia, the main producers of palm oil. In Indonesia, for example, the area assigned to palm trees grew from 297,000 acres (120,000 hectares) in 1968 to 15 million acres (6 million hectares) in 2007; every minute, a naturally wooded area the size of four soccer fields disappears. On the other hand, this highly profitable crop creates huge numbers of jobs.

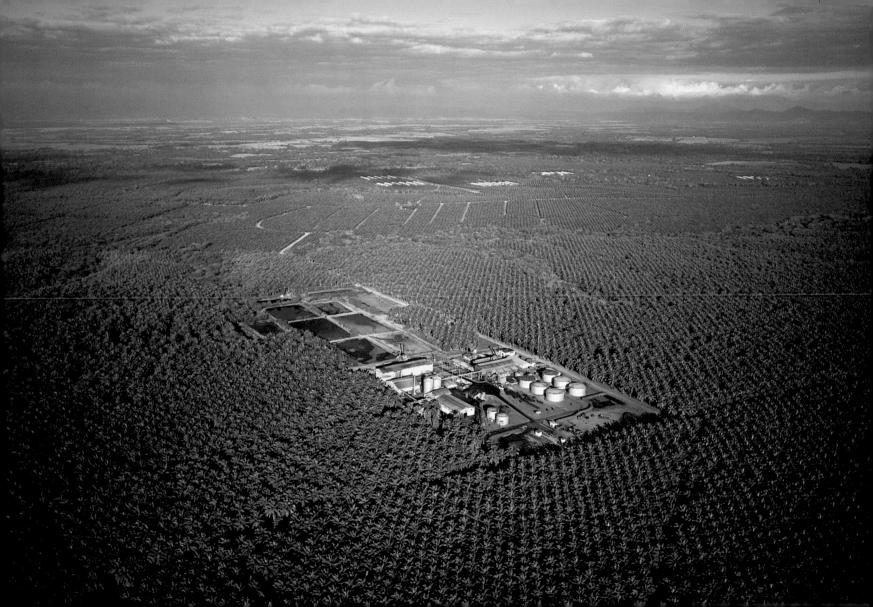

Palace of Justice, Palermo, Sicily, Italy (38°07'N - 13°22'E)

Palermo, on the Tyrrhenian Sea, stands in a broad gulf dominated by Mounts Pellegrino and Catalfano. Among its monuments is the Palace of Justice built in 1882 by Gaetano and Ernesto Rapisardio. The building is a center of the struggle against the Mafia; Judge Giovanni Falcone spent eleven years there fighting a ceaseless battle against organized crime, before being assassinated by the Cosa Nostra in 1992. Every year organized crime costs \$9.6 billion (€7.5 billion) in the south of Italy. It is estimated that, since 1981, were it not for the continual pillage carried out by the Mafia, the Sicilian economy would have caught up with that of Northern Italy. The wealth siphoned off in the Mezzogiorno (Apulia, Basilicata, Campania, Calabria, Abruzzo, Molise, Sardinia, and Sicily) corresponds to 2.5 percent of the South's total yearly output. However, the head of the Cosa Nostra, Bernardo Provenzano, was arrested on April 11, 2006, after spending forty-two years on the run. He was caught when the laundry his wife sent him was traced to a local farmhouse.

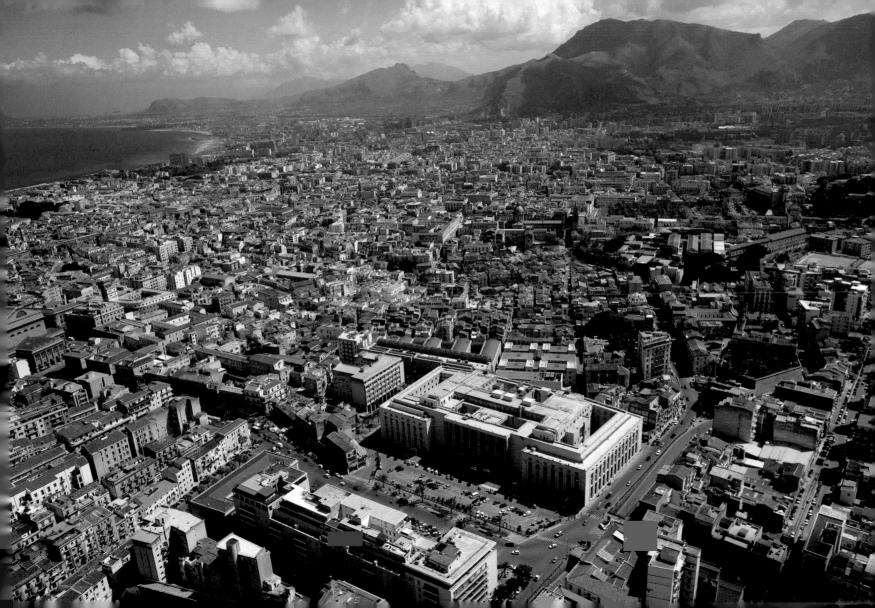

Monument Valley Navajo Tribal Park, Arizona, USA (36°25′N - 110°00′W)

The landscapes of Monument Valley are world famous; since the 1930s they have acted as the setting for many a Western movie. Today, even though it is a major tourist attraction, Monument Valley is not an American national park, but a tribal reservation. Behind the tall buttes of red sandstone lives the Navajo Nation, whose 25,000-square-mile (65,000-square-kilometer) territory occupies the northeastern quarter of Arizona and overflows into Utah and New Mexico. The Navajo Nation numbers over 300,000, of whom 174,000 live in the tribal park. Like the 563 other tribes recognized by the U.S. federal government, the Navajos have their own government; its capital is Window Rock. The Navajo language, unlike many others in North America that are disappearing, remains the everyday tongue of more than 100,000 people, and is taught to children all the way through school. In taking care to preserve their threatened language, the Navaios recognize that their identity, their culture, and their future are their sole responsibility. Linguists predict that 90 percent of the six thousand languages still spoken on earth today will have vanished by the end of this century.

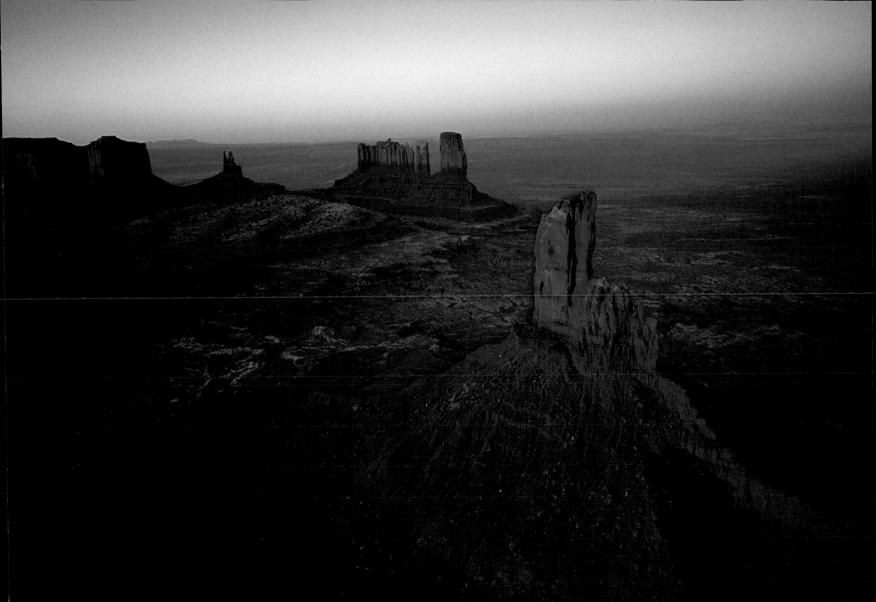

Temple of the Earth at Ayutthaya, Thailand (14°21'N - 100°34'E)

Ayutthaya is a manmade island at the junction of the river Chao Phraya and the rivers Prasak and Lopguri. The capital of the kingdom of Siam for over four hundred years (from 1350 to 1767), its splendor, cultural dynamism, and economic muscle astonished seventeenth-century European visitors. The extent of Wat Phra si Samphet, the royal sanctuary of the city since 1491, bears witness to this magnificence, but of the gigantic former temple, only three *chedi* are still intact. Many of these monuments contain sacred relics—here, the ashes of the Siamese sovereigns—and symbolize the stages that must be surmounted on the path to nirvana. Buddhism, the religion subscribed to by 95 percent of Thais, is the cement that binds the country together, and the temples that used to be centers of education, hospices, and orphanages are still at the heart of Thai public life. At one time or another, nearly every Thai has worn the monk's habit, sometimes for a few weeks only, but more often for three months during the monsoon season.

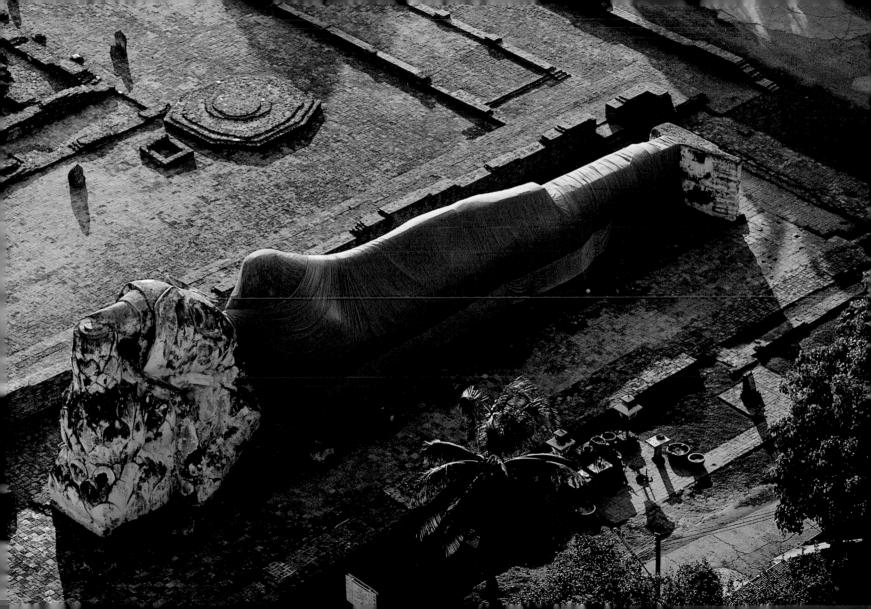

Volcanic landscape, Ghoubet El-Kharab, Republic of Djibouti (11°41′N - 42°20′E)

The regions of Lake Assal and Lake Ghoubet, where the Eritrean Ocean is slowly coming into being, are remarkable, to say the least. Here at the southeastern extremity of the Rift Valley, the continental crust is tearing the continent of Africa little by little from the Arabian Peninsula, stretching, thinning, and breaking it loose along thousands of fault lines. As the landscape sags (Lake Assal is currently 515 feet [157 meters] below sea level), lava bursts forth from the depths of the earth. Cooling, it forms volcanic cones and black lava fields that will one day form the ocean bed. In this place, the earth is growing a new crust and skin for itself; but since the planet is not extensible, elsewhere, perhaps thousands of miles away, the old depths are disappearing, plunging beneath the continents to rejoin the primary matter of creation.

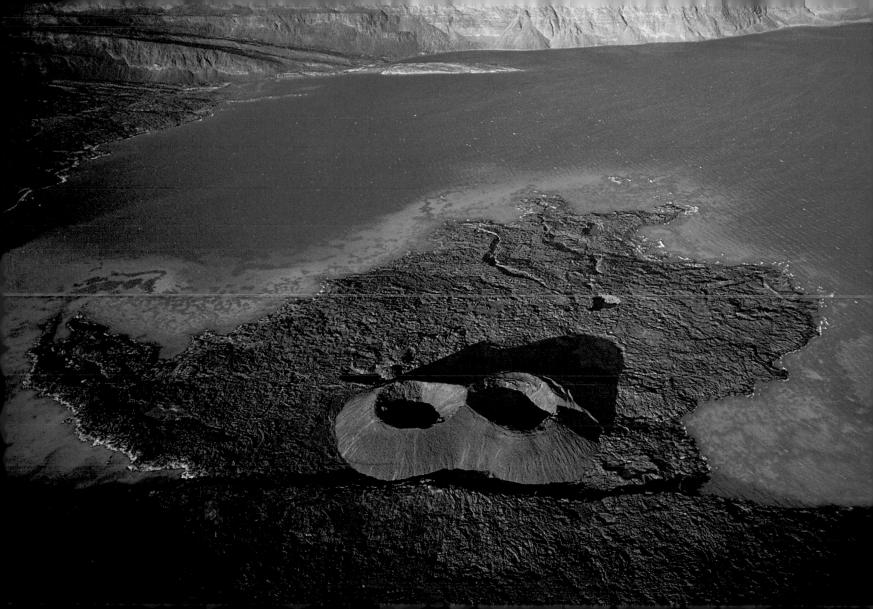

AGROECOLOGY— AN ALTERNATIVE FOR THE FUTURE

The soil—how many of us understand the silent soil we walk upon all our lives? The soil outside our cities, so strange to us, and foreign?

Of the four primary elements, the nurturing soil is the only one that didn't exist at the start. It took millions of years to amass the thin, 8-inch (20-centimeter) layer of it on which terrestrial life depends. The soil is a soundless universe, extremely complex, a hub of intense activity ruled by a mysterious, immanent intelligence. In this universe are bred the substances that make it possible for plants to feed, blossom, and reproduce, and it is to these plants that animals and human beings owe their survival. Mother Earth is no poetic metaphor. Mother Earth is a fact of life. The earth is our mother.

The logic of the soil is rooted in the cohesion of all living things. Soil, plant, animal, and human being are united and inseparable. To imagine that humankind can stand apart from this logic, control it, or transgress it—and remain unpunished—is dangerous folly.

In our era of science, technology, productivity, and unbridled merchandising, we are blind to any use for soil and plants beyond their capacity to generate profit. Selected seeds that are degenerative or nonreproducible, fertilizers, pesticides, monocultures, wasteful irrigation methods: no doubt but modern agriculture, which is where the money lurks, is caught in the logic of productivity. By following procedures and mechanisms dictated by markets and the hope of profit, we have wrought terrible damage on the nurturing soil. Doing so has exacted an appalling ecological, social, and economic price: the destruction of humus, the pollution of water, the elimination of domestic animal and vegetable biodiversity, the annihilation of traditional farming (along with its practitioners' wisdom and savoir faire), the bleeding white of rural areas, the advance of desertification, and the manipulation and patenting of seeds for crops.

The soil is a living entity, and it cannot be subjected to exactions like these without serious consequences for the future.

Our hapless mode of agricultural production is proving to be the most onerous, tenuous, and demanding—and least profitable—endeavor in the history of humanity. Today we need 1,057 gallons (4,000 liters) of water to produce 2 pounds (1 kilogram) of meat. We need between 2 to 3 tons of oil to manufacture 1 ton of fertilizer. And we need 12 calories of energy to derive 1 calorie of food.

When we in the developed world weigh our wealthy excesses, our wastefulness, and our outrageous overconsumption of food against the destitution and famine that persists in the bulk of the world, it is clear that production-oriented agriculture, having been given free rein for decades, has now hit a dead end. The magnificent term *nourishment* has symbolic and poetic echoes that go far beyond the idea of nutritive matter to a world of subtle tastes that rejoice the body and soul. But today the idea of *nourishment* has given way to the idea of *food*—by which is meant a superabundant, adulterated, manipulated, polluted matter. We are dimly aware that the blessings of the earth no longer come to us seasonally and fittingly, at the most propitious times and in the most propitious places, and we are disillusioned.

Now at last we have begun to make the connection between cause and effect, between our food and our civilization's modern diseases, which, despite our scientific knowledge and our sophisticated medical equipment, continue to spread unchecked. Food, air, and water, the basic conditions and guarantors of life from its earliest stirrings on this planet, are now the accomplices of death. How often must we be told that it will never be possible, whatever we do, to consume food of good quality unless we understand, respect, and care for the soil that produces it?

We need to find ways of ensuring our own survival while respecting life in all its other forms if we wish to avert the coming of a famine of an unimaginable scale.

We believe it to be critically important that the principles of agroecology we have been teaching and applying for decades be spread throughout the world. Agroecology consists of the use of techniques inspired by natural processes, such as composting, the application of vegetable manures, companion plant-

ing, and the strict minimizing of all disturbance of the soil. These practices can allow people to regain their autonomy and ensure that their food supply is healthy and secure, with the added benefit of regenerating and preserving food reserves for future generations. They are practices based on a proper understanding of the biological phenomena that regulate the biosphere in general and soils in particular. They are universally applicable.

Agroecological methods have the potential to enrich and refertilize soils, to roll back desertification, to preserve biodiversity, and to optimize the use of water. They are perfectly adapted to even the poorest people and the poorest soils. By stabilizing natural and local resources and giving them new value, these methods can deliver farmers from an addiction to chemicals. They can also release farmers, and the rest of us, from means of transport that generate massive pollution—and from the absurdity of delivering anonymous foodstuffs thousands of miles each day rather than producing for local consumption. Finally, the use of agroecological methods can supply us with nourishment of true quality—the basis of good health for the soil and for all living things.

Properly understood and applied, agroecology can be the beating heart of real social change. It can be a life ethic that postulates a new relationship between the nurturing soil, the natural environment, and ourselves, and one that can put an end to the destructive, predatory cycle we find ourselves in today.

Agroecology is much more than an economic alternative. It calls on us to respect life in all its forms, and it engages us, as human beings, in a solemn responsibility toward all other living things, renouncing superficial satisfactions. Ultimately, it has the power to reunite us with the enchantment our earliest forebears felt for the planet, their understanding that the earth and everything on it is simply sacred.

Pierre Rabhi

Founder of the Movement for Humanism and the Earth, international expert on the struggle against desertification, pioneer of ecological agriculture in France

Village between Tahoua and the Aïr Mountains, Niger (15°03'N - 5°12'E)

This village near Tahoua, in southwestern Niger, is architecturally characteristic of the Hausa tribe, with cuboid houses made of *banco* (a mixture of clay and vegetable fibers) side by side with splendid oval stores of grain. The Hausa form a majority (55 percent) in Niger and are generally settled farmers, but they also have a great reputation as crafts- and businesspeople. In fact, for several centuries past, the Hausa city-states north of Nigeria imposed their commercial power on various African countries. Today the Tahoua region is crossed by a road leading north, generally referred to as the uranium road. A deposit of this mineral was found in 1965 in the subsoil of the Aïr Mountains and led to the installation of substantial mines at Arlit. Every year 3,200 tons of uranium is extracted—about 8 percent of total world output.

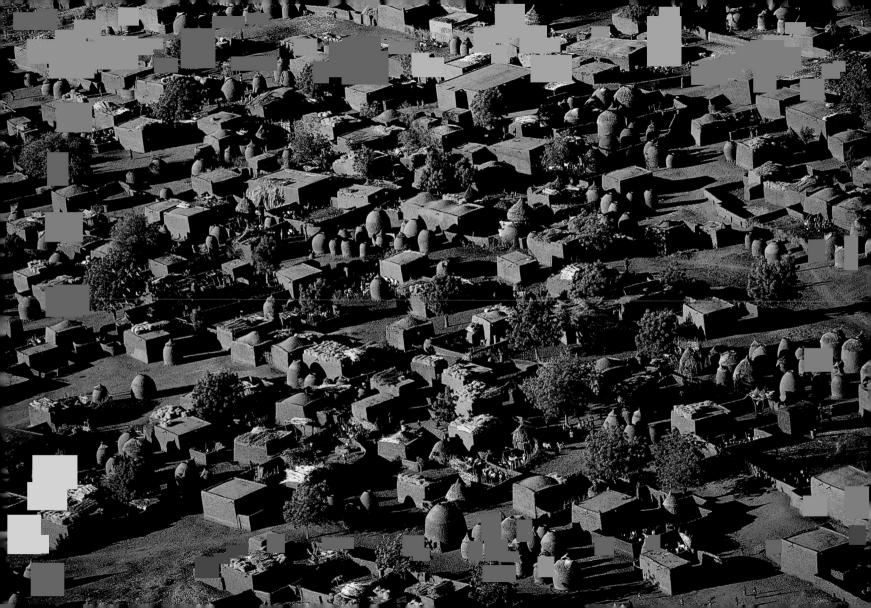

Boats at the Damnoen Saduak, Bangkok region, Thailand $(13^{\circ}44'N - 100^{\circ}30'E)$

Citronella, galangal, garlic, ginger, mint, basil, coriander: sold in Thailand's innumerable markets, herbs and spices like these—not to mention hot peppers—are omnipresent in Thai cooking. At the crossroads of many peoples, languages, and cultures, Thailand has contrived for centuries to ride the influences of India, China, and Europe in such a way that it now possesses a culinary tradition of the highest order, allying the pleasure of the palate with that of the eye. Its sculpting of fruit and vegetables and its subtle blending of color and taste give Thai cuisine a genuinely artistic dimension, much appreciated by visitors. Indeed, tourism is among the country's main industries, generating 12.2 percent of domestic revenue and employing 10 percent of the working population. Before the 2004 tsunami, between 5 and 10 million people visited Thailand every year, making it one of the top tourist destinations in Asia. Today, tourism in the country is almost identical to what it was before the disaster.

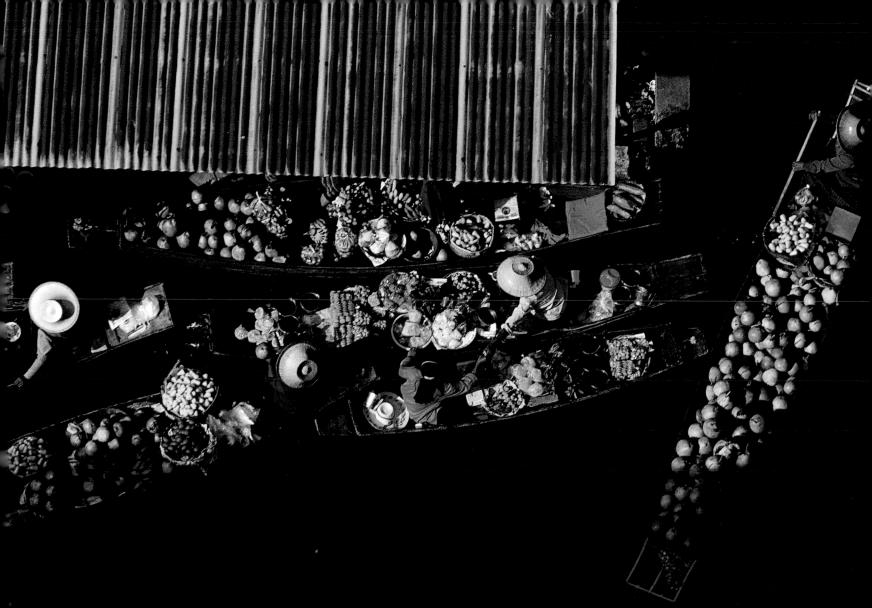

Former headquarters of the North Korean Communist Party, Pocheon, Gyeonggi, South Korea (37°5′N - 127°10′E)

More than fifty years ago, this imposing building was the seat of the Communist Party of the Democratic People's Republic of Korea (North Korea). It was located in the vicinity of the 38th parallel, which in 1945 divided the two Korean states. After the Korean War (1950–1953), the signing of a cease-fire agreement edged the demarcation line northward, and this building found itself on the southern side. The new frontier has been known ever since as the DMZ (demilitarized zone). It is ill-named, given that the 2.5-mile-wide (4-kilometer-wide) buffer zone is the scene of the biggest military standoff on the planet and a reminder that a peace treaty has never been signed between the two countries. The front line is marked by a 10-foot-tall (3-meter-tall) wall—topped with rolls of razor wire—which is guarded on either side by a patrol road dotted with guard posts. Seoul itself is only 37 miles (60 kilometers) from the DMZ; seven successive lines of obstacles and tank traps protect the capital from a potential invasion by North Korea, an isolationist, totalitarian state.

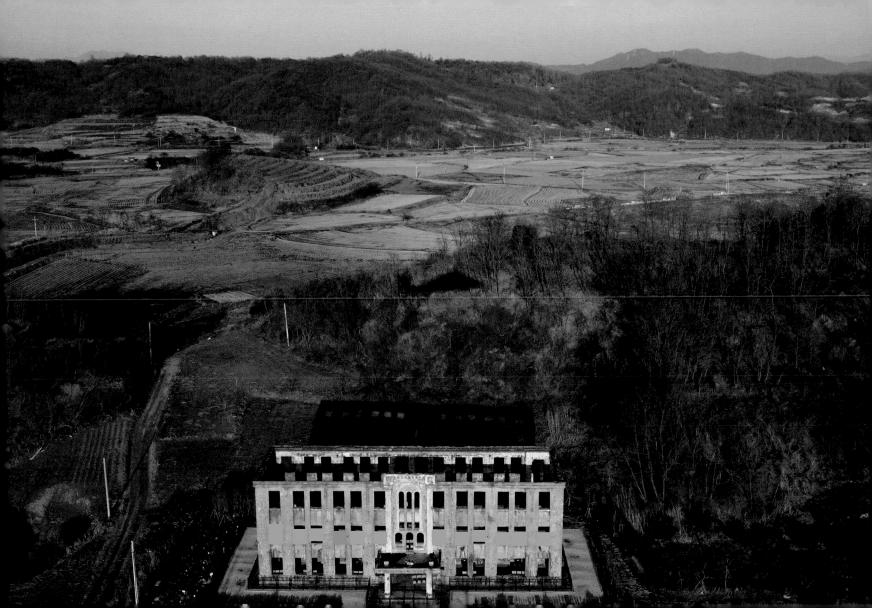

The Temple of Garni, overlooking the Azad gorges, Kotayk Province, Armenia $(40^{\circ}06' \text{ N} - 4^{\circ}43/\text{E})$

A mountain region squeezed between Turkey and Iran, Armenia is a place of spectacular landscapes; 75 percent of the country rises between 3,300 and 8,200 feet (1,000 and 2,500 meters) in altitude. At the heart of the volcanic Kegham range, whose high ridges are worn smooth by erosion, the Temple of Garni stands 984 feet (300 meters) above the gorges of the river Azad. Built of volcanic stone (basalt), it was raised in the first century AD by King Tiridates, probably for the cult of Mithras, god of fire and light. It resembles a miniature Parthenon from afar, but in fact its architecture is as much Armenian as Hellenic. The Armenians have always fused incoming influences with their own culture; converted to Christianity in the fourth century AD, they are still neither Catholics nor Protestants nor Orthodox, but members of their own Armenian Apostolic Church.

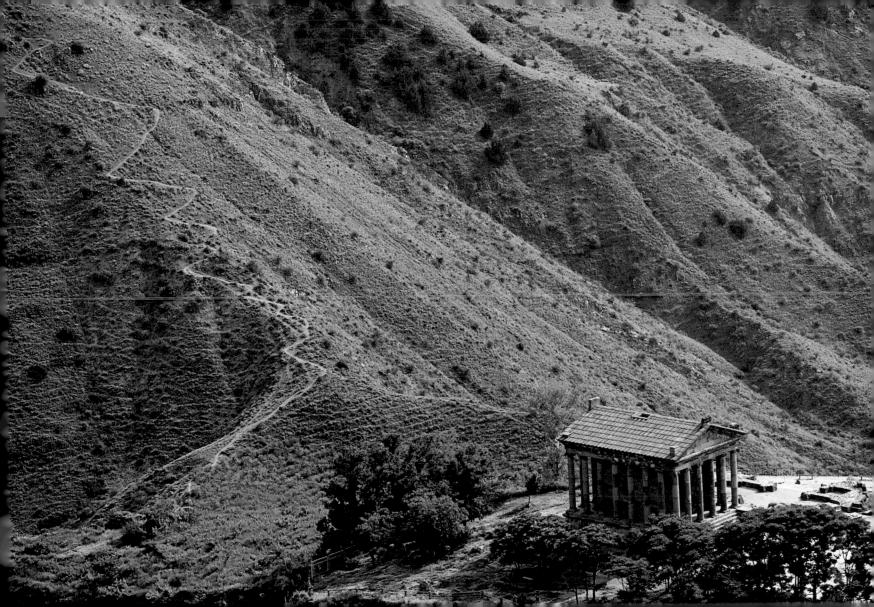

Schoolchildren at San Pedro, Ivory Coast (4°44′N - 6°39′W)

Only 56 percent of Ivorian children go to primary school. Girls are particularly affected; 50 percent of them attend school, as opposed to 62 percent of boys. They also go to work earlier and get married earlier than boys (one-third of young Ivorian women are married before the age of eighteen). The political instability created by the military coup d'état of 1999 made this situation worse. and the division of Ivory Coast into two zones since 2002 has all but wrecked the educational system. The violence and insecurity that reign today in the rebel-controlled North have obliged many teachers to flee to the governmentcontrolled zone in the South. Consequently, many northern schools have closed down, and the few that continue to function go without the validation of any official examination process. Meanwhile the educational establishments in the South are totally saturated, despite the creation of temporary schools for refugee children. Since 2003, when the ethnic and civil conflict drove many teachers and functionaries out of Ivory Coast, about 1 million young Ivorians have been deprived of their right to an education.

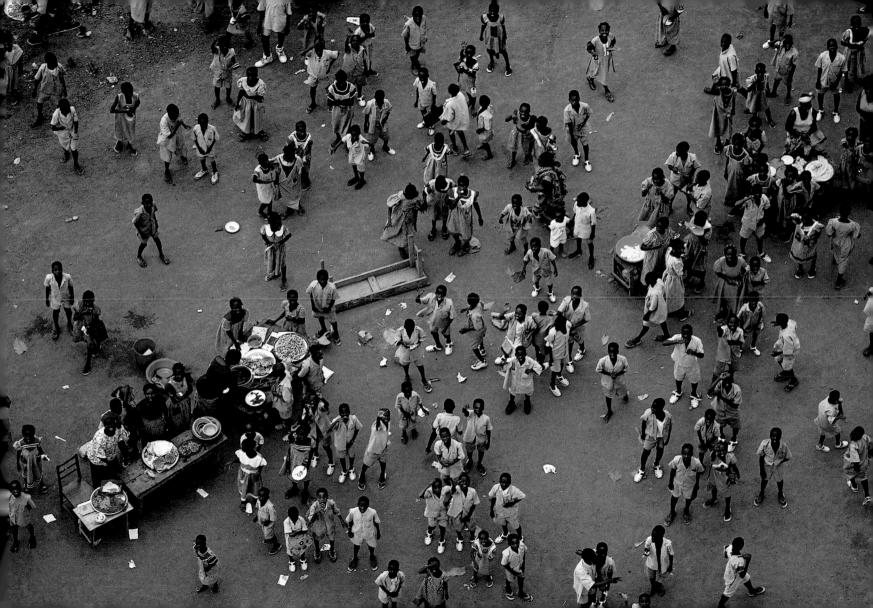

Bottle cases near Braunschweig, Germany (52°20′N - 10°20′E)

Not far from Braunschweig (Brunswick), in northern Germany, a mountain of bottles of mineral water, beer, fruit juice, and carbonated beverages fills a wholesaler's open-air depot. Worldwide, the bottled-water industry is flourishing. Bottled, the most elementary of drinks has become the most profitable, with consumption increasing by 12 percent annually. To contain the 5 billion gallons (19 billion liters) of mineral water distributed round the world each year, 1.5 million tons of plastic are used; Europe is the largest consumer. This resort to bottled water may be justified in countries where the available water is unfit for consumption (Africa, Latin America, and Asia) but this is emphatically not the case in Western nations, where tap water is not only abundant but is also subject to strict health controls. Most of the oil-based bottles used in the mineral-water trade are never recycled, and end up scattered all over the planet after being used just once.

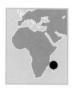

The Tsingy Mountains near Vilanandro, Mahajanga, Madagascar (16°30'S - 45°25'E)

In Malagasy, the language of Madagascar, *tsingy* means "to walk on tiptoe"—and indeed there isn't much latitude for anyone to walk normally in the impenetrable labyrinths of the Tsingy Mountains in Namaroka National Park. The mountains cover 40,000 acres (16,000 hectares) southwest of Mahajanga. They are shaped by erosion, the acidity of the rain having gradually dissolved the limestone plateau, chiseling it into sharp ridges. This strange milieu would doubtlessly fascinate any naturalist; the Indian Ocean's "big island"—227 square miles (587,000 square kilometers) of earth that has been isolated from the southern African mainland for 165 million years—harbors an array of animal and vegetable life that is unique and diverse. The flora and fauna are extraordinary; 90 percent of Madagascar's 12,000 plant species and 80 percent of its animals are endemic and found nowhere else. Shockingly, however, most of these are threatened with extinction as a consequence of Madagascar's rampant deforestation.

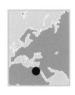

Fox on a pyramid, Cairo, Egypt (29°58′N - 31°07′E)

Famed above all for its archaeological treasures, the largely desertic countryside of Egypt does not lack fauna and flora—far from it. There are a number of ecosystems—lotus, papyrus, acacias, mangroves—which are home to many creatures well adapted to the arid climate: 430 bird species, 100 mammal species (camels, donkeys, and gazelles), 34 snake species, and several crocodile species. At the same time, such large animals as leopards, oryx, hyenas, and lynx have been hunted out of existence. Egypt is lagging behind in the field of environmental protection. Cairo, with 16 million inhabitants, is grappling with very serious air and water pollution. All the city's wastewater is dumped into the Nile, usually untreated, and the air degradation caused by its 1 million aging cars, most of them ill-maintained and still running on leaded gasoline, makes Cairo one of the most polluted cities on the planet.

Headquarters of the International Committee of the Red Cross, Geneva, Switzerland ($46^{\circ}12'N - 6^{\circ}09'E$)

The Red Cross is an independent, neutral organization whose goal is to bring protection and assistance to victims of war, armed violence, and natural catastrophes, ensuring international human rights. In 1863, the Swiss national Henry Dunant, moved by the fate of wounded soldiers after the Battle of Solferino (1859), created an international committee to bring help to people injured in war. Originally the red cross was to be its sole symbol; but after the Crimean War, the Turks added the emblem of the red crescent, considering that the cross was a Christian symbol that evoked the Crusades. Other Muslim countries followed suit, and the red crescent was eventually accepted as an alternative emblem in 1929. But since December 2005, as a consequence of radical Muslim lobbying, the red crystal, which has no political, religious, or cultural connotation, has become an additional symbol for the 183 national associations of the combined Red Cross and Red Crescent.

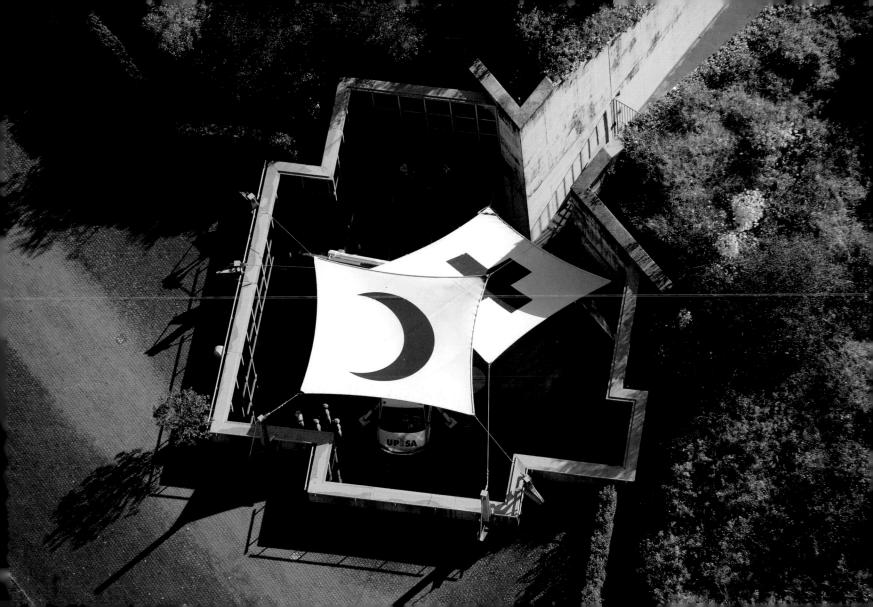

Pelicans in the Senegal River estuary, near Saint-Louis, Djoudj National Bird Sanctuary (16°15′N - 16°19′W)

Pelicanus onocrotatus is easily identified by its white plumage, dark wing tips, and bulky, deep-pocketed yellow beak. Pelican Island in the Djoudi National Bird Sanctuary is home to about five thousand of these birds. This vast wetland area—a humid savanna surrounded by desert—is one of the principal refuges for the nearly 3 million migratory birds that cross the Sahara every year, making survival possible for many different species. The world's third-largest bird sanctuary, it owes its name to a branch of the Senegal River, the Djoudj. The reserve's 39,500 acres (16,000 hectares) contain pink flamingoes, purple herons, African spoonbills, egrets, and cormorants, among many others. Created in 1970, Djoudj was listed as a UNESCO World Heritage Site in 1981; nevertheless, today it is threatened by the Diama dam project. Land below the dam has been drained for agriculture, and the equilibrium of the sanctuary itself is now in peril because the project has created ideal conditions for the rapid spread of water ferns and water lettuce, which now choke the shores of the reservoir. These plants prevent the water from oxygenating properly and serve as habitat for huge colonies of mosquitoes and snails that transmit numerous diseases such as bilharzia. To counter these invasions, a species of herbivorous South African beetle was introduced into the sanctuary in 2001.

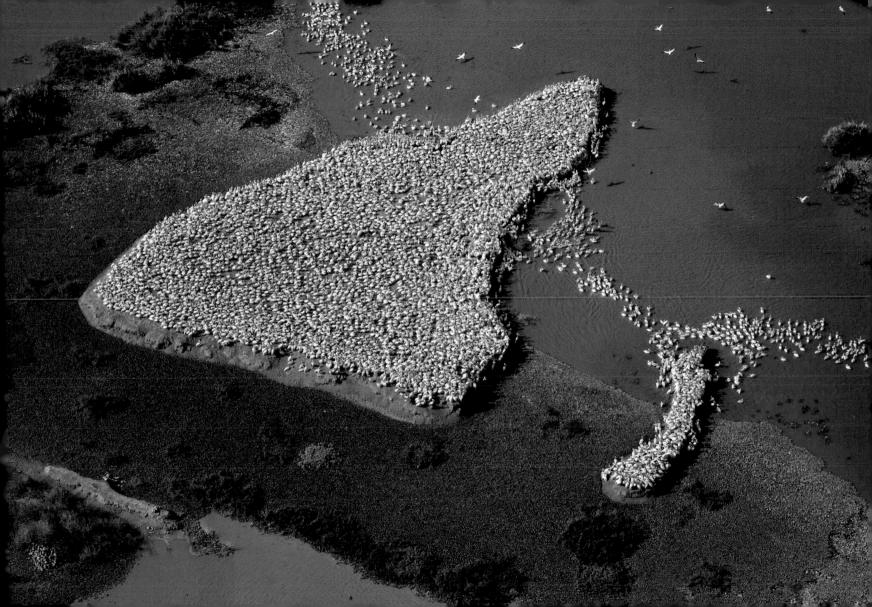

Agricultural landscape, Idaho Falls, Idaho, USA (43°28'N - 112°01'W)

In 1996, America was the first nation to authorize the commercialization of genetically modified (GM) crops. The organisms in question are plants whose genetic structure has been altered by the introduction of genes from another species, with a view to embedding in them new properties, such as resistance to a disease or an insect, or increased tolerance to a given herbicide. A decade later, the United States remains the world's leading producer of GM crops, with 87 percent of its soybeans, 78 percent of its cotton, and 63 percent of its maize genetically modified. In 2007, four countries (the United States, Argentina, Brazil, and Canada) together raised 95 percent of the world's 222 million acres (90 million hectares) of GM crops. The use of GM crops is still highly controversial, and whether they figure in the agricultural, research, or economic sector, they have vehement supporters—and opponents.

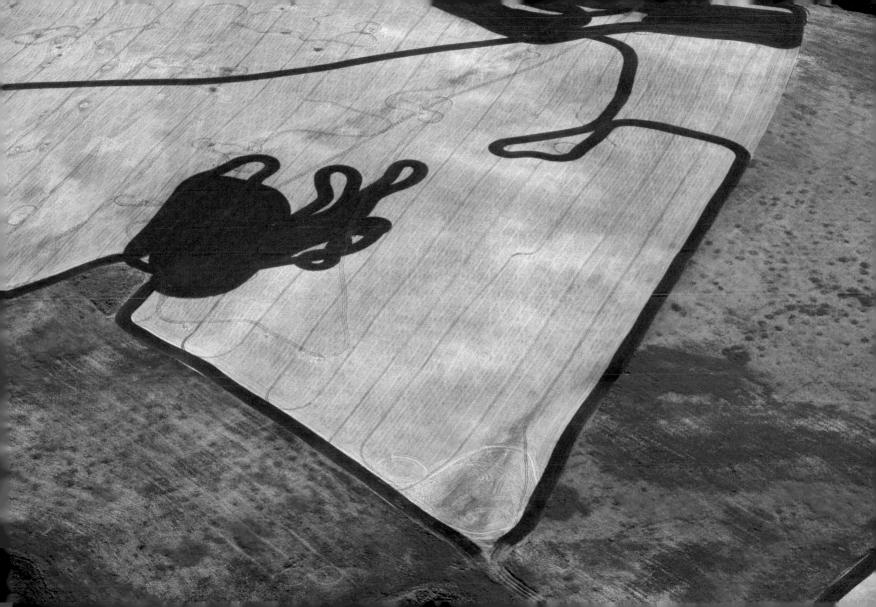

Israeli colony in Palestinian territory, West Bank (32°00'N - 35°15'E)

"Without an agreement on water, there will be no agreement for Israel, Water is more important than peace." This quote from the assassinated prime minister of Israel Yitzhak Rabin shows just how crucial a factor water has become in the Israeli-Palestinian conflict, outweighing even religious and historic considerations. In 1917, following the Balfour Declaration, which promised the creation of a Jewish national homeland, the president of the World Zionist Organization asked that the projected frontiers be moved northward to include more water resources, notably the Jordan valley. Today, about 40 percent of the water used by Israel comes from the Jordan River and Lake Tiberias, and 60 percent from aguifers beneath the hills of the West Bank and the Gaza Strip. While the Israelis try to remedy their lack of water—a chronic problem all over the Middle East—the Palestinians consider that they are being robbed of what is rightfully theirs. In the occupied territories, the Israelis have imposed severe restrictions on the Palestinians, notably in the matter of drilling for water, and oblige them to pay the high prices set by Mekorot, the national water company. The Palestinians consume on average one-seventh or one-eighth the quantity of water per head that the Israelis do. And yet the Geneva Convention of May 14, 1997, on the right to use water for purposes other than navigation, imposes equality of access to shared water resources for all neighboring states.

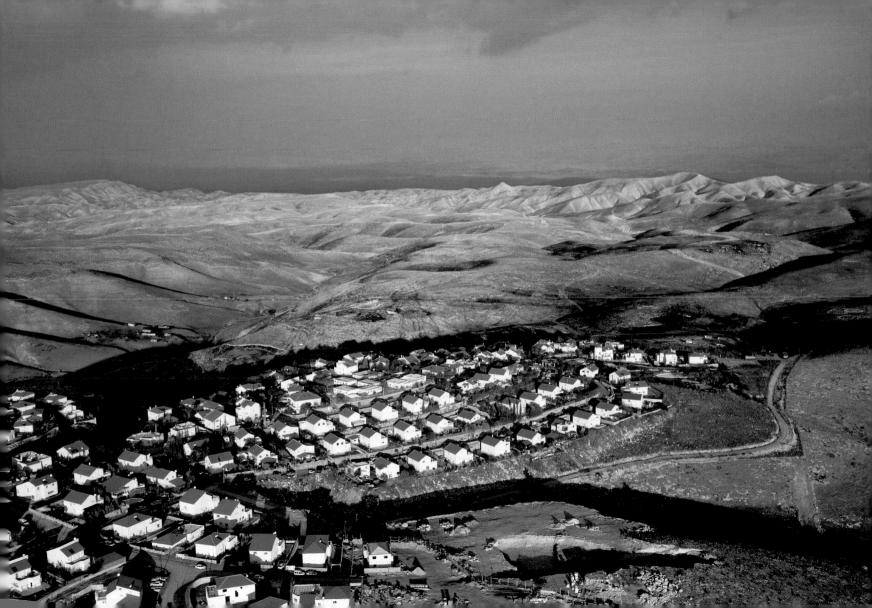

Fish farm near Maspalomas, Canary Islands, Spain (27°45′N - 15°37′W)

The fishing industry was one of the foundations on which the Mediterranean culture was built, and today 3 million Mediterranean people of varying nationalities depend on it directly for a livelihood. But in Spain, Europe's largest producer of wild fish—as in many other countries—more than 70 percent of commercial stocks are now heavily overexploited or on the brink of exhaustion. In this context, fish farming might appear to be a viable solution. But it is crucial to keep control over the intensification of shallow-water fish farms, because they expel great quantities of noxious waste and can quickly deteriorate whole coastlines. In addition, their use of chemical treatments against disease has to be strictly monitored. With its present techniques, fish farming is still a false solution to the problem of overfishing. Most people do not know, for example, that it takes vast quantities of wild fish to feed the (usually carnivorous) farmed fish. Thus, to produce 2.2 pounds (1 kilogram) of salmon, sea bass, or sea bream, it takes 9 pounds (4 kilograms) of wild fishmeal made of herring, sardines, and mackerel. The ratio soars to 33 pounds (15 kilograms) to produce a single red tuna. For more than a billion human beings, fish is the principal source of animal protein—and according to the Food and Agriculture Organization of the United Nations, fish farming could provide 50 percent of the world's fish requirements by 2030.

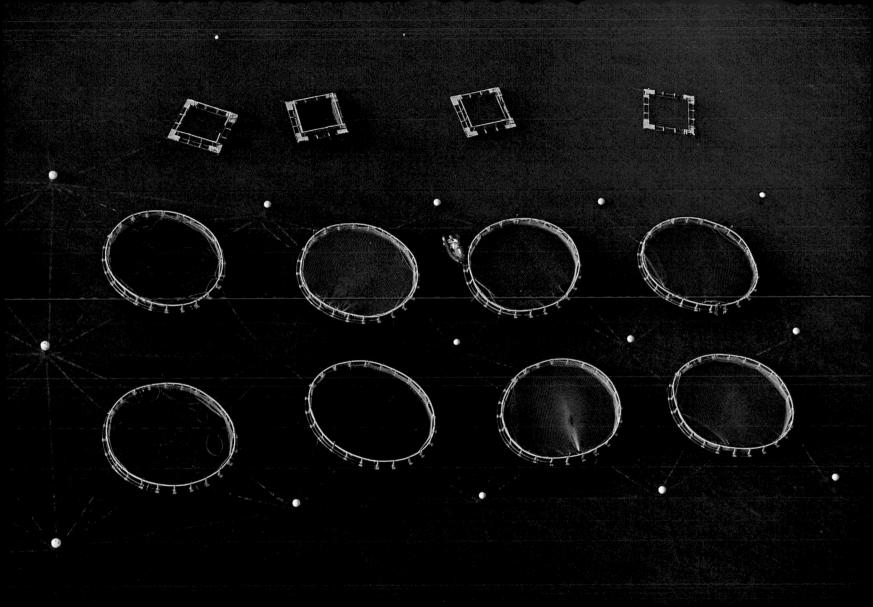

Camels drinking at a well between Kidal and Timbuktu, Mali $(17^{\circ}36'N - 0^{\circ}50'W)$

Water points dictate the territorial framework of each group of Tuareg herders, and each well is a veritable meeting place between the tribes or fractions of tribes that share it. Camels (or dromedaries, to be precise) are the herders' basic livestock asset, constituting a food resource (milk and meat) and a reliable income source that can be sold on the hoof to ensure survival. Because camels are much more resistant to drought than other ruminants like sheep, goats, and cattle, they are growing in numbers—fortunately, since the terrible droughts of 1970 and 1980 forced large numbers of herders to renounce cattle breeding. The physiology of the camel, which is perfectly adapted to the desert environment, is little short of astonishing; for example, its red corpuscles can allow it to rehydrate with extraordinary rapidity (26 gallons [100 liters] in ten minutes). It would kill any other creature to absorb such a vast quantity of water in so short a time.

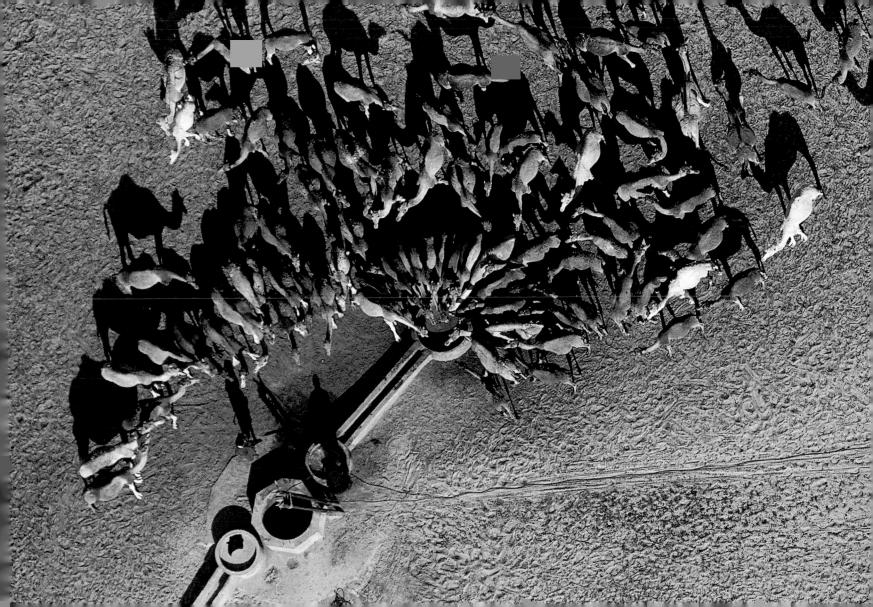

Walls on the island of Inishmore, Aran Islands, County Galway, Ireland $(53^{\circ}07'N - 9^{\circ}45'W)$

The Aran Islands, off Ireland's west coast, with their 300-foot (90-meter) sea cliffs, are Galway Bay's bastion against the violent winds and currents of the Atlantic. Inishmore, the largest of the islands (9 by 2.5 miles [14.5 by 4 kilometers]), is also the most populous. For centuries the islanders have fertilized their soil by regularly spreading a thin, arable humus consisting of sand and seaweed; rare, delicate flowers and ferns grow as a result. To protect their precious land parcels from wind erosion, Aran Islanders have built a vast 7,500-mile (12,000-kilometer) network of low wind-breaking walls, which, viewed from above, resembles a giant puzzle. With their resources of fish, agriculture, and livestock, Aran Islanders have most of what they need, but they derive extra income from the swelling numbers of tourists who come to visit the majestic castle of Dun Aonghasa, with its ocean view, and the churches and hermitages built at the dawn of Christianity.

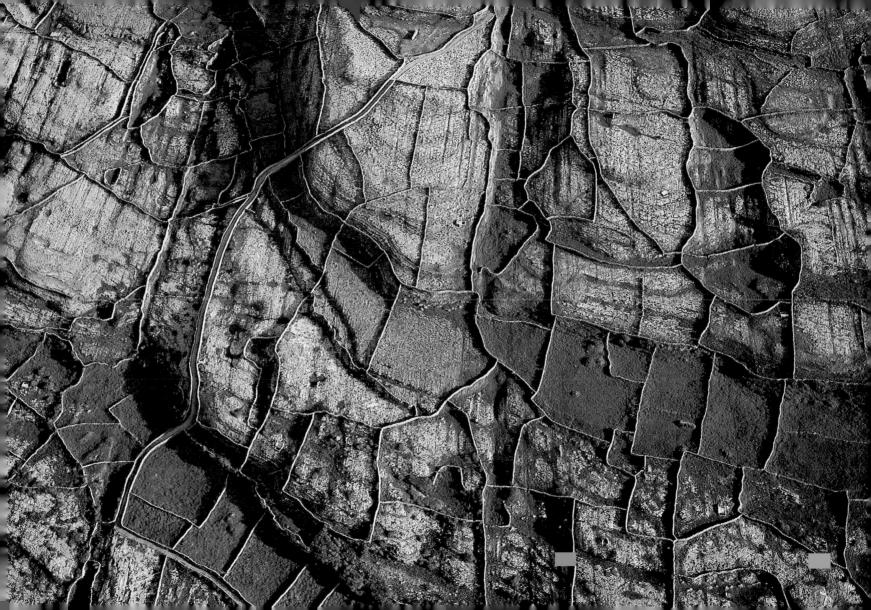

Rock Islands, Republic of Palau (5°00'N - 137°00'E)

Like fragments of a mosaic, the lush Palau Islands compose a 188-square-mile (488-square-kilometer) area in the heart of the Philippine Sea. Tourism, subsistence agriculture, and fishing (notably for bonito, a member of the tuna family) are the country's principal economic activities. Formerly an American dependency (1944-1994), Palau became an independent republic in 1994; 33 percent of its revenues still derive from U.S. financial aid. The tiny nation is seriously threatened by climate change and rising sea levels, hence it has ratified the Kyoto Protocol and agreed to respect the UN convention on maritime law, with a view to studying and preserving its rich marine heritage. Fortunately, despite its proximity to Indonesia, the wild sanctuary of Palau was miraculously spared from the tsunamis that ravaged Southeast Asia's coastlines in December 2004 and July 2006.

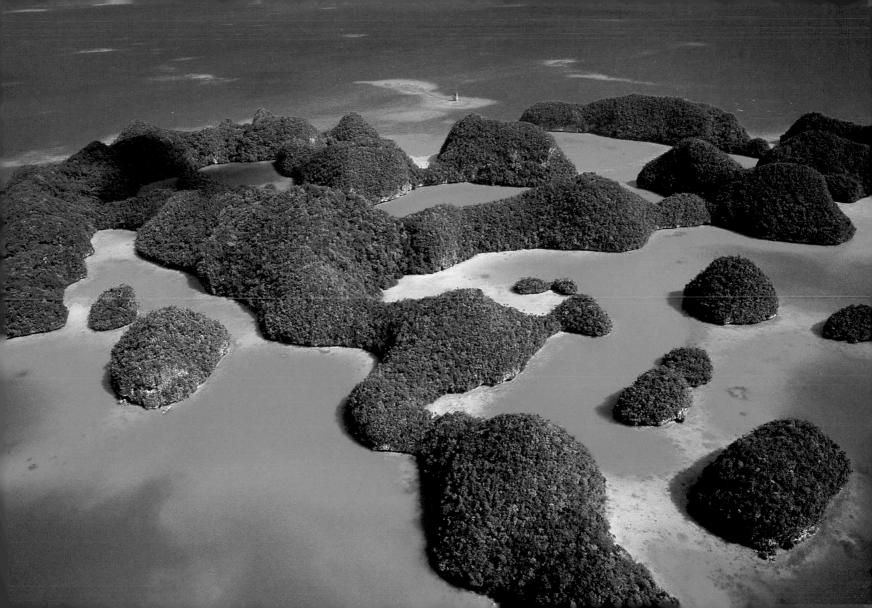

Colony of emperor penguins, Beaufort Island, Antarctica (South Pole) $(72^{\circ}00'\text{S} - 167^{\circ}00'\text{E})$

With inland temperatures that plunge as low as -112°F (-80°C), Antarctica is the world's coldest place by some distance. A rare few creatures manage to survive the region's ferocious climate, by resorting to seasonal migration or by otherwise adapting. To keep their bodies at a constant 100°F (38°C), even in the depths of winter, emperor penguins—which are flightless, unlike the penguins of the Arctic—possess rigid, tight, impermeable plumage; fluffy down; and a thick layer of fat between skin and muscle. In the mating season they gather in flocks of several thousand pairs on the rugged Antarctic coastline, where they stand with their backs to the wind, pressed tightly together for warmth. Since 2000, however, the reproductive cycle of the Beaufort Island emperor penguins has been disrupted; gigantic icebergs have been drifting into the Ross Sea, hindering the penguins' access to the water and depriving them of food (krill, mollusks, and fish) at this most critical period in their life cycle.

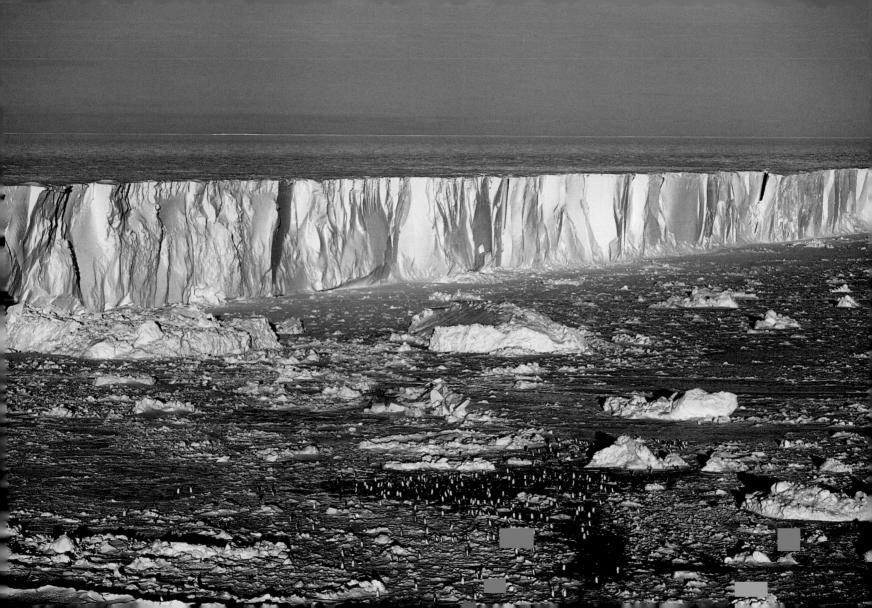

Nurek Dam, Tajikistan (38°22′N - 69°20′E)

Nurek Dam, on the Vakhsh River, is the tallest reservoir in the world—its dam soars to a height of 980 feet (300 meters). The 43-mile-wide (70-kilometer-wide) lake began to be filled in the 1970s and today holds about 350 billion cubic feet (10 billion cubic meters) of water; its hydroelectric plant has a power output of 2,700 megawatts. Rogun, an even taller dam (1,066 feet [325 meters]), is under construction on the same river, farther upstream. Hydroelectric power is one of Tajikistan's principal resources, reaching a total output of 15.4 billion kilowatt hours; exported, this electricity helps the country pay its foreign debt. But neighboring Uzbekistan looks on all this infrastructure with a jaundiced eye, given that it allots Tajikistan almost total control over the water flow of the Amu Darya. The only alternative to armed conflict over this is some kind of cooperation, but neither of the two Central Asian Republics seems inclined to share control over the Amu Darya and Syr Darya basins, which ultimately feed the Aral Sea.

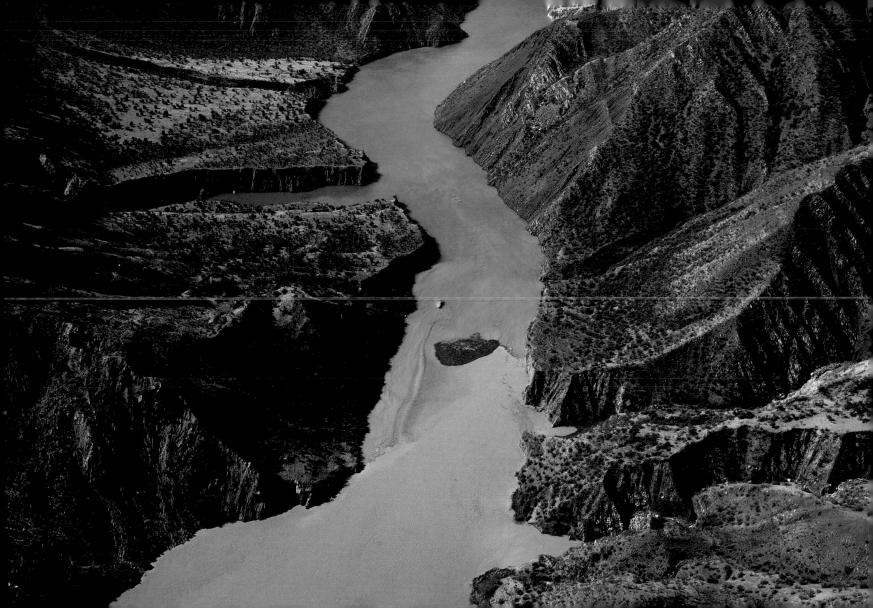

Neoprovençal villas at Grimaud-Beauvallon, Var, France (43°17′N - 6°34′E)

In 2006, there were about 1,248,000 private swimming pools in France, 810,000 of which were inground. The total of all swimming pools grew by 8 percent in 2006 and has doubled in the last decade. The development in this photograph was designed so that every house could have its own private pool. The pools, which are supplied by the public drinking water network, are refilled every year, which is a waste of a precious resource. Worse, their maintenance requires vast quantities of toxic chemical products. When they are emptied, the process involves pumping chlorinated water into the natural environment, which endangers animal and plant life. Their pumps and filters consume quantities of energy, as do their heating systems. In regions where the water supply is ever more problematic, the existence of private swimming pools in ever-increasing numbers would seem to be directly contrary to the public interest.

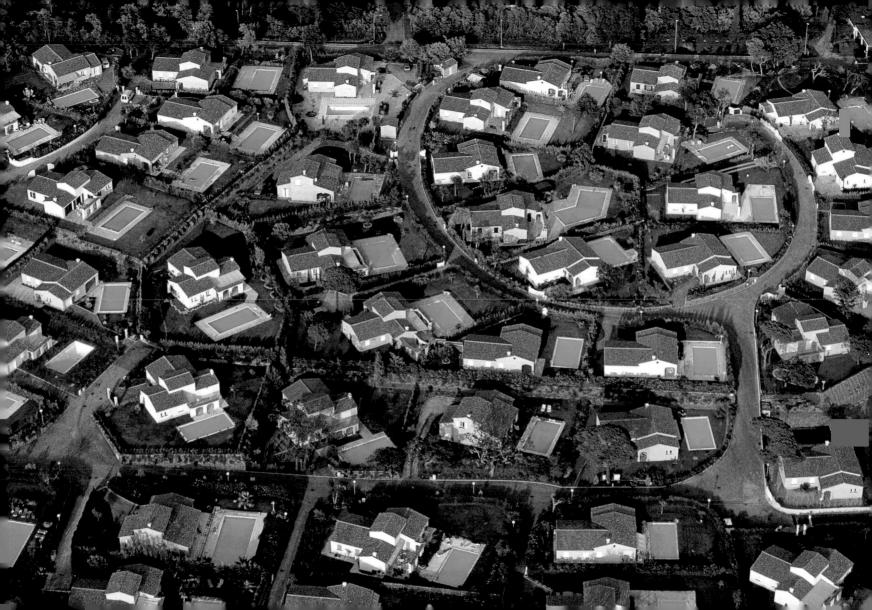

Abattoir near Agra, Uttar Pradesh, India (27°10′N - 78°00′E)

India's long tradition of vegetarianism is founded on religious and philosophical principles. But lately the consumption of meat in the country is on the increase. Worldwide, about two-thirds of the population eats a largely vegetarian diet—making one-third of the population meat eaters. The land areas and the quantities of energy and water required to produce meat greatly exceed those required to yield plants, and heavily meat-influenced diets put great pressure on the environment. Future generations will be deprived of essential resources if the world continues to consume its present-day quantities of meat. What's more, nutritionists have proved that the overconsumption of meat causes cardiovascular disease and numerous forms of cancer. A rational evolution toward a more balanced diet, richer in vegetables and fruit, would be beneficial both for the planet and for its inhabitants.

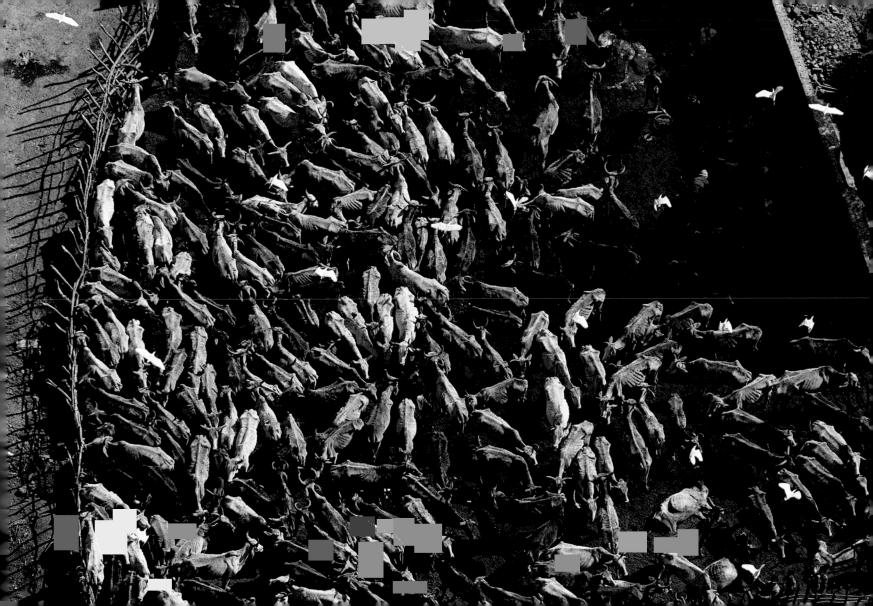

Mountain landscape near Jengish Chokusu, Ysyk-köl region, Kyrgyzstan $(42^{\circ}00' \, \text{N} - 80^{\circ}00' \, \text{E})$.

Mountains cover 95 percent of Kyrgyz territory, in the heart of central Asia. The climate is harsh and typically continental, with freezing winters lasting from October to May and temperatures varying between -12°F (-24°C) in winter and 86°F (30°C) in summer. The Tian Shan range that forms the country's natural eastern border with China is second only to the Himalayas in its abundance of peaks, of which the tallest is Jengish Chokusu (altitude 24,400 feet [7,439 meters]). High ridges alternate with the broad valleys that shelter Kyrgyzstan's principal cities and towns; the pattern of the landscape clearly evidences the wrinkling of the earth's crust, as a result of ongoing collision and convergence between continental landmasses. Hence Kyrgyzstan is frequently subject to earthquakes, which in turn provoke avalanches, landslides, and rock falls. These threaten not only the villages nestled in the high valleys but also the wandering nomads who in summer take their livestock to graze in the mountain pastures.

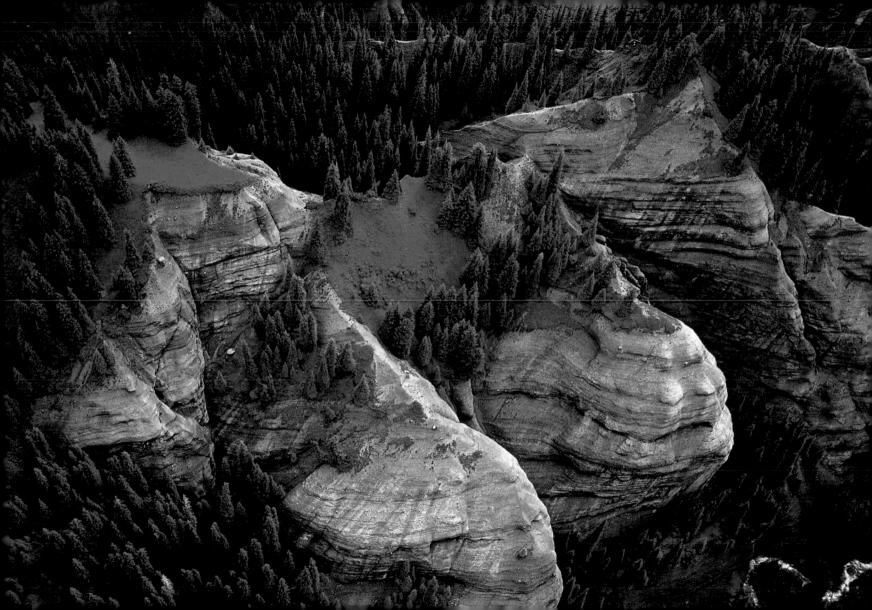

Traditional village, southwest of Antananarivo, Madagascar (18°49'S - 47°32'E)

Madagascar is one of the twenty poorest countries in the world and spends less money on the health of its citizens than any other African nation does (eighteen dollars annually per head). But despite this, Madagascar is one of the few nations of sub-Saharan Africa that has had no serious AIDS epidemic. For nearly thirty years, this disease has grown alarmingly elsewhere. In 2005, more than 25 million Africans were HIV positive—70 percent of the world total—and 2.4 million people died from it (the figure in Western Europe was 2,252). In four southern African countries, the percentage of HIV-positive adults is quite simply terrifying: 38.8 percent in Swaziland, 37.3 percent in Botswana, 28.9 percent in Lesotho, and 24.6 percent in Zimbabwe. The human losses are now such that the epidemic is having major repercussions on the continent's economy and is perpetuating a crisis in its food supply. The phenomenon has yet to reach its height, and the international community—states, nongovernmental organizations, and international institutions combined—has yet to find a response that can in any way match the magnitude of the disaster.

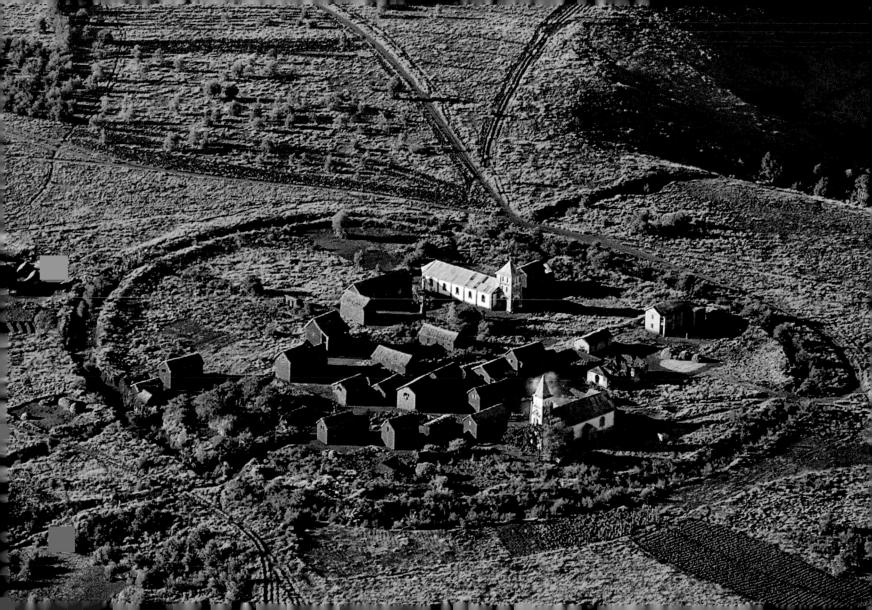

The Pisa River, Poland (53°15'N - 21°52'E)

Poland, at the heart of the great northern European plain, stretches from northern France to the Ural Mountains, and is bordered to the south by the Carpathian range and to the north by the Baltic Sea. The inland regions of northeastern Poland are covered in gentle hills, the Baltic Crests, which are filled with lakes and rivers. In the Masurian Lakeland region, where the Pisa River has its source, roughly 5,000 acres (2,000 hectares) were set aside for a UNESCO biosphere reserve and for the conservation of wetlands protected under the Ramsar Convention on Wetlands. The gently winding Pisa, with its adjoining meadows, has been managed in a thoroughly natural way, with no construction and no artificial embankments. Any construction too close to the river would be hazardous, given that the river's course alters quite naturally from year to year; the water flows more rapidly on the outer edge of each turn, inevitably eroding the far bank and broadening its bed. On the other hand, the water circulates more slowly on the inside of the oxbow, and the land there is gaining ground from the river, as its eddies deposit silt that fills the shallows.

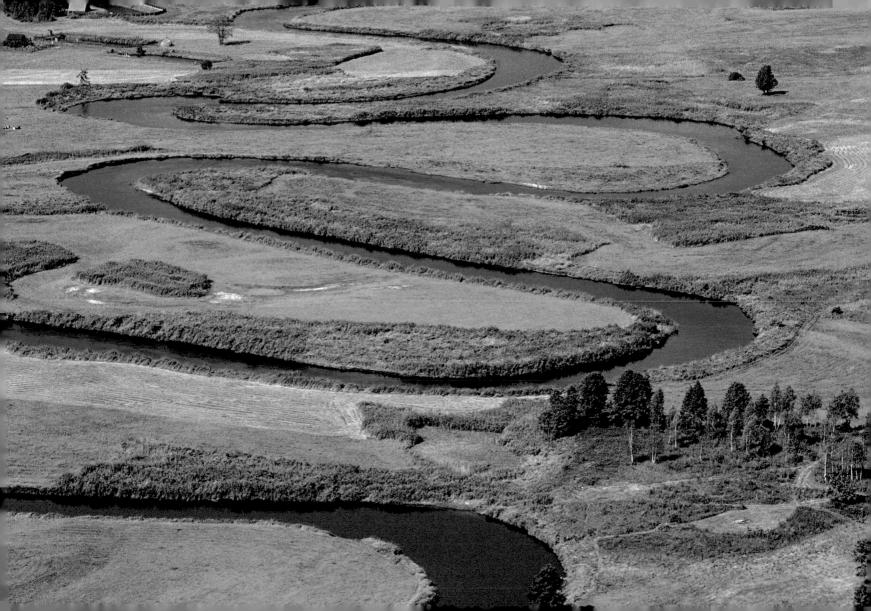

Pyramid of King Snefru, Egypt (29°47′N - 31°13′E)

This rhomboid monument stands a few miles from Saqqara, in the Dahshur necropolis, which has been open to the public for only ten years. Its strange shape is accidental; it was originally designed without steps, but its master builders had to rectify their plans as they went along to keep the structure from collapsing. Far from being discouraged by this mishap, the "good king" Snefru decided to build another pyramid—this time straight-sided—and this became the Red Pyramid, the forerunner of the Great Pyramid of Giza. Snefru, the first king of the Fourth Dynasty, is otherwise known for having created the office of vizir, for keeping count of the pharaoh's livestock. Much loved by his people, he led military expeditions to Sinai, Nubia, Lebanon, and Libya, and even became the object of local religious cults in Sinai and Dahshur. The rhomboid pyramid of Snefru represents the intermediate stage between the stepped pyramid (Djoser) and the classic, square-based pyramid (Cheops).

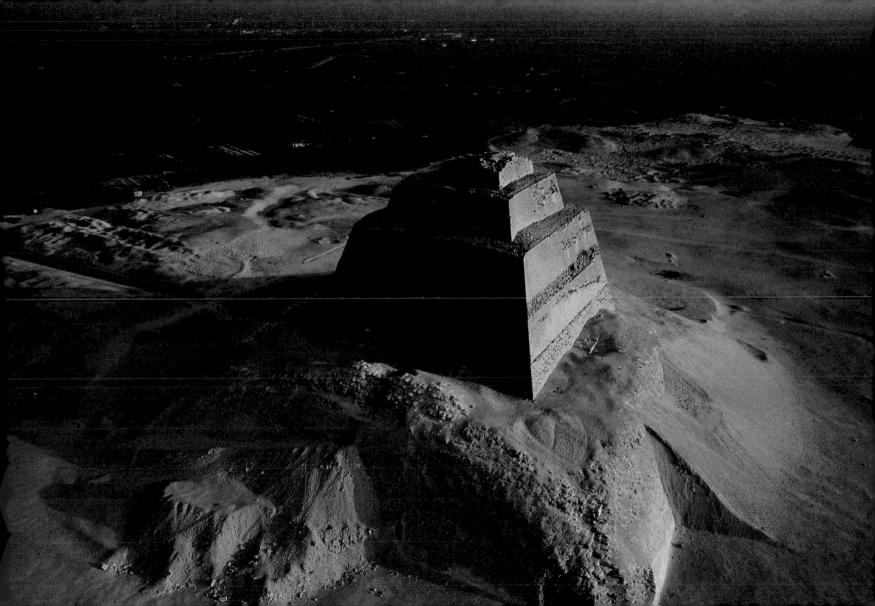

Family allotments, Avanchets housing estate, Geneva, Switzerland $(46^{\circ}12'N - 6^{\circ}09'E)$

The first workers' gardens in Europe were created at the end of the nineteenth century to allow laborers to improve their diet and health. After the First World War, Switzerland followed suit, allotting some 900,000 land parcels to Swiss families; today these occupy 124,000 acres (50,000 hectares) of land, the equivalent of three thousand average-size agricultural enterprises. Worldwide, there are thought to be some 800 million amateur smallholders operating in urban areas. In the cities of Southeast Asia, in certain conurbations of Central and South America, and throughout Europe, many people depend on their small farms for their survival. In Berlin, there are over 80,000 city cultivators; in Russia more than 72 percent of urban families sow and weed their own small piece of ground or use their balconies or even their roofs to grow things. Urban agriculture is expanding at a rapid pace, and the numbers of people practicing it could well double in the next twenty years. Yet in Switzerland and all these countries, urban soils are heavily polluted and may actually contaminate the fruits and vegetables grown in them.

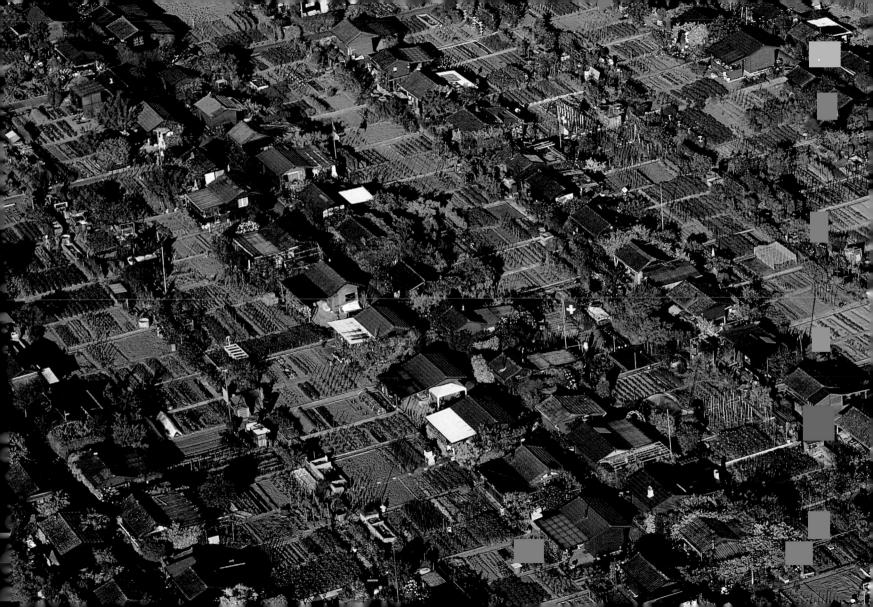

Ice sculpted by the wind, summit of Mount Discovery, Antarctica (South Pole) $(78^{\circ}20'S - 165^{\circ}00'E)$

On the summit of this extinct 8,800-foot (2,681-meter) volcano, the snow and ice are sculpted by the katabatic winds of the Transantarctic Mountains. Very cold and extremely violent, these winds begin at the top of the ice cap and reach speeds of up to 186 miles (300 kilometers) per hour as they blast down the slopes to the shore. Because of its climatic isolation, Antarctica is covered in a layer of ice some 8 million cubic miles (33 million cubic kilometers) in volume. The weight of this ice is so immense that the continent is partially below sea level. This icy carapace is—with the Southern Ocean and its masses of water that flow up to the Northern Hemisphere—the largest climate-control system on our planet. The Antarctic is a land of paradox; no other continent has such vast reserves of freshwater as Antarctica (it boasts 70 percent of the planet's total)—but its water is frozen and unavailable, and the continent is thus the world's driest desert.

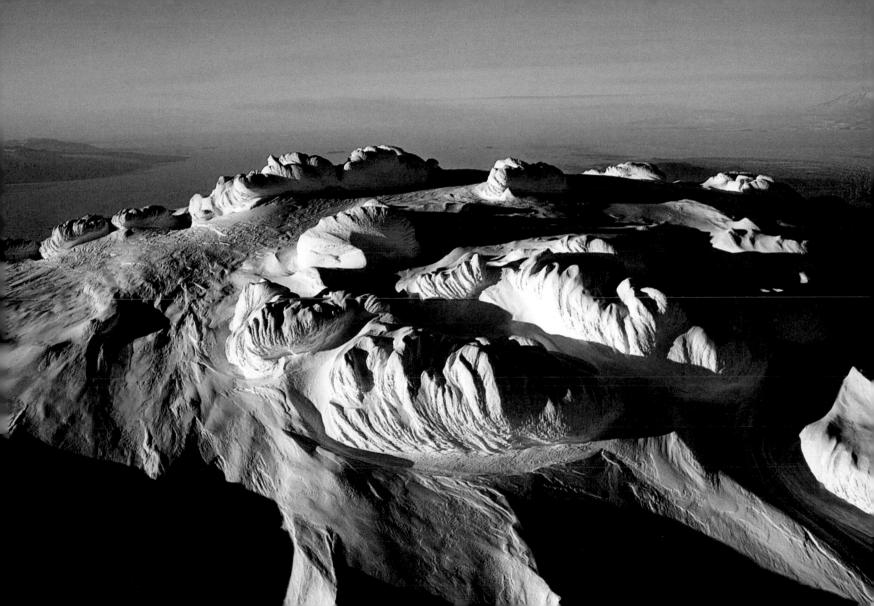

Parasols on a beach, south coast of Phuket Island, Thailand (7°49'N - 98°18'E)

For millennia, humankind has made use of the resources of the oceans and mountains without having to develop or disfigure them to create holiday resorts. But ever since the 1950s, the growth of easy transportation and tourism has made it possible for millions of people to travel thousands of miles in search of their dream destinations. The tourist industry does support socioeconomic development and jobs, but its infrastructures (roads, hotels, airports, supermarkets, coastal development) are frequently put in place without consulting local people and without the least respect for the natural environment. The bargain prices offered by travel agencies also contribute to the exploitation of local working people, especially children. In Thailand, for example, tourism is a major economic sector that employs more than 10 percent of the active population. In 2007, the number of tourists traveling abroad increased yet again by 6 percent. Tourism, the mirror image of globalization and the standardization of cultures and ways of life, now generates 12 percent of the world's gross national product.

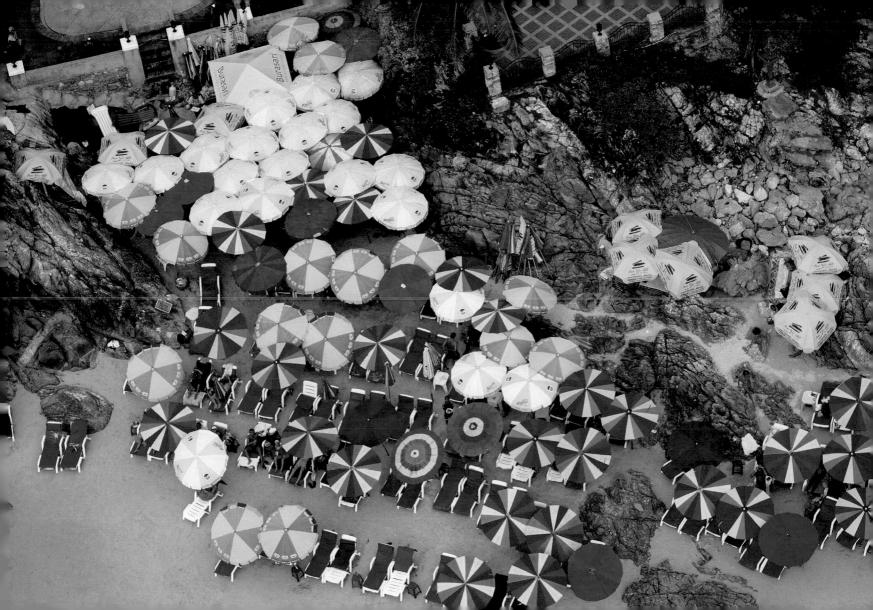

Graveyard of military vehicles, Mount Lebanon, Jbeil, Lebanon $(34^{\circ}07'N - 35^{\circ}39'E)$

Jbeil, 31 miles (50 kilometers) north of Beirut, is the modern version of ancient Byblos. These armored military vehicles, aligned as if on parade, do nothing to evoke this age-old history, but rather evoke the hideous Lebanese Civil War. which caused the deaths of 140,000 people between 1975 and 1990. In those years, a conflict between different communities and religions, with a backdrop of Arab-Israeli rivalry, engulfed this tiny country, impacting its 3.5 million inhabitants. Fortunately, Jbeil, unlike Beirut, was able even at the height of the war to keep the peace between its majority Maronite Christians and its Shiite Muslims. Not far from Jbeil, many of Mount Lebanon's villages were destroyed during the "Mountain War" (1983-1985) between Christian Lebanese forces and the Druze fighters of the Progressive Socialist Party. In 1985 the Taef Accords provided for a general disarmament of militias and the departure of Syrian troops from Lebanon. But Syrian evacuation only became a reality in 2005, and some of the militias have yet to disarm. The region's history of war offers a grim reminder that, on a global basis, 90 percent of all victims of war are civilians.

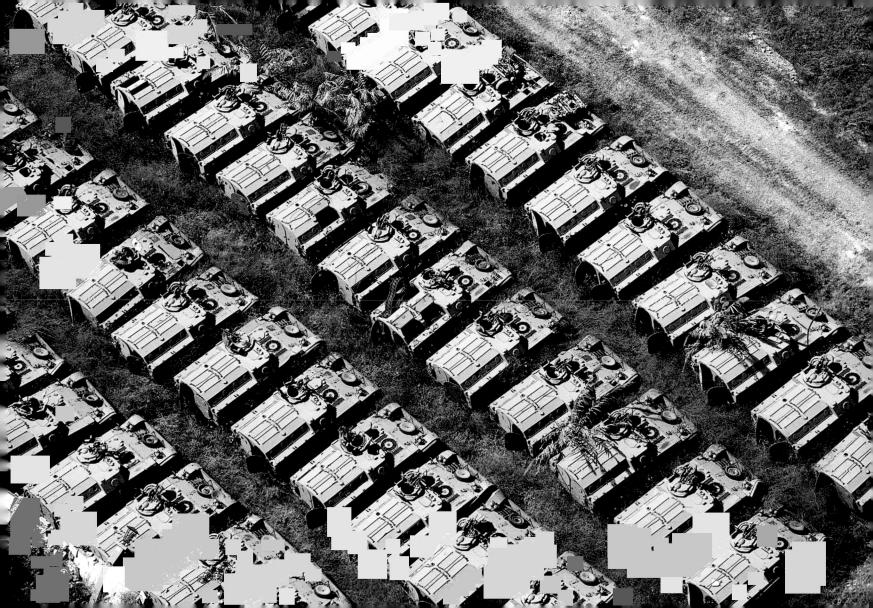

Facade of the Dolmabahçe Palace, Istanbul, Turkey (41°01'N - 28°58'E)

Since October 2005, Turkey has been involved in negotiations to join the European Union. The parliamentary republic (population 70 million), where universal suffrage has been the rule since 1950, has become a huge issue for Europe. While the country has made great strides in terms of establishing a market economy and democracy—two essential criteria for European Community (EC) membership—it has lagged significantly in terms of women's rights, freedom of religion, union rights, and the protection of minorities. Moreover, Turkey, which still refuses to admit its twentieth-century genocide of Armenians, continues its military occupation of northern Cyprus, whose sovereignty it disputes (although the Cypriot republic is already a full member of the EC). All too many minorities in the world are forced to live under acutely difficult conditions; 900 million people, all told, belong to marginalized groups, and of those, 359 million are discriminated against on account of their religion. As for ethnic minorities, they are represented by some 370 million people throughout seventy countries.

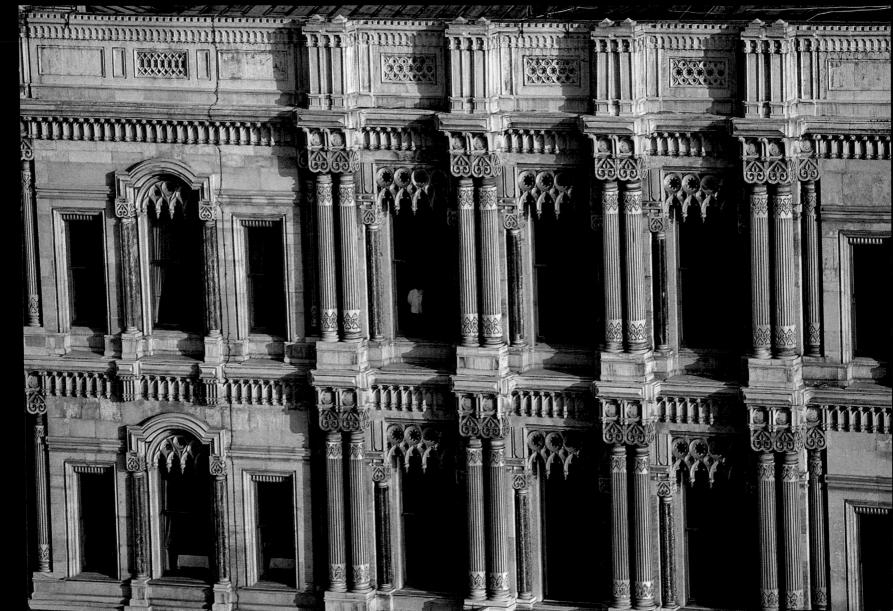

Mo'orea atoll, Society Islands, French Polynesia (17°31'S - 149°49'W)

Blue sky, turquoise sea, white sandy beaches shaded by coconut palms—in addition to such visions of paradise, the islands of French Polynesia harbor a great natural treasure: 10 percent of the coral reefs and 20 percent of the atolls on planet earth. The responsibility for protecting this precious heritage, which falls to France, is a great one—the less than 1 percent of the seabed that is actually covered in coral contains at least 100,000 different animal and vegetable species, and 20 percent of the world's population depends on these for its sustenance (it's probable that more than 1 million coral species still remain to be discovered). Despite all this, humankind's total annual investment in protecting these reefs is less than twenty-five hundred dollars per square mile (a thousand dollars per square kilometer). Today, 60 percent of the world's coral reefs have been deteriorated by pollution, overfishing, tourism, and rising water temperatures.

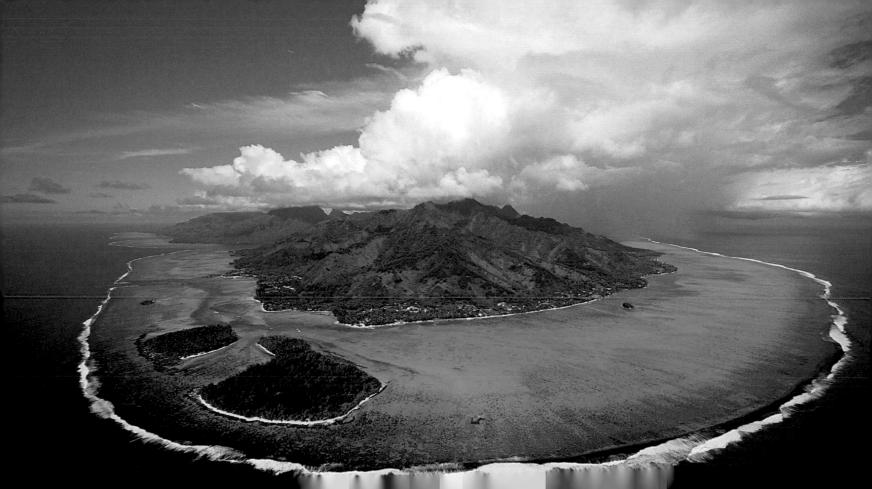

Parabolic solar cooker, Toamasina, Madagascar (17°55'S - 48°08'E)

Madagascar, the fourth-largest island in the world, lies 249 miles (400 kilometers) from the African continent in the Indian Ocean. With its mud-built houses, this landscape is reminiscent of Africa, and although the tropical climate may not be as roasting hot, it is nevertheless ideal for the use of solar energy. The presence of a parabolic oven in this photograph is testimony to the recent realization of the problems caused by deforestation in a country where 90 percent of the primary forest has been destroyed. Madagascans have always cooked with wood fires; a typical family would use an average of 220 pounds (100 kilograms) of charcoal per year, representing about a quarter of its income. Using Archimedes's system of mirrors, the parabolic oven focuses the rays of the sun to produce a high temperature that can roast, fry, or boil. It can also be used to dry fabrics, as well as to sterilize surgical instruments and water. The parabolic reflector is made of shiny weather-resistant aluminum, with a galvanized steel support. The technique is perfectly adapted to the milieu and has many advantages; for example, families spend much less time and money on obtaining charcoal and wood because there is no need for a fire. Instead, the solar process is hygienic, produces no harmful smoke, emits no carbon dioxide, and avoids deforestation.

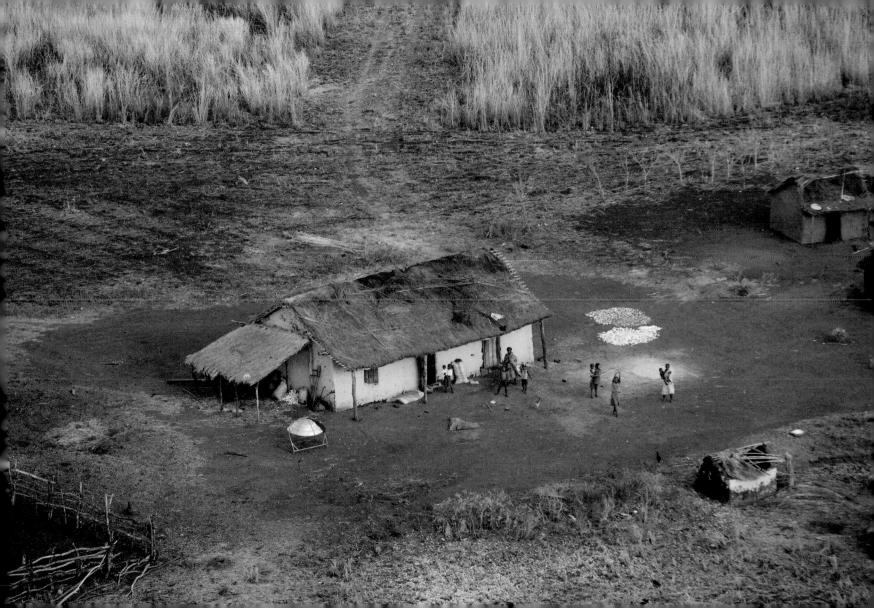

RENEWABLE ENERGY

The International Energy Agency (IEA) predicts that primary global energy needs will increase by 55 percent between 2005 and 2030, at an annual rate of I.18 percent. This is the equivalent of a demand for 17.7 billion tons of a fuel oil equivalent (FOE) in 2030 as opposed to 11.4 billion tons in 2005. Oil, gas, and coal would represent 84 percent of this extra demand.

The developing countries whose economies and populations are growing most rapidly will create 74 percent of the growth in world energy consumption according to this scenario, with 45 percent credited to China and India.

The environmental effects of growth on this scale are extremely alarming if we go by the rises in temperature already observed, and by the climate events whose intensity and frequency are currently increasing. Even from a strictly economic standpoint, this situation confronts us with a reality to which we must now adapt: namely, that the era of cheap energy is over. The rising price of a barrel of oil since 2003 says it all—\$25 a barrel in 2002, \$30 in 2003, \$40 in 2004, \$50 in 2005, \$60 in 2006, \$72 in 2007, and over \$110 a barrel in 2008. The European Union, which is only too aware of this state of affairs, now plans to adopt a directive on renewable energy sources that would derive 20 percent of European energy consumption from renewable sources by 2020.

It hasn't quite sunk in yet that this directive will significantly disrupt people's habits and behavior. In France, the change was launched in October 2007 at what has become known as the Grenelle de l'Environnement conference. This negotiation brought together all the key institutions involved in sustainable development in France (the state, local authorities, businesses, environmental associations, and NGOs) for a dialogue with a view to immediate and long-term decisions. Every sector was discussed, from the building industry to agriculture, from transportation to energy. For the renewable energy sector, the meeting led to concrete proposals that were reflected in a plan for the development of renewable energy sources of high environmental quality. The plan provides for the installation of 25,000 megawatts of wind

power (6,000 of which will be generated offshore), 5,400 megawatts of solar cells, 9 million wood-heated homes, 4.3 million homes fitted with solar heating, and 2 million homes fitted with heat pumps.

A major revolution in France is currently under way. From now until 2020, no new construction will be undertaken other than on the model of the positive-energy house. Thanks to systems of renewable energy production, such as photovoltaic modules, solar water heaters, ground-coupled heat exchangers, and heat pumps, all in combination with free solar energy and adequate insulation, the buildings of tomorrow should produce more heat than they consume. In time it will become just as incongruous to build houses like thermal sieves as to suggest a return to the days when street lamps were lit by hand. In the meantime, today it is urgent for us to embrace sound practices, choose sound materials, and drastically reduce the negative impacts that will present themselves at various stages in the life of a building. Bad workmanship or errors of conception can engender high-energy consumption. Bioclimatic architecture is good practice. It is evidenced by a will to build with the climate, to magnify the contribution of solar energy, to protect ourselves from the wintry weather and prevailing winds, and to let in natural light wherever possible. In this sense, we may affirm that the solar houses built in the course of the last twenty years are the older sisters of positive-energy houses.

The rapid development of renewable energies is now a tangible reality that nobody can ignore. Who would have imagined, ten years ago, that by 2007 the European Union would have installed 56,000 megawatts of wind power production units, over 236 million square feet (22 million square meters) of solar heating panels, and almost 5,000 megawatts of photovoltaic cells? Who would have believed us capable of mobilizing 62 million FOE of biogas and close to 8 million FOE of biofuel? The energy change that will lead us from fossil fuel to renewable fuel—and which will take into account the vast power of small, evenly distributed energy sources alongside major centralized sources—is well under way, and it will be world-wide. For these reasons, we are bound to witness the development of the notion of "intelligent" electrical

transportation networks. These will take into account the diversity of supply sources, as well as variables of production and consumption and the appearance of a concentrated form of management, which will be at once local and international. As far as solar electricity is concerned, we are going to see a major growth in power supplies from concentrated solar power plants, also called helio-thermodynamic plants. These, installed in the countries of the so-called Sun Belt, will render us a major service and above all relieve some of the pressure exerted by the world's tightening energy constraints.

Renewable energy will develop very strongly in emerging countries. China is positioned today as a future leader in wind power and photovoltaic production, while India has already reached the forefront in wind power. This stand taken by major developing countries is excellent news, because it will reinforce the international competition that has already begun between Europe, the United States, and Japan, while lowering prices and broadening the research and development effort that is already under way.

Renewable energy sources of high environmental quality are powerful tools. Just open your eyes and you will see them and eventually use them. They have reached the stage of critical balance and will shortly attain maturity, or rather the age of reason. Planetary reason, naturally.

Alain Liébard

President, Renewable Energy Observatory

Village of Joal-Fadiout, Senegal (14°10'N - 16°51'W)

The island of Fadiout is linked by two wooden bridges to the village of Joal; together, the two townships form a commune of 35,000 souls. Situated on the Petite Côte about 62 miles (100 kilometers) from Dakar, Joal-Fadiout has one of the highest standards of living in Senegal. The village is a tourist attraction; it was the childhood home of Leopold Sédar Senghor, the black advocate and first president of the Republic of Senegal, who is also buried there. Joal is also the country's main traditional fishing port, thanks to the abundant variety of marine life along this coast (*sardinelles*, threadfin, mackerel, grouper, sea bream, shrimp, and spiny lobsters). The sheer volume of local catches has stimulated an intense processing industry, which is largely supervised by women. Traditionally, women also gathered shellfish, whose empty shells were famously used to pave the streets of Fadiout, hence its English name, Sea Shell Island. Here the ground is blindingly white and crunches underfoot. According to the elders, the village itself is founded on shells accumulated by their ancestors.

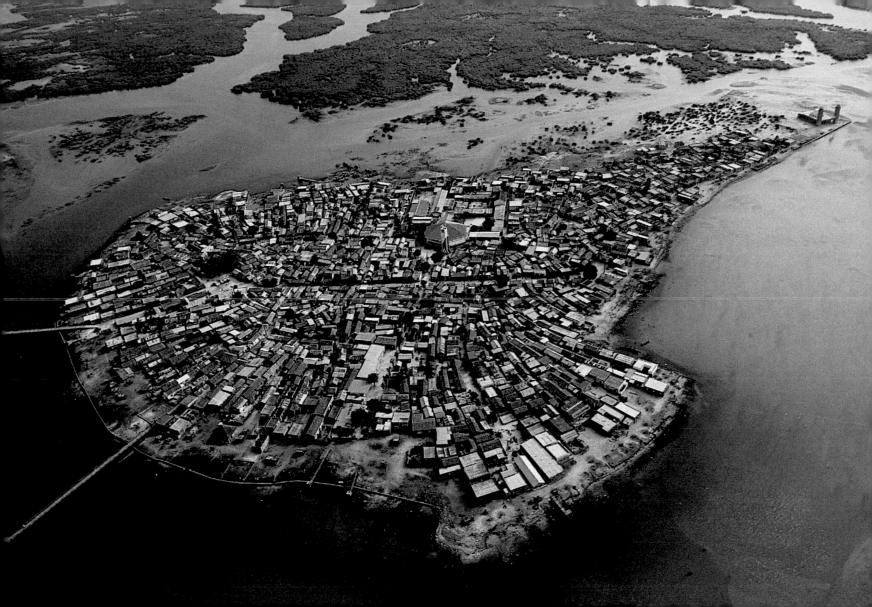

Drying peppers, Nayarit, Mexico (22°00′N - 105°00′W)

When these Mexican peppers are ripe, they are picked and left to dry in the open air; they are later ground into powder and used for sauces. Among the most basic ingredients in Mexican cooking, dried peppers also yield a red pigment that can be used as a colorant for salted meats such as chorizo; chicken farmers even add them to hen feed, to give egg yolks a darker color. The world's widest variety of chilis and sweet peppers is grown in Mexico, where they originated from a single species, *Capsicum annuum*. China produces the largest quantity; Turkey, India, Indonesia, Spain, Nigeria, and the United States are also substantial growers. In Mexico, 173,000 acres (70,000 hectares) is apportioned to pepper growing, one-fifth of the total area used for vegetable cultivation.

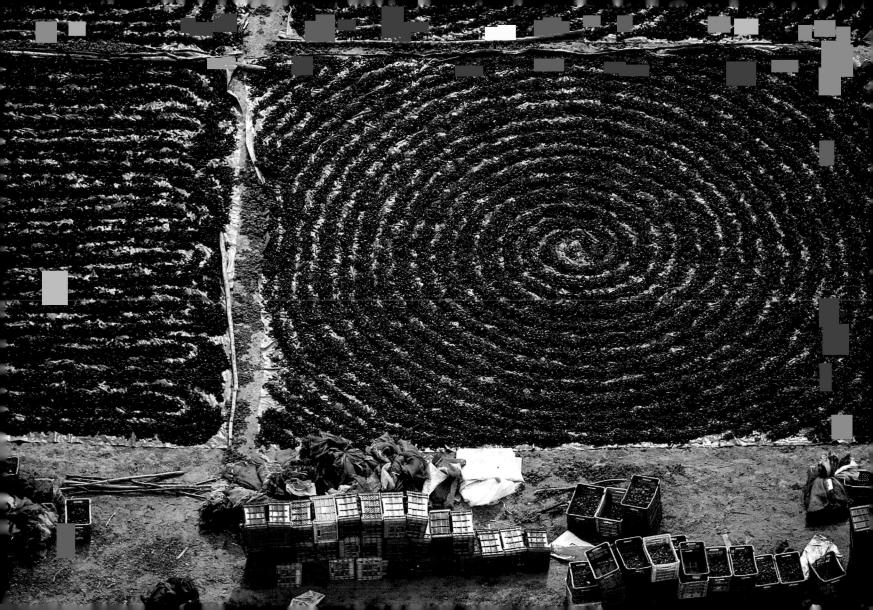

Cattle grazing in the pantanal, Brazil (17°36'S - 57°30'W)

With more than 72,500 square miles (187,800 square kilometers) of land, the pantanal ("marsh" in Portuguese) forms one of the world's largest wet zones, extending across southwestern Brazil right through to Bolivia and Paraguay. In the dry season, thousands of cattle graze the pantanal's grass-covered plains, gouging deep tracks in the mud along their passage. But these natural pasturelands are short-lived; from November to March they are entirely flooded by the swollen Paraguay River and its tributaries. During these months the cattle retreat to a few dry islands, giving way to 650 bird species to feed on 250 species of fish. This extraordinary Noah's ark of a region, whose biodiversity is comparable to that of the Amazon, is also the haunt of jaguars, caimans, tapirs, and giant otters. However, it remains a fragile ecosystem, threatened by overgrazing and included in UNESCO's list of World Heritage Sites since 2000.

Ice in the Turku archipelago, Finland (60°15′N - 21°51′E)

One-quarter of Finnish territory lies within the Arctic Circle, and every winter the country's coasts are completely choked by ice. To overcome this geoclimatic constraint, which severely hampers its commercial activities, Finland has developed an industry dedicated to the construction of icebreakers. For several months at a time, a fleet of eighty of these ships cruises the Baltic, coming to the assistance of vessels stuck in the ice and keeping the major seaways (such as Helsinki-Tallinn) open. These mighty ships use raw power to work their way through the frozen sea, riding up on the ice pack and shattering it with their weight. Thereafter, their bows simply thrust the broken pieces aside. Since 1950, the total area of sea ice on the planet has shrunk by 10 to 15 percent in the Northern Hemisphere, and by 40 percent in the Arctic Ocean.

Condor in flight above the Encantada valley, Neuquén, Argentina (39°00'S - 70°00'W)

The Andean condor (*Vultur gryphus*) spreads its 10-foot (3-meter) wingspan and floats without apparent effort above the fall foliage of Patagonia. Formerly revered by the Incas, the world's largest bird remains a living symbol of the wild Cordillera. Before the arrival of colonists in the sixteenth century, these raptors were abundant throughout the Andes, from Venezuela to Tierra del Fuego by way of the Peruvian coast. But condors acquired a bad reputation as carrion eaters and were so persecuted that they vanished altogether from certain regions, notably in Venezuela and Colombia. Today they are being reintroduced in those countries, and in Argentina and Chile they have been well preserved in certain pockets. Raptors in general have benefited from protection campaigns all over the world, and their futures look brighter as a result. But other bird species have not been so lucky; 12 percent of them are now seriously threatened with extinction.

El-Atteuf, M'Zab valley, Algeria (32°27' N - 3°44' E)

About 621 miles (1,000 kilometers) south of Algiers, beyond the ridges of the Saharan Atlas Mountains, the Wadi M'Zab winds across the first plateaus of the Western Grand Erg. All along it are towns built of pinkish *crépis*, with narrow. covered alleys and soft light. The climate is harsh, hot, and windy, and rain seldom falls. But the towns, originally built by the Mozabites in the eleventh century, are marvels that have intrigued the greatest architects of the West, among them Le Corbusier and Frank Lloyd Wright. All these towns have an extraordinary unity, and all are set on hilltops beyond the reach of the rare but violent floods that afflict the wadi. Moreover, they are all built according to the same plan, with houses constructed outward from a mosque—which stands at the highest elevation—and down to the ramparts. Beyond the ramparts are groves of palms, which provide fruit and cool shade during the summer months. The houses are generally organized around a main room, with a ceiling that has a broad square open above the central patio, where the family comes together. A staircase leads from there up to a terrace, sometimes edged by small rooms for sleeping during the winter.

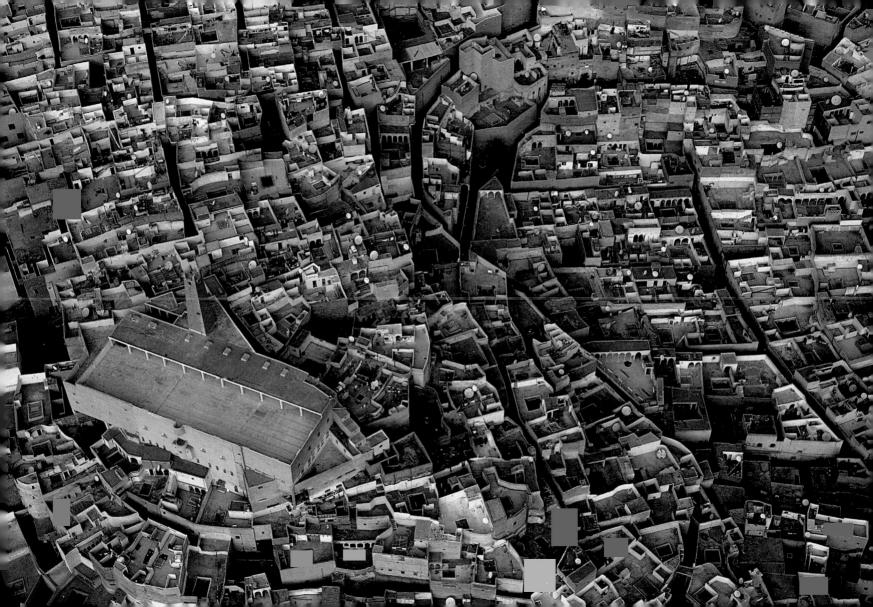

Architectural landscape near Yanggu, Gangwon-do Province, South Korea (38°00′N - 128°15′E)

South Korea, a new industrial power and the world's eleventh-largest economy in 2007, now owes less than 3 percent of its gross national product to agriculture. Arable land in this mostly mountainous country occupies a mere 16.6 percent of total acreage, and half of that is exclusively devoted to rice growing. This misty agricultural basin surrounded by craggy peaks is no exception—even its shape reminds Koreans of a rice bowl. In winter, the furrows fill with snow, but in summer the rice paddies reflect the sunshine in a complex marguetry of green and ocher, the epitome of a quiet, carefully tended landscape. Machines scoop up the soil and deposit it in piles to improve its fertility; it's renewed before the rice is planted out. In its quest for self-sufficiency, South Korea has made rice growing a political priority; in 2004, only 4 percent of the rice consumed in the country was imported. To underscore this objective, the government has raised all manner of obstacles against rice imports, at the same time paying subsidies to its own farmers. Since 2005, however, South Korea has been honoring its commitment to the World Trade Organization by gradually doing away with these protectionist measures and increasing its rice importation quota to 8 percent by 2014.

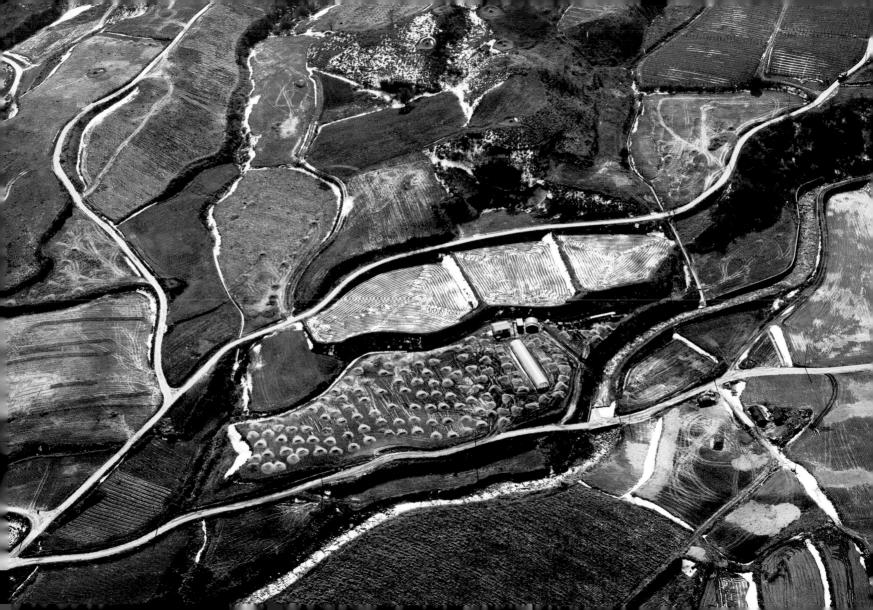

Terminal 2, Charles de Gaulle International (Roissy) Airport, Val d'Oise, France $(49^{\circ}00' \text{N} - 2^{\circ}31' \text{E})$

Pollution linked to air corridors has emerged as a very serious threat to the environment and to human health. About 1 million people living within a 3-mile (5-kilometer) perimeter of France's Roissy Airport are subjected to sound and atmospheric pollution as a direct result of airport activity. The deafening roar of aircraft taking off and landing is a continual nuisance to local people. Meanwhile. the local air levels of nitrogen dioxide are regularly 20 percent higher than those recorded in the center of Paris. Worldwide, air transport emits more greenhouse gases per year than the entire yearly range of activities carried out in a country the size of France. A return flight from Paris to New York emits nearly a ton of carbon dioxide per passenger. A plane passenger emits about 8 ounces of CO2 per mile (140 grams of CO₂ per kilometer), while a motorcar passenger emits 6 ounces per mile (100 grams per kilometer). But while motor transport is taxed each time a driver buys gasoline, air transport is affected by no particular tax, and no international agreement exists to reduce the levels of pollution for which it is responsible. Air transport, in short, is a forgotten sector in the Kyoto Protocol—yet it is growing at an annual rate of 10 percent.

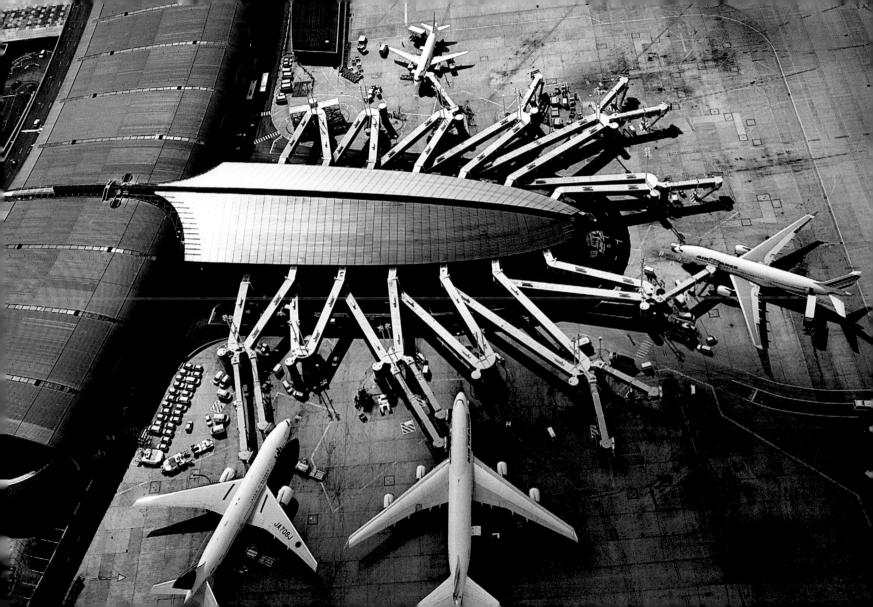

Irrigation near El Oued oasis, Algeria (33°22′N - 6°52′E)

The Souf, 373 miles (600 kilometers) southeast of Algiers, is an oasis on the edge of the desert. El Oued, its capital, owes its prosperity and its reputation to the variety of dealet-nour dates produced by its palm groves and exported to Europe. To expand their economy, the Soufis have intensified their production by broadening the perimeters of the irrigated produce destined for sale in the big cities. Cereals, fodder, and vegetables are cultivated in broad circular parcels each of which can cover up to 148 acres (60 hectares)—which are watered around a central pivot. The powerful machinery involved hugely reduces production costs—but the real picture is more an image of catastrophe than of flowering desert. Massive irrigation and the installation of running water in the town are rapidly emptying the deep table from which the water is drawn. As soon as it is pumped to the surface, the water is polluted by herbicides and fertilizers, whereupon it filters into the shallow water table. This is now greatly swollen in places, making houses damp and killing plants. Already a million palm trees have died in the area, asphyxiated by stagnant water.

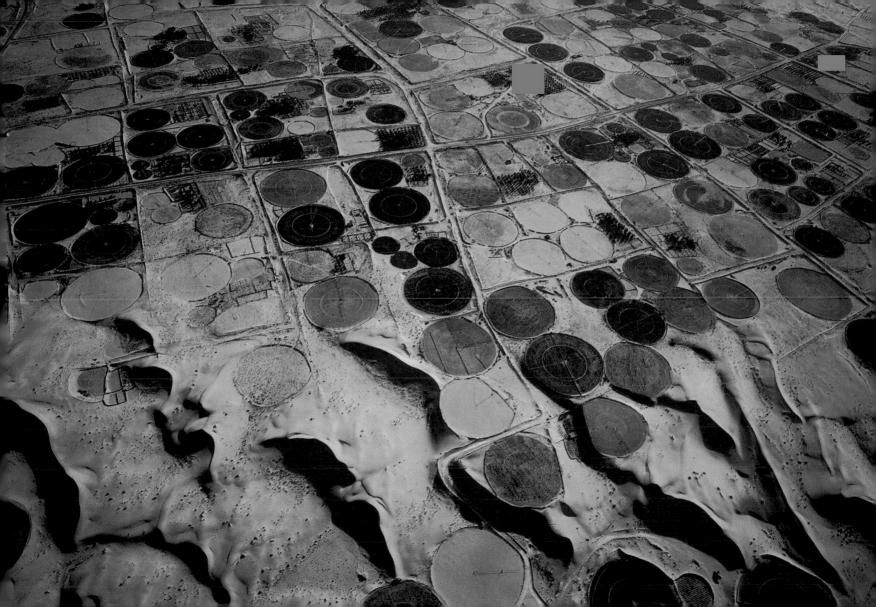

Christian and Muslim cemeteries, Gibraltar (36°08'N - 5°21'W)

Christians and Muslims share a burial ground on the British outpost of Gibraltar. This 2.4-square-mile (6-square-kilometer) rock in southern Spain stands at the junction of Europe and Africa, controlling the passage from the Mediterranean Sea to the Atlantic Ocean. A major crossroads between two worlds and two seas. for centuries Gibraltar has been a place of exchange as well as of conflict, notably between the Muslim and Christian cultures. In the eighth century, it was the point of departure for the Arab conquest of the Iberian Peninsula by Tarik Ibn Zevad. who gave his name to the rock; Jabal-Al-Tariq (mountain of Tariq), which was named Gibraltar at the time of the Castilian Reconquista in the fifteenth century. In 1705, the British took the rock, and it was formally recognized as a British possession at the Treaty of Utrecht in 1713. This key point of Mediterranean-Atlantic relations is still the object of a long-running Anglo-Spanish dispute. Formerly a strategic refueling base for pirates and slave-traders, the island today has become a center for contraband, drugs, and prostitution. On the outer frontier of the European Union, the Strait of Gibraltar, 8.4 miles (14 kilometers) wide, is currently a route for illegal immigration from Africa to Europe: in fact, more than a hundred people drowned in the Strait in 2007, while attempting to reach Europe.

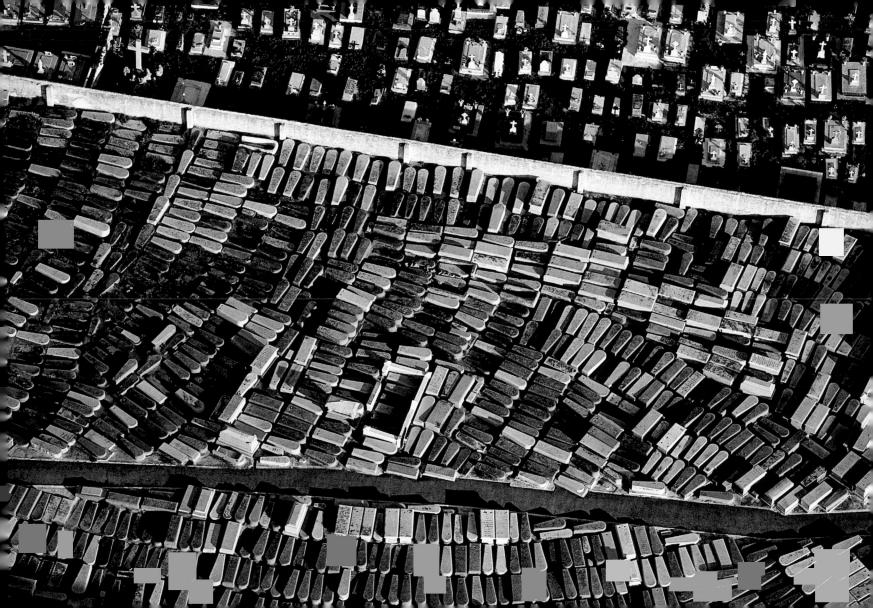

Fortified city of Jaisalmer, Rajasthan, India (26°55′N - 70°54′E)

The Raiputana (today's Rajasthan), or Country of the King's Son, in northwestern India, formerly consisted of about twenty princely states. Founded in 1150 by Rao Jaisal, the Raiput sovereign who established his own Bhatti clan as masters of the city, the fortress of Jaisalmer occupied a strategic point on the Spice Road traveled by caravans between central Asia and India. The crenellated ramparts of the citadel are a reminder of the endless assaults and sieges mounted by the Muslim sultans of Delhi against the Bhattis, and of the famous occasion when Raiput men and women opted to immolate themselves in the flames of a jauhar (collective sacrifice) rather than surrender to their enemies. In the sixteenth century, the maharawals of Jaisalmer stoutly resisted the Mogul offensive before finally submitting to imperial rule. After this the city prospered and the sumptuous golden sandstone facades of its havelis (rich merchants' houses in the lower town) were intricately decorated with lattice gratings, balconies with finely chased colonnettes, and other fragile stonework. The rise of sea-trade routes in the nineteenth century brought about the decline of Jaisalmer, though its silhouette remains a timeless mirage on the edge of the Thar Desert.

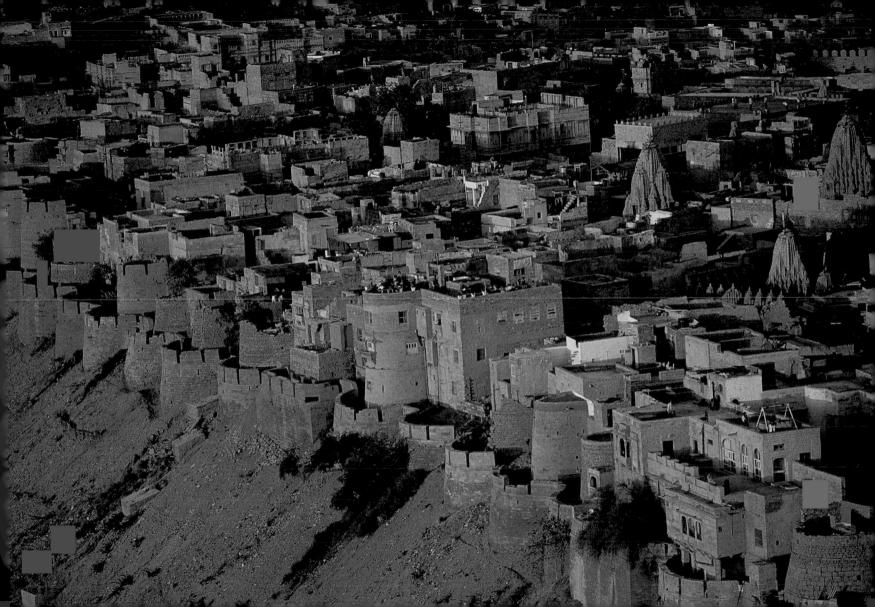

Mountain landscape near Mælifellssandur, Mýrdalsjökull region, Iceland (63°51′N - 19°18′W)

Iceland is a young volcanic island in geological terms; its oldest basaltic rocks go back only 20 million years. Positioned on the junction of the Eurasian and North American plates, it came into existence as a result of the parting of the mid-Atlantic dorsal ridge. A place of high volcanic activity, it has experienced every form of volcanic event; but each time, as soon as the lava has cooled, life has gradually crept back. Ice, snow, and water first flatten the volcanic reliefs and channel them. Next, summer after summer, bacteria, lichen, and mushrooms prepare the soil for plants, notably mosses, which are well adapted to the hostile environment. Little by little, plants colonize the most favorable places and form a new ecosystem.

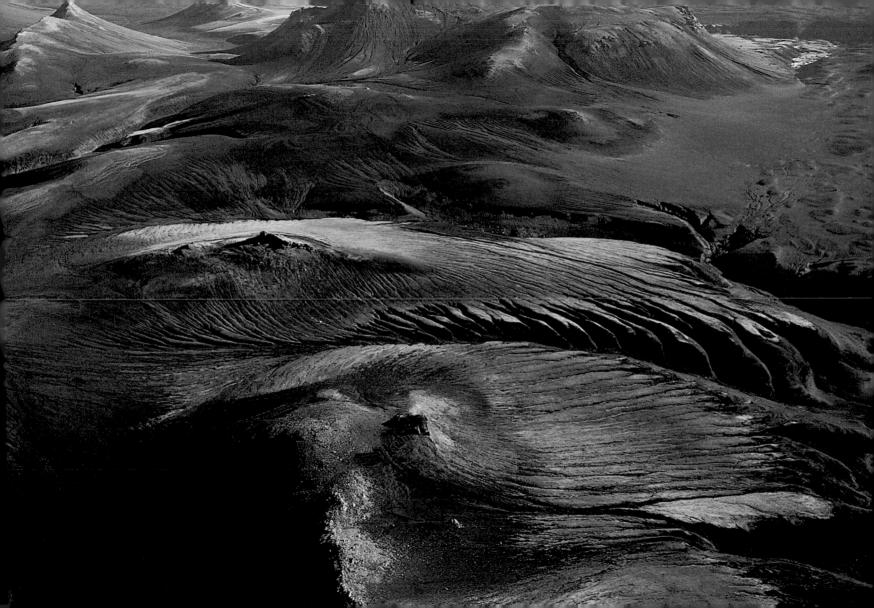

Sandbank in the Betsiboka delta, near Mahajanga, Madagascar ($16^{\circ}03'S - 46^{\circ}36'E$)

From the white sand beaches of its west coast to the rugged cliffs of its east, Madagascar boasts nearly 2,800 miles (4,500 kilometers) of seacoast and lakeshore. The Betsiboka, one of the largest rivers in the country, winds along for 326 miles (525 kilometers) before it reaches the Indian Ocean off the industrial port of Mahajanga, the economic center of the island's northwest. The Mahajanga coast still has plenty of mangrove forests, full of seashells and crustaceans and offering refuge to dugongs, turtles, and seabirds. But the mangroves today are under severe threat from humans seeking fuel for limekilns or space for shrimp farms. More than a third of the world's mangrove forests have been destroyed in the last few decades, and half of those that remain are endangered. They are being cleared even more rapidly than tropical forests—yet mangroves not only have a role to play in sheltering ecosystems, but they also serve as bastions that can break the force of a cyclone. Madagascar is in a high-risk weather zone, and so is particularly concerned; every three or four years, cyclones cause heavy flooding, catastrophic erosion, and general destruction all over the island.

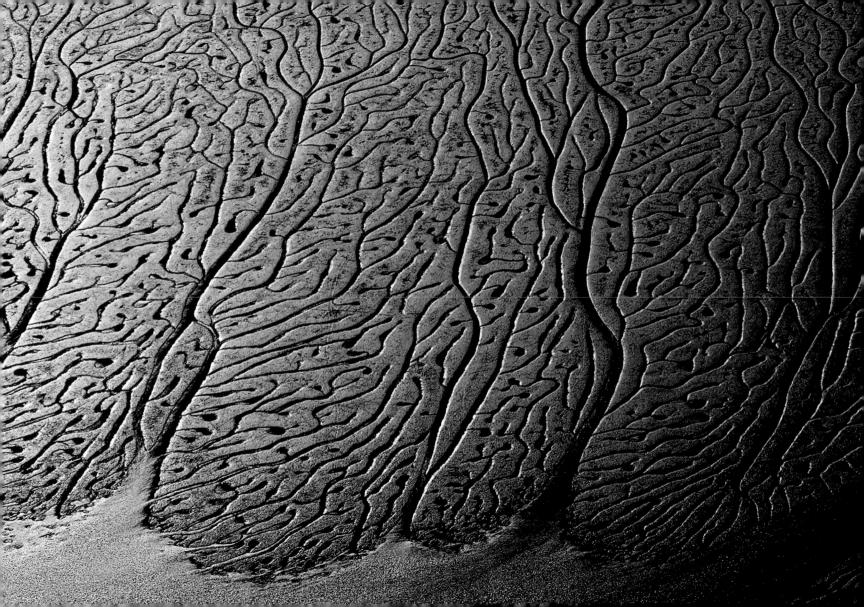

Point of the Cape of Good Hope, Republic of South Africa (34°21′S - 18°29′E)

The Cape of Good Hope, at the southwestern extremity of South Africa, is the mythic point where the waters of the Atlantic and the Indian oceans meet and mingle. First discovered by the Portuguese navigator Bartholomew Diaz in 1488, the Cape was rounded in 1497 by his rival, Vasco da Gama, who thereafter opened the sea route to the Indies. Five centuries after its discovery, this stormy granite spur still frightens mariners, who dread its powerful crosscurrents. But the meeting of the cold Benguela current and the hot Needles current also fosters an extraordinary habitat from which the point of the Cape and the entire peninsula benefits. A natural reserve since 1938, the site possesses literally thousands of endemic species, with more than 250 types of birds, in addition to turtles, zebras, and antelope. It also plays host to the unique spectacle of whales, seals, dolphins, and penguins swimming in the waters of two different oceans. Today the Cape of Good Hope Reserve is part of the Table Mountain National Park (19,200 acres [7,770 hectares]), which covers 25 miles (40 kilometers) of coastline.

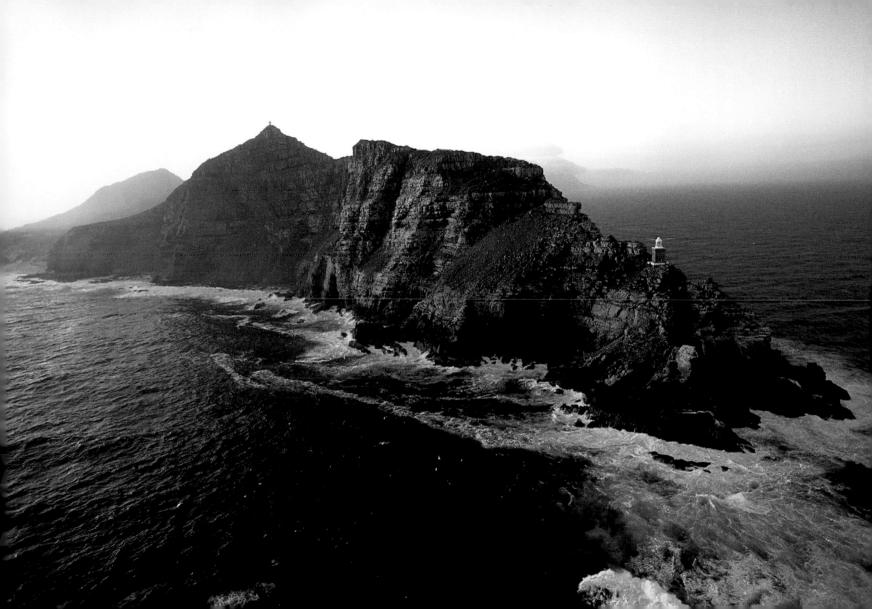

Wheat drying east of Pokhara, Nepal (28°12′N - 84°05′E)

The fertile zones of Nepal are shrinking rapidly under the twin pressures of overpopulation and deforestation, which in turn cause the erosion and deterioration of agricultural land. Consequently, only 20 percent of the nation's soil is cultivable. The vast majority of Nepalis live in a state of near-total self-sufficiency, depending on the crops they extract from their small parcels of land. They buy only the most basic products, walking many miles along high mountain trails to fetch sugar, salt, tea, or domestic items. In Nepal, about 40 percent of the population lives below the poverty line. But, in fact, most economic activity (up to 70 percent of Nepal's output, according to some estimates) is based on barter, and thereby circumvents the monetary system. In this way, farmers from the Himalayan foothills exchange salt for cereals grown around Pokhara, in the central plains.

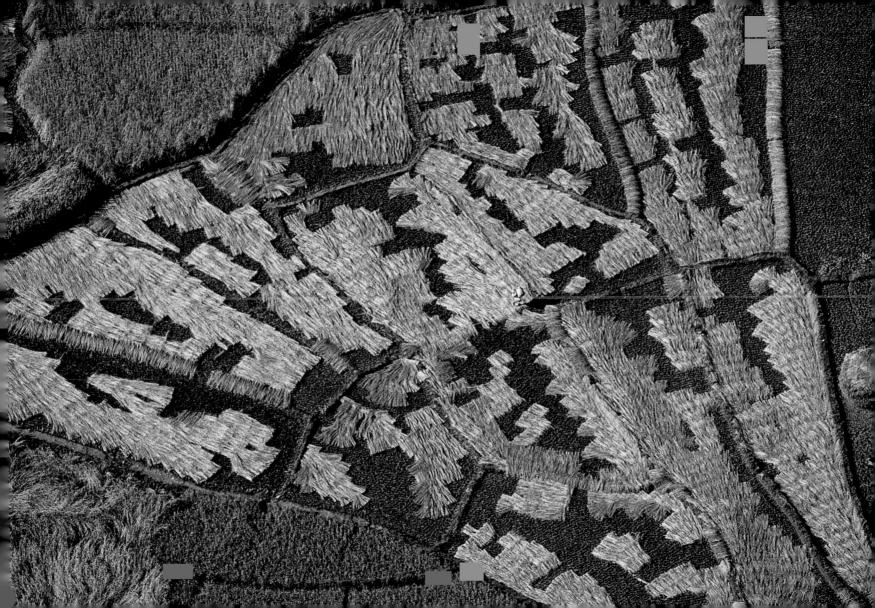

Grand Bazaar, Istanbul, Turkey (41°00'N - 28°57'E)

At Istanbul's Grand Bazaar, the idea is not just to buy but to bargain, too. The art of haggling (parzarlik) adds spice to the innumerable products displayed in the four thousand shops that make up the maze of alleys. Built of wood in 1461 on the site of an older market, the bazaar originally traded in wool and silks. As the centuries passed, the "city of bargains" gradually developed, extended, and modernized, while retaining its specialized areas, like those dedicated to jewelers, leather sellers, and clothiers. Today Turkey has one of the twenty most vigorous economies in the world. It continues to evolve commercially on both sides of the Bosphorus; on one it is strengthening ties with the European Union, and on the other it controls access to emerging oil and gas markets and to the mineral resources of the Caucasus and central Asia. At the same time, it preserves its linguistic and historic links with the region's former Soviet republics. These two facts make Turkey the meeting point of Europe and Asia.

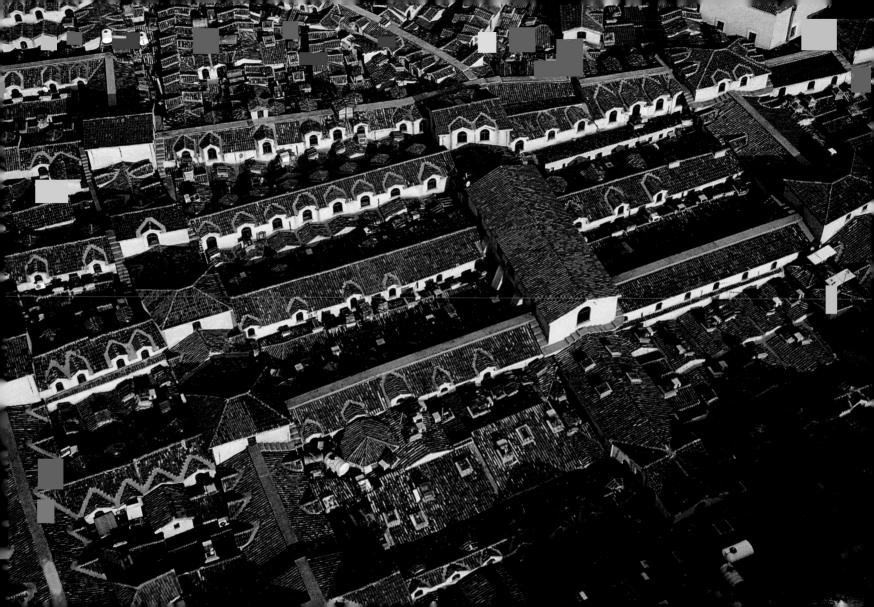

Pedestrians in the streets of Tokyo, Honshu, Japan (35°42'N - 139°46'E)

The old city of Edo, renamed Tokyo, or the Capital of the East, by Emperor Meiji in 1868, is now the world's greatest metropolis, with 28 million inhabitants living within a radius of 87 coastal miles (140 coastal kilometers). Repeatedly destroyed by fires, earthquakes, and above all by the bombings of the Second World War, Tokyo is a city in permanent mutation, with audacious new construction continually springing up all over. But beyond the main hubs and the sky crisscrossed by freeway overpasses, there is a village Tokyo of private houses and small buildings, where cyclists and pedestrians are kings. With its passage from the anonymity of the megalopolis to the conviviality of the neighborhood, the city of Tokyo is a constant surprise; certain houses have no apparent address, security is excellent—Tokyo has one of the lowest crime rates in the world—and people in general are models of good citizenship, happily returning possessions mislaid in shops, trains, and subways.

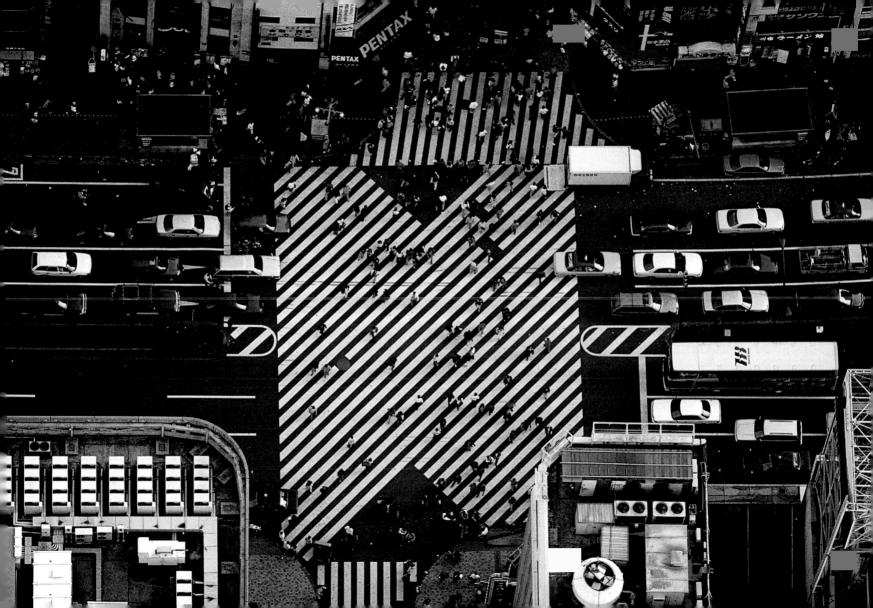

Pool of the Titan Enceladus, Château de Versailles, Yvelines, France $(48^{\circ}48'N - 2^{\circ}05'E)$

In Greek mythology, the Titans rejected the primacy of the Olympian gods and declared war upon them. The Titan Enceladus made a great pile of stones in an attempt to reach the realm of Olympus, only to be hurled down again by Zeus. This statue at Versailles representing the death of the Titan was Louis XIV's veiled warning to any man who might pretend to be his equal. An image of timeless expressionism, it also symbolizes the triumph of civilization over primitive forces, a victory that is never quite complete. The park at Versailles suffered considerably during the great storm of 1999, when violent winds uprooted more than 10,000 trees and devastated Le Nôtre's gardens. To restore the palace grounds to their former glory, citizens "adopted" a tree, making a donation of 150 euros to have it planted. In the rest of France, the 1999 storm flattened 1.2 million acres (500,000 hectares) of forest, in all about 300 million trees. Today, the country's woodlands are well on the way to recovery.

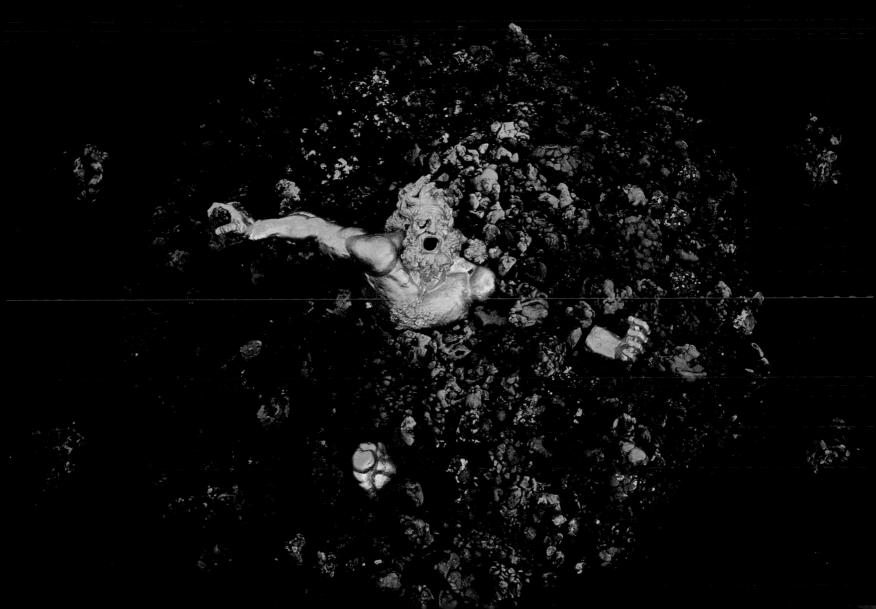

Azat reservoir, Ararat Province, Armenia (39°46'N - 44°47'E)

Armenia, a biblical country whose entire arid territory sits over 3,300 feet (1,000 meters) above sea level, is wholly dependent on irrigation for its crop productivity. The construction of reservoirs, canals, and aqueducts was a priority of the Soviet Socialist Republic of Armenia from the 1920s onward. The work has continued but the system is poorly maintained, and only 540,000 acres (220,000 hectares) of irrigated arable land receive water in an efficient manner. Nevertheless, in this small country bordered by Turkey, Azerbaijan, Iran, and Georgia, agriculture provides a livelihood for about 46 percent of the population and represents 17.2 percent of gross national product. In 1990, Armenia was the first ex-Soviet republic to privatize its cultivable land. This reform and the fertility of its volcanic soils have benefited the growing of wheat, barley, pastureland (for sheep), cotton, tobacco, sugar beet, vegetables—and all manner of fruits. In fact, many commentaries on the Book of Genesis place the Garden of Eden in Armenia.

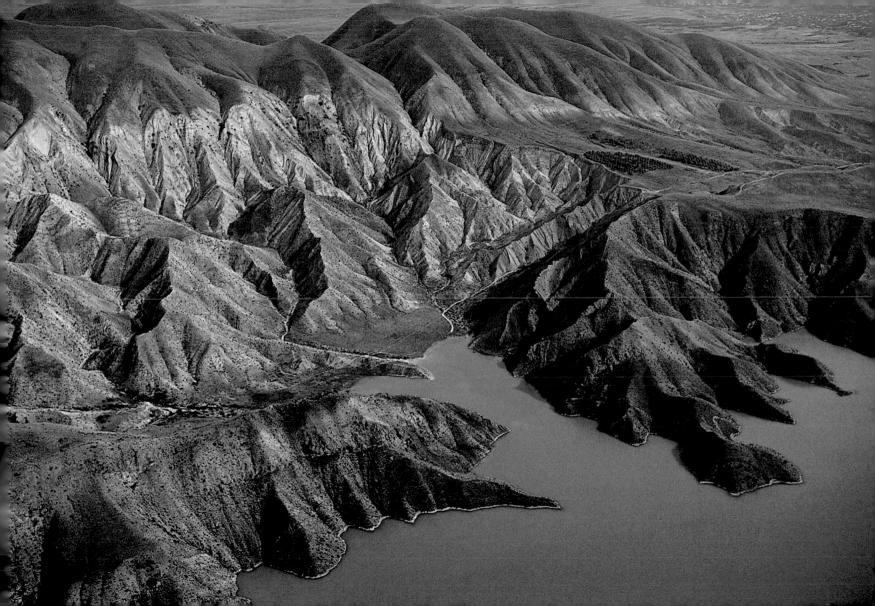

Grain on village roofs, south of Bouna, Ivory Coast (9°16′N - 2°59′W)

In West Africa, harvested cereals like millet, sorghum, and cassava are spread out in courtyards or on roofs. There they dry for a few days before being stored in granaries that are raised aboveground to keep out termites. Traditionally, these cereals are cultivated in the North, a region of savanna where the climate is drier than in the South, which is clothed in dense jungle and *Hevea* plantations. These geoclimatic contrasts have created an economic rift across Ivory Coast. The North was a driving force of growth from its independence to the late 1980s, while the South was something of a poor relation. This state of affairs is tragically echoed in the political and military crisis that has destabilized the country ever since 2002. Today's Ivory Coast is divided into two zones: the rebel North and the government-controlled South. Despite many attempts at mediation, the crisis is unresolved and the country lives in a state of permanent conflict.

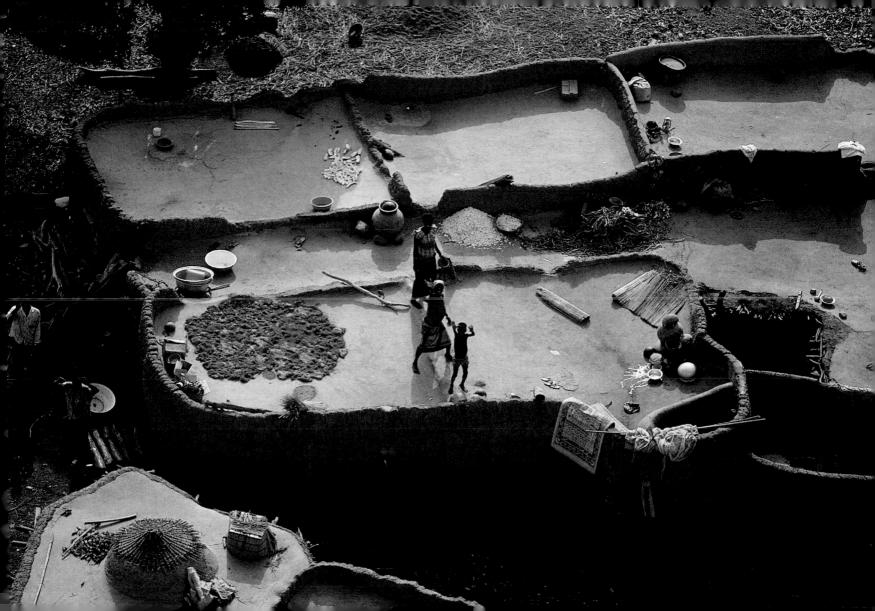

Workers in rice paddies along the shores of Lake Itasy, Antananarivo, Madagascar ($18^{\circ}55'S - 47^{\circ}31'E$)

In the course of the last two centuries, wet rice cultivation, an intensive form of farming controlled by rich landowners, has taken over the Lake Itasy region's agricultural domain. The move from polyculture to irrigated monoculture has led to an epidemic of malaria on the high Madagascar plateaus; this is because the rice's period of growth coincides with the reproduction period of a species of mosquito, *Anopheles funestus*, an efficient carrier of the disease. Every year, malaria kills at least a million people worldwide, most of them in poor countries. Since the 1950s, the World Health Organization has tried to eradicate it, but it has lacked sufficient funds to carry out research and treatment simultaneously. In 2001, the organization set out to remedy the problem by creating the World Health Fund. By some estimates, 90 percent of total worldwide expenditure on medical research is dedicated to just 10 percent of the diseases that affect the planet.

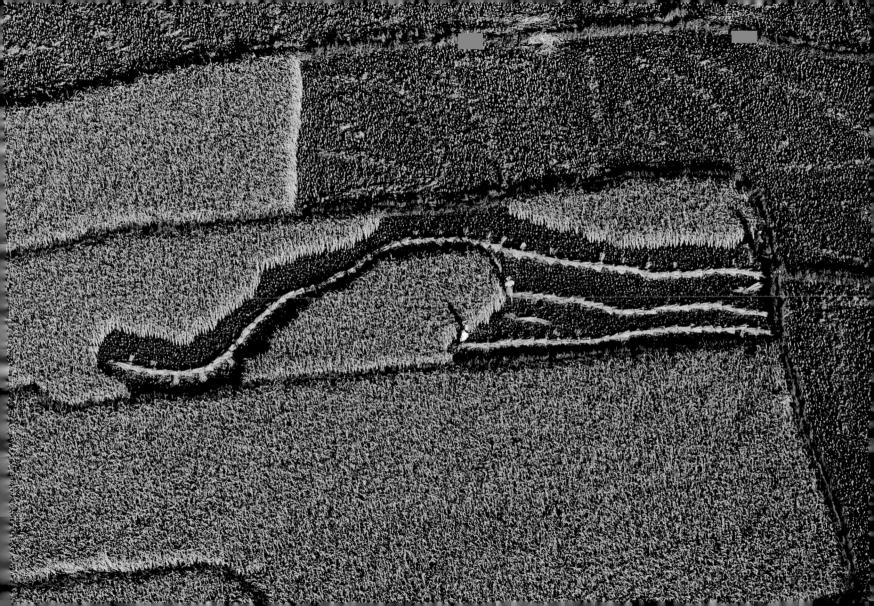

Tourist complex at Calahonda, Andalusia, Spain (36°30'N - 4°42'W)

Calahonda, on the Costa del Sol a few kilometers east of Marbella, attracts crowds of tourists every year, some of whom stay behind to take up permanent residence. The area started to become popular in 1963 when a series of developments began between the coast and the hills—essentially luxury villas, apartment blocks. swimming pools, lush green parks, and golf courses. As it has done everywhere else on the Mediterranean coast, tourism spawned installations that required immense quantities of water—such as golf courses that consume, on average. 312 gallons per day. Today, thanks to these tourist hotspots. Andalusia holds the record in the European Union for daily water consumption per inhabitant, with an average of 47 to 71 gallons (180 to 270 liters) (the European average is 26 to 53 gallons [100 to 200 liters]). This is in direct contrast to the fact that although the economic development of Andalusia has been spectacular in recent years, it remains the second-poorest region of Spain. Heavily dependent on tourism, with 7 million foreign visitors each year, the region is held back by a poorly developed industrial sector and insufficient investment. Because of its remoteness and its gross product per individual, which is less than 75 percent of the EU average. Andalusia has been classed as an "objective I zone" within the framework of the Union's regional policy. This financial support is intended to help the least developed regions of member states catch up economically with the rest. Before 2013, Andalusia is scheduled to receive major subsidies totaling \$15.5 billion.

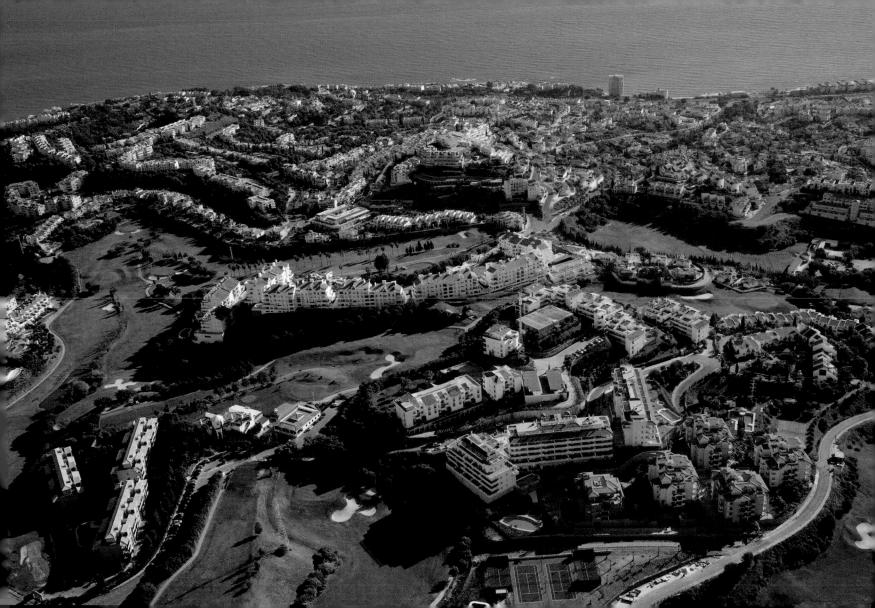

Pirogue on the river Niger, Gao region, Mali (16°12'N - 0°01'W)

The Niger, which rises in Guinea, is the third-longest waterway in Africa (at 2,600 miles [4,184 kilometers]). It runs through Mali, Niger, and Nigeria. In Mali, the Niger is the lifeblood of the nation; nearly all the country's economic activity takes place on the river's banks, and 80 percent of the population depends on Niger-irrigated arable land, or on fishing. The river also acts as the main thoroughfare for a population of close to 14 million people. Already threatened by desertification and pollution, in recent years the Niger has come up against a third fearsome invader: the beautiful but pernicious water hyacinth. First introduced into the country as an ornamental plant, it has proliferated to the point that it is endangering socioeconomic activity all along the Niger, asphyxiating fish by drawing off oxygen from the water, hampering river transport, clogging hydroelectric plants, and blocking canals along the river's irrigated banks. Since 1995, Mali—one of the world's poorest nations—has been forced to spend hundreds of millions of dollars a year in the battle against this green pest.

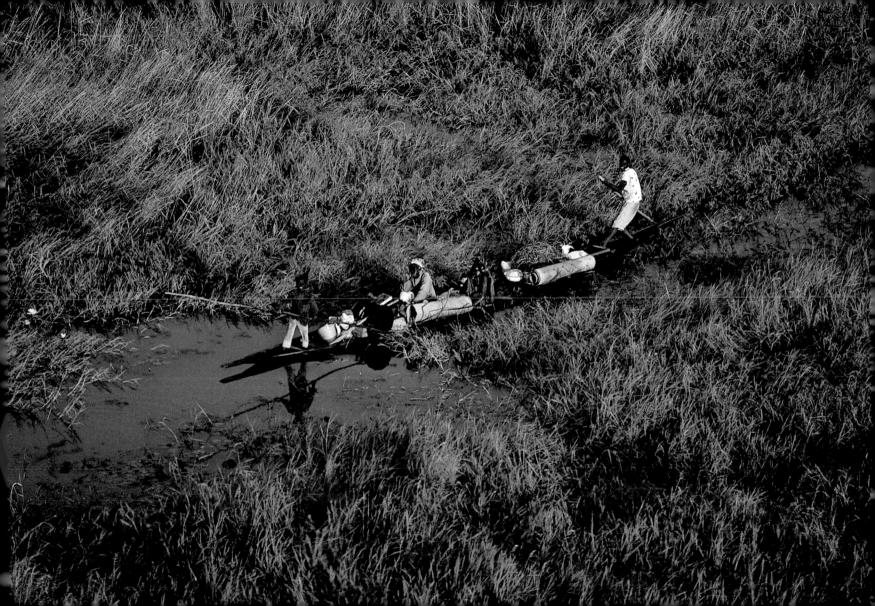

Glacier near Khan Tengri peak, Savy-Jaz, Ysyk-Köl, Kyrgyzstan (42°10′N – 80°00′E)

Kyrgyzstan is one of the highest countries in the world, with innumerable glaciers on its terrain. These frozen mountaintop ice masses are the water towers of our planet. Although they store only 4 percent of the world's freshwater, half of the planet's population relies on that water. Glaciers regulate water's availability, accumulating precipitation in the cold season in the form of snow, and releasing ice melt in the summer. But today glaciers all over the planet are thawing at an alarming rate. It is thought, for example, that even the glaciers in the Himalayas will have largely disappeared before 2050. The first consequences of this melting are already being felt; many mountain lakes are at the point of overflowing and flooding the populated valleys below them. In Nepal, high-altitude lakes are filling so rapidly that forty of them are expected to spill over before 2010. If nothing is done to stabilize the warming of the atmosphere, floods of this kind will eventually give way to an era of acute water shortages. And reconstituting the glaciers is an impossible feat for humankind.

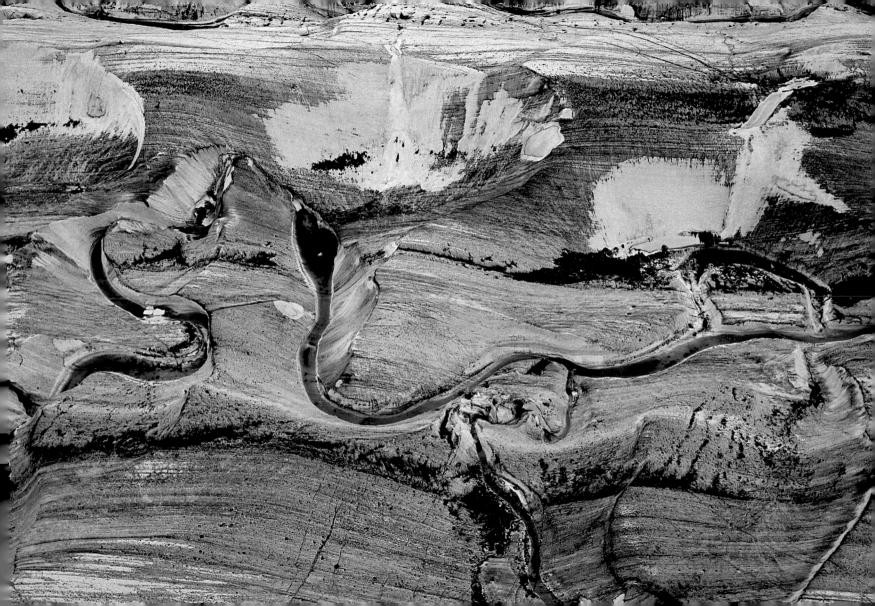

Volcano in the Aïr Mountains, Niger (18°00'N - 8°30'E)

This extinct crater in the heart of the Sahara is one of only a few mountains of volcanic origin in the crystalline Aïr range, which covers some 30,000 square miles (77,000 square kilometers). The result of 28 million years of volcanic activity, these topographic markers in the Ténéré Desert created major rivers in their time, which today are fossilized or transformed into *koris* (temporary rivers) during rainstorms. In the valleys, stubborn layers of water are concentrated just feet under the sandy surface. But this landscape hides all manner of other riches, such as Neolithic rock carvings and, at Gadafowa, the enormous deposits of fossils—including those of dinosaurs—discovered in 1906. In close collaboration with France and the United States, Nigerian researchers continue to study these great fossilized reptiles, a priceless scientific heritage from 135 million years ago.

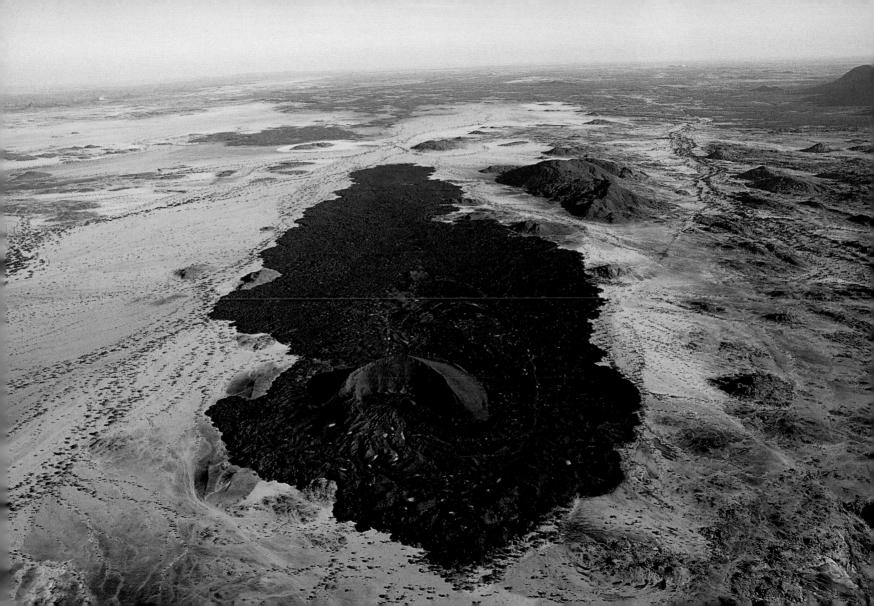

The ghats of Varanasi, Uttar Pradesh, India (25°20′N - 83°00′E)

Chats describes both the huge plateaus stretching from the Himalayas to the Ganges and the markets along the banks of the holy river. The ghats of the sacred city of Varanasi (Benares) attract Hindu pilgrims who come for purification, religious rites, or the cremation of their dead. Hindus believe that if they lead a virtuous life and duly accomplish their dharma (duty), their chances of reincarnation in a higher caste will be greatly improved. In India the two-thousand-year-old caste system defines people's social position according to their birth. Nearly 170 million Indians (one in six) are excluded from the higher castes—classified as priests, warriors, merchants, and servants. Although the constitution forbids all discrimination on grounds of caste, the untouchables, or Dalits, still have no chance of owning land, still live in zones isolated from the other castes, and are still forced to accept the most degrading jobs and the violation of their basic rights. In 2005, UNESCO estimated that two-thirds of Dalits were illiterate and that only 7 percent of them had access to drinking water, electricity, or toilets.

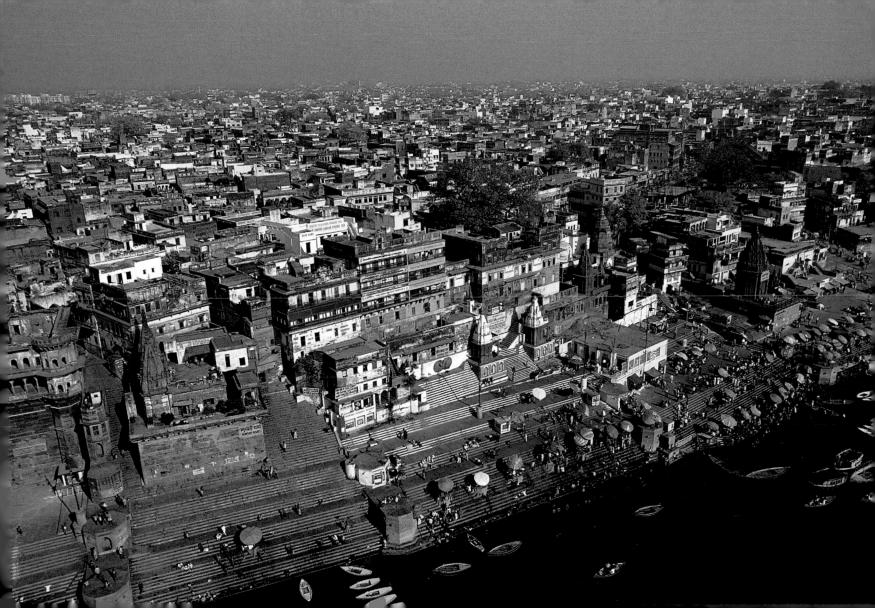

Lake Powell, Creek Bay, Utah, USA (37°18′N - 110°45′W)

The Colorado River rises in the Rocky Mountains and flows 1,400 miles (2,300 kilometers) to the Gulf of California, after crossing some of the most arid regions of North America. For more than a century, American hydrologists have programmed its development, controlled its flood periods, and exploited its water. Many dams are located along its course, one of the largest of which is Glen Canyon, completed in 1963; it took seventeen years for Lake Powell to fill up behind this concrete barrier. Since the 1990s, which saw years of drought, the water level has fallen by more than 131 feet (40 meters)—as the white watermarks on the red sandstone bank show. Every year, 2.5 percent of the volume of this precious reserve is lost through simple evaporation. The dam's hydroelectric turbines are still fueled by the lake water that has slowly replenished since 2005, however, dams do not always fulfill their early promise, especially in times of accelerating climate change.

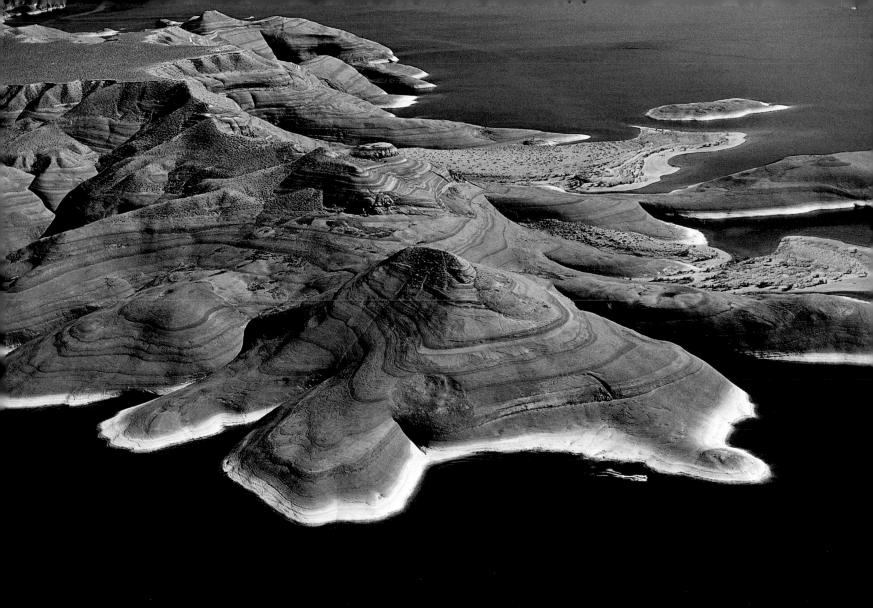

Rubber tire marks in a playground near Doha, Qatar (25°17′N - 51°32′E)

Teenagers on motorbikes composed these remarkable arabesques on a playing field near Doha, Qatar. The peninsula of Qatar has a population of 900,000, three-fifths of whom are immigrants. It is a complex mixture; the Qatari minority, jealous of its traditions, lives alongside an Arab and Western elite—with whom they must share the key economic posts—and a huge population of Pakistani, Indian, and Iranian immigrants. This final group represents nearly 50 percent of the total population and composes the workforce—most of which is male. In Qatar men outnumber women by two to one.

Radio telescope near Arecibo, Puerto Rico (18°21'N - 66°45'W)

From the beginning of time, humans have gazed at the stars, and at a very early stage this long tradition of observation gave birth to the science of astronomy. This radio telescope is sited 10 miles (16 kilometers) south of the town of Arecibo in a natural hollow of the land, which, coupled with the proximity of the equator. makes it possible to observe the other planets in the solar system with great clarity. Consisting of a spherical antenna 1,000 feet (305 meters) in diameter and receptors more than 328 feet (100 meters) overhead. Arecibo's spectacular radio telescope was made world famous by the James Bond film GoldenEye. Opened in 1963, in 1974 the radio telescope was used to transmit a message to any extraterrestrials that might be listening; it also yielded the first-ever image of an asteroid in 1989, and revealed the first two planets ever observed outside the solar system in the 1990s. Far from being obsolete, on February 11, 2008, it detected the presence of the first triple system of asteroids in earth's vicinity; these asteroids, the largest of which measures over a mile (2 kilometers) in diameter, revolve around each other at a distance of 6.8 million miles (11 million kilometers) from earth. The Arecibo site employs 140 people and makes it possible for 200 scientists to carry out vital research, but its future is currently threatened by budget cuts.

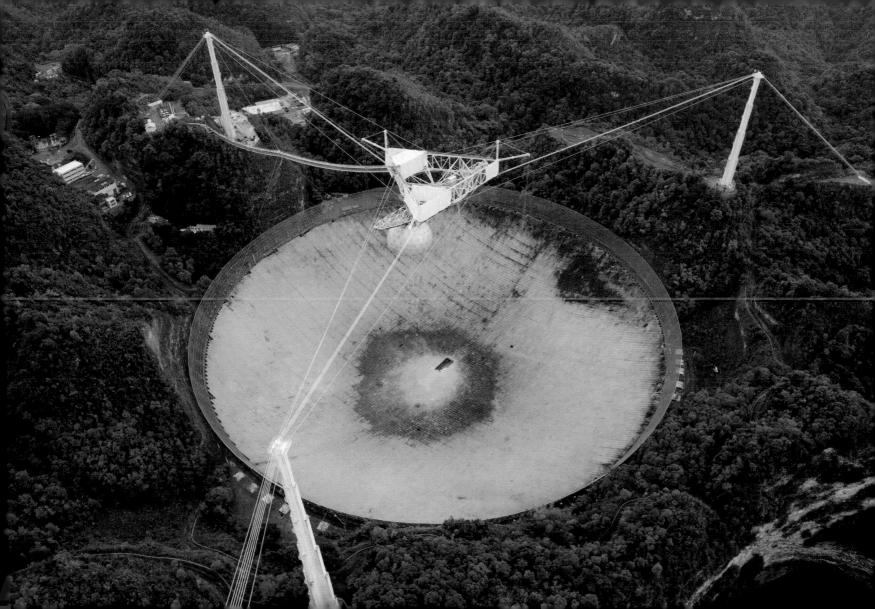

Traditional plowing methods near Zamora, Michoacán, Mexico (19°16'N - 99°06'W)

After the 1910 Mexican Revolution, the Mexican government implemented wideranging agrarian reforms, redistributing wealthy landowners' estates to peasant communities known as ejidos. Between 1924 and 1984, some 190 million acres (77 million hectares, more than a third of Mexican territory) was parceled out in this way. The 28,000 ejidos were collective properties—all that the peasants actually possessed was the right to farm the land. They could neither sell nor rent and were obliged by law to cultivate their portions. This gave the peasantry a means of subsistence, and as a result they were less tempted to flock to the cities than they might have been if they lived in other countries; but at the same time they were unable to invest in, modernize, or improve the productivity of their holdings, which were usually too small to make much of. In 2007, agriculture occupied 98 percent of the active population (29 percent in the state of Michoacán) but represented only 4 percent of gross national product. Since 1992, Mexican peasants have owned their land outright and are thus permitted to sell if they choose. Nevertheless, few farms have changed hands; rural communities are generally opposed to the reform, which they blame for growing inequalities. But what they dread most of all is a return to the vast landholdings that existed before the revolution.

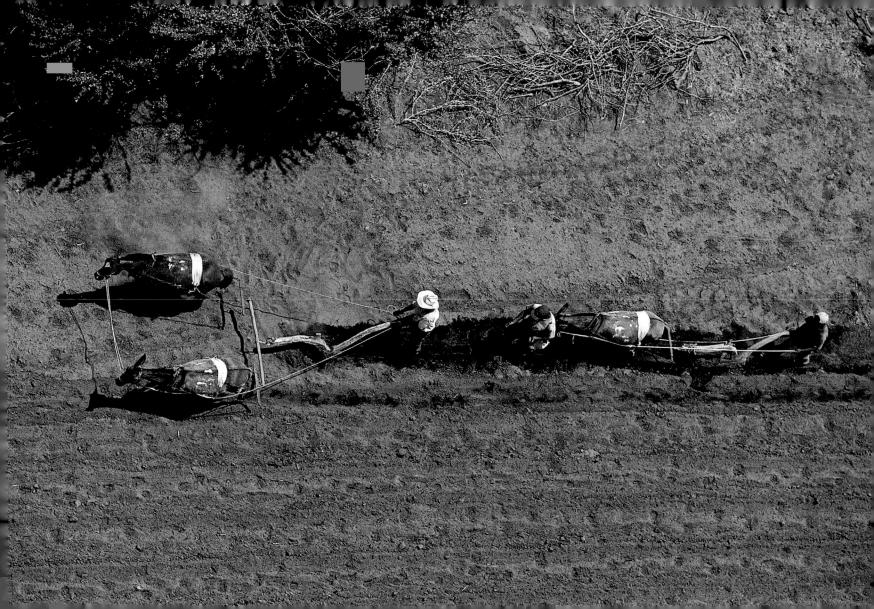

Raiatea, Society Islands, French Polynesia (16°50'S - 151°01'W)

Lost in the immensity of the South Pacific and more than 3.100 miles (5.000 kilometers) from the nearest continent (Australia), these 118 Polynesian islands and islets of volcanic origin constitute a world in miniature, inhabited by endemic vegetable species. Borne by the sea currents on floating pieces of wood, or otherwise spread via the wind or the soles of passing mariners' shoes, these plants have adapted to the Polynesian climate and today form one of the world's most precious ecosystems. Like the local birds (twenty-seven species of which are protected) and the coral (an ecological treasure trove threatened by overfishing and global warming), the plants of Polynesia are extremely vulnerable. The introduction of a single new foreign species can interrupt the entire balance as is proving true with Miconia calvescens, an ornamental tree imported from America, which is currently gaining the upper hand over locally established species and invading the island's natural environment. Thirteen plants, one species of snail, and four species of bird are currently outlawed in Polynesia, on account of the threat they pose to local biodiversity.

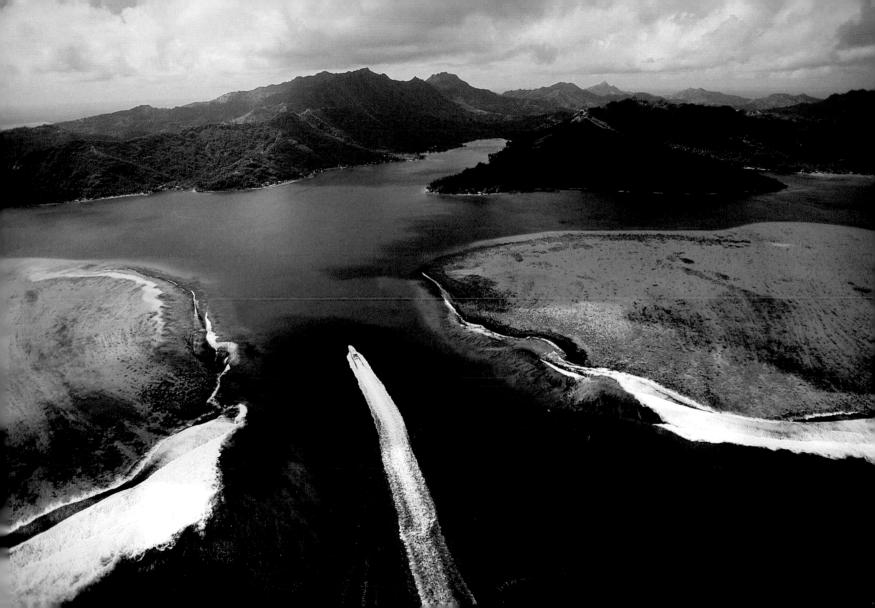

MOBILITY,

EQUITY, AND

Transport has a major impact on everyone's lives. Lack of transport in Africa and parts of Asia, such as Bangladesh, and areas of India hamper economic development and are a burden on women who carry water, fuel, and crops over hundreds of miles. In other parts of the world, too much transport is the cause of serious gridlock, congestion, pollution, and children's health issues. Congested traffic conditions in California, the southwest of England, and around Frankfurt, Germany, result in the loss of billions of U.S. dollars to the economy and serious disruption of everyday life. Road traffic accidents—currently the cause of over 3,000 deaths per day—are a significant public health problem and a serious blight on the lives of pedestrians, cyclists, and bus users in developing countries.

Transport is now recognized as a significant public health problem in the world's rapidly growing cities. The impact of air pollution on health is dramatic. According to the World Health Organization (WHO) air pollution from vehicles and industrial emissions account for approximately 3 million premature deaths per year worldwide. This impact is a growing problem as car ownership and use grows in the megacities of Asia (a megacity being more than 10 million people) and city planning repeats the mistakes of the United States and Australia in opting for low-density urban sprawl supported by new road infrastructure. This sprawl reduces the use of walking, cycling, and public transport and accelerates higher levels of car use on longer trips. Airquality problems can be addressed by a number of different interventions, including improved fuel quality, vehicles, and fuel standards supported by intensive enforcement, and by a new style of urban planning that gives priority to short distances and steers transport investment away from flyovers, freeways, and bypasses.

As the world's population moves higher and higher up the "mobility ladder," demands for more investment in roads, railways, and airports becomes more strident. These investments make up a significant proportion of public expenditure. At the same time, all over the world, health care, pension, and social infrastructure costs are rising fast. Rising oil prices in 2008 and increasing concern about the ability of oil production to keep pace with consumption add extra force to arguments in favor of traffic reduction in a low-carbon economy.

The growth in the demand for transport is a major factor in the growth of greenhouse gas emissions and the problems associated with climate change. Transport growth has shown itself to be immune from

most of the discussions surrounding sustainable development or the promotion of environmentally friendly modes of transport, especially walking and cycling. Every year, most of us expect to travel farther to carry out even the most mundane activities, such as traveling to school or work. Even if we use the latest low-emission vehicles, our increased miles of travel cancel out those gains and put us further up the greenhouse gas emission curve. The more we want to travel, and the more we abandon environmentally friendly modes, the more we damage the global environment.

Environmental problems are also created by the enormous growth of new road and motorway building. New motorways in Eastern Europe are already encroaching on sensitive environmental sites and polluting the atmosphere and watercourses. New roads in the United Kingdom are cutting a huge swathe of tarmac and concrete through open countryside, which has traditionally been protected. These new roads, in their turn, encourage yet more traffic and switch more trips from public transport to private cars. New roads also change the geography and contribute to the spreading out of everything we do. The spread of business parks, out-of-town centers, and low-density suburban housing in the United States, the United Kingdom, and even in Kolkata, India, is a consequence of new highway investment.

The British government has shown that most transport investment benefits those who are already wealthy. Transport spending is inequitable and socially divisive. Rich people fly more and drive more often than poor people. The policy response to serious traffic and transport problems has traditionally been to invest money in more infrastructure. More roads, more airports, and more high-speed trains are still the norm. Even in developing countries, where the pressure on the tax dollar is particularly acute, the bias in investment is towards these "wealthy" modes. This, consequently, takes investment dollars away from the needs of the rural poor.

The city of Bogotá, Colombia, has shown that a completely different path is now possible. The former mayor of Bogotá, Enrique Peñalosa, implemented a series of radical transport policies and funding real-locations to serve the needs of the poor and those who travel short distances to work and school in their own neighborhoods. Bogotá has developed the tradition of closing its main arteries to motor vehicles for

seven hours every Sunday so that people can use the roads for cycling, jogging, and meeting up. The total amount of road space closed to traffic has doubled and now represents about 70 miles (120 kilometers) of main city roads. Investment in cycling has resulted in building more than 185 miles (300 kilometers) of protected bicycle paths and a steady increase in people using bicycling as a chief mode of transportation. Public investment of approximately \$2.5 million per mile in the TransMilenio passenger buses now means that city residents take more than 540,000 daily trips by bus.

The Bogotá approach has set a new standard for environmentally friendly, sustainable, and socially just policies. London's congestion charge, introduced in February 2003, sets another standard. The congestion charge of £8 (about U.S. \$16) raises considerable sums of money, the majority of which is spent on improving public transport and areas for walking and cycling in London. This is socially just. Only 20 percent of the trips in London every day are by car. This minority of trips imposes a serious burden on poorer Londoners who cannot afford the high price of a house in the country where they, too, could escape pollution. To everyone's benefit, the congestion charge has reduced traffic and improved conditions for cycling and bus users.

It is possible to improve living and working conditions in the world's cities as well as the poorest rural areas. There is nothing to lose and everything to gain. The only serious barrier is political conservatism—that is, the distorted perceptions of politicians who think that moving in an environmentally and socially just direction will cost them votes. It will not. The time has arrived for a new transport paradigm, one that rewards the cyclist, pedestrian, and the bus user while making motorists and trucking companies pay the full cost of the environmental damage they impose on society. There are signs that this is happening, but it will require individuals as determined and clear-sighted as Enrique Peñalosa and Ken Livingstone, the former mayor of London, to make it happen. One thing is clear, we have all the relevant transport expertise we need, and we understand the problems and the solutions that will deliver a sustainable, vibrant, socially just, and child-friendly future. We lack only the political vision and the political leaders to make it happen.

John Whitelegg and Gary Haq Stockholm Environmental Institute; University of York, England

Wheat fields, Mandi, Chad (13°28' N - 14°42' E)

Traditionally, the people living on the shores of Lake Chad have practiced a form of agriculture based on rising and falling water levels, on emergent or empoldered land. When the polders are drained, several harvests are possible every year; this has huge benefits in a country where only 1 percent of the land is cultivable. The land chief, who is appointed by the village chief, divides the polder into parcels, which are apportioned to families according to their size and the contribution they make to community work. On the Mandi polder, wheat has become a cash crop—this is astonishing for the tropics. Still harvested by hand, this cereal stands up well to drought conditions and helps to feed the inhabitants of N'Djamena, the Chadian capital (although most of the wheat consumed throughout the country is still imported). A recent development plan for the Lake Chad region proposed the construction of fifteen modern polders covering about 30,000 acres (12,000 hectares). Dikes, water intakes, and pumping stations will one day ensure complete control over the region's water.

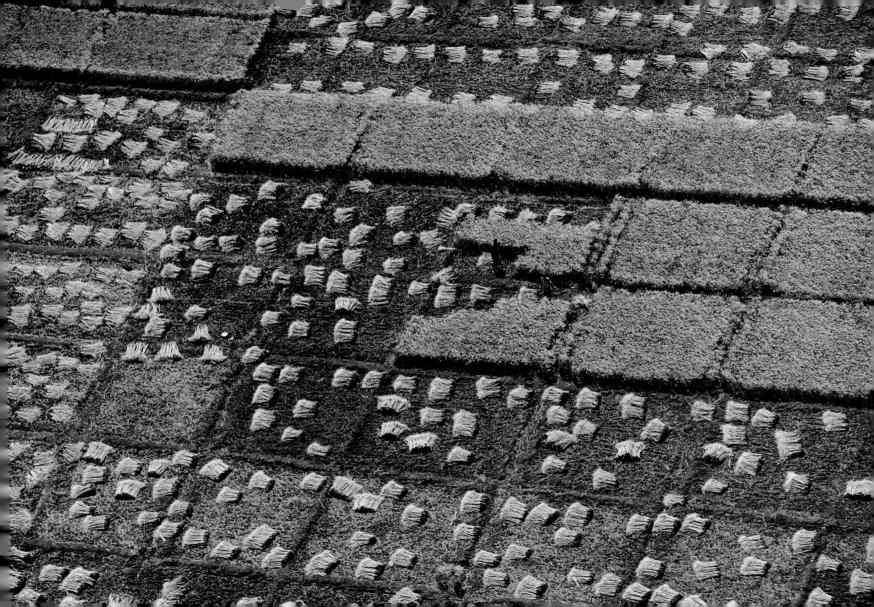

Monastery on Mount Athos, Mount Athos Peninsula, Greece $(40^{\circ}09'N - 24^{\circ}20'E)$

Mount Athos—also called the Holy Mountain—is in Macedonia, on the easternmost of the three Chalcidice peninsulas. It is more than 6,600 feet (2,000 meters) high, and its wooded hillsides slope steeply down to the Aegean Sea. Since the tenth century, this remote place has been the headquarters of an orthodox monastic republic, which has autonomous status within Greece. There are twenty monasteries, where one to two thousand monks known as Athonites, or Aghorites, live together. The majority of these are grouped in communities (cenobites), but a few anchorites (hermits) still live in inaccessible caves in total solitude. Greek is the official language of Mount Athos, but Russian, Serbian, Bulgarian, and Romanian communities also occupy the place. Notably, the monasteries possess an immense collection of Greek and Byzantine art, including frescoes, illuminated manuscripts, and priceless objects of all kinds. Access to this universe of culture and contemplation is heavily regulated, and women are strictly forbidden. Mount Athos has been listed as a UNESCO World Heritage Site since 1988.

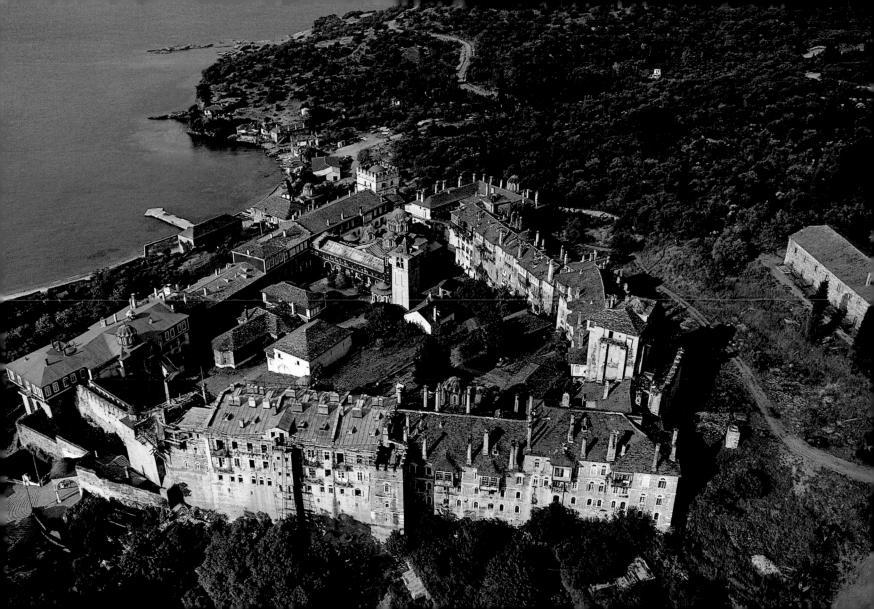

Fishing nets spread across the beach at Saham, Al Batinah region, Oman $(63^{\circ}00'\,\text{N} - 24^{\circ}20'\,\text{E})$

This long seine, which has been specially adapted for dragging along the sandy sea bottom, is ready for another pass. Having patiently folded it alongside their boats, all the fishermen need to do now is to haul in both ends to bring in their catch. Traditional methods like this furnish 80 percent of Oman's domestic supply of fish—but the sultanate intends to modernize the fishing sector. Aware that its reserves of oil are strictly limited (only 700 million tons of crude oil remain, according to some estimates), the Omani government wishes to diversify its economy; training young fishers is one of its options. With their help Oman expects to increase the national fish yield significantly, while managing fisheries in a sustainable way. Although there is no shortage of fish in the Gulf of Oman, some species there are under threat. The overexploitation of fisheries is a global concern, and catches are declining everywhere. In the North Atlantic, for example, a major fishing zone, they have fallen by 25 percent since 1970.

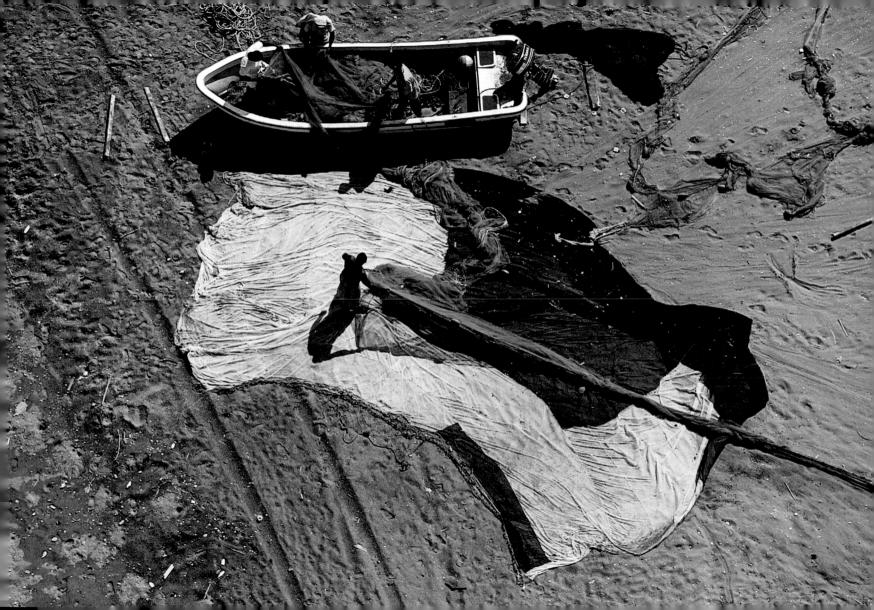

Square in front of the Changdeokgung Palace, South Korea (37°33′N - 126°58′E)

In the fourteenth century, the Choson dynasty set up its capital in Seoul; the palace of Changdeokgung (now a UNESCO World Heritage Site) was the center of Korean royal power for the next three hundred years. It was built at the foot of the mountains, on the north bank of the Han River, strictly according to the rules of pungsu geomancy—a divinatory art by which positive and negative flows of energy are identified according to the relief of the landscape. In 1949, Seoul began to extend to the south side of the river, and today its historic quarters are in stark contrast to the modern skyline of high-rises and concrete buildings. In the last thirty years, the city's residential areas have grown rapidly, yet Seoul is still a capital solidly anchored in its land and its mountain backdrop; fields, open spaces, and forests occupy more than 40 percent of the city precinct, and agriculture 5 percent. Recent construction continues to respect the rules of geomancy as much as possible; a few years ago the National Museum was demolished and the Korean high-speed railway was diverted so as not to cut off certain favorable geomantic energy flows.

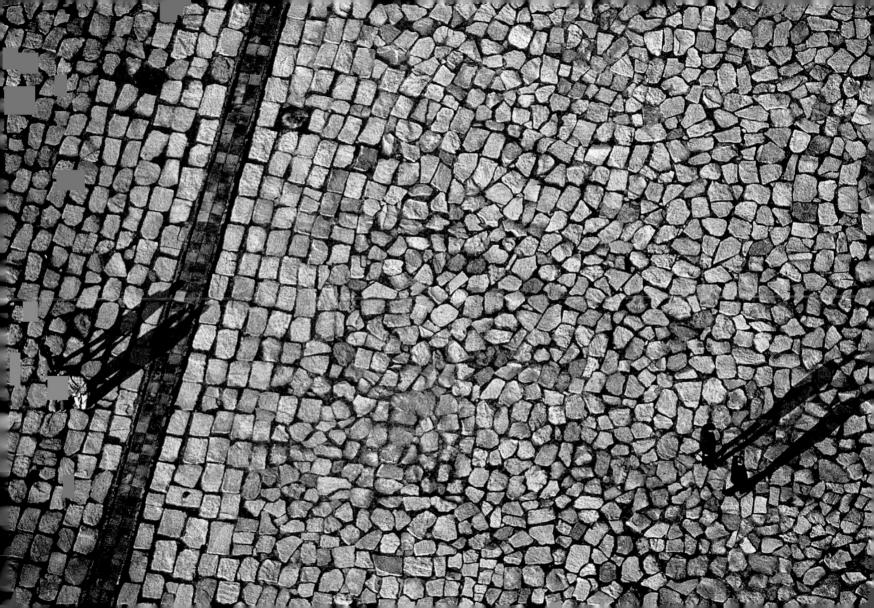

Watering fields in the Beqaa Valley, Lebanon (34°03′N - 36°08′E)

Irrigation by watering, and in full sunshine to boot, is an aberration in the Beqaa Valley, since the water evaporates almost immediately. Moreover, a third of it is lost before it even reaches the fields because of defective pipe systems. Water is a rare resource in this Mediterranean country; in Lebanese cities, the supply is often cut off during the summer, and the sight of Beirut residents buying it by the jerry can from itinerant tank trucks is a common one. Yet by comparison with its parched neighbors, Syria and Israel, Lebanon has no real shortage of water. Its rivers, streams, and springs are fed by abundant winter rains and spring snowmelt. With this water from the mountains and from amply renewed underground aquifers, the farmers of the Beqaa can irrigate their crops as much as they like. But their abundance of water is not always wisely managed. In many Mediterranean countries, 75 to 90 percent of available water is appropriated by agriculture (in the rest of the world, the figure is 70 percent). The simple measure of installing drip irrigation would make it possible to economize half of that water.

The vanished snows of Kilimanjaro, Tanzania (3°04′S - 37°22′E)

Made famous by Ernest Hemingway in 1939, the famous "eternal" snows of Kilimanjaro are now at the point of vanishing altogether, more than 11,000 years after they first appeared. In 1900, there were 5 square miles (12 square kilometers) of snow on the summit; today the white cap of Africa's highest mountain has been reduced to 0.7 square miles (2 square kilometers). Not only has the ice cap diminished by 80 percent in the space of a century, but the remaining ice has grown much thinner, losing up to 3 feet (1 meter) of its earlier volume. At this rate, scientists predict its complete disappearance by 2020. The melting of the snows of Kilimanjaro, and of many other glaciers around the world, is one of the most visible signs of worldwide global warming. In the end, the consequences will be disastrous for the populations and ecosystems dependent on these water resources. Thus the glaciers of the Canadian Rockies have lost 75 percent of their area, those of the Himalayas are shrinking by 50 feet (15 meters) a year, and the polar ice cap has reduced in the last thirty years by 380,000 square miles (988,000 square kilometers)—an area twice the size of France and 8 percent of its total surface. Indeed, the Arctic ice cap may vanish altogether before the end of this century.

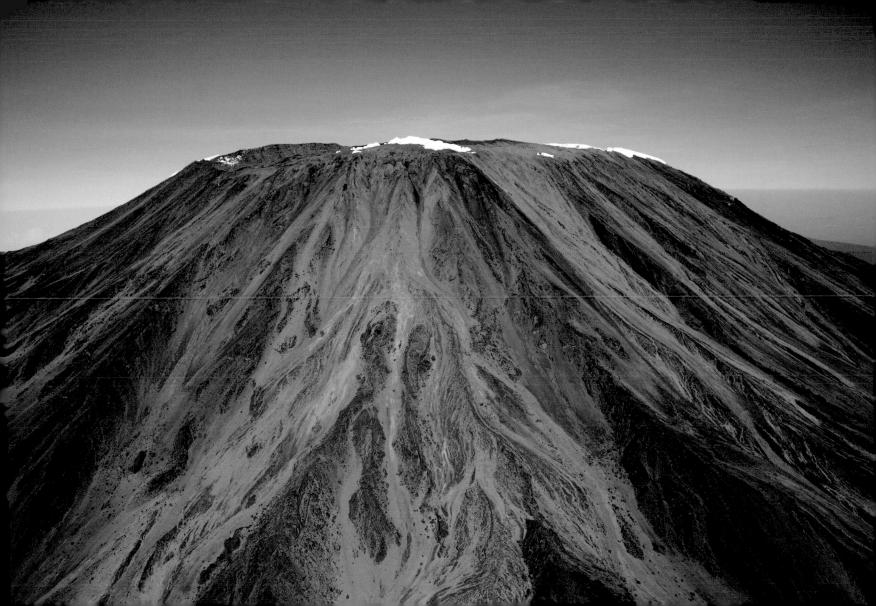

Design in a village courtyard, west of Jodhpur, Rajasthan, India (26°21′N - 72°45′E)

In the state of Rajasthan, India, the walls and courtyards of houses often feature decorative motifs executed in lime or other mineral substances. Mostly found in rural areas, the drawings represent a five-thousand-year-old tradition and are of two types: mandalas, geometrical designs; and thapas, human or animal figures. Crafted by women on walls and floors covered with a mixture of clay and cattle manure, they are renewed on every feast day. The designs give each house a personal touch, but quite apart from their aesthetic character, they perform an important social function in reflecting the relative prosperity of a home's inhabitants. They are also thought to confer happiness, and houses in which occupants are mourning for a dead relative are not decorated for a full year after the funeral.

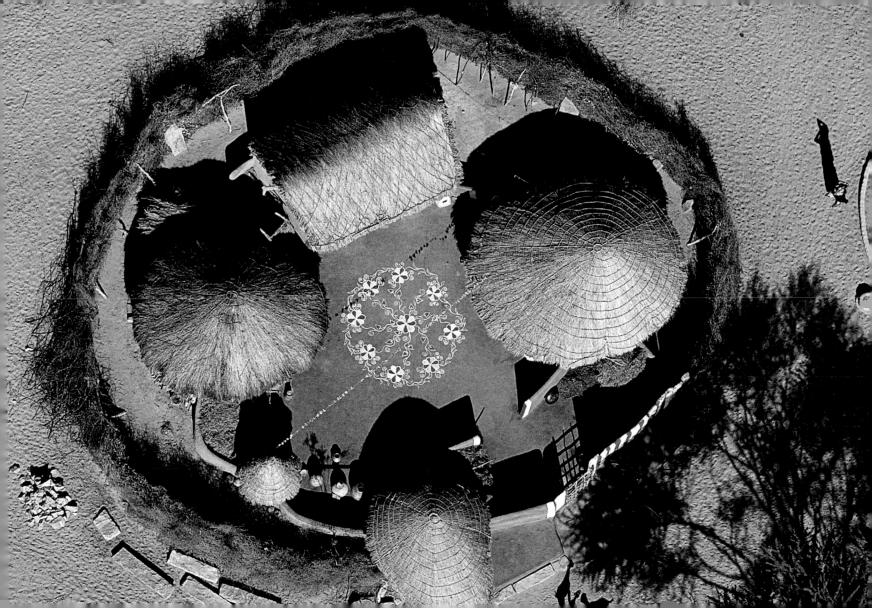

Gongola Ridge and MacKay Glacier, dry valleys in Antarctica (South Pole) (77°02'S - 161°50'E)

The Antarctic, the terra australis incognita of explorers between the seventeenth and nineteenth centuries, today remains a continent as captivating and mysterious as any distant planet. It was not until 1899 that Carsten Borchgrevink became the first human being to survive a full winter there. Today the Antarctic is a world "dedicated to peace and scientific knowledge," belonging to no nation, and governed by the Antarctic Treaty, signed in 1959 and reinforced in 1991. From astronomy to biological prospecting (research on unknown organic molecules), virtually every scientific discipline has its own ongoing research program in Antarctica. In the 1980s, the Halley base, run by the British, was the first to observe that a hole had appeared in the atmosphere's ozone layer; today, at McMurdo, American scientists are studying fossil evidence of the Big Bang, the gigantic explosion believed to have preceded the birth of our universe 15 billion years ago. Antarctica is also the spot where scientists have collected the most exact data on the history of the earth's climate, even studying the bubbles of air imprisoned in the ice for hundreds of thousands of years.

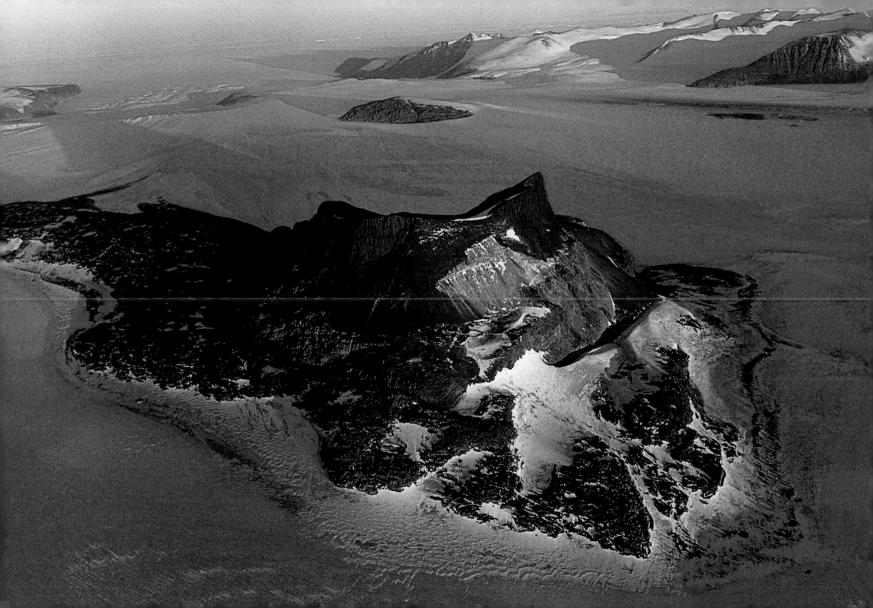

Village and ramparts of Monteriggioni, Tuscany, Italy (42°23′N - 11°13′E)

Built in 1213 by the Sienese, the hilltop fortress of Monteriggioni represents the typical Tuscan *terra murata* (walled land), designed for the strategic defense of the territory. This stronghold was built as a bastion against the former republic of Florence, the sworn enemy of the Sienese Republic during the Middle Ages and the Renaissance. The towers here are especially famous; in the fourteenth century they inspired Dante Alighieri in his description of the guardians of the ninth and last circle of Hell, before Purgatory (*The Divine Comedy*, Inferno, Canto XXXI). Today, the medieval walls remain in excellent condition. The ramparts are over 33 feet (10 meters) high and boast eleven towers and two gates—the effect is that of a crown resting on the hilltop. More than 70,000 visitors come to Monteriggioni every year.

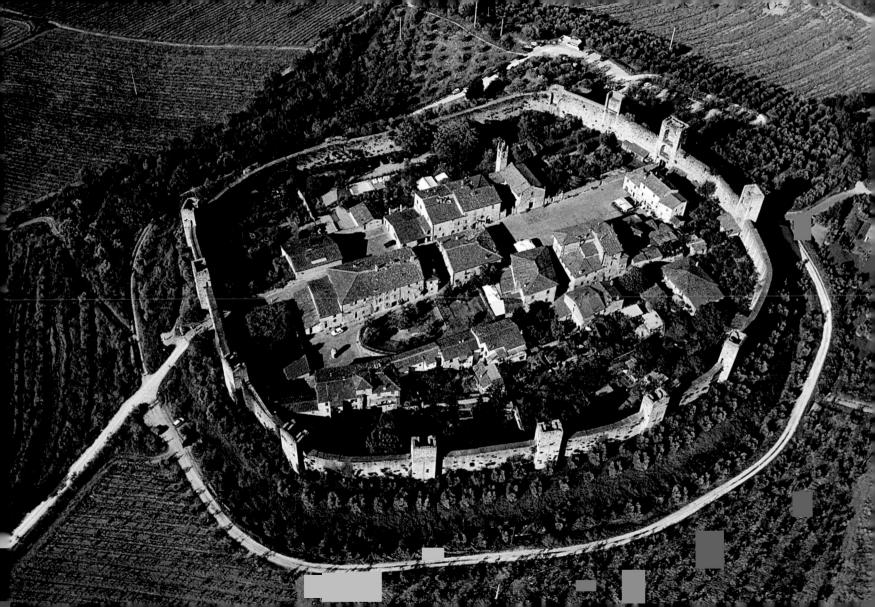

Island in the Buyo reservoir, Ivory Coast (6°15′N - 7°02′W)

Since the 1980 construction of a hydroelectric dam on the Sassandra River, the village of Buyo has changed completely. Thanks to the irrigation of its land, this former marigo (marshy zone), which used to be isolated in the middle of the equatorial forest, has joined Ivory Coast's coffee belt, attracting thousands of migrants in search of agricultural land. But today Lake Buyo has become extremely polluted, and farmers are suffering from the poor quality of its water. In order to increase yields they impregnate their crops with highly toxic pesticides (DDT, lindane, aldine, and heptachlorine), which cause cancers and growth anomalies. Worse, because the region lacks proper drainage and sanitation, waterborne diseases like malaria and dysentry have proliferated. Local people find it very difficult to obtain any kind of health care, and poverty is widespread. The situation has not improved since the collapse of coffee prices and the division of the country during the first years of the new millennium. Since 2005, its oil exportation exceeds that of coffee and cocoa combined.

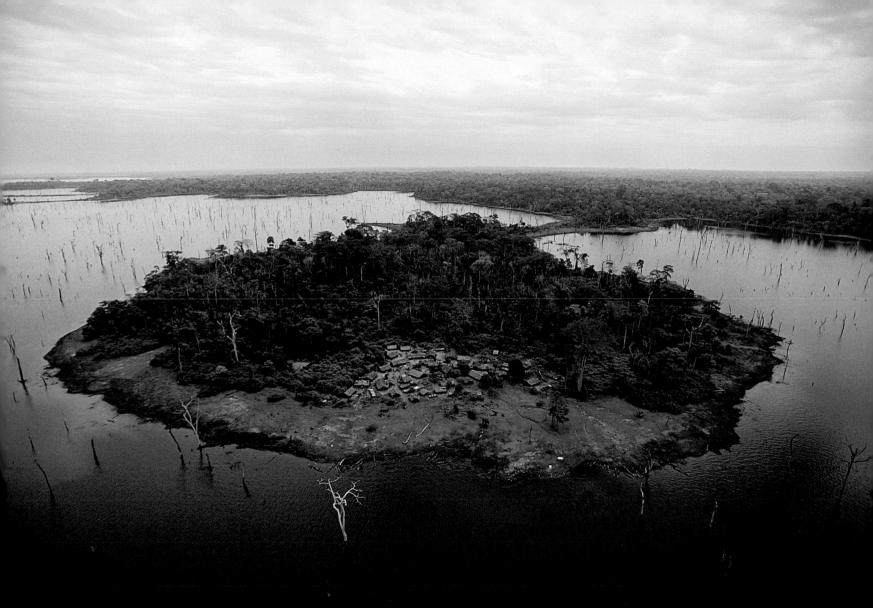

Herd of Kuri cattle, Lake Chad region, Chad (13°15'N - 15°12'E)

The marshes and fertile alluvial plains around Lake Chad are grazed by herds belonging to Kanembu, Peul, and Fulbe nomads, and also by cattle belonging to the sedentary Buduma tribe, who live on islands in the lake. Every evening the herders light fires; the animals then stand in the thick smoke, which protects them from the swarms of mosquitoes that infest the region and carry fearsome diseases. But another threat hangs over the Kuri cattle breed, which today totals some 400,000 head. These animals, with their majestic horns that serve as floats, are exclusive to the islands of Lake Chad, and their destiny is closely linked to that of the water—which has shrunk by 95 percent in the last forty years as a result of human activity and climate change. Today, 50 percent of its surface is choked by aquatic plants. The countries surrounding it—Chad, Niger, Nigeria, and Cameroon—are discussing a plan to divert one of the tributaries of the Congo to save Lake Chad, but so far no decision has been reached.

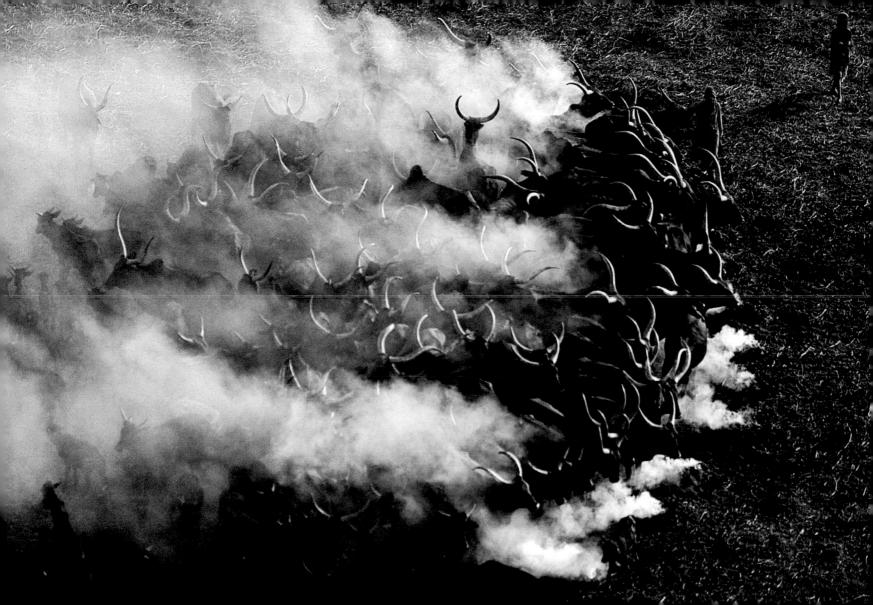

The Casbah, Algiers, Algeria (36°45′N - 3°1′E)

The Casbah of Algiers, which backs onto the Bouzareah massif north of the capital, owes its name to the citadel built in 1516 by the Turkish corsair Khair ad Din. With its winding alleys interspersed with steps and its architecture, which is at once Turkish and Arab, military and civilian, it is a most untypical Muslim city (medina) and has been a UNESCO World Heritage Site since 1992. As the prime focus of Algerian life in the sixteenth and seventeenth centuries, a shelter for resistance fighters during the Algerian War of Independence, and finally a hideout for armed Islamic groups in the 1990s, the Casbah encapsulates within its walls all the recent history of Algiers. Sadly, it is falling into ruin today; the violent earthquake that shook the Algerian coast on May 21, 2003, seriously weakened the buildings of this working-people's quarters, famous for its profound sense of community.

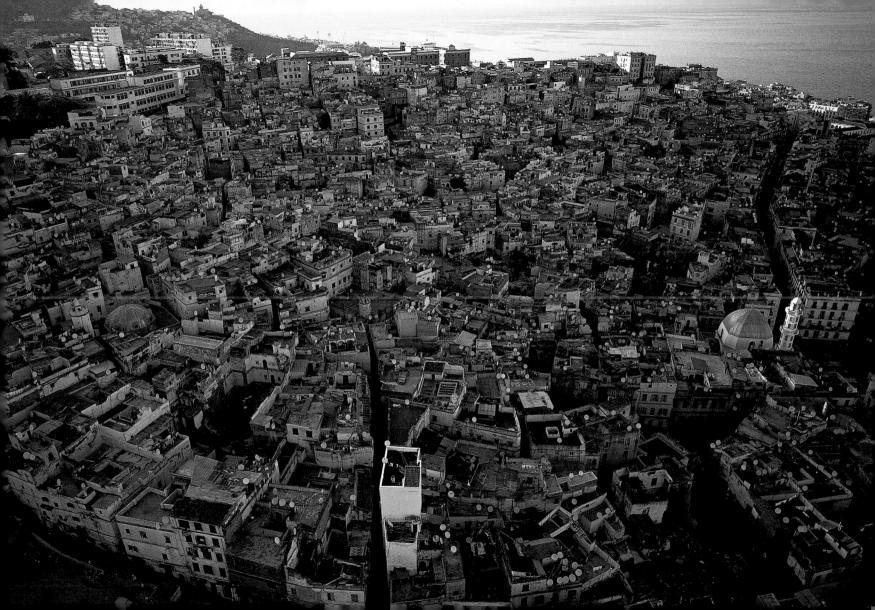

Lake Enriquillo, Dominican Republic (18°30'N - 71°35'W)

The Dominican Republic and Haiti share Lake Enriquillo, the largest salt lake in the Caribbean (at 100 square miles [265 square kilometers]). Sitting 130 feet (40 meters) below sea level, this stretch of water was created during the last ice age, when the lowering of the sea level eradicated the bay that divided the island in two, creating a giant bowl of saltwater, which is now entirely cut off from the open sea. From this distant marine past, Lake Enriquillo has preserved corals, seashells, and a salinity that is three times greater than that of the ocean. It also boasts some remarkable fauna: two hundred wild American crocodiles—a species threatened with extinction—along with the spectacular rhinoceros iguana. In the middle of the lake is the Cabris Island National Park, to which several dozen species of birds migrate, including the pink flamingo. A UNESCO World Heritage Site and (since 2002) a biosphere reserve, Lake Enriquillo is scheduled for future use as an ecotourism destination. Haiti and the Dominican Republic, which have long disputed the ownership of this shared natural heritage, are jointly sponsoring the project.

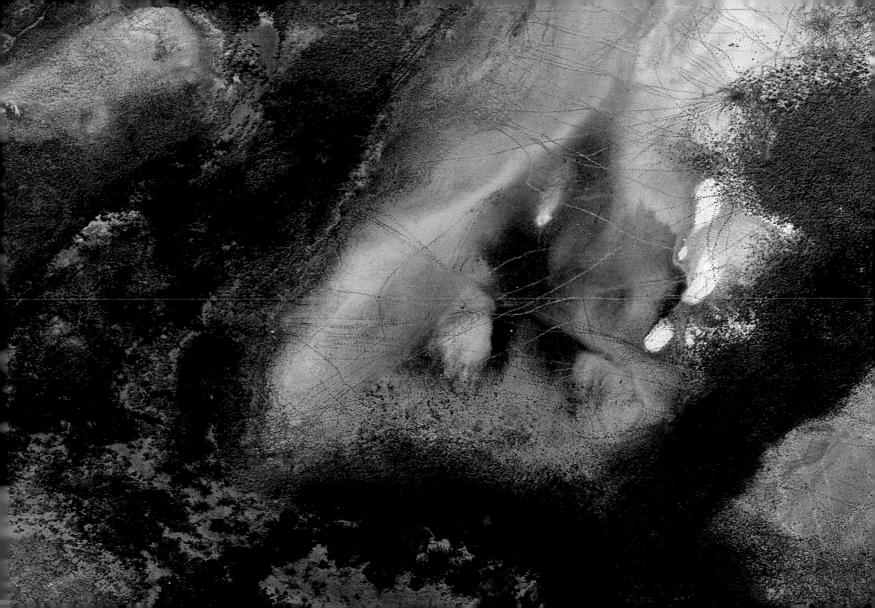

Garbage dump at Entressen, Bouches-du-Rhône, France (43°35'N - 4°56'E)

With six thousand open-air dumps and thirteen uncertified incinerators, France lags behind much of Europe in garbage management. The dump at Entressen is currently the focus of a pitched battle between ecologists and the urban community of Marseille. For nearly a century, more than 460,000 tons of garbage have been dumped at Entressen each year, polluting acres upon acres of surrounding land. Meanwhile, the mistral constantly blows down the dump's high fence, raining plastic bags and detritus all over the countryside. Despite a law passed by the French State in 1992 requiring all sites of this kind to close down before 2002, the Entressen dump was legalized in 1998. Since 2003, Marseille has proposed that it be replaced by an incinerator at Fos-sur-Mer. But local residents are hesitant, and ecologists flatly oppose the idea, fearing the incinerator will emit too many dioxins. In France, only 12 percent of domestic garbage is recycled—compared with 60 percent in Germany.

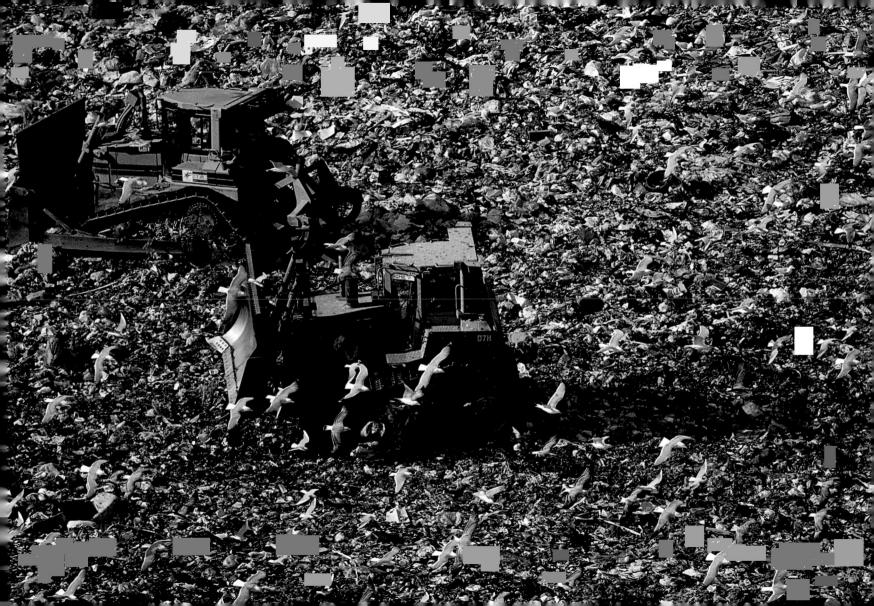

The Betsiboka delta near Mahajanga, Madagascar (15°43'S - 46°17'E)

Laid bare by intense deforestation and leached by tropical storms, the red soils of Madagascar are carried headlong into riverbeds, giving rise to its nickname. the Big Red Island. Every year, erosion is responsible for the disappearance of 2.500 to 5.000 acres (1.000 to 2.000 hectares) of arable Madagascan land. The entire country is affected, from the intensively farmed highlands, where plants are being poisoned and slash-and-burn techniques are employed, to the eastern regions, which are at the mercy of tropical storms that eat away at the lake and seashore environments. The iron-rich soils of Mahajanga, in the western part of the country, are especially sensitive to erosion. This region is home to 13 percent of Madagascar's population on 25 percent of its territory. It is packed with mineral wealth, but population pressures are aggravating deforestation, compounding the effects of erosion. It is a vicious circle, especially in a country where the annual per capita income is less than two hundred dollars. Tourism based on respecting the marvels of Malagasy biodiversity could bring substantial revenue, but at the moment only 560,000 ecotourists come to the Big Red Island every year.

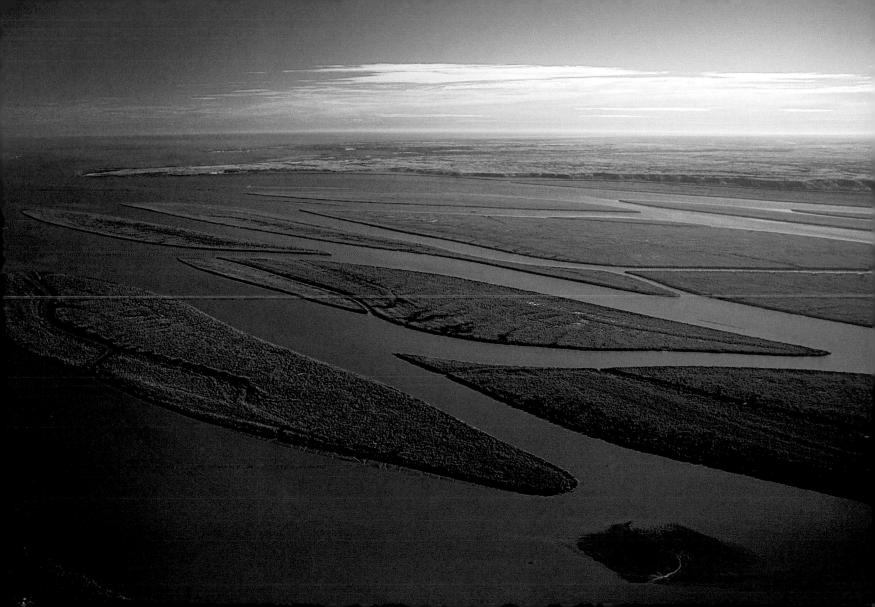

Mountains and houses near Bamyan, Afghanistan (34°50′N - 67°40′E)

The province of Bamyan, in eastern-central Afghanistan, is poor and arid; like 85 percent of Afghans, the local population depends on agriculture for its survival. Preserving the quality of the environment is essential in a country so dependent on its natural resources, but the droughts, the massive deforestation, the overgrazing, and the lack of a stable government—after a quarter century of war—have led to severe soil erosion that is threatening the country's agriculture. Afghanistan's forestland is disappearing little by little, its wood being sold on the black market to neighboring countries. The first victims of this traffic, and of the lack of any official control, are wild animals like the Siberian crane, the snow leopard, and the wild goat, all of which are on the road to extinction or already extinct. Their skins, their horns, and even their flesh can quite simply yield a better return than the meager harvests of impoverished soil.

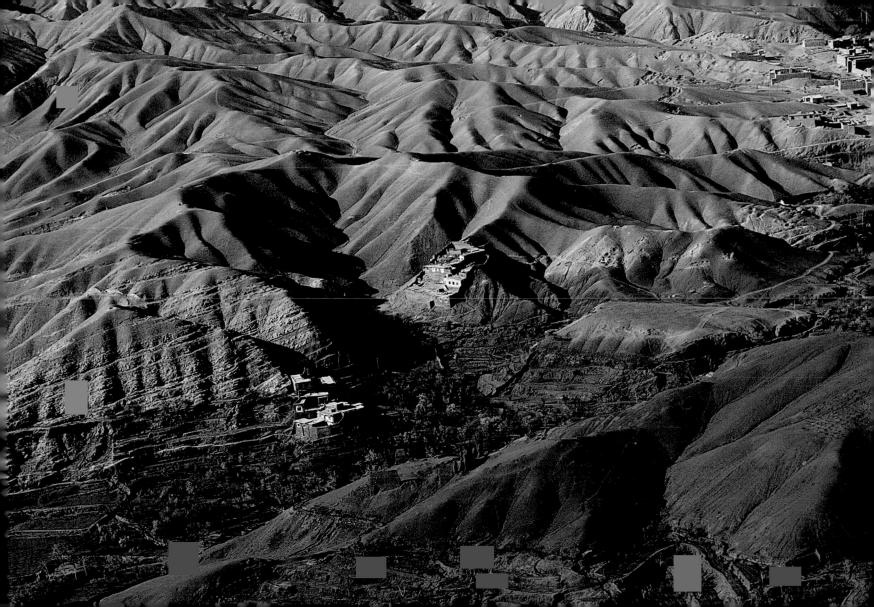

The Belorussian frontier, seen from a Lithuanian border guard's helicopter, Lithuania $(54^{\circ}53' N - 25^{\circ}49' E)$

The frontier between Lithuania and Belorussia has changed recently, not in its margins—as has been the case several times in the past century—but in its nature. Ever since the Republic of Lithuania joined the European Union in May 2004, this zone has become the de facto external boundary of the union's twenty-five member states. Fifteen years ago, it was easy to move to and fro within the Soviet Union; today, police and customs controls between the two newly independent republics complicate frontier crossings. But within the EU, the countries that have signed the Schengen Agreement—which Lithuania joined in December 2007—have given up identity checks on their borders, and the "free circulation" of peoples and merchandise has facilitated exchanges—making the need to strengthen controls along the outer frontiers all the more pressing.

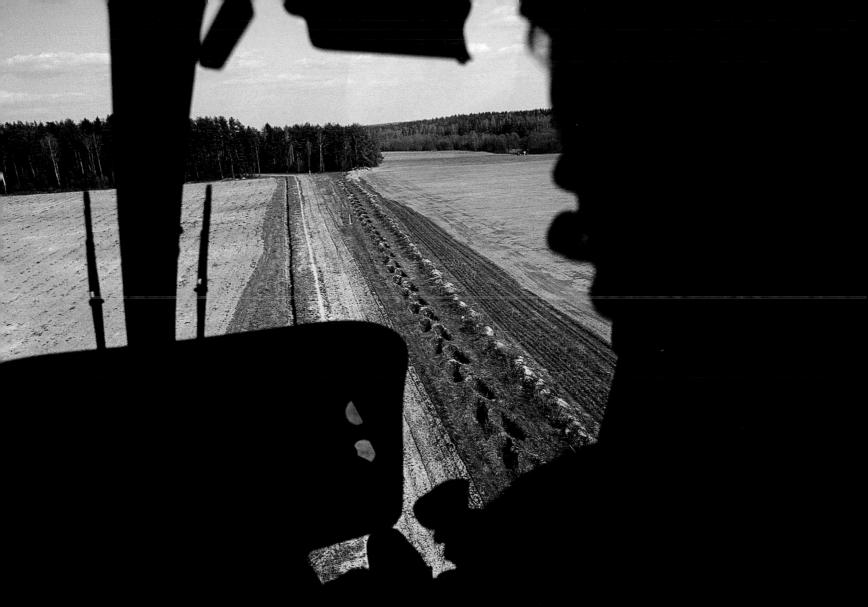

Brickmaking near Karal, Chad (12°50′N - 14°45′E)

Most of the houses in Chad are built of sun-dried mud. Referred to as *banco* (a Mandingo term) or *poto-poto* (after a workers' quarter in Brazzaville), clay is first kneaded with the feet, then churned together with chipped straw before being molded into bricks and put out to dry in the sun. This construction material, one of the oldest known to humankind, first appeared five hundred years ago in Egypt and Mesopotamia and is still very much in use in most parts of the world. Abundantly available and easy to work with, clay has numerous other advantages, too. Clay-brick buildings keep interiors cool when the weather is hot and keep them warm when the weather is cold; they are soundproof, fire resistant, and ecologically sound. Bricks also dry in the sun within a matter of days and can generally be made on a local level. For all these reasons, clay bricks are undergoing a renaissance in developed countries, where there has been a revival of interest in the ecological habitat and all its components.

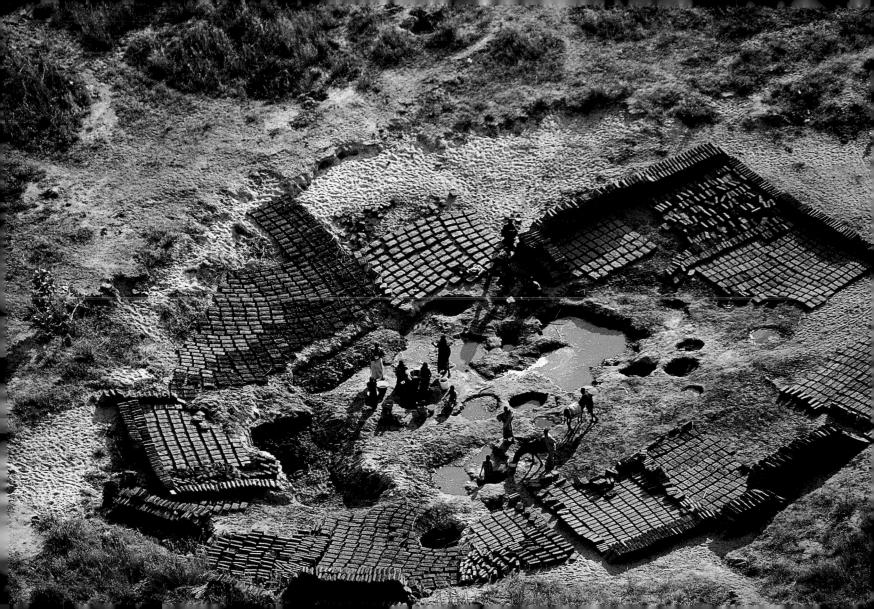

Agricultural landscape near Idaho Falls, Idaho, USA (43°28'N - 112°01'W)

The agricultural regions of the United States are severely affected by erosion. According to geologists, under normal circumstances the continents lose 65 feet (20 meters) of soil every million years. The natural regeneration of land usually compensates for this phenomenon, but today, the loss is at a rate of 1,640 feet (500 meters) per million years, twenty-five times greater than it should be. Between 1982 and 2001, simple measures, like the maintenance of grass strips alongside watercourses and contour plowing, have reduced erosion losses by 43 percent. Worldwide, it is thought that one-third of our arable land has been lost to erosion in the last four decades. Nearly 25 billion acres (10 billion hectares) are directly affected by this phenomenon every year—a process of erosion that is ten times the natural rate. This is a cause for great concern; soil not only sustains agriculture but is also an integral part of the balance of an ecosystem. And, most importantly, it is not a renewable resource.

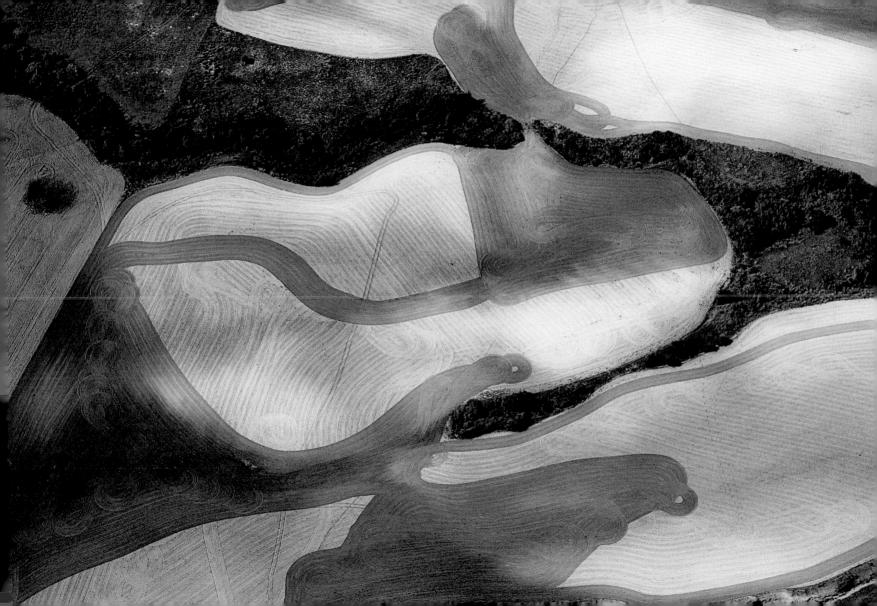

Market northeast of Abidjan, Banco National Park, Ivory Coast (5°19′N - 4°02′W)

Most markets in Africa sell sundry items of secondhand clothing imported en masse from Europe and the United States. Paradoxically, these markets offer an intriguing glimpse at consumer habits in developed countries; Americans, for example, constantly renew their wardrobes, sending their castoffs off to Africa. American and German items are usually in very good condition and much sought after; items from France, on the other hand, tend to arrive totally threadbare. But buying old clothes at bargain prices is not just a poor man's occupation. The Missebo market in Cotonou, Benin, is the biggest of its type in West Africa and a fashionable venue through which all sorts of Africans like to wander in search of the latest items, including jeans and T-shirts bearing the names of prominent designers and brands.

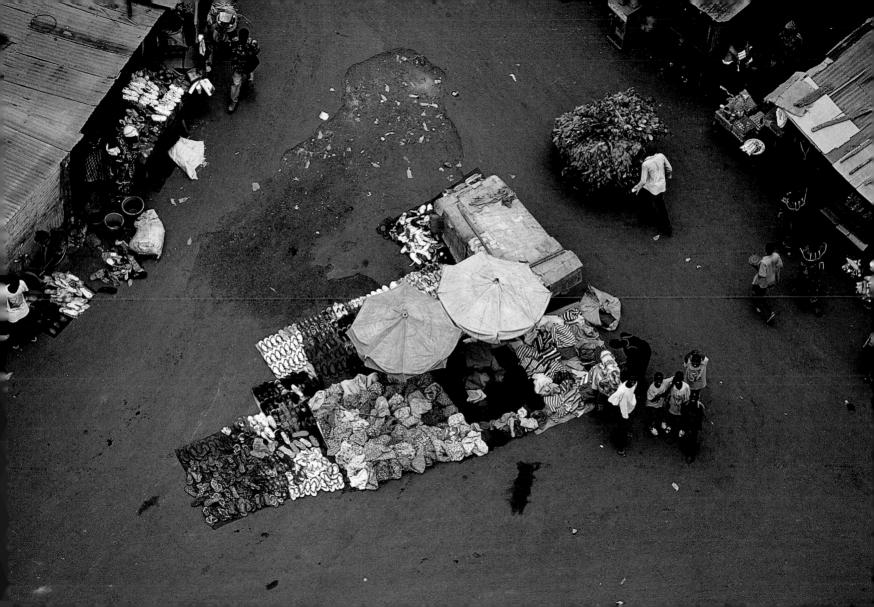

Remains of an ancient "desert kite" gazelle trap, between As Safawi and Qasr Burku, Mafraq, Jordan (32°28′N - 27°34′E)

Between seven and eight hundred "desert kites" are scattered all around the Middle East; these ancient formations appeared to pilots of the British Air Mail route across Transjordan in the 1920s. Built by hunters—probably Neolithic nomads—the traps, used to capture herds of gazelles, consisted of 0.6 to 1.2 miles (1 to 2 kilometers) of converging walls, which acted as a kind of funnel into a circular enclosure hundreds of feet in circumference. The traps were usually concealed on the far side of a ridge. The terrified animals would disperse within the space, while hidden groups of hunters awaited them with spears. Petroglyphs of these scenes exist from the Sinai to the Caucasus; the sculptors used their rock supports like the reliefs of a landscape, so as to produce virtual scale models of these massive desert snares.

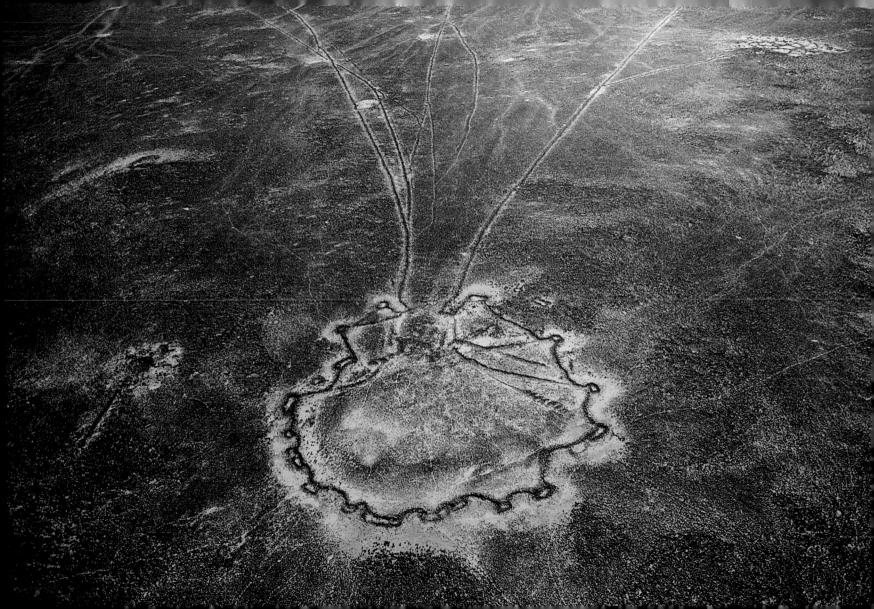

Moraine in the McMurdo Dry Valleys between Debenham and Miller glaciers, Antarctica (South Pole) $(77^{\circ}50'S - 165^{\circ}60'E)$

The polar glaciers are formed by "inlandsis"—broad, lens-shaped caps characterized by predominantly "cold" ice (whose temperature is below 32°F [0°C] all year round). They peter out in glacial outfalls where cold ice must coexist with temperate ice (whose temperature hovers above or below 32°F [0°C]), and this makes them peculiarly sensitive to climate change. Thus the glacial front advances and retreats like a bulldozer, carrying with it all kinds of other materials; as it goes along it tears up rocks and sediment, which form moraines alongside and ahead of it. This one has been baptized the "Ringer" because of its near-circular shape. These spectacular landscapes attract more and more tourists every year; close to 35,000 people visited the snow desert of Antarctica during the 2006–2007 season—up from 4,800 in 1990. By virtue of a 1998 protocol to the Antarctic Treaty concerning the protection of the environment, each nation is responsible for its own portion of Antarctic territory and must keep a close eye on all expeditions mounted there.

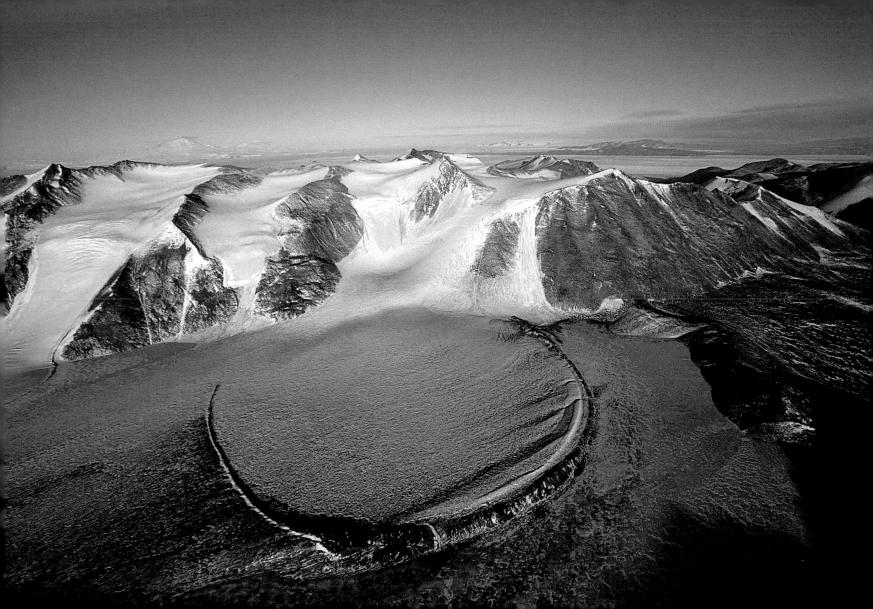

Grape harvesting north of Cape Town, Republic of South Africa (33°54′S - 18°51′E)

On his arrival at the Cape to open an East India Company trading post in 1652, the Dutchman Jan van Riebeeck planted a few vines brought from France—and the first South African vineyard was born. Following the revocation of the Edict of Nantes in 1685, the vineyards were expanded and diversified by French Huguenots arriving in South Africa to escape France's persecution of Protestants. Today South Africa's wine district represents 1.5 percent of the world's total wine growing area (370,000 acres [150,000 hectares]) for 3 percent of its production, making South Africa the eighth-largest producer in the world. With its Mediterranean climate, the beautiful Cape region is well suited to this most demanding of professions, and has several different production zones, including Franschock (the "French corner"), Stellenbosch, Constantia, and Durbanville. The vineyards grow right up to the edge of Cape Town; indeed, some parcels are now surrounded by suburban developments. Every type of wine is represented in South Africa, including sweet and dry whites, traditional reds, and sparkling wines.

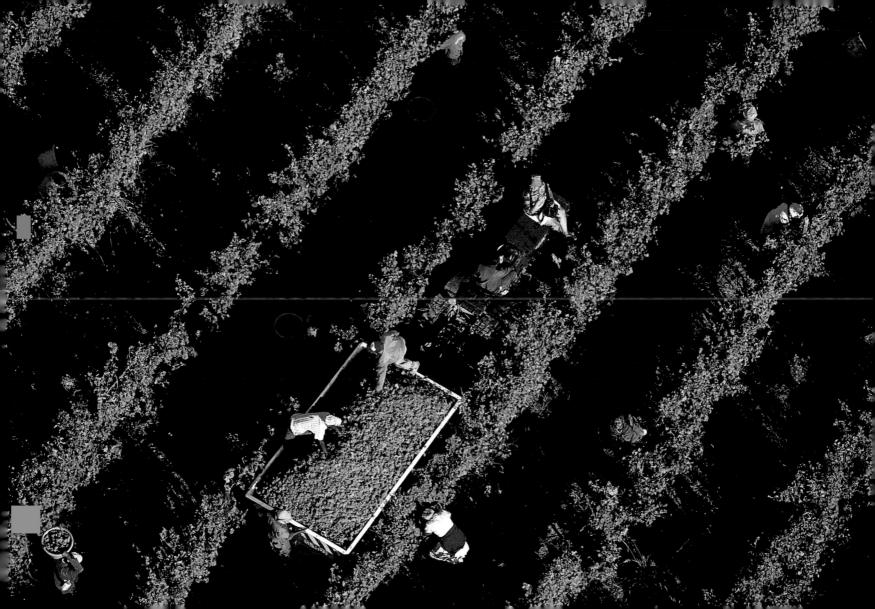

The Tiergarten quarter, Berlin, Germany (52°30'N - 13°22'E)

The Tiergarten quarter, with its park and pedestrian zones, is the green lung of central Berlin. Today, in many great European centers, city planners are limiting automobile traffic in favor of bicycle and pedestrian traffic. Novel initiatives are appearing all over the Continent that enable city dwellers to move about by diverse means, without resorting to automobile transport. Bicycle parking lots are more and more numerous, for example; managed by municipal authorities, these allow pedestrians to borrow a bike in one part of town and deposit it in another, continuing on foot or on public transport as they wish. Cities built before the advent of motor vehicles are poorly adapted to them and even less suited to big trucks carrying merchandise; indeed, city traffic has become so dense that a car in London or Paris gets you to your destination no faster than a horse-drawn carriage once did. It is also estimated that on European territory alone several hundred thousand people—mostly city dwellers—suffer from breathing ailments directly linked to fine airborne particles emitted by motor vehicles.

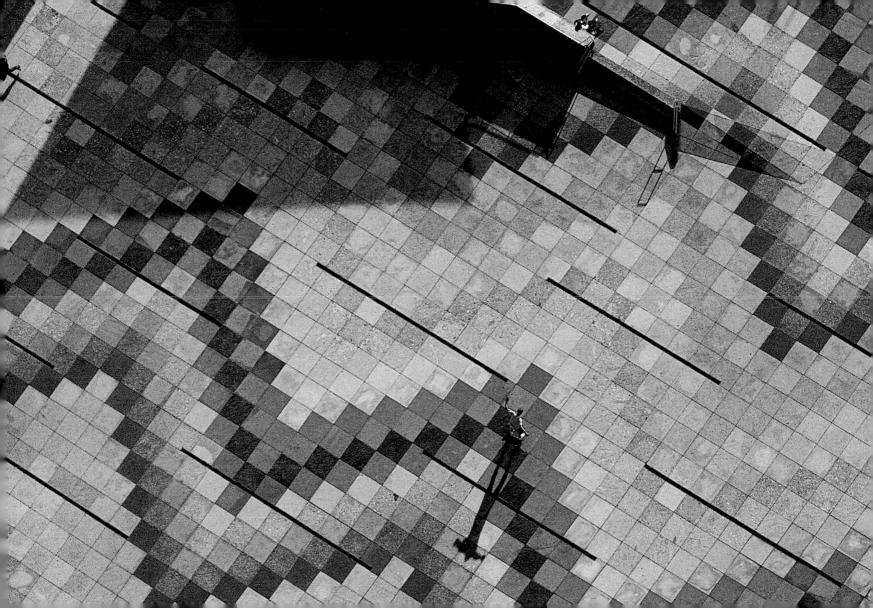

Mountains stripped of vegetation north of Comendador, Dominican Republic frontier, Haiti (19°08'N - 71°44'W)

As the first colony established by Christopher Columbus in 1492, the island of Hispaniola was long known as the Pearl of the Antilles. Its plantations of sugar, coffee, indigo, and spices were manifold and diverse, the soil was fertile, and forest clothed the greater part of the territory. Officially separated in 1844, the Dominican Republic and the Republic of Haiti have had very different destinies. The latter, racked by a succession of dictatorships and coups d'état, gradually sank into an extreme poverty that precluded any form of environmental policy. In its search for kitchen charcoal, the growing Haitian population has systematically razed its forests, which are now confined to only 1.4 percent of the terrain. Stripped in this way and leached by violent tropical rains, the land has quickly eroded and deteriorated. Poverty and population pressure are at once the causes and the consequences of rampant deforestation, a cycle that is almost impossible to break.

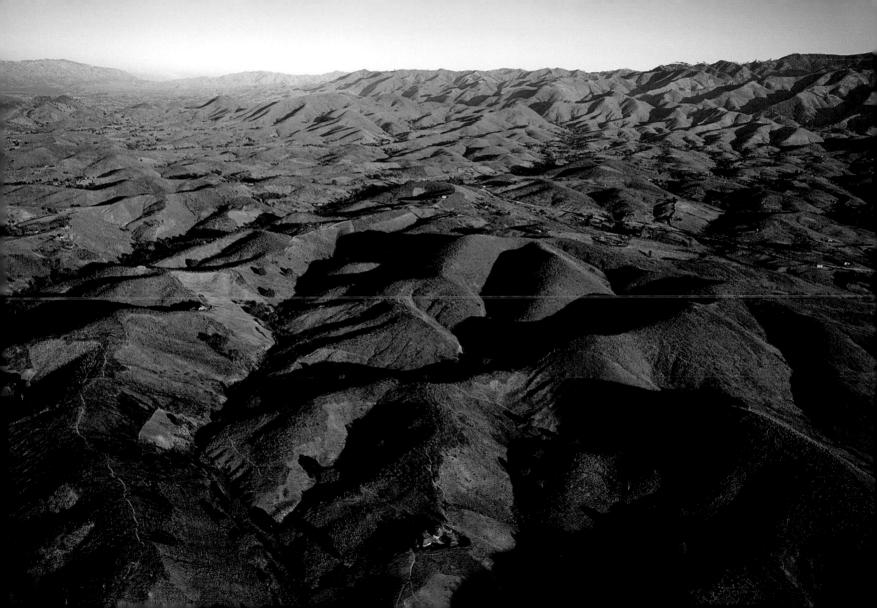

Flock of sheep crossing the Arerunguá River, Salto, Uruguay (31°5′S – 56°3′W)

Sheep raising for meat and wool in Uruguay dates back to the nineteenth century, a development that can be explained by the vast expanses of pasture in this pampas region. Nevertheless, sheep stocks fell by more than half in the last century, from 26 million to less than 10 million. This reduction is due to the growth of beef exports, cattle being more profitable overall than sheep. Much of the wool, meat, and skins from Uruguayan sheep is exported to the European Union, where a June 2005 study concluded that Uruguayan sheep were unaffected by the "staggers" (the sheep equivalent of mad cow disease). In 2006, Uruguay was the world's second-largest producer of combed wool (midway between raw wool and carded wool). Despite the benefits it brings to humanity, the raising of livestock harms the environment because on a global scale it produces 18 percent of greenhouse gases and emissions.

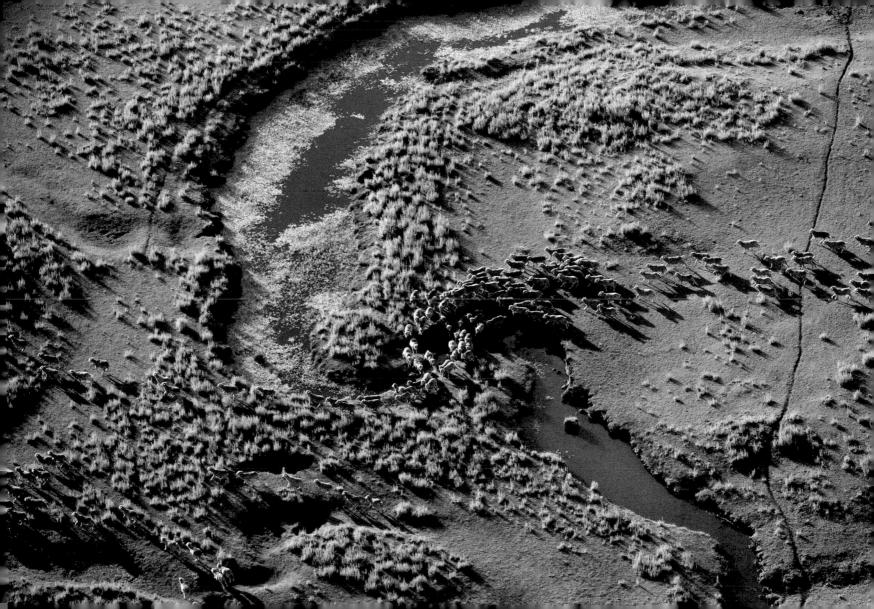

Animal tracks on a hillside, Jalisco, Mexico (20°20'N - 103°40'W)

In the Mexican state of Jalisco, there are simply no more forests at all. On the hillsides, livestock has grazed the grass down to its roots, leaving nothing but hoof marks. Much of the organic matter has vanished, soil microorganisms are dying, and the land is slowly losing all fertility. Grass is harder and harder to find. During the rainy season, mud, sand, and gravel flow downhill and obstruct the streambeds. In Mexico, 70 percent of arable ground is threatened to a greater or lesser degree by desertification as a result of deforestation, agricultural overexploitation, and overgrazing. The country is losing 870 square miles (2,250 square kilometers) of arable land with every passing year. Consequently, 700,000 to 900,000 people are leaving the countryside annually, heading for the suburbs of Mexico's great cities or for the American border. Overgrazing is a worldwide phenomenon that affects about 1.7 billion total acres (680 million hectares) of land; livestock—in the form of 3.3 billion cattle, sheep, and goats—is now essentially concentrated on land too dry or too steep for cultivation.

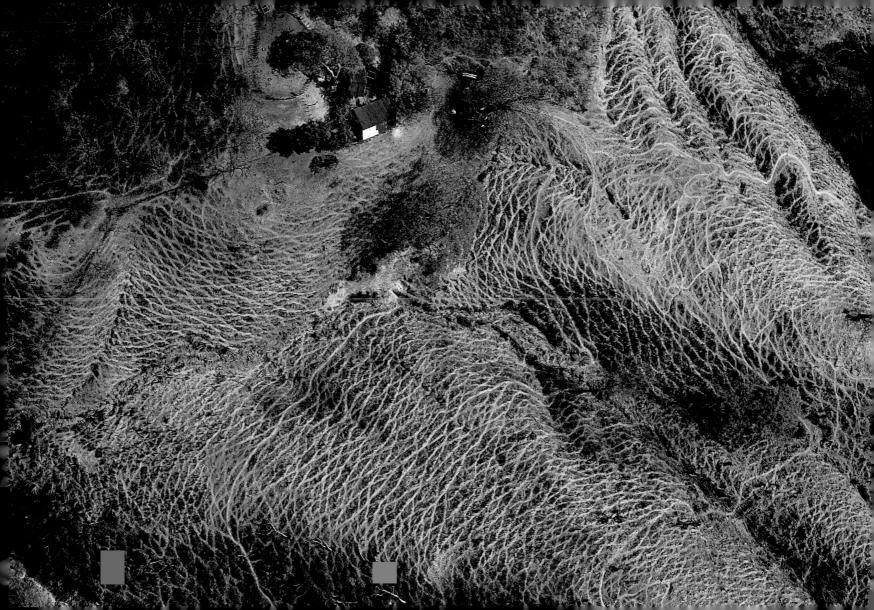

Village of Koh Pannyi in the bay of Phang Nga, Thailand (8°12'N - 98°35'E)

The west coast of Thailand, on the Andaman Sea, consists of a series of bays and islands, including the tourist destination of Phuket. The bay of Phang Nga came into being at the end of the last ice age, 18,000 years ago. At that time rising waters submerged arid limestone mountains, leaving only their summits, which were eventually colonized by tropical vegetation. Classified as a marine park since 1981, this geological marvel is the site of the floating village of Koh Pannyi, which was built on stilts two centuries ago by Muslim fishermen from Indonesia. Its inhabitants, known as the "sea gypsies," live by fishing in the traditional way. Today Koh Pannyi is much visited by tourists, as is the neighboring island of Ko Ping Gan, nicknamed James Bond Island because *The Man with the Golden Gun* was filmed there. Protected by its convoluted shape, the back of this bay suffered far less damage from the tsunami of December 26, 2004, than did neighboring areas.

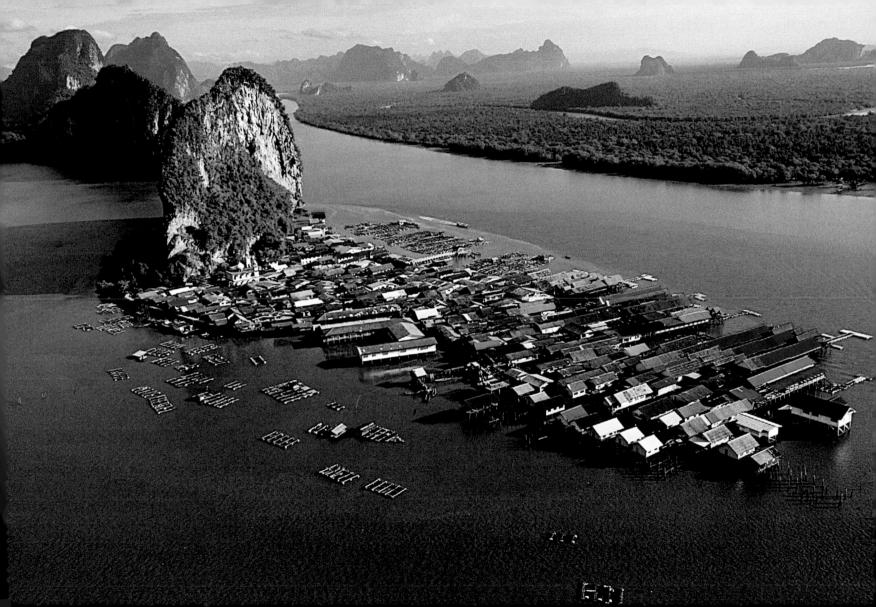

Training camels, Ar Rayyan, Qatar (25°17′N - 51°25′E)

In Qatar, as in the other countries of the Arabian Peninsula, camel racing is extremely popular. Historically, the camel served as a pack animal or was raised for its milk, meat, and hair; it was indispensable to the itinerant Bedouins. Today, the racing camel, like the falcon, is a source of pride to its Arab owners. Racing camels are tended with the utmost care and are raised using the most modern genetic and nutritional approaches and training techniques. The result is a long-backed creature with a small hump, a narrow abdomen, and elongated hooves. The Qataris go to their "cameldromes" in force to watch up to three hundred camels race at a time, running distances from 3 to 6 miles (5 to 10 kilometers) that require both speed and endurance. These races are patronized by the emir of Qatar, Sheik Hamad bin Khalifa al-Thani, out of respect for Arabian tradition. The royal family also sponsors trophies and prize money, which makes this sport not only prestigious but also highly lucrative.

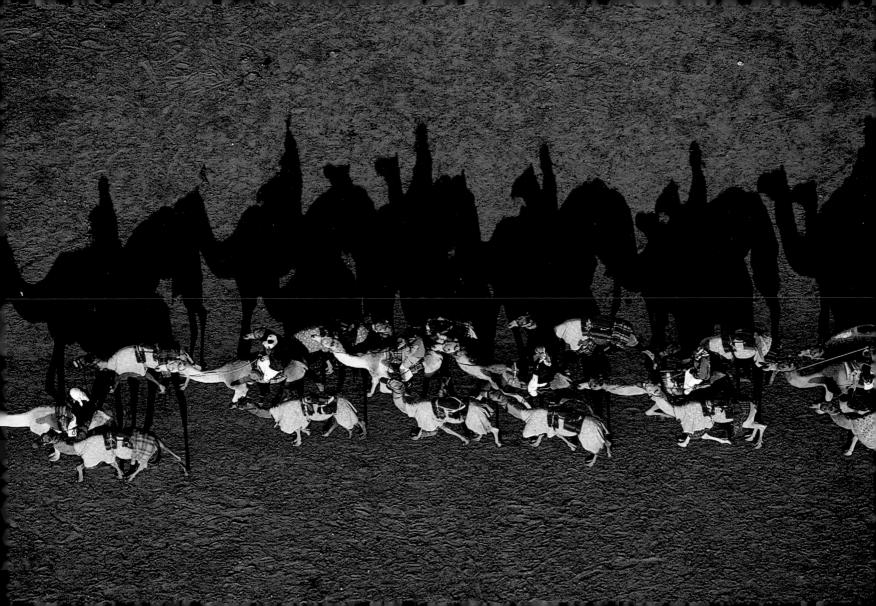

River in the marshes, Okavango delta, Botswana (18°45'S - 22°45'E)

Extending 808 miles (1,300 kilometers), Okavango is the third-longest river in southern Africa. It rises in Angola before widening in Botswana into an interior delta covering some 6,000 square miles (15,000 square kilometers). Its 636 billion cubic feet (18 billion cubic meters) of water are then progressively absorbed by Kalahari Desert sand, or evaporate in the dry air. Because of the geological phenomenon of *endoreism*, the "river that never meets the sea" loses itself in a vast marshy labyrinth inhabited by countless wild creatures. But these fabulous expanses are threatened today by diamond mining; Botswana is the world's second largest producer of diamonds—an activity that consumes huge quantities of water. The Okavango, which is protected through its status as a natural reserve and through the vigilance of its native Bochiman tribe, is nonetheless showing the effects of a fall in adjacent water-table levels, which are so heavily pumped that they may be exhausted by 2010.

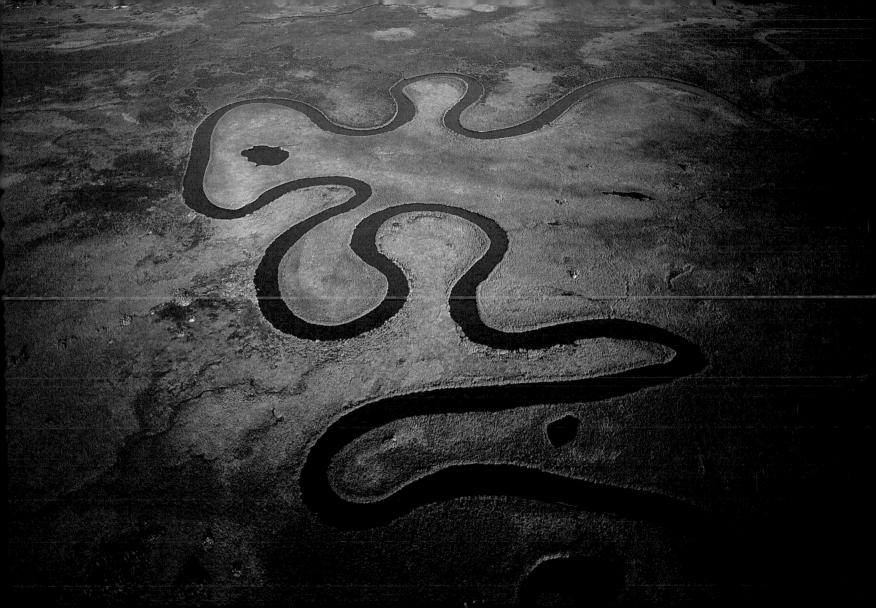

ABOLISHING POVERTY

The legacy of recent centuries is one of scientific and technological progress, one that offers us a source of hope in our struggle to rid the world of epidemics, diseases, droughts, floods, and the destruction of natural resources. The priceless bequest is also one of enshrined universal values and unconditional respect for human rights. Fortified by its power to create equal opportunity for all, humanity has shown itself to be committed to the total and immediate elimination of any source of injustice. We have already abolished slavery, attacked the roots of discrimination against women and minorities, smashed colonization, and triumphed over the deepest shame of the modern era; apartheid.

These advances and many others promise a better world in the future. And yet we continue to be afflicted by galloping poverty, newly hatched forms of exclusion, and the arrogant triumph of the profit motive and the law of the market over quality of life. Human beings—heirs though they are to the affirmation of fundamental rights—are compromising in this area so as to deny themselves the freedom to live as individuals and citizens. This fuzzy logic reduces the human being to an insignificant participant in a profit chain, which itself exists to serve a utopian view of power, as defined by the advocates of a free market. Worse, it is leading to the destruction of our planet's resources and, by the same token, to our own self-destruction. As things stand, our hope of restoring the human rights of all individuals looks to be fading. Today, one human being in every four lives in wretched, dehumanizing conditions that are quite avoidable. This is exclusion. We tolerate the suffering of hundreds of millions of women, children, and older individuals who are prey to filth, disease, peril, and death. Our proud world of progress, which sheds tears of sympathy over the occasional tourist taken hostage, shamelessly abandons a billion human beings to live in inhuman conditions.

In 2000, the international community undertook to reduce by half, before 2015, the number of individuals living on less than a dollar a day—the criterion chosen to define "extreme" poverty. The goal is perfectly praiseworthy. But it will only be accomplished through great effort and systemic change—and

even if it is successful, it will leave behind hundreds of millions of men and women in the same state of wretchedness. This is not a matter of arithmetic; extreme poverty is the agent that perpetuates the denial of human rights. In 1993, at an international conference in Vienna, it was correctly acknowledged that of the five types of human rights proclaimed as inherent by the Universal Declaration of Human Rights—civil, cultural, political, economic, and social—poverty invariably violated the last, and all too often the other four as well. It is by violating their rights that we imprison the poorest people in their poverty.

Since 1993, there has been a succession of similar, muffled alarm bells and vain appeals to reason. But any realistic attack on poverty must begin here; a violation of rights cannot be "attenuated"—we must simply put a stop to it and do our best to make amends for the fact that it ever existed. Poverty, as a violation of human rights, is not an evil to be reduced, but one to be abolished. This is the only relevant response. The rights of the poor are the responsibility of governments and the agents of governance around the world, of those who direct the global economy, and of each one of us individually. These rights are weapons only if the demand is met head on by the obligation that pauperism—which is today grafted onto the very structure of society—be removed forever. This is not to say that the abolition of poverty signifies equality—a utopian ideal that invariably engenders even more abominable want, if history is any guide.

All we need to do is allow human beings the right to effectively exercise all their rights. Indeed, the emphasis on the obligation to abolish poverty is a good deal less utopian than one might think; slavery and apartheid were defeated because public opinion held that its own values were being betrayed. By the same token, we are ashamed that poverty persists; after all, poverty is a synthesis of slavery and apartheid, and worse than either alone. The law can be an extremely powerful lever, provided it's taken seriously enough to force people to face up to their obligations. Real conviction and real action by sovereign states on behalf of their citizens are all that it takes. We hide these facts from ourselves, without realizing that in so doing we are violating the human rights of others.

Our duty to be lucid demands contemplation of our own rights and values, and effective action; the reward will be a livable, sustainable future for all. If adhesion to human rights is not enough, then the desire to act more effectively, and the recognition that this is a vital issue of worldwide human security should mobilize every state and every individual in the battle to abolish poverty. This battle is a just one, and it presupposes no particular ideology. If human rights are made a reality for all, then liberty and humanity will do the rest. The infinite wealth of human diversity will at last be able to make the best use of the earth's resources, of the advances we have made in the course of history, and of the vitality of the present; only on this basis can we build the matrix of a global sustainable development.

Pierre Sané
UNESCO Deputy Director General for Human and Social Sciences

Greenhouses between Nara and Osaka, Honshu, Japan (34°37′N - 135°41′E)

Since the 1960s, Japanese agriculture has been radically altered by the development of dairy and fruit production and the growth of an industrial meat sector. This change has had a radical effect on the landscapes of the Japanese countryside. Vinyl greenhouses for intensive fruit and vegetable growing have appeared on the peripheries of larger cities like Tokyo and Osaka. They have also encroached on traditional rice-growing areas like the Nara plain, Honshu Island, and Okoyama on the Inner Sea, to the point where they have sometimes supplanted them altogether. Traditional Japanese crops, such as mulberries, tea, and cereals, are diminishing little by little, forcing the country to import large quantities of wheat, barley, and even of silk, although Japan had been the world's largest exporter of silk only thirty years ago.

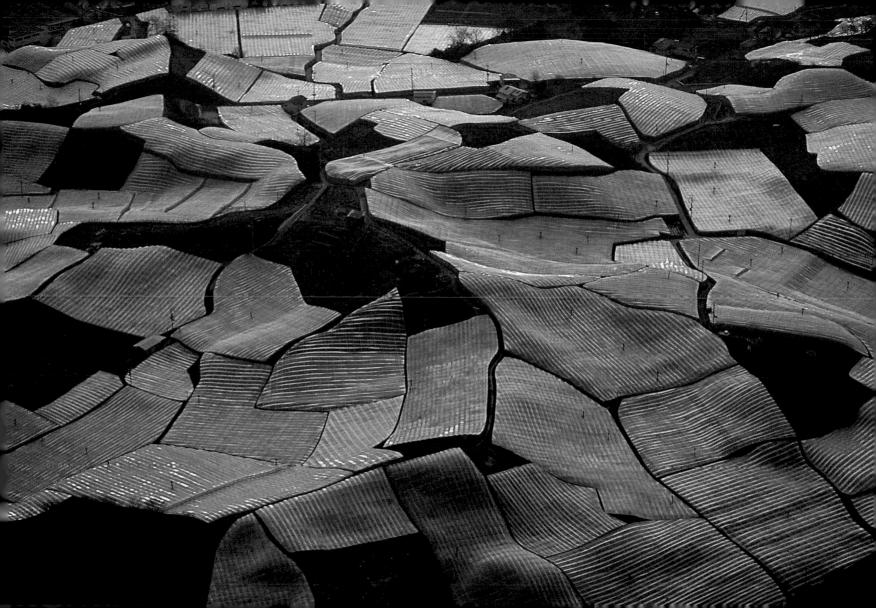

Pack ice forming around the Turku archipelago, Finland (60°27′N - 22°00′E)

The Baltic's thin ice covering forms in tiny fragments like a broken mirror, reflecting the dim light of the Finnish winter. Drifting with the waves and sea currents, the ice is first subjected to contrary, dislocating pulls; separated pieces then crowd together, accumulating until the pack ice attains its maximum thickness (20–24 inches [50–60 centimeters]), around the beginning of April. It quickly vanishes with the onset of spring, freeing the islands of the Turku archipelago; although Finland lies on the same latitude as Alaska and Greenland, it has a relatively temperate climate, influenced by the Gulf Stream. But this mighty sea current, which crosses the Atlantic and warms the western European seaboard, may well disappear as a result of climate change and the melting of the polar ice cap—in which case Europe's climate will become more like Canada's.

Tea gardens at Boseong, Jeollanam-do Province, South Korea $(34^{\circ}47'N - 127^{\circ}04'E)$

Terraced tea gardens run all along the southern coast of Korea, in the Boseong region; the mountainous land, where flat bottomlands occupy no more than a fifth of the surface, is well suited to the crop. Moreover, Boseong has warm weather and plenty of sunshine and sea air, conditions that favor the green tea that has become this region's most famous product. Tea has been part of Korean culture, which stretches back 2,800 years before the Christian era, for time immemorial. The first seeds were imported from China during the Tang dynasty, between 600 and 57 BC. Thereafter, green tea gradually supplanted the white tea *Paektusan*, made from the young shoots of a species of azalea. One of the most famous green teas is called *sparrow's tongue*, in reference to the shape of its leaves.

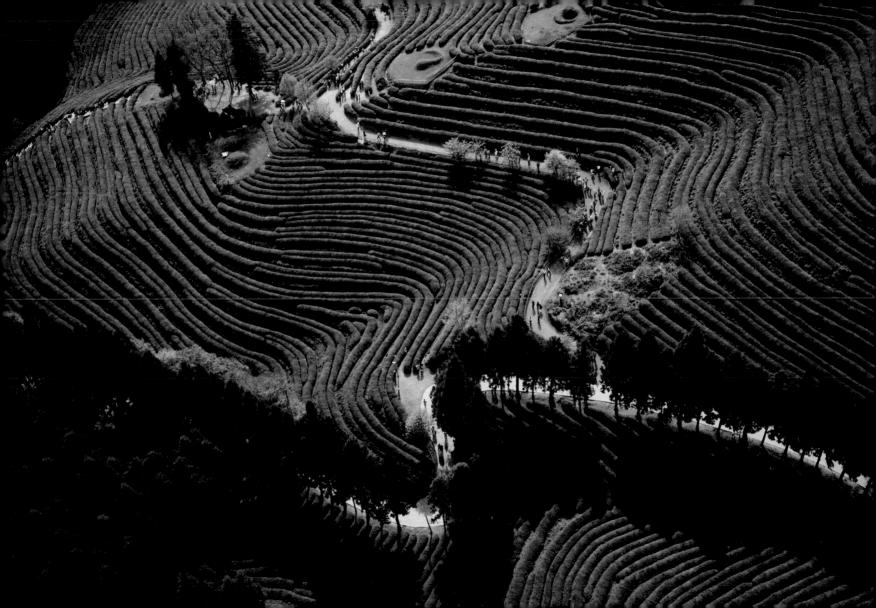

Village of Skärhamm, Bohuslän Islands, Västra Götaland, Sweden (58°00′N – 11°33′E)

The fishing villages of Sweden's west coast are clamped like limpets to the region's barren rocks. Västra Götaland County, a broad archipelago that stretches from Götaland to the Norwegian frontier, is the second most populous region of Sweden (after Stockholm). Here many villages continue to fish for their livelihood, a tradition begun in the seventeenth century with the growth of the herring industry. This lean, protein-rich fish, which the ancient Gauls called the "wheat of the sea," used to be the most common catch in Europe. Herring move in close-packed schools in the cold waters of the Atlantic and Baltic. They are easy to catch but difficult to preserve—so difficult that curing factories were created dockside, bringing prosperity to many a small seaport. Today, herring is still one of the world's most sought-after fish; fortunately, unlike many other species—including Atlantic salmon, red Mediterranean tuna, cod, hake, sole, and red prawn—it is not threatened with extinction.

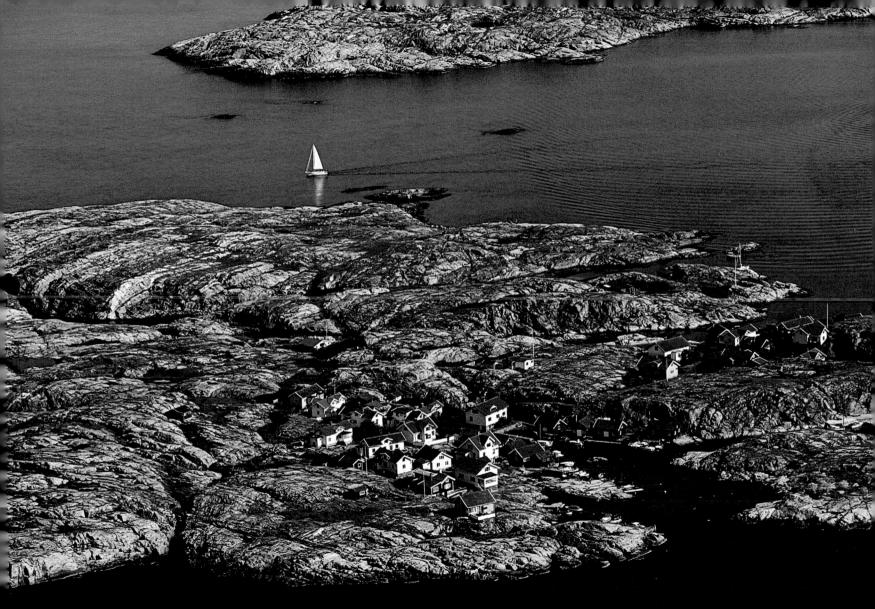

Gardens of the Sans-Souci Palace, Potsdam, Germany (52°17' N - 13°23'E)

This jewel of the German rococo style was built at Potsdam during the reign of Frederick the Great. Often likened to Versailles owing to the magnificence of its architecture and its refined gardens, Sans-Souci continued to be the seat of the royal court of Prussia even after Berlin was made the official capital. It was not until 1918, after the abdication of Kaiser Wilhelm II, that Potsdam lost its status as a second capital. In April 1945, Potsdam was the target of massive British bombing raids, which annihilated its historic center but spared the palace; after the war, the Neuer Garten (New Gardens) at Sans-Souci played host to Stalin, Churchill, and Truman when they made the historic decision to demilitarize Germany, hold it accountable for \$20 billion in war reparations, abolish the Nazi Party, and bring German war criminals to trial.

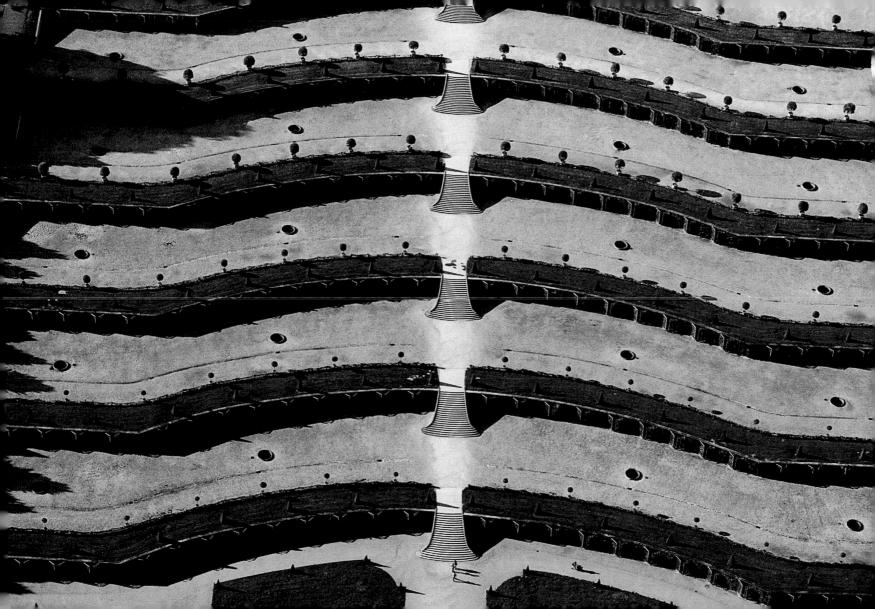

Market at Kasserine, Tunisia (35°00'N - 8°45'E)

In west-central Tunisia, people come to this local market to sell clothes and fabrics. More than 200,000 people live directly from the textile industry in Tunisia. Most of the raw materials are imported—notably cotton, the world's leading textile fiber. The growing of cotton (26 million tons of it were produced between 2004 and 2005) provides a livelihood to 350 million people on the planet but also creates serious environmental and health problems; the cotton industry alone employs 25 percent of the pesticides used agriculturally every year (on only 2.5 percent of the planet's cultivated land). It is also the world's third largest consumer of water for irrigation. Several strategies could be applied to reduce this damage, from the cultivation of organic cotton at source to a global brake on consumption at the end of the chain. Buying high quality clothing that will last, and giving away, recycling, or exchanging the items we no longer need is another effective way to limit cotton's environmental impact.

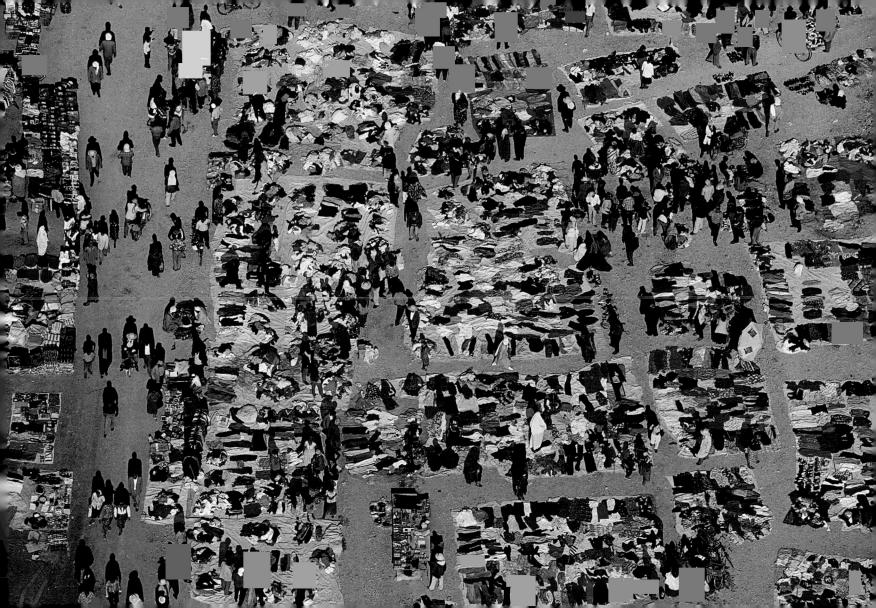

Lumber on the Amazon, near Manaus, Amazonas, Brazil (3°03'S - 60°06'W)

In a region where the density of vegetation complicates access to forestry felling zones, flotation is the cheapest means of moving lumber. Brazil is the world's fifth largest producer of industrial timber and its second-largest producer of tropical woods. But all this activity is adding to the destruction of the Amazon rain forest. which has already lost more than 16 percent of its original surface area. While some timber merchants are beginning to promote the utility of a protected forest as opposed to a devastated one, the pace of deforestation continues to grow, engendering conflicts of interest that sometimes lead to bloodshed. In February 2005, murders carried out by pistoleiros paid by unscrupulous timbermen moved the government to cordon off 12 million acres (5 million hectares) of forestland into fully protected zones, with immediate effect. But the timber industry is not the only culprit behind the deforestation of the Amazon; the expansion of the soya crop is also to blame. Soybeans, which can be exported to industrialized countries as animal fodder, respond well to intensive cultivation—which further harms the environment.

The Caroní River in the Canaima National Park, Bolívar, Venezuela $(6^{\circ}00'N - 60^{\circ}52'W)$

In the dry season, temporary islands emerge from the dark bed of the Caroní River. Like all the rivers that cross the Guayana region in Bolívar State, the Caroní is rich in alkaline and tannins from the decomposing vegetation of the dense jungle—hence it is known as one of the "black rivers," as opposed to the "white rivers" that tumble down from the Andes filled with rock sediment. But the concentration of gold-mining activities in the valleys is deteriorating many of these watercourses. Mercury, which is used in extracting gold from sediment, is being dumped into the rivers, contributing to serious fetal malformations among humans and animals alike. Worse still, the proliferation of extraction ponds is breeding vast swarms of mosquitoes, leading to malaria, even in areas that were formerly relatively free from disease.

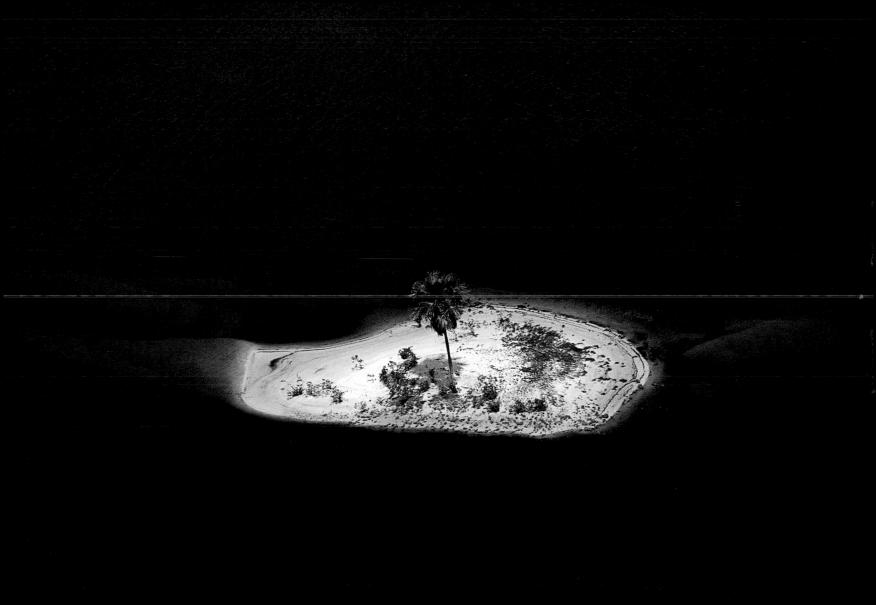

Oradour-sur-Glane, Haute-Vienne, France (45°56'N - 1°02'E)

"Oradour n'a plus de forme / Oradour, ni femmes ni hommes / Oradour n'a plus d'enfants / Oradour n'a plus de feuilles / Oradour n'a plus d'église." These verses by the poet Jean Tardieu describe the martyrdom of a quiet Limousin village that was savagely wiped out on June 10, 1944. Four days after the Allied landings in Normandy, SS divisions—harassed by the Resistance on their way to the front—carried out a series of bitter reprisals. Oradour-sur-Glane was the scene of a systematic execution; the men of the village were seized and locked up in barns, while the women and children were imprisoned in the church. The buildings were burnt to the ground, and anyone who sought to escape was shot dead. By the end of the day, nothing remained of Oradour but flames and ashes; 642 people were dead, the victims of Nazi rage. Only six villagers survived the massacre. Ever since that terrible day, the ruins of the village have been left untouched as a memorial. Oradour will remain forever a shameful symbol of humankind's potential for cruelty.

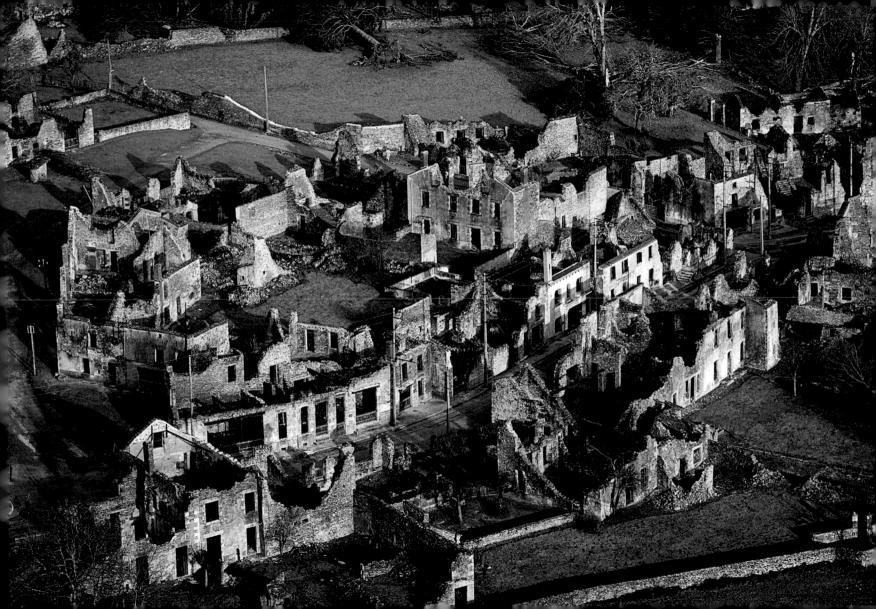

Threshing floor, Pamir Mountains, Tajikistan (38°16′N - 72°31′E)

The central Asian Republic of Tajikistan has been independent since 1991, and remains the poorest territory of the former Soviet Union. Its population of 6.5 million basically subsists on agriculture and livestock raising (67 percent). In this mountainous region, where half the territory is more than 10,000 feet (3,000 meters) above sea level, only 7 percent of the land is cultivable. The main products are cotton, fruit, vegetables, livestock, and cereals—but the per capita production of cereals is the lowest of all the former Soviet republics, and there are regular food shortages. Agricultural production fell sharply during the 1992–1997 civil war, which saw the dissolution of collective farms, the decline of mechanization and, above all, the deterioration of irrigation systems—in a region where 62 percent of arable land wholly depends on them.

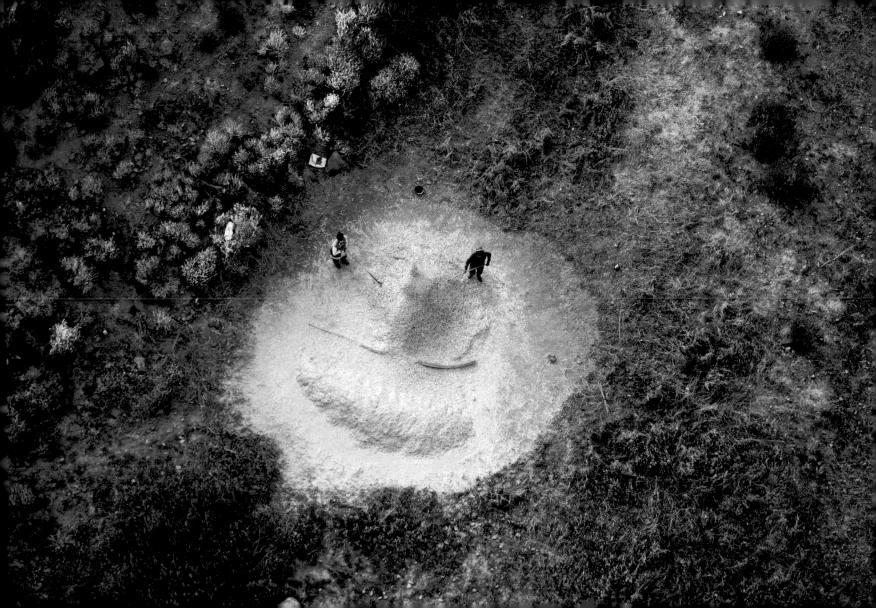

Tongue of Taylor Glacier, Beacon Valley, Dry Valleys region, Antarctica (South Pole) (77°48'S - 160°50'E)

Antarctica, the southern continent, is a vast frozen land, 1.5 times the size of Europe and covered with the world's largest ice cap. This icy layer is so thick and broad that it covers 98 percent of the continent and imprisons no less than 70 percent of the world's stock of freshwater. Near the American research station of McMurdo, the Dry Valleys region is one of the few areas of the Antarctic not covered in ice. The katabatic winds blowing from the heart of the continent are so cold and so violent (reaching speeds of up to 190 miles [300 kilometers] per hour) that snow cannot accumulate. Instead, the rock is stripped and bare, revealing ocher layers of sediment originating from lakes and rivers, infiltrated by black volcanic basalt. Even here, certain forms of life persist: bacteria, single-cell algae, lichens (within the rocks), and nematodes—which dry out and go into hibernation at the approach of winter, only reawakening once conditions improve.

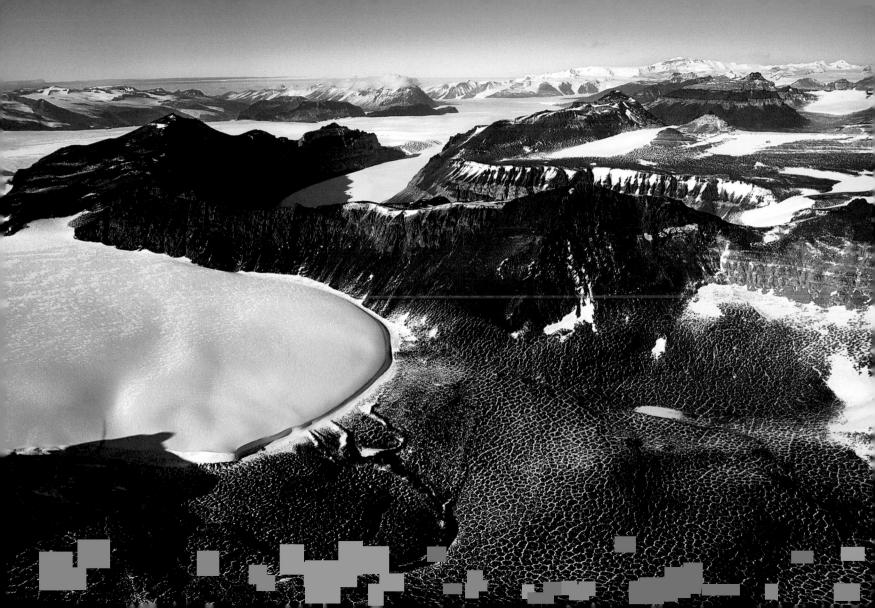

Village near Diafarabe, Mopti region, Mali (14°10'N - 5°00'W)

In this village in the Mopti region of Mali, the *banco*-constructed houses around the central mosque look as though they have sprung straight from the ground. Banco, a mixture of clay and vegetable fibers, has to be resurfaced every year if it is to survive the rainy season. After the harvest, the roof terraces in town are used to dry sorghum; together, sorghum and millet cover 41 percent of Mali's cultivated land. But the country's self-sufficiency in terms of food is highly precarious, stretched as it is by population growth (at a rate of 3 percent per annum) and desertification; today the desert is advancing at a rate of 3 miles (5 kilometers) per year, along a 1,240-mile (2,000-kilometer) front. Since the advent of democracy in 1991 the overall situation in the country has improved, notably in the education sector. Although progress has been slow, in 2005, Mali's foreign debt was canceled (along with that of sixteen more of the world's poorest countries)—Mali had long been asphyxiated by its foreign debt, which consumed 40 percent of its budgetary revenue.

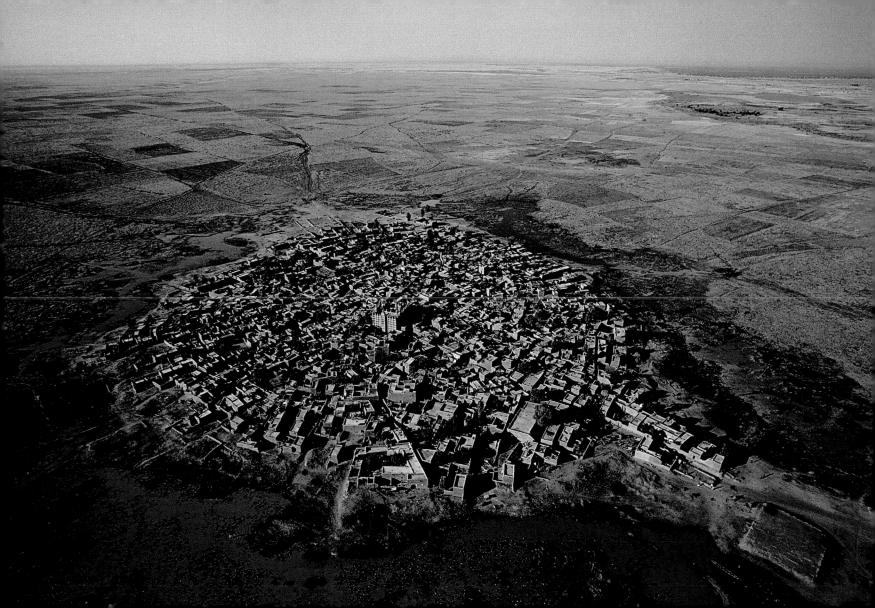

Whale cruising offshore near Table Mountain National Park, Cape Province, South Africa (34°09'S - 18°18'E)

Commonly known as the southern right whale, Eubalaena australis is 50 to 60 feet (15 to 18 meters) long and weighs 30 to 50 tons. Although the species has been protected since 1937, its situation is still alarming. Despite intense pressure from Norway, Iceland, and Japan to reinstate commercial whaling, the moratorium that has remained in force since 1986 was recently extended to 2012. Right whales, which are regularly visible off South Africa's coastline, have been a major tourist attraction that provide immense benefits to national economies, with 87 countries and territories offering whale-watching cruises. This tourist activity brings in 10 million people a year worldwide, generating about one billion dollars. In fact, so successful has the enterprise been that it now poses a new threat to the whales—the jostling tourist boats sometimes collide with them and leave them mangled and dying. Two of the thirteen whale species formerly hunted by human beings are now threatened with total extinction: only a few thousand blue whales remain, and the group is classed as imperiled by the International Union for the Conservation of Nature (IUCN). As for the northern right whale, it is thought that there are only 300 to 350 of these mammals left alive in the ocean.

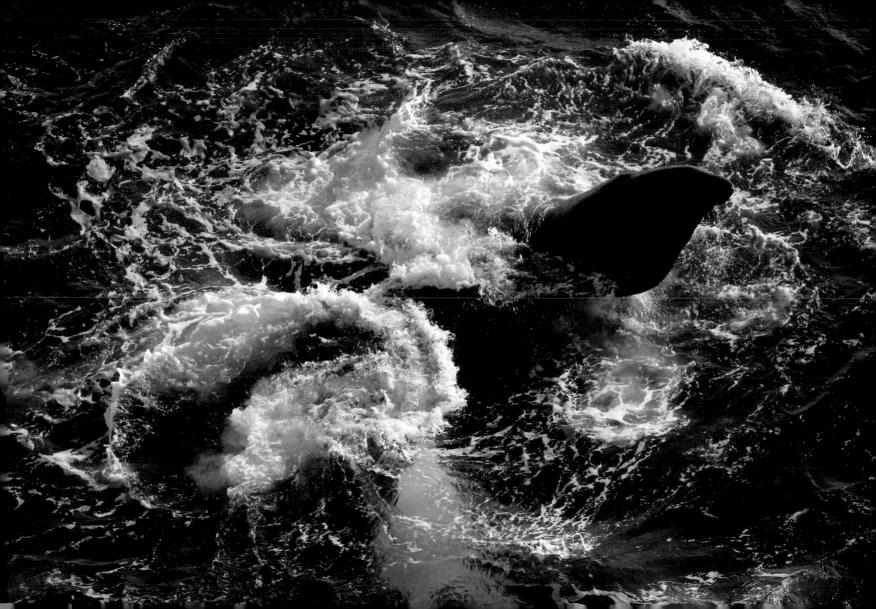

Village in the tropical forest near Soudre, Ivory Coast (4°58'N - 6°05'W)

The equatorial forest now only survives in the southern half of Ivory Coast; between 1956 and 1996 its total area was divided by six, and today only 16,000 square miles (30,000 square kilometers) remains, mostly in national parks. Ivory Coast is by no means exceptional in this regard—the whole of West Africa is affected by the shrinking of forestlands. For the last ten years, 3,000 square miles (7,000 square kilometers) of forestland has been vanishing annually. This situation is the consequence of damage wrought by extensive slash-and-burn agricultural techniques, the increasing demand for firewood, a boom in commercial plantations (pineapples, rubber, cacao), and industrial timber operations. Every year Africa produces 2.5 billion cubic feet (70 million cubic meters) of tropical wood, the bulk of which comes from Ivory Coast, Gabon, and Ghana.

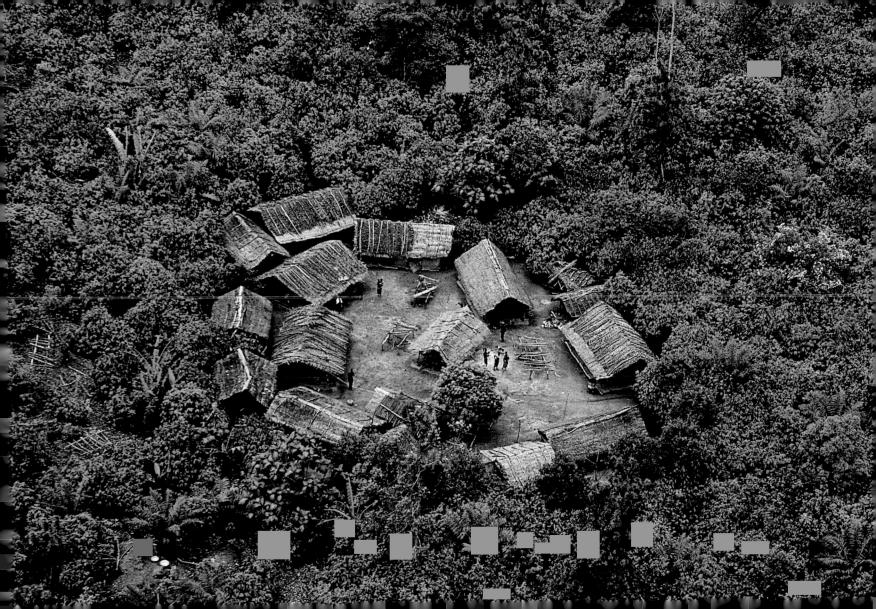

Island of Burano, Venice, Italy (45°28'N - 12°25'E)

Yellow, blue, red, and green: the island of Burano is known for its flamboyant facades and the white frames of its doors and windows. According to legend, in this little fishing town the women always choose bright colors for their homes so their husbands can recognize them through the thick mist (or fumes of alcohol). Burano is also famous for its lace, a prized commodity ever since the Renaissance, worn by nobles and princes all over Europe. Burano lace workshops competed strongly against Louis XIV's royal factories; in 1665, Colbert imported the craft of lace making to France, and notably to Normandy, where Alençon lace acquired a great reputation. Today, the islands of the Venetian lagoon still ply a brisk trade in lace, but local lace makers trained in the old techniques are now few and far between, and the merchandise offered for sale is more liable to hail from Naples or Palermo than from the island of Burano.

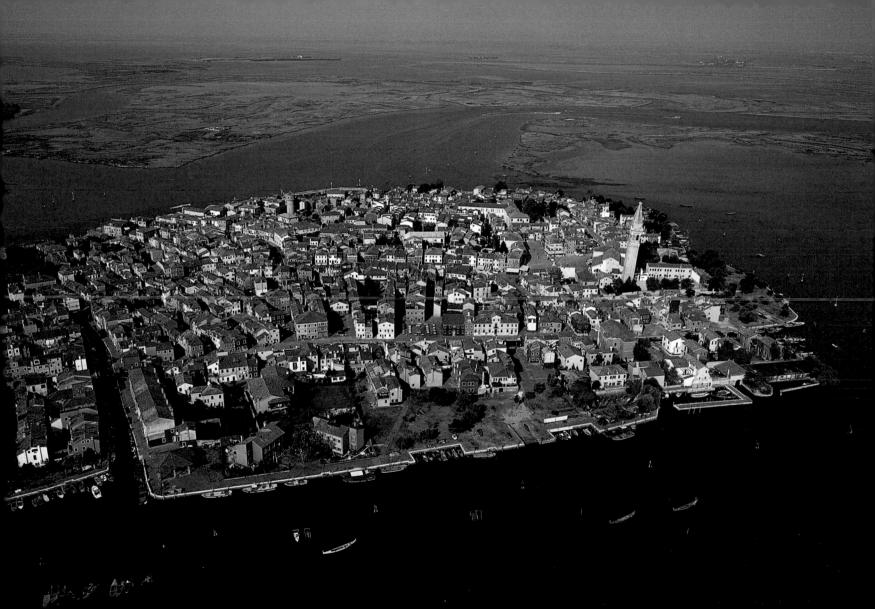

Plowing near Hlatikulu, Shiselweni region, Swaziland (26°56'S - 31°21'E)

Subsistence agriculture is the norm in southern Swaziland, where small plots are farmed by village communities. With a population of over a million, Swaziland is one of the smallest and poorest countries in the world: simply to own a cow in this country is an indication of wealth. The successive prolonged droughts and high temperature of the 2006-2007 season devastated the maize crop, which was the worst on record, totaling 60 percent less than the preceding year. In May 2007, the Food and Agriculture Organization (FAO) estimated the number of Swazis threatened with famine at 407,000, and calculated the country's urgent need for staple foods at 40,000 tons. The Swazi agricultural sector produces less than 10 percent of the nation's wealth, but employs 80 percent of the population. Problems of malnutrition and access to drinking water in some villages, coupled with the ravages of AIDS (40 percent of the population is HIV positive) has placed a huge strain on Swaziland's economy. There is every reason to expect a severe and prolonged crisis, all the more so because the prices of imported goods are continually rising and the Swazi authorities appear powerless to act without international help.

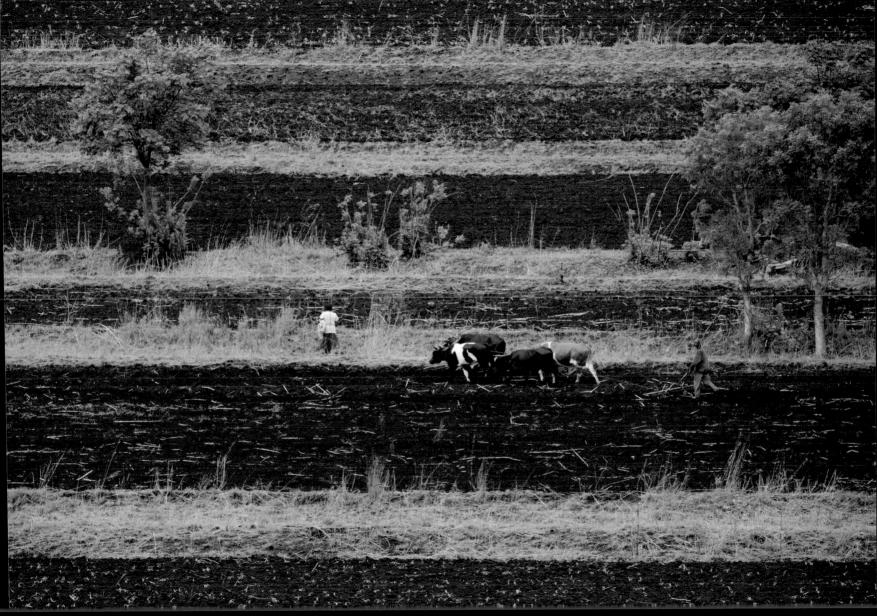

Fishermen in their pirogue, Gulf of Guinea, Ivory Coast (4°58'N - 4°27'W)

Every day, Ivorian fishermen put themselves in harm's way as they cross "the bar," that dangerous zone where the great Atlantic rollers swell and break on the shore. Their experience allows them to calculate precisely when the waves are right to launch their pirogues toward the open sea. Until the nineteenth century, this natural obstacle, which characterizes the whole of the Gulf of Guinea, was instrumental in isolating the countries around it from the outside world. But today the Gulf of Guinea is at the point of becoming a major geostrategic locale on the international map. Countries like Nigeria—Africa's largest oil producer—and Angola are extremely rich in hydrocarbons, and eventually the region could be seen as a safer production zone than the Middle East. International oil-prospection permits have already been granted to international companies in regions with oil fields of vast potential, notably Gabon. Africa supplies about 11 percent of the world's oil, and still possesses enormous reserves.

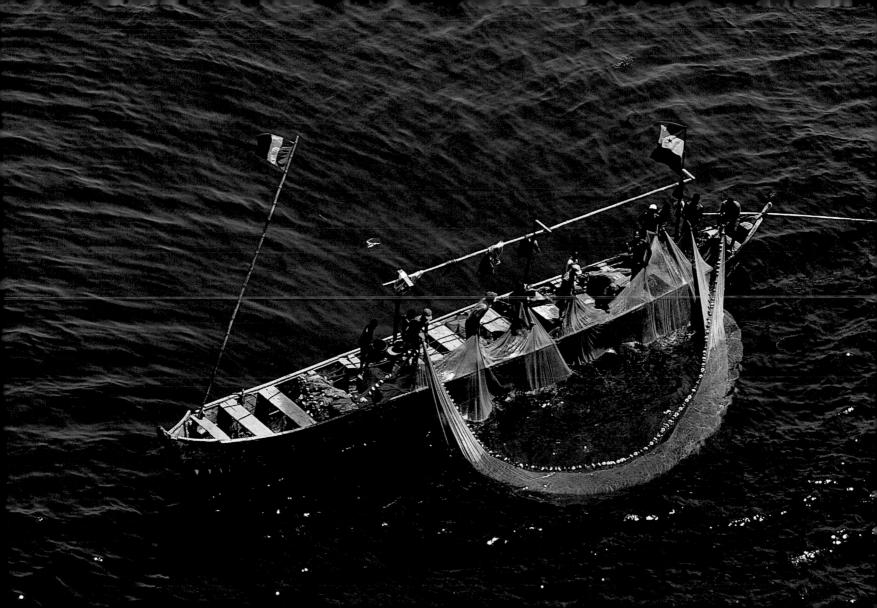

Dachau KZ, Bavaria, Germany (48°15′N - 11°27′E)

The little town of Dachau, 12 miles (20 kilometers) from Bavaria, boasts a castle overlooking a cluster of ample Bavarian houses where German painters and writers were wont to assemble—until 1933. On March 22 of that year, the German Nazi Party inaugurated its first concentration camp, Dachau KZ, on the site. From that day on, the name *Dachau* ceased to evoke images of artists and jolly Bavarian households. Almost immediately the first internees appeared. Dachau would detain more than 200,000 individuals, sentenced to forced labor; 76,000 of them would die there. Today there remain under the cypresses only the outlines of the camp's thirty-six interminable prison blocks. In the past decade, more than 3.6 million people have died in the world's various domestic conflicts, because they voiced dissident opinions or because they belonged to a particular ethnic group.

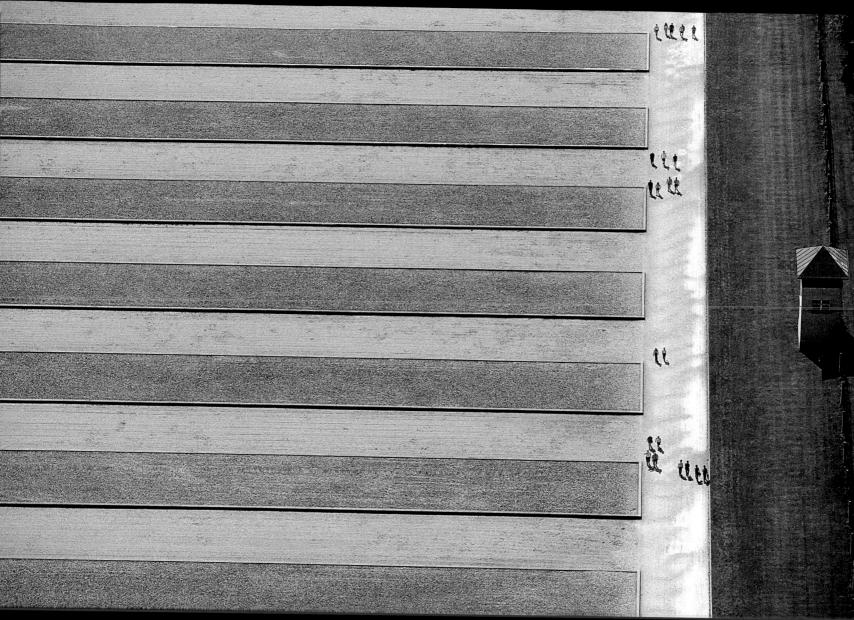

The Temple of Isis at Philae, Egypt (2°03'N - 32°48'E)

The island of Philae was the domain of Isis, the goddess who reassembled the scattered pieces of her husband Osiris to make the first mummy. Ironically, the temple of this mother-deity—associated with the high waters of the Nile dispensing their blessings throughout Egypt—was itself threatened with drowning by the Aswan Dam in 1978. As part of UNESCO's campaign to save the great Nubian archaeological sites, this great center of ancient Egyptian worship was moved stone by stone to the neighboring island of Agilkia, 1,000 feet (300 meters) away and 43 feet (13 meters) higher. The temple has kept its *naos*, the sanctuary that contained the goddess's statue. The myth of Isis remained vigorous until Nubia was converted to Christianity by Theodosius in the fourth century AD; indeed, it was to this temple that the last devotees of the old religion retreated, before it finally died out in the sixth century AD.

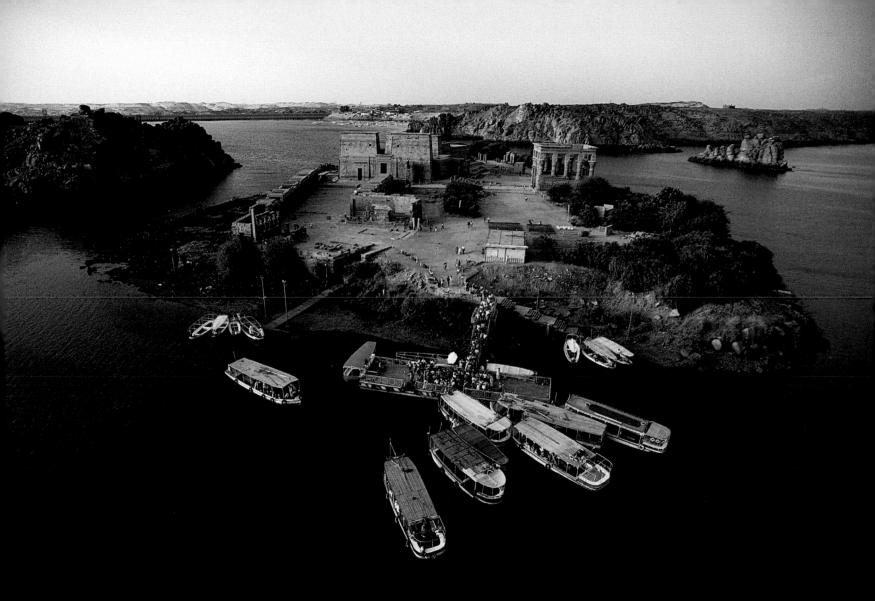

Tobacco drying near Mexcaltitán, Nayarit, Mexico (21°54′N - 105°28′W)

Nayarit is Mexico's principal tobacco-producing state. At the end of the dry season, the Huichol Indians come down from the Sierra Madre Mountains to the coastal plain, where they sell their labor to the tobacco planters. The harvesting of tobacco leaves is harsh work that endangers the health of the women and children who (principally) do it. The pesticides on the wet foliage are absorbed through the skin, and the nicotine-laden sap provokes serious skin conditions. Everywhere it is grown, tobacco drains the soil of nutrients, and the pesticides and fertilizers required to grow it pollute the environment. In many developing countries, wood is used to build barns for tobacco drying, and above all as a combustible to dry the leaves. Every year, about 500,000 acres (200,000 hectares) of forest are felled for the sake of tobacco. Since smoking is a grave danger to health—and according to the World Health Organization, there are 1.3 billion smokers in the world—the growing of tobacco must be considered a root cause of poverty. The battle against tobacco is anything but a luxury reserved for wealthy nations.

Pig farm, Brionne, Eure, France (49°12′N - 0°43′E)

This domestic pig is clearly contented. It has plenty of room to forage in the open air, it can lie down wherever it likes, and it can shelter itself from the weather if it needs to. Few of its breed are so fortunate, however. Industrial pig farms are the rule, and the fate of most piglets is entirely less pleasant. Scarcely have they left the dark nursery pens where their mothers farrow down before they are moved to boxes built on slats over a cesspit. Here they spend the rest of their lives. In the early stages of their growth they can move around, but this ceases to be possible as they continue to fatten on their way to adulthood. They never once see the light of day. By concentrating large numbers of animals in a limited area, industrial pig farms create untold pollution. The production of 2.2 pounds (1 kilogram) of pork, in effect, engenders 51 pounds (23 kilograms) of pig slurry. When this is spread on the land, nitrogen and phosphorus are released, the surplus of which makes its way into the rivers and causes water pollution. In Brittany, a region that concentrates over 50 percent of France's pig farms on only 7 percent of the total available land, 60 percent of water sources are thoroughly polluted.

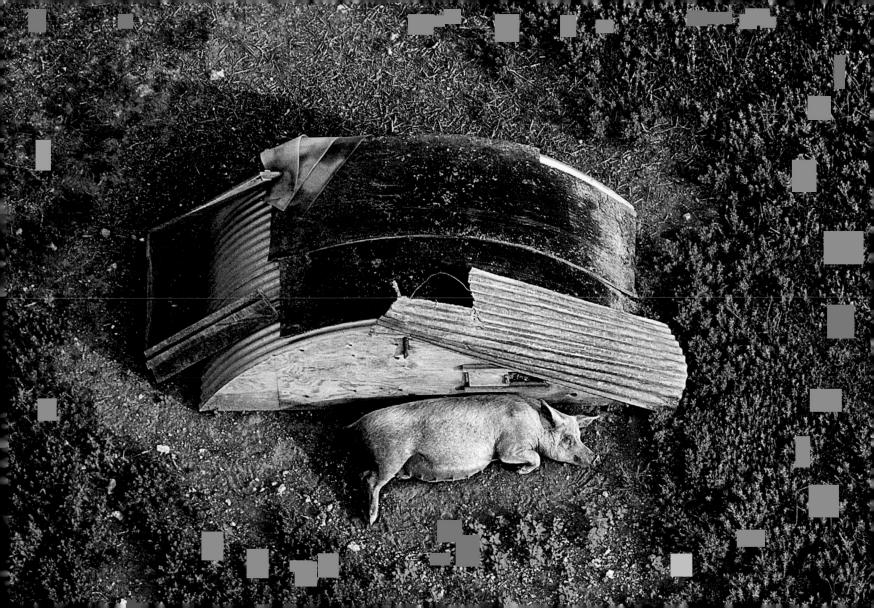

Dokdo Islands (Liancourt Rocks), South Korea (37°14′N - 131°52′E)

Named the Dokdo Islands by the Koreans; Takeshima by the Japanese; and Liancourt by the French (after the whaling captain who discovered them in 1849), these uninhabited rocks, located in the Sea of Japan (or the Eastern Sea, according to Korean preference) are the focus of a long-running geopolitical dispute. In conformity with the treaties that concluded the hostilities of the Second World War, this zone is controlled by South Korea, yet Japan continues to claim it. As recently as 2003, Japan officially approved school history books that failed to make mention of the atrocities committed during the annexation (1910-1945) and that described Takeshima as having been "illegally occupied" by the Koreans. Apart from the issues of history and identity this raises, the question of fishing and (especially) whaling rights is central to the ongoing debate. Japan has consistently ignored the 1956 international moratorium banning commercial whaling. Along with Norway and Iceland, it continues to slaughter whales for "scientific purposes," and even threatens to increase its catch, which already went up from 440 whales to 1,000 in 2007. Since 1986, more than 28,000 cetaceans have been killed.

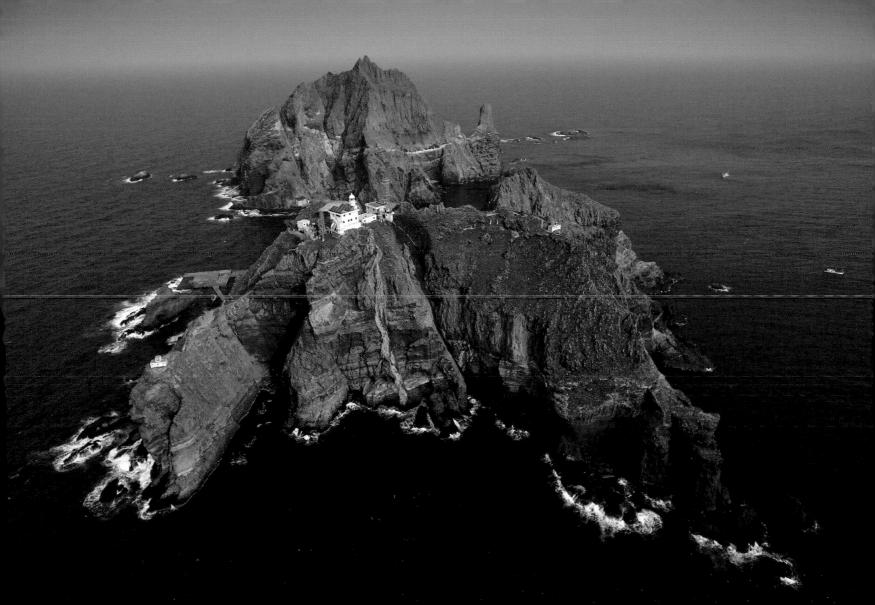

Building at Clichy-sous-Bois, Seine-Saint-Denis, France (48°55'N - 2°33'E)

In the fall of 2005, the suburbs of Paris and other French cities were consumed by rioting for three weeks in succession. The disturbances were sparked when two teenagers running from the police took refuge in an electrical transformer at Clichy, near Paris, and were electrocuted. Angry mobs set fire to cars and public buildings, prompting the declaration of a state of emergency, and hundreds of arrests. In all, some 752 quarters of major cities are qualified as "sensitive urban zones" within the framework of the authorities' urban policy. In these quarters, the unemployment rate and the school dropout rate are twice the national average, and the number of medical establishments is half the national average. Moreover, the people living in these areas earn an average of 42 percent less than those living in other parts of the same cities. The differences in revenue between Paris and the rest of the Ile-de-France, too, have grown consistently over the last twenty years.

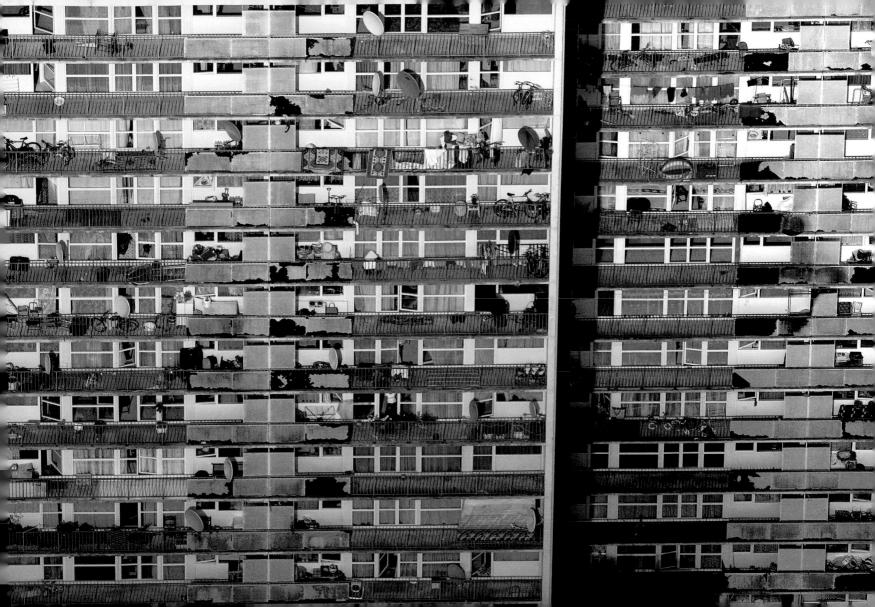

Monastery in the Dundgovĭ region, Mongolia (46°00′N - 105°00′E)

Little remains of the old temples, lamas' palaces, and monks' quarters, other than a few scattered buildings within a square precinct that was once—like most monastic complexes in Mongolia—a great center of spiritual, philosophical, and scientific life. Mongolia today is still strongly marked by shamanism, which holds that a spirit resides in all created things; yet, there is also a long and powerful Buddhist tradition that dates from the 1576 conversion of the great Mongol prince Altan Khan. In the twentieth century, the country broke with the old imperial system and adopted a Communist regime (September 1921), which became the People's Republic of Mongolia until 1992, following the collapse of the Soviet Union. This period left some terrible scars, notably inflicted by the religious persecution that reached a climax in 1937–1938, when nearly all of the country's 767 monastic centers were destroyed "to get rid of their monks," as was then declared by a Mongol center dedicated to religious affairs. Since December 23, 1990, the Mongols have once again had the right to worship as they please.

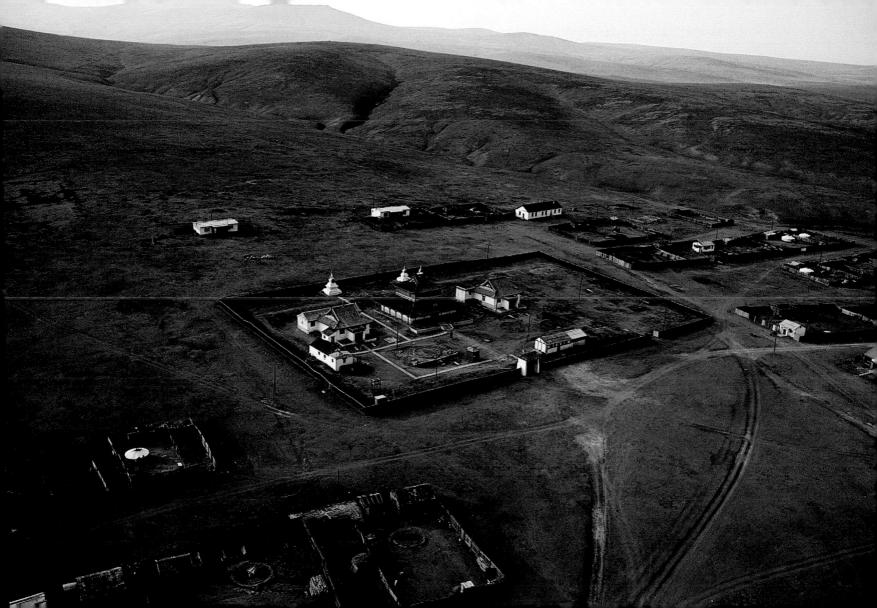

Potato harvest near the Mitidja, Algeria (36°34′N - 3°08′E)

The Mitidja plain extends in an arc over 62 miles (100 kilometers) to the immediate outskirts of Algiers, gently rising to the high barrier of the Atlas Mountains. Throughout the nineteenth century, generations of Algerian colonists fought to improve this land, which was originally a mosquito-infested marsh where malaria was rife. It was a long battle that cost many lives, but today the Mitidja offers one of the country's most beautiful agricultural landscapes. The soil is rich, and the rainfall adequate for potatoes, rice, and vines, though citrus fruits are the main crop. In the 1990s, economic and social life in the Mitidja was upset by Islamist violence. Islamist militants used the region as a strategic corridor between the mountain *maquis* and the capital, forcing many of the inhabitants into temporary exile. Today, the farmers have returned to their land, and agricultural activity has resumed.

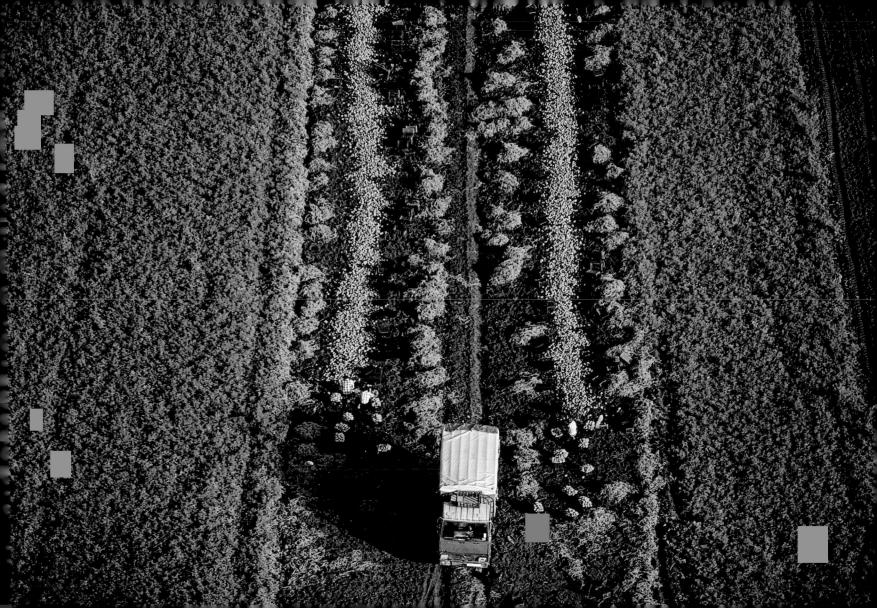

Northwestern quarter of New Orleans, near Lake Pontchartrain, after the passage of Hurricane Katrina, Louisiana, USA (30°00′N - 90°05′W)

At the height of the flood, the roofs of New Orleans barely showed above the stew of wastewater, gasoline, and chemical products; bacteria proliferated, with temperatures exceeding 86°F (30°C) during the day. On August 29, 2005, Hurricane Katrina (Category 5 on a scale of 5) hit the American coast of the Gulf of Mexico. Battered by 124-mile-per-hour (200-kilometer-per-hour) winds, the waves washed over the levees, breaching them in several places and leaving 80 percent of New Orleans underwater. Tens of thousands of people were stranded by the rising water, in particular the poorest 30 percent of inhabitants, who often had no means of leaving the area. This catastrophe was partly avoidable, given that local and federal authorities were alerted years in advance that the levees were weakened and decrepit and that provisional evacuation measures were entirely inadequate.

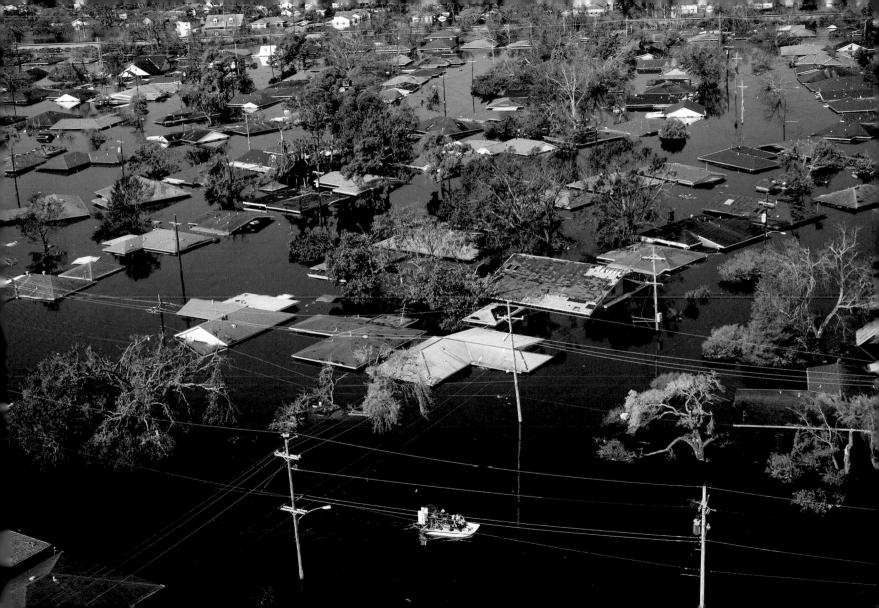

Village near Tom Marefin, Chad (12°30'N - 14°55'E)

Among these green trees is the palaver tree under which the villagers meet to discuss local affairs. Here, disputes are settled and collective decisions made. The paths beat out across the open ground are the ones taken every day by the villagers and their animals on their way to gather firewood or to draw water from the well. Near the capital of N'Djamena, this traditional village of the former kingdom of Baguirmi, in the region of Chari-Baguirmi, features a circular ground plan. The huts, round or rectangular, are thatched or built with roof terraces. Each has its own enclosure, or paddock, for household animals (chickens, sheep, and goats). Pastoral activities, rather than agricultural ones, determine the organization and structure of the space.

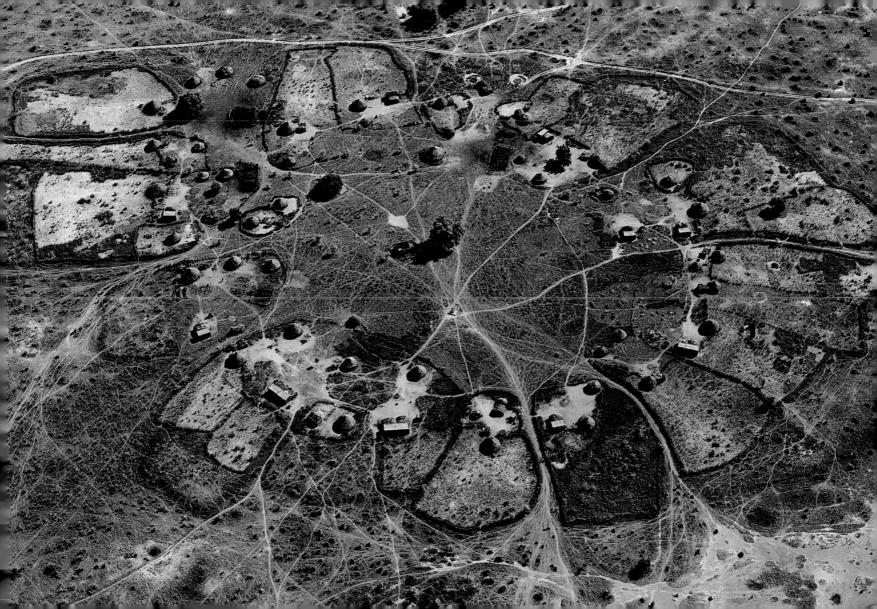

Detail of the Landmannalaugar Mountains, Mýrdalsjökull region, Iceland (63°30'N - 19°06'W)

Iceland has been the scene of some of the greatest volcanic events in recorded history. The most destructive volcano of all was Laki, part of the Mýrdalsjökull system. On June 8, 1783, came the first rumblings of an eruption that continued until February 7, 1784. In the interval, all along a 16-mile (25-kilometer) fissure, about 6 cubic miles (15 cubic kilometers) of lava poured forth, covering a surface of 218 square miles (565 square kilometers). There was no gigantic explosion, but the quantities of sulfurous gases (122 million tons, emitted largely in the form of sulfur dioxide) were immense. They poisoned livestock and destroyed crops with acid rain. A quarter of the Icelandic population died in the three years that followed, and during the summer of 1783, observers in England and France noted that the sun was veiled by a bluish haze. The following winter was exceptionally cold throughout Europe. Meteorologists speculate today that the aerosol cloud projected into the higher atmosphere by the volcano caused a lowering of the temperature in the Northern Hemisphere that averaged around 2° Fahrenheit (1° Celsius).

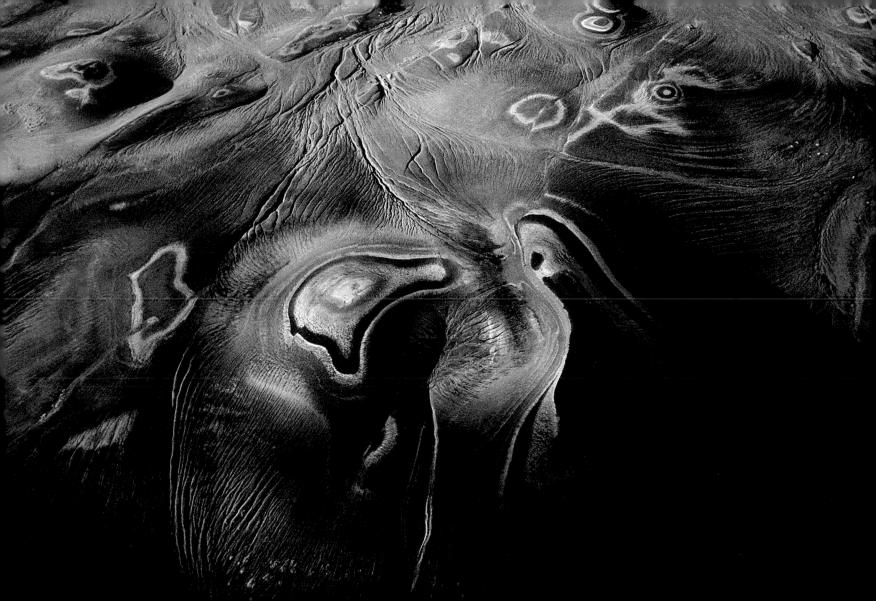

Automobile breaker's yard, Saint-Brieuc, Côte-d'Amor, France (48°31'N - 2°46'W)

Compressed and then crushed into one another, these automobile carcasses are awaiting recycling and reuse. Before they reach this graveyard, the old cars are taken apart and depolluted, and any parts that still have value are recovered for the secondhand market or for recycling. There are about two thousand professional automobile breakers in France, but only four hundred of these are certified by a national committee of automobile professionals as fully respecting security and environmental-protection criteria. As the last link in the automobile chain and the first in the recycling chain, breakers play a vital role in the treatment of waste generated by the car industry. In France, about 1.5 million cars are condemned every year. A recent European directive on vehicles beyond use forces automobile manufacturers to recycle 85 percent of the weight of vehicles from 2006 onward (95 percent beginning in 2015); it is a first step toward sustainable and responsible management in the sector.

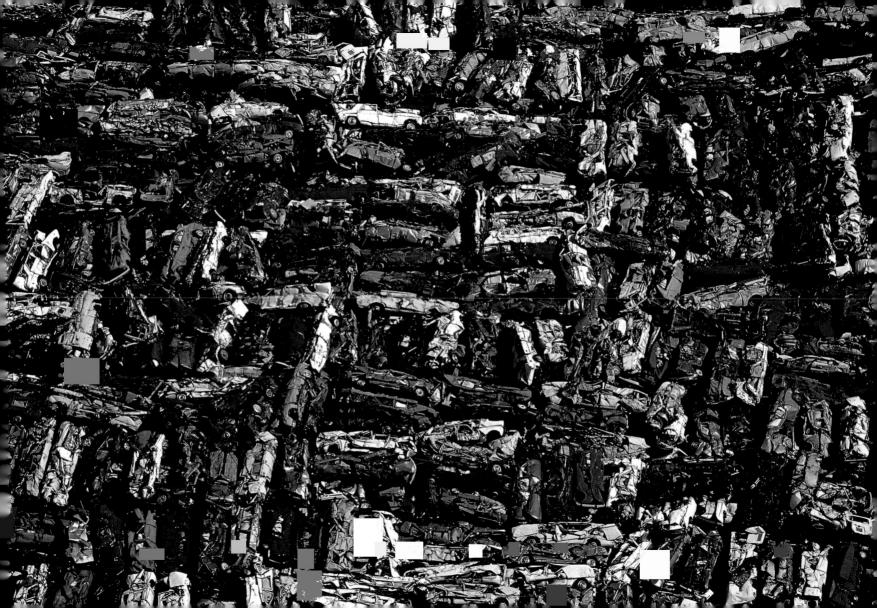

Harvesting near Bosnes, Tyrifjorden, Norway (60°04'N - 10°08'E)

Forest covers a quarter of Norway's territory. But beside the lake at Tyrifjorden, near Oslo, woodland is gradually giving way to cereal crops, which thrive in the moderate climate of southern Norway. Cultivated land and plantations occupy only 3 percent of Norwegian territory, which generally consists of mountains, forests, and lakes. Even so, Norway manages to meet more than half (50-70 percent) of its population's annual cereal requirement. As in much of the world, agriculture in Norway changed beyond recognition during the twentieth century, increasing its productivity at the expense of the environment. But respect for nature has always been an essential component of the national identity, and Norwegians—concerned with preserving soil resources, environmental values, and their health—have since obliged their governments to convert part of the country's intensive agriculture to organic production. Worldwide, organic agriculture accounts for less than 2 percent of food production.

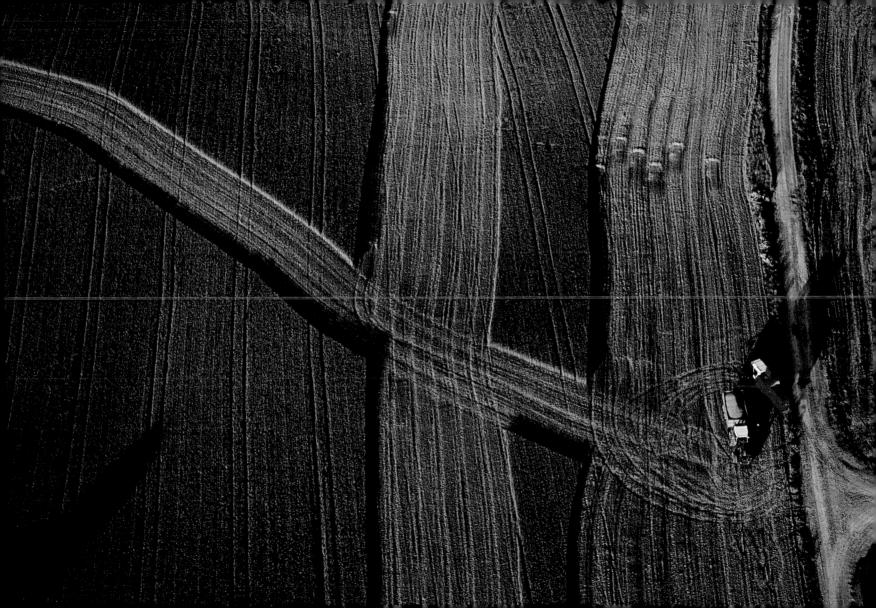

Gorée Island, off Dakar, Senegal (14°38' N - 17°21' W)

Visits to the Slave House on Gorée Island conclude at a gate opening onto the open sea and the "voyage of no return." For many years Gorée was a major staging post for the slave ships that furnished "ebony wood" for the colonial plantations of the Caribbean. Slaves were held there under appalling conditions while they awaited embarkation. The abolition of the slave trade at the Congress of Vienna in 1815 brought an end to this odious traffic, but between the sixteenth and nineteenth centuries, about 15 million Africans were deported across the Atlantic. Today the island is an important memorial of the slave trade, and for that reason it has been named a UNESCO World Heritage Site. But this symbolic function has now become the focus of a major debate; because the history of the slave trade in Africa involves other sites, like Ouidah in Benin, many historians dispute Gorée's claim to symbolic exclusivity. Nevertheless, the island remains the most popular tourist venue in Senegal. Today, it is estimated that there are nearly 200 million slaves of one kind or another, and that the trade in human beings (exploitation of labor, prostitution under duress, the creation of child-soldiers, debtor-servitude) continues unabated—and barely unacknowledged.

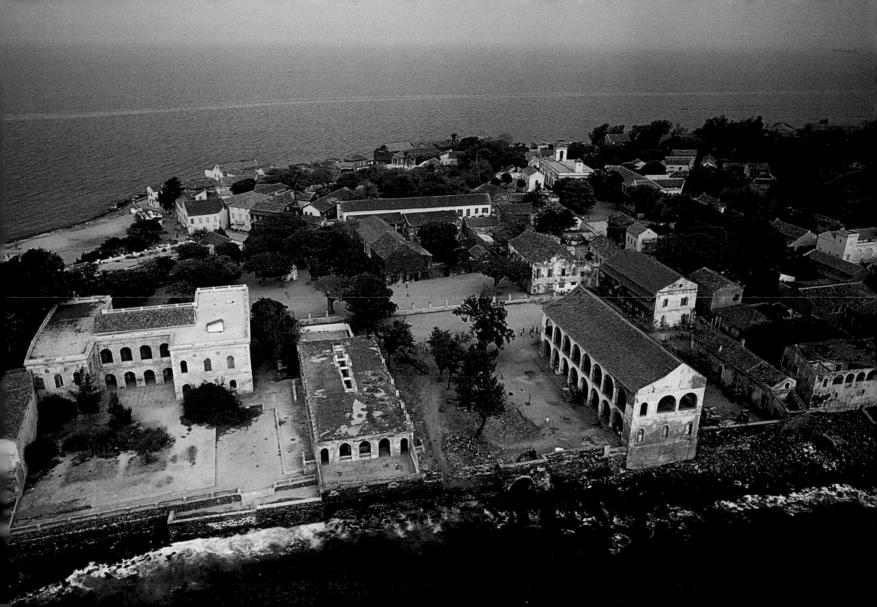

HUIJAIJITARIAN WORK AND SUSTAINABLE DEVELOPMENT

There is no such thing as a natural catastrophe. This much I have learned from twenty-five years of humanitarian work. Earthquakes, volcanic eruptions, droughts, and floods are natural phenomena. But to be *catastrophes* they have to interact with human activity. The death toll of the December 2004 tsunami would not have been anything comparable to what it was had it occurred two thousand years ago, when the coasts it devastated were virtually deserted, and when thick mangroves acted as a barrier for all the coastlines.

A wave of drought sweeping over the African continent will have different effects depending on the countries it hits. The disasters it causes will be of different types and intensities depending on whether the country is urban or rural, on the agrarian policy of its government, and on its current state of peace or war.

When help is deployed, local and human aspects must be taken into account. Too many aid workers bringing help to a so-called natural catastrophe forget that they are not arriving on the moon. They will be dealing with people who have a history, rivalries, long-time strategies, and a cultural heritage. They discover, sometimes painfully, the fundamentally human nature of these disasters. And if, as frequently happens, the affected zone is also a theater of civil conflict, the aid workers who originally set out to operate in the "pure" space of a nature-induced catastrophe will find themselves under fire from people whose fight is for human and political causes. With the recent reawakening of civil violence in Sri Lanka, aid operations there were embroiled in exactly this kind of situation. So-called natural catastrophes, and catastrophes whose origins are political, are one and the same. Some people bewail this fact. I believe we should be grateful for it.

The fantasy of humanitarian work unconnected with political issues is not only misleading but also very dangerous. Human beings remain responsible for their own destinies, even in catastrophic situations. To set out to relieve passive humanity is to overlook the proper response to these situations.

Humanitarian work never offers a lasting solution. It resolves nothing. Immediate aid helps people get through the most difficult times, and it is very useful for that. But its spectacular, media-friendly appearance should not delude us. The real action is elsewhere, bearing not so much on the critical phase of the drama, but on its underlying causes.

Let us imagine, for example, that Mount Vesuvius were to erupt sometime in the near future. Obviously, the victims would be in need of immediate assistance. But the most effective intervention would take place in advance—right now. The approaching catastrophe would be all the more severe if houses had been indiscriminately built on the flanks of the volcano.

Those responsible for delivering humanitarian aid have a choice. Either they can anesthetize the TV viewers, or they can play a role in stimulating real debate about the state of the planet and the future that awaits us. Correctly interpreted, a given catastrophe can be formidably revealing. The Lisbon earthquake of 1755, thanks to Voltaire and others, provoked a Europe-wide debate on the human condition, freedom, providence, submission to God and his representatives on earth, the clergy, and the king. It is no exaggeration to say that these ideas—born of the indignation felt over the spectacle of innocent children being crushed to death in the ruins of the cathedral to which they had come to pray—was one of the sparks that eventually ignited the French Revolution.

Today's catastrophes, if we can only stop viewing them as "natural," can have effects just as profound. An example is the ongoing debate in the United States in the wake of the flood that engulfed New Orleans. What detached media reporting, what reasoned analysis could have exposed the ghettoized structure of American cities as brutally as this?

Our duty as witnesses of and participants in these horrors is to never forget their human causes. Catastrophes warn us of the direction in which humanity is moving, of the tragic distortions of our development, and of the ecological fragility of our societies.

These issues are not merely to be measured after the event, when the victims are there for the world to see. We can also assess them in a preventive capacity. In 2005, Action Against Hunger produced a study on urban development in poor countries. Since the end of the Cold War, the international community has had to intervene in numerous war-torn cities—Sarajevo, Kabul, Monrovia, Kigali, Mogadishu—to relieve acute shortages. These cases are only the start of a far wider trend. Nineteen of the world's twenty-three cities with populations exceeding 10 million are in developing countries.

Can we afford to sit back and wait for a catastrophe to occur among these urban giants before we bother to reflect on the problems and dangers that threaten them?

Jean-Christophe Rufin
A founder of Médecins sans frontières (Doctors Without Borders)
Honory president of Action contre la faim (Action Against Hunger)

Baseball fields north of Boca Chica, Dominican Republic (18°27′N - 69°36′W)

Baseball (*pelota*) is a national sport in the Dominican Republic. Even the most remote villages have their *play*, and young people dream of escaping poverty by becoming baseball stars like the great Dominican players in the United States. For many years now the American Major League has been enriched by foreign talent—and with more than five hundred full-time players, among them the superstars Pedro Martínez and Sammy Sosa, the Dominican Republic is the foremost supplier. A third of these stars come from San Pedro de Marcoris, the local baseball capital, where they have built luxurious homes to show off their social and financial success. Sammy Sosa, for example, is the archetypal shoeshine boy made good; in 1998 he became a national hero by breaking the record of home runs in a season. Today, Sosa is for Dominicans what Pelé is for Brazilians: a god.

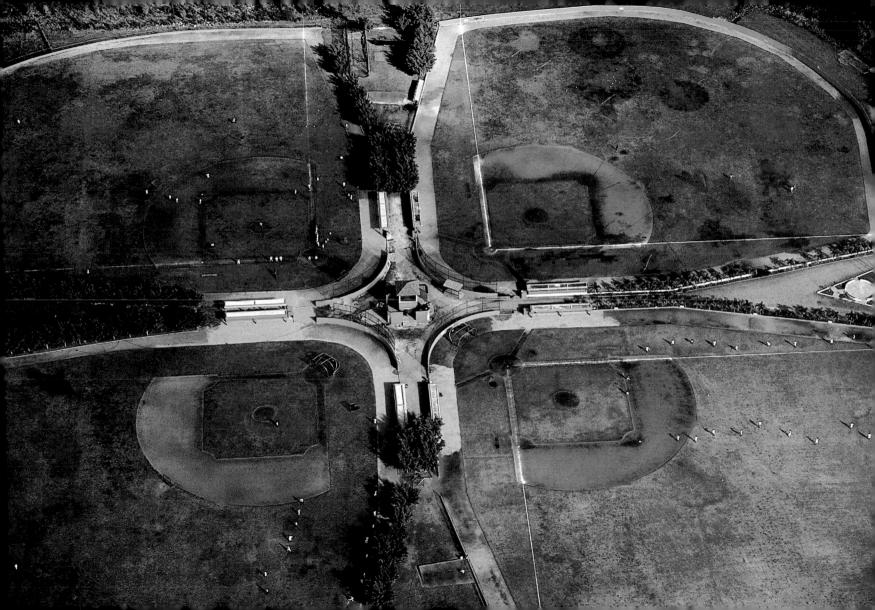

Supply boat approaching Houtskär Island, Turku archipelago, Finland $(60^{\circ}15'N - 21^{\circ}50'E)$

With its 22,000 fragments of gray and red granite, the Turku archipelago in southwestern Finland is a world apart from the rest of the country. The region is the warmest in this high-latitude country; beech trees thrive, whereas in other areas only conifers will grow. But the islands' special peculiarity is its Swedish culture and language. In the twelfth and seventeenth centuries, residents supported the conquest of Finland by Sweden; the two countries have long disputed the islands' ownership. Today the Turku's inhabitants have managed to preserve their traditional way of life based on fishing and agriculture; in the winter ships come in, escorted by icebreakers, to supply what they cannot provide. The archipelago, where humankind lives in harmony with the environment, has been classified as a UNESCO biosphere reserve since 1984.

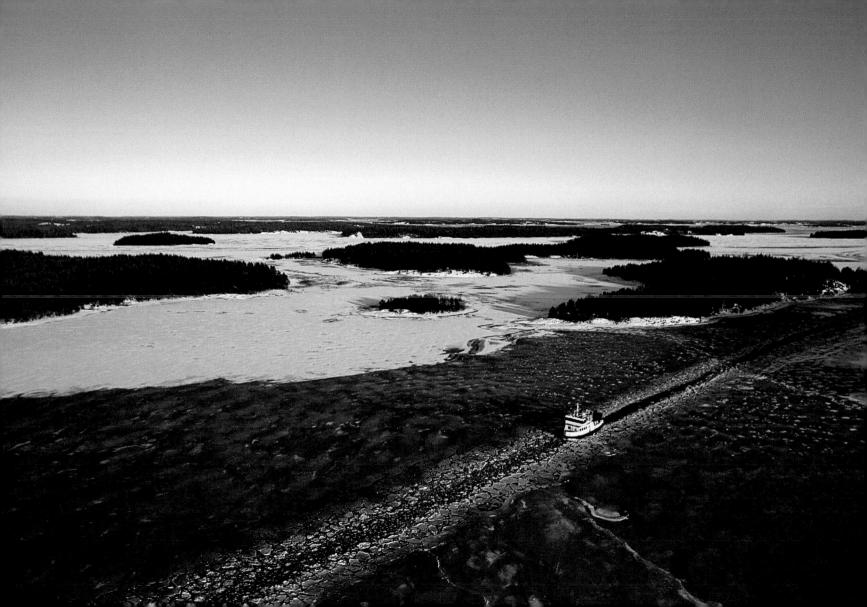

San Andreas Fault, Carrizo Plain, California, USA (35°08'N - 119°40'W)

Over a hundred tectonic fault lines crisscross California, of which the San Andreas Fault is the most spectacular and best known. The prolongation of the Eastern Pacific Ocean ridge into the American continent, the San Andreas Fault is about 745 miles (1200 kilometers) in length and 87 miles (140 kilometers) wide. stretching from San Francisco to the Gulf of California in Mexico. On either side of the fault the rock formations follow the movement of the plates to which they belong, each slipping laterally at a speed of about 2 inches (5.5 centimeters) per year; at this rate, Los Angeles will have shifted to a position close beside San Francisco within ten million years. The tensions accumulated in the terrain are extreme, and when this energy breaks free—as it has done before—the result could be catastrophic for this heavily populated region. Two-thirds of the city of San Francisco was destroyed in the earthquake of 1906 and the fires that followed and, despite improvements in building design, large earthquakes still have the power to cause severe damage. While the physics behind earthquakes is better understood today, they remain unpredictable phenomena whose consequences we can only attempt to minimize. Keeping people fully informed, organizing rescue services, and adapting buildings to earthquake resistance norms are measures that are being taken all over the world, especially in China, Japan. Russia, and the United States.

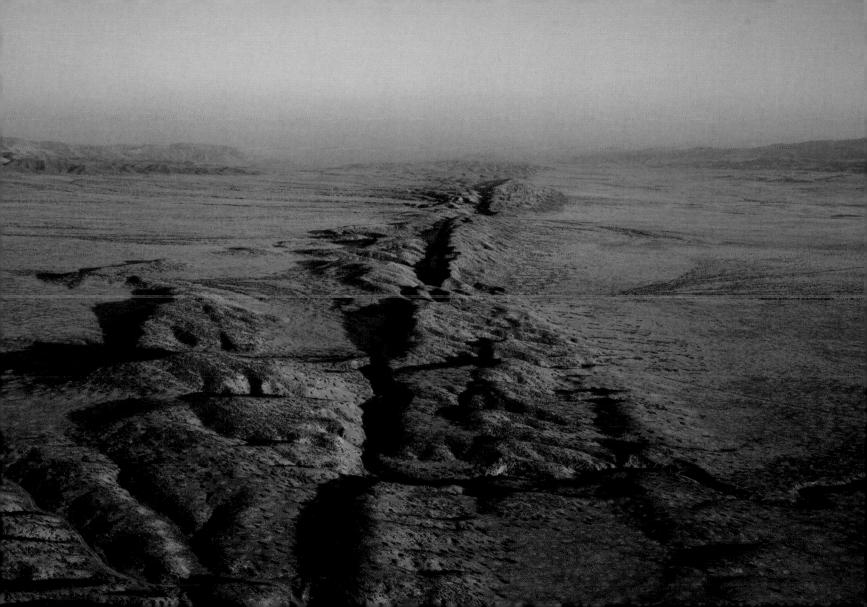

Village with a small cocoa plantation, Man, Ivory Coast (7°24′N - 7°32′W)

Introduced in the nineteenth century by the European colonists in the extreme southwest of Ivory Coast, coffee and cacao growing has moved steadily northward ever since, resulting in a broad belt of specialized production from Sassandra to Man. From the 1960s to the late 1970s, what amounted to an Ivorian economic miracle depended on these two export crops; the coffee-cacao sector remained an economic powerhouse until prices collapsed in the 1980s. After exhausting its funds to support prices, the state sought to disengage from the sector, and it was subsequently entirely privatized in 1998. As the world's largest producer of cacao and tenth largest producer of coffee—far behind Brazil and Vietnam—Ivory Coast suffers year by year from price variations in these highly speculative commodities. The civil war fed by this economic crisis, which has divided the country since 2002, has also done much to disorganize matters, and the demarcation line between the rebel North and the government-ruled South partially cuts through the coffee belt. In West Africa, plantations of cacao, coffee, and rubber are spreading at the expense of the equatorial forest-40,000 square miles (100,000 square kilometers) has disappeared since 1900.

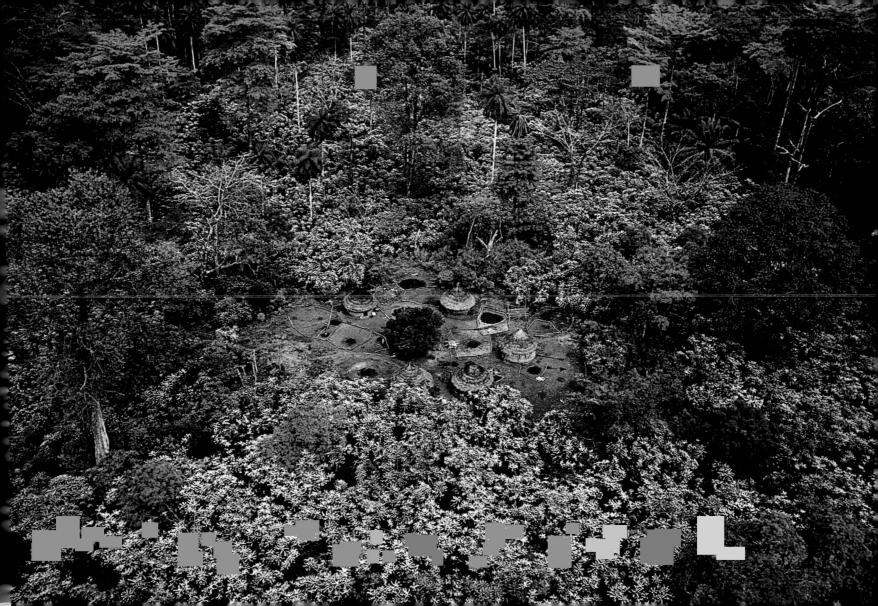

Al Khiran, Kuwait (28°39'N - 48°23'E)

Built in 1986 to meet the needs of a growing population—sprouted by 43 percent since 1985—this city is part of a major town-planning program in the south of Kuwait; its economy depends on tourism and the service industry. In this arid country, temperatures sometimes hit 124°F (51°C). The implementation of desert infrastructure and increased traffic contribute to city dust and sandstorms of growing frequency. This atmospheric disturbance, known locally as *toz*, occurs on an average of sixty-three days each year; it causes considerable material damage, and there has been a significant parallel increase in lung disease. Since 1976, with the financial support of the Kuwaiti State, the Kuwait Environmental Protection Society (KEPS) has been trying to build awareness around environmental concerns. Like its neighbors, Kuwait must reconcile respect for nature with the exploitation of hydrocarbons.

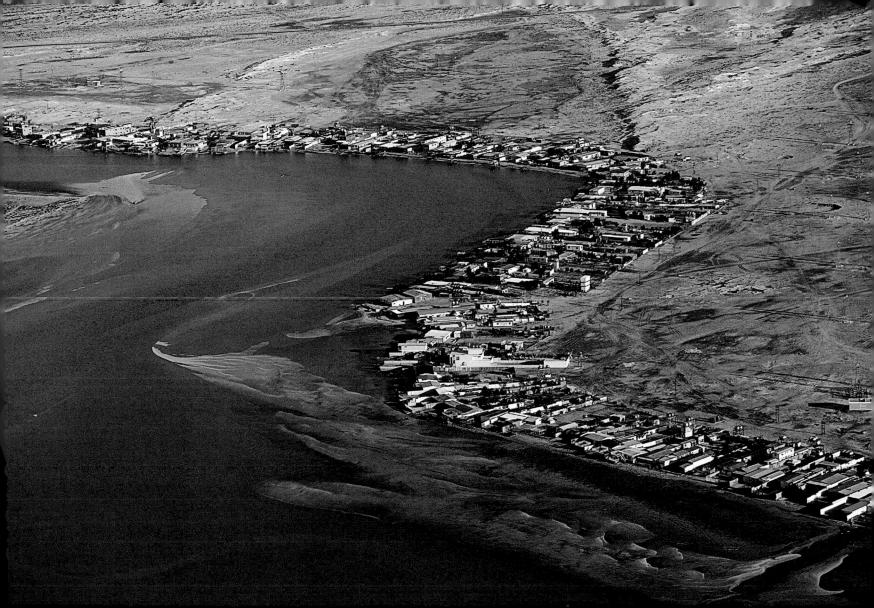

Sheep-rearing sheds near Aradipan, Cyprus (34°57′N - 3°34′E)

The Mediterranean basin produces a full half of the world's sheep's milk; the milk, along with vines and olives, is also one of the pillars of the local diet. But with the onslaught of large intensive-farming operations, small family-run enterprises are gradually disappearing. In Cyprus, three-quarters of the small farms have already gone under, replaced by farms a hundred head strong, or stronger. Worse, these changes are taking place in the immediate vicinity of the cities; 40 percent of the new industrial buildings are located near inhabited zones. For thirty years there has been a free fall in sheep production, and the local sector is ever more dependent on the imported cereals used for feed. The main threat posed by this rapid change is the standardization of breeds in the interest of globalizing agriculture—at the expense of local breeds that have evolved over centuries to suit their environment. By favoring intensively reared breeds that yield standardized, easily exportable products, these new systems are beginning to impoverish the world's genetic heritage.

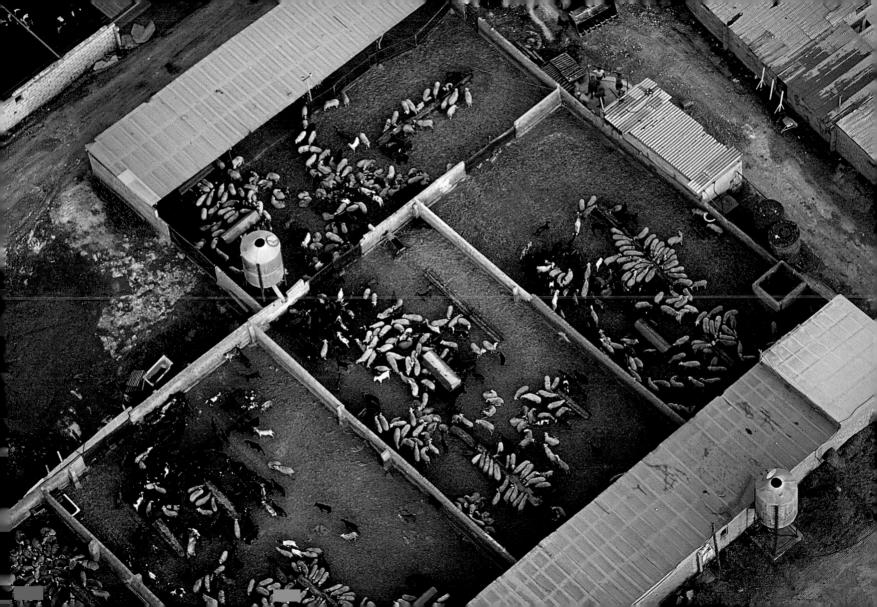

Tourists near the Spitzkoppe Mountains, Damaraland region, Namibia $(22^{\circ}03'S - 17^{\circ}02'E)$

In the wild, desert region of Damaraland, in the northwest of Namibia, stand the Gross Spitzkoppe (5,700 feet [1,728 meters]) and the Klein Spitzkoppe (5,200 feet [1,584 meters]) mountains. These granite domes emerged from sedimentary soils as a result of the combined action of the wind, rain, and lava flows that eroded the plateau 120 million years ago. The landscapes of Namibia are generally magnificent, and the country boasts some of the most beautiful reserves in Africa. Despite the harsh climate, nearly 695,000 tourists came to see the parks and wild fauna in 2007, and their number has been on the rise for the last fifteen years. This extraordinary natural heritage is safeguarded by the Namibian Constitution—among the first in the world in which the protection of the environment has been enshrined.

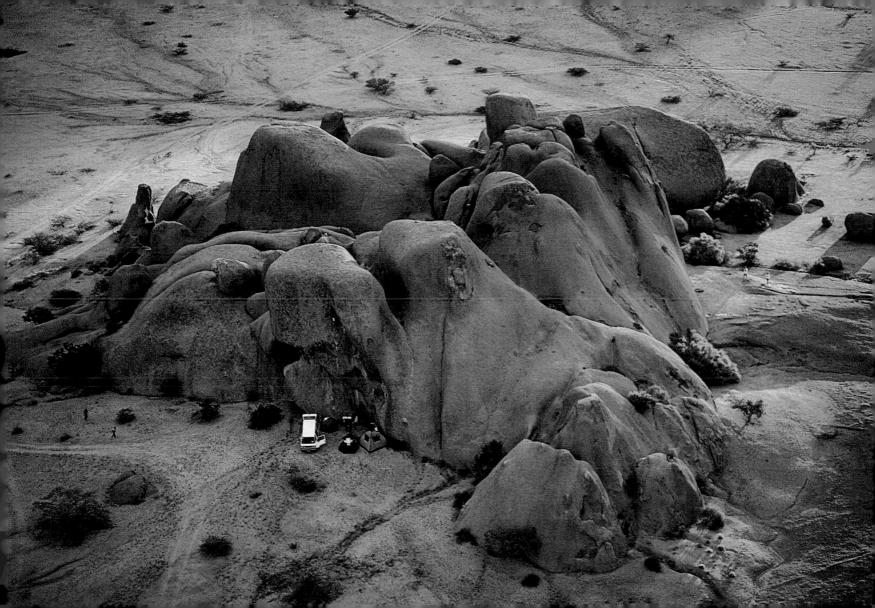

Field work, west of Jaisalmer, Rajasthan, India (26°51'N - 70°51')

Cashew nuts, peanuts, sesame seeds, millet, cardamom, ginger, pepper, cumin, and tea: India is the world's principal producer of all these foodstuffs. It contributes half of the world's mango supply and is also one of the leading producers of rice, wheat, vegetables, cotton, and milk. Conclusion: India is one of the most prolific producers of food on the planet. And yet India is deeply affected by malnutrition and undernourishment; 300 million Indians live in absolute poverty and have difficulty satisfying their vital needs. Moreover, inequalities are growing apace as the purchasing power of the Indian middle class—representing 80 million households and about 400 million people—increases. Eating habits among this group are changing too, aligning with Western tastes. By 2030, the Indian population is expected to swell to 1.4 billion, and its demand for meat, eggs, and fish will probably triple.

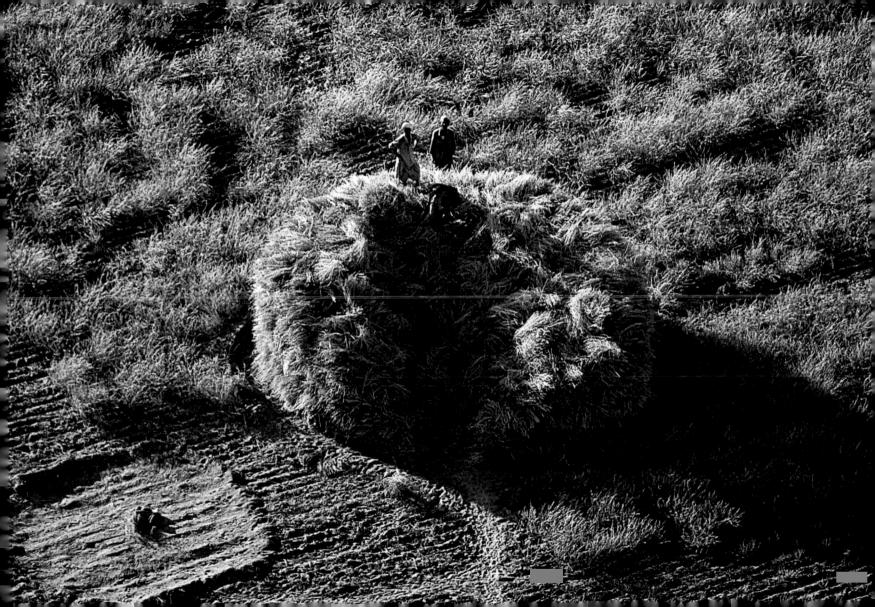

Deforestation in Amazonia, Mato Grosso, Brazil (12°38'S - 60°12'W)

Every year, close to 5 million acres (2 million hectares) of Amazon rain forest are stripped bare. This deforestation, which is constantly on the increase, is of practically no benefit to the local population; it mainly serves to clear agricultural land for growing cereal crops (notably soybeans) to feed livestock in developed countries. These exportable crops bring in foreign currency, and to expand them farmers do not hesitate to attack new areas of virgin forest on a regular basis. Worldwide, the expansion of agricultural land areas, a rapacious lumber industry, and the building of roads are destroying 32 million acres (13 million hectares) of natural tropical forest every year—the combined land area of Holland, Belgium, Switzerland, Denmark, and the U.S. state of Florida.

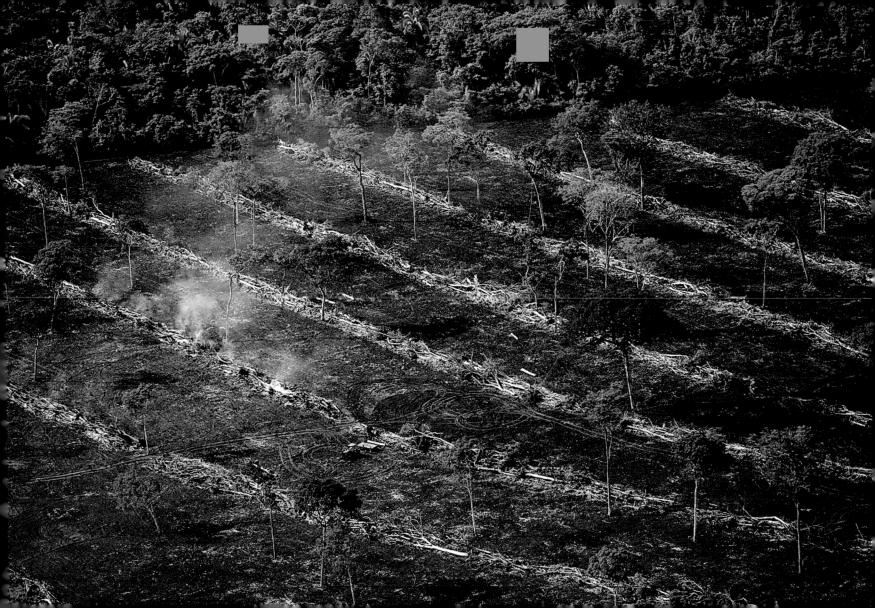

Rice fields between Antananarivo and Ankazobe, Madagascar (18°47'S - 47°23'E)

Rice supplies about half of the calorie intake of Madagascar's population, with an average of 264 pounds (120 kilograms) per year per inhabitant. Rice arrived as a crop on the island in the tenth century, brought by Southeast Asian migrants. Rice paddies now form part of the landscape of Madagascar, 80 percent of whose population lives in rural areas. Ancestral rice farming techniques are still used, such as the trampling of fields by cattle to prepare the soil for planting. About 65 percent of Madagascan families grow this cereal, and as a consequence Madagascar is the world's second-largest rice consumer after Burma. In mountain areas, rice-growers use the tavy burning technique, whereby the soil is laid bare and quickly erodes into deep gullies, obliging farmers to move on every two years. Faced with the sheer scale of soil depletion in Madagascar, the authorities have banned tavy farming, but it still continues unchecked. Worse, the cultivation of rice on flooded soils emits greenhouse gases, engendering over 2 ounces of methane for every pound of rice produced (120 grams for every kilo). Rice paddies are the second top source of methane gas on earth, after domestic animals. In emerging countries, the production of methane contributed more to climate change and global warming than that of carbon dioxide.

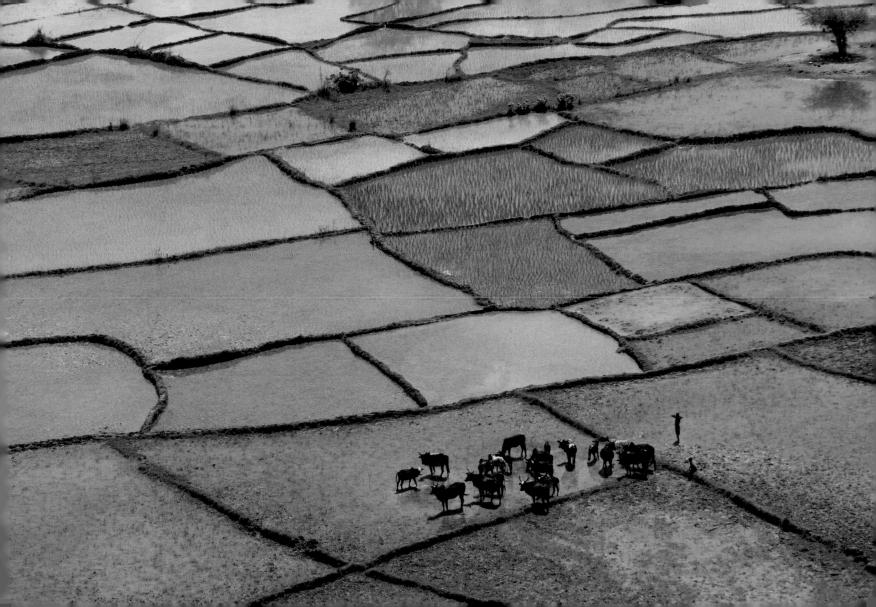

Ship breakers' yard, Chittagong, Bangladesh (22°20′N - 91°49′E)

Cargo ships from all over the world can expect to make their final voyage to Chittagong in the Bay of Bengal. This industrial port in southern Bangladesh has become the world's second-most important site for dismantling ships (after Alanga, India). Since the late 1960s, ship breaking has become a major industry here; indeed, it supplies about 60 percent of Bangladesh's steel requirements. Every year in Chittagong, seventy ship carcasses are dismantled and recycled, down to the last bolt, providing work for some 30,000 laborers; in Bangladesh as a whole, several hundred thousand people owe their livelihood to the industry. Workers are paid an average of \$2 per day, which enables them to feed their families, but they have no protective equipment, not even gloves; they are daily exposed to highly toxic, inflammable residues from ships (asbestos, mercury, and oil derivatives) as well as frequent explosions. Greenpeace has counted some 200 dead and 6,600 injured at Chittagong over the last fifteen years. Every year, around the world, five hundred to seven hundred ships are declared unseaworthy and are sent to the breakers. However, they need to be decontaminated before they go, and international regulations ensuring this are long overdue.

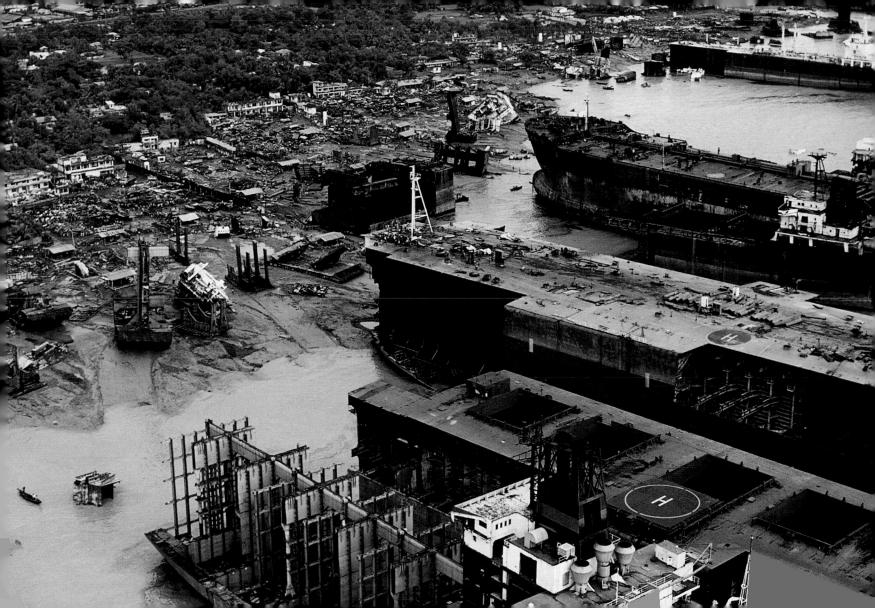

Agricultural landscape near Pullman, Washington, USA $(46^{\circ}44'N - 117^{\circ}00'W)$

The agricultural sector of the United States is the most mechanized and industrialized on the planet. In this country, the energy that goes toward food production, from field to dinner table, represents 17 percent of the total fossil fuel consumed, roughly equivalent to all the energy used each year in a country like France. The most energy-hungry sphere is refrigeration. Next comes agricultural production with, in declining order of importance, the manufacture of fertilizers and pesticides, the fuel used by agricultural machinery, the transportation of harvested crops, irrigation, and the heating of buildings and other facilities for livestock, crop drying, and so on. Scientists calculate that the average American farm uses 3 calories of fossil-derived energy to produce 1 calorie of food. In France, agriculture accounted for 26 percent of greenhouse-gas emissions in 2004. If the energy used for transportation and industrial transformation of food is added to this, food production turns out to be responsible for an entire third of greenhouse-gas emissions.

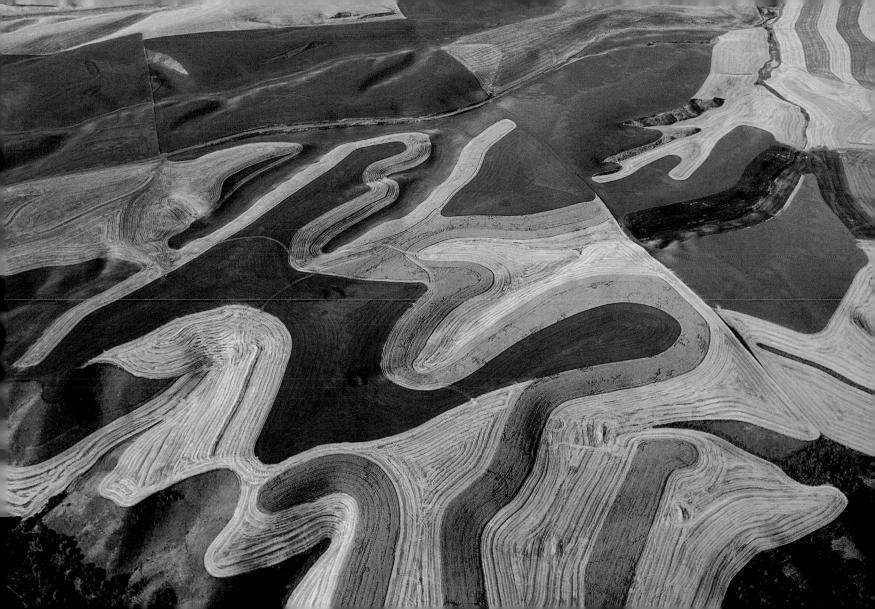

Dolphins off Pointe Saint-François, Corsica, France (42°35'N - 8°45'E)

Nearly two hundred dolphins of the genus Tursiops truncatus live around the Corsican coast, cohabiting more or less contentedly with humans, and giving particular pleasure to tourists when they swim alongside ships. But for fishermen they pose serious competition, and they often damage the fishers' nets. To improve relations between the humans and dolphins sharing these coastal fishing grounds, local, national, and European agencies (among them the Corsican Office of the Environment) launched the Life LINDA project in 2003. Since then, the dolphins have been counted and followed, and the frequency of their attacks on nets has been monitored. At the same time, the fishermen have been encouraged to avoid the animals. Today, thanks to its plankton-rich waters and its mild climate, the Mediterranean is home to more than 25.000 dolphins and nearly 3,000 rorquals (whales). These marine mammals are protected across 34,000 square miles (87,500 square kilometers) of maritime territory between Hyères, France, and Tuscany, Italy, through a Mediterranean sanctuary created in 1992, jointly administered by France, Monaco, and Italy.

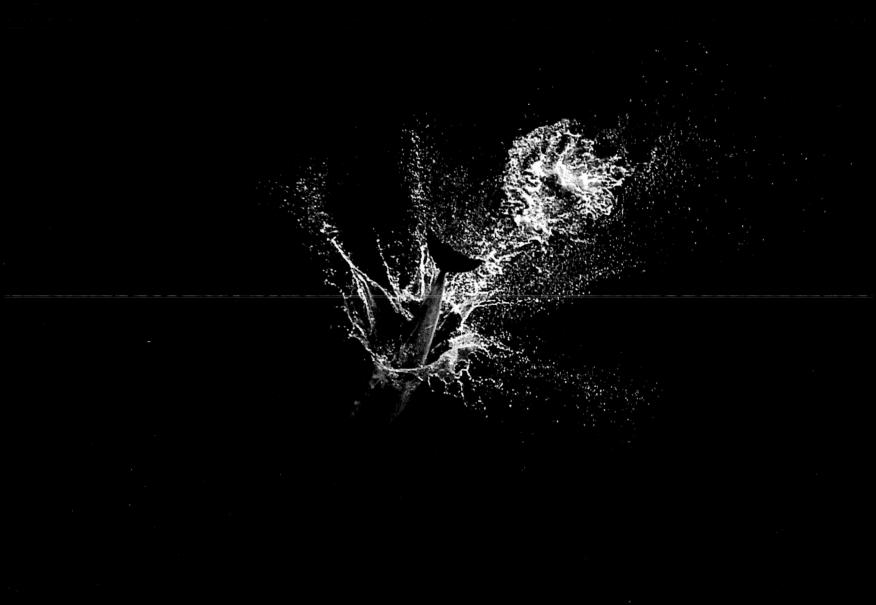

Temple of Abu Simbel, Lake Nasser, Egypt (22°21′N - 31°37′E)

The rescue of this archaeological site, built during the reign of Ramses II (1301–1235 BC), was the first major project carried out under the auspices of UNESCO after its creation. When this region of Nubia was threatened by the construction of the Aswan Dam in 1954, nearly fifty nations gathered and made the decision to move the temple, stone by stone, to higher ground. This international effort toward conservation provided impetus for the notion of a common responsibility for the heritage of all humankind. For four years, between 1963 and 1967, nine hundred laborers cut these temples into more than a thousand separate blocks and rebuilt them in identical fashion, 200 feet (60 meters) higher, on an artificial cliff supported by a concrete arch—at a cost of more than \$40 million. Since 1979, the Temple of Abu Simbel has stood as a prominent emblem of the UNESCO World Heritage Program.

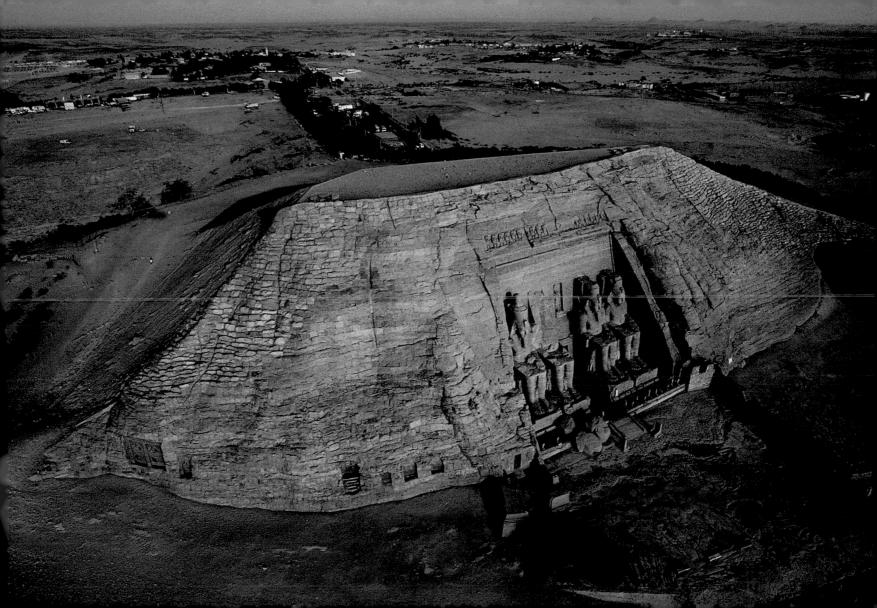

Plant nursery at Pillnitz, southeast of Dresden, Saxony, Germany $(54^{\circ}00' N - 13^{\circ}52'E)$

Traditionally practiced in great river valleys where the climate is largely temperate, commercial horticulture has spread to all parts of the world, including northern European countries where none existed before. Germany is now the second-largest European producer of flowers (after the Netherlands). Formerly adapted to the rhythm of the seasons—bulbs in spring, geraniums and petunias in summer, ferns in fall—plant cultivation has freed itself of all climatic or soil-based restrictions, thanks to greenhouses and hydroponic growing methods. Developing countries are also beginning to export their share of flowers around the world. But the workers in this industry are often exploited, and their health threatened, by the vast quantities of pesticides employed. As a response to these problems, a "flower campaign" was launched in Germany in 1990, resulting in the 1997 creation of an international code governing flower work and respect for the environment. Flowers sold with a Flower Label Program tag are guaranteed to have been grown under ethical and ecological conditions.

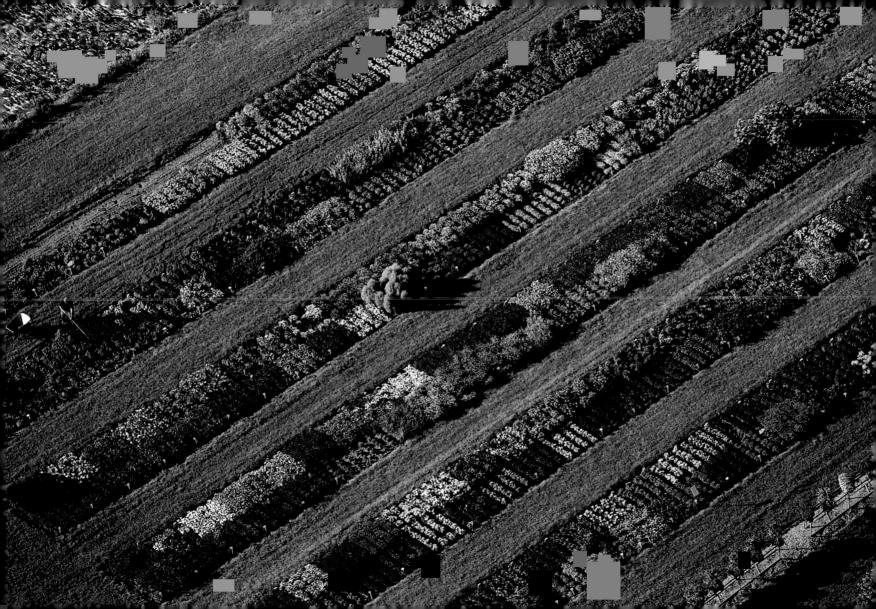

Harvesting salt near Belo sur Mer, Madagascar (20°45'S - 44°04'E)

Belo sur Mer is one of the most active shipyards on Madagascar's western coast. For more than a century, craftsmen here have been building vessels to carry, among other things, locally produced salt to the other towns on the island. Despite the worldwide use of refrigeration techniques, many countries still use salt to preserve food, notably meat and fish, which makes it a substance in great demand. Salt also plays an important role in health care; in many countries around the world, lack of iodine causes goiter (the swelling of the thyroid), which leads to anomalies of development in children. Mental retardation caused by lack of iodine is irreversible. In 1995, according to a study made by the World Health Organization (WHO), 22.8 percent of six-to-twelve-year-old Madagascans were affected by goiter. In 2003, one in three people worldwide lacked sufficient iodine and one in seven had goiter symptoms. WHO recommends the general use of iodized salt in human and animal diets to combat iodine deficiency.

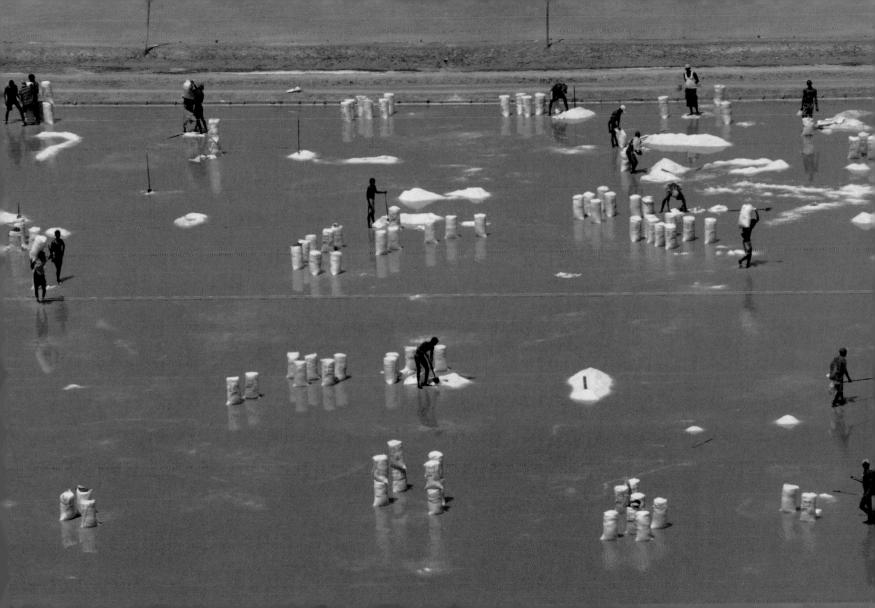

Village on Lake Chad, Chad (13°23'N - 14°05'E)

On the islands of Lake Chad, the fishermen first dry their catch of perch, catfish, and carp, then smoke it in traditional ovens. Lake Chad, which used to straddle the frontiers of Chad, Cameroon, Nigeria, and Niger, has lost 95 percent of its surface in the last three decades. This is an ecological catastrophe of the first order, and it is principally a result of the wholesale irrigation and diversion of water, along with a steady decrease in rainfall—which has caused appalling droughts. Farmers, herders, and fishers are suffering from acute shortages, which have led to thin harvests, the deaths of many animals, the failure of fisheries, and an increasing salinity of the soil, which makes it even less productive. This situation is no less than explosive; it affects 20 million people in adjoining countries and is causing great political friction among them.

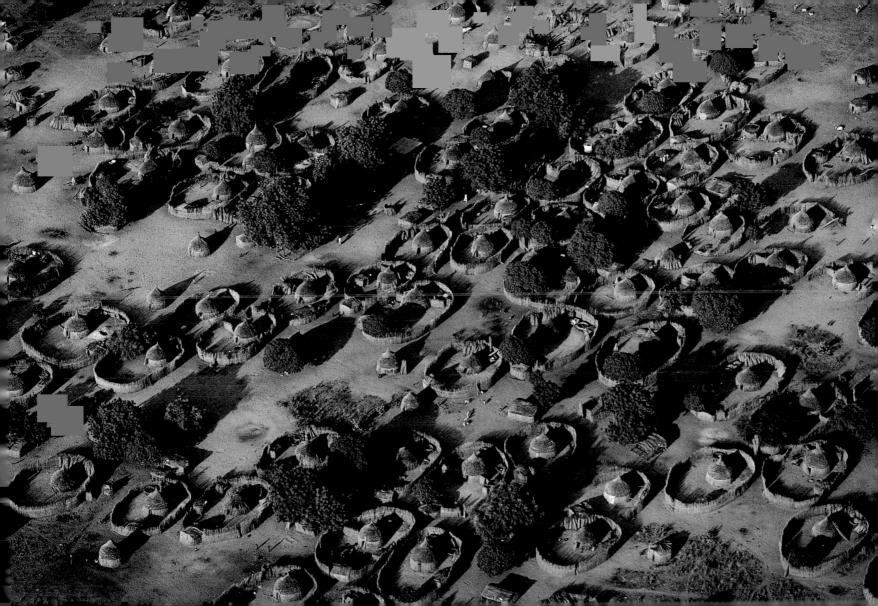

Banda Aceh, Lhok Nga Mosque, after the tsunami of December 26, 2004, Sumatra, Indonesia $(5^{\circ}33'N - 95^{\circ}18'E)$

On December 26, 2004, an earthquake registering 9.0 on the Richter scale provoked a massive tidal wave, killing 200,000 Indonesians. After its passage the province of Aceh in northern Sumatra was a scene of total desolation. The smashed minaret and gutted buildings of the mosque of Lhok Nga remind us that Indonesia, with its population of 200 million, is the largest Muslim nation on the planet (87 percent). But other religions are also practiced in Indonesia, and there has been conflict in the past; Timor, a largely Christian island, won independence after much violence in 2002, and in the Moluccas, Chinese and Christian minorities continue to be persecuted. Moreover, ever since 1976 there have been secessionist rumblings in the province of Banda Aceh. Following the tsunami, however, the guerrillas of the Gerakan Aceh Merdeka (Free Aceh Army) and the Indonesian army made a provisional truce, which resulted in a peace agreement in July 2005.

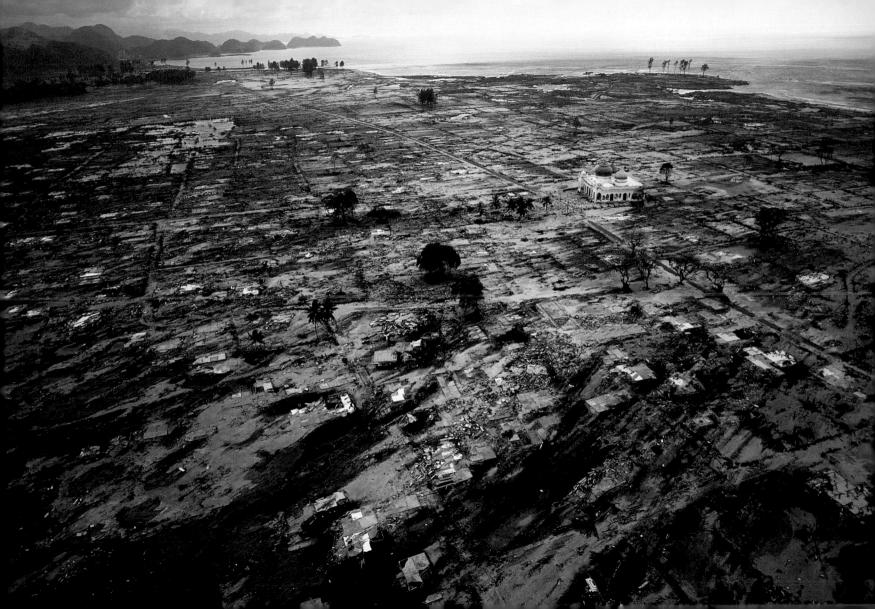

Valley of Wadi El Abiod, Algeria (38°05'N - 6°10'E)

The Aurès Mountains in northeastern Algeria, with their long parallel ridges separating narrow, deep valleys, are famous for their beauty. Wadi Abdi and Wadi El Abiod thread their way through the massif, coming together near Biskra before their waters peter out in the sands of the Sahara. The south side of the massif is dry and torrid; all life takes refuge in the valleys. In the gorges of Wadi El Abiod, villages cling to the steep, rocky slopes, and the vegetation watered by the river forms a patchwork of green along the canyon. During the war for independence, this valley was an impregnable stronghold of the National Liberation Front, at war with the French colonial army. Today, many young people prefer to leave this isolated territory to try their luck elsewhere, in the cities of the coastal Constantine region or in Europe. Unemployment among young Algerians runs at 30 percent, and is a powerful incentive to leaving.

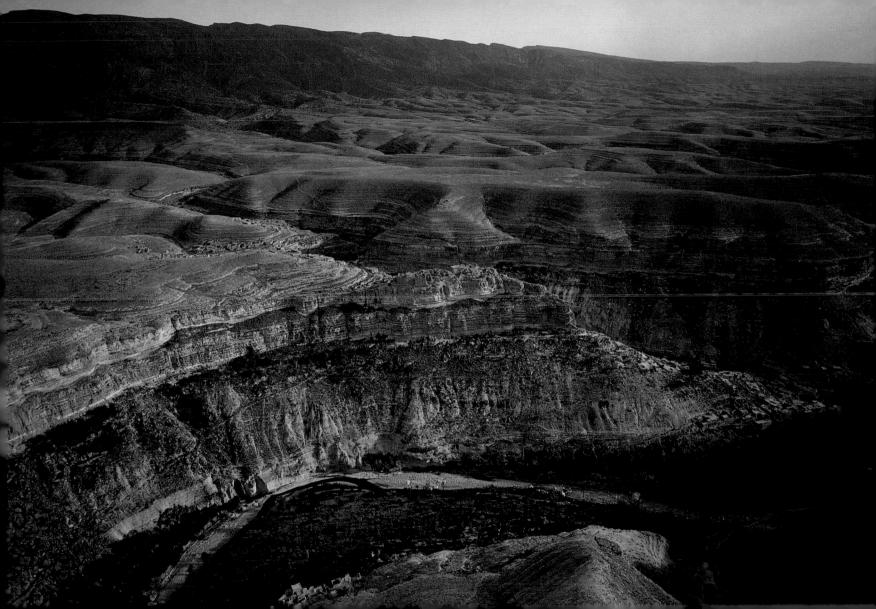

Fruit and vegetable market near Man, Ivory Coast (7°30'N - 7°29'W)

Pineapples, mangoes, coconuts, onions, tomatoes, taro, and plantains are all grown in the Man region, and farmers regularly bring them to the city market. In Africa, the cities have spawned intense agricultural activity. There can be no comparison between the fresh produce for domestic consumption and the crops destined for export, which bring in foreign currency but which also engender political dependence. The surplus of fresh produce is distributed in the cities, which provide a vigorous and seemingly insatiable market. Farmers often adapt their crops to the tastes of the city folk to increase their gains; in the Ivory Coast, for example, they reduce cassava to the coarse flour (attieke) that urban consumers like best.

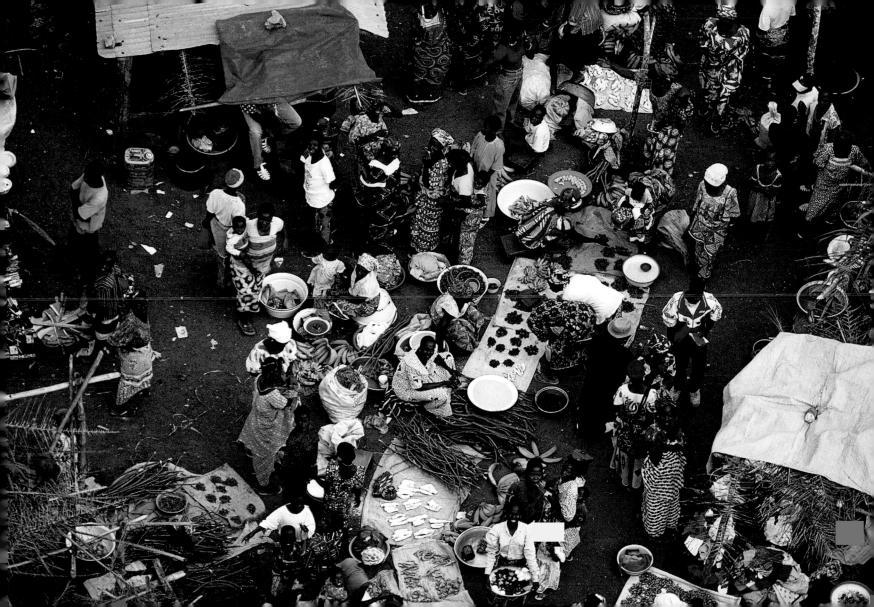

Island of Janitzio, on Lake Pátzcuaro, Michoacán, Mexico (19°35′N - 101°35′W)

Janitzio is the largest of the five islands on Lake Pátzcuaro, a vast expanse of water surrounded by mountains in the state of Michoacán. Ever since 1930, a gigantic statue of José María Morelos, one of the heroes of the Mexican War of Independence (1810–1821), has stood at the top of the island. Morelos was shot on December 22, 1815, after being captured by Spanish forces, and so did not live to see the end of the war. Inside the 131-foot-high (40-meter-high) monument is a staircase that leads up to a *mirador*, which is set in Morelos's raised fist. For the people of Janitzio, the Feast of the Dead (October 31–November 2) is the high point of the year; they head toward the island's cemetery carrying candles, bouquets of marigolds, and food. All night long families watch, chant, and pray for the souls of their departed relatives, whose tombs are decorated for the occasion. Every year, however, more and more tourists are coming to the Janitzio festival, and its authenticity is now under threat.

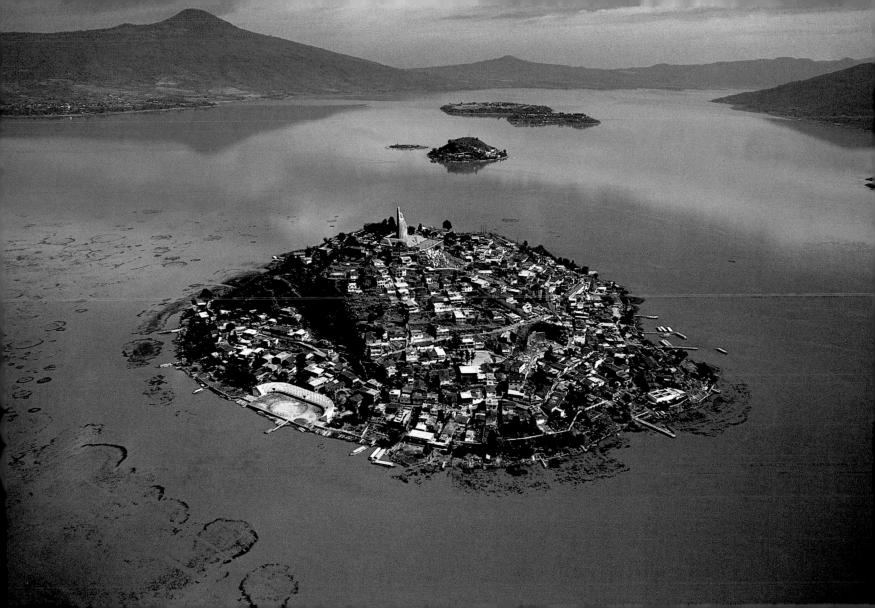

Grain stores in a village near Goz Beïda, Chad (12°13'N - 21°24'E)

In the regions of the Sahel, where agriculture and livestock rearing are the mainstays of the population, grain stores are filled during the lengthy dry season with harvested cereal crops (millet and sorghum) and peanuts. They are grown during the brief rainy season, and then consumed locally. The sight of these grain stores may be reassuring, but their very existence testifies to the fears of the 800,000 people living in the provinces of Ouaddaï and Biltine, in the east of Chad, who often go hungry. In Chad. 84 percent of the population is undernourished, so this kind of insecurity is only too well understood. The rains are not to be relied on, most of the soil is degraded, and agricultural productivity is very low. Recent years have seen long months of relentless heat, and the food situation has been further aggravated by the arrival of famished refugees (230,000 since 2003) from the war in Darfur, in neighboring Sudan, Hunger may seem to be on the retreat worldwide, but there are still 800 million people who are permanently short of food, and 2 billion who suffer from chronic nutritional deficiencies. notably in India and sub-Saharan Africa.

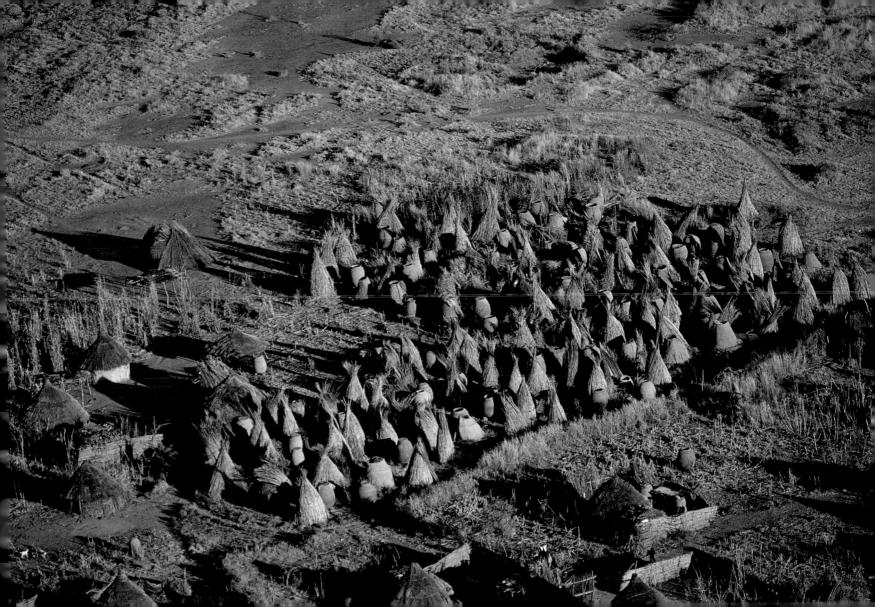

Island quarry in the leshima archipelago, Inner Sea, Japan $(34^{\circ}40'\,N-134^{\circ}31'\,E)$

The Seto Inner Sea, between two of the four principal islands of Japan, Honshu and Shikoku, plays host to more than a thousand islands of various sizes. Among these, the leshima archipelago (8 square miles [20 square kilometers]) consists of a group of 40 islets about 12 miles (20 kilometers) from the Honshu coast. The archipelago owes it name to the largest of these islands, leshima, which has a population of five thousand. Two of the smaller islands, Tangoshima and Nishishima, are island quarries that have been exploited for at least a century. More than a third of the rock on these islands has already been removed; they have become so much smaller that, if nothing is done, in a few years they may vanish altogether. Since the 1950s, steady human pressure on finite natural resources has been exhausting the planet's ecosystems. This consumption of the earth's resources far outstrips their capacity to renew themselves and raises the question of what will be left for future generations.

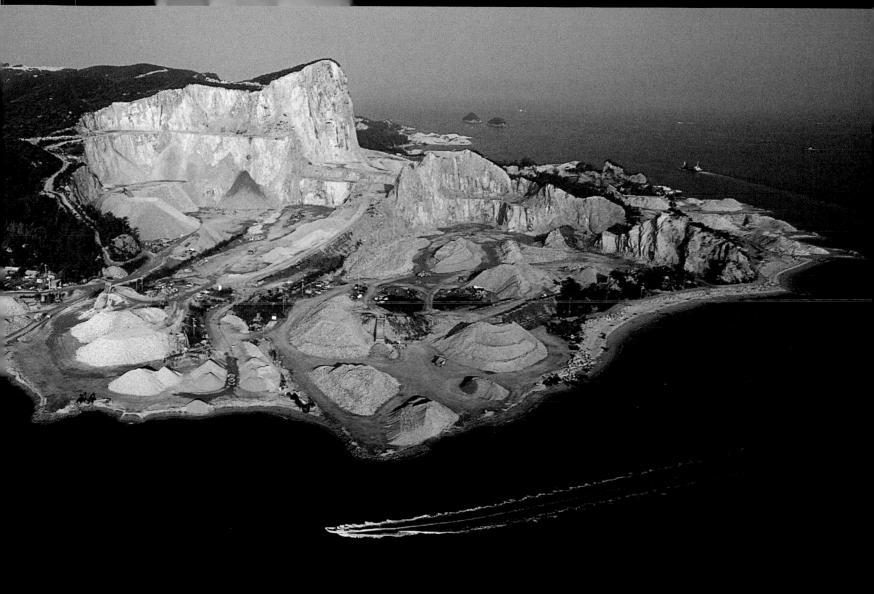

Almond picking, Majorca, Balearic Islands, Spain (39°36'N - 3°02'E)

Almonds originated in central Asia and were popularized throughout the Mediterranean by the Greeks and Phoenicians. The Romans referred to the almond as the "Greek nut." In the Balearic Islands, the growing of almonds remains a traditional activity, like vine and olive husbandry; the fruit is harvested by shaking the trees and catching the almonds in spread tarpaulins. Almond trees are not especially productive (an average yield is 4 to 11 pounds [2 to 5 kilograms] per tree), and substantial acreage is required; in fact, the amount of land planted in almonds has diminished significantly in recent years—the old trees are seldom replaced with new ones. Nonetheless, with an output of 200,000 tons in 2005, Spain is the world's number two producer (number one being the United States, which furnishes more than 70 percent of the world's crop—670,000 tons in 2005). Spanish almonds cover the European market, where they are increasingly prized for pastries and candies.

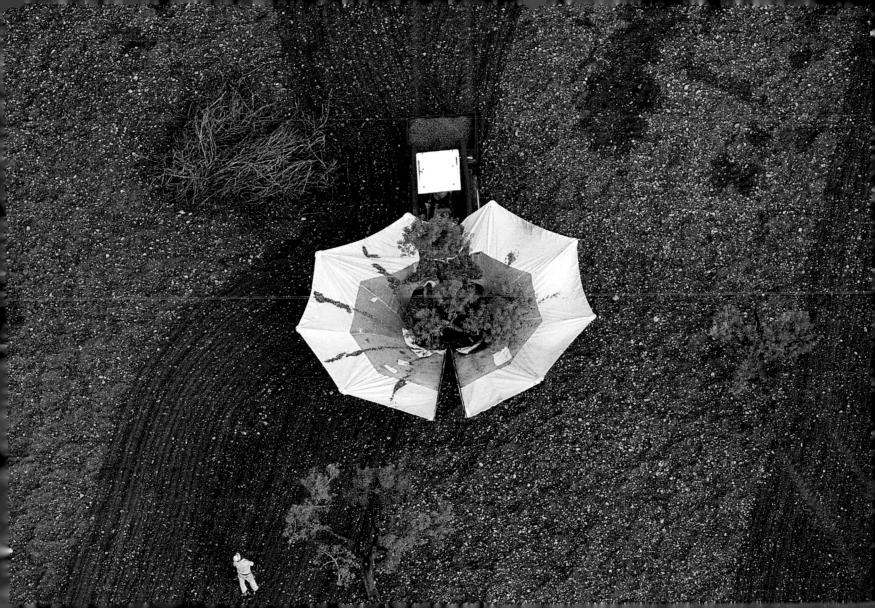

Wild deer in the Vallée de Chevreuse, Yvelines, France (48°50'N - 1°47'E)

According to the French authorities, the red deer population in France tripled between 1985 and 2000, and now stands at well over 120,000 head. Roe deer and wild boar have also proliferated in the last fifteen years, and damage to crops by wild animals is increasing. Since 1993, with the financial support of hunting associations, pieces of land have been set aside as wild animal reserves around the edges of French woodlands, with a view to providing abundant food for wild fauna and promoting biological diversity. In 2005, these areas covered more than 74,000 acres (nearly 30,000 hectares) and hunters paid almost \$2 million to farmers to maintain them. Experiments have shown that set-aside land can help reduce crop damage caused by wild creatures and promote the reproduction of many animal and plant species. In France, the pressure of agriculture on biological diversity is considerable, given that 53 percent of French territory is cultivated land.

POSCO electrical steelworks, Gwangyang, Joellanam-do, South Korea (34°55′N - 127°45′E)

In an electrical steelworks facility, steel is produced using waste metal that is melted down by electrical energy. The combustion of the various raw materials produces heavy atmospheric pollution (mainly cadmium, lead, and mercury). Even when emitted in small amounts, these heavy metals accumulate in the soil and eventually are incorporated into the food chain. According to the World Health Organization (WHO), heavy metals can cause pathologies in humans, such as bone and liver lesions, behavioral disorders, high blood pressure, and lung cancer. In this region of Korea, the surface water has been so badly acidified that it is no longer drinkable. Since 1992, POSCO, the world's third-largest steel producer, has been running a factory on an artificial island at Gwangyang; like other industrial giants today, the company is trying to reduce the pollution generated by its waste products. In the last twenty years, the South Korean industrial economy has developed at a headlong pace, with little regard for the environmental consequences. Having been listed as a developing country under the Kyoto Protocol, whereby the industrialized nations agreed to tackle climate change by reducing greenhouse gas emissions, South Korea did not have to make the same environmental commitments as the Appendix I countries.

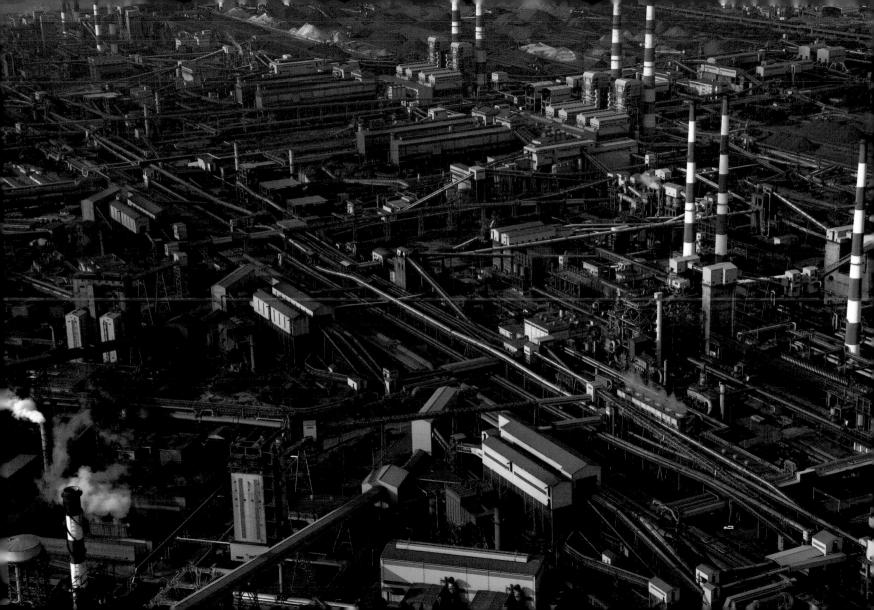

Sheep farm near Lake Coleridge, Canterbury region, South Island, New Zealand $(43^{\circ}22' \text{ S} - 171^{\circ}31' \text{ E})$

This country of just 11,000 square kilometers (29,000 square kilometers) has 40 million sheep and only 4 million human inhabitants. On South Island, sheep farming is the dominant agricultural activity. The animals spend the whole year in the open air, in enormous pastures enclosed by electric fences: they are only gathered for shearing, or for shipping to the slaughterhouse. New Zealand sheep farms depend on the worldwide exportation of meat and wool. Stocks of ewes have diminished recently, but lamb production has remained stable, at about 25 million per year, of which 85 percent is exported. Sheep farming has its adverse effects on the environment, ruminants in large numbers being a major source of methane—the gas ranked third in its contribution to climate change (after carbon dioxide and Freon). In New Zealand's case, this gas already accounts for more than 50 percent of greenhouse emissions; worldwide, livestock produces 18 percent of methane emissions, the remainder deriving from agriculture (rice paddies) and the fermentation of garbage wastes (biogases). There is a good deal less methane than carbon dioxide in the atmosphere, but its emissions are growing much more rapidly.

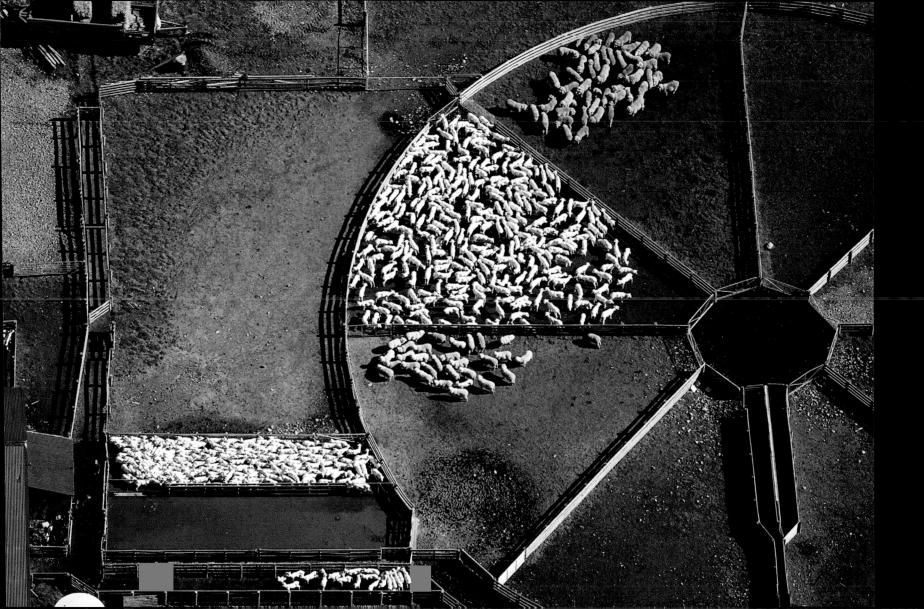

Crops in the Aïn Touta Region, Aurès Mountains, Algeria (35°22′N - 5°52′E)

The former colonial village of Aïn Touta, created in 1872, is 3 miles (5 kilometers) from Batna. Today it has turned into a major agricultural zone, with some 34,000 inhabitants. The Algerian relationship to the land is an important element of the collective national identity; during the period of French colonization, nearly half of the country's 18 million acres (7.5 million hectares) of arable territory was confiscated from its owners and reallocated to colonists. After independence, agrarian reform provoked a crisis and a massive exodus to the cities. But since the turn of the twenty-first century, agriculture has become a new engine for growth, contributing 12 percent of gross national product and employing 25 percent of the working population. But this is not yet enough; Algeria still has to import foods such as cereals, milk and other dairy products, oils and fats, and sugar and sugar-based products.

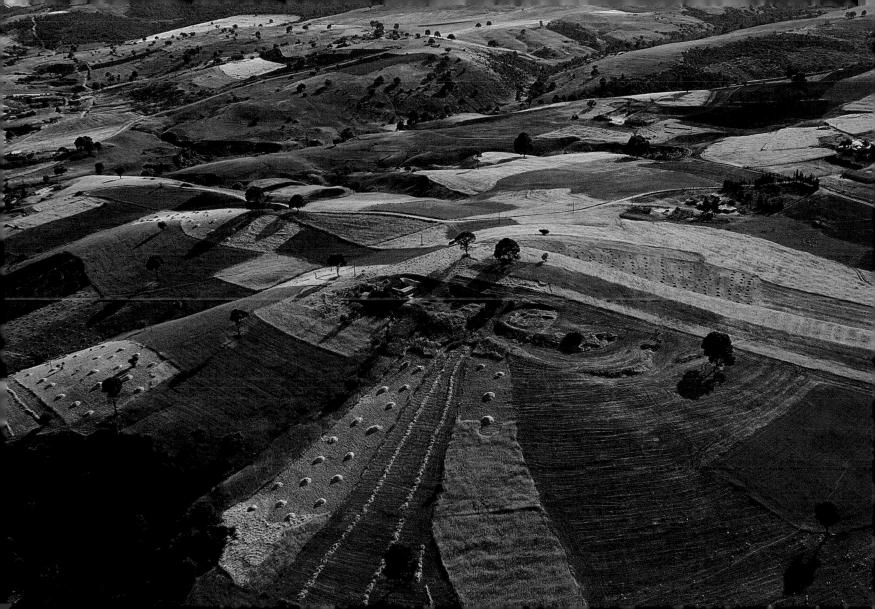

Fishing nets on Hak Dong beach, Gyeongsangnam-do, South Korea $(34^{\circ}44'N - 28^{\circ}37'E)$

At the southernmost point of Geoje-do there is a small fishing village, with a few boats moored at the dock. Local fishermen have to cross the isthmus to repair and overhaul their nets on a more accessible beach. Along South Korea's 1,500 miles (2.400 kilometers) of coastline and its three thousand islands, fishing is a traditional activity. The country's high population density and the relative scarcity of arable land have obliged it to manage fishing resources with special care. The Korean fishing fleet is the tenth largest on the planet and cruises every ocean, but on its margin there exists a subsistence industry operating from small boats, which brings the total number of Korean fishermen to 120,000. In the south of the country, on the island of Jeju-do, the traditional haenyo fishing still survives, whereby women dive without breathing apparatus to gather conches, octopus, or abalones; however, their numbers are dwindling as the years go by. This decline contrasts strongly with the dynamism of the modern sector; in order to avoid depleting their own resources the Koreans go out to fish in international waters. Worldwide every year, 7 million tons of fish are netted and killed.

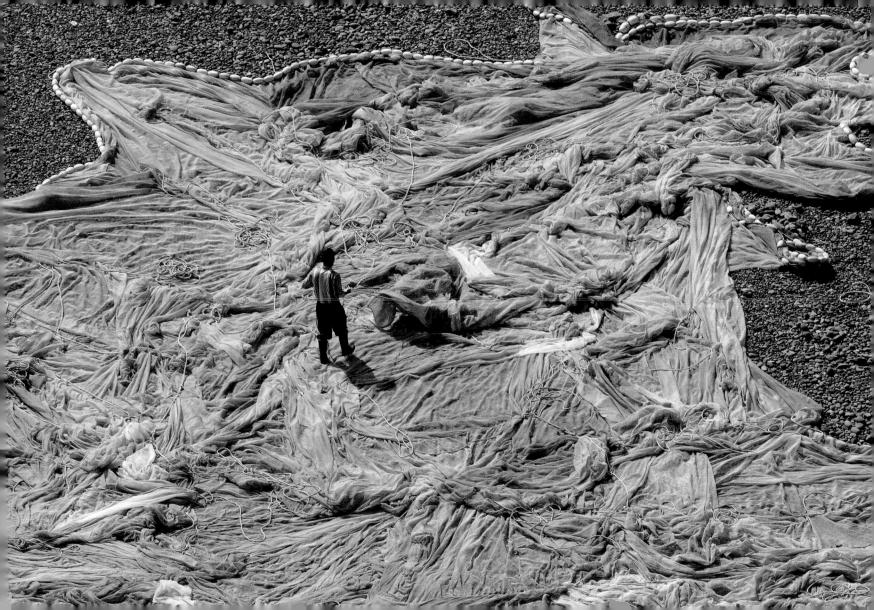

The bay of Mont-Saint-Michel in the mist, Normandy, France $(48^{\circ}37'N - 1^{\circ}30'W)$

The bay of Mont-Saint-Michel between Brittany and Normandy opens onto the English Channel, which sees the highest tides in Europe (up to 46 feet [14 meters]). The abbey here was founded in the eighth century, and the pilarims who flocked to Mont-Saint-Michel had to brave quicksand and tides coming in "faster than a galloping horse." Many perished. Today the site is a major tourist attraction with 3.5 million visitors every year, eclipsing its religious vocation. A raised causeway, built in 1880, facilitated the heavy tourist traffic by linking the rock of Mont-Saint-Michel to the mainland, but the structure also accelerated the sanding-up of the bay, disrupting its ecological balance by creating the conditions for vegetation to take hold. Since 2005, work has been underway to restore the original maritime and insular landscape. The old causeway has been remodeled. Its last mile has now been replaced by a bridge on pylons and the car park has been demolished, returning 37 acres (15 hectares) to nature. The complete disappearance of motor traffic between the mainland and the Mont (1,000 vehicles used to make the crossing every hour during high season) is expected to restore the original justification for the site's double inclusion on UNESCO's World Heritage list: for its architecture and for the unique natural beauty of its site.

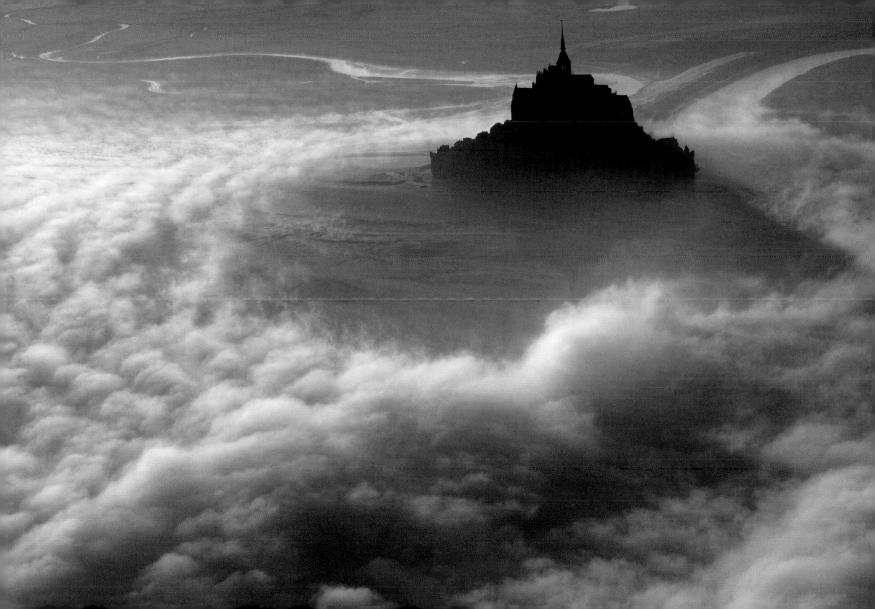

TRADE WILL BE FAIR

William Ruby is forty-five years old and has been growing cocoa beans in Ghana for more than thirty years. Yet he has never tasted a chocolate bar in his life. In this he is no different than most of the other small producers in his village of Awaham. In Awaham there is only powdered cocoa, distributed by a major international brand, which the locals can only purchase by the spoonful because it is so expensive. This situation is a perfect illustration of the inequality of the terms of exchange between the small producers of the Southern Hemisphere and the world of agribusiness in the Northern Hemisphere. The case of these small producers is anything but a one-time affair; it directly concerns over one billion farmers all over the world, who with their families represent more than 4.2 billion individuals. So the issue is not purely incidental. These people on average cultivate an agricultural area of 2.5 acres (1 hectare) each and earn between \$130 and \$650 per year, barely enough to survive.

In general, the market offers them price levels that hover between 50 and 70 percent less than their real production costs. For example, in the case of coffee, they make an average of \$24 per sack, while it is estimated that their real production cost is \$84 per sack. Even at this present time of steep increases in the price of raw materials, these increases only affect small producers of the materials to a minimal extent. The greater benefit goes to speculators and middlemen and rarely to small, isolated producers deep in the bush. The fair trade movement aims to participate in the development of a billion small farms by guaranteeing the farmers fairer conditions under which to market their produce—meaning guaranteed minimum prices, payment of development premiums, organization of fully inclusive trading networks, long-term contracts, and environmental commitments.

Fair trade is not confined to the payment of fair prices; it has a broader mission in its participation in the defense of family-based agriculture and its multiple advantages, which include the promotion of agroforestry, agricultural biodiversity, biological agriculture, and the maintenance of population levels in the countryside. At the same time, it works for the preservation of producers' self-sufficiency in terms of food supply, and furthers education about development. This is a holistic approach to the notion of civic responsibility in the matter of consumption. Some people concentrate purely on trade, others on biological production; but we are convinced that the two approaches are thoroughly complementary and need to be integrated. Fair trade advocates a different

model of production to that of intensive agriculture and mass consumption, which is often seriously destabilizing for people and their environments both in the South and the North—indeed it is among the root causes of evils such as exploitation, enslavement, wholesale pollution, conspicuous consumption, and human obesity.

At present, rural development has once again become the number one priority of international organizations, ranging from the Food and Agriculture Organization (FAO) to the World Bank and the International Monetary Fund (IMF), which had been less vocal on these subjects in recent years. The current worldwide food crisis has offered a brutal reminder that agriculture in the Southern Hemisphere badly needs support, and that urgent investment in agricultural development is required, notably in Africa, if the population is to be fed. Indeed Africa must have its own green revolution, but what model should it adopt? Should the model be conventional, with chemical agriculture and genetically modified crops—and their accompanying serious repercussions? Or should it be biological, with biodynamic, fair-trade agriculture, whose many benefits for producers and consumers are tried and true? In India, the so-called green revolution, conducted along the lines of chemical and genetically modified agriculture, led to more than 10,000 suicides among small farmers and to the extinction of many rice varieties.

Everywhere in the world we observe that biological agriculture can be just as productive, if not more so, than conventional agriculture, especially once petrochemical input has been removed from the equation. A different and better model for agriculture and consumption is possible and necessary if we are to reconcile our growing need for food with a greater respect for mankind and his environment. Intensive agriculture, previously presented as more productive and less expensive than any other form, actually exacts a very high price if we count its full social and environmental cost. We pay a very high price for using child labor for the development of our countries, for creating discrimination, and for contracting the many forms of cancer linked to the use and consumption of chemical products. And in the end we are left with ecosystems devastated by pollution.

The facts are becoming more and more frighteningly obvious, and they cry out for radically different modes of production for our planet. Since its introduction into the mass distribution system, fair trade has

proved its worth as an economically viable model that responds to an overwhelming demand on the part of consumers. Consumers have understood that in fair trade they have found a satisfactory way of taking action on behalf of the planet and a form of activism that is actually exhilarating. We are reinventing consumption, by linking it to civic responsibility without renouncing in any way the pure pleasure that goes with the act of purchase.

Fair trade is useful and does justice to the agricultural world; at the same time it is preferred by consumers both on account of the added quality it entails, and in terms of its deeper meaning. There is no reason why fair trade should not continue to develop on an ever-broader scale. This is already the case with the proliferation of sustainable initiatives and products, some of them launched by the giants of the food-processing industry. While in many cases the aim has been to appropriate and parasitize the image of fair trade for a fraction of the cost, at least the original idea has caught on and is continuing to spread. This is cause for real satisfaction, heralding as it does a new era of consumption wherein the added social and environmental value of a product will also be a key element of its perceived worth as an option. It is now the duty of individual governments to regulate this market as it takes hold, just as they have already regulated biological farming; and ultimately it is up to consumers and citizens to opt for the methods that they feel have greatest merit.

Fair trade is a model for the future, indeed the only one we have that guarantees a fair return for two-thirds of the world's population while preserving their ecosystems and agricultural biodiversity. It, along with all forms of responsible consumption (biological, green, ethical, supportive, carbon off-setting), should no longer be considered as constraints, but rather as authentic competitive and strategic advantages for commercial brands. Only this will ensure our rapid, long-term development. At issue here is the implementation of a green social revolution for both producers and consumers all over the planet. Make no mistake, all trade will one day be fair.

Tristan Lecomte
Founder, Alter Eco

Sarez Lake, Pamir Mountains, Tajikistan (38°15′ N - 72°37′ E)

In 1911, an earthquake registering 7.4 on the Richter scale caused a gigantic landslide more than 1,600 feet (500 meters) deep that blocked the valley of the river Murgab in the Pamir Mountains. Over time an immense lake formed at 11.000 feet (3.300 meters) above sea level, upstream from the rockfall. The river was thrown back 37 miles (60 kilometers), and the resultant lake now contains 4 cubic miles (17 cubic kilometers) of water. Following a series of earthquakes in the 1990s, leaks began to appear in this natural dam, and experts started to worry that it would suddenly break-a catastrophic scenario-or that it would be overwhelmed by a new landslide. There is always a risk of landslides in this region, where powerful earthquakes are very common. Were it to happen, the bursting of Sarez Lake would release a wave 330 feet (100 meters) high that would wreak havoc downstream for more than 620 miles (1,000 kilometers), not only in Tajikistan, but also in Afghanistan, Uzbekistan, and Turkmenistan-affecting 5 million people. To counter this risk, the World Bank has financed the local establishment of an observation and early-warning system.

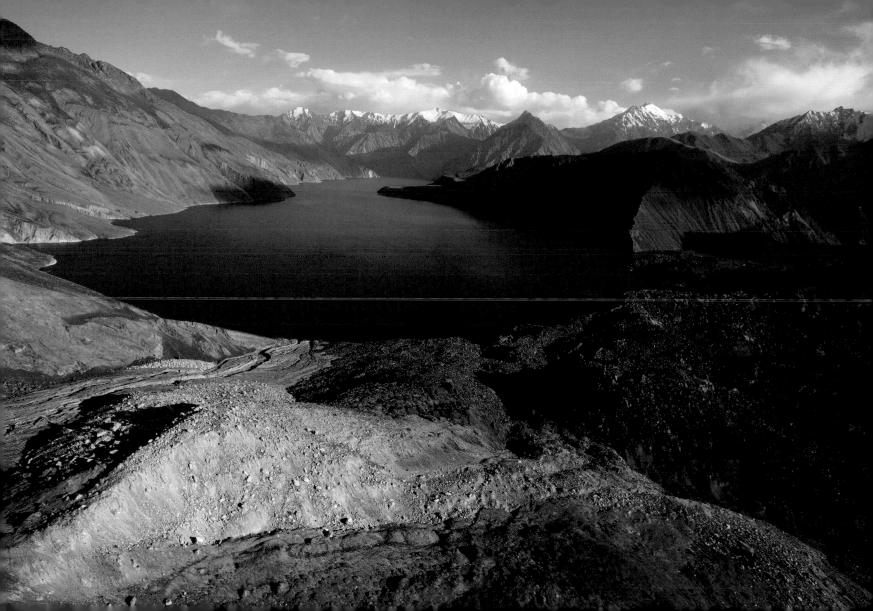

Seals in the Baie de la Somme, Department of the Somme, France $(50^{\circ}14' \, N - 1^{\circ}33' \, E)$

Along France's Channel coast, for a distance of about 44 miles (70 kilometers), land and water are blended in a broad, humid coastal plain known as the *plaine maritime picarde* (Picardy sea flats). The region is famous for its rich bird life; close to 340 bird species nest there or linger in the area during their great spring and fall migration between Europe and warmer climes. France's largest colony of calf seals (*Phoca vitulina*)—seventy-plus strong—also resides here. The seal pups are born in the summer months, and when the tide is on the ebb, the adult seals come to rest with their young on the sand banks. It is vital that they remain undisturbed; under pressure, they take to the sea, and the unweaned pups can lose their mothers in the confusion, leading to their certain death. This is one of France's largest natural wet zones. Fragile ecosystems of its type, despite being few and far between, are among the most productive on earth; they are also heavily threatened. In the last thirty years, half of France's wetlands have been sorely damaged or have disappeared entirely.

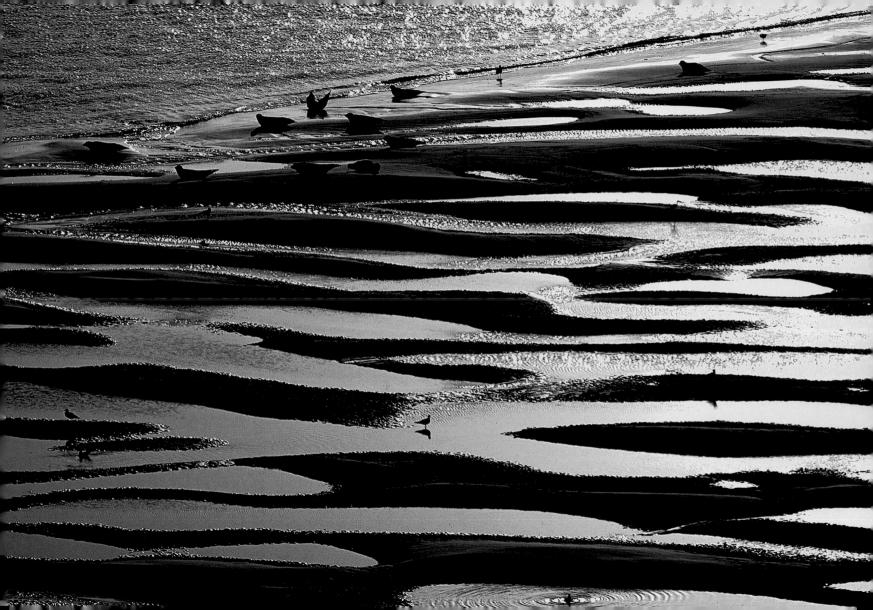

Corinth Canal, Sterea Ellada, Greece (37°55'N - 22°59'E)

The Isthmus of Corinth links the Peloponnesian peninsula to continental Greece, separating the Ionian Sea from the Aegean. Historically, it was always an obstacle to navigation; the journey from one sea to the other involved going right around the Peloponnese and rounding a number of dangerous capes. In the seventh century BC, the Corinthians constructed a paved road across the isthmus, the *dioclos*, over which ships could move on wagons. Later, a succession of Roman emperors dreamed of excavating a canal in its place, and eventually Nero took the bull by the horns, inaugurating the works himself with a golden shovel. At his death the canal was still unfinished, however, and the works were abandoned for economic reasons. When the work was finally begun in earnest at the end of the nineteenth century, the engineers followed exactly the line mapped out by the ancients. Today, the waterway is 70 feet (21 meters) wide and 21,000 feet (6,343 meters) long; nearly 11,000 vessels—mostly carrying tourists—pass through it every year.

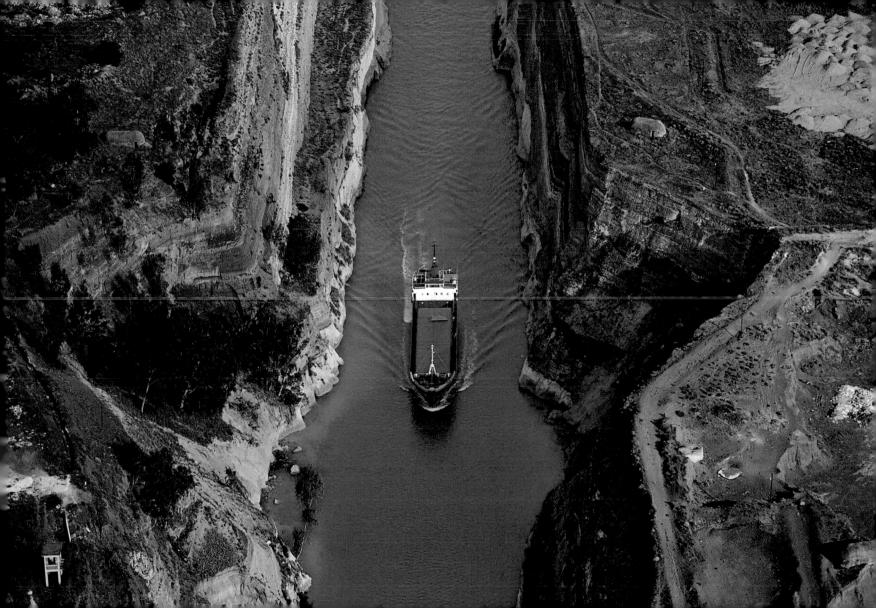

Village of Al Hajarayn, Wadi Doan, Yemen (15°04'N - 43°42'E)

Wadi Doan, like many watercourses of its type, is punctuated by green oases; it winds its way down from the mountain heart of Yemen to the Red Sea. Until the eighth century, this valley, running between high cliffs, was the main route for the silk and spice caravans making their way northward from Dhofar in Oman to Egypt. Even today, a dozen or so villages still cling to the steep flanks of the Wadi Doan canyons. One of these—Al Hajarayn, meaning "the two rocks"—overlooks the entrance to the wadi. Its tall houses, built of pisé (a sun-dried mixture of straw. water, and clay), boast magnificent doors made of rare woods, and seem to defy gravity. Fields of millet spread out below the town, which, despite its isolation, seems full of activity, thanks largely to funds sent home by patron expatriates in Saudi Arabia. Yemen is the poorest country in the Arabian Peninsula, and its economy depends on such remittances from its citizens abroad. This, at any rate, is Yemen's second-largest source of revenue between oil, which accounts for 9 percent of exports, and agriculture. Khat, a hallucinogenic plant, represents one-third of Yemen's agricultural exports.

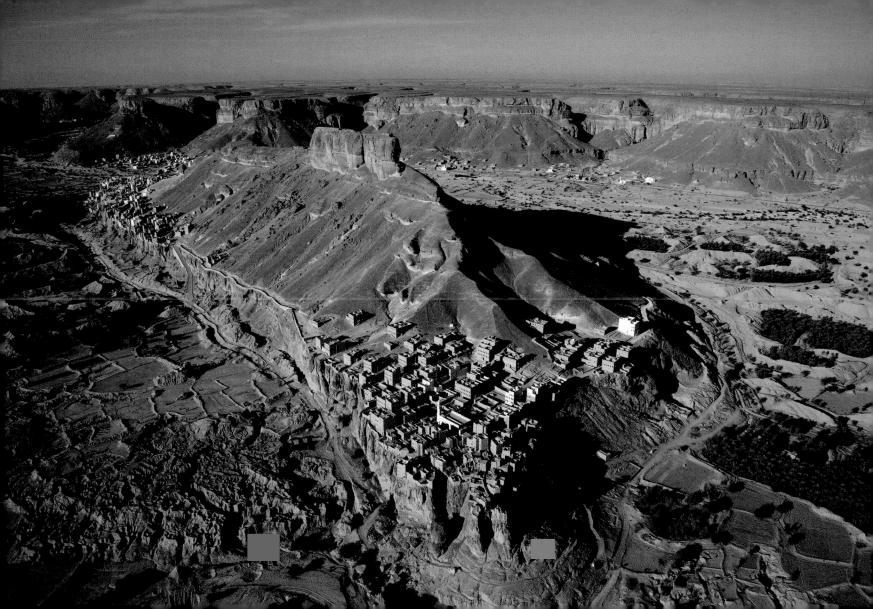

Yams drying in the sun, north of Bondoukou, Ivory Coast (8°43′N - 2°39′W)

Yams are traditionally grown in mounds of earth; they are consumed locally in most of the world's tropical countries. In Africa this protein- and starch-rich vegetable is particularly common in zones around the southern edges of forest regions, from Ivory Coast to Cameroon. It is a staple of the African diet for rural folk as well as town dwellers, and forms the basic ingredient for one of Ivory Coast's most popular dishes, *foutou*, a kind of compacted puree. Ivory Coast is Africa's third-largest producer of yams (after Nigeria and Ghana). In Africa, about 55 percent of the population is still employed in agriculture, though this figure is steadily declining.

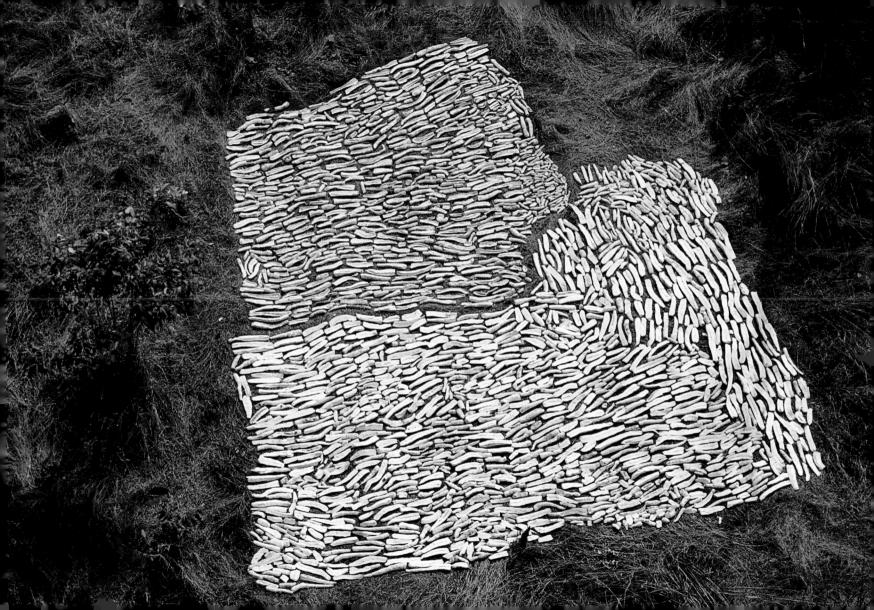

Washerwomen in an oxbow lake of the Niger River, near Kayes, Mali $(14^{\circ}28'N - 11^{\circ}28'W)$

An oxbow lake is a part of a river that has been cut off from the main flow. becoming a pool that eventually silts up. Everywhere in the world, water sources are places of encounter and exchange, and rivers have always attracted human beings. All along the 2,600-mile-long (4,200-kilometer-long) Niger, people use its waters to wash, bathe, and clean their clothes and possessions. The developed countries once had exactly the same tradition, but it faded away with the coming of industrialization, after which changes in human living conditions led to the introduction of domestic appliances for every purpose under the sun. For example, today 93 percent of households in France own a washing machine. and the industry in general has become one of incessant self-renewal. The consumption of water in people's homes increases in direct proportion to their living standards. An American will use, on average, between 65 and 78 gallons per day, while an average person in the African nation of Gambia will only use 1 gallon per day. In Mali, 60 percent of the population has zero access to drinking water, and in some developing countries 90 percent of sewer water and 70 percent of industrial wastewater is poured straight back into the natural environment completely untreated. Worldwide, one inhabitant in six has no access to proper drinking water, and one inhabitant in two has not even the most basic sanitary facility, such as a latrine.

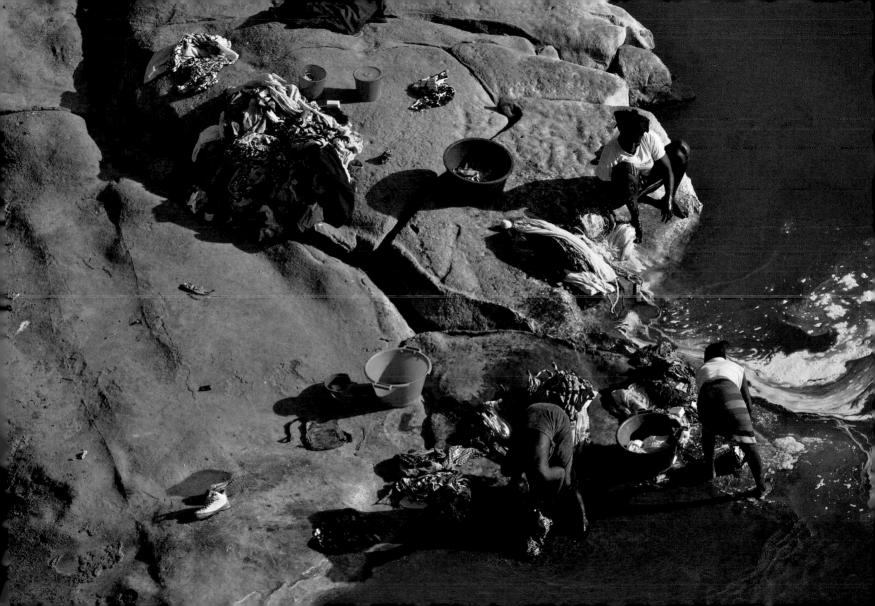

Burnt eucalyptus plantation near Sabie, Mpumalanga Province, South Africa (25°45′S - 30°58′E)

No tree has been so widely planted by man as the eucalyptus, a species that today occupies over 12 million acres (about 5,000,000 hectares) in Africa alone. At the end of June 2007, fires fanned by a strong wind raged across 135,900 acres (55.000 hectares) near Sabie, almost 99.000 acres (40.000 hectares) of which were forests and plantations. Many villages were destroyed and ten people lost their lives. For decades, plantations of eucalyptus had been steadily taking the place of pastureland in the region. Eucalyptus grandis originated in Australia and is a fast-growing tree that consumes large amounts of water (up to 80 gallons [300 liters] per day). In the past, it had been deliberately planted to dry out swamps, where malarial mosquitoes breed. Some eucalyptus species grow to 24.5 feet (7.5 meters) within a year of being put in the soil, and can be almost 200 feet (60 meters) tall when mature. The tree is cultivated not only for its wood but also for the manufacture of wood pulp and essential oils used by the pharmaceutical industry and others. Today the eucalyptus is considered an invasive species because it tends to spread greedily outside its plantations and to take over natural areas, leading to a general impoverishment of the ecosystem and an erosion of biodiversity. Today it is estimated that the eradication of invasive species in South Africa alone will cost about \$60 million.

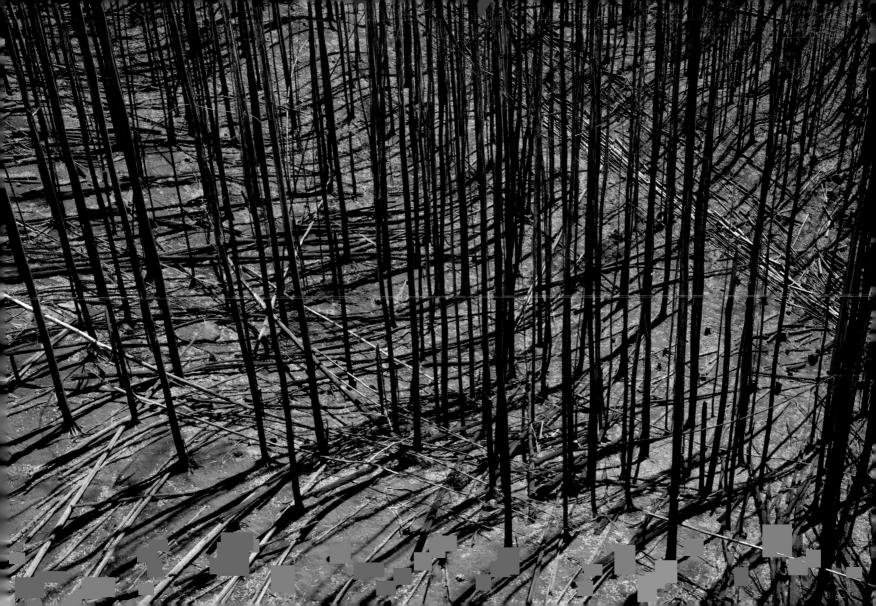

Crops near Kiffa, Mauritania (16°35'N - 11°24'W)

In Mauritania, which is three-quarters desert and where the water table is gradually drying up, the agricultural way of life is severely threatened by chronic drought. Here farmers constitute 45 percent of the population—and 80 percent of the poor. Cereal cultivation is concentrated in the south of the country, near the town of Kiffa, and along the Senegal River, but the sorghum, maize, wheat, and date palms only cover 20 percent of the inhabitants' needs. Little by little, a lack of water is destroying the remaining pockets of farming activity and propelling people into the towns—especially Nouakchott, the capital, where the population has multiplied by twenty in the last thirty years. The rural exodus and the sedentary way of life forced upon nomads has hugely increased urban pressures and pollution. In the 1960s, only 5 percent of the Mauritanian people were city dwellers; today that figure is 55 percent. Worldwide, half of the population lives in urban centers; by 2050, that figure will reach 70 percent.

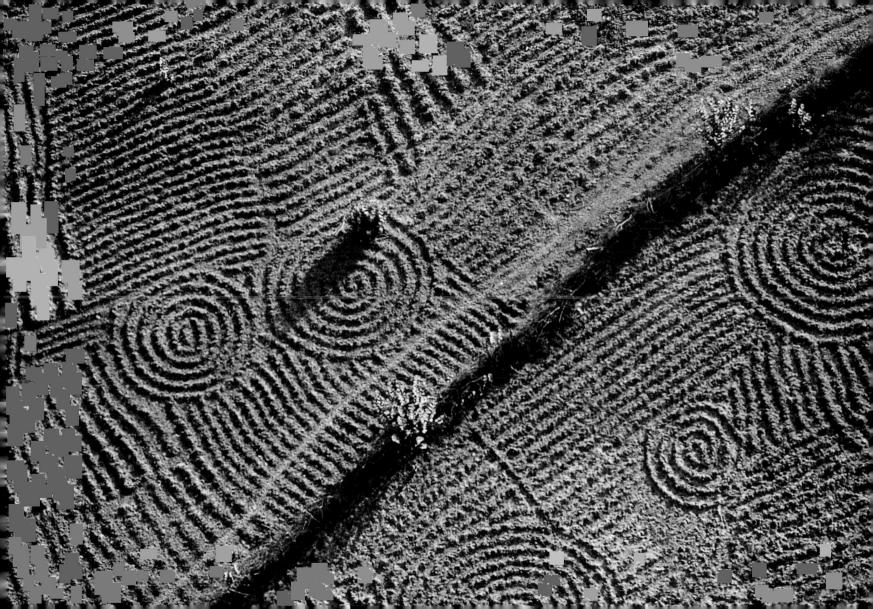

Voui volcanic lake, Aoba, Republic of Vanuatu (15°25'S - 167°50'E)

Tracing a Y shape in the middle of the Coral Sea, the twelve islands and eighty-three islets of the Vanuatu archipelago form a chain of active volcanoes. Among these is Lombenben, which emerges as Mount Manaro. The volcano is topped by two very large craters, or *calderas*, at 5,000 feet (1,496 meters) above sea level. Lake Voui is the inner crater. Following a December 2005 eruption, an island of ashes formed in the lake—and in June 2006, in less than ten days, the pale blue waters were turned purple by deposits of iron oxide. This very rare phenomenon had only occurred once before, in Indonesia, which is also located on the Ring of Fire, where 90 percent of the world's active volcanoes exist. The lives of Vanuatu's 210,000 inhabitants are dominated by intense volcanic and seismic activity, bearing witness to the instability of the Melanesian crescent.

PHOTOGRAPH © PHILIPPE METOIS

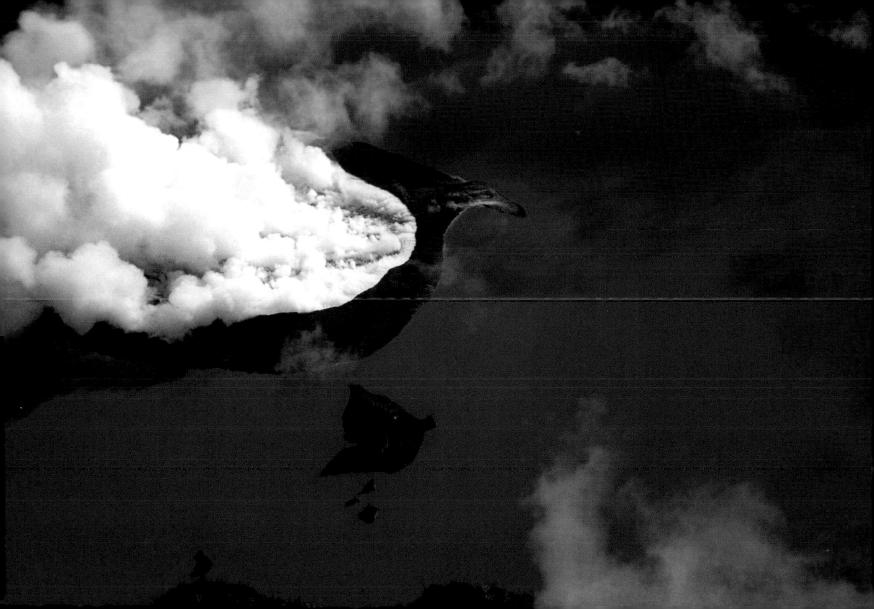

Fields on a mountainside near Cuzco, Peru (13°31'S - 71°59'W)

Cuzco is located at an elevation of 11,000 feet (3,400 meters) in the Andean cordillera, in the hollow of a high, fertile alluvial valley whose climate favors farming. In these mountain zones, agriculture employs more than a quarter of the active Peruvian population, and is largely concerned with staple crops. After Machu Picchu was discovered in 1911, Cuzco was rescued from oblivion and quickly grew into a tourist city of some 200,000 inhabitants with a prodigious amalgam of Inca and Spanish colonial cultures and a store of extraordinary archaeological remains. But in the last fifteen years, as a result of government policies designed to encourage tourism, the fine heritage of the town's center has been forced to give way to commercial and hotel infrastructure. It is perfectly possible, however, to reconcile tourism with protection of the environment—this is precisely the point of ecotourism, which is growing at an annual rate of 20 percent around the world.

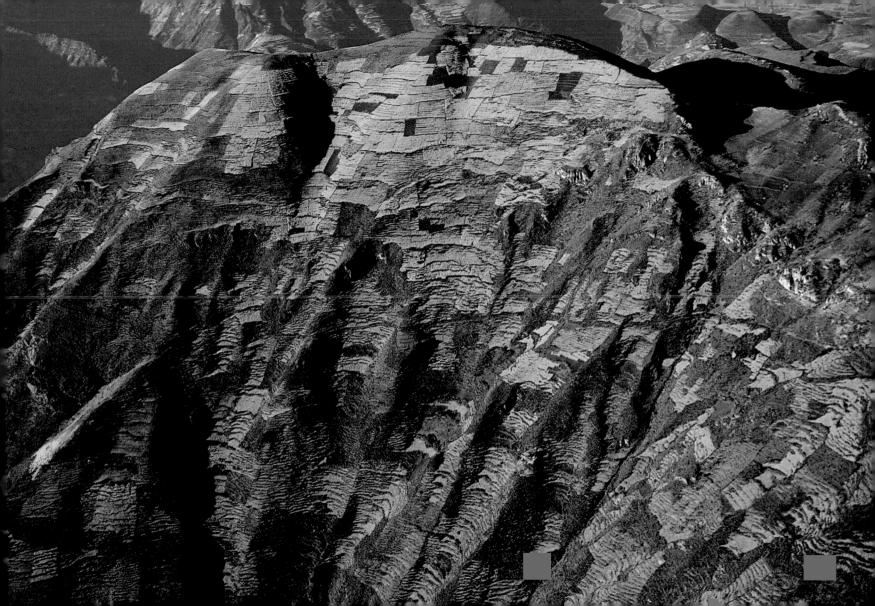

Kochi nomads north of Kabul, Afghanistan (34°40'N - 69°10'E)

Afghanistan, an important crossroads for the ancient silk roads, has always been in tune with the caravan trade. A part of its population remains nomadic, living in semidesert or mountain areas too inhospitable to support any kind of permanent settlement. Formerly able to prosper with their sheep, goats, camels, and cattle—whose manure fertilized the arid soils—today's nomads have become desperately poor, and their movements are severely hampered by the general insecurity of the country, not to mention antipersonnel mines. The droughts of 1998–1999 forced many of them to become sedentary. Today, a census is under way to clarify where the population stands after twenty-five years of warfare, but it would seem that there remain only about 1 million nomads—commonly known as *kochis*—in Afghanistan (out of a total 28 million people). Today the United Nations estimates the number of nomads in the world to be about 80 million.

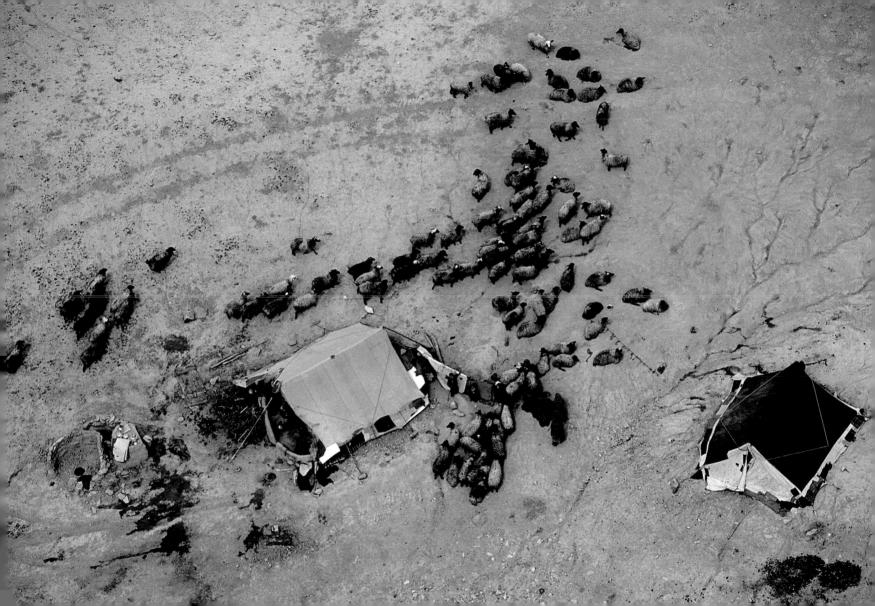

Bahla Fort in the Jebel Akhdar Mountains, Oman (22°58'N - 57°18'E)

Bahla Fort in northern Oman stands at the foot of the Jebel Akhdar Mountains (10,000 feet [3,018 meters] at their highest point), close to the oasis of the same name. Around the fortress is a scattering of forty-six villages. The fortress itself is built of sun-dried bricks and is a monument to the prosperity of the Bani Nabhan clan, which imposed its power on the surrounding communities between the twelfth and fifteenth centuries. However, it was abandoned for many years. and the walls of the fortress gave way more and more with every rainy season. In response to this, and to locally initiated development projects that showed little respect for the site, the fortress was placed on UNESCO's list of imperiled World Heritage Sites in 1988. Subsequently, Omani authorities renounced all use of modern materials and techniques in the fortress's vicinity, and this eventually made it possible to remove Bahla from the endangered list. Everywhere in the world, work is continuing on the identification and protection of such sites, which will make it possible to preserve the treasures of the past for future generations. In 2007, 851 sites were officially designated World Heritage Sites.

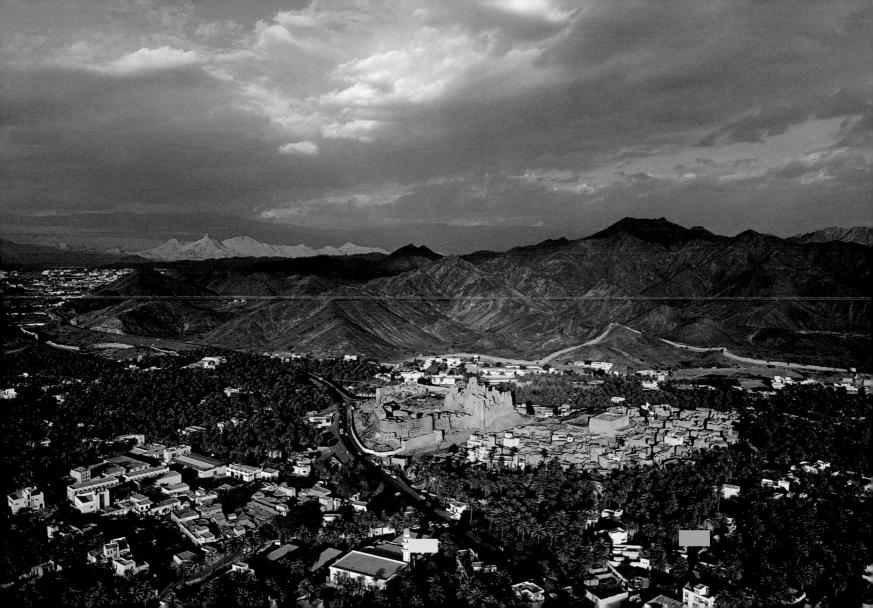

Drying rice in a village near Ihosy, Fianarantsoa, Madagascar (22°25′S - 46°08′E)

Agriculture is the principal economic activity in Madagascar; the gigantic island possesses 90 million acres (36 million hectares) of cultivable land, mostly producing rice and cereal crops. But the country's fertile land is mostly located in the central highland plains, in the vicinity of the city of Fiantarantsoa, and depends almost exclusively on irrigation. Only 31 percent of it is actually used, owing to the lack of water. Worldwide, irrigation supplies about 20 percent of land under cultivation, and 40 percent of the total food output depends on it. Because of the acute water shortages affecting so many countries, the world's security in terms of food now depends on improving irrigation techniques—and notably on the installation of drip systems, which can reduce the amount of water used by up to 70 percent. Another vital initiative must be intelligent selection of crops, based on those best adapted to local climate conditions—that is, crops that will require minimum watering for maximum yields.

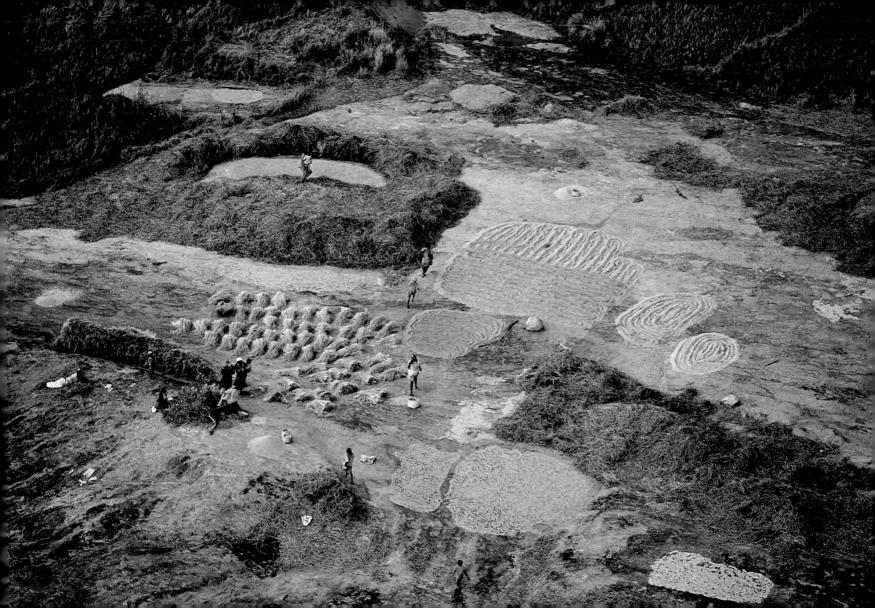

Waterhole near Tadjoura, Goda Mountains, Republic of Djibouti (11°55′N - 42°24′E)

The Republic of Diibouti is a poor country, with half a million inhabitants and chronically insufficient food resources. Over the last few years, it has seen a succession of severe drought, when what little rain there was proved insufficient and too erratic to replenish water holes or regenerate pastures. Indeed, in the northwest and southeast of this former French colony, nearly all the water holes have run dry. The nomads of the country's interior, as well as those of neighboring Somalia, Ethiopia, and Eritrea, have been forced to bring their sheep, goats. and camels down to the seacoast. The concentration of all these animals on the little remaining pastureland has quickly exhausted it; the herders have lost large numbers of animals, sometimes their entire stocks. Famine has now set in with a vengeance, and water shortages are even affecting human beings. The combination of climate conditions and the restrictions on movement between countries has obliged more and more nomads—who before the drought still represented 25 percent of the population—to abandon their traditional way of life. Today, 85 percent of them are sedentary. This means they have nothing, and are fully dependent on local or international food aid.

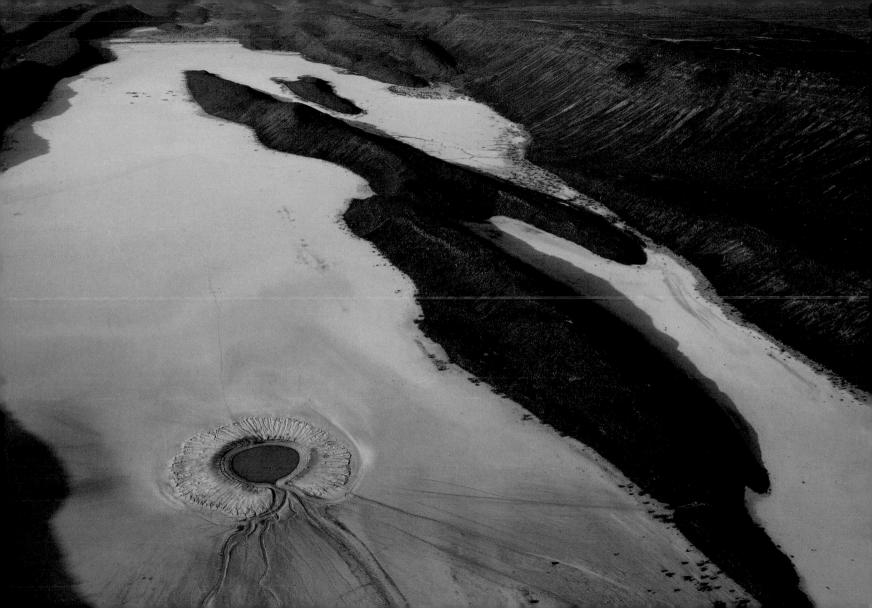

Remote cabin in Los Haitises National Park, Dominican Republic (19°03'N - 69°36'W)

The thick forest of mangroves and lianas, with its bamboos, orchids, and tree ferns, makes Los Haitises nearly impenetrable. The hills alternate with deep caves that form an extraordinary subterranean network about which little can be known, while a multitude of limestone islets with tufts of vegetation (called mogotes) are scattered around the Bay of Samana, which borders the park. This Caribbean bay is home to whales, sea turtles, and over 110 species of fish. But the Dominican Republic is confronted with a raft of problems that threaten its long-term development; population pressure, lack of drinking water and arable land, and the urgent need to generate income. All these pose a direct threat to the country's ecosystems. Already, a number of sublime ecological reserves have been transformed into tourist centers. Here, as in so many other parts of the world, biodiversity is in acute danger. In the last thirty years, the planet has lost 30 percent of its biodiversity, populations of temperate and tropical forests have declined by 12 percent, marine species by 35 percent, and freshwater species by more than 50 percent.

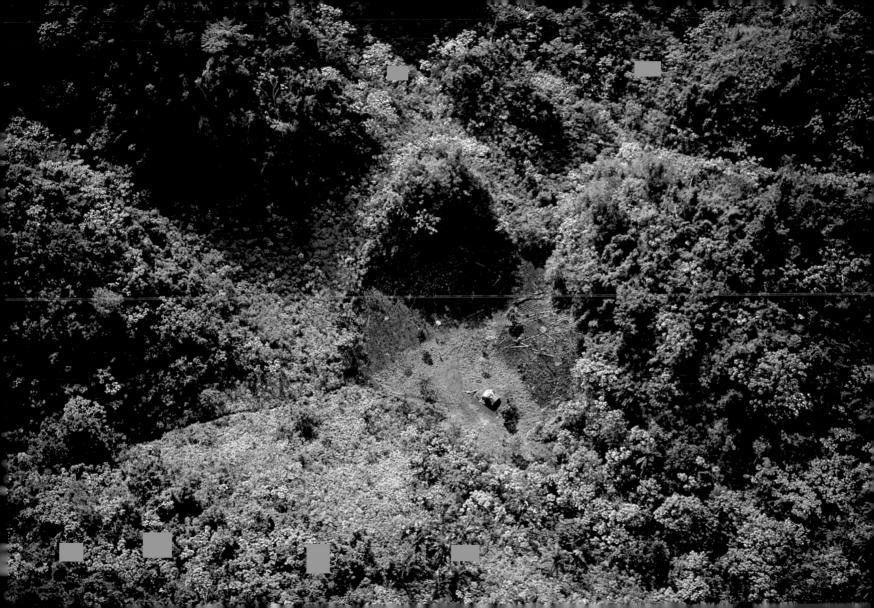

Salt pans of Guérande, Loire-Atlantique, France (47°20'N - 2° 25'W)

Guérande, from the Breton *Gwen Ran*, meaning "white country," has been a land of salt for more than a thousand years. Over the centuries, the people of the marshes, known as *paludiers*, have transformed the coastal mudflats into a salt-producing zone. This is a highly ecological development inasmuch as it uses nothing but the two natural elements of sunshine and seawater. Today the 12,000 acres (5,000 hectares) of salt marshes at Guérande are a "green lung" standing against the creeping concrete construction of the French Atlantic coast. Protected by a couple of organizations, they are valuable for many reasons, not least of which is their status as a refuge for vast numbers of native birds—in all, about 180 species, of which 6 are protected, among them egrets, spoonbills, and avocets. In what otherwise would be considered simply a production zone, the alliance of thoughtful human labor with the beauty of nature has fashioned a remarkable cultural landscape.

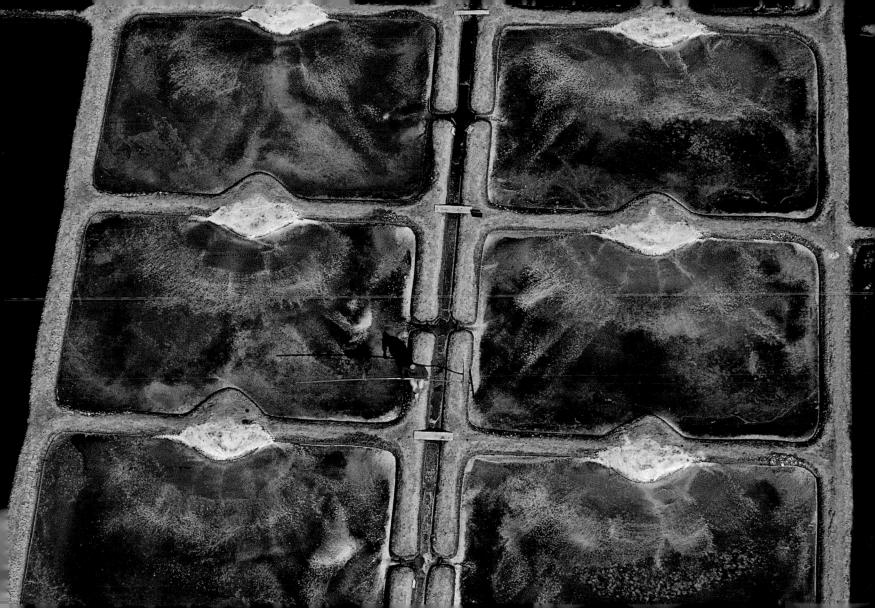

Field between the Dominican Republic frontier and Port-au-Prince, Haiti $(18^{\circ}31'N - 72^{\circ}06'W)$

Coffee in the mountains; cacao, cotton, indigo, sisal, and sugar cane in the plains—these crops, which have devoured the forest areas of Haiti, now supply the basis of its agricultural produce. And yet agriculture does not ensure sufficient revenues, and the food supply in Haiti remains a major concern. On this Caribbean island, which is a constant victim of drought and storms, the land is martyrized; rural overpopulation (74 percent of Haiti's 8 million people live in the countryside) is exhausting the soil, and there is a major erosion problem. This phenomenon is at work around the globe; forest clearing for agricultural purposes now threatens 20 percent of forested areas. In the world's developing countries, 800 million people suffer from hunger.

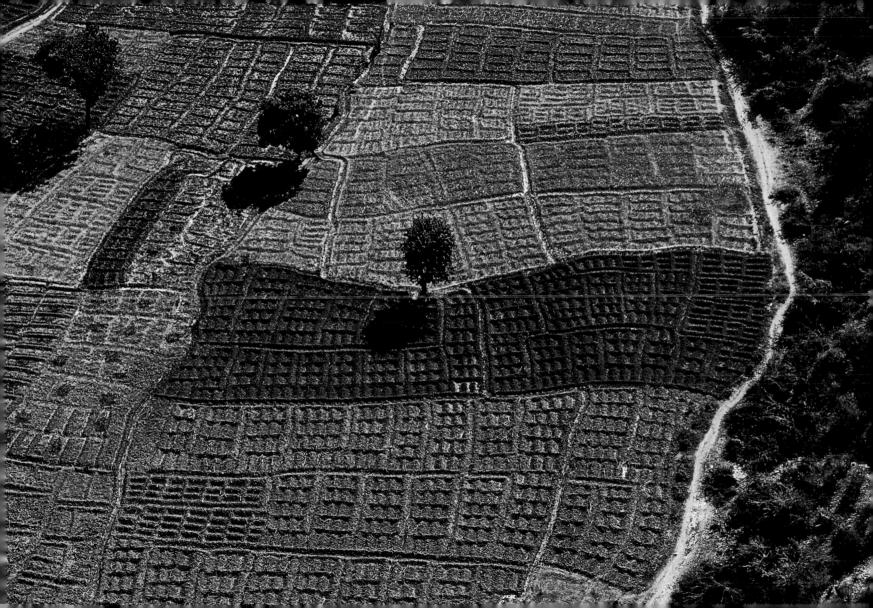

Cobes Lechwe in the Okavango Delta, Botswana (18°45'S - 22°45'E)

Two million years ago, the Okavango River joined the Limpopo and flowed on to the Indian Ocean, but faults created by intense tectonic activity have since diverted it from its initial course. The "river that never meets the sea" now flows no farther than Botswana, into a broad inner delta of 6,000 square miles (15,000 square kilometers) at the edge of the Kalahari Desert. This marshy labyrinth shelters some four hundred species of bird, ninety-five species of reptile and amphibian, seventy species of fish, and forty species of large mammal. Hidden among the clumps and islets of vegetation, which provide them with food and protection against predators, these *Cobes lechwe*, or marsh antelope, are abundant in the marshes of the Okavango Delta. Since 1996 this zone has been protected by the Ramsar Convention on Wetlands, which seeks to reconcile human, social, and economic activities with natural balances. These conventions encompass 1,650 sites of international importance.

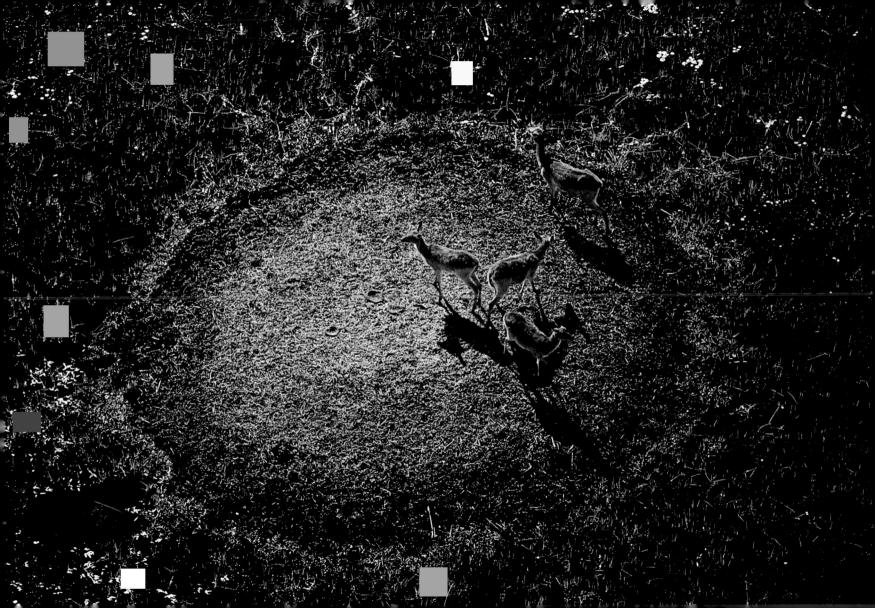

Loading cotton east of Odienné, Ivory Coast (9°31'N - 7°33'W)

The world's most widely cultivated variety of cotton is Gossypium hirsutum, a plant originating in the British Antilles. It was introduced into West Africa in the nineteenth century. At the beginning of the twentieth century, the European colonial powers encouraged the African production of cotton to counter the monopolies held by the United States and Egypt. At that time the raw material represented 80 percent of the world textile market—today that figure is 40 percent, on account of the development of synthetic fibers. The production and manufacture of cotton garments still employs 1 billion people on the planet, but since 1995, a fall in cotton prices has plunged a number of countries into crisis—especially in West Africa. The chemicals that are employed so heavily in the cultivation of cotton are extremely expensive; faced with producers' hardships, some governments are encouraging cotton growers to reduce the quantities of pesticides they use and to set up equitable commerce systems. This would assure them of better incomes and of working conditions more in conformity with international norms. Today, the growing of cotton accounts for one-quarter of the pesticides in use worldwide.

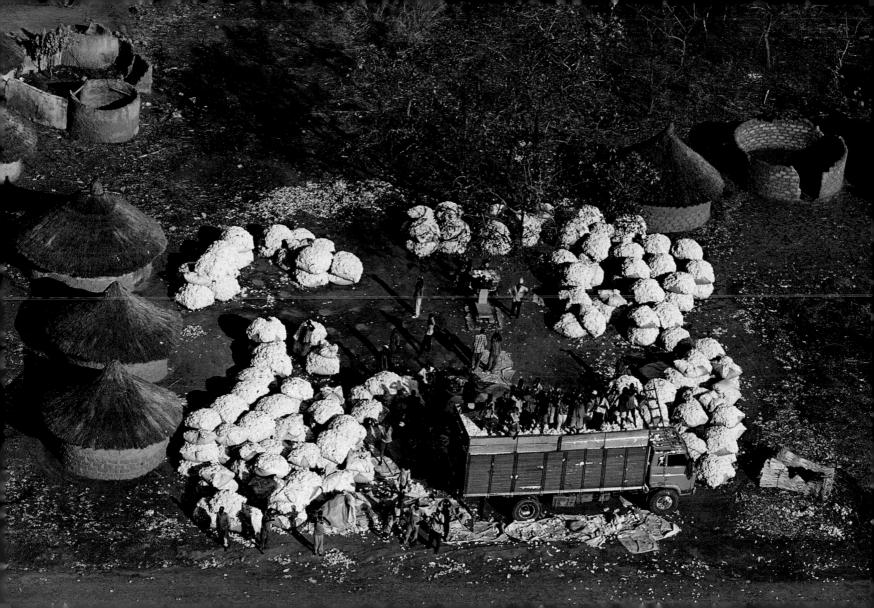

West Beacon, Taylor Valley, Dry Valleys, Antarctica (South Pole) (61°5′S - 161°00′E)

The extraordinary mineral landscape of Antarctica's Dry Valleys is covered in neither ice nor snow. Instead, katabatic winds from the pole sweep across it at over 186 miles (300 kilometers) per hour, preventing the snow from ever settling. The winds' force is such that they erode the rock and lay bare the sedimentary layers beneath it. The West Beacon Massif, which overlooks the frozen river of Taylor Glacier, seems to be made up of volcanic layers of black basalt (Ferrar dolerites is the geological term), which have infiltrated the ocher-colored sedimentary strata of the original rivers and lakes (the Beacon Supergroup). Arid and icy, this 6,000-square-mile (15,000-square-kilometer) polar desert is among the planet's most hostile environments. Even so, a few bacteria and single-cell life forms known as extremophiles have adapted to it. To protect this unique zone, which is also perfect terrain for research into the history of the planet and the adaptation of life to its various conditions, the Dry Valleys were decreed an Antarctic Specially Managed Area in 2004. The Americans and the New Zealanders, who maintain bases in the McMurdo region, share the responsibility for managing it.

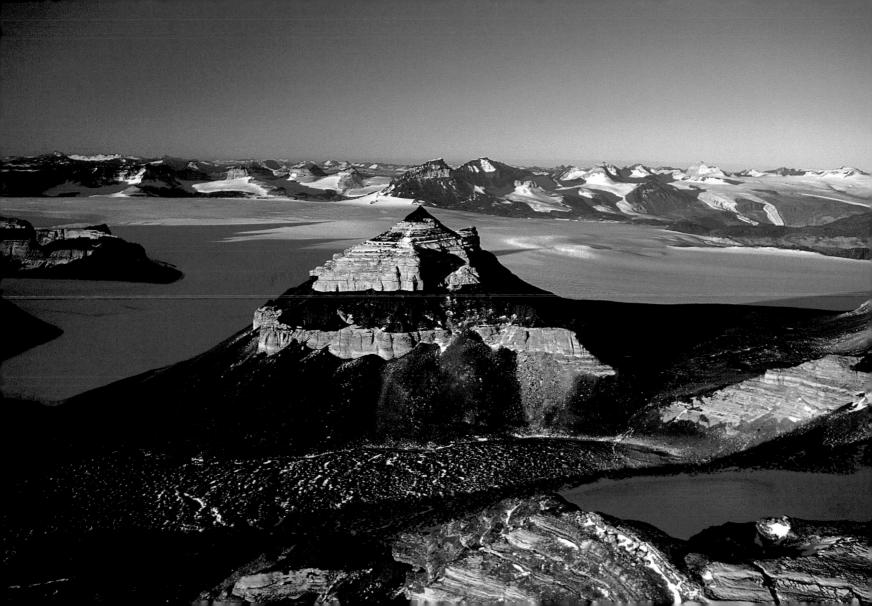

Tulip fields near Lisse, Amsterdam region, the Netherlands $(52^{\circ}15' \, \text{N} - 4^{\circ}37' \, \text{E})$

Each year in spring, the Dutch countryside puts on its multicolored livery. Since the first flowering in 1594, when the Austrian ambassador brought bulbs from the Ottoman Empire, four centuries of selection has produced more than eight hundred varieties of tulip. Around Lisse they are grown for their bulbs, which are later sold. On roughly 60,000 acres (23,500 hectares), the Netherlands provides 65 percent of the world's total flower-bulb output, some 10 billion bulbs in all. But this brilliant result has taken a heavy toll on the environment; during the 1990s the levels of pesticides used on these crops were among the highest in Europe. The authorities and the companies involved have now agreed on rules for the proper use of chemicals, waste products, and energy, imperatives that are spreading rapidly throughout the world. For example, in the French town of Rennes and in several Canadian cities, the use of chemical products in public gardens has been banned.

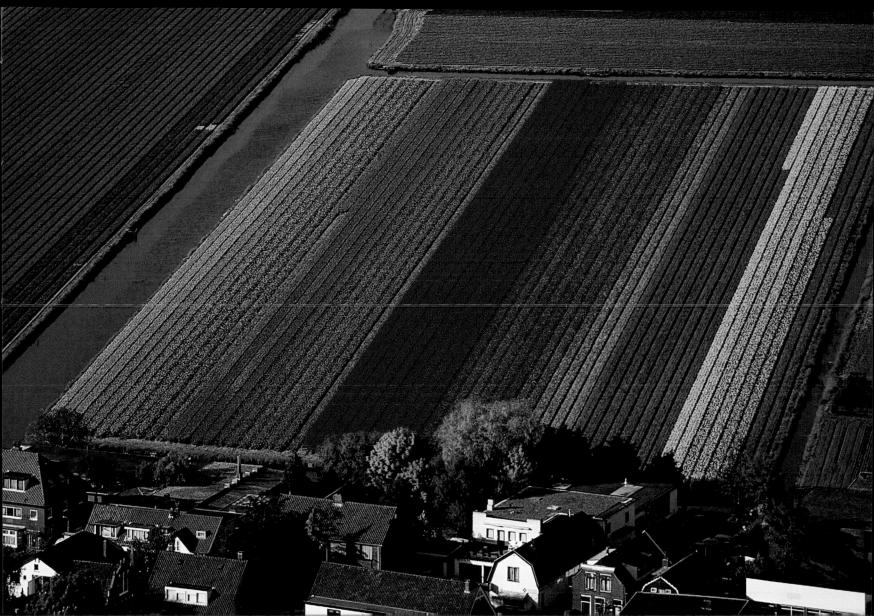

Farm on the Anta Plateau, Cuzco, Peru (13°29'S - 72°09'W)

The Cuzco region, in the bowl of a high-altitude valley, is one of the few Andean zones that favor agriculture. Subsistence production is focused on small farms, or *minifundios*, of about 5 acres (2 hectares). In a country where half the inhabitants live in poverty, agriculture provides a livelihood for a full third of the population. But with a price of \$1.40 per pound (\$3.10 per kilo), coca is by a distance the most profitable crop, and more than 50,000 families derive a substantial income from it. Although coca has long been confined to traditional uses locally, coca leaf cultivation has vastly increased since cocaine consumption began to rise in the United States during the 1970s. Peru became the world's second-largest producer; in 2007, coca covered 128,500 acres (52,000 hectares) of land—and 90 percent of that crop (52,500 tons in 2004) fed the illegal drug trade. Because finding other crops that would produce any kind of comparable revenue would be next to impossible, the reduction of illicit plantations will require major financial support.

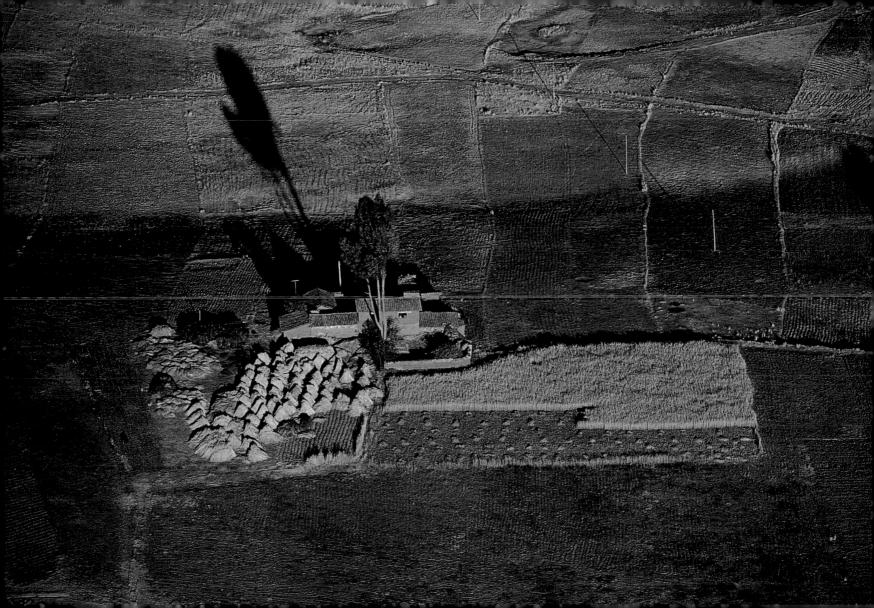

School at Clichy-sous-Bois, Seine-Saint-Denis, France (48°55′N - 2°33′E)

A children's slide, miniature road designs: the gaiety of this school yard belies the surrounding social gloom. It is built in a "priority education zone," a classification established by the French government to attenuate inequalities of opportunity in particular regions. All over France, the poorest people are being forced into ghettolike situations on account of the high price of housing. To halt this trend, national social integration programs have been in force since 2000; the aim was to address 20 percent of public housing in each commune, but by 2005, two hundred sizable towns had still done nothing. France has the second highest birth rate in Europe, but in 2006 it ranked only twelfth in Europe for expenditure on education; only 6.3 percent of gross national product was allotted to the sector. Nor is this state of affairs likely to improve anytime soon; in spring 2008 the government expected to cut 11,200 jobs in schools, colleges, and lycées, for a saving of about \$650 million (€500 million). At the same time, \$637 million (€490 million) extra was allotted to the national defense budget.

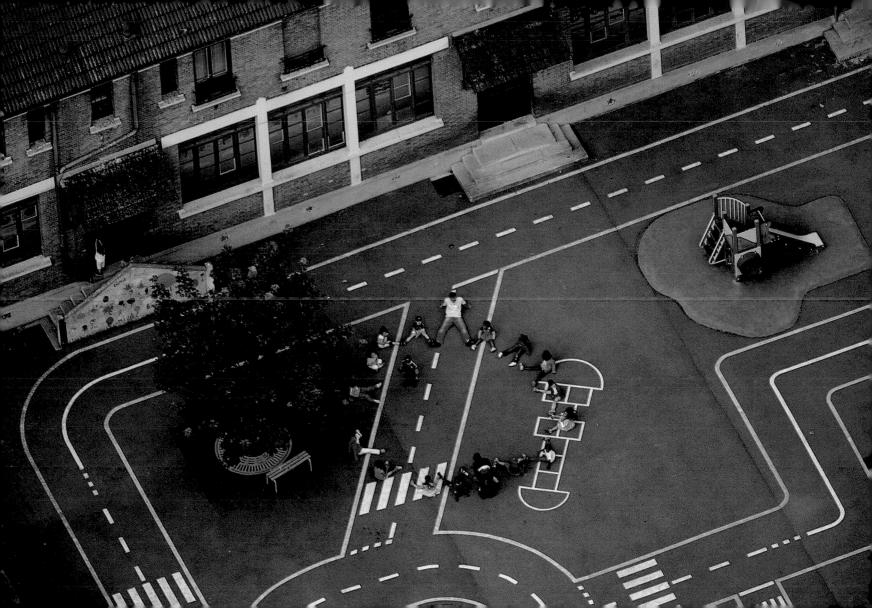

Masada, Judaean desert, Israel (31°18'N - 35°20'E)

Between 37 and 31 Bc, Masada—"fortress" in Hebrew—was built during the rule of Herod the Great on the western edge of the Judaean desert. *The War of the Jews*, by the historian Flavius Josephus, remains the only written source on its tragic history. In 66 AD, Flavius took part in a Jewish nationalist revolt against Rome. A few years later, after surrendering, he wrote a chronicle of the rebellion and in so doing turned Masada into a myth. Jerusalem fell to the Romans in 70 AD, but Masada held out for three years longer. It took 10,000 legionnaires to finally overcome the 967 Jewish Zealots besieged in the fortress; when all hope was gone, the rebels chose honor over life. The last defenders of the citadel drew lots to determine the unfortunate ten whose terrible duty it was to kill all of their comrades before committing suicide themselves. Recently, evidence has been discovered at archaeological sites that supports this story. In this highly symbolic place of Jewish resistance, cadets in the armed unit still take an oath in its honor: "Masada shall never fall again."

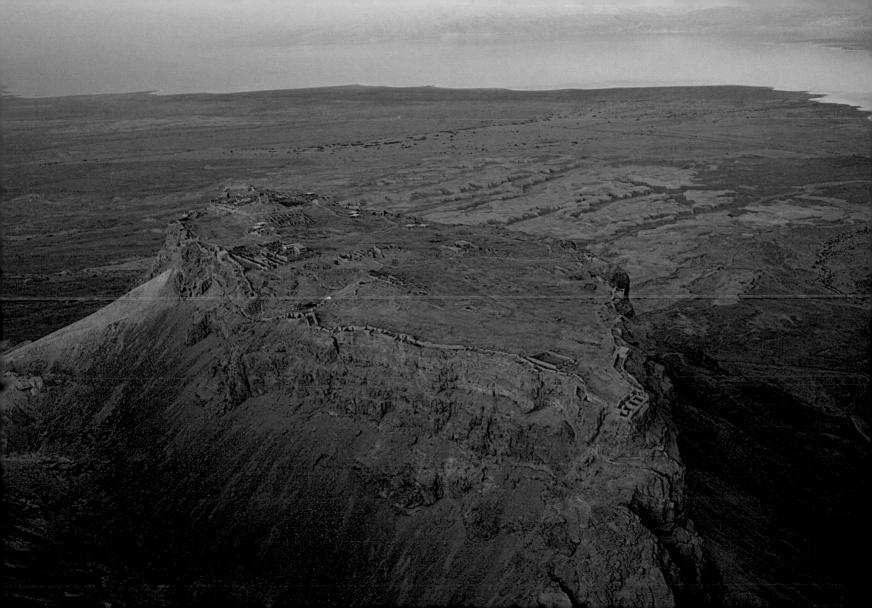

Hippos in Lake Naivasha, Kenya (0°44′S - 36°22′E)

Hippopotamus amphibius has a reputation as the most dangerous and unpredictable animal in Africa. Its relationship with humankind is fraught; hippos do not hesitate to attack fishermen's boats. On the other hand, hunters—and especially poachers—have massacred hippos in large numbers for food and for their valuable ivory tusks, principally in the Democratic Republic of the Congo. where 95 percent of hippos have been exterminated in the last fifteen years. Consequently, this symbolic African species has been classified since 2006 as one of the many animals and plants threatened with extinction—along with the polar bear, the Dana gazelle, and sundry ocean sharks, freshwater fish, and Mediterranean flowers. In all, of the roughly 40,000 animal and vegetable species listed in the World Conservation Union's "Red List of Threatened Species," 784 are officially extinct, 65 only exist in captivity or in artificial surroundings, and 16,119 are threatened with extinction—one amphibian in three, one conifer in four, and one bird in eight. And for 99 percent of these species, humans are the sole predator.

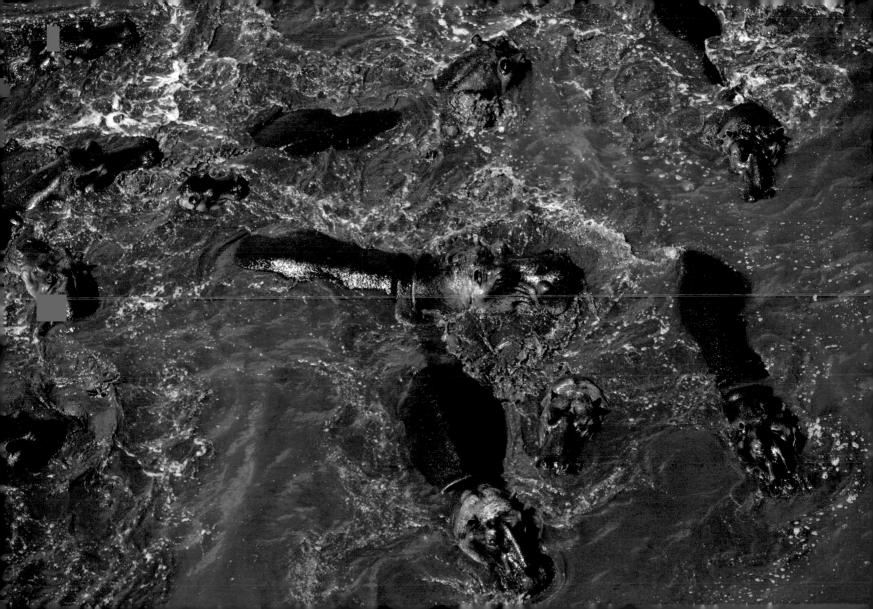

Village of Buk Peong, South Korea (34°40'N - 26°50'E)

Around the multicolored roofs of the village of Buk Peong stand rank upon rank of greenhouses. In this country, which is 95 percent mountainous, nearly all vegetables are grown in greenhouses. Like the rest of South Korea's economy, agriculture has been vastly modernized since the Second World War. During the 1970s, South Korea's per capita income was comparable to that of the poorest countries of Africa and Asia. Today, it is many times that of North Korea and equal to that of some of the European Union's economies (at eleventh in the world). But over the years South Korea's agriculture has shrunk economically, and today it survives largely thanks to government help. Farmers, as victims of growth and the globalization of the economy, are progressively leaving the countryside to live in shantytowns around the big cities.

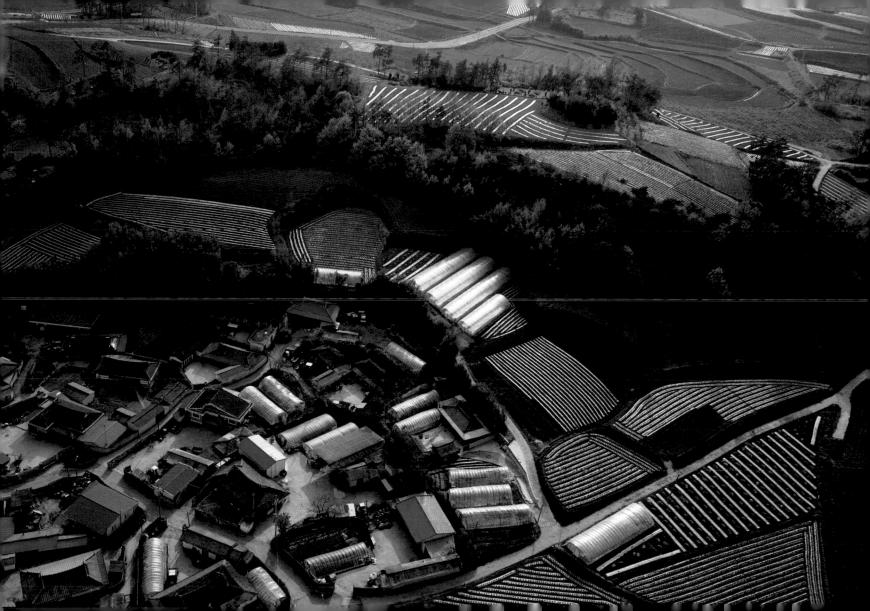

Tea plantations in the Kericho region, Kenya (0°20'S - 35°15'E)

Worldwide, tea production reached a record 3.6 million tons in 2006. In Kenya, the yield was 328,000 tons, less than India (345,000 tons) or China (1.05 million tons), but unlike those countries, Kenya only consumes 5 percent of the tea it produces, exporting the rest. The outbreak of ethnic violence that followed the 2007 presidential election—resulting in more than 1 million deaths and 600,000 displaced persons—decreased Kenya's tea production by 10 percent. Indeed. in 2004. Kenya was the world's largest net tea exporter, with 21 percent of the market, just ahead of Sri Lanka and China. Bringing in 215,000 tons (156,000 of those going to the United Kingdom alone), the European Union is the main importer of tea—outstripping Russia (at 172,000 tons). Pakistan (at 140,000 tons). the United States (at 99,000 tons), and Japan (at 56,000 tons). While tea consumption has remained steady in producing countries, it has continued to increase in nonproducing countries, where advertising campaigns ceaselessly ram home the message that tea is good for the health. For this reason, the price of tea has fallen to a much lesser degree than that of many other agricultural raw materials—by only 2 percent between 1993 and 2003, as compared to the price of cacao, which fell by 39 percent, and coffee, which fell by 38 percent.

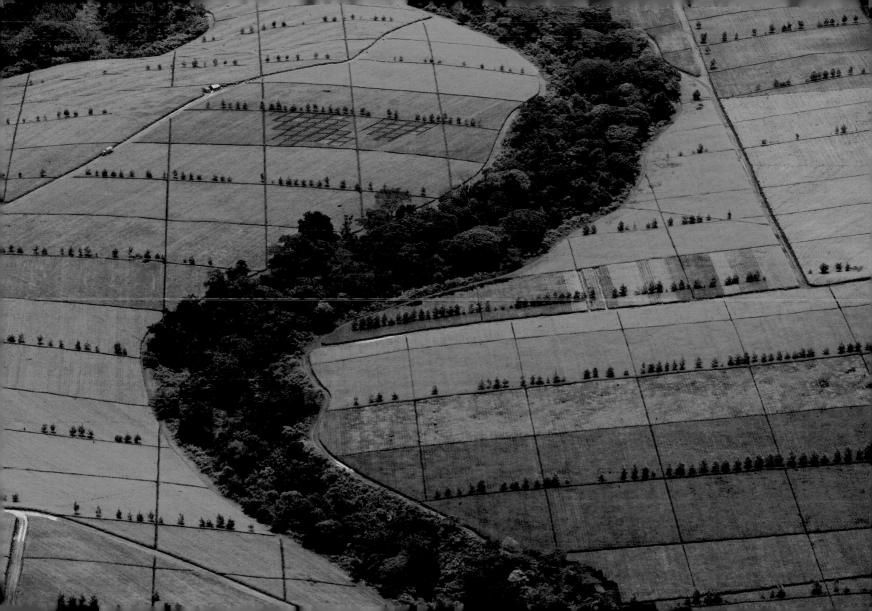

Peace Blanket: an installation by the artist Clara Halter, Jerusalem, Israel $(31^{\circ}6' N - 35^{\circ}14'E)$

Not far from the wall of separation constructed by the Israelis to cut off
Jerusalem from the rest of the West Bank, this 12,000-square-foot piece
(1,120-square-meter piece) of fabric was laid across the Abu Tor cliff, facing
Jerusalem, between May 17 and 25, 2006. It bore the word *peace* in ten languages.
Ever since Hamas won its majority in the Palestinian Parliament on January
26, 2006, the local situation has steadily worsened. The State of Israel and
the Palestinian National Authority mutually refuse to recognize one another's
legitimacy. The Israeli armed forces continue to bombard Gaza, while armed
Palestinian groups deliberately attack Israeli civilians, often using suicide bombers.
Between annexations, conflicts, and peace treaties, the frontiers in this region of
the Middle East have not ceased altering since the United Nations partitioned the
territory in 1947.

repeace peace peac tenfrieden frieden fri tacens na ens no en haris laris baris baris macen

A stamp of protest on a GM maize field, Grézet-Cavagnan, Lot-et-Garonne, France ($44^{\circ}23'N$ – $0^{\circ}07'E$)

Up until the day it was harvested, this maize field bore the mark of a cross in a circle, making it clear that the crop was genetically modified (GM). On July 27, 2006, Greenpeace activists marked the field in protest against a decision handed down by a French court that barred Greenpeace from posting the exact locations of GM crops on its Web site. But there was nothing to stop activists from "posting" the location on the spot. This symbolic action was a reminder that transparency on the growing of all GM crops is required under European law, which obliges communes and rural district administrations to declare any GM crops in their territory. In 2007, 54,360 acres (22,000 hectares) of MON810 maize (the only GM variety permitted at that time) were sown for livestock feed. In February 2008, in light of new scientific evidence highlighting the health risks posed by it, the cultivation of MON810 was outlawed.

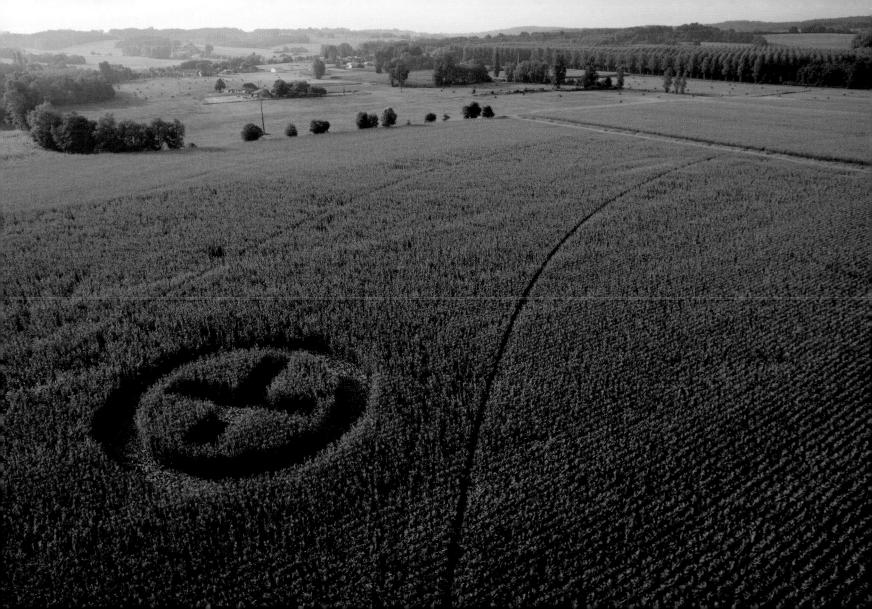

Recreation in a schoolyard at Hlatikulu, Shiselweni region, Swaziland (26°58'S - 31°19'E)

In a country where no newspapers or magazines are published in locally spoken languages, those children who actually go to school need to learn the two official languages—English and Swati—at the same time. School manuals exist in Swati up to the end of secondary school, but mastery of English is indispensable to anyone wishing to attend university. Swaziland's dependency on British investment capital and good commercial relations with South Africa impose the use of English; indeed the Swaziland Ministry of Education actively encourages the teaching of it, within an overall program of study that is based on the British system. School here has never been free of charge, and a child can only be admitted if tuition fees are paid up. While 80 percent of Swazi children are officially receiving an education, access to schools is sporadic at best. Many children are obliged to suspend their studies from time to time or even permanently, according to their parents' financial means. At least 70 percent of the 1.1 million inhabitants of Swaziland live below the poverty line, and nearly 35 percent of Swazi adults are HIV positive, the highest rate on the planet. Problems of school attendance seem to have increased in step with the pandemic. Life expectancy in Swaziland at birth is less than forty years, and according to UNICEF, 20,000 Swazi children a vear are orphaned because of AIDS.

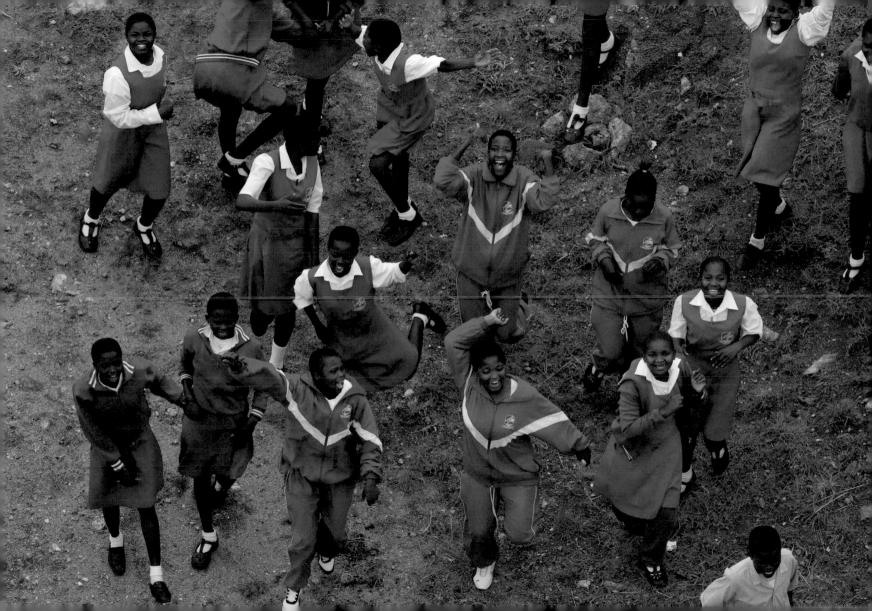

Message beside a heliport, New York, USA (40°42′N - 74°00′W)

Uxmal, the Mayan archaeological site in Yucatan, Mexico, is referenced in this unique marriage request on a New York rooftop. With over 301 million people (in 2007), the United States is the third-most-populous country on the planet (after China and India). While the population of France, for example, rose by 3.4 percent between 1990 and 2000, over the same period America's increased by 13.1 percent. At the start of the twenty-first century, America leads the world in the number of immigrants it takes in, with a net annual intake of 3.5 immigrants per 1,000 inhabitants. In 2002, 220,000 Mexicans legally immigrated to the United States; 250,000 immigrated illegally. According to the Pew Hispanic Center, in 2006 illegal immigrants numbered between 11.5 and 12 million, three-quarters of whom were from Latin America.

INDEX

Afghanistan January 6, April 28, September 16, December 11 Algeria March 3, March 16, March 22, April 6, April 20, June 3, June 21, August 6, August 9, September 12, October 25, November 19, November 28 Antarctica February 4, March 28, April 7, July 17, July 26,

September 8, September 22, October 11, December 20 **Argentina** January 10, February 14, February 23, June 5, August 5

Armenia July 4, August 19 Australia January 18, March 21 Austria June 22

Bangladesh June 1, November 11 Botswana February 27, September 30, December 18 Brazil January 3, January 16, March 15, April 16, May 5, May 31, August 3, October 7, November 9 Burkina Faso April 11

Canada January 14 Chad March 27, June 13, September 1, September 11, September 18, October 27, November 17, November 22 Chile March 14 Cyprus March 1, November 6

Denmark January 7 Djibouti, Republic of February 8, April 12, May 24, June 30, December 14 Dominican Republic February 9, April 5, May 6, May 11, May 13, May 30, June 26, September 13, November 1, December 15

Ecuador May 1 Egypt February 26, July 8, July 24, October 19, November 14

Finland August 4, October 2. November 2 France January 8, January 9, January 11, January 15, January 23, January 24, February 3, February 15, March 7, March 10, March 16, March 26, April 4, May 9, May 18, June 7, June 10, July 19, July 30, August 8, August 18, August 31, September 14. October 9. October 21, October 23, October 29, November 13, November 25, November 30, December 2. December 16. December 23, December 29

Germany February 11, April 22, May 21, July 6, September 24, October 5, October 18, November 15 Gibraltar August 10 Greece January 17, February 28, June 19, September 2, December 3

Grenada February 1 **Guatemala** March 19

Haiti June 17, September 25, December 17 Honduras May 25

Iceland January 2, April 8, May 17, August 12, October 28 India February 15, March 8, March 13, April 2, April 9, May 8, July 20, August 11, August 26, September 7, November 8 Indonesia June 11, November 18 Ireland July 15 Israel January 20, January 31, April 14, April 19, May 2, May 20, May 28, July 12, December 24, December 28 Italy January 29, March 4, June 27, September 9, October 15 Ivory Coast February 19, February 24, March 5, June 6, July 5, August 20, September 10, September 20, October 14, October 17, November 4, November 20, December 5, December 19

Japan August 17, October 1, November 23 Jordan January 21, June 16, September 21

Kenya January 12, March 12, March 20, March 30, April 18, May 29, December 25, December 27 Kuwait April 29, June 8, November 5

Kyrgyzstan April 17, April 27, June 9, June 12, June 20, July 21, August 24

Lebanon February 22, April 30, July 28, September 5 **Lithuania** September 17

Madagascar January 30, February 7, February 18, June 15, July 7, July 22, July 31, August 13, August 21, September 15, November 10, November 16, December 13 Mali July 14, August 23, October 12, December 6 Mauritania January 19, December 8 Mexico January 4, April 1, April 21, August 2, August 30, September 27, October 20,

November 21

Mongolia October 24 Morocco February 2

November 7 **Nepal** May 10, August 15 **Netherlands, The** February 25, December 21

Namibia February 16, April 24.

Nigeria May 26, July 1, August 25 Norway October 30 New Zealand March 9, May 27, November 27

Oman March 31, September 3, December 12

Palau July 16 Peru December 10, December 22 Poland July 23 Puerto Rico February 12, February 17, August 29

Qatar January 13, February 5, March 2, May 12, August 28, September 29

Senegal January 1, February 13, April 26, July 10, August 1, October 31

Singapore February 20 Somalia January 25 South Africa January 26, April 13, May 3, June 14, June 18, June 25, July 14, August 14, September 23, October 13, December 7 South Korea January 5,

October 13, December /
South Korea January 5,
January 27, February 6,
February 10, March 18, March 23,
April 3, April 23, May 16, May 19,
July 3, August 7, September 4,
October 3, October 22,
November 26, November 29,
December 26
Spain May 23, June 2, July 13,
November 24

Swaziland October 16

Sweden March 6, October 4

Switzerland March 25, June 4, July 9, July 25, August 22

Tajikistan May 4, July 18, October 10, December 1 Tanzania September 6 Thailand February 21, March 17, March 29, May 22, June 29, July 2, July 27, September 28 Tunisia October 6, December 30 Turkey March 11, May 7, May 14, June 24, July 29, August 16

United Arab Emirates June 23 United States January 22, March 24, June 28, July 11, August 27, September 19, October 26, November 3, November 12, December 31 Uruguay April 10, April 25, May 15, September 26

Vanuatu December 9 Venezuela October 8

Yemen January 28, April 15, December 4

ACKNOWLEDGMENTS

As we complete this final page, which brings back so many pleasant memories from the four corners of the world, there is an inevitable anxiety that some of the many people who have helped us to bring this project to fruition may have been forgotten. If so, we are profoundly sorry—and we extend our warmest gratitude both to them and to the many others who have contributed behind the scenes to our harebrained undertaking.

UNESCO: Mr. Federico Mayor, Director General, Mr. Pierre Lasserre, Director, Ecological Science DivIslon, Mmes Mireille Jardin, Jane Robertson, Josette Gainche and Mr. Malcolm Hadley, Mme Hélène Gosselin, Mr. Carlos Marquès, Mr. Oudatchine (Bureau of Public Information), Mr. Francesco di Castri and Mme Jeanne Barbière (Environment Coordination Bureau) and Mr. Gérard Huber, who supported our project within the framework of that organisation.

FUJIFILM: Mr. Masayuki Muneyuki, President, Messrs.Toshiyuki "Todd" Hirai, Minoru "Mick" Uranaka, of Fujifilm Tokyo, Mr. Peter Samwell of Fujifilm Europe and Mme Doris Goertz, Mme Develey, Messrs. Marc Héraud, François Rychelewski, Bruno Baudry, Hervé Chanaud, Franck Portelance, Piotr Fedorowicz and Mmes Françoise Moumaneix and Anissa Auger of Fujifilm France.

AIR FRANCE: Mr. François Brousse, Mme Christine Micouleau and Mmes Dominique Gimet, Mireille Queillé and Bodo Ravoninjatovo.

EUROCOPTER: Messrs. Jean-François Bigay, Xavier Poupardin, Serge Durand and Mme Guislaine Cambournac.

COOPI: Giacomo Franceschini.

AFGHANISTAN: French Embassy, Colonel Daniel Chambon; the forces of ISAF: General Ethem Erdagi, Commander of ISAF in Afghanistan, Commander Ozkan, head of the Turkish military helicopter detachment, ISAF, Commandant Volkan, Air Operations Officer ISAF, Daniel Massat-Bourrat of CCF Helmand, Sultan Ahamad Bahee, and the pilots of the Afghan Air Force: General Amir Djan, General Dawran, Mr. Loudin, Mr. Hamid Karzaï and Mr. Jaoued Loudin, Mr. Zaher Mohammed Azimi.

ALBANIA: ECPA, Lt-Colonel Aussavy, DICOD, Colonel Baptiste, Capitaine Maranzana and Capitaine Saint Léger SIRPA, Mr. Charles-Philippe d'Orléans, DETALAT, Capitaine Ludovic Janot; the French Air Force crews, Messrs. Etienne Hoff, Cyril Vasquèz, Olivier Ouakel, José Trouille, Frédéric Le Mouillour, François Dughin, Christian Abgral, Patrice Comerier, Guillaume Maury, Franck Noyak, pilots.

ALGERIA: President Abdel Aziz Bouteflika; the Ministère de l'Aménagement du territoire et de l'Environnement: M. le Ministre Chérif Rahmani, Mr. Mohamed Si Youcef, Mme Lylia Harchaoui, Mr. Farid Nezzar. All the Wilayas, Walis and Environmental Directors. French Embassy, Algiers: Mr. Anis Nacrour, Mr. Michel Pierre. Tassili Airlines: Mr. Mohamed Boucebci, Mr. Rachid Nouar. Pilot: Samir Rekibi

ANTARCTIC: Institut français pour la recherche and la technologie polaires; Mr. Gérard Jugie; The Astrolabe, capitaine Gérard R. Daudon, Sd capitaine Alain Gaston; Heli Union France, Mr. Bruno Fiorese, pilot; Messrs. Augusto Leri and Mario Zucchelli, Projetto Antartida, Italie Terra Nova. McMurdo US Air force Base, Raytheon: Ms. Elaine Hood, Ms. Karen Yusko, Ms. Melba Gabriel; National Science Foundation: Mr. Guy Guthridge, Pilots: Dustin and

Scott. Helicopter operations; Monika and Patrick. Mecanics: Bob, Ron, Bob and Steve. Helicopter supplies: Wendy.

ARGENTINE: Sr. Jean-Louis Larivière, Ediciones Larivière; Sras Mémé and Marina Larivière; Sr. Felipe C. Larivière; Sras Dudú von Thielman; Ms. Virginia Taylor of Fernández Beschtedt; Cdt Sergio Copertari, pilot, Emilio Yañez and Pedro Diamante, co-pilots, Eduardo Benítez, mecanic; Federal Pulice Air Squadron, Sr Norberto Edgardo; Gaudiero Capt. Roberto A. Ulloa, former governor of Salta province; Police HQ, Orán, province of Salta, Cdt Daniel D. Pérez; Military Geographique Institute; Sr Rodolfo E. Pantanali; Aerolineas Argentinas; Argentina Tourist Office, France; Helisul Taxi Aéro Ltda.

ARMENIA: Michel Pazoumian Léon Bagdassarian of SABERATOURS. Embassy of Armenia, France, especially HE Edward Nalbandian and Ruben Kharazian. Embassy of France in Armenia, HE. Henri Cuny, Ambassador, Mr.Gérard Martin, co-operation attaché. The Armenian Development Agency and Arthur Babayan. The Armenian ministry of foreign affairs, especially Shahen Avakian and Hamlet Gasparian; Christophe Kebabdijan and Max Siyaslian.

AUSTRALIA: Mrs Helen Hiscocks; Australian Tourism Commission, Ms. Kate Kenward, Ms. Gemma Tisdell, and Mr. Paul Gauger; Jairow Heliconters; Heliwork, Mr. Simon Eders; Thaï Airways, Mme Pascale Baret; The Club Meds of Lindeman Island and Byron Bay Beach.

AUSTRIA: Hans Ostler, pilot.

BAHAMAS: The Club Meds of Eleuthera, Paradise Island and Columbus Isle.

BANGLADESH: Mr. Hossain Kommol and Mr. Salahuddin Akbar, external publicity

wing, ministry of foreign affairs, HEr Tufail.K. Haider, Ambassador of Bangladesh, Paris and Mr. Chowdhury Ikthiar, first secretary, HEmc Renée Veyret, French Ambassador in Dacca, Messrs. Mohamed Ali and Amjad Hussain of Biman Bangladesh Airlines and Vishawjeet, Mr. Nakada, Fujifilm Singapour, Mr. Ezaher of the Fujifilm laboratory, Dacca, Mr. Mizanur Rahman, director, Rune Karlsson, pilot and J. Eldon Gamble, technician, MAF Air Support, Mrs. Muhiuddin Rashida, Sheraton Hotel of Dacca, Mr. Minto.

BELGIUM: Thierry Soumagne, Wim Robberechts, Daniel Maniquet, Bernard Séguy, pilot.

BOTSWANA: Mr. Maas Müller, Chobe Helicopter; Mr. Frédéric BERARD, Cooperation Attaché, French Embassy.

BRAZIL: Governo do Mato Grosso do Norte e do Sul; Fundação Pantanal, Mr. Erasmo Machado Filho and les Parcs naturels régionaux of France, Messrs. Emmanuel Thévenin and Jean-Luc Sadorge; Mr. Fernando Lemos; HE. Pedreira, Brazil's Ambassador to UNESCO; Dr Iracema Alencar of Gueiros, Instituto de Proteção Ambiental do Amazonas and his son Alexandro; Tourist Office, Brasilia; Mr. Luis Carlos Burti, Burti publications; Mr. Carlos Marquès, UNESCO OPI Division; Ms. Ethel Leon, Anthea Communication; TV Globo; Golden Cross, Mr. José Augusto Wanderley and Mrs Juliana Marquès, Ilôtel Tropical, Manaus, VARIG; Mauricio Copetti.

BURKINA FASO: Jean Leclerc, Hôtel Canne à Sucre, Banfora; Commandant Marie-Yvonne Magnan Cessna pilot.

CAMEROON: HE Jacques Courbin, French Ambassador to Chad, Yann Apert, cultural attaché, Sandra Chevalier-Lecadre and the French Embassy in Chad; Lael Weyenberg and "A Day in the Life of Africa" Thierry Miaillier of RJM aviation, Jean-Marie Six and Aviation Sans Frontières, Bruno Callabat and Guy Bardet; pilot, Gérard Roso.

CANADA: Ms. Anne Zobenbuhler, Canadian Embassy in Paris; Tourist Office, Mme Barbara di Stefano and Mr. Laurent Beunier, Destination Québec; Mme Cherry Kemp Kinnear, Nunavut Tourist Office; Mmes Huguette Parent and Chrystiane Galland, Air France; First Air; Vacances Air Transat; André Buteau, pilot, Essor Helicopters; Louis Drapeau, Canadian Helicopters; Canadian Airlines.

CHAD: HE Jacques Courbin, French Ambassador to Chad, Yann Apert, cultural attaché, Sandra Chevalier-Lecadre and the services of the French Embassy in Tchad; Lael Weyenberg and "A Day in the Life of Africa" Thierry Miaillier of RJM aviation, Jean-Marie Six and Aviation Sans Frontières, Bruno Callabat and Guy Bardet, pilots, Gérard Roso, colonel Kalibou Aviation Sans Frontière: Jean-Claude Gérin Bruno Callabat Thierry Miailler.

CHILE: Véronica Besnier, Luis Weinstein, Jean-Edouard Drouault d'Eurocopter Chilli, Capitan Fernando Perez of Aviación del Ejército de Chile, Capitan Carlos Lopez, pilot, Capitan Patricio Gallo, director of operations, Eurocopter Chili, Capitan Carlos Ruiz, pilot Capitan Gonzalo Maturana, co-pilot, Capitan Yerko Woldarski, pilot Capitan Hernán Soruco, co-pilot and corporal David Espinoza; SE Elisabeth Beton Delegue, Ambassador of France; La Marine française, especially the Prairial and SIRPA Marine.

CHINA: Office of Tourism, Hong Kong, Mr. Iskaros; Embassy of China, Paris, HEr Caifangbo, Mme Li Belfen; Embassy of France, Beijing, HE. Pierre Morel, French Ambassador to Beijing; Mr. Shi Guangeng of the Foreign Ministry, Mr. Serge Nègre, Mr. Yan Layma.

CROATIA: Franck Arrestier, pilot.

CYPRUS: Mme Sylvie Hartmann, Mr. Michel Morisseau; The Cyprus Police: Mr. Mario Mbouras (pilot).

DENMARK: Weldon Owen Publishing, the entire production staff of "Over Europe"; Stine Norden; Rémy Marion, Pôles d'Images.

DJIBOUTI, REPUBLIC OF: Mr. Ismaïl Omar Guelleh, president of the republic; Mr. Osman Ahmed Moussa, minister of presidential affairs; Mr. Fathi Ahmed Houssein, divisional general and head of the armed forces; Mr. Hassan Said Khaireh, military chef de cabinet; Mme Mouna Musong, presidential counsel; National Tourist Office of Djibouti; Thierry Marrill, of Etablissements Marrill, pilot.

DOMINICAN REPUBLIC: HE Jean-Claude Moyret, French Ambassador, Dominique Dollone (cultural attaché); Marianne of Tolentino: Nestor Acosta (pilot).

ECUADOR: Messrs. Loup Langton and Pablo Corral Vega, Descubriendo Ecuador; Mr. Claude Lara, Ecuadorian foreign ministry; Mr. Galarza, Ecuadoran consulate, France; Messrs. Eliecer Cruz, Diego Bouilla, Robert Bensted-Smith, Galapagos National Park; Patrizia Schrank, Jennifer Stone, « European Friends of Galapagos »; Mr. Danilo Matamoros, Jaime and Cesar, Taxi Aero Interslas Mr. T.B.; Mr. Etienne Moine, Latitude O°; Mr. Abdon Guerrero, San Cristobal airport.

EGYPT: Rallye des Pharaons, "Fenouil," organiser, Messrs. Bernard Seguy, Michel Beaujard and Christian Thévenet, pilots; the teams of the Paris-Dakar rally, 2003, and Etienne Lavigne of ASO.

FINLAND: Satu Kahila; Stine Norden; Dick Lindholm, pilot.

FRANCE: Mme Dominique Voynet, ministre de l'Aménagement du territoire et de l'Environnement; ministère de la Défense/SIRPA; Préfecture de Police de Paris, Mr. Philippe Massoni, Mr. Michel Gaudin, Mr. Henri d'Abzac, Mr. Christian Lambert, Mme Raymonde Colin and Mme Seltzer; Skycam Hélicoptères, Messrs. Franck Arrestier and Alexandre Antunès, pilots; Hélifrance, Charles Aguettant; Trans Hélicoptères Service, Dominique Moreau; Comité départemental du tourisme

d'Auvergne, Mme Cécile da Costa; Conseil General des Côtes-d'Armor, Messrs, Charles Josselin and Gilles Pellan; Conseil General de Savoie, Mr. Jean-Marc Evsserick; Conseil General de Haute-Savoie, Messrs, Georges Pacquetet and Laurent Guette; Conseil General des Alpes-Maritimes, Mmes Sylvie Grosgojeat and Cécile Alziary; Conseil General des Yvelines, Mr. Franck Borotra. president, Mme Christine Boutin, Mr. Pascal Angenault and Mme Odile Roussillon; CDT des départements de la Loire; Rémy Martin, Mme Dominique Hériard-Dubreuil: Mme Nicole Bru. Mme Jacqueline Alexandre: Mr. Philippe Pierrelee, Hachette, Mr. Jean Arcache: Moët and Chandon/Rallye GTO, Messrs, Jean Berchon and Philippe des Roys du Roure: Printemps de Cahors, Mme Marie-Thérèse Perrin; Mr. Philippe van Montagu and Willy Gouere, pilot SAF helicopters; Mr. Christophe Rosset, Hélifrance, Héli-Union, Furope Helicoptère Bretagne, Héli Bretagne, Héli-Océan, Héli Rhône-Alpes, Hélicos Légers Services, Figari Aviation, Aéro service. Héli air Monaco, Héli Perpignan, Ponair, Héliinter. Héli Est: La Réunion: Office du tourisme of La Réunion, Mr. René Barrieu and Mme Michèle Bernard; Mr. Jean-Marie Lavèvre, pilot, Hélicoptères Helilagon; Nouvelle-Calédonie: Aline Marteaud and Rebecca Rocklin, Mr. Charles de Montesquieu, Daniel Pelleau and Alain Queval of Hélicocéan and Bruno Civet of Héli Tourisme, Henri Maniguant: Antilles: the Club Meds of Les Boucaniers and la Caravelle: Mr. Alain Fanchette, pilot; Polynesia: the Club Med of Moorea: Haute-Garonne: Carole Schiff; Lyon and region: Béatrice Shawannn, Christophe Schereich, Daniel Pujol (Pilot, Saône flooding, Taponas); Camargue: François Duplenne of Trans Hélicoptères Services and Jacques Ripert of Hélitec; Pyrénées-atlantiques: DICOD and SIRPA: Corsica: Jacques Guillard (publisher) Marie-Joseph Arrighi-Landini (journalist) Jean Harixcalde (photographer) Gilbert Giacometti (pilot), Office du Tourisme de Corse: Xavier Olivieri: Toulon: Amiral Jean-Louis Battet, Chef d'État-major of the Marine nationale, La Marine nationale, Région maritime Méditerranée, bureau de communication régionale: Capitaine de Corvette Antoine Goulley, La préfecture

maritime de Méditerranée: Vice-amiral d'escadre Jean-Marie Huffel, Maître David Hourrier, Enseigne de Vaisseau Rousselet Direction générale de l'armement, Centre d'essais des Landes et de la Méditerranée: Mr. Pierre Lussevran, Mr. Jacques Pertois Cristina and Jean-Charles de Vogüé, Yann Negro, directeur de cabinet de la préfecture de Meurthe-and-Moselle François Charritat, direction des opérations aéroportuaires de Paris/Roissy and Louis Hirribaren, chef du contrôle du service circulation Patrick Gaulois, Maire du Mont-Saint-Michel, Jean-Philippe Setbon, sous-préfet de Saint-Malo, Bernadette Malgorn, préfet de la région Bretagne, Véronique Nael, Bureau des libertés publiques et des réglementations de la préfecture de la Manche. Philippe Martel, Commissaire à l'aménagement du domaine de Chambord, Monsieur Petitjean, Conservateur du Château of Chenonceau. Claude Dilain, mayor of Clichy-sous-Bois, and Jérôme Bouvier organizer of "Clichy sans clichés": Richard Sarrazy, Antoine de Marsily, Francis Coz, Bernard Séguy, Gustave Nicolas, Michel Beaujard, Dominique Cortesi, Alain Morlat, Serge Rosset, Michel Anglade, Daniel Manoury, Thierry Debruyère, Gilbert Giacometti, Raphaël Leservot, Jean Roussot and Jean-Luc Scaillierez, helicopter pilots; French Guiana: Mr. Nicolas Sarkozy, then Minister of the Interior, and his chef de cabinet Laurent Solly. Eric Hansen, naturalist and ornithologist. Didier Aubry, pilot of HDS Guyane.

GERMANY: Peter Becker, pilot Ruth Eichhorn, Geneviève Teegler and the entire staff of GEO Germany; Wolfgang Mueller-Pietralla of Autostadt; Frank Müller-May and Tom Jacobi of *Stern* Magazine.

GIBRALTAR: David Durie, Gouvernor of Gibraltar; John WOODRUFFE of the Governor's office, Colonel Purdom, Lieutenant Brian Phillips, Béatrice Quentin, Peggy Pere, Franck Arrestier, pilot, Jérôme Marx, mechanic.

GREECE: Ministry of Culture, Athens, Mme Eleni Méthodiou, Greek delegation to UNESCO; the Greek Tourist Office; the Club Meds of Corfou Ipsos, Gregolimano, Hélios Corfou, Kos and Olympia; Olympic Airways; Interjet, Messrs. Dimitrios Prokopis and Konstantinos Tsigkas, pilots and Kimon Daniilidis; Meteo Center, Athens; HE Christophe Farnaud, French Ambassador, and Frédéric Bereyziat, councilor.

GUATEMALA & HONDURAS: Sres. Giovanni Herrera, director and Carlos Llarena, pilot, Aerofoto, Guatemala City; Sr. Rafael Sagastume, STP villas, Guatemala City.

HAITI: HE Jean-Claude Moyret, French Ambassador in Santo Domingo, Marianne de Tolentino, French Embassy in Santo Domingo.

HUNGARY: The staff of the French Embassy in Budapest; the Mayor of Budapest. The Institut français of Budapest.

ICELAND: Messrs. Bergur Gislasson and Gisli Guestsson, Icephoto Thyrluthjonustan Helicopters; Mr. Peter Samwell; National Tourist Office. Paris.

INDIA: The Indian Embassy in Paris, HE Kanwal Sibal, Ambassador, Mr. Rahul Chhabra, First Secretary, MSK Sofat, Air Marshal, Mr. Lal, Mr. Kadyan and Mme Vivianne Tourtet; Ministry of Foreign Affairs, Messrs. Teki E. Prasad and Manjish Grover; MNK Singh of the Prime Minister's office; Mr. Chidambaram, member of parliament; Air Headquarters, SI Kumaran, Mr. Pande; Mandoza Air Charters, Mr. Atul Jaidka Indian International Airways, Cpt Sangha Pritvipalh; Embassy of France in New Delhi, HE Claude Blanchemaison, Ambassador of France to New Delhi, Mr. François Xavier Reymond, First Secretary.

INDONESIA: Total Balikpapan, Mr. Ananda Idris and Mme Ilha Sutrisno: Mr. and Mme Didier Millet; Force Navales Françaises: Amiral Jean-Louis Battet, chef d'État-major de la Marine nationale; Anne Culler, capitaine de frégate; the crew of the helicopter carrier Jeanne d'Arc and Capitaine de vaisseau Marc de Briançon. The pilotes of ALAT (Aviation Légère de l'Armée of Terre); Chanee, Kalaweit Program.

IRELAND: Aer Lingus; National Tourist Office of Ireland; Capt. David Courtney, Irish Rescue Helicopters; Mr. David Hayes, Westair Aviation Ltd.

ISRAEL: Edna Degon, Orly Shavit Yuval, Mr. Dan Oryan of the Israeli foreign ministry; Raphael Brin and Boaz Peleg, pilot.

ITALY: French Embassy in Rome, Mr. Michel Benard, press office; Heli Frioula, Messrs. Greco Gianfranco, Fanzin Stefano and Godicio Pierino; Diego Cammarata, mayor of Palermo.

IVORY COAST: Vitrail & Architecture; Mr. Pierre Fakhoury; Mr. Hugues Moreau and pilots Jean-Pierre Artifoni and Philippe Nallet, Ivoire Hélicoptères; Mme Patricia Kriton and Mr. Kesada, Air Afrique.

JAPAN: Eu Japan Festival, Messrs. Shuji Kogi and Robert Delpire; Masako Sakata, IPJ; NHK TV; Japan Broadcasting Corp.; the Asahi Shimbun press group, Mr. Teizo Umezu.

JORDAN: Mme Sharaf, Messrs. Anis Mouasher, Khaled Irani and Khaldoun Kiwan, Royal Society for Conservation of Nature; the Jordanian Royal Air Force; Mr. Riad Sawalha, Royal Jordanian Regency Palace Hotel; HE Dina Kawar, Ambassador of Jordan in France; Samir and Saadi, pilots.

KAZAKHSTAN: HE Nourlan Danenov, Kazakh Ambassador to Paris; HE Alain Richard, French Ambassador to Almaty, and Mme Josette Floch; professor René Letolle; Heli Asia Air and their pilot Mr. Anouar.

KENYA: Universal Safari Tours of Nairobi, Mr. Patrix Duffar; Transsafari, Mr. Irvin Rozental Canon Europe: Mr. Ian Lopez, (manager of Canon Europa's Pro Imaging Department) Mr. Andrew Boag (directeur of communications, Canon Europe) Mme Adelina Marghidan; Alexis Pelletier, pilot, and André Saint-Germès; Everett aviation: Simon Everett (manager), Chris J. Stewart (pilot) and Seigui (pilot); Michel Toulouse Laplace.

KUWAIT: Kuwait Centre for Research & Studies, Pr Abdullah Al Ghunaim, Dr Youssef; Kuwait National Commission for UNESCO, Sulaiman Al Onaiz; Kuwaiti Delegation to UNESCO, SE Dr Al Salem, and Mr. Al Baghly; Kuwait Air Force, Squadron 32, Major Hussein Al-Mane, Capt. Emad Al-Momen; Kuwait Airways, Mr. Al Nafisy.

KYRGYZSTAN: Mr. René Cagnat, Mlle Jacqueline Ripart

LEBANON: Lucien George Georges Salem. Members of the Lebanese armed forces.

LITHUANIA: The Lithuanian frontier guards; Mme Neria Lejay, Hili Flights: Mr. Alguis.

LUXEMBURG: Bernard Séguy, pilot.

MADAGASCAR: Messrs. Riaz Barday and Normand Dicaire, pilot, Aéromarine; Sonja and Thierry Ranarivelo, Mr. Yersin Racerlyn, pilot, Madagascar Hélicoptère; Mr. Jeff Guidez and Lisbeth.

MALAYSIA: Club Med, Cherating.

MALDIVES: Club Med, Faru.

MALI: TSO, Paris-Dakar Rally, Mr. Hubert Auriol; Messrs. Daniel Legrand, Arpèges Conseil and Daniel Bouet, Cessna pilot; Mohamed Isselmou; Commander Marie-Yvonne MAGNAN, Cessna pilot.

MAURITANIA: TSO, Paris-Dakar Rally, Mr. Hubert Auriol; Messrs. Daniel Legrand, (Arpèges Conseil) and Daniel Bouet, Cessna pilot; Mr. Sidi Ould Kleib; Elyval Daoud; Commander Marie-Yvonne Magnan, Cessna pilot.

MEXICO: The Club Meds of Cancun, Sonora Bay, Huatulco and Ixtapa.

MONGOLIA: S.E.Mr. Jacques-Olivier Manent, French Ambassador to Mongolia, S.E.Mr. Louzan Gotovddorjiin, Mongolian Ambassador to France, Tuya of Mongolie Voyages. Members of the Mongolian armed forces. MOROCCO: Gendarmerie royale marocaine, General El Kadiri and Colonel Hamid Laanigri; Mr. François de Grosrouvre.

NAMIBIA: Ministry of Fisheries; French Cooperation Mission, Mr. Jean-Pierre Lahaye, Mme Nicole Weill, Mr. Laurent Billet and Jean Paul Namibian; Tourist Friend, Mr. Almut Steinmester.

NEPAL: The Nepal Embassy in Paris; Terres d'Aventure, Mr. Patrick Oudin; Great Himalayan Adventures, Mr. Ashok Basnyet: Royal Nepal Airways, Mr.JB Rana; Mandala Trekking, Mr. Jérôme Edou, Bhuda Air; Maison de la Chine, Mmes Patricia Tartour-Jonathan, directrice, Colette Vaquier and Γabienne Leriche; Mmes Marina Tymen and Miranda Ford, Cathay Pacific.

NETHERLANDS: Paris-Match; Mr. Franck Arrestier, pilot.

NIGER: TSO, Paris-Dakar Rally, Mr. Hubert Auriol; Messrs. Daniel Legrand, (Arpèges Conseil) and Daniel Bouet, Cessna pilot.

NORWAY: Airlift AS, Messrs. Ted Juliussen, pilot, Henry Hogi, Arvid Auganaes and Nils Myklebust.

OMAN: SM Sultan Quabous ben Saïd al-Saïd; Ministry of Defence, Mr. John Miller; Villa d'Alésia, Mr. William Perkins and Mme Isabelle de Larrocha.

PERU: Dr Maria Reiche and Ana Maria Cogorno-Reiche; Ministerio de relaciones Exteriores, Mr. Juan Manuel Tirado; Policía nacional del Perú: Faucett Airlines. Mme Cecilia Raffo and Mr. Alfredo Barnechea; Mr. Eduardo Corrales, Aero Condor.

PHILIPPINES: Filipino Air Force; "Seven Days in the Philippines," Millet publishers, Ms. Jill Laidlaw

PORTUGAL: The Club Med of Da Balaia; Ana Pessoa and ICEP HeliPortugal and Mme Margarida Simplício, IPPAR.

PRINCIPALITY OF MONACO: HH Prince Albert of Monaco, Colonel Lambelin, Colonel Jouan Catherine Alestchenkoff of the Grimaldi Forum; Patrick Lainé, pilot.

PUERTO RICO: Mr. William Miranda Marin, mayor of Caguas; Jim Cruz, Operations Director, Caribbean Heli-jets; and Ruth Lopez.

QATAR: Qatar Fondation: Mr. Saeed Salem Al-Eida. The pilots of Gulf Helicopters.

RUSSIA: Mr. Yuri Vorobiov, vice-minister and Mr. Brachnikov, Emerkom; Mr. Nicolaï Alexiy Timochenko, Emerkom, in Kamtchatka; Mr. Valery Blatov, Russian delegation to UNESCO.

SAINT-VINCENT & AND THE GRENADINES: Mr. Paul Gravel, SVG Air; Mme Jeanette Cadet, The Mustique Company; David Linley; Mr. Ali Mediahed, baker; Mr. Alain Fanchette.

SENEGAL: TSO, Paris-Dakar Rally, Mr. Hubert Auriol; Messrs. Daniel Legrand, (Arpèges Conseil) and Daniel Bouet, Cessna pilot; the Club Meds of Les Almadies and Cap Skirring; Jean-Claude Gérin, president of Aviation Sans Frontières; Lamine Fall and Amath Kane; Commander Marie-Yvonne Magnan. Cessna pilot.

SINGAPORE: The French Armed Forces; Eurocopter Singapore; Dider Millet, Antoine Monod, Nigel Tan.

SOMALIA: HH Sheikh Saud Al-Thani of Qatar; Messrs. Majdi Bustami, E. A. Paulson and Osama, the office of of HH Sheikh Saud Al-Thani; Mr. Fred Viljoen, pilot; Mr. Rachid J. Hussein, UNESCO-Peer Hargeisa.
Somaliland; Mr. Nureldin Satti, UNESCO-Peer, Nairobi, Kenya; Mme Shadia Clot, the Sheikh's correspondent in France; Waheed, agence of voyages Al Sadd, Qatar; Cécile and Karl, Emirates Airlines, Paris.

SOUTH AFRICA: SATOUR, Mme Salomone, South African Airways, Jean-Philippe de Ravel, Victoria Junction, Victoria Junction Hotel; South African tourist Office - Karine Foraud; Airborne Camera Experts, Gert Uys. SOUTH KOREA: Miok Hong Hyung, Joon Jean-Luc Oh; Mi-Sun Park, Korean Armed Forces: Mooyeol, Kim Jongsun, Park Jean-Luc Maslin, Coopération and Cultural Action advisor, French Embassy in Seoul; Estelle Berruyer, cultural attachée, French Embassy in Séoul, Colonel Loïc Frouard, defence attaché, Frenchembassy in Seoul; Seongwoo, Yoon Chankgsik, Kim Kevin W. Madden, Colonel, US Army, Yoo Jay Kun, chairman of the defence committee.

SPAIN: SE Sr. Jesus Ezquerra, Spanish Ambassador to UNESCO: The Club Meds of Don Miguel, Cadaguès, Porto Petro and Ibiza Canaries: Tomás Azcárate y Bang, Viceconseiería of Medio Ambiente Fernando Clavijo. Protección civil de las Islas Canarias: Messrs, Jean-Pierre Sauvage and Gérard of Bercegol, Iberia; Sras Elena Valdés and Marie Mar, Spanish Tourist Office: The Basque country: the Basque regional government. Sr. Zuperia Bingen, director, Sras Concha Dorronsoro and Nerea Antia, press and communication department, of the Basque regional government, Sr. Juan Carlos Aguirre Bilbao, head of the Basque police helicopter unit (Ertzaintza) la corrida: Sra Joséfina Mariné of the Catalan Tourist Office in Paris: the staffs of the power stations of Sanlucar la Mayor and Jumilla.

SWEDEN: Stine Norden.

SWITZERLAND: Thierry Lombard, Lombard Odier Darier Hentsch, Anne-Marie Koermoeller, Lombard Odier Darier Hentsch, Linda Kamal, Lombard Odier Darier Hentsch, Patrick Arluna, pilot, Thierry Fauet, pilot.

TAJIKISTAN: M. Pierre Andrieu, French Ambassador; Hakim Feresta, representative of the Aga Khan in Tadjikistan.

TAIWAN: Hélène Lai, Office of Civil Aviation of the Taïwan Ministry of Transport.

TANZANIA: Seigui (pilot)

THAILAND: Royal Forest Department, Messrs. Viroj Pimanrojnagool, Pramote Kasemsap, Tawee Nootong, Amon Achapet; NTC Intergroup Ltd, Mr. Ruhn Phiama; Mme Pascale Baret, Thaï Airways; Thai National Tourist Office, Mme Juthaporn Rerngronasa and Watcharee, Messrs. Lucien Blacher, Satit Nilwong and Busatit Palacheewa; Fujifilm Bangkok, Mr. Supoj; Club Med of Phuket; Editions Millet, Didier Millet, Laura Jeanne Gobal, Tanya Asawatesanuphab, Nicholas Grossman; General Anouk of l'Armée of the Thai Air Force; and Sasi-on Kamon.

TUNISIA: The President of the Republic, Zine Abdine Ben Ali; Office of the President, Mr. Abdelwahad; Abdallah and Mr. Haj Ali; Air Force Base of Laouina, Colonel Mustafa Hermi; TheTunisian Embassy in Paris, HE Bousnina, Ambassador, and Mr. Mohamed Fendri; Tunisian National Tourist Office, Messrs. Raouf Jomni and Mamoud Khaznadar; Editions Cérès, Messrs. Mohamed and Karim Ben Smail; Hotel The Residence, Mr. Jean-Pierre Auriol; Basma-Hôtel Club Paladien, Mr. Laurent Chauvin; Meteorological Centre, Tunis, Mr. Mohammed Allouche.

TURKEY: Turkish Airlines, Mr. Bulent Demirçi and Mme Nasan Erol; Mach'Air Helicopters, Messrs. Ali Izmet, Öztürk and Seçal Sahin, Mme Karatas Gulsah; General Aviation, Messrs. Vedat Seyhan and Faruk, pilot; The Club Meds of Bodrum, Kusadasi, Palmiye, Kemer, and Foça.

UKRAINE: Mr. Alexandre Demianyuk, Secretary General of UNESCO; Mr. A.V. Grebenyuk, director of administration of the Chernobyl exclusion zone; Mme Rima Kiselitza, attachée of Chornobylinterinform, Marie-Renée Tisné, office de protection contre les Rayonnements ionisants.

UNITED KINGDOM: England: Aeromega and Mike Burns, pilot; David Linley; Mr. Philippe Achache; Environment Agency, Messrs. Bob Davidson and David Palmer; Press Office of Buckingham Palace; Scotland: Mme Paula O'Farrel and Mr. Doug Allsop of Total Oil Marine, Aberdeen; lain Grindlay and Rod of Lothian Helicopters Ltd, Edinburgh.

UNITED STATES: Wyoming: Yellowstone National Park, Marsha Karle and Stacey Churchwell; Utah: Classic Helicopters;

Montana: Carisch Helicopters, Mr. Mike Carisch: California: Robin Petgrave, of Bravo Helicopters, Los Angeles and pilots Miss Akiko K. Jones and Dennis Smith: Mr. Fred London, Cornerstone Elementary School: Nevada: John Sullivan and pilots Aaron Wainman and Matt Evans, Sundance Helicopters, Las Vegas: Louisiane: Suwest Helicopters and Mr. Steve Eckhardt: Arizona: Southwest Helicopters and Jim Mc Phail: New York: Liberty Helicopters and Mr. Daniel Veranazza: Mr. Mike Renz, Analar helicopters, Mr. John Tauranac: Florida: Mr. Rick Cook, Everglades National Park, Rick and Todd, Bulldog Helicopters of Orlando, Chuck and Diana, Biscavne Helicopters, Miami, The Club Med of Sand Piper: Alaska: Mr. Philippe Bourseiller, Mr. Yves Carmagnole, pilot: Denver: Elaine Hood of Raytheon Polar Services Company and Karen Wattenmaker, New Orleans: the helicopter pilots of USS IWO JIMA: The American Embassy in Paris and Anne Turnacliff: Helinet Aviation Services. John Burton

URUGUAY: HE Jean-Claude Moyret, French Ambassador to Montevideo, Lieutenant General Enrique Bonelli, Air Chief Marshal of the Uruguayan Air Force; Colonel Antonio Alarcón, Director of the Uruguayan Air Force photographic and cartographic service.

VENEZUELA: Centro de Estudios y Desarrollo, Mr. Nelson Prato Barbosa; Hoteles Intercontinental; Ultramar Express; Lagoven; Imparques; Icaro, Mr. Luis Gonzales.

UZBEKISTAN: (not flown over) Uzbek Embassy in Paris, HE Mamagonov, Ambassador, and Mr. Djoura Dekhanov, First Secretary; HE Jean Claude Richard, French Ambassador to Uzbekistan, and Mr. Jean-Pierre Messiant, First Secretary; Mr. René Cagnat and Natacha; Mr. Vincent Fourniau and Mr. Bruno Chauvel, Institut français d'études sur l'Asie centrale (IFEAC).

YEMEN: Khadija Al Salami of the Yemeni embassy to France; Al Shater, army communications director, Bachir Al Mohallel, guide and interpreter. We would also like to thank the various companies that have made it possible for us to carry out this work by placing orders or organizing exchanges. These include:

AEROSPATIALE: Messrs. Patrice Kreis, Roger Benguigui and Cotinaud

AOM: Mmes Françoise Dubois-Siegmund and Felicia Boisne-Noc, Mr. Christophe Cachera

CANON: Guy Bourreau, Pascal Briard, Service Pro, Messrs. Jean-Pierre Colly, Guy d'Assonville, Jean-Claude Brouard, Philippe Joachim, Raphaël Rimoux, Bernard Thomas, and of course Daniel Quint and Annie Rémy who have assisted us on frequent occasions throughout the project.

CITE DE L'IMAGE: Stéphane Ledoux, Richard Ruchon, Yann Guerlesquin, Anne-Sophie Deimat, and Olivier Jeanin

CLUB MED: Mr. Philippe Bourguignon, Mr. Henri de Bodinat, Mme Sylvie Bourgeois, Mr. Preben Vestdam, Mr. Christian Thévenet

CRIE: (world express mail), Mr. Jérôme Lepert and his staff

DIA SERVICES: Mr. Bernard Crepin

FONDATION TOTAL: Mr. Yves le Goff land his assistant Mme Nathalie Guillerme, JANJAC, Messrs. Jacques and Olivier Bigot, Jean-François Bardy, and Eric Massé

KONICA: Mr. Dominique Brugière

METEO FRANCE: Mr. Foidart, Mme Marie-Claire Rullière, Mr. Alain Mazoyer and all the forecasters

RUSH LABO: Messrs. Denis Cuisv

WORLD ECONOMIC FORUM OF DAVOS:

Dr. Klaus Schwab, Mme Maryse Zwick, and Mme Agnès Stüder

THE EARTH FROM ABOVE TEAM:

Agence Altitude: Photographic Assistants: Franck Charel, Françoise Jacquot, Sibylle d'Orgeval, Erwan Sourget, who have been with us throughout the project, not forgetting Aurélie Micquel, who joined us more recently, and all those others who were involved at different times during these years of flying: Ambre Mayen, Denis Lardat, Frédéric Lenoir, Arnaud Prade, Tristan Carné, Christophe Daguet, Stefan Christiansen, Pierre Cornevin, Olivier Jardon, Marc Lavaud, Franck Lechenet, Olivier Looren, Antonio López Palazuelo, Thomas Sorrentino.

PILOT OF THE COLIBRI EC 120 EUROCOPTER: Wilfrid Gouère, otherwise known as "Willy."

PRODUCTION COORDINATOR: Hélène de Bonis (1994-99) and Françoise Le Roch-Briquet.

SCIENTIFIC AND EDITING ADVISOR: Olivier Milhomme, from July 2006 onwards

PUBLICATION AND CAPTIONS EDITING COORDINATOR: Anne Jankeliowitch (2000–02) and Isabelle Delannoy (2002–06), Pascale d'Erm (first 6 months of 2006).

EXHIBITION COORDINATOR: Catherine Arthus-Bertrand and Agathe Moulonguet-Malègue, Marie Charvet (2003 to June 2006), Tiphanie Babinet and Jean Poderos (2002 and 2003).

PRODUCTION ASSISTANTS: Antoine Verdet, Catherine Quilichini, Gloria-Céleste Raad (Russia).

PICTURE DOCUMENTATION; Isabelle Bruneau, Isabelle Lechenet, Florence Frutoso, Claire Portaluppi. Most of the photographs in this book were taken on Fuji Velvia (50 ASA) film. Yann Arthus-Bertrand worked primarily with CANON EOS 1N camera bodies and CANON L series lenses. Some pictures were taken with a numeric Canon EOS-1 Ds Mark II with focals ranging from 24 mm to 200 mm. Others were taken with a PENTAX 645N and a FUJI GX 617 panoramic camera.

The photographs of Yann Artus-Bertrand are distributed by Altitude photo agency, Paris, France. www.altitude-photo.com

For further information, see www.yannarthusbertrand.org

GOOD Planetorg is a non-profit organization founded by Yann Arthus-Bertrand. It is dedicated to the promotion of a sustainable world that is also ecologically, socially, and economically viable.

GOODPLANET.ORG'S OBJECTIVES

- To make the world's problems clear to as many people as possible, so every one of us can contribute in some way to shaping a better future for our planet and for all living things.
- To mobilize key political and economic players, by associating them with GoodPlanet's actions and helping them to implement their own approaches to sustainable development.
- To set up programs that offer concrete responses to the perils that threaten the earth and its inhabitants.

With a view to pooling its efforts with those of other French environmental organizations, GoodPlanet.org is a member of Alliance pour la planète and Comité 21.

GOODPLANET'S INITIATIVES

www.GoodPlanet.info

This bilingual (French/English) website provides essential information covering every aspect of sustainable development and the state of the earth's environment. Also included are analyses and discussions by international experts, aimed at encouraging the general public to discuss and assess ecological initiatives on their own account. www. goodplanet.info

6 milliards d'autres (6 Billion Others)

In a sensitive, human portrait of the inhabitants of this planet, a group of video filmmakers has compiled nearly 6,000 interviews with men and women the world over, raising issues that are universal to every age and culture—family, the trials of life, happiness, war, joy, fear, laughter, and grief. A major exhibition around this theme was mounted in Paris in January 2009, which subsequently traveled to other cities in France and around the world. www.6milliardsdautres.org

Action Carbone (Carbon Campaign)

Voluntary CO_2 compensation and the reduction of greenhouse gas emissions are proven ways of combating climate change. In 2006, Yann Arthus-Bertrand set up Action Carbone with the aim of limiting the impact of his own activities on the climate. Today, with the support of

ADEME (France's Agence de l'environnement et de la maîtrise d'energie), this program helps companies, institutions, and private individuals calculate and compensate for their own greenhouse gas emissions by financing energy-efficient and renewable energy projects. Apart from CO₂ compensation, the projects backed by Action Carbone invariably bring social and economic benefits wherever they are applied, in the form of better living standards, enhanced purchasing power, and new jobs. www.actioncarbone.org

Vivants (Alive)

This free exhibition displays beautiful photography of animals and nature in juxtaposition to the appalling impact of humankind's activities on the planet—and the initiatives now under way to reverse that impact. Vivants makes us aware of a desperate state of affairs, urging a comprehensive change in our collective and private behavior to tackle it. www.goodplanet.org

Operation posters écoles (Operation School Posters)

This exhibition, which is available free of charge to all schools in France, deals with a different sustainable development issue every year. It includes a score of posters with photographs and learning texts, as part of a joint project with the French Ministère de l'Education Nationale and the Ministère de l'Ecologie, du Developpement et de l'Aménagement durable.

Children on Port-Cros

The aim of this initiative is to make it possible for children to spend part of a holiday period learning about nature and its preservation—with a view to training future generations to respect their environment. In collaboration with the French Ligue de l'enseignement, the Fédération des oeuvres laïques du Var, and the Parc national de Port Cros. Goodplanet.org offers children ten free days during which they learn the habits of protecting the environment and economizing water and energy, while they explore the island of Port-Cros in all its biodiversity. This project is to be extended throughout France, enabling thousands of children each year to discover the basic rules of world eco-citizenship.

The GoodPlanet.org Catalog: 1,000 ways to consume responsibly

This catalog, published in April 2008, offers a comprehensive list of the consumer products currently available in the form of eco-responsible materials, equipment, and services. Find new products through the catalog's blog at www. cataloguegoodplanet.org

WWW.GOODPLANET.ORG